CRITICAL THINKING ABOUT SEX, LOVE, AND ROMANCE IN THE MASS MEDIA

Media Literacy Applications

EDITED BY

Mary-Lou Galician
Arizona State University

Debra L. Merskin
University of Oregon

LEA LAWRENCE ERLBAUM ASSOCIATES, PUBLISHERS

2007 Mahwah, New Jersey London

CRITICAL THINKING
ABOUT SEX, LOVE, AND ROMANCE
IN THE MASS MEDIA

Senior Acquisitions Editor: Linda Bathgate
Senior Assistant Editor: Karin Wittig-Bates
Cover Design: Tomai Maridou
Full-Service Compositor: MidAtlantic Books & Journals, Inc.

This book was typeset in 10/12 pt. Goudy Old Style, Italic, Bold, and Bold Italic, with Americana and Goudy Handtooled.

Lawrence Erlbaum Associates, Inc., Publishers
10 Industrial Avenue
Mahwah, New Jersey 07430
www.erlbaum.com

CIP information for this volume can be obtained from the Library of Congress

ISBN 978-0-8058-5615-6 (case)
ISBN 978-0-8058-5616-3 (paper)

Books published by Lawrence Erlbaum Associates are printed on acid-free paper, and their bindings are chosen for strength and durability.

Printed in the United States of America
10 9 8 7 6 5 4 3 2 1

Contents

Part III Conflict

Appendix

ALTERNATE CONTENTS: CHAPTERS BY MASS MEDIUM

Television

Recorded Music

Internet

Appendix

Preface

Although much has been written about how women are depicted in the media and an increasing body of literature addresses portrayals of men in the mass media, little scholarship has focused on how romantic coupleship is represented across the entire media spectrum (books, newspapers, magazines, popular music recordings, movies, television, and the Internet) and all three major media functions (entertainment, advertising, and news/information).

That is why I wrote the first book to do so: *Sex, Love, and Romance in the Mass Media: Analysis and Criticism of Unrealistic Portrayals and Their Influence* (Galician, 2004). Honored as a Recommended Resource by the Center for Media Literacy, the textbook is in wide use in mass media courses and interpersonal courses around the country. It is centered around the 12 mass media myths and stereotypes of my popular *Dr. FUN's Mass Media Love Quiz*©* and the corresponding 12 "antidotes" to these myths and stereotypes—*Dr. Galician's Prescriptions*© (Rxs) for healthy coupleship, which summarize research-based and reality-based relational strategies that are seldom portrayed by the mass media.

While conducting national workshops for instructors who use my media literacy textbook and traveling around the country giving *Realistic Romance*® presentations and leading seminars, I was heartened to learn that other scholars and teachers were very interested in actively participating in my "mission" to bring media literacy skills to bear on the problems of what I call "The Romanticization of Love in the Mass Media." I also discovered that these diverse individuals had their own fascinating perspectives, approaches, and experiences to share.

Dr. Debra Merskin of the University of Oregon, one of the first adopters of my textbook, was one of these committed and creative individuals. After an extended long-distance correspondence about a variety of media literacy issues to which we are both committed, we met face-to-face at the 2002 national convention of the Association for Education in Journalism and Mass Communication

*I earned the nickname "**Dr. FUN**" (by which I am affectionately and widely known) because of the trademarked musical motivation program I created: *FUN-dynamics!*®—*The FUN-damentals of DYNAMIC Living.* ("FUN" is my acronym for "Fire Up Now!") For many years, I helped individuals and institutions nationwide beat burn-out, the blues, and the bad news—and get Fired Up Now!

(AEJMC) in Miami Beach. We became fast friends as well as colleagues, and a few months later—prior to creating her own sex, love, and romance in the mass media course at the University of Oregon—Debra attended my teaching workshop at the 2002 national convention of the National Communication Association (NCA) in New Orleans. Both of us were impressed and inspired by the variety of unique concepts that the workshop attendees described for the development of their classes based on my book as well as for their own related research.

It was Debra who immediately suggested (insisted!) that we work together to produce a second book on this important topic that would incorporate a variety of these individualized approaches. From our national call for chapters exploring one or more of the 12 myths/stereotypes of the *Quiz* and the 12 *Rxs*, we were able to accept 24 outstanding original chapters whose 30 authors range from established academics to promising graduate students. We are especially pleased with and proud of this exciting mix, which brings together (as one reviewer noted) welcome "fresh voices" as well as seasoned veterans. These authors discuss the myths/stereotypes and prescriptions without being bound to or by them. Rather, the myths/stereotypes and prescriptions serve as a common starting point for each chapter to address specific questions and problems.

The result is an anthology of thematically related but highly individualized chapters. Consequently, *Critical Thinking About Sex, Love, and Romance in the Mass Media: Media Literacy Applications* can be used as a supplementary companion to my textbook, as a stand-alone textbook, or as a research and reference volume.

For students and their instructors, each chapter provides study questions and recommended exercises. For researchers, theory-based critiques with extensive bibliographies serve as significant sources. And Debra's concluding chapter of resources offers additional material useful for anyone interested in this subject matter. Our contributors represent a rich diversity of theoretical perspectives (e.g., cultural/critical, feminist, and descriptive) and methodological approaches (quantitative and qualitative)—all with a media literacy foundation that goes beyond the study of media effects and promotes critical thinking and action.

In all media literacy studies, engagement is the goal. Thanks to the relevance of critical thinking about sex, love, and romance to our lives as students, teachers, scholars, and human beings, we believe that every chapter in this volume invites readers to become activists for media consumer empowerment. As one of our students remarked (and as many have echoed): "Finally, a class that's relevant to my life now!"

ACKNOWLEDGMENTS

Both Debra and I extend our deepest thanks to our students, from whom we learn so much. I also thank my workshop attendees, program audiences, and seminar participants for their inspiring insights.

We have the deepest appreciation of and admiration for Linda Bathgate, our marvelous Editor at Lawrence Erlbaum Associates (who was also the editor of *Sex, Love, and Romance in the Mass Media*). It is a joy to work with her and with her most capable and congenial assistant, Karin Wittig Bates, who was always helpful and highly efficient.

We are grateful to the anonymous reviewers, whose generous and enthusiastic support for this book was heartwarming and whose valuable suggestions gently challenged us to rethink several important details and greatly enhanced the organizational flow of the chapters.

We are honored by the passionate participation of our chapter contributors, and we are grateful for their timely attention to all our requests.

We are fortunate indeed to have had the expert editorial assistance of Debbie Macey, a gifted doctoral student at the School of Journalism and Communication at the University of Oregon, whose sharp eye never missed a needed edit and whose own writing talents are considerable.

Finally, we thank our wonderful husbands—Dr. David Natharius (Mary-Lou's) and Douglas Beauchamp (Debra's)—for modeling the Prescriptions for Realistic Romance® and for their unswerving and loving support of our mission to spread the media literacy message.

—Mary-Lou Galician
Debra L. Merskin

CHAPTER 1

"Dis-illusioning" as Discovery: The Research Basis and Media Literacy Applications of Dr. FUN's Mass Media Love Quiz© and Dr. Galician's Prescriptions©*

Mary-Lou Galician

Arizona State University, Tempe

> It's a difficult task to find anything in the media that has much to teach us about the realities of love.
>
> —Robert J. Sternberg, *Cupid's Arrow*

Whether we like to admit it or not, the mass media are powerful socialization agents that rely on simplification, distortions of reality, and dramatic symbols and stereotypes to communicate messages from which consumers learn and model many behaviors—both healthy and unhealthy (e.g., see Bandura, 1969, 1971, 1977, 1986; Galician, 1986a, 1986b; Galician & Vestre, 1987; Gerbner et al., 1986; McLuhan, 1964; McQuail, 2000; Potter, 2001; Silverblatt, 1995; Sparks, 2002). One area of social learning or cultivation from mass media concerns sexual socialization and role models for romantic coupleship. In fact, romance and mass media share a long association: The present-day notion of romance, which dates from 12th century "courtly love," was first disseminated to the masses by troubadours (precursors, in a sense, of modern mass media recording artists) and later by the early chapbooks and romance novels ("romans") of the very first mass medium—books (for example, see Hopkins, 1994).

Unfortunately, as noted in the epigraph at the beginning of this chapter—a statement by Yale University's Robert Sternberg (1998, p. 76), one of the nation's leading scholars of the psychology of love—the mass media seldom present models

*Portions of this chapter appeared in *Sex, Love, and Romance in the Mass Media: Analysis and Criticism of Unrealistic Portrayals and Their Influence* (Galician, 2004) as well as in earlier essays and presentations. This media literacy work is my "mission," so I frequently reiterate the fundamentals.

of realistic, healthy sex, love, and romance. According to Baran (1976), "If the individuals do indeed depend on the mass media for their sexual socialization, the accuracy of these media portrayals of sexual behaviors becomes critical. If their presentations are inaccurate, their effects maybe damaging" (p. 468). Laner and Russell (1995) argued that when couples have expectations based on inappropriate or counterproductive impressions from mass media, their judgment could be impaired, resulting in behavioral and/or emotional responses to each other that could be inappropriate. Unrealistic expectations about coupleship can create dysfunctional relationships, including much unhappiness and counterproductivity. Depression, abuse, and violence are among the possible outcomes.

In my own research of what I have termed "The Romanticization of Love in the Mass Media" (Galician, 1995, 1997, 2004), I have found that unrealistic attitudes are linked to both romantic and nonromantic movies as well as to men's and women's magazines focused on appearance (i.e., fashion and sports/fitness) and television (including music videos). Moreover, unrealistic expectations are linked to dissatisfaction in actual coupleship. Unrealistic expectations and stereotypes are held by large numbers of women and men. The societal and personal costs of such dysfunctions are enormous, including not merely unhappiness but also serious emotional and physical harm from depression, abuse, and violence.

THE NEED FOR RESEARCH

Losing an illusion makes you wiser than finding a truth.
—Ludwig Borne, 19th century German political writer

Because these widely held mass media myths and stereotypes can seriously diminish the personhood of individuals of both sexes and all ages (often socializing them without their knowledge and consent), it is important to study the consequences of the media's dissemination of unrealistic but normalized portrayals and of the public's adoption of these portrayals as models. Although considerable scholarly research about love has been conducted in the last two decades and a great deal of research has been conducted concerning the effects of the mass media, very little research tying these two vital areas of study has been conducted. Many researchers have examined mediated images of women, and some have studied images of men. However, when *couples* are the focus of study, the portrayals are often limited to only one medium: movies, or romance novels, or television soap operas, for example.

Since 1993, my own research and teaching have been focused on bringing media literacy perspective to the examination of unrealistic portrayals of sex, love, and romance across all of the mass media—books, newspapers, magazines, movies

(including animated features), recorded music, television and videos, and the Internet. My ongoing study encompasses portrayals of coupleship in all three primary media functions: entertainment, news/information, and advertising/ promotion. And the media consumers I study and address include males and females of all ages—from young children to senior citizens—and couples as well as singles. In addition, I have interviewed professionals in the media, in related social sciences and humanities disciplines, and in the helping professions.

Because the chapters in this book are all based on my work, which is intensely personal as well as professional and public, I believe it is important to identify my philosophy. Although I can clearly be considered a *feminist* with total allegiance to the aim of sexual equity and peer coupleships (which I believe are in the best interest of both sexes), I nevertheless prefer to describe myself as a *personist*— a term I coined to express my passionate aim and continual effort to extend equal respect, dignity, and opportunity to all persons without regard to their sex. I do not tolerate "male-bashing." Males who attend my programs and participate in my courses and seminars on The Romanticization of Love in the Mass Media are as interested in this topic as the females. It is my belief that unrealistic, mythic, and stereotypic portrayals of sex, love, and romance adversely affect males to the same degree as they affect females.

Dr. FUN's Mass Media Love Quiz©

In 1995 I was invited to appear on one of ABC-TV's national network shows to talk about my research of how mass media portrayals affect both sexes' romantic love expectations and satisfactions. To more easily and quickly communicate my complex scholarly studies to a national television audience and to help viewers assess their "romantic realism," I created my true-false *Dr. FUN's Mass Media Love Quiz©*, based on the major mass mediated myths and stereotypes that my research had uncovered. (See the numbered items in Table 1–1. The *Quiz* is also available for people to take without charge at www.RealisticRomance.com.)

The 12 myths in the *Quiz* are numbered in logical order, from the simple (#1) to the more complex (#12), and they are closely interrelated. Here is an overview:

> Myth #1 naturally connects to Myth #2 and #3: If someone is cosmically predestined for you (#1), you'll fall in love the minute you spot each other (#2), and you'll be able to "read" each other easily (#3). These three myths flow into the perfect, easy sexual relations of Myth #4. The ideal woman for these activities (models and centerfolds—a standard to which many men are now held as well) is described in Myth #5, which begins the delineation of role assignments detailed in Myth #6 (male superiority).

TABLE 1–1.
Dr. FUN's Mass Media Love Quiz© with Dr. Galician's Prescriptions (Rxs)©

1. Your perfect partner is cosmically pre-destined, so nothing/nobody can ultimately separate you.

 R_x: CONSIDER COUNTLESS CANDIDATES.

2. There's such a thing as "love at first sight."

 R_x: CONSULT your CALENDAR and COUNT CAREFULLY.

3. Your true "soul mate" should KNOW what you're thinking or feeling (without your having to tell).

 R_x: COMMUNICATE COURAGEOUSLY.

4. If your partner is truly "meant for you," sex is easy and wonderful.

 R_x: CONCENTRATE on COMMITMENT and CONSTANCY.

5. To attract and keep a man, a woman should look like a model or a centerfold.

 R_x: CHERISH COMPLETENESS in COMPANIONS (not just the COVER).

6. The man should NOT be shorter, weaker, younger, poorer, or less successful than the woman.

 R_x: CREATE CO-EQUALITY; COOPERATE.

7. The love of a good and faithful true woman can change a man from a "beast" into a "prince."

 R_x: CEASE CORRECTING and CONTROLLING; you CAN'T CHANGE others (only yourself).

8. Bickering and fighting a lot mean that a man and a woman really love each other passionately.

 R_x: COURTESY COUNTS; CONSTANT CONFLICTS CREATE CHAOS.

9. All you really need is love, so it doesn't matter if you and your lover have very different values.

 R_x: CRAVE COMMON CORE-VALUES.

10. The right mate "completes you"—filling your needs and making your dreams come true.

 R_x: CULTIVATE your own COMPLETENESS.

11. In real life, actors are often very much like the romantic characters they portray.

 R_x: (DE)CONSTRUCT CELEBRITIES.

12. Since mass media portrayals of romance aren't "real," they don't really affect you.

 R_x: CALCULATE the very real CONSEQUENCES of unreal media.

From this traditional hegemonic role assignment, it's an easy step to the Myth #7 victim-persecutor-rescuer roles from the Karpman Drama Triangle that this beautiful (#5) and subordinate woman (#6) can play in passive-aggressive fashion with any beasts who need to be fixed. (Of course, the sex roles in Myth #7 are sometimes reversed.) And it's easy to see why such couples will engage in battle-mode behavior (#8). (Myth #8 can be viewed as the other side of Myth #2: Both assert that the "proof" of love is unbridled passion.)

Many of the mis-matchings captioned by these myths are contained in the concept of Myth #9, a more complex myth about the supremacy of love, even in the face of different and opposing values. (For example, if you're preordained, what power would different values have? Further, relationships with unequal power distributions, as in Myth #6, frequently relate to values differences.) In a rational evaluation, of course, it's apparent that people with different values frequently try to change each other (#7) and wind up fighting dysfunctionally (#8).

Finally, the culminating Myth #10 essentially encompasses all nine of the earlier ones. Myth #11 adds a note about specific real people—actors and actresses—who serve as media influencers for their many fans in portrayals that enact many of the first 10 myths both in dramatic performances as characters and in their highly reported personal lives. And the final myth—Myth #12—is perhaps the most damaging myth of all: If we're unaware of the influence of the other 11 myths, we're more likely to fall under their power. (Galician, 2004, p. 116)

Although the origin of my *Quiz* was television's need for simplification, I have since used it successfully as both a practical and stimulating teaching tool and as a constructive research instrument, as have countless others. Thousands of people nationwide have taken the *Quiz* as part of my studies, in group administrations in my seminars and classes, and via my Web sites.

It is important to understand that—for the individual taking the *Quiz*—there are no "right" or "wrong" answers. You either agree or disagree with each of the 12 statements. I always say, "Don't worry: No one will grade you!" I'm not making a joke when I say this, because the purpose of the *Quiz* is *heuristic* (an educational method in which learning takes place through discoveries that result from investigations made by the learner); in other words, the *Quiz* is really a starting point for individuals and couples to begin to assess their own views and to begin to explore how mass mediated portrayals contribute to these views.

Remember also that myths and stereotypes are not necessarily or entirely false. The problem is that they are usually atypical rather than the norm, so they are poor and even dangerous as models for our real-life thoughts, feelings, or behaviors. They are often better understood metaphorically, in which case they are not apt to be as potentially harmful and can even be beneficial. (For example, we might better understand the "Beauty and the Beast" myth as a metaphor for integrating our own good and bad sides, rather than trying to change lovers we think are beastly or "bad" while presuming ourselves to be saintly and "good.")

Further, although myths and stereotypes are sometimes applicable within their originating culture and their own time, they are usually not transposable to our own modern day: They do not necessarily describe 21st century relationships.

As you use the *Quiz* and read the chapters that address different aspects of it, keep its purpose and these distinctions in mind. And be aware that not everyone answers the items honestly and that some people genuinely "agree" or "disagree" in their mind though their actual related behavior might be just the opposite.

Dr. Galician's Prescriptions© for Getting Real About Romance

The *Quiz* focuses attention on unrealistic media portrayals. However, in and of itself, it is incomplete. To conduct a complete analysis and criticism, it is crucial to compare the unrealistic portrayals against a standard that offers a healthy alternative. That is why each of the 12 mass media myths about love in the *Quiz* has a related "antidote" from *Dr. Galician's Prescriptions© for Getting Real About Romance* (see Rxs in Table 1–1), which are based on the rational models discussed in my textbook (Galician, 2004), my own research and personal experience, and the advice of other experts, including my husband, Dr. David Natharius.

The *Prescriptions* encapsulate the realistic relationship models that constitute the benchmarks for analysis and criticism of media portrayals of sex, love, and romance. They are also helpful as you seek to identify the rare media manifestations that are constructive. And the *Prescriptions* are also useful as guidelines for real-life romantic relationships.

Please note that *realistic* does not mean lowering your ideals: It is actually about raising your personal standards, as you will see when you study the Rxs. And it does not mean giving up romance—or FUN. The *Prescriptions* are about pRE-SCRIPTing unproductive and negative beliefs and behaviors with successful relational strategies.

The *Quiz* and the *Prescriptions* are at the center of my research and teaching, including the Sex, Love, and Romance in the Mass Media course I inaugurated several years ago (with 200 students per semester). They are the centerpiece of my textbook *Sex, Love, and Romance in the Mass Media: Analysis and Criticism of Unrealistic Portrayals and Their Influence* (Galician, 2004), which was honored as a Recommended Resource by The Center for Media Literacy (CML). For the book you now hold, *Critical Thinking About Sex, Love, and Romance in the Mass Media: Media Literacy Applications* (Galician & Merskin, 2006), 30 scholars wrote research-based chapters addressing the *Quiz* and *Prescriptions*.

Everything I learn from my ongoing research and teaching continues to convince me that as consumers in our 24/7 global media world, we must all learn to empower ourselves with facts and truth rather than enslaving ourselves with images and illusions.

THE NEED FOR MEDIA LITERACY APPLICATIONS

Media literacy is not so much a finite body of knowledge but rather a skill, a process, a way of thinking that, like reading comprehension, is always evolving. To become media literate is not to memorize facts or statistics about the media, but rather to raise the right questions about what you are watching, reading or listening to. At the heart of media literacy is the principle of inquiry.

—Elizabeth Thoman, "Mission Statement," *Media&Values*

As a media literacy advocate, I believe that media literacy (activist) strategies can empower media consumers (preferably, beginning at an early age) through the development of critical thinking skills. The Alliance for a Media Literate America (2004) has declared, "Being literate in a media age requires critical thinking skills, which empower us as we make decisions, whether in the classroom, the living room, the workplace, the board room or the voting booth" (n.p.).

But as a nation, we are not media literate. Unlike Canada and the United Kingdom, for example, we have not embraced media literacy education. If we— as individuals and as a society—want to empower ourselves to use the media rather than having the media use us, if we want to control our media rather than having our media control us, then we must make a serious and long-term commitment to stamping out the media illiteracy that is rampant in this nation.

The pioneering Center for Media Literacy (2004)—a nonprofit educational organization that continues to serve as a leading force in the movement—has long advocated a philosophy of "Empowerment through Education" with three intertwining concepts:

1. Media literacy is education for life in a global media world.
2. The heart of media literacy is informed inquiry.
3. Media literacy is an alternative to censoring, boycotting, or blaming "the media."

Although all three points emphasize the positive nature of media literacy education, the third point is an important caveat: It situates ultimate responsibility for informed media consumption on media consumers, and it underscores the purpose of media literacy education, which is not to prevent or reduce media usage but rather to use media wisely. I'm always amazed by parents who boast that they "don't allow" their children to watch television or use the Internet. (Of course, these are usually the same parents who think they can "trust Disney"![1]) I wonder how

[1]Parents tend to trust Disney primarily because there's no foul language or overt sexuality and the story lines seem so sweet. Although these are important factors in selecting mass media for children, what is ironic is that most parents do not bother to interrogate the insidious messages their children get from Disney's often mythic and stereotypic presentations and from Disney's unconscionable embedded sales pitches for collateral products and their hypercommercialized cross-promotions (for example, with McDonald's).

these parents make good on their threat in our 24/7 media environment. More-over, mass media—including television and the Internet—offer many genuine benefits to children and adults. Instead of imposing a "quarantine," a more en-lightened and empowering parental practice would be to provide "immunization."

One way to do that has been detailed by Elizabeth Thoman, a pioneer in the U.S. media literacy movement and the founder and president of CML, whose *CML MediaLit Kit™* (2003) provides a framework centered on *"Five Key Questions* that, if learned and applied universally by young and old, could 'change the world' by transforming the way individuals of all ages interact with and learn in today's media culture" (Thoman & Jolls, 2004, p. 24). The five questions are

1. Who created this message?
2. What creative techniques are used to attract my attention?
3. How might different people understand this message differently from me?
4. What lifestyles, values, and points of view are represented in—or omitted from—this message?
5. Why is this message being sent? (pp. 25–27)

I also believe that the attitude of the media-literate citizen–consumer should be skeptical but not cynical—and that appreciation and validation of what is good in the media must be part of the practice of media literacy. As the authors of the chapters in this book demonstrate, we can be critical as well as constructive—and still enjoy the mass media.

DR. GALICIAN'S SEVEN-STEP DIS-ILLUSIONING DIRECTIONS©

Dis-illusion comes only to the illusioned. One cannot be dis-illusioned of what one never put faith in.

—Dorothy Thompson, *The Courage to Be Happy*

From the great variety of media analysis and criticism methods and approaches, I have synthesized the common core components and added some specific strate-gies and skills of media literacy to create *Dr. Galician's Seven-Step Dis-illusioning Directions©*, which I explained in great detail in *Sex, Love, and Romance in the Mass*

I certainly do not advocate preventing children from exposure to Disney. In fact, many Disney mes-sages are positive and healthy. However, after their exposure to irrational Disney ideology and market-ing, children should be debriefed. I have provided sample debriefings in my textbook *Sex, Love, and Romance in the Mass Media: Analysis and Criticism of Unrealistic Portrayals and Their Influence* (Galician, 2004).

Media: Analysis and Criticism of Unrealistic Portrayals and Their Influence (Galician, 2004, pp. 106–112). The seven steps are

1. Detection (finding/identifying)
2. Description (illustrating/exemplifying)
3. Deconstruction (analyzing)
4. Diagnosis (evaluating/criticizing)
5. Design (reconstructing/reframing)
6. Debriefing (reconsidering/remedying)
7. Dissemination (publishing/broadcasting). (pp. 106–107)

Too frequently, formal media criticism follows a model that goes only as far as Step 4 (Diagnosis). My Seven-Step framework includes three extra steps (5, 6, and 7) that "incorporate the *Reflection* and *Action* elements of a more dynamic plan—Action Learning's Empowerment Spiral (Awareness, Analysis, Reflection, and Action), which I consider to be crucial to our work" (p. 107).

I chose the term *"dis-illusion"* as a richer synonym for analysis and criticism. The term can be a noun or a verb—and it can have a negative connotation (deprivation or destruction of dreams) or a positive connotation (freedom from unhealthy illusions). I suggest that we *dis*-illusion both our media and ourselves.

I always say: "The *dis*-illusioning process is a process of '*dis*-covery.' As such, it's creative and stimulating—and FUN!" (p. 107). I hope you will find it to be so.

DR. FUN'S STUPID CUPID & REALISTIC ROMANCE® AWARDS™

Another related "FUN" media literacy activity in which the public participates annually is my *Dr. FUN's Stupid Cupid & Realistic Romance® Awards™* for media portrayals of sex, love, and romance—announced each year on Valentine's Day. The awards are a media literacy service intended to draw attention to portrayals that are unhealthy (in other words, that illustrate the myths and stereotypes of the *Quiz*) as well as to honor those rare portrayals that illustrate the *Prescriptions* for healthy relationships. Based on nominations made through ballots on my Web sites, the panel of judges awards a Stupid Cupid for each of the 12 *Quiz* items, and a Realistic Romance® Award is made for each of the 12 *Prescriptions* (*Rxs*). A Stupidest Cupid Award is also conferred, as is a Realistic Romance® Grand Prize. Nominations can be portrayals in any medium (books, magazines, songs, television, film, and so forth), but we tend to get a lot of movies, television programs, and popular songs—because the wider audience is more familiar with them and can more easily relate to them.

The list of winners for each year (including the award citation with the reason for the award) is maintained in the Award Archives on my Web sites. Studying them is a good starting point for gaining deeper understanding of the value of the *Quiz* and the *Prescriptions* as aids in *dis*-illusioning yourselves and your media. As part of your preparation, I suggest that you visit www.Realistic Romance.com and browse through the Awards Archives before reading the in-depth *dis*-illusionings in the following 24 chapters of this book. And I hope you will submit your own nominations.

ORGANIZATION OF THIS BOOK

Although all the chapters address at least one of the myths or prescriptions, each chapter stands on its own, providing a unique perspective. A variety of accessible methodologies are used, and all the media are studied (as are all 12 myths/stereotypes and many of the prescriptions). Thus, readers can create their own ordinal organizational plan.

Nevertheless, I have purposively grouped the chapters by thematic approach and arranged them in a sequential order that offers smooth transitions.[2] In addition, this sequence tends to follow (though not slavishly) the numerical order of myths and prescriptions in terms of the major myth (or prescription) addressed—although most chapters discuss more than one in their examination of cutting-edge topics and current controversies. The myths and stereotypes are tightly intertwined, as I described above.

The Four Major Themes: Attraction, Hegemony, Conflict, and Completion

Four major themes constitute the four parts of this book. *Part I: Attraction* presents four chapters that focus on media narratives about how individuals attract each other to form a coupleship: beginning with real people's personal reports about their matches via an Internet dating site and a classic advertising campaign that featured two neighbors who flirt in their apartment building—with Myths #1 and #2 prominently portrayed—to the role of magazines in normalizing ideal sex and body images and concepts (Myths #4 and #5). The authors of the seven chapters of *Part II: Hegemony* examine mediated stories in which the central issue is the distribution of power: gender hegemony (Myth #6) or the attempt to represent equality of the sexes (Rx #6). *Part III: Conflict* covers Myths #7 (archetypal "fixing" of a partner's shortcomings), #8 ("battles of the sexes" that are supposedly

[2]I have also provided an alternate Table of Contents that groups chapters by mass medium.

the *sine qua non* of sit-coms), and #9 (foundational values misalignment), all of which are related in most of the eight chapters of this section. *Part IV: Completion* has four chapters about mediated weddings (ranging from stories of real couples featured in a variety of popular reality television programs to fictional couples in a variety of popular films—all illustrating Myth #10) and one chapter that studies how Valentine's Day markets Myth #10 (and #3) and the misery as well as the joy the day brings.

As the alternate Table of Contents shows, portrayals in television and film are the most frequent subjects of these chapters' *dis*-illlusionings (as are most of the winners of *Dr. FUN's Stupid Cupid & Realistic Romance® Awards™*)—because it is these media with which the widest audience is familiar and, therefore, these media by which this audience is most likely to be engaged.

In addition to *dis*-illusioning myths and stereotypes of the *Quiz* and, in some cases, providing instances of the rare media portrayals that illustrate the *Prescriptions*, the authors of the chapters in this book also provide stimulating *Study Questions/ Recommended Exercises* at the end of their chapters.

A brief description of each chapter follows, with some information about each author's teaching and/or research; detailed bio-sketches of the authors appear at the end of their chapters.

Part I: Attraction

Chapter 2—Cyberdating Success Stories and the Mythic Narrative of "Living Happily-Ever-After With The One"

Sharon Mazzarella, founding and lead co-editor of the journal *Popular Communication* and editor of *Girl Wide Web: Girls, the Internet, and the Negotiation of Identity*, initiates Part I with a timely and engaging chapter that details her qualitative, textual analysis of 86 "true success stories" submitted to the Match.com Web site and grounded in a mythic narrative she calls "living happily-ever-after with the one" (Myths #1, #2, and #10) that perpetuates the *Cinderella* fairy tale. That she acknowledges that she herself met "a very special man" through this very site adds to the reflexivity of her thoughtful analysis.

Chapter 3—Brewing Romance: The Romantic Fantasy Theme of the Taster's Choice "Couple" Advertising Campaign

In his rhetorical analysis of the well-known serialized advertising campaign featuring an evolving romance between two neighbors in an apartment building, advertising professor Olaf Werder discusses the "dramatic realism" within which Myth #1 and Myth #2 are at play as the advertiser attempts to transfer positive feelings about the plot into motivations to purchase a product.

Chapter 4—Promoting Easy Sex Without Genuine Intimacy: Maxim and Cosmopolitan Cover Lines and Cover Images

Internationally renowned magazine authority Sammye Johnson asks: "What happens when the *Cosmopolitan* woman meets the *Maxim* man? How are their expectations about sex, romance, and relationships shaped by the magazines they read?" In her in-depth comparative content analysis of the covers of these two similar popular magazines, she explores which one contains more cover lines with sexual content and which one more frequently portrays women as sexual objects (Myth #4 and Myth #5).

Chapter 5—What's Love Got to Do with It? Mode Readers Expose and Perpetuate Mediated Myths of Romance

Also examining issues central to Myth #5, Julie Ferris (who teaches and studies gender and beauty in the mass media) analyzed every published issue of now defunct *Mode* magazine's letters to the editor to see how its plus-sized readers both subscribed to and attempted to resist myths and stereotypes of mediated love through their engagement with one another in their epistolary forum.

Part II: Hegemony

Chapter 6—Write Romance: Zora Neale Hurston's Love Prescription in Their Eyes Were Watching God

The issue of equality (Rx #6) in the fiction and personal life of an enigmatic U.S. literary genius—who reigned as a star during the Harlem Renaissance known for its outstanding literary talents (including Langston Hughes, Claude McKay, and Dorothy West)—is the subject of a fascinating biographical *dis*-illusioning conducted by Meta G. Carstarphen, a journalism professor who spent 1997–1998 as a research fellow at The Poynter Institute for Media Studies examining how journalists cover race issues.

Chapter 7—Interracial Love on Television: What's Taboo Still and What's Not

The issue receives further scrutiny from nationally recognized media, race, and gender expert Sharon Bramlett-Solomon, who explores historical hegemony from the early days of television to the present in the tensions of mediated interracial romance, which—amazingly in the 21st century—appears to be still not ready for primetime: Despite the presence of more individuals of different races over the years, *I Love Lucy*, she finds, remains the only interracial couple to have headlined a primetime television show.

Chapter 8—*Jennifer Lopez and a Hollywood Latina Romance Film: Mythic Motifs in* Maid in Manhattan

Myth #6 and three others are dominant in the interracial and inequitable coupling of a working-class Latina with a wealthy WASP Prince Charming examined by Diana I. Rios (editor of *Brown and Black Communication*) and Xae Alicia Reyes (author of *Language and Culture in Qualitative Research*), who argue that popular films such as the one they discuss reinforce notions of justified white patriarchal power in our society. They also comment on the difficulty fans have in detaching from iconic performers who can be strong role models (Myth #11).

Chapter 9—*Myths of Sex, Love, and Romance of Older Women in* Golden Girls

Jo Anna Grant (whose research of communication and aging appears in gerontology journals) and Heather L. Hundley (whose ground-breaking study of the portrayal of beer and sex on *Cheers* has been widely cited) also focus on four myths in their thorough discursive content analysis of 37 episodes of the 1985–1992 sitcom *Golden Girls*, which has a loyal following in syndication. Although the pioneering four seniors countered stereotypes of older women on television, they nevertheless succumbed to mythic behaviors when the story lines focused on sex, love, and romance.

Chapter 10—*"Love Will Steer the Stars" and Other Improbable Feats: Media Myths in Popular Love Songs*

Anne Bader, who served as a research assistant on Art Silverblatt's *International Communication: A Media Literacy Approach* and who is a member of several national media literacy organizations, analyzed 100 popular songs (50 top songs of the 1960s and the 1990s) for the presence of each of the 12 myths of the *Quiz*. Myth #6 was the most prevalent, appearing in fully two-thirds of the love songs, and Myth #10 was next—in slightly more than half of the songs. She provides many examples of musical mythology.

Chapter 11—*Power, Romance, and the "Lone Male Hero": Deciphering the Double Standard in* The Da Vinci Code

Using a cultural studies approach that includes textual and virtual audience analysis, Christine Scodari (author of *Serial Monogamy: Soap Opera, Lifespan, and the Gendered Politics of Fantasy*) and Rhonda Trust (a doctoral student who studies the function and role of communication in romantic relationships) conclude that the *New York Times* #1 best seller that purports to decry the devaluation of women in society actually perpetuates the hegemony described by Myth #6. They

also scrutinize reader commentaries to determine whether they reflect, reproduce, and/or resist the ultimately double standard.

Chapter 12—Gender Equity Stereotypes or Prescriptions? Subtexts of the Stairway Scenes in the Romantic Films of Helen Hunt

A pioneer in gender communication and gender equity and the author of *Explorations in Visuality*, David Natharius similarly examines two cinema texts—*What Women Want* and *Dr. T and the Women*—that present themselves as feminist but that, upon a close reading, reveal themselves to be primarily stereotypic and in need of *dis*-illusioning.

Part III: Conflict

Chapter 13—Taming Brian: Sex, Love, and Romance in Queer as Folk

Employing a media literacy framework that is informed by queer theory and arguing for the importance of critical media literacy for the understanding of all relationships in the mass media, R. Anthony Slagle (who has twice chaired the National Communication Association (NCA) Caucus on Gay and Lesbian Concerns and was the founding chair of NCA's Gay/Lesbian/Bisexual/Transgender Communication Studies Division) and Gust A. Yep (who co-authored *Privacy and Disclosure of HIV in Interpersonal Relationships*, which was nominated for the 2004 International Communication Association "Book of the Year" Award, and served as lead editor of *Queer Theory and Communication: From Disciplining Queers to Queering the Discipline*[s]) analyze the relationship between Brian and Justin in the first two seasons of the show. They find that the relationship is a textbook example of Myth #7 and its Prescription, despite the heterosexual assumption of the myth's statement.

Chapter 14—Myths of Romantic Conflict in the Television Situation Comedy

To investigate whether conflict is portrayed as a sign of love, Aileen L. S. Buslig and Tony M. Ocaña (a wife-and-husband team who teach and study communication, conflict, and gender and who "almost always" have "constructive conflict") present a content analysis of conflict episodes between romantic partners in 25 modern television sitcoms appearing during a 1-week period. Myth #8 was the most prominent, along with Myth #7 and Myth #3 and, to a far lesser degree, their Prescriptions—a disturbing finding, given the ability of humor to disarm and subtly persuade.

Chapter 15—'Til Politics Do Us Part: The Political Romance in Hollywood Cinema

As a hybrid genre, Hollywood's political romance promotes the myth (#9) that romantic relationships flourish despite—and even because of—profound differences in core values. Jeanne Lynn Hall (author, with husband and colleague Ronald V. Bettig, of *Big Media, Big Money: Cultural Texts and Political Economics*) examines a variety of films from both classical and contemporary Hollywood cinema and discovers four distinct ways in which the conflict is symbolically resolved while perpetuating unrealistic and even dangerous notions about romantic love as well as trivializing or pathologizing political conviction and activism as threats to love and happiness.

Chapter 16—"Five Total Strangers, with Nothing in Common": Using Galician's Seven-Step Dis-illusioning Directions to Think Critically About The Breakfast Club

Graduate student and former high school English teacher Jennifer Hays presented an earlier version of this chapter in the first semester that I taught the course I created, Sex, Love, and Romance in the Mass Media. Using my Seven-Step *Dis*-illusioning Directions to study one of the earliest and most popular romantic teen comedies, she finds its manifestations of Myth #9 as well as Myth #8 to be disturbing as well as disturbed, especially for a teen audience.

Chapter 17—Cue the Lights and Music: How Cinematic Devices Contribute to the Perpetuation of Romantic Myths in Baz Luhrmann's Moulin Rouge

Doctoral candidate and public relations professional Amber Hutchins was also in my inaugural class, in which she presented an earlier version of her chapter, which also explores the "different values don't matter" issue, with a focus on the use of cinematic devices such as special effects and soundtrack to create an emotional atmosphere that contributes to the perpetuation of romantic myths while using a kind of shorthand of identifiable logos and music to create an emotional connection with the audience.

Chapter 18—Carpe Diem: Relational Scripts and "Seizing the Day" in the Hollywood Romantic Comedy

In a different approach to the conflict theme, Laura L. Winn, who holds degrees in psychology and family studies in addition to her doctorate in speech communication, argues that romantic movies often pose a theme of "seizing the day" in which significant relational change occurs within a single dramatic and portentous

moment. She challenges this unrealistic expectation in her analysis of popular romantic film comedies of the 1980s and 1990s.

Chapter 19—Gangster of Love?
Tony Soprano's Assault on Romantic Myths

From their close reading of five seasons of HBO's *The Sopranos*, Ron Leone (who teaches media and cinema studies and publishes research about the MPAA film ratings) and Wendy Chapman Peek (who balances the teaching and research of literature of the European Middle Ages and films of the American West) conclude that despite being criticized for stereotyping Italian Americans and women, the hit series offers insight into romantic relationships exposing conflict and communication myths as false rather than perpetuating them. They demonstrate how the show dispels these myths through the interactions of main character Tony Soprano with three prominent women in his life: wife Carmela, therapist Dr. Jennifer Melfi, and mistress Gloria Trillo.

Chapter 20—Remakes to Remember: Romantic Myths
in Remade Films and Their Original Counterparts

Jennifer J. Asenas, a doctoral candidate who studies modern myth, collective memory, narrative, and social change, analyzed three sets of films—*An Affair to Remember* (1949) and *Love Affair* (1994); both the 1961 and 1998 versions of *The Parent Trap*; and finally *The Shop Around the Corner* (1940) and *You've Got Mail* (1998)—and found that not much has evolved in these cinematic reflections of society: Remakes continue to espouse the same myths as their original counterparts.

Part IV: Completion

Chapter 21—"Must Marry TV": The Role
of the Heterosexual Imaginary in The Bachelor

Andrea M. McClanahan (whose research focuses on the alternative life choices of heterosexual women—including the choice to remain single and/or childless—and how these choices are conveyed in the media and received by society) explores how the reality television show, *The Bachelor*, perpetuates the heterosexual imaginary—or the belief that to feel complete in life one must be paired with an opposite-sexed other in a romantic relationship (Myth #10). Positioning 25 women against each other for 1 eligible, ready-to-get-married man, the show is constructed around three prominent themes conducive to the heterosexual imaginary: the competition between the 25 women for the 1 bachelor, the view that the women's lives could be more complete if only they had the

bachelor to provide for them, and the construction of the rejected bachelorettes as losers in the heterosexual imaginary.

Chapter 22—"Real" Love Myths and Magnified Media Effects of The Bachelorette

Looking at the companion show, Lisa Glebatis (a doctoral candidate who studies the rhetoric and effects of media) argues that reality romance programs such as *The Bachelorette* may even affect viewers more than purely fictitious programming because similarities to soap operas and documentaries—along with the suspense created—invite viewers to form parasocial relationships with the show's personalities and to have higher perceptions of realism.

Chapter 23—The "Reality" of Reality Television Wedding Programs

Erika Engstrom (whose research on televised weddings and gender in the mass media is widely published and who had a "spur-of-the-moment wedding at a Las Vegas wedding chapel in 1999") discusses how The Learning Channel's *A Wedding Story,* Oxygen's *Real Weddings from the Knot,* and Bravo's *Gay Weddings* might educate viewers about the details of wedding planning, but they also perpetuate widely held and often mistaken ideas about love and romance along with an idealized version of love and commitment in which the wedding serves as the high point of a romantic relationship rather than the beginning of married life.

Chapter 24—Unrealistic Portrayals of Sex, Love, and Romance in Popular Wedding Films

In a qualitative analysis of more than one dozen films that feature weddings (including the engagement, planning, wedding, and honeymoon), Kevin A. Johnson—a doctoral candidate who, in his master's thesis, examined more than 300 articles that made arguments against same-sex marriage to understand popular conceptions of the desirable characteristics of marriage (and who is married to Jennifer Asenas, another author in this book)—finds examples of all 12 myths and proposes two additional myths specific to these mediated wedding depictions.

Chapter 25—The Agony or the Ecstasy? Perceptions of Valentine's Day

Deborah Shelley, who focuses her teaching and research on issues regarding sex, love, and romance in the mass media (including perceptions of Valentine's Day and readers' responses to romance novels), examines media portrayals to determine

how they market the valentine "myth" (#10, as well as #3). She also compares individuals' Web site postings to responses of university students who were interviewed about their attitudes concerning Valentine's Day gift-giving and receiving to determine whether, and to what extent, both groups buy into the media hype surrounding the occasion, which can be met with a wide range of emotions.

Resource Guide to Sex, Love, and Romance in the Mass Media

Chapter 26—Some Additional Publications, Films, Television Shows, Songs, and Web Sites

In this final section of our book, my co-editor Debra L. Merskin—who is currently writing a book on race, gender and media and teaching courses in communication and cultural studies; media and society; sex, love, romance, and media; and girl culture and the media—offers some additional resources for teachers, students, and researchers: nonfiction books and scholarly journal articles that could be used as supplemental readings or research sources; samples of films with weddings; television shows that illustrate myths and stereotypes about sex, love, and romance; and popular songs that can be used for study or for creating classroom atmosphere. Also included are media literacy Web sites and—"just for fun," notes Debra—a few related fiction and popular books.

CONTINUING THE CONVERSATION

Connecting with these outstanding and exciting writers, researchers, and teachers who genuinely care about media literacy and its ability to empower us all has been a great joy. Some were longtime colleagues (and even a husband); others are new friends. We would be delighted to hear from you[3]—students, teachers, or researchers—as we enlarge the circle of media literacy advocates who recognize the dangers of believing in Myth #12 ("Since mass media portrayals of romance aren't "real," they don't really affect you.") and the value of adopting Rx #12 ("Calculate the very real consequences of unreal media.") (Galician, 2004, p. 55).

REFERENCES

Alliance for a Media Literate America. (2004). *What is media literacy?* Retrieved June 9, 2004, from http://www.amlainfo.org/home/media-literacy.

[3]Please feel welcome to email me: DrFUN@RealisticRomance.com or DrFUN@asu.edu.

Bandura, A. (1969). *Principles of behavior modification.* New York: Holt, Rinehart & Winston.

Bandura, A. (Ed.). (1971). *Psychological modeling: Conflicting theories.* New York: Aldine-Atherton.

Bandura, A. (1977). *Social learning theory.* Englewood Cliffs, NJ: Prentice-Hall.

Bandura, A. (1986). *Social foundations of thought and action: A social cognitive theory.* Englewood Cliffs, NJ: Prentice-Hall.

Baran, S. J. (1976). How TV and film portrayals affect sexual satisfaction in college students. *Journalism Quarterly, 53,* 468–473.

Center for Media Literacy. (2003). *CML MediaLit Kit™: A framework for learning and teaching in a media age.* Retrieved June 9, 2004, from http://www.medialit.org

Center for Media Literacy. (2004). *About CML.* Retrieved June 9, 2004, from http://www.medialit.org/about_cml.html#edphil

Galician, M.-L. (1986a). "Good news" and "bad news" in the mass media: Television viewers' comparisons of magazines, newspapers, radio, and television. *Southwestern Mass Communication Journal, 2*(1), 52–64.

Galician, M.-L. (1986b). Perceptions of good news and bad news on television. *Journalism Quarterly, 63,* 611–616.

Galician, M.-L. (1995, October). *The romanticization of love in the mass media: A comparison of the relationship among unrealistic romantic expectations, ideal role models, heterosexual coupleship satisfaction, and mass media usage of Baby Boomers and Generation Xers.* Paper presented at the annual meeting of The Organization for the Study of Communication, Language, and Gender, Minneapolis/St. Paul, MN.

Galician, M.-L. (1997, February). *The romanticization of love in the mass media: The relationship of mass communication media usage, unrealistic romantic expectations, coupleship dissatisfactions of Baby Boomer and Generation X males and females.* Paper presented at the annual meeting of the Western States Communication Association, Monterey Bay, CA.

Galician, M-L. (2004). *Sex, love, and romance in the mass media: Analysis and criticism of unrealistic portrayals and their influence.* Mahwah, NJ: Lawrence Erlbaum Associates.

Galician, M.-L., & Vestre, N. D. (1987). Effects of "good news" and "bad news" on TV newscast image and community image. *Journalism Quarterly, 64,* 399–405, 525.

Gerbner, G., Gross, L., Morgan, M., & Signorielli, N. (1986). Living with television: The dynamics of the cultivation process. In J. Bryant & D. Zillmann (Eds.), *Perspectives on media effects* (pp. 17–40). Hillsdale, NJ: Lawrence Erlbaum Associates.

Hopkins, A. (1994). *The book of courtly love: The passionate code of the troubadours.* New York: HarperSanFrancisco.

Laner, M. R., & Russell, J. N. (1995). Marital expectations and level of premarital involvement: Does marriage education make a difference? *Teaching Sociology, 23,* 1–7.

McLuhan, M. (1964). *Understanding media: The extensions of man.* New York: McGraw-Hill.

McQuail D. (2000). *McQuail's mass communication theory: An introduction* (4th ed.). Thousand Oaks, CA: Sage.

Potter, W. J. (2001). *Media literacy* (2nd ed.). Thousand Oaks, CA: Sage.

Silverblatt, A. (1995). *Media literacy: Keys to interpreting media messages.* Westport, CT: Praeger.

Sparks, G. G. (2002). *Media effects research: A basic overview.* Belmont, CA: Wadsworth.

Sternberg, R. J. (1998). *Cupid's arrow: The course of love through time.* New York: Cambridge University Press.

Thoman, E., & Jolls, T. (2004). Media literacy—A national priority for a changing world. *American Behavioral Scientist, 48,* 18–29.

Dr. Mary-Lou Galician (The Original "Dr. FUN")—a media literacy advocate who lectures and consults nationally and internationally and is frequently interviewed and cited by the mass media—is Head of Media Analysis & Criticism in the Walter Cronkite School of Journalism & Mass Communication at Arizona State University, where she created the popular course Sex, Love, & Romance in the Mass Media. A former newspaper columnist, public television producer/director and nighttime talk show host, and national marketing and advertising executive, she earned her doctorate in 1978 from Memphis State University (now University of Memphis), with a clinical residency in Human Values & Medical Ethics from the University of Tennessee Center for the Health Sciences. She was the University Fellow in Broadcasting at Syracuse University (M.S., 1969) and a Conolly College Scholar at Long Island University (B.A., 1966), and she was named a national 2005–2006 AEJMC/ASJMC Journalism Leadership in Diversity (JLID) Fellow.

Dr. Galician is the author of Sex, Love, and Romance in the Mass Media: Analysis and Criticism of Unrealistic Portrayals and Their Influence, which was honored as a Recommended Resource by the Center for Media Literacy, and a forthcoming trade book for the general public, REALISTIC ROMANCE®. The centerpiece of both books is her widely used Dr. FUN's Mass Media Love Quiz©, which she has administered on national television, her Dr. Galician's Prescriptions©, and her Dr. Galician's Seven-Step Dis-illusioning Directions©. Her Dr. FUN's Stupid Cupid & Realistic Romance® Awards™ for mass media portrayals of sex, love, and romance are announced each Valentine's Day as a media literacy service.

She is also the editor of the Handbook of Product Placement in the Mass Media: New Strategies in Marketing Theory, Practice, Trends, and Ethics, and she was guest editor of a special double issue of American Behavioral Scientist (September and October 2004) that she devoted to media literacy. Her research of television's good news and bad news ("The American Dream & the Media Nightmare") has been published in Journalism Quarterly, The Journal of Mass Media Ethics, and Southwestern Mass Communication Journal. She maintains two Web sites with media literacy resources: http://www.public.asu.edu/~drfun and www.RealisticRomance.com.

With her husband, Dr. David Natharius (an expert in gender communication), she conducts Realistic Romance® seminars and workshops. They also enjoy consuming a wide variety of mass media, traveling together to romantic places around the world, and "communicating courageously."

I

ATTRACTION

CHAPTER 2

Cyberdating Success Stories and the Mythic Narrative of Living "Happily-Ever-After with the One"

Sharon R. Mazzarella

Clemson University

While doing the background research for this chapter, I looked up Galician's (2004) book, *Sex, Love, and Romance in the Mass Media: Analysis and Criticism of Unrealistic Portrayals and Their Influence*" on Amazon.com. Regular users of Amazon.com, I'm sure, are familiar with the Web site's plug that accompanies each book listing: "Customers interested in this title may also be interested in. . . ." Surprisingly, or perhaps not surprisingly, what followed, in this case, was not a list of related book titles but rather "sponsored links" to online dating sites.[1] Moreover, the tag lines of each of these sites were quite telling. Lovecave.com pronounces itself to be "the new place to meet singles!" eHarmony.com promises the opportunity to "find the love of your life today!" Similarly, FindRomance.com wants you to "fall in love for the right reasons." Although not specifically a link from Galician's book's Amazon.com listing, the online dating site Match.com promises "millions of possibilities."

Indeed, it is the prospect of finding one's soul mate from those millions of possibilities that draws many singles to online dating sites. (I do not discount the fact that countless others are drawn by the possibility of sex. In fact, some sites are devoted primarily or exclusively to such pursuits.) Of the many dating sites available, Match.com is one of, if not the largest. Begun in 1995, Match[2,3] claims it is

[1] These links are inserted by Amazon.com, which alone profits from them. Book authors (in this case, Galician) have no control over this advertising.

[2] It is standard practice to refer to Match.com simply as Match, a practice I will follow in this chapter.

[3] Today, Match is owned by IAC/InterActiveCorp, a conglomerate specializing in interactive business, which also owns Ticketmaster (InterActiveCorp, 2004a). USA Networks, Inc. (USAI) acquired Match.com in May 1999 (InterActiveCorp, 2004b). In June 2003, USAI was renamed InterActiveCorp., and today, Barry Diller is Chairman and Chief Executive Officer of the corporation (InterActiveCorp, 2004c), which lists as assets Home Shopping Network (HSN), Expedia, Hotels.com, Ticketmaster, Match.com, and Lending Tree among others (InterActiveCorp, 2004a).

"responsible for arranging hundreds of thousands of relationships for its members" (Match.com, 2004a). According to the site, in 2003, "more than 89,000 Match .com members reported they found the person they were seeking" (Match.com, 2004a). Indeed, I am one of them. Yes, in the digital age, 40-something-year-old, mild-mannered college professors have been known to turn to the Internet in their search for love and romance.

As a media studies scholar, I am, as I go about the business of my daily life, continuously analyzing assorted cultural artifacts and phenomena. I can't help it. It is rooted in years of academic training. My personal experiences during the several months I spent as a member of Match spilled over into my professional interests, and I found myself mentally deconstructing everything from the marketing of the site, to the "profiles" written by members (loosely similar to newspaper personal ads), to the members' photos.

Although studies of newspaper personal ads have been conducted since the 1980s (see, for example: Epel, Spanakos, Kasl-Godley, & Brownell, 1996; Goode, 1996; Hayes, 1995; Jagger, 2001; Koestner & Wheeler, 1988; Merskin, 1995; Merskin & Huberlie, 1996), serious academic scrutiny of online dating sites is just beginning, and those studies have, for the most part, focused on the content of member profiles (see, for example, Hatala, Milewski, & Baack, 1999; Small, 2004; van Acker, 2001).

Yet, despite their derivation from newspaper personal ads, even a quick glance at these sites provides evidence that they are "not just newspaper personals transferred online" (Orr, 2004, p. x). An Australian study examining a range of opportunities for meeting people on the Internet (dating services, personal ads, and chat rooms) concluded that "websites offer contradictory possibilities for romantic rituals and intimacies" (van Acker, 2001, p. 103). Similarly, in another study of the Australian dating site, RSVP, narratives of the self presented through member profiles were examined (Small, 2004). The author concluded: "The ways in which the self is narrated through the use of online personals is structured both by the spatiality and the ordering of everyday life and the increasing intimacy of the computer/user relationship" (2004, p. 93). Although these and other studies focus on the content of member profiles, in this chapter, instead, I deconstruct the "true success stories" submitted by couples happily brought together by Match.

"MILLIONS OF POSSIBILITIES"

So, I'm walking on a treadmill at the gym a couple of months ago, flipping through the pages of a magazine, and a blurb about a guy who bills himself as "eCyrano" jumped out at me. eCyrano, a.k.a. Evan Marc Katz, a former consultant for MatchNet, had started an online consulting service "which offers essay improvement services and online dating advice" (Katz, 2003, p. xiii), all to tutor prospec-

tive online daters in "how to master the dating game and find true love online" (Katz, 2003, book jacket). In addition, his book, "*I Can't Believe I'm Buying This Book*": *A Commonsense Guide to Successful Internet Dating* (Katz, 2003) had just been published by Ten Speed Press. "What?" I asked myself. "Someone wrote an advice book about online dating?" Given that I was just starting this project, it was a book I had to order.

Again, I returned to Amazon.com only to find out that Katz's book was not the only one out there. Lo and behold, there are dozens of advice guides on Internet dating (see, for example, Abernathy & Ballard, 2004; Bacon, 2004; Fagan, 2001; Griffen, 2003). There are books specifically written for men looking to meet women online (Edgar & Edgar, 2003), a book written by a former police chief on Internet dating "safety" (Nagy, 2003), and even an online dating advice book in the ubiquitous "For Dummies" series (Silverstein & Lasky, 2004). But the books do not stop there. Reuters correspondent Andrea Orr (2004) has written what the book jacket describes as "the complete chronicle of the online dating revolution." Moreover, Ben-Ze'ev (2004) has written a scholarly treatise examining cyberlove and cybersex, published by that bastion of scholarly publications, Cambridge University Press. Clearly, online dating has become, to quote Katz (2003), "the wave of the present" (p. 1), "the new mainstream" (p. xiv).

No one can argue that online dating has, indeed, become mainstream. Katz (2003) cited statistics showing that between January 2002 and May 2003, the number of people visiting online dating Web sites jumped from 11 million to 45 million—a number that represents "over 40 percent of all the single adults in America" (p. 1). Orr reported that online dating services represent "one of the most lucrative dot-com business models" (2004, p. viii), whereas Katz labeled it "the lead paid content category on the Internet" (2003, p. xiv), with U.S. consumers spending $215 million during the first half of 2003. Match reported $185 million in revenues last year (CBS News, 2004) and boasted between 8 and 9 million members worldwide, depending on the source cited (Orr, 2004; Katz, 2003, respectively). Yet, although that may seem like a tremendous amount of people, it should be explained that one does not need to pay to be a member. Although Match charges $24.95/mo (Orr, 2004), that fee enables the user to contact others listed with the service. Yet, one can register, post a free profile/pictures, and browse the profiles of other members for free, not having to pay until desiring to actually contact someone else. Match registers approximately 55,000 new people each day in the United States (CBS News, 2004); the goal of the company, however, is to get as many of them as possible to pay the monthly fee. To that end, one strategy Match uses is to feature links to "true success stories" on its introductory pages.

I first became aware of these true success stories while browsing the introductory pages of the site, in particular a link to "Proof Match.com works" (Match.com, 2004d). At that point, users are informed: "Last year hundreds of thousands of

people met someone special on Match.com. Take a sneak peek at just a few of our exciting True Stories." Clicking on that link brings the user to a handful of true success stories, accompanied by a photo of each happy couple, an invitation to read more of each of those specific stories, or a separate invitation to read even more true stories (Match.com, 2004b). Clicking on that latter link takes users to a listing of 50 stories, where they can select from the "headlines" which stories they wish to read (Match.com, 2004e).

The headlines make announcements such as: "It couldn't have been more perfect," "I instantly knew he was the one," "I found my Prince Charming," and "What a whirlwind romance!" Ah, but those 50 are only the tip of the iceberg. Another related feature and link enable users to search for stories by category (marriage, dating, engaged, friendship, relationship, and other) (Match.com, 2004c). Specifically, users are informed:

> Our members love to share their experiences with finding someone special through Match.com. Be inspired by these true success stories of committed relationships, romantic dates, fairytale weddings, lifelong friends and newborn babies. (Match.com, 2004c)

Once in this section, clicking on "marriage," for example, will bring up all of the stories submitted by couples who met on Match and have since married. If users are so inclined, they could also search by keywords. For example, an October 2004 search using the phrase "soul mate" yielded 64 hits—an underestimate because many of those using this phrase in their stories spelled it "soulmate," a misspelling that would have resulted in those stories being missed in my "soul mate" search (pun intended). For whatever reason users might have, they could also search stories by zip code and or location. Finally, Match offers their "Top 10 Most Popular Stories" in each of the preceding categories, although the ranking criteria are nowhere to be found (Match.com, 2004c).

GETTING STARTED

Although there are hundreds of true success stories in the database, I wanted to focus on the stories that Match highlights and makes easily accessible to users. For the purpose of this chapter, then, I analyzed 49 of the 50 stories appearing after clicking on Match's link inviting me to read even more true stories. (One was a duplicate.) In addition, I analyzed all of the stories in the "top ten" listings for marriage, dating, engaged, relationship, and other. (Friendship had only two entries listed, and they were really not relevant to this project.) After removing the top ten listings that were duplicates of the original 49, a total of 86 listings comprised the entire sample. Not surprisingly, 63.95% ($n = 55$) of the original 86 sto-

...cludes with a "thank you" to Match.com for bringing the couple together... example,

Darla: Toward the end of March, I found him: my perfect match! . . . Thank you, Match.com, without you we would have never found our perfect matches. And for all you just getting started and looking for a little bit of hope and encouragement in these stories—keep at it—your perfect match is out there too!

...ve at First Sight (Myth #2)

...ese stories offer more than the possibility of finding one's soul mate online. ...ey also provide evidence that it can and will happen quickly—a phenomenon ...licican described as "right away, you know" (2004, p. 55). One's life can, to ...ote the author of one Match.com success story, be "changed overnight." Gali-...n argued that such narratives "reinforce and create unrealistic expectations" ... 129). In fact, many of these stories are accompanied by a chronology of dates: ...st e-mail, first date, date of engagement, and date of marriage. I was amazed at ...w quickly many of these couples progressed through these stages, but the fact ...at such dates were emphasized evidenced the importance placed on finding ...e quickly.

...Although not using the phrase "love at first sight," roughly half of the stories ...k about phenomena such as "an instant connection." For example, writers re-...rt how they "clicked right away," were "immediately impressed," felt "chemistry ...first sight," "fell instantly in love," "hit it off right away," "experienced imme-...ate attraction," "instantly . . . had a rapport," "knew from the beginning," "fell ...love quickly," "completely hit it off," "were attached at the hip immediately," ...d "were immediately attracted." One woman's story that she and her match ...ere not all that impressed with each other at [their] first meeting" stands in ...arp contrast to the abundance of instant connections reported.

...Two stories in particular (Emily's and Susan's) stand out for their almost fairy-...le-like, love-at-first-sight scenarios.

Emily: There are moments when the stars are aligned, the sun shines on your face, your heart beats with excitement and everything just seems to go your way. That was the mutual feeling between Will and me when we first saw each other. . . . It was magical, as corny as that sounds.

...Aware as she is that her words sound corny, Emily is sketching a scenario that ...fers hope for others who are themselves searching for their own love at first

ries were contributed by women (all heterosexual), whereas 23.25% ($n = 20$) of the stories were contributed by men (two of whom were homosexual). It was impossible to tell the sex of the authors of 11 of the stories (12.79%), either because photos were not attached and/or Match screen names were used instead of real first names. Even though the authors referred to their partners by name or sex, I didn't want to assume they were heterosexual and deduce that the writer was of the other sex. Of the 75 stories with an identifiable author sex, 73.3% ($n = 55$) were written by women and 26.7% ($n = 20$) were written by men. The fact that nearly three-quarters of the gender-identifiable sampled stories were written by women supports Galician's observation that "Little girls are conditioned to want the dream in [*Cinderella*]" (2004, p. 203). It was the female partner who took the time to write and tell of how her dream had come true.

THE MYTHIC NARRATIVE OF LIVING "HAPPILY-EVER-AFTER WITH THE ONE"

One does not need to wade through all of the hundreds of such true stories to spot the mythical narrative permeating most. In fact, it is quite easy to identify Galician's (2004) mass media myths in these stories, in particular, three interrelated myths:

- Myth #1: "Your perfect partner is cosmically predestined, so nothing/nobody can ultimately separate you." (p. 119)
- Myth #2: "There's such a thing as 'love at first sight.' " (p. 127)
- Myth #10: "The right mate 'completes you'—filling your needs and making your dreams come true." (p. 201)

Taken together, these combine to form the mythic narrative I call "living happily-ever-after with the one."

Soul Mates (Myth #1)

Galician cited the results of a Rutgers University National Marriage Project study in which 94% of respondents in their 20s agreed with the statement: "When you marry you want your spouse to be your soul mate, first and foremost" (Whitehead & Popenoe, 2001, as cited in Galician, 2004). The idea that you can find your soul mate (or "soulmate" as writers often misspelled the phrase) on Match is a common theme in these stories. Approximately half of the stories analyzed refer to this idea in some way. Phrases such as "soul mate," "Mr./Ms. Right," "The One," "man/woman of my dreams," "match made in heaven," "love of my life,"

"perfect match," "my one and only," "my true love," "meant to be," "made for each other," "the person each of us was looking for," and "what every girl wishes for" abound.

In fact, you would not even need to read the stories to find evidence of the acceptance of the soul mate myth. Often, story headlines announce: "Our soul-mate search has ended"; "I met the love of my life at 45"; "Only three streets away was the love of my life"; and "Found the love of my life!"

Many stories tell the tale of individuals who have been waiting and/or searching their whole lives for the perfect partner, a search that has ended successfully thanks to their experience on Match.

Marcia[4]**:** He is my best friend and the one I have waited for my whole life.

Sylvia: Craig was everything I had been searching for.

Janine: I had just about given up finding "Mr. Right.". . . It felt so natural to be around him that I couldn't imagine myself with anyone else. We knew from our first conversation that we wanted to be with each other forever.

Phil: I'd been searching for years for the right woman, and I finally found her very close by me. . . . It's almost like I've found a female version of myself. She is the woman I've been waiting my whole life for.

Tamara: This is the same guy that I have been dreaming about all my life! . . . I found my soul mate in him and he finally found his co-pilot.

More interesting, some writers point out their initial skepticism about potentially meeting "the one" in an online dating site. For example, Lucinda questioned whether spending her time trying to find a man while sitting alone at home on her computer was wise because she really expected to meet someone through a friend:

> I didn't want to be sitting at home and waiting for Mr. Right to come along. Well, little did I know that Mr. Right was on Match.com himself and doing the same thing I was doing! . . . Thanks, Match.com, for helping me weed through the frogs to find my Prince Charming.

She is not the only one to express her skepticism about online dating.

Julie: In February, I was flipping through Match.com on a whim, when I was startled to find John's picture and profile. He sounded and looked exactly like the man I was looking for but didn't believe existed. . . . I immediately knew from our correspondence that we looked at the world the same way;

he seemed like a guy version of me. . . . we're both tha settle for an "okay" relationship when something so w for us. . . . Despite my initial skepticism, I now s Match.com as an option for anyone really ready to mee

Miranda: Within 2 weeks, we'd fallen in love, and I ju one—he is the best of everything I could have ever wis up in a 6′1″ package! . . . If anyone had told me that I w soul mate on an internet dating site, I would have had

Roberto: We were both looking for "the one" and we d happen through Match. A month after we met, thougl our subscriptions because we were in love! . . . We kn each other. . . . Dreams come true, real love exists! If y (as we had to be), you can find true love.

It is clear that these writers have themselves subscribed to th for one's soul mate; and, in writing these stories, they are perpe probability for others using or considering using Match to f mates. In fact, some writers subtly acknowledge the mythic, far ing one's "soul mate" but offer their stories of evidence that "dre

Carla: After a few emails, I knew this was "the one." I know that, but I truly knew it! After meeting him, it was cor

Joe: I've been living a fantasy life, and I'd like to thank Mat me to meet the woman of my dreams. At 45-years-olc we're experiencing the love of our lives, and that's an ir

It is not surprising that successful Match.com daters would h tial skepticism. Despite Match's millions of users, Melanie A marketing specialist, admits there is still a stigma about using su meeting a partner through such computer-mediated means. He "help eradicate that stigma" (Orr, 2004, p. 143). Indeed, on evidence of Match's attempt to do just that in the highlighting cess stories. Moreover, it is clear that these writers are well awa ing function of their stories; that is, that Match.com is using on its Web site and in its paid advertising to entice others to bec bers of its services.[5] Just about every story, whether fitting th

[4]All author names are pseudonyms as are the names mentioned in their stories. In addition, I did not alter the authors' spelling and grammar.

[5]One link from the success story site is for members of the media. Specificall interested in how they can "use a success story in the media" to contact its public information. Of course, Match makes it very clear that it "welcome[s] press inquirie concerning Match.com's true success stories" (Match.com, 2004c).

sight experience. Yes, we all know it's corny, but Match offers her story as "proof" that it is also possible. Susan offered an even more fairy-tale-like description of her first date with her now husband:

> **Susan:** After I arrived, I was walking out to get something from my car, and we saw one another immediately. Our eyes met, we came together, and without uttering a word, he cupped my face in his hands and kissed me softly on the lips before our first word of hello. We haven't been apart one day since.

She is not alone.

> **Connie:** I was not expecting him to be everything I wanted: I was very pessimistic about finding my "true love" (probably because I never had). But when I walked into that Starbucks, we locked eyes and I don't think we looked away the entire time.

Indeed, the writing in these true success stories reads as if it had been lifted from the pages of a romance novel, complete with its struck-by-lightening narrative.

Remember, it is these stories of love at first sight that Match.com has selected to highlight on its Web site. It makes sense that Match would highlight stories of such immediate connections because, as Galician (2004) noted: "Sex sells. Emotional sells. Excitement sells. And they're far easier to portray (and simpler for audiences to follow) than the more cerebral and time-intensive processes of love" (p. 129). Indeed, the link between searching for one's soul mate and online dating has become so firmly entrenched in our culture that a recently published "how to" guide to online dating begins with a parody table of contents in which 14 of 18 chapters are titled "Looking for My Perfect Soul Mate," whereas another is titled "Still Looking for My Perfect Soul Mate," and so on (Bacon, 2004).

Happily-Ever-After (Myth #10)

According to Galician (2004, p. 203): "Many people feel vaguely incomplete without a mate, longing for someone to enter their life, sweep them off their feet, and ensure that they live happily-ever-after." Roughly half of the true success stories analyzed made some reference to this myth. The rhetoric of living happily-ever-after permeates these stories in which writers glowingly tell of looking "forward to the rest of [their] lives together," having "a wonderful and exciting life together," enjoying "a lifetime of happiness," and of "nothing but a wonderful future ahead of" them—again, all thanks to Match.com. Although none used the exact word "completion," the concept appears in many stories.

Teri: I met a man whose life seems to mirror my own. He knows what I am saying before I say it. He is so incredible, kind and handsome. I truly believe he may be what I've been missing all these years.

Sean: My wife is my life, and she defines who I am in every way. I know that she is the best thing that happened in my life and will be the most important thing in my life!

Moreover, often linked with these tales of happy endings is an acknowledgment of the important role Match played in the process.

Chiara: We're so happy, we can't imagine what life would have been like had we never met each other, and we have you to thank. He is the man of my dreams, and I have never been so happy in my life.

Juanita: Without Match.com, I might have never met my one and only, and our story of all the different chances we could have had to meet would not have had this wonderful ending. Thanks for my life time of happiness!

Charles: The rest is history! We have been joined at the hip ever since. I never knew happiness could be so enveloping. Don't give up on Match.com. It can change your life. I almost gave up, and it scares me to think that I was really close to being without her in my life.

In many cases, authors do not write of a metaphorical completion but rather of joining lives together such as the one who announces: "We've merged households, furniture, cats and clothes, and we couldn't be happier;" or the one who reports: "We joined our two souls into one. We couldn't be happier!" In fact, one writer describes Match as "a great way to meet your 'other half.'"

Initially, I was surprised at how many writers made a concluding reference to moving into a new home. Announcements of couples moving into their "dream home," "a beautiful oceanview home," or their "first house together" are plentiful. In retrospect, however, it is not all that surprising because it is the culmination of the fairy tale. It is not just the person who "completes" you but also the whole package. After all, Cinderella didn't just marry her Prince Charming. She also moved into his castle.

Although the aforementioned writers do not blatantly refer to fairy tales, romantic movies, or romance novels, others do, as they equate their successful Match experience with such mediated works of fiction. For example, the couple in the following story initially had a spur-of-the-moment civil wedding ceremony. But that was not enough to complete the fairy tale.

Ginger: The fairytale was complete when we remarried in a fantastically romantic "fairy princess" wedding on April 12 the next year. . . . Our love

was sealed with two perfect days, and now we're moving into our first home together.

But Ginger is not alone in referencing mythic romantic stories in her narrative of completion.

Jodi: I know now that all those corny romantic movies are possible. I am living the fairy tale that every little girl hopes for and every woman secretly desires. And the rest, as they say, is history, as Daniel and I began our new story together as husband and wife this past December.

Karen: Thank you, Match.com, for helping me find my Prince Charming! I couldn't have done it without you!

Liza: He really is a prince and I will be happy to spend the rest of my life with this incredible man.

MAKING SENSE OF IT ALL

The fascinating thing about applying Galician's myths and stereotypes to the analysis of online personal sites such as Match.com is that the "audience" (i.e., the writer, in this case) is directly complicit in their perpetuation. In other words, this is not an instance of some Hollywood media machine cranking out myths in their latest blockbuster movie or of some Madison Avenue agency marketing to us using images of physical perfection. No, in this instance, the users of the medium are both its producers and its audience/consumers—marketing their "successful" romantic experiences to an audience of others eager to experience the same happily-ever-after scenario.

Although I say that the users of Match.com are complicit in perpetuating these myths, it cannot be denied that they themselves have been influenced by a lifetime of exposure to mass culture's images of love, romance, dating, sex, and physical attractiveness. Moreover, those mass-produced "scripts" cannot help but affect the way they and others go about their searches for love as well as the narratives they use in their true success stories. For example, Jodi wrote:

> I got his email, and saw a quote from the movie "Serendipity" (one of my favorite movies). It caught my attention, and I decided to respond.

Of interest, Galician (2004), when discussing examples of the "soul mate" myth in media content, specifically refers to the example of the movie *Serendipity*, which "is constructed so completely on this myth that the preferred reading is explicit, if not blatant" (p. 121). Jodi's appropriation of cinematic scripts goes

further when she writes that her response to getting "the most perfect [engagement] ring" was to ask: "'What do we do now?' since they never show that part in the movies."

In a bizarre cycle, Match then appropriates these recycled narratives and applies them to their campaign to get others to subscribe to its services—and, one might add, to subscribe to the myths themselves. What better advertisement for Match than the words of one woman who likened her romance to the movies:

> **Deb:** Watching true love unfold in the movies would always make me feel so warm and deeply happy inside. That is, until the movie ended . . . and I realized it was just a movie. I mean, come on, that type of love doesn't really exist. Right? I'm thrilled to say I was wrong. That type of love does exist, and when it happens to you, it's the best love story of all.

As noted earlier, just about every true success story read for this project included some kind of thank you to Match or an acknowledgment of the role played by the site in bringing the now happy couple together. Interestingly, investing Match with the power to bring these couples together parallels Galician's point about how the evolution of our longing for completion and for a soul mate "can be understood as *cosmic*, as controlled by the gods and beyond our mental and physical control" (p. 36). Today, in our high tech, secular society, "the gods" of romance have been replaced by an Internet dating site and a guy named eCyrano.

> **Rita:** Thanks, Match.com, for a match made on Earth that feels oh so much like heaven!

STUDY QUESTIONS/RECOMMENDED EXERCISES

1. The author asserts that the writers of these true success stories are complicit in perpetuating media myths of love, dating, sex, and romance. How does this happen?

2. The author does not offer any conclusions or suggestions as to why the prevalence of these myths in these stories might be problematic. Do you find them to be problematic? Why/Why not? If yes, what might be some of the effects on potential Match.com members reading these stories?

3. Go to www.Match.com. Click on the link to success stories, and search for stories submitted in your zip code. How do they compare to the ones discussed in this chapter?

4. Go to www.Match.com. Click on the link to success stories, and, using the keyword search function, search for stories that specifically use one of the following phrases: "soul mate," "soulmate," "the one," "Prince Charming," "Mr. Right," or "Ms. Right." Deconstruct how these stories perpetuate Myth #1: "Your perfect partner is cosmically predestined, so nothing/nobody can ultimately separate you" (Galician, 2004, p. 119). (This exercise could be repeated with the other two myths discussed in this story.)

5. Go to www.Match.com. Click on the link to success stories, and read the two or three stories highlighted at that time. Rewrite the stories so as to debunk the myths in them.

6. As noted in the chapter, Match.com uses these true success stories in their advertising and allows journalists to refer to them in their articles/packages. Using the Lexis-Nexis database or some other online newspaper database, search for stories about Match.com (and/or other online dating sites) and determine whether the press perpetuates these myths in the stories about online dating

REFERENCES

Abernathy, D. D., & Ballard, N. C. (2004). *Internet dating: Find your mate in 90 days or less.* San Clemente, CA: One Dana Press.

Bacon, B. (2004). *Meet me . . . don't delete me. Internet dating: I've made all the mistakes so you don't have to!* Burbank, CA: Slapstick Publications.

Ben-Ze'ev, A. (2004). *Love online: Emotions on the Internet.* Cambridge, England: Cambridge University Press.

CBS News. (2004, August 18). *Love in the 21st century.* Retrieved August 19, 2004, from http://www.cbsnews.com/stories/2004/04/27/60II/main614019.shtml

Edgar, H. B., Jr., & Edgar, H. M., II. (2003). *The ultimate man's guide to Internet dating: The premier men's resource for finding, attracting, meeting and dating women online.* Aliso Viejo, CA: Purple Bus Publishing.

Epel, E., Spanakos, A., Kasl-Godley, J., & Brownell, K. D. (1996). Body shape ideals across gender, sexual orientation, socioeconomic status, race, and age in personal advertisements. *International Journal of Eating Disorders, 19,* 265–273.

Fagan, E. F. (2001). *Cast your net: A step-by-step guide to finding your soul mate on the Internet.* Boston: The Harvard Common Press.

Galician, M.-L. (2004). *Sex, love, and romance in the mass media: Analysis and criticism of unrealistic portrayals and their influence.* Mahwah, NJ: Lawrence Erlbaum Associates.

Goode, E. (1996). Gender and courtship entitlement: Responses to personal ads. *Sex Roles: A Journal of Research, 34,* 141–169.

Griffen, R. (2003). *Internet dating: Tips, tricks & tactics.* Lawrenceville, NJ: Roman Griffin.

Hatala, M. N., Milewski, K., & Baack, D. W. (1999). Downloading love: A content analysis of Internet personal advertisements placed by college students. *College Student Journal, 33,* 124–129.

Hayes, A. F. (1995). Age preferences for same- and opposite-sex partners. *The Journal of Social Psychology, 135,* 125–133.

InterActiveCorp. (2004a). *About IAC/InterActiveCorp.* Retrieved October 10, 2004, from http://www.iac.com/about.usai/index.html

InterActive Corp. (2004b). *Corporate history/major transaction.* Retrieved October 10, 2004, from http://www.iac.com/index/overview/overview_history.html

InterActiveCorp. (2004c). *People: Board of directors.* Retrieved October 10, 2004 0/10/04, from http://www.iac.com/management.html

Jagger, E. (2001). Marketing Molly and Melville: Dating in a postmodern, consumer society. *Sociology, 35,* 39–57.

Katz, E. M. (2003). *"I can't believe I'm buying this book": A commonsense guide to successful Internet dating.* Berkeley, CA: Ten Speed Press.

Koestner, R., & Wheeler, L. (1988). Self-presentation in personal advertisements: The influence of implicit notions of attraction and role expectations. *Journal of Social and Personal Relationships, 5,* 149–160.

Match.com. (2004a). Corporate Site. Retrieved March 4, 2004, from http://corp.match.com/index/default.asp

Match.com. (2004b). *MatchScene.* Retrieved October 10, 2004, from http://match.com/match scene/articleM.aspx?articleid = 2194&sid = C9F37EF4–242B–4FD7-BF23–531768D 55D04&trackingid = 0&theme = 215&lid = 108

Match.com. (2004c). *Success.* Retrieved October 11, 2004, from http://success.match.com/

Match.com. (2004d). *Tour.* Retrieved October 10, 2004, from http://match.com/tour/tour.aspx?sid = C9F37EF4–242B–4FD7-BF23–531768D55D04&trackingid = 0&theme = 215&lid = 4

Match.com. (2004e). *True Stories.* Retrieved October 10, 2004, from http://match.com/match scene/truestories.aspx?sid = C9F37EF4–242B–4FD7-BF23–531768D55D04&trackingid = 0&theme = 215

Merskin, D. (1995). Getting personal: Daily newspaper adoption of personal advertisements. *Newspaper Research Journal, 16*(3), 75–81.

Merskin, D., & Huberlie, M. (1996). Companionship in the classifieds: The adoption of personal advertisements by the daily press. *Journalism & Mass Communication Quarterly, 73,* 219–229.

Nagy, D. J. (2003). *Dating 911: The ultimate guide to Internet dating safety.* New York: Writers Advantage.

Orr, A. (2004). *Meeting, mating, (. . .and cheating): Sex, love, and the new world of online dating.* Upper Saddle River, NJ: Reuters.

Silverstein, J., & Lasky, M. (2004). *Online dating for dummies.* Hoboken, NJ: Wiley.

Small, B. (2004). Online personals and narratives of the self: Australia's RSVP. *Convergence: The Journal of Research into New Media Technologies, 10,* 93–107.

van Acker, E. (2001). Contradictory possibilities of cyberspace for generating romance. *Australian Journal of Communication, 28,* 103–116.

Sharon R. Mazzarella *is Associate Professor in the Department of Communication Studies at Clemson University, where she teaches courses in mass media and popular culture. She received her Ph.D. from the University of Illinois in 1993. Her research focuses on youth culture and mass media, specifically the representational politics of mediated portrayals of youth. She is founding and lead co-editor of the journal* Popular Communication *(Lawrence Erlbaum Associates) and has published articles in* Popular Music and Society, Journal of Broadcasting & Electronic Media, *and* Communication Research. *She is editor of the new book series,* Mediated Youth *(Peter Lang), editor of* Girl Wide Web: Girls, the Internet, and the Negotiation of Identity *(2005, Peter Lang) and* Kid Stuff: Twenty Questions about Youth and the Media *(forthcoming, Peter Lang), and co-editor of* Growing Up Girls: Popular Culture and the Construction of Identity *(1999, Peter Lang). She currently is working on a book about marketing to young people in the new media marketplace. She thanks Match.com for helping her meet a very special man.*

CHAPTER 3

Brewing Romance: The Romantic Fantasy Theme of the Taster's Choice "Couple" Advertising Campaign

Olaf Werder
University of New Mexico

In a world of coffee commercials, in which the main question between couples in the morning was "decaf or not decaf?" the television coffee campaign of the Taster's Choice "Couple" hit like a bomb in terms of consumer attention when its first spot aired in November 1990 (Dagnoli & Bowes, 1991). Expecting to see another typical coffee spot, the TV audience witnessed the beginning of a "chaste little soap opera" (Lippert, 1991, p. 29), starring British actors Sharon Maughan and Anthony Head, that followed the romantic encounters of a man and a woman who shared a fondness for Taster's Choice coffee. These serialized commercials created a soap opera environment whose cliffhangers teased viewers into watching the next commercial to find out how the relationship would progress.

The commercials were economically successful in that they produced a 10% increase in product sales for Taster's Choice soon after they started airing (Vadehra, 1996). More than this, though, the advertising created a fervent interest in the fictive couple's life. The U.S. series was originally modeled after the very successful 1987 British campaign for Gold Blend Coffee—the brand name for Taster's Choice in the United Kingdom (Dagnoli & Bowes, 1991). There, the commercials spawned a paperback novel based on the ads entitled *Love Over Gold*. In the United States, announcements of day and time of the spots appeared in *TV Guide* so viewers would not miss an "episode." Interviewees in a random poll conducted by NBC's *Today Show* (Zucker, 1994) complimented the Hepburn-Tracy-esque interplay between the couple and declared that the spots gave viewers a hope for romance.

In and of itself, the slice-of-life approach in the advertising was not anything new. As early as the 1920s, advertisers started emphasizing consumer satisfaction via a trend called "dramatic realism" (Marchand, 1985). This style derived

from the romantic novel and was soon institutionalized in radio soap operas. Marchand (1985) argued:

> This approach intensified everyday problems and triumphs by tearing them out of humdrum routines, spot-lighting them as crucial to immediate life decisions, or fantasizing them with enhanced, luxurious social settings. In selling leisure, enjoyment, beauty, good taste, prestige, and popularity along with the mundane product, advertisers assumed that the customer was pre-sold on these satisfactions as proper rewards for the successful pursuit of the American dream. (p. 24)

What made the Taster's Choice spots particularly appealing, though, was the continuing quest for romance throughout the entire campaign. Frye (1976) interpreted the endless quest for love and romance as a "romantic dream in which we can keep losing ourselves" (p. 370). In other words, the transport of romance from episode to episode elicits an underlying rhetorical vision of the audience. Although the couple's interaction in the advertisements reflected at times more British than American norms, it was interpreted as reflective of the social and interpersonal aspirations of American consumers, something more accurately described as "social fantasy" (Bormann, 1972, p. 397).

In this chapter I provide a rhetorical analysis of how advertising tableaux can function quite similarly to biblical parables. Like a parable, advertising attempts to draw practical moral lessons from the incidents of everyday life. Similar to parables, advertising exaggerates real life to dramatize a central message and perhaps invoke a reaction. Bormann (1972, 1985), who is widely regarded as the architect of fantasy theme analysis, argued that a fantasy theme, if repeated frequently, leads to the formation of new or the reinforcement of held values among the audience without the audience's being aware of the persuasive character of the text. The reason, he stated, lies in the fact that a mass audience partakes in a larger "rhetorical vision" (Bormann, 1972, p. 399), an experience he called symbolic convergence.

Four mass-mediated myths and stereotypes from *Dr. FUN's Mass Media Love Quiz*© are perpetuated by the Taster's Choice campaign: Myth #1: "Your perfect partner is cosmically predestined, so nothing/nobody can ultimately separate you" (Galician, 2004, pp. 119–126); Myth #2: "There's such a thing as 'love at first sight'" (pp. 127–134); Myth #3: "Your true soul mate should KNOW what you're thinking or feeling (without your having to tell)" (pp. 135–142); and Myth #10: "The right mate 'completes you'—filling your needs and making your dreams come true" (pp. 201–208). I argue that the Taster's Choice campaign responded to and reinforced traditional virtues and gender roles as well as an escape into a world of ideal relationships.

THE RHETORICAL CONTEXT OF THE TASTER'S CHOICE "COUPLE' ADVERTISING CAMPAIGN

Freeze-dried coffee has been around since World War II. Nestlé S.A., the Swiss-based premier global food company, invented freeze-dried coffee in 1938, after being asked by Brazil to help find a solution to its coffee surpluses. First introduced in Switzerland in the 1940s, the new coffee product was called Nescafe. In 1967, Nestlé introduced its U.S. version under the name Taster's Choice (Bellis, 2002). However, at the time U.S.-based coffee companies, most prominently Folgers and Maxwell House, had huge market shares in the instant coffee segment, and Taster's Choice sales languished for years. To overcome the competition, Nestlé USA decided in 1990 to launch a different kind of advertising campaign.

The idea of a romantic serial originated with the London office of Nestlé's lead agency, McCann-Erickson, which had been charged to promote Nestlé's Gold Blend coffee product. Running from 1987 to 1993, the campaign increased Nestlé's U.K. coffee sales by 20% after the first 18 months and 40% overall (Dagnoli & Bowes, 1991). Moreover, articles about the couple appeared in the tabloids, and a romantic novel title, based on the couple's romantic encounters, sold more than 150,000 copies (Reichert, 2003).

Based on the success of the British series, the same concept and the same two British stage actors were chosen for the U.S. "Couple" campaign of Taster's Choice. As a matter of fact, the first two episodes were identical to their British predecessors. After the two originally British versions had aired, the third episode marked the start of a U.S.-centric version of this romance saga, focusing more on American fashion, vernacular, lifestyle, and romance behavior. The campaign was an immediate sensation in terms of popularity and sales in the United States as well. By 1993, television viewers ranked the campaign eighth in popularity among television commercials, and by 1992 sales had surpassed sales for both Folgers and Maxwell House, making Taster's Choice number one in the instant coffee segment (Reichert, 2003; Vadehra, 1996).

After 5 months and two aired episodes, write-ups had appeared in *The New York Times* and *USA Today*, and Nestlé Beverage's headquarters in San Francisco was swamped with complimentary letters. After the third episode of the campaign, as mentioned earlier, *TV Guide* started advertising the time a particular episode would air, so viewers would not miss it. The obvious success was attributed to "the modern-style, self-assertiveness of the two mid-40s career singles" (Lippert, 1991, p. 29), "sexiness of the spot" (Zucker, 1994, n.p.), and "the element of surprise adding to the appeal" (Lippert, 1991, p. 29). A female interviewee in the *Today Show* survey summarized people's feelings for the spot by saying

that "it gives you this distinct hope for romance, I think, that's wonderful" (Zucker, 1994, n.p.).

The spots gave the audience two main reasons for the appeal of modern romance: to escape and to find inspiration for freer, less constrained interpersonal relationships. In a time of vanishing open human relations in a technology-dominated, impersonal environment, confounded by a rather Puritan reaction of the then-government that was afraid of the major shifts in American society (working women, gay rights, single parents, Generation X, and technological advancements, to name a few), the campaign filled an emotional hole in viewers, quite similar to a romance novel (Vanderfeld Doyle, 1985).

THEORETICAL FRAMEWORK:
ROMANTIC FANTASY THEME

Advertising's primary task is to increase sales, market share, or recall value of products or services. But advertising also has other functions. It communicates, directly or indirectly, evaluations, norms, and propositions about matters other than the products that are to be sold (Andrén, 1978; Langholz Leymore, 1975). Therefore, advertising can be understood as a rhetorical device to shape and disseminate cultural standards (Wicke, 1988). Cawelti (1976) pointed out:

> A literary formula is a combination or synthesis of a number of specific cultural conventions with a more universal story form or archetype, a generalization of cultural themes to fulfill man's needs for enjoyment and escape. If literary formulas in advertising are reinterpreted as ways to represent and relate certain images, symbols, themes, and myths, a more rhetorical view of advertising, possessing many of the characteristics of literature or drama, can be achieved. (p. 62)

Formula can be described as an archetypal story pattern embodied in the images, symbols, themes, and myths of a particular culture. Through study of the use of symbolic forms, material reality comes to be known. In the symbolist tradition of Burke (1969) and Duncan (1962), fantasy theme analysis tries to examine the relationship between dramatic constructions and audience perception in popular art, using literary formulas or archetypes of moral fantasies (Bormann, 1972). Formulas seem to be the means through which popular art can emerge as an arena in which conflict can be addressed and resolved symbolically, possessing a social influence that makes popular art fit squarely with the role of liberal or pluralist views of the role of media in society (Bakhtin & Voloshinov, 1989).

Next to the adventure story, a popular formula in all media is the romance story, with its organization of action around the development of a love relationship, usually between a man and a woman. The *gothic romance* or *contemporary*

romance, one of the most popular present-day formulas, uses mystery as an occasion for bringing two potential lovers together, by placing temporary obstacles in the path of their relationship and ultimately making the solution of the obstacles a means for clearing up the separation between the lovers (Cawelti, 1976; Frye, 1976). The moral fantasy of the romance is that of love triumphant and permanent, overcoming all obstacles and difficulties. The formulaic romance stands in contrast to the mimetic form of the romantic tragedy, in which the lovers' love is doomed (e.g., *Romeo & Juliet*). On the contrary, the formulaic romance oftentimes ends in happy marriages or, to use Hollywood's catch phrase, happy endings.

Advertising stories by their nature as a sales force have to end on a positive note. Even the simplest, textbook-style dramas have to find a solution for their respective problem or obstacle, usually with the product as hero or answer (Schudson, 1984; Wicke, 1988). The either trite simplicity or mind-boggling entanglement of the plots is clearly formulaic, taking aside the fanciful accessories (talking objects, supernatural powers, or care-free characters).

In that respect advertising, adhering to the same principles as formula romance novels, attains its persuasive potency from repeated exposure to similar dramatic plots. Bormann (1972) pointed out that dramas including fictitious characters, if repeated frequently, could become part of an indirect suggestion to action or belief. Audiences might gradually form new attitudes or have currently held attitudes reinforced without being aware of having been persuaded. The reason might lie in the confirmation of predictable values; that is, members of a mass audience experience some emotions, actions, or beliefs jointly, as they partake of a larger reality or "rhetorical vision," an experience called *symbolic convergence* (Bormann, 1985, p. 130). When participants have shared a fantasy theme, they have come to symbolic convergence in terms of common meanings and emotions. Those can be set off by an agreed-upon cryptic symbolic cue, such as an inside joke or yet-unresolved but growing tension between two individuals. The relationship between a rhetorical vision (here, romance) and a specific fantasy theme (here, a romantic quest between two fictitious characters) explains why so much *persuasive* communication simply repeats what the audience already knows (Bormann, 1972).

In using the romance form as a formulaic fantasy archetype, advertising just responds to a general desire or need, in this case the escape into a world of ideal relationships. The romantic form distinguishes itself from romantic association within the plot. Whereas the latter employs props—such as fragrances, clothes, jewelry, or even soup—to serve as stimuli for romantic interests or savior from separation or grievance, the former puts the product in a background role to the romantic tension between the protagonists. By pulling the focus away from the fact that a product is sold, the audience is more involved in the advertising (Dagnoli & Bowes, 1991), and the product itself is transformed into an object of seduction (Zucker, 1994) or at least "Cupid" in a romantic quest, guaranteeing the evolution of the gothic romance. Emotional involvement in the story and

the product leads participants to the symbolic convergence. The advertised product itself will attain the transfigurative meaning of a cue to trigger the rhetorical vision.

ANALYSIS

Given consumers' typical passivity and lack of attention when it comes to advertisements, advertisers typically attempt to give brands specific identities. Advertisers use "readily identifiable symbols, story lines, and cultural signifiers—people and things that evoke a common meaning for many people" (Reichert, 2003, p. 218) to connect an identity with the advertised brand, and thus position the brand in consumers' minds, a process commonly known as *branding*.

One of the most striking aspects of the Taster's Choice "Couple" advertising campaign is that it used a rather unromantic and un-sexy beverage as the magic potion in a love-at-first-sight romance narrative. This version of the romantic fantasy used all the elements of the familiar soap opera on U.S. television in which the fate of the characters remains unresolved throughout multiple episodes while the sexual tension slowly increases. On average, this episodic format was rather unusual for a business vehicle that must swiftly grab attention and close the deal. However, with women as the primary shoppers for grocery products, the organization of the series along a romance novel structure primarily targeted women's fantasies.

Description of the Text

The Taster's Choice "Couple" advertising campaign began quite innocently when the first of 13 episodes was launched in November 1990. In the first 45-second spot, "Doorbell," the two characters meet for the first time. A mid-40s woman—whose name, by the way, is never revealed—interrupts her dinner party in her apartment to borrow some coffee from her neighbor, whom she has apparently not previously met and whose name we later learn is Michael. She says, "Hello. I'm sorry to bother you, but I'm having a dinner party and I've run out of coffee." From her look and demeanor, we glean that she is intrigued by her handsome neighbor. Michael responds, "Would, uh, Taster's Choice be too good for your guests?" He walks off to get the jar. When he hands it to her, she quips, "Oh, I, uh, think they could get used to it."

It's obvious that both share an immediate mutual attraction, "love-at-first-sight," so to speak. Playful conversational jousting and lighthearted double meanings hint at a barely concealed passion between the two, prompting *Newsweek* to later call them "those lusty Taster's Choice love birds" (Miller & Nayyar, 1994, p. 48). A major ingredient of each spot was its serial formula, in which, at a point

of dramatic tension, a shot of a cup of the coffee with the voice-over "Savor yourself the sophisticated taste of Taster's Choice" interrupts. Each spot also routinely ended on a cliffhanger—usually accompanied by a witty remark by one of the two actors, in which the appearance of mysterious others or unforeseen circumstances foreshadowed twists in the relationship. All this left viewers hanging until the next episode.

The subsequent episodes fleshed out in greater detail the workings of cosmic predestination (Myth #1; Galician, 2004, p. 119*ff.*), love-at-first sight (Myth #2; p. 127*ff.*), mind-reading (Myth #3; p. 135*ff.*), and completion through the other (Myth #10; p. 201*ff.*). In Episode 2, "Return," the character played by Sharon Maughan appeared at his door to replace the borrowed jar while "Michael" is entertaining a relative in his living room. The flirtatious banter ended with his apologizing for being busy at the moment but also suggesting that "perhaps some other time" they could meet. She leaves, repeating the word "perhaps."

In Episode 3, "Dinner Party," Michael shows up late to his sister's dinner party, only to find out that his neighbor is sitting at the table as well. After he takes his seat next to his attractive neighbor, she quietly asks, "Are you always this late?," to which he replies," I won't be tomorrow." "What's happening tomorrow?" she inquires. He answers, "I'm inviting you to dinner." She fakes a protest. "What makes you think, I'll accept?" The spot ends on his response, "You can't resist my coffee" (see Figure 3–1).

With only two to three episodes appearing randomly each year over the course of the entire campaign, the suspense of the possible fulfillment of the predestined relationship (When will they kiss? When will they get together?) was heightened. Besides not knowing what would happen next, the audience also did not know when it would happen. Ironically, the 1993 episode, "Kiss," which had a cathartic effect, also ended the interest of the audience in the couple's fictive life (Vadehra, 1996). In this episode, the couple connected in Paris, where Michael had gone on business. At their meeting in his hotel room, Michael says,

FIGURE 3–1. From the 1991 Taster's Choice commercial "Dinner Party." Michael invites his mysterious neighbor to dinner. (Courtesy of Nestlé USA, McCann-Erickson.)

"I got your telegram." "I just had to come to Paris," she responds. "This is won-derful . . . the view, the Taster's Choice. . .," he says. She asks, "Is that all?" "No," he replies and embraces her, giving her a tender kiss (see Figure 3–2).

The campaign's popularity faded like a stereotypical summer romance. By the end of 1996, sales for Taster's Choice had dropped, and Americans began to fall in love with Starbucks and other gourmet coffees (Vadehra, 1996). Lack of sales triggered the end of the commercial series. As a result, the romance ended in 1996 without a dramatic resolution after 7 years of tease (Reichert, 2003). In the final episode, Michael, who surprised her while her ex-husband was visiting, left abruptly and displeased. The ex-husband calls the following day to apologize to his former wife, "I'm sorry about last night." "I'm not," she interrupts. After that conversation, no more spots were produced. Lack of sales rather than enter-tainment value led to the campaign's demise, a reminder that advertising's purpose is not to entertain but to move product (Jicha, 1998).

Interpretation of the Fantasy Theme

Marchand (1985) likened the use of fantasy themes in advertising to what he la-beled a "melodramatic parable" (p. 206). This kind of "parable serves to divert at-tention away from the advertiser as interested 'seller' and toward the ad's mes-sage, well adapted of luring readers into active involvement" (p. 207). The reason for the effectiveness of this narrative of shared experience can be found in a cru-cial difference between stage plays and ads. In a play or television series, actors generally portray particular people with particular names who, in the fictive uni-verse they occupy, exist in a set of relations with other fictional characters and have a range of meanings within that world. An advertisement is not like this, be-cause it does not construct a fully fictive world. The actor or model does not play a particular person but a social type or demographic category (Schudson, 1984).

FIGURE 3–2. From the 1993 Taster's Choice commercial "Kiss." Meeting in a Paris hotel room, the Taster's Choice couple finally kisses after years of innuendoes. (Courtesy of Nestlé USA, Mc-Cann-Erickson.)

The mere fact that the two characters were barely introduced—we learned only eventually that his first name is Michael; her first name and each character's last names as well as their street, building, jobs, and hometown were never revealed—invited viewers to partake in the romantic quest. One underlying theme of this parable was the importance of first impressions. In the highly mobile society of the time in which many personal interactions were fleeting, decisions and relationships seemed arbitrary and impersonal. Faced with those anonymous social relationships, the idea of making a good first impression was important. The advertisements in a way suggest that external appearance is the best index of underlying character (Marchand, 1985).

By acting out their romantic desires in a more up-front manner than was typical for American society of the late 1980s to early 1990s, the two characters gave the audience a prompt to find inspiration for freer, less constrained interpersonal relationships. In a time of romantic paucity generated by computer impersonality, yuppie culture, and sociopolitical pressures, the Taster's Choice couple filled an emotional hole in many women (Sivulka, 2003). The campaign's fantasy appeal of the perfect romantic encounter allowed women "to extend their vision of themselves by permitting them to escape from problems in the real world and to 'try on' interesting or provocative roles" (Sivulka, 2003, p. 55).

In the romance formula the campaign used, the "crucial defining characteristic was not that it starred a woman, but that the organizing action involved the advertised product bringing two potential lovers together in a deeper, more secure relationship" (Sivulka, 2003, p. 59). The essential elements of this formula were (a) a romantic man-and-woman situation, (b) a dominant yet dormant sensuality expressed by "savoring the sophisticated taste" as key to a love-at-first-sight infatuation, and (c) the superior taste of a coffee that opened the door to social contact and potential intimacy.

More specifically, the longing for the perfect partner who is predestined to walk into our life (Myth #1, Galician, 2004, pp. 119–126) formed the backbone of this advertising campaign. From the very first encounter, each glance and innuendo exchanged between the Taster's Choice couple moved these "soul mates" a step closer to the ultimate union. Even her utterance of the word "perhaps" implied that cosmic forces rather than free will brought these two strangers together. Ironically, these cosmic forces seemed to reside in the instant coffee jar.

Intricately connected to the previous myth is the repeatedly used myth of love-at-first-sight (Myth #2; Galician, 2004, pp. 127–134). In all fairness to the Taster's Choice campaign, we have to admit that this archetypal myth of being pierced by Cupid's arrow was not exclusively created for this campaign. Many commercials (usually pitching fragrance or fashion products) play on an instant love (or lust) idea. Unlike those other campaigns though, the Taster's Choice campaign did not focus on physical arousal or infatuation but on a burgeoning romance. A good

example for this was the look of delighted surprise on the woman's face when the handsome Michael opened the door in the initial episode.

The most commonly used myth throughout the advertising campaign was the myth of being capable to read each other's mind (Myth #3; Galician, 2004, pp. 135–142). It served not only as a support element for the previous two myths (people who are meant to be know each other's thoughts), but it also allowed the campaign to keep the dialogue between the couple short and ambiguous. Recall the third episode, "Dinner Party." The conversation that ensued after Michael, who arrived late, has taken his seat next to his attractive neighbor (the only open chair, by the way) was surprisingly clipped and vague for two people who find each other attractive and are given the chance to engage in a more intimate and longer conversation. His equivocal responses ("I won't be tomorrow. You can't resist my coffee!") to her questions regarding his late arrival and his confidence in her acceptance of his invitation exemplified the mind-reading skills that should be expected between true lovers. Ultimately, the episode invited the viewers to complete the love story by using Myth #3 themselves. After Michael's quip about the irresistibility of his coffee (a more or less veiled placeholder for himself), she never provided an answer to his dinner invitation. In a sense, the commercial played on the viewers' own mind-reading dysfunction in love relationships that assumes that perfect relationships do not require good communication (Galician, 2004).

Finally, the use of the myth of completion through the other (Myth #10; Galician, 2004, pp. 201–208) can be seen as a direct result of Myth #1. This myth, which draws on people's feeling of incompleteness without a mate and their "longing for someone to enter their life, sweep them off their feet, and ensure that they live happily-ever-after" (Galician, 2004, p. 203), was best illustrated in the campaign by the (temporary) happy ending of the couple's romance in the Paris hotel room. As a matter of fact, the entire campaign is constructed to arrive at this ultimate point. What the campaign conveniently omitted was how the two lovers complete each other. Because we are never told what they do when they are not flirting over a cup of Taster's Choice, we might have a hard time answering this question. However, the overall portrayal of the two as successful singles might have rendered this point excusable and less important in the end.

Overall, the continuation of the romantic quest throughout the campaign was an important characteristic of its success. Frye (1976) described the endless romance:

> [The] linking together of a series of stories by a frame providing a unified setting (. . .); such stories do not end. They stop and very frequently can be started again. They are designed to provide a kind of idealized shadow of the continuum of our lives, an endless dream world, in which we can keep losing ourselves. (p. 370)

The transport of the romance from episode to episode served to elicit the underlying rhetoric vision of the audience. This was achieved in the campaign by a climactic cliffhanger at the end of each episode, as a key to keep the tension between the couple alive. However, it is an oversimplification to attribute the campaign's success to its episodic format, as it would neglect the fact that it did not invent the episodic format (Dagnoli & Bowes, 1991; Lippert, 1991). It would also neglect the fact that—being a TV commercial—it had various constraints, such as the 30- to 60-second corset or the reality-centered purpose. After all, it had to sell a product.

At the same time the product transformed from priced commodity to a symbol or metaphor for the couple's relationship. With this, the advertisement changed from a regular sales vehicle to a parable. The subtext of the spots, as the advertising agency's shooting director so eloquently put it, read, "I already have Taster's Choice, you big hunk of a man" (Zucker, 1994, n.p.). The jar of coffee brought the two together. The jar emerged as a fetish for seduction. The difference between the Taster's Choice campaign and others was not so much the clever use of the product within the plot. There are possibly certain characteristics of coffee as a generic commodity that distinguish it from other commodities in a way that make it more suitable for the romance formula. For instance, it personifies relaxation and enjoyment. Nonetheless, the main difference that gave this campaign a lot of attention from critics and supporters alike is the fact that the spots were basically not selling coffee but selling the possibility of instant love through the purchase of their brand of instant coffee.

In our understanding of the power of this campaign as a popular art form and accepting its more symbolic than explicitly economic message content, the text itself became appealing by "offering symbolic constructions of human experience and representing and, sometimes, resolving anxiety and conflicts, [as well as] providing a range of satisfactions to its audiences" (Swanson, 1990, p. 32).

CONCLUSIONS

In this chapter I traced advertising's form as a rhetorical formula through the application of archetypes and fantasy themes similar to other works of popular media. The example of the Taster's Choice "Couple" coffee campaign lends itself well to this purpose, as it enjoyed attention to a greater degree than the usual television commercial. Whereas the use of a literary form and series of sequential TV ads was a fresh idea for the campaign, the subsequent serialized assassination trials against the Energizer Bunny, the Bud Bowl, and Michael Jordan and Bugs Bunny of past Super Bowls are but a few examples that this tactic had gradually

become more common overall. The attention the campaign caused was observably directed toward the narrative itself.

Advertising, according to Schudson (1984), simplifies and typifies:

> It does not claim to picture reality as it is but reality as it should be. The advertisement does not so much invent social values or ideals of its own as it borrows, usurps, or exploits what advertisers take to be prevailing social values. It reminds us of beautiful moments in our own lives, or it pictures magical moments we would like to experience. (p. 221)

This also seems to be the reason that the Taster's Choice commercials were effective as a narrative propagating the romance myths (Galician, 2004) I analyzed in this chapter. They simply reinforced and exploited unrealistic romanticized attitudes about intimate relationships held by many as a result of wide circulation of these myths in the media. Operating like popular fiction, they encouraged the viewer to suspend disbelief about the perfect match and predestined love.

Both the myths of cosmic predestination (Myth #1; Galician, 2004, p. 119ff.) and love-at-first-sight (Myth #2; p. 127ff.) are a direct progeny of the classical fiction of finding the perfect partner through divine intervention. These myths appear real because viewers of media have been conditioned that "these myths convey some deeper, self-evident, and universal truths about life" (Olson, 1999, p. 108).

In taking a closer look at Myth #1 and #2 applied in the narrative, one wonders why these two neighbors have never met downstairs by the mailbox or elevator and have made small talk about something else than coffee. It also appears a bit strange that a woman hosting a dinner reception for some plain-clothed friends would walk around the apartment in a little black dress and drop earrings (indicating meticulous preparation) but forgot to stock up on after-dinner coffee. Why indeed did the cosmic forces that bring about the perfect match wait until she ran out of a rather mundane product?

Enter Myth #3, "Your true soul mate should KNOW what you're thinking or feeling (without you having to tell)" (Galician, 2004, p. 135ff.), to add the potential for conflict and drama to the plot. The sophisticated yet ambiguous banter between the couple required conflict and misunderstandings as a prerequisite for the persuasive nature of the text. This is where advertising's characteristic problem–solution approach is best applied: Ads solve someone's problem through the introduction of the company's brand. The instant coffee serves as the lifesaver in times of awkward or dramatic tension and as such becomes the code (perfectly interpreted by either partner) for the continuation of the romance.

The last myth we analyzed (Myth #10; Galician, 2004, p. 201ff.) surfaced in the long-awaited "Kiss" episode as the quasi-finale for the romance saga. Although, in general, moments idealized as a big finale in the media hardly represent

an ending but rather a beginning in real life (Galician, 2004), the viewer is left as uncertain about the future of the Taster's Choice couple given that their character development beyond a mutual taste for freeze-dried coffee was less than desirable.

As a result, this episode in which the lovers kissed marked the beginning of the end as viewers lost interest, suggesting that people are often more interested in the rising action—the "tease"—than the romantic aftermath (Reichert, 2003). Whereas people could identify with that initial excitement of meeting someone, they lost interest after the "happy ending."

Because advertising stories—unlike other popular fiction or mass media narratives—are tied to the mundane effort of selling a product, the Taster's Choice "Couple" campaign was only deemed successful in the eyes of its creators as long as the shared romance fantasy helped the viewers remember—and buy—the product. In the end, the sexual appeal of the campaign led to its ultimate doom, pointing to the fact that an ad can be as powerful a tool in creating mass media myths as any other form of fiction, but it can never overcome its ultimate purpose of having to sell a product.

STUDY QUESTIONS/RECOMMENDED EXERCISES

1.　How can myth analysis be used to critique advertisements?

2.　What influence do social values have on the success of advertising?

3.　Is advertising different from other mass media messages (music, TV shows, or movies) in its use of relationship stereotypes?

4.　Find other print or TV ads that use relationship stereotypes to sell the product.

5.　How has advertising changed in the last decades in regards to its use of sex, love, and romance themes?

REFERENCES

Andrén, G. (1978). Rhetoric and ideology in advertising: A content analysis study of American advertising. Stockholm, Sweden: Liber Förlag.

Bakhtin, M., & Voloshinov, V. (1989). Discourse in life and discourse in art. In R. C. Davis & R. Schleifer (Eds.), *Contemporary literary criticism* (pp. 48–61). New York: Longmann.

Bellis, M. (2002). Inventors: Coffee history and related innovations. Retrieved September 11, 2004, from http://inventors.about.com/library/inventors/blcoffee.htm

Bormann, E. (1972). Fantasy and rhetorical vision: The rhetorical criticism of social reality. *The Quarterly Journal of Speech, 58,* 396–407.

Bormann, E. (1985). Symbolic convergence theory: A communication formulation. *Journal of Communication, 35,* 128–138.

Burke, K. (1969). *A rhetoric of motives.* Berkeley, CA: University of California Press.

Cawelti, J. (1976). Adventure, mystery, and romance: Formula stories as art and popular culture. Chicago: University of Chicago Press.

Dagnoli, J., & Bowes, E. (1991, April 8). A brewing romance: Sexy duo perks up Taster's Choice ads. *Advertising Age, 62,* 22.

Duncan, H. (1962). *Communication and social order.* New York: The Bedminster Press.

Frye, N. (1976). *The secular scripture: A study of the structure of romance.* Cambridge, MA: Harvard University Press.

Galician, M.-L. (2004). *Sex, love, & romance in the mass media: Analysis & criticism of unrealistic portrayals & their influence.* Mahwah, NJ: Lawrence Erlbaum Associates.

Jicha, T. (1998, April 8). TV minisoap ends as Taster's Choice unveils new ad campaign Thursday. *Orlando Sun-Sentinel,* n.p.

Langholz Leymore, V. (1975). *Hidden myth: Structure & symbolism in advertising.* New York: Basic Books.

Lippert, B. (1991, May 6). A coffee break from Taster's Choice. *Adweek's Marketing Week, 32,* 29.

Marchand, R. (1985). *Advertising the American dream: Making way for modernity, 1920–1940.* Berkeley, CA: University of California Press.

Miller, A., & Nayyar, S. (1994, September 26). Ads of our lives. *Newsweek, 124,* 48.

Olson, S. (1999). *Hollywood planet: Global media and the competitive advantage of narrative transparency.* Mahwah, NJ: Lawrence Erlbaum Associates.

Reichert, T. (2003). *Erotic history of advertising.* Amherst, NY: Prometheus Books.

Schudson, M. (1984). *Advertising, the uneasy persuasion: Its dubious impact on American society.* New York: Basic Books.

Sivulka, J. (2003). Historical and psychological perspectives of the erotic appeal in advertising. In T. Reichert & J. Lambiase (Eds.), *Sex in advertising: Perspectives on the erotic appeal* (pp. 39–63). Mahwah, NJ: Lawrence Erlbaum Associates.

Swanson, D. (1990). Popular art as political communication. In R. Savage & D. Nimmo (Eds.), *Politics in familiar contexts: Projecting politics through popular art* (pp. 13–61). Norwood, NJ: Ablex.

Vadehra, D. (1996, August 5). Taster's Choice ads lose flavor with consumers. *Advertising Age, 67,* 21.

Vanderfeld Doyle, M. (1985). A fantasy theme analysis of Barbara Cartland novels. *The Southern Speech Communication Journal, 51,* 24–48.

Wicke, J. (1988). *Advertising fictions: Literature, advertisement and social reading.* New York: Columbia University Press.

Zucker, J. (Executive Producer). (1994, January 6). Report on Taster's Choice advertising campaign. *The Today Show* [Television broadcast]. New York: National Broadcasting Company.

Olaf Werder *is an assistant professor in the Department of Communication and Journalism at the University of New Mexico in Albuquerque, where he primarily teaches advertising, promotions, and organizational communication. He received a B.S. in Business from the University of Dortmund, Germany, in 1992, followed by an M.S. in Advertising from the University of Illinois in Champaign, in 1994. In 2002 he received a Ph.D. in Mass Communication from the University of Florida in Gainesville. Dr. Werder's research interests comprise the search for social influences and cultural patterns as they relate to attitudes and behavior in mass communication. He is the author of several conference papers that have also been published in* Environmental Communication Yearbook, Business Research Yearbook, The International Journal for Communication Studies, *and* Global Media Journal, *and he is a contributor to a new textbook on strategic media decisions. He currently works on Latino consumer attitude models and message frames to achieve youth health behavior and environmental consciousness. Dr. Werder is also very involved with the regional advertising and media community through guest speeches, consulting, and the establishment of an active internship and alumni relations program.*

CHAPTER 4

Promoting Easy Sex Without Genuine Intimacy: *Maxim* and *Cosmopolitan* Cover Lines and Cover Images

Sammye Johnson
Trinity University

She is 18 to 34 years old and identifies herself as one of the "millions of fun, fear-less females who want to be the best they can be in every arena of their lives" (*Cosmopolitan* Media Kit, 2004). A college-educated single woman, she has bought into the upbeat idea that "You can be it, you can do it. . . . Go for it!" (*Cosmopolitan* Media Kit, 2001). She's an avid reader of *Cosmopolitan*.

He is in the same age bracket and boasts a bachelor's involvement in "sex, sports, beer, girls, and gadgets"—words that run at the top of every issue of *Maxim* along with a photo of a scantily clad female. He depends on the magazine as his irreverent guidebook to "The *Maxim* Years . . . that magic time when everything—careers, partying, relationships—comes together. It's a time when a man knows what he wants and has the cash to make it happen" (*Maxim* Media Kit, 2001).

What happens when the *Cosmopolitan* woman meets the *Maxim* man? How are their expectations about sex, romance, and relationships shaped by the magazines they read?

UNDERSTANDING MEDIA

American media consumers at the start of the 21st century are savvy individuals. They know what to expect from various media, and they head for a specific medium to fill a specific need. Researchers of the 1920s and 1930s who studied mass media effects saw the media audience as a faceless blob, a mass of unnamed and undifferentiated nobodies (Johnson & Prijatel, 2000, p. 6). Those researchers assumed that media effects worked like a hypodermic needle or magic bullet,

injecting or shooting a message that everyone received and reacted to in the same way. By the 1970s, researchers said it was time to stop and look at audience members as individuals and to question what motivated them and why (Johnson & Prijatel, 2000, p. 6). This led media scholars to study the way in which Americans used their media and the gratifications they received from this use. Called *uses and gratifications theory*, this approach encourages researchers to focus not on the medium but on the user of that medium. Katz, Gurevitch, and Haas (1973) suggested that contemporary consumers use media to fulfill five needs: cognitive, affective, personal, social, and tension release. In particular, *Cosmopolitan* and *Maxim* provide strong personal and social uses by reinforcing certain values, by providing confidence and self-understanding, and by helping readers fit within their society. This reinforcement results in a community of readers who feel comfortable with the opinions, interpretations, and advice found in the magazines and who develop a sense of ownership of the editorial content. Magazines do not try to be all things to all people. Magazine editors target a precise niche and study the demographic and psychographic characteristics of the individuals in that narrowly defined focus group.

Agenda Setting

Not only do the readers of *Cosmopolitan* and *Maxim* identify with their respective publications, but they also accept the agenda setting that takes place through the content of those magazines. According to McCombs and Shaw (1972), the focus in agenda setting theory is on the belief that media do not tell us how to think—they tell us what to think about. Magazines act as agenda setters when they identify and frame the issues for their readers. They tell the public, in essence, that something is important and should be discussed, supported, or followed. Magazines also frame the issues addressed in their pages. The emphasis on some stories or topics over others—particularly the decision as to what is placed on the cover—leads the audience to perceive a rank order of issues (Reese, 1991). Over time, these "frames" become "the organizing principles that are socially shared and persistent over time, that work symbolically to meaningfully structure the social world" (Reese, 2001, p. 11). Thus, these frames provide myths and metaphors that shape the cultural and social expectations of readers.

On their covers and in their editorial content, *Maxim* and *Cosmopolitan* set the agenda and frame ideals of physical appearance and expectations of sexual ecstasy. According to Galician (2004)—who articulated 12 mass-mediated myths and stereotypes of sex, love, and romance—magazines often portray unrealistic ideals and expectations, including her Myth #4: "If your partner is truly meant for you, sex is easy and wonderful" (p. 51) and Myth #5: "To attract and keep a man,

a woman should look like a model or a centerfold" (p. 51). *Cosmopolitan* and *Maxim* stress sexual perfection and prefer centerfold looks, suggesting that fantastic sex is possible (if you just know what to do), and that a woman should look like a supermodel or celebrity. The result is that the relationship—or coupleship—is grounded in an unrealistic, mythological approach to romance and love.

HISTORY OF COSMOPOLITAN AND MAXIM

The historical beginnings of *Cosmopolitan* and *Maxim* are as far apart as women being from Venus and men from Mars. Yet despite their differences in background and longevity, the two magazines have arrived at the same place in terms of their appeal to a specific audience. In fact, readers of *Cosmopolitan* and *Maxim* share similar demographic traits in terms of age, education, income, and attitude. The primary difference is in gender and the expectations that go along with being male or female.

Cosmopolitan

Cosmopolitan has come a long way from its founding in 1886 as "a first-class family magazine . . . with articles on fashions, on household decoration, on cooking, and the care and management of children, etc." (Mott, 1957, p. 480). Historian Algernon Tassin (1916) described the initial magazine as "a clergyman's child . . . conservative and domestic" (p. 358). Acquired by the Hearst Corporation in 1889, *Cosmopolitan* became one of the top muckraking magazines of the late 19th and early 20th century, with forceful essays and in-your-face investigative articles about corruption in the U.S. Senate, the need for child labor laws, and bribes in city and state governments. By 1912, however, *Cosmopolitan* had dropped its muckraking tone to focus on fiction. Soon, *Cosmopolitan* was one of the leading literary magazines in the United States, with serialized novels, short stories, poetry, and travelogues. But by the early 1960s, circulation had declined, advertising was flat, and the format had grown dull.

 In one of the most amazing about-faces in magazine history, *Cosmopolitan* was remade from a staid general interest magazine into a sexy, sophisticated relationship guidebook that spoke to the newly liberated woman of the mid-1960s. The force behind that metamorphosis, Helen Gurley Brown, modeled the magazine after her successful book, *Sex and the Single Girl*. Her advice to *Cosmopolitan* readers was clear: "The fact is, if you're not a sex object, that's when you have to worry. To be desired sexually, in my opinion, is about the best thing there is" (Roberts, 1997, p. 46).

Editor-in-chief Brown called her idealized 18- to 34-year-old reader "the *Cosmo Girl*" [not to be confused with *Cosmo*'s off-shoot for teen girls, *CosmoGIRL!*[1]], and each issue featured a gorgeous, perfect model whose notable neckline either plunged to the waist or tickled the chin in see-through filmy fabric. If this sounded like a description of a *Playboy* Playmate, that image was not far from Brown's mind: "A guy reading *Playboy* can say, 'Hey, That's me.' I want my *Cosmo Girl* to be able to say the same thing" (Ouellette, 2003, p. 120). Along with cleavage and sex tips on every cover ("How to Be Very Good in Bed," "*Cosmo*'s Complete Guide to Enjoying Sex," "Secrets of Sensational Sex"), *Cosmopolitan*'s editorial content was anchored by the sex quiz and its explicit questions. That was followed by advice on improving your sex life and your appeal to men, even if he were more interested in his car than you: "Appeal to his fixation: Perfume the bedroom with an auto air freshener. Attach fuzzy dice, like tassels, to your breasts" (Carlson, 1997, p. C7).

Under Brown's leadership, *Cosmopolitan* became the best-selling young women's lifestyle magazine in the world, with 29 international editions (Carlson, 1997, p. C7). When Brown retired in 1997 at age 73, the "*Cosmo Girl*" label was dropped in favor of the "fun, fearless female" designation that currently drives the magazine. Still the leading young women's magazine after more than 30 years, *Cosmopolitan*'s formula remains provocative, titillating, and sexy. The covers continue to feature fabulously beautiful, busty women (although more celebrities than models appear now, such as Jennifer Lopez, Britney Spears, Sarah Michelle Gellar, and Brittany Murphy), and the cover lines perpetually emphasize sex ("100 Sex Tips from Guys," "Have More Fun in Bed," "7 New Pulse-Pounding Positions"). Obviously, the fun, fearless female is beautiful and bold—she does not wait for a man to make the first move, no matter what that move might be.

Today, *Cosmopolitan* is published in 26 languages and 47 international editions. It is sold in more than 100 countries, "making it one of the most dynamic brands on the planet" (*Cosmopolitan* Media Kit, 2004). In its list of the top 300 magazines, *Advertising Age* (2004) ranked *Cosmopolitan* 11th in total advertising and circulation revenue for 2003. As of December 31, 2003, *Cosmopolitan*'s total paid circulation was 2,918,062. Its nearest category competitor, *Glamour*, ranked 24th in total advertising and circulation revenue and had a total paid circulation of 2,328,846. Even more significant, *Cosmopolitan* sells out on the newsstands, issue

[1]Established in 1999 for teen girls aged 12 to 17 years, *CosmoGIRL!* was "born of the most recognized women's brand in the world, *Cosmopolitan*." *CosmoGIRL!* quickly reached a circulation of more than 1.2 million, challenging the long dominant *Seventeen* with its edgy tone, sassy attitude, and mixture of practical and puff articles. The magazine is a branding tour de force, with *CosmoGIRL!* readers being told they are "Born to Lead"—a logical prequel to becoming a "Fun, Fearless Female" (*CosmoGIRL!* Media Kit, 2004).

after issue, for full cover price; it consistently is number one in single copy sales according to the Audit Bureau of Circulations (*Cosmopolitan* Media Kit, 2004). With an enviable secondary or pass-along rate of 5.3 readers per copy, *Cosmopolitan* reaches more than 14.2 million readers every month. *Cosmopolitan* also is the number one selling title in college bookstores, as it has been for the past 23 years (*Cosmopolitan* Media Kit, 2004).

Maxim

Maxim made its American debut in 1997, one of several "lad" magazines to be exported in name and content from England. *Maxim* quickly made a splash in the men's market and in less than 2 years became the number one general interest men's lifestyle magazine in the United States. By 1999, magazine industry watchers were referring to the "*Maxim*-ization of America" and calling *Maxim* "the millennial magazine of the moment" (*Maxim* Media Kit, 2004).

In 2000, *Advertising Age* named *Maxim* the "Magazine of the Year," and in 2002, *Adweek* named it the "Hottest Magazine of the Year." Other magazines on the *Adweek* list that year were *Vanity Fair, ESPN, Good Housekeeping, Teen People, In Style, YM, Martha Stewart Living, Cooking Light,* and *Marie Claire.*

Until *Maxim*, the assumption was that guys in the highly desirable 18- to 34-year-old age group did not buy magazines. According to the *Ragan Communications Media Relations Report* (2002):

> Pictorial mags like *Playboy* and *Penthouse* were too blatant for many men to buy (at least publicly), and GQ and *Esquire* were considered too fashion-oriented and too literary, respectively. *Maxim* came into the market saying, "We're a magazine for men who don't think about anything except sex, cars, music, beer, and gadgets." *Maxim* made a smart move in deciding not to use blatant nudity in its editorial so a guy can buy it and leave it on his coffee table, and his girlfriend won't get angry at him. (n.p.)

In fact, she is likely to pick up the magazine and read it; 23% of *Maxim*'s readers are women (*Maxim* Media Kit, 2004). The magazine often has a section devoted to their letters, and the monthly "Says Her" takes a female (even occasionally feminist) point of view. Founding Editor-in-chief Keith Blanchard said women read *Maxim* because "it's a peek into the playbook" (P. Johnson, 2002, p. 3D). What distinguishes *Maxim*'s "playbook" from other men's magazines is its raunchy, frat-house sense of humor. *Maxim* mocks everyone and everything ("Monkeys & Lesbians: Eeep! Eeep! Eeep!"), including themselves ("Date Out of Your League: Pickup Tips So Good You Won't Believe Your Luck!") on the cover and inside the magazine (three pages on how to "beat the crap out of somebody" has the *Maxim* lad bashing a Gandhi look-alike).

As Blanchard (2002) explained in an address to students at the Columbia University Graduate School of Journalism's Summer Publishing Course:

> *Maxim* provides world-class sex and relationship advice. . . . The cover is necessarily shorthand, right down to the main image, which you'll notice on *Maxim* is almost never a shot of Bret Favre looking pensive. It turns out, shock of all shocks, that the most reliable way to catch a guy's eye quickly is with a sexy girl. To the wandering critic, this apparently translates to the lowest-common-denominator. But who cares? It does the job for the reader, and that's all I care about. (n.p.)

So it is not surprising to find *Maxim* cover lines such as "Unleash Her Inner Nympho," "Sex Express! How to Spot the Girl with a Condom in Her Purse," and "Jump-start Your Sex Life! We Even Show You Where to Put the Alligator Clips!"

Advertising Age (2004) placed *Maxim* 28th in total advertising and circulation gross revenue in 2003, with a circulation of 2,504,932 (p. S-6). Its pass-along rate is more than 4, for a reach of about 11.5 million readers. Although *Playboy* has a larger circulation, at 3,045,244, its revenues are considerably less, resulting in a rank of 43rd on the *Advertising Age* list. Plus, *Playboy* appeals to an older demographic, with many of the "lads" considering it to be the magazine that their fathers read. *Maxim* places third among best-selling magazines in college bookstores and is the number one men's lifestyle magazine (CSE, 2004, p. 28). Consequently, it makes sense for *Maxim* to state on the spine of every issue that it is "the best thing to happen to men since women."

Media buyers in the magazine industry have noticed the similarity between *Maxim* and *Cosmopolitan* in terms of cover designs and messages, saying the two publications have a "boyfriend and girlfriend-like relationship" (Davids, 1999, p. 16). Priya Narang, senior vice-president/media director of DeWitt Media in New York, simply stated, "*Cosmo* is like *Maxim*" (Davids, 1999, p. 16).

MAGAZINE RESEARCH REALITIES

In a special issue of the *Journal of Magazine and New Media Research* devoted to the magazine covers, I examined the paucity of published research about magazines in general from 1924–1999 in journalism and mass communication journals as well as those in such disciplines as art, sociology, and gender studies (S. Johnson, 2002). I pointed out that only a handful of articles focused on magazine cover research.

Christ and I (1985) established the significance of cover research when researching *Time* "Man of the Year" covers; we found covers give a sense of "who wields power and influence" (Christ & Johnson, 1985, p. 892). We argued that the choice of who or what to feature on the cover is not only an editorial one

but also can be studied as a social indicator of where any individual or group in society is today in terms of importance and value.

In our two studies about women appearing on the covers of *Time* magazine, Christ and I (Christ & Johnson, 1985; Johnson & Christ, 1995) illustrated the "cultural artifact" model. In summarizing our purpose for studying *Time*, we wrote:

> To investigate the covers of *Time* is to investigate an international cultural artifact. The covers, serving as benchmarks to history and culture, indicate which individual women attained power and status in their time. Additionally, the covers, with their indication of occupational status, allow researchers to see what myths or misconceptions, if any, were being communicated. (Johnson & Christ, 1995, p. 218)

Malkin, Wornian, and Chrisler (1999) analyzed covers of 21 popular men's and women's magazines ranging from *Field and Stream* to *Ms.* for gender messages related to bodily appearance. Each cover was reviewed using a checklist designed to analyze visual images and texts as well as the placement of each on the covers. They reported, "Seventy-eight percent of the covers of the women's magazines contained a message regarding bodily appearance, whereas none of the covers of the men's magazines did so" (p. 647).

Sumner (as cited in S. Johnson, 2002) explained why few scholars are attracted to studying magazine covers:

> I think the reason for the dearth of research is that designing magazine covers that work is an art and not a science. Because covers are primarily art and not text, they can't be studied by content analysis as easily as text for "positive," "negative," or "neutral" directional content. (n.p.)

Sumner also noted that scholars and professional journalists take different approaches in studying magazine covers:

> Editors and journalists assume that the cover is simply a way to sell the magazine. It never occurs to editors whether their covers are an accurate reflection of the demographics of society, of social trends, or whether they reflect any of their own political or ideological orientations. They just want to sell the magazine so they can keep their jobs and preferably get promoted to a better job. . . . Scholars from other disciplines assume that magazines are supposed to be a "cultural artifact" and in some vague way accurately reflect or influence society. It never occurs to scholars that magazines have to make money to stay in business. They think that designing a cover so that it will sell the magazine is the result of some lowly, beastly motive. (S. Johnson, 2002, n.p.)

Nevertheless, both industry and academic researchers have concluded that the cover must set the tone and personality of the magazine. They agree with former *People* managing editor and former *Time* editor James Gaines, who said, "Your

cover defines you in popular perception" (Johnson & Prijatel, 2000, p. 314). In terms of culture, then, "the most dominant cover factor is the image. Most people remember the image and who was on the cover the last time," according to John Peter, a New York magazine consultant (Johnson & Christ, 1995, p. 216).

Sumner (2002) summarized the conventional wisdom about covers found in professional literature as having five generally accepted principles:

1. Covers with women sell better than covers with men. Even women's magazines portray mostly women on their covers.
2. Covers with people on them sell better than covers with objects.
3. Movie stars and entertainers sell better than politicians or business leaders.
4. Sex sells.
5. Good news sells better than bad news. Most covers emphasize positive, upbeat themes and cover lines. (n.p.)

According to Lambiase and Reichert (2001), best-selling covers tend to feature the voluptuous female body, which men lust for and women aspire to have: "Magazine publishers construct covers that are sexually provocative and attention-getting precisely because they know this stimuli will increase the likelihood of magazine purchases" (pp. 8–9). That supports McCracken's (1993) argument that a beautiful female image is difficult for either sex to resist. McCracken said for the readers of *Cosmopolitan*, the cover is the "window to the future self" that allows them to "imagine that I can someday be like the women in the magazine— beautiful, successful, etc." (p. 6). By communicating who their ideal reader is through the covers, magazines provide "selective frames that color both our perceptions of idealized femininity and what is to follow in the magazines" (p. 14).

Thus, the choice of whom or what to feature on the cover is not only an editorial one but also can be studied as a social indicator of the status of any individual or group in society in terms of importance and value.

METHODOLOGY

If *Cosmopolitan* is like *Maxim*, what cover components do they have in common? Are similar images and messages about sex, romance, and relationships being presented to the readers? Are myths, such Galician's (2004) Myth #4 about sexual perfection and Myth #5 about centerfold looks (p. 51), presented on the covers of *Cosmopolitan* and *Maxim*? I considered two questions in this research:

1. Does *Maxim* portray women as sexual objects through the cover lines and the images more frequently than *Cosmopolitan*?

2. Does *Maxim* contain more cover lines associated with sexual content than *Cosmopolitan*?

The sample I chose to study consisted of 24 magazines: all 12 of the 2002 issues of *Cosmopolitan* and all 12 issues of the 2002 *Maxim*. The year 2002 was chosen as representing a 5-year benchmark for both magazines. *Cosmopolitan* had been using its "fun, fearless female" designation since 1997 and *Maxim* celebrated its fifth anniversary in 2002. Five years is a turning point for magazine start-ups and campaigns, a time when magazines show significant financial and editorial success (Johnson & Prijatel, 2000). Additionally, 2002 was selected because *Maxim* had been named "hottest" magazine for that year by the prestigious trade magazine *Adweek* (*Maxim* Media Kit, 2004). Physically accumulating an entire year of each magazine was not an easy task, despite the promises of ebay.com and other auction sites offering copies for sale. Few libraries archive such popular magazines, and attempting to "blow up" thumbnail covers (from Web sites) on standard computer screens does not result in an easy—or accurate—reading of all the cover lines. Eventually, all 24 issues for 2002 were acquired as hard copies in original publication form.

The magazine covers were analyzed individually and coded based on research from Goffman (1979), Kang (1997), and Malkin et al. (1999). To consistently code the cover images, I developed a checklist of eight criteria: (a) what type of body-revealing clothing was worn by the image (mini-skirts, tight skirts, any article of clothing that showed cleavage, see-through clothing, and whether the attire was appropriate for public wear); (b) what was the amount of body exposure of the image (partial nudity, full nudity, or being clothed only in a towel); (c) whether the image was touching anything; (d) where the image was looking; (e) what type of body shot was portrayed; (f) what view of the head was illustrated; (g) in what pose was the image positioned; and (h) where the image's hands were in reference to the body. Also, the appearance of an identifiable celebrity—a movie star, TV star, musician, entertainer, or sports figure—was coded. The appearance of a model, whether named or unnamed, also was coded.

Cover lines were categorized as being about sex, romance, or relationships. *Sex* cover lines such as "Jump-Start Your Sex Life," "Sexy Hair," or "In Bed with Tara Reid" were identified, whereas *romance* cover lines were "25 Little Rituals That Make Love Last" or "Sarah Michelle Gellar: Her Smokin' Career and Sizzling Romance." *Relationship* cover lines included "Denise Richards Talks about Marrying Hollywood's Bad Boy," "Did She Poison Her Husband?," or "Are You Too Honest with Your Man?" The category of *miscellaneous* was added to include cover lines that did not clearly fit any of the above categories but had a sexual, romantic, or relationship overtone, such as "Our Bitch List" or "A Cross-Dressing Billionaire." Cover lines about beauty, fashion, diet, exercise, food, entertainment, cars, or gadgets were not coded unless they had a sexual, romantic, or relationship overtone.

Twelve issues of each magazine were examined.[2] If there was a question about the meaning of the cover line, the actual article was studied. All cover content was coded by three independent coders with an intercoder reliability of .95 for each variable based on Holsti's (1969) formula.

RESULTS

The results revealed that although both magazines emphasized sex on their covers, *Cosmopolitan* had more cover lines associated with sexual content than did *Maxim*. *Cosmopolitan* had 54 cover lines (50%) focusing on sex, whereas *Maxim* had 36 cover lines (50%) about sex. *Cosmopolitan*'s covers contained more cover lines during the year (108 to *Maxim*'s 72), a percentage comparison does not accurately reflect the overall frequency or number of cover lines per issue dealing with sex. *Maxim* depicted women as sexual objects on all 12 issues (100%) in terms of image position and clothing, whereas *Cosmopolitan* did not. All of *Maxim*'s cover women were shown partially nude or with very minimal clothing, whereas all of *Cosmopolitan*'s cover women had on sexy yet traditional clothing that could be worn in public.

Images

All 24 covers for *Maxim* and *Cosmopolitan* published during 2002 displayed females with cleavage wearing body-revealing clothing. In all 24 issues studied, their gaze was aimed toward the camera in a frontal shot. However, the remaining criteria varied from cover to cover.

All *Cosmopolitan* covers featured the woman in a frontal shot of the body in a standing pose showing her figure from above the knees to the head. All of the women gazed directly at the camera, with either a toothy or closed lip smile. All 12 of the women on the covers of *Cosmopolitan* were touching themselves, with all but 2 are shown with both hands on their hips, thighs, or a hip and a thigh. For example, the February issue positioned the woman with her hands behind her head, rather than touching her hips or thighs; the position was closer to a stretch than a thrust. The hands of the woman on the October issue were behind her, touching her buttocks. Seven of the women on *Cosmopolitan*'s covers, or 58%, were celebrities: Britney Spears, Cameron Diaz, Jennifer Lopez, Denise Richards, Sarah Michelle Gellar, Katie Holmes, and Halle Berry. Five of the women were professional models.

Seven of the women wore sexy yet traditional feminine attire, with 4 wearing a low-cut dress and 3 wearing a mini-skirt and revealing top. On 5 covers, the

[2]The author thanks Stephanie Gustafson and Jennifer Gillespie for their work on this project.

women wore slacks and a sexy, revealing top. Seven of the *Cosmopolitan* issues showed the models' midriffs and all showed cleavage. None of the women wore revealing lingerie or swimsuits, nor were any of the women shown in partial nudity. All clothing could be worn in public.

Whereas *Cosmopolitan* showed the midriff on 7 of its covers, *Maxim* showed the midriff on 9 of its covers. All of the *Maxim* cover women stared at the camera in a frontal shot of the head; in 6 of the covers, the woman's eyes were tilted slighted upward at the camera. Only 2 of the women were smiling; 10 women had slightly open, glistening lips.

Eight of the *Maxim* covers showed the women touching themselves on their hips or thighs. The woman on the April cover had her arms folded across her bare breasts. The November issue showed the woman with one hand covering her crotch and the other arm above and behind her head in a thrusting pose; the June issue also portrayed the woman with her arm behind her head in a thrusting motion, with her other hand on her thigh. The January issue was the only one for which the woman was not touching her own body; instead, her arms were positioned behind her as if on a table or sofa, resulting in an elevation of her upper torso. The December 2002 issue, billed as a special collector's edition, was the only cover with multiple women. With a pullout page, a total of 7 women wearing bras, garter belts, fishnet hose, and black gloves were depicted.

All but one of the *Maxim* covers, or 92%, featured a celebrity. These included Jessica Simpson, Tara Reid, Leonor Varela, Kelly Hu, Jeri Ryan, Shakira, Beyoncé, Lucy Liu, Mila Kunis, Rebecca Romijn-Stamos, and Christina Applegate.

All of *Maxim*'s cover women were shown partially nude or with very minimal clothing. Four of the covers featured women in revealing or see-through lingerie, 4 women wore hip-hugger panties (not the kind that could be worn in public) and revealing tops, one wore a bikini bottom with no top (her arms crossed her breasts, covering her nipples), one wore a scanty swimsuit, and 2 women wore hip-hugger slacks and bustiers. Five women were pictured standing, cropped at the crotch; 2 women were shown standing in a mid-thigh to the top of the head pose. Four women were seated, and one had a furry white blanket wedged between her spread legs. Only the December issue showed full body shots from head to below the knee.

Cover Lines

The number of cover lines on each magazine varied from issue to issue. *Cosmopolitan* contained the most cover lines, with an average of 9 cover lines per issue. *Cosmopolitan*'s 12 issues contained a total of 108 cover lines, whereas *Maxim* had 72 cover lines for the entire year.

The most prevalent topics for the cover lines were sex for both *Cosmopolitan* and *Maxim*. *Cosmopolitan* had 54 (50%) cover lines about sex, 5 were (5%) about

romance, 13 (12%) were about relationships, and 7 (6%) were miscellaneous (with a sexual, romantic, or relationship overtone). Seventy-nine (73%) of *Cosmopolitan*'s total cover lines dealt with either sex, romance, or relationships. *Maxim* had 36 (50%) cover lines about sex, none about romance, none about relationships, and 3 (4%) miscellaneous out of a total of 39 (54%) cover lines dealing with sex, romance, or relationships.

DISCUSSION

Of the 108 *Cosmopolitan* cover lines, 79 (73%) dealt with sex, romance, or relationships; within that triad, 54 (68%) of the cover lines focused on sex. Overwhelmingly, *Cosmopolitan*'s cover lines supported Myth #4: "If your partner is truly meant for you, sex is easy and wonderful" (Galician, 2004, p. 51). Specific suggestions to make that sex "easy and wonderful" were offered on the covers, often through a step-by-step approach or a list: "Blow His Mind! Lock the Doors, Dim the Lights, and Try This Naughty 'Number' Tonight," "Make Him Ache for You: Shoot to the Top of His To-Do List with Our Saucy Moves," "15 Places to Have 'Fast Love,'" "75 Sexy Ways to Thrill a Man," and "35 Ways to Turn a Man into a Mushball."

Hair, clothing, and beauty tips also played into Myth #5: "To attract and keep a man, a woman should look like a model or a centerfold" (Galician, 2004, p. 51). Looking sexy is a key part of a successful relationship for *Cosmopolitan* readers, as shown by "The Sexiest Jeans," "Sexy Swimsuits," and "Sexy Party Clothes (Guaranteed to Jingle His Bells)." Additionally, the women shown on the covers—beauties such as Halle Berry, Cameron Diaz, and Sarah Michelle Gellar—simply reinforced the physical attractiveness needed in a relationship under Myth #5.

Several of the sex cover lines presented men as sexual objects—positioning *Cosmopolitan*'s "fun, fearless female" as a woman who is as sexually sophisticated and predatory as a man. Examples of these cover lines were "His Butt: What the Size, Shape, and *Pinchability* of Those Sweet Cheeks Reveal about His True Self," "Naked Men! Well, Half-Naked. Feast Your Eyes on Our Hunks in Trunks," and "30 Seductive Lines to Use on a Guy." This reinforced the idea that *Cosmopolitan* is indeed like *Maxim*.

Romance played a back seat to sex in *Cosmopolitan*, with romantic covers lines making up only 5 (5%) of the overall cover line total. The romantic cover lines were presented simplistically and stereotypically: "The Love Test: Answer These 5 Questions to Know If He's a Keeper," "25 Little Rituals That Make Love Last," and "Are You Meant for Each Other?"

Some of the 13 (12%) relationship cover lines in the overall total offered a message about commitment but not enough to counteract the dominant sex mes-

sages. Relationship cover lines fell into two areas: (a) suggestions for couples and (b) cautionary stories. About half of the relationship cover lines presented obvious suggestions for couples such as "You and Him, Happy as Hell: How to *Stay Blissfully Bonded*," "The 6 Signs a Guy Is Hooked," "Will He Cheat? Give Him This Test?," "5 Games You *Should* Play in a Relationship," and "Are You Too Honest with Your Man? 5 Times to Zip It." However, the tone of these relationship cover lines lacked support for Galician's "antidote" to her Myth #4—Rx #4: "Concentrate on commitment and constancy" (p. 51). Their emphasis about being hooked, cheating, or being too honest was not consistent with concentrating on the core values of commitment and constancy.

Other relationship cover lines were presented as cautionary "real-life reads," such as "Her Boyfriend Did a Shocking Thing in His Sleep. Could Yours?," "Did She Poison Her Husband? You Be the Jury," "The Terrifying Way Her Ex Tried to Win Her Back," and "I Found His Ex in Our Bed!" These real-life relationship cover lines were negative rather than positive.

Only the sex cover lines were consistently positive about achieving sexual bliss, empowering the woman to be aggressive. However, as Galician (2004) pointed out in her discussion of Myth #4, the likelihood of achieving such sexual perfection is slim without following her Rx #4 to "concentrate on commitment and constancy" (p. 51).

The 7 (6%) miscellaneous cover lines dealt with violence and sex ("4 Tricks Rapists Use in Summer" and "The Surprising Thing That Can Make You a Target for Rape"), women and their relationships with one another ("You'll Be Shocked by What 39% of Women Do With Their Girlfriends"), and women's attitudes toward sex, romance, and relationships ("Your Bitch List: 30 Things You Should *Never* Apologize for" and "Bedside Astrologer"). Although Helen Gurley Brown (as cited in Carlson, 1997) made the following statement in her final column as editor in 1997, the message is still central to today's *Cosmopolitan*:

> Sex is one of the three best things there is. . . . I'm not sure what are the other *two*. Yes, it's best with someone you love and adore, but each encounter doesn't *have* to be heaven-scripted—an affectionate friend is okay, too. (p. C7)

Maxim's sex cover lines were as salacious and seductive as *Cosmopolitan's*— yet *Maxim* had considerably fewer of them. Of the 72 cover lines on the 12 issues of *Maxim*, 39 were devoted to sex, romance, or relationships, for a total of 54% to *Cosmopolitan*'s 73%. However, *Maxim* had no cover lines devoted to romance or to relationships; half of the cover lines (50%) focused on sex, and 4% were miscellaneous.

Maxim's cover lines often had a raunchy, frat-boy quality to them, even though they were clearly focusing on sex. For example, the January cover promoted "3 Girls in a Bed: The *Maxim* 'Big O' Test," and March declared, "Compare

Yourself: How Your Salary, Sex Life, and . . . Gulp! Sausage Stack Up." Other examples of sex cover lines included "Sex Express! How to Spot the Girl with a Condom in Her Purse," "Naked Twister! It's *Maxim*'s New Sex Guide—Take Your Positions," "Master Your Johnson," "Collect 'Em All! 7 Kinds of Sex: Pick Your Get-lucky Number Tonight!," and "A Foreplay Cheat Sheet." The three miscellaneous cover lines were: "A Cross-dressing Billionaire Murderer? We Can't Make This Stuff Up," "The Macho World of Broadway Musicals!," and "Are You a Girl? Take This Quiz and Find Out, Nancy!"

Carolyn Kremins (as cited in Kaufman, 2002), *Maxim*'s advertising group publisher, said, "We have created a vehicle that's entertaining. It wasn't brain surgery. Guys are guys, and we gave them what they wanted" (p. C11). And what they wanted, besides pictures of scantily clad women, was "information they're not going to ask their buddy or girlfriend or wife about." According to *Maxim* marketing director Kim Willis (as cited in Kaufman, 2002), although sex sells to young men, using humor is a way of connecting and relating to them:

> We've succeeded in helping men better relate to women, not some tramp . . . but real women they'd want to have relationships with. Guys are given a bad rap. They are sensitive and caring and all this stuff, but it's just a matter of semantics. If you ask a guy, "Do you care about your relationship?," he'll say no. But if you say, "Do you want to have more sex?" Yes. "Do you want to fight less?" Yes. It's semantics. (p. C11)

As stated by Helen Gurley Brown in 1962 and still true more than 40 years later: "Sex is a powerful weapon for a single woman in getting what she wants from life" (Ouellette, 2003, p. 124). This is essentially the same advice given to men on the covers of *Maxim*—that sex is a powerful weapon for them to use in their relationships with women.

The cover lines for both magazines offered simplified tips that reinforced the ability to have perfectly wonderful sex every time. According to the cover lines on both *Cosmopolitan* and *Maxim*, there's no need to worry about knowing or understanding your partner or to have developed a loving, respectful relationship first. These two magazines promulgate Galician's Myth #4 about sexual perfection, offering readers unrealistic beliefs about sex, love, and relationships (p. 51). For a *Cosmopolitan* or *Maxim* reader, sex is the critical, most important and affirming aspect of a relationship. That's unrealistic because sex—or passion—is only one of the three key elements of the Triangular Theory of Love (Sternberg, as cited in Galician, 2004, pp. 6–7, 148). Also necessary for a successful, happy, and long-term relationship are intimacy or connected bonded feelings and commitment (Galician, 2004, p. 7). Those components were not reflected on the covers of *Cosmopolitan* or *Maxim*.

In their analysis of bodily appearance, Malkin et al. (1999) stated that "visual images on both men's and women's magazine covers tend to portray what women

should look like and what men should look for" (p. 652). That certainly was the case with the Cosmopolitan and Maxim images. All the women on the covers were young and beautiful and wore revealing clothing, although considerably more skin was revealed on Maxim's covers than on Cosmopolitan's. The clothing worn by the Cosmopolitan women could be worn in everyday situations in public—if you don't mind exposing your belly button. Only three of the outfits worn by the Maxim women might be appropriate for public situations—and those three revealed more flesh than the Cosmopolitan clothes. The Maxim women were clothed as sexual objects, ready to have sex (not romance and not a relationship), whereas the Cosmopolitan women were clothed as sexy individuals, with the power to entice men or make women jealous.

The images on Cosmopolitan and Maxim, showing women in poses and clothing that do not match everyday life, focus on the centerfold unreality of Myth #5 (Galician, 2004, p. 51). The focus on beauty, combined with the emphasis on sex in the cover lines, results in an irrational standard of beauty. Galician explained that many men's and women's magazines "promote an ideal of beauty that is unattainable by most normal people" (p. 155).

Women's fashion and beauty magazines have been accused of objectifying women for years, sending mixed messages to their readers with an emphasis on cleavage and sex-dominating cover lines. Yet the women on the covers of Cosmopolitan did not seem as sexually objectified as did the Maxim women. Cosmopolitan's women had a more straightforward gaze, as opposed to the upward glancing "come hither" look of several of Maxim's women. Also, Cosmopolitan's hands-on-the-hips stance by all but one woman was more reminiscent of Mae West taking charge of Cary Grant than of a sex kitten wanting to be stroked. The fact that all of the Cosmopolitan women were standing—not sitting or leaning—also makes a statement of independence and sexual power. Clearly, the Maxim women were presented as more submissive and fantasized objects of desire than the Cosmopolitan women; the Maxim women touched themselves more suggestively and offered themselves as being sexually available by their seated and thrusting poses, more like Playmate centerfolds than like models who often exude an aura of unavailability in their perfection.

CONCLUSION

Cosmopolitan covers portray women as sexual beings through the cover lines and do so more frequently than Maxim. Although the clothing of the women on the covers of Maxim was more provocative than the clothing worn by the women on the Cosmopolitan covers, Cosmopolitan sent more messages via the cover lines that emphasized women's sexual roles in relation to men. That is not to say that Cosmopolitan presented a positive role model for women; the emphasis on sex and

glamorous looks is not realistic—or healthy. Wood and Taylor (1991) suggested that when women see desirable images (ones they want to attain), they become motivated to achieve that goal. They compare their looks to those of the women on the covers and inside the magazines and try to eliminate the distance between their real image and the idealized one. As a result, the message presented by the images on both magazines was that to attract and keep a man, a woman should look like a model or celebrity, supporting Galician's (2004) Myth #5 about centerfold looks.

There are numerous ways in which women are depicted that define gender roles, but a few are more common than others. One of the most prevalent is the image of the woman as a sex partner. Walsh-Childers (2003) claimed, "In significant ways, they [the media] create expectations about how women should *be* as sex partners, instructing men and women, boys and girls how females should look to be considered desirable sex partners and how women can be expected to respond to men's sexual initiatives" (p. 141).

Galician (2004) asked whether popular magazines were becoming "manuals for easy, wonderful sex" (p. 148). This study clearly answers that question: Yes, they are. The explicit cover lines on *Maxim* and *Cosmopolitan* promote sex as an elixir, a myth that Galician said needs to be "*dis*-illusioned" (p. 149). As an antidote to the sexual perfection myth, Galician offered Rx #4: "Concentrate on commitment and constancy." She added:

> As with all intimacy, genuinely good sex takes time, trust, and togetherness. In real life (unlike in the pages of *Playboy* and *Cosmo* or the music videos of seductive singers), sex is only one of three essential elements of love. Without the other components, it's mere infatuation, which is fleeting and lacking in commitment or communication. (p. 149)

Galician also addressed how magazines were promoting an unrealistic standard of attractiveness in Myth #5 about needing centerfold looks to attract and keep a man (p. 155). Both *Cosmopolitan* and *Maxim* offer an unrealistic connection between appearance and identity. They promise that sexual gratification can be achieved if you look like the women on the covers. Obviously, their bodies are their best assets—not their minds or their sense of humor or their compassion, three crucial components to a successful, realistic, and loving relationship. As Galician (2004) stated:

> Even though they might not realize it, many men subconsciously use actresses, models, and centerfolds as a standard for their own real-life partners, who cannot help disappointing them (unless they, too, have the surgical and photographical enhancements that pop culture icons get). (p. 160)

Galician's Rx #5 to *dis*-illusion the myth is to "cherish completeness in compan-
ions (not just the cover)" (p. 160).

This study of cover lines and images on the covers of *Cosmopolitan* and *Maxim*
revealed how expectations about sex, romance, and relationships are shaped by
magazines. Overwhelmingly, the cover lines promoted easy and wonderful sex
without real intimacy. The important values of constancy and commitment in a
relationship were ignored. With their emphasis on the physical attractiveness of
the women shown on the covers, the magazines also set up standards of beauty
that were unrealistic. As Galician (2004) stated:

> What's distressing about the appeals used by these publications is that despite their
> pretense at offering healthy concepts for physical and emotional improvement, they
> ultimately reduce male-female relationships to appearance and sexuality. And they
> rob individuals of their personhood when they dispense advice with the implication
> that it will work on everyone. (p. 156)

Being aware of the messages and images presented by magazines such as *Maxim*
and *Cosmopolitan* helps men and women avoid unhealthy myths and stereotypes.
With the information from this study, readers can move forward in clarifying their
own values and become better media consumers or mass media creators.

STUDY QUESTIONS/RECOMMENDED EXERCISES

1. What other men's lifestyle magazines look like *Maxim*, in terms of the
cover images and cover lines? What does this say about the kinds of magazines
being published for young men who are 18–34 years old?

2. What other women's lifestyle magazines look like *Cosmopolitan*, in
terms of the cover images and cover lines? What does this say about the kinds of
magazines being published for young women who are 18–34 years old?

3. Go to a bookstore and look at the magazines being sold. Who or what
is being depicted on the covers, in general? Is it true that most of the covers have
movie stars or celebrities? Notice the clothing, the pose, and the gaze of the im-
age. What differences are there between men's and women's magazines?

4. Go to a bookstore and look at the magazines being sold. Study the cover
lines. What kinds of stories are being promoted on the covers? Are most of the
cover lines on men's and women's lifestyle magazines touting stories about sex?

5. If women read *Maxim* to learn more about their boyfriends and lovers,
do men read *Cosmopolitan* to become more knowledgeable about women?

REFERENCES

Advertising Age special report. (2004, September 20). Top 300 magazines. *Advertising Age*, S-6.

Blanchard, K. (2002, July 25). *Maxim* saves journalism: Editor Keith Blanchard's speech on how he's not uplifting his readers—and why that's good for them. [Electronic version]. *Folio* online. Retrieved July 26, 2002, from http://foliomag.com

Carlson, P. (1997, February 11). Original *Cosmo* girl puts last issue to bed. *Washington Post*, pp. C1, C7.

Christ, W. G., & Johnson, S. (1985). Images through *Time*: Man of the year covers. *Journalism Quarterly, 62*, 891–893.

CosmoGIRL! media kit. (2004). New York: Hearst Magazines Division.

Cosmopolitan media kit (2001). New York: Hearst Magazines Division.

Cosmopolitan media kit (2004). New York: Hearst Magazines Division.

CSE. (2004, September). Recovery or recession. *College Store Executive, 26*–32.

Davids, M. (1999, October 25). Let's talk about sex. *Brandweek*, 16.

Galician, M.-L. (2004). *Sex, love, & romance in the mass media: Analysis & criticism of unrealistic portrayals & their influence.* Mahwah, NJ: Lawrence Erlbaum Associates.

Goffman, E. (1979). *Gender advertisements.* New York: Harper.

Holsti, O. R. (1969). *Content analysis for the social sciences and humanities.* Reading, MA: Addison-Wesley.

Johnson, P. (2002, July 15). Young men (and women) get the *Maxim* benefit. *USA Today*, p. 3D.

Johnson, S. (2002). The art and science of magazine covers. *Journal of Magazine and New Media Research, 5*(1). Retrieved November 24, 2004, from http://aejmcmagazine.bsu.edu

Johnson, S., & Christ, W. G. (1988). Women through *Time*: Who gets covered?" *Journalism Quarterly, 65*, 889–897.

Johnson, S., & Christ, W. G. (1995). The representation of women: The news magazine cover as an international cultural artifact. In D. A. Newsom & B .J. Carrell (Eds.), *Silent voices* (pp. 215–235). Lanham, MD: University Press of America.

Johnson, S., & Prijatel, P. (2000). *Magazine publishing.* Lincolnwood, IL: NTC Contemporary Publishing.

Kang, M. (1997). The portrayal of women's images in magazine advertisements: Goffman's gender analysis revised. *Sex Roles, 37*, 979–996.

Katz, E., Gurevitch, M., & Haas, H. (1973). On the use of the mass media for important things. *American Sociological Review, 38*, 164–181.

Kaufman, H. (2002, April 11). The women of *Maxim*: Behind the racy men's magazine is a female staff that swears the publication makes better men. *Boston Globe*, p. C11.

Lambiase, J., & Reichert, T. (2001, August). *Sex noise makes macho magazines both teasing and tedious.* Paper presented at the annual meeting of the Association for Education in Journalism and Mass Communication, Washington, DC.

Malkin, A. R., Wornian, K., & Chrisler, J. C. (1999). Women and weight: Gendered messages on magazine covers. *Sex Roles, 40*, 647–655.

Maxim media kit. (2001). New York: Dennis Publishing.

Maxim media kit. (2004). New York: Dennis Publishing.

McCombs, M. E., & Shaw, D. L. (1972). The agenda-setting function of mass media. *Public Opinion Quarterly, 36*, 176–187.

McCracken, E. (1993). *Decoding women's magazines: From Mademoiselle to Ms.* New York: St. Martin's Press.

Mott, F. L. (1957). *History of American magazines, 1885–1905* (Vol. 4). Cambridge, MA: Harvard University Press.

Ouellette, L. (2003). Inventing the *Cosmo* girl: Class identity and girl-style American dreams. In G. Dines & J. M. Humez (Eds.), *Gender, race, and class in media: A text-reader* (pp. 116–128). Thousand Oaks, CA: Sage.

Ragan Communications media relations report. (2002, February 28). "Lad mags" reach young men with money to burn. [Electronic version]. Retrieved March 3, 2002, from http://www .ragan.com/mrr

Reese, S. D. (1991). Setting the media's agenda: A power balance perspective. In J. A. Anderson (Ed.), *Communication yearbook 14* (pp. 309–340). Newbury Park, CA: Sage.

Reese. S. D. (2001). Prologue—Framing public life: A bridging model for media research. In S. D. Reese, O. H. Gandy, Jr., & A. E. Grant (Eds.), *Framing public life* (pp. 1–20). Mahwah, NJ: Lawrence Erlbaum Associates.

Roberts, R. (1997). The oldest living *Cosmo* girl. In T. Beell (Ed.), *Messages 4: The Washington Post media companion* (pp. 45–50). Boston: Allyn & Bacon.

Sumner, D. E. (2002). Sixty-four years of *Life*: What did its 2,128 covers cover? *Journal of Magazine and New Media Research 5*(1). Retrieved November 24, 2004, from http://aejmc magazine.bsu.edu

Tassin, A. (1916). *The magazine in America.* New York: Dodd, Mead.

Walsh-Childers, K. (2003). Women as sex partners. In P. M. Lester & S. D. Ross (Eds.), *Images that injure: Pictorial stereotypes in the media* (pp. 141–148). Westport, CT: Greenwood.

Wood, J. V., & Taylor, K. L. (1991). Serving self-reliant goals through social comparison. In J. Suls & T. A. Wills (Eds.), *Social comparison: Contemporary theory and research* (pp. 23–50). Hillsdale, NJ: Lawrence Erlbaum Associates.

Sammye Johnson *is a professor in the Department of Communication at Trinity University in San Antonio, TX, where she holds the Carlos Augustus de Lozano Chair in Journalism and teaches classes in magazine writing, magazine history, magazine production, arts criticism, reporting, editing, public relations, women's studies, and film studies. Johnson received both the Bachelor of Science degree in Journalism, cum laude, and the Master of Science degree in Journalism, summa cum laude, from Northwestern University, Medill School of Journalism, Evanston, IL. Prior to joining the faculty at Trinity, Johnson was an award-winning magazine editor and writer for more than a decade. She continues to freelance; since 1985, she has published more than 350 articles in a variety of consumer, trade, association, and public relations magazines and received 18 writing awards.* Her work has appeared in magazines ranging from Ladies' Home Journal, Ultra, *and* The Underground Shopper *to* Newsbasket *and* Cotton Grower. *Johnson is the co-author of* Magazine Publishing *(2000) and* The Magazine from Cover to Cover *(1999), which are used by more than 40 journalism and mass communication courses. Her extensive research and analysis of magazine content and history, which often focuses on the depiction of women, has been published in* Journalism Quarterly, Journalism Educator, Journal of Magazine and New Media Research, Southwestern

Mass Communication Journal, Studies in Journalism and Mass Communication Journal, *and* Public Relations Review, *and she has contributed 11 chapters to books specifically dealing with magazine publishing in America. Johnson also serves as a magazine consultant to companies starting up a magazine or needing direction in repositioning or reviving an existing publication, and she gives workshops on a variety of editorial and design topics. She is a judge for the National Magazine Awards, considered the Pulitzer Prizes of the magazine industry.*

What's Love Got to Do with It? *Mode* Readers Expose and Perpetuate Mediated Myths of Romance

Julie E. Ferris
University of Alabama in Huntsville

Critical cultural studies allow scholars to engage popular texts at a micro level and investigate where power lies within such often mass mediated texts. As a result, most critical studies allow for critique of texts that yields a positive, active opportunity for resistance or media savvy. Women's fashion magazines, long studied as both purveyor of stereotypes and gender roles as well as women's cultural forum, offered just such an opportunity with the rise of plus-size fashion.

Mode magazine, a plus-size publication launched in 1997 and questionably cut from the market in 2001, was one of the first successful niche market magazines addressing bodies in fashion that were not the norm. According to Sam Wolgenmuth, Freedom Magazine's president, "*Mode* is a precedent-breaking magazine. It doesn't treat these women like there is something wrong with them.... We bought that concept first" (Kerwin, 1997, p. 4).

Among reasons cited for the magazine's demise when it folded in October 2001 were post-9/11 revenue failures and poor advertising (Granatstein, 2001). At its close, the title's circulation was more than 600,000 (p. 30).

It is important to recognize that the failures of the magazine, which changed its tag line from "Style Beyond Size" to "The New Shape in Fashion," might not have been caused by bad business or poor handling of the market. More than the economics and practices of publishing were at stake in the survival of this plus-size publication. The bodies represented in *Mode* are often not represented in popular culture in this way at all, nor are they praised, sold to, or commented on in such a way. It is this element of *Mode* magazine that opens the discussion of the power and potential of the plus-size form in mass media. As Butler (1993) argued, these bodies have for so long been excluded to the "illegible domain" (p. xi), functioning as the necessary opposite to the requisite thin form. For Butler, these bodies on the outside of understanding or intelligibility "do not matter in the same way" (p. xi). To matter culturally, and as women, is exactly what *Mode* readers wanted.

MODE AND WOMEN'S FASHION MAGAZINES

Mode magazine adhered to the same conventions as other women's fashion magazines in its presentation of famous actresses or models on the cover, bold headings promising quick and easy reads within, and its size and shape. Within its pages, however, were advertisements for clothing "up to size 24!," a column launched by plus-sized model and TV host, Emme, and a "fit test" column examining new clothing in larger sizes for fit and figure-flattering ability.

Absent, however, from *Mode*, were other more traditional women's fashion magazine dictates. There were no romantic advice columns, no steamy storytelling, and no "how to land a man" articles. Equally invisible were the health and fitness columns so popular in contemporary women's fashion publications. These absences were not lost on readers, as their letters clearly indicated. The debate within the letters to the editor section about these issues frames a unique and active group of readers, working to co-construct the meaning of their magazine and how it would allow them to be transgressive, intelligible, and available to society as women.

To better understand how the plus-size readers of *Mode* magazine negotiated space for themselves in a market that formerly ignored them, it is useful to investigate how they responded to the editorial construction of *Mode* magazine through these complex letters to the editor. Among the debates that surface over 5 years of dialog is whether *Mode* should work to sponsor heterosexual romantic relationships for plus-size women through columns or articles addressing the subject. Many readers objected to such normative constructions, whereas others insisted it would help to further complete the new plus-size woman's march into the center from the margins. The more she matched a culturally constructed "woman," romance and all, the more successful she would be.

Readers engaged one another by first taking on the slew of letters that seemed to ask for more romance columns and romantic advice in particular because the letters included comments about self-esteem and revolved around how or whether the writers are attractive to men. These letters, however, explicitly focused on strictly heterosexual relationships and dating practices, so, much like the move from contested marginal space to the seemingly productive center regulated by capitalism, a similar tension exists here. It appears that readers understood that to construct themselves as "normal" dating "women," embracing the heterosexual paradigm became necessary for productive gains to be made in this letters section of the magazine. What is more clear is that such normative and widely recognized heterosexuality is that center they strive for.

A second category that emerges within this debate is a set of letters that demonstrated that men, too, can participate in the framing of the plus-size body and of *Mode* readers. This category is directly influenced by the magazine's editors

and later discussed and challenged by the readers. Special attention to the inclusion of letters from men who wrote to praise *Mode* and its plus-size readers as "real women" to whom all men should be attracted served to reinforce the heterosexual norm and myths about romantic relationships portrayed in this interactive section of the magazine.

Dear *Mode*: How Readers Framed the Magazine

Mode magazine's letters to the editor section included a variety of responses from readers about the magazine. An overall shift happened from the first issues to the later ones when the editors added more and more article-specific responses (e.g., "Thanks for the article on breast reduction" or "Thanks for telling me where to find that great red dress"), but the central theme of the letters page remained from beginning to end of publication general praise for *Mode* magazine as a resistant cultural form. More than 450 letters appeared during *Mode*'s publication tenure. For this analysis, the letters are profiled as a space of reader consciousness, and the letters presented serve as exemplars of this process.

The consciousness readers demonstrated involves first, a savvy about the magazine industry, one they frequently commented on. Next, demonstrating an active role as both consumer and constructor of the text, readers' responses engaged the magazine on multiple levels, not simply as general responses to the items or ideas pitched to them. Rather, readers recognized the processes at stake in the pages of a women's fashion magazine and responded with equally complicated frames and definitions of the world they wanted Mode to represent. Finally, the consciousness readers demonstrated involved an active critique of the magazine and its language. This move recognized that language is a constructive template and that its flexibility should be better used to "free" plus-size women from its culturally dictated constraints.

Questions arise over the validity of reading letters to the editor in magazines as the voice of the reader, given that the process of selection and reprinting the letters is heavily influenced by editorial constraints and routines. Journalism and public opinion scholars have long defended the use of letters as viable text for understanding readers (Grey & Brown, 1970; Hill & Dyer, 1981; Pritchard & Berkowitz, 1991; Tarrant, 1957). Important to note, however, in this study is that perhaps the most important concern about the letters is not necessarily that editorial selection may be a factor but rather that the letters have been found to be representative of class and a more articulate readership (Tarrant, 1957). Obviously, not all *Mode* readers addressed the magazine in this way, and those who took time to put pen to paper and express many of the thoughts I analyze here are competent communicators and particularly savvy about language. These readers are still important when assessing the impact of this medium and the power readers may

find within it because, as a sample, these readers may represent a particular class of letter writers, but they also represent the majority of plus-size readers of *Mode* who actively participated in the consumer-directed goals of a women's fashion magazine.

RESISTING WITH THE BODY

Understanding the plus-size body as "excess" has traditionally been the way we treat bodies out of the norm. More focused on excess as fatness, LeBesco and Braziel (2001) proposed as a primary research question in their project on the re-conceptualizing of corpulence in American society, "How does the dominant American popular view of fatness, as bodily excess, diverge from other configurations of fatness?" (p. 1). Similarly, *Mode* magazine serves as a text that seems to have discussed, through its readers, a divergent configuration of fatness, a reclaiming of the term and the body. Kent (2001) addressed the fat body as abject, "that which must be expelled to make all other bodily representations and functions, even life itself, possible" (p. 135). This abject status of the fat body has worked on the boundaries of the intelligible, as Butler (1993) would have it, and shored up a vision of the thin ideal that is suddenly in question. *Mode* magazine was one space where the question was raised. This media outlet chose to allow for plus-size bodies, or the excess of them, to be present, to be spoken to, and to speak back. These bodies were suddenly intelligible, even if only as consumers.

Wilton (1999) manipulated the question of excess, however, in an unusual way, deliberating on how much we create the body and where the body has power to create itself. She argued that the ability of individuals to rewrite their bodies (like the weightlifter or transvestite who undergoes surgery) puts them in conversation with the "self" and the "social" (p. 57). If these plus-sized bodies were rewriting themselves by being called upon by the consumer and romantic myths of *Mode* magazine, they were also creating a new response, an active transgression. Wilton claimed that the body changes its physical and material nature constantly over its lifetime and different physical, emotional, and culturally signified moments in time determine the body and its potential. If then, a body is not a stagnant text, but rather a dynamic set of ever-changing processes, an event, then it can in fact converse with culture.

For *Mode* readers, this conversation their bodies were having with their labels, definitions, and abjection can be read through the letters written to the magazine. The letters often comment on bodily changes or the culturally situated processes that shape their materiality, making them an event. A reading of events can provide unique perspectives on media and corporeal literacy.

Succumbing to the myths of romantic love the mass media continually perpetuate is one conversation the bodies engaged fully and one that worked to

demonstrate new and unique ways of reading media and the construction of the plus-size body.

HOW READERS ADDRESSED THE MYTHS
AND PRESCRIPTIONS IN MODE MAGAZINE

In this chapter, I examine how these culturally marginalized readers addressed two of Galician's (2004) mass media myths about love: Myth #5: "To attract and keep a man, a woman should look like a model or a centerfold" (p. 225) and Myth #10: "The right mate 'completes' you, filling your needs and making your dreams come true" (p. 225). I also present evidence that these women were desperate to make use of Rx #12: "Calculate the very real consequences of unreal media" (p. 225).

For each of her 12 myths, designed to point out media messages that often reinforce confining and unattainable cultural norms about our romantic relationships, Galician also offered prescriptive advice for combating the preferred reading of such messages. Although the resistant stance readers could take would be to subscribe to the prescriptions that counteract each myth, these readers were ambivalent. For the most part, *Mode* readers inaccurately or incompletely used these prescriptions for understanding or negotiating media myths about love.

Myth #5: Looking Like a Centerfold,
or How to Be "Modacious"

First, Myth # 5, claiming that women should look like a model or centerfold to attract a man (Galician, 2004, p. 225), became a focus of the debate. Readers wrote about their true-life experiences as "Modacious" women and the way that their body, figure, behavior, or style attracted others. R[1], from Carmel, CA, explained in February 2000, that her new dentist noticed her pouring over the magazine while waiting for her appointment. According to R., "from behind me appeared this man who was quite handsome—my new dentist. He said 'Oh, you're a *Mode* girl.' I didn't understand what he meant until he explained that he and his staff read the magazine often, and that he hopes one day to meet the *Mode* woman of his dreams. I hope he realizes she's right in front of him" (*Mode*, February 2000, p. 21). This event, depicted as though Claudia Schiffer herself had the great fortune to be hit on by her dentist, demonstrates that *Mode* readers recognized the myth that you must look like and have lived a centerfold's dramatic life to successfully pick up and meet men. They also recreated the concept of centerfold by calling themselves "*Mode*" women.

[1]*Mode* identified all of its letter writers only by initials and locations (and not by their names).

Another way these women approached the myth that centerfolds' bodies and beauty are required for romance was by redefining what makes a centerfold. K.R. of Memphis, TN, wrote in January 2000, "So no matter if a woman is tall, short, skinny, or curvy, we can all be sexy. That's how I explain it to friends and suitors who wonder why they find me so irresistible. It's not my body or my face (as sexy as they are)" (pp. 10–11). Rx #5, to cherish completeness in a mate, not just the cover image (Galician, 2004, p. 225), seems fitting here until K.R. used the parenthetical afterthought to reaffirm that she is, in fact, sexy. Her completeness must include, for her, a sexy body and face.

Even more dramatic were women who wrote more generally, simply confirming their spirit—a sense of place, purpose, and confidence that Mode was meant to inspire—and its appropriateness for Mode magazine, such as J.M. of Winnipeg, Canada, who wrote:

> If I were in a movie, it would be a high-energy, action-packed thriller with techno up loud and pumping. I would be the star, of course, sexy curves and all. In my movie, I would leap over tall buildings, dodge bullets, and defeat the enemy with a flick of my wrist. The man would be mine (if I decided I wanted him), the innocent victims would be saved, and the world would be safe from all the forces of evil. Thanks, Mode, for giving me the power to dream. (October 1999, p. 26)

This action-packed fantasy is clearly functioning within the myth. First, its very visual, visceral description is quite movie-like, recreating the foundation of the myth perpetuated in other media for J.M. and recreated in this one. Second, her description of both herself and her role was nearly identical to the roles Halle Berry, Rebecca Romijn, and Jennifer Garner portray as the actress–model–centerfold type in mass media.

This myth is also supported by some of the male response to Mode. Men wrote to praise the magazine, but not necessarily for its wise, appealing information and articles. More frequently, men wrote words of thanks for inspiring their partner, comments on the beautiful models, or comments on beauty in general. Most of the men's letters either positioned Mode women in relation to a centerfold archetype or they worked to redefine the archetype with a parallel set of requirements for plus-size beauty.

In September 1999, Mode published a host of small snippets of commentary from male readers who praised the women pictured, but only in terms of the centerfold archetype—beauty and sexiness predominate. B.T. e-mailed, "As a male reader, I can tell you that women of size are indeed very attractive and sexy" (p. 36), and J.D. from Long Island, NY, wrote, "My wife subscribes to Mode. I look forward to each issue, for it is in your magazine that I get a chance to see beautiful real women" (p. 36). Even women commented on their husband's appreciation of the Mode models within and their beauty, as C.W. from Atlanta, GA, said "My

husband also likes women who look like real women. . . . I don't dare throw an issue away, he is always 'reading' them" (p. 36). Her letter clearly positioned the women in *Mode* as centerfolds. The age-old joke about "reading" *Playboy* for the articles comes to mind when she joked that her husband's attention is drawn to the women of *Mode*. This comparison further connects the revisioning of beauty that the women readers of *Mode* hope they are accomplishing to combat the troubling and powerful ideal of beauty. To be successful as a plus-size woman, one must be found beautiful or behave as a centerfold and have the male gaze to prove it.

It should be noted that *Mode* faced criticism from readers about the male responses the magazine published (usually one to two letters bimonthly). L.M.M. from Hazelton, PA, wrote, "I have concluded that the 'letters' from 'male readers' MUST be fake! I have never met a man in my whole thirtysomething life who would rather be with a full-figured woman than with a waif" (May 2000, p. 29). The editors replied:

> We are sorry that you have not met a man who appreciates the curves of a full-figured woman. However, the numbers speak for themselves: If 6 out of every 10 women in America are size 12 and up, then there are either a lot of lonely men out there or a lot of men who are with beautiful full-figured women. (p. 29)

This answer defiantly announced that there is a new beauty standard in town, true to *Mode*'s mission, but that beauty is also measured by the men it has earned.

Myth #10: Complete Me, or Calling All Men

The second myth relevant to this discussion is Myth #10, that the right mate "completes you" (Galician, 2004, p. 225). *Mode* readers debated whether a magazine that has been so inspiring to women should "bring them down" with mythical discussions of relationships that focused on the construction of heterosexual partnering. Nevertheless, the women encouraged one another to keep watching for a man. They had come to accept their bodies and find great new wardrobes, and now they must find romance.

T.W. wrote via e-mail (July 2000, p. 18), "For those plus-size women still hiding in the shadows, don't doubt that there are men out there who love, adore, and desire us." This encouragement to hold on for that last step was echoed by V.C., writing from Hamburg, Germany (January 1999, p. 14), who explained "Please keep your articles on romance coming. I have to tell your readers that the men are out there. Just strut your stuff as if you were Cleopatra herself. Your presence alone will attract them. Believe me, I know." Further, C.D. wrote via e-mail (March 1999, p. 46) and verified that romance and a heterosexual love life are the hardest things to accomplish, and one of the most trying: "As a woman of size,

I know the emotional trials we all go through. One of the biggest—of course—is relationships. I met my husband in high school . . . he had the courage to let his attraction for my soft, curvaceous body show. . . ." She added that *Mode* had been integral in the romantic process of accepting viable plus-size women as datable, saying it had "inspired a lot of . . . men to seek sexy curves out and to love them" (p. 46). Although this conversation focuses on women's completeness in some ways, at the core of these letters was an identification with capturing and finalizing a romantic relationship. Finding the right mate matters, and for these women, the "right" mate is one who finds these women attractive and sexy. This is not a gesture toward revaluing their size, as they told it, it is more about making do with their attractiveness and using whatever they have to capture a man.

The continued focus on men accepting these women and these women being able to get a man is framed in a uniquely positive way. No one entered this portion of the debate with questions about why worrying about a man joining your life is problematic. Furthermore, lesbian courtship or friendships were never mentioned. These women wrote in praise of the changes *Mode* had brought to their lives and then, almost like sorority members, added that the changes allowed them to be finally complete via romance, and soon you, sister reader, will be, too. Readers also wrote to share tips about dating or romance as further encouragement. In fact, *Mode* editors rewarded this kind of encouragement by naming a letter from B.M. of Canyon City, OR, "letter of the month" and sending the author a bottle of champagne for providing a clipping from a singles' column in her local newspaper: " 'Seeking *Mode* Woman. . . . If you're slim/skinny, skip this'" (December 1999, p. 13). B.M. noted, "I thought all your readers would enjoy knowing that there really are men out there looking for us. I may even give him a call!"

Other women more subtly made their sister readers aware that they have reached new heights in their "success" with their bodies, their lives, and their loves, yet the importance of heterosexual love to complete their lives remained. Another letter of the month, this one in March 2000, described this sense of completeness. D.C. explained that in her entire life she had not had confidence in her body, but "then your magazine came along and confirmed that I am a sexy, sensuous, creative, and loving woman, . . ." (p. 49). She explained that the moment that sparked her realization was when cuddling with her husband, she felt confident about her body. She added, "My man turned to me and said, 'I'm thankful for my health and more importantly the hot body lying next to me." D.C. explained her response was a simple "thank you" and thanked *Mode* for "giving me the confidence to simply accept his compliment rather than push it away." The romantic scene she presented (lying by the fire on Thanksgiving with "her man") is right out of a movie. Her letter works not only to thank *Mode* for her personal enhanced confidence but also to inspire readers that love will come to them, too.

Overall, the comments in this portion of the letters work to cultivate an understanding that plus-size women can find love, but this idea is cultivated as a final

step to happiness, the one goal you should have. After first, accepting yourself, then reveling in your body, then dressing it appropriately, you can then pronounce yourself truly sexy and able to land a man. Equally distressing in the perpetuation of this myth, is that in their desperate attempt to converse and participate in this myth, the readers completely neglected alternative means of loving oneself. Rather than validate themselves with the love of a man, none of the letters discussed the love of a female partner, of being partner-less, or of heightened friendships. A few letters mention growth in mother–daughter relationships, but only as part of the process, not a goal.

Myth #12: Truth and Consequences, or What's Love Got to Do with It?

Finally, Rx #12 (Galician, 2004, p. 225), which calls attention to the consequences of unrealistic media portrayals of romantic relationships, is especially important here. *Mode* readers' struggle over whether romance should be portrayed in *Mode* at all indicates their awareness that such dream-like presentations of love may not be accurate. (Indeed, as they noted in their lives it has not been.) The debate began in the magazine's second year of publication when "A Romantic Reader" wrote:

> What about love? Where is the romance section of your magazine? I know this is a fashion magazine, but perhaps you could include some intelligent articles about romance. Where are the tender testimonials of big women and the men who love them? (*Mode*, June/July 1998, p. 18)

However, in January 2000, S.M.A. wrote from Sparks, NV, begging, "I have one request: Please don't turn into all of those magazines out there that just cover relationships and how to find a man. I think you should save the relationship stuff for Valentine's Day. . . ." (p. 13). In response, the February 2000 issue contained M.H's letter via e-mail:

> Regarding your recent query about *Mode* men, please don't go there!!! Virtually every other women's magazine on the market has scores of articles on men, sex, dating, etc. . . . I don't need any more advice on relationships or men or anything else. Please keep your magazine in its original, fresh, relevant, and helpful state. (p. 21)

It is in these letters that readers began to express an understanding of Rx #12, "Calculate the very real consequences of unreal media" (Galician, 2004, p. 225). The problem, however, may be that although they have contemplated the very real consequences of media myths, the women readers of *Mode* actively worked to participate in many of the myths.

CONCLUSION

It is very clear that the letters to the editor of the unique and ill-fated *Mode* magazine represent readers who, by Galician's (2004) diagnosis, had fallen prey to mass media myths about love and romance. What made readers' letters worth exploring is the ambivalence they communicated relative to the myths and prescriptions. *Mode* readers wrote about centerfold mentality and centerfold beauty as a goal, but they also praised their new-found confidence, new lust for life, and their new understanding of how they respond to and can use media images.

The search for centerfold qualities was a major element of the letters, but it granted readers two means of transgression. First, it became a space of critique in which they did not chastise themselves for not measuring up. They instead praised the opportunity and space (*Mode* magazine) to finally show how they, too, were centerfolds. Second, by redefining the confining image, *Mode* readers moved past the margins where they and their plus-size bodies have long been held hostage.

A similar resistance and power can be found in analysis of letters that illustrate the second myth. These women noted that self-love is a quality that makes you more lovable by others. Although they encouraged each other to look for the right man, proclaiming that he's out there, they also noted that finding him isn't a matter of luck. They proclaimed that he's available to you if you love yourself, privilege your uniqueness and your beauty, and express your confidence. While demonstrating that they believe that the "right mate" exists, they simultaneously "cultivate[d] their own completeness," the prescription for overcoming the myth.

Finally, Galician's prescription to "calculate the very real consequences of unreal media" became the center of debate about whether the magazine should cover sex, love, and romance.

STUDY QUESTIONS/RECOMMENDED EXERCISES

1. Examine the letters to the editor sections of a variety of magazines, including news publications and women's fashion magazines. Discuss how much of the reader response is written for other readers and how much is written in specific response to magazine material. Next, examine other interactive qualities within the magazine: Can readers vote for a cover or for bachelor of the month? How do the magazine editors speak to their readers?

2. We often look at women's fashion magazines as a detrimental form of mass media. Why might that be? In what ways could these magazines be a useful form of communication?

3. What elements of the centerfold myth do you find yourself perpetuating? How do you make use of the related prescription?

4. Plus-size bodies are becoming more noticed and discussed in popular culture. What might some of the reasons be for this renewed attention?

5. Go online and follow the chat room of a popular magazine. How do the comments there differ from those in the editorial sections of the magazine? Are people speaking more to each other or to the magazine editors? Does the conversation stray from the topics presented by the Web site? How so? Which model of speaking back to magazines might be most effective—online groups sponsored by the magazine or its editorial pages?

REFERENCES

Butler, J. (1993). *Bodies that matter: On the discursive limits of "sex."* New York: Routledge.

Galician, M.-L. (2004). *Sex, love, and romance in the mass media: Analysis and criticism of unrealistic portrayals and their influence.* Mahwah, NJ: Lawrence Erlbaum Associates.

Granatstein, L. (2001 October 1). End of the road. *Media Week, 11*(36), 30–31.

Grey, D. L., & Brown, T. R. (1970). Letters to the editor: Hazy reflections of public opinion. *Journalism Quarterly, 47,* 450–456, 471.

Hill, D. B., & Dyer, J. B. (1981). Letter opinion on ERA: A test of the newspaper bias hypothesis. *Public Opinion Quarterly, 45,* 384–392.

Kent, L. (2001). Fighting abjection: Representing fat women. In J. E. Braziel & K. LeBesco (Eds.), *Bodies out of bounds: Fatness and transgression* (pp. 130–152). Berkeley, CA: University of California Press.

Kerwin, A. M. (1997, September 22). Freedom Magazines buys 50% stake in fashion title. *Advertising Age, 68*(38), 3–5.

LeBesco, K., & Braziel, J. E. (2001). Editor's introduction. In J. E. Braziel & K. LeBesco (Eds.), *Bodies out of bounds: Fatness and transgression* (pp. 1–15). Berkeley, CA: University of California Press.

Mode. (1998, June/July). 2(5).

Mode. (1999, January). 3(1).

Mode. (1999, March). 3(3).

Mode. (1999, September). 3(9).

Mode. (1999, October). 3(10).

Mode. (1999, December). 3(11).

Mode. (2000, January). 4(1).

Mode. (2000, February). 4(2).

Mode. (2000, March). 4(3).

Mode. (2000, May). 4(5).

Mode. (2000, July). 4(7).

Pritchard, D., & Berkowitz, D. (1991). How readers' letters may influence editors and news emphasis: A content analysis of 10 newspapers, 1948–1978. *Journalism Quarterly, 68,* 388–395.

Tarrant, W. D. (1957). Who writes letters to the editor. *Journalism Quarterly, 34,* 501–502.
Wilton, T. (1999). Temporality, materiality: Towards a body-in-time. In J. Arthurs & J. Grimshaw (Eds.), *Women's bodies: Discipline and transgression* (pp. 48–66). New York: Cassell.

Julie E. Ferris is an Assistant Professor at the University of Alabama in Huntsville. She holds a B.A. in Speech Communication (1997), a B.A. in Sociology and Women's Studies (1997) and an M.A. in Rhetoric (1998)—all from Eastern Illinois University; her Ph.D. is in Mass Communications (2003) from the University of Iowa. Her work has appeared in the Journal of Communication Inquiry, *and forthcoming publications include further work on the women of* Mode *magazine and their treatment of health and fitness as well as fashion. Other projects and interests include celebrity fitness and the treatment of obesity in stars such as Carnie Wilson, Al Roker, and Anna Nicole Smith. She teaches courses in media representation, communication theory, and gender and beauty in the mass media. Her work received top paper honors at the 2003 International Communication Association annual convention.*

II

HEGEMONY

CHAPTER 6

Write Romance: Zora Neale Hurston's Love Prescription in *Their Eyes Were Watching God*

Meta G. Carstarphen
University of Oklahoma

"Tall, dark, and handsome" was literally the order of the day when an iconoclastic author of the early 20th century chose to deliver up romance laced with the intraracial politics of African Americans in the rural South. Author Zora Neale Hurston (1942/1996) stated that she wrote her stunning literary gem, *Their Eyes Were Watching God*, in 3 weeks while coping with a failed romance of her own. Aside from the novel's artful prose, *Their Eyes Were Watching God*, offers an ironic contrast to the life of an author who imagined, in her fictional life, a better romantic marriage than she ever experienced in her own life. Since her death in 1960, biographers have attempted to piece together the facts of her closely guarded personal life (see Hemenway, 1977; also Boyd, 2003; L. A. Hurston, 2004). One truth, however, resounds through all of the accounts: This fiercely independent African American woman born in 1899 loved her work and loved her men but could not find a way to love both a man and her work equally. Despite the "totally opposite values" of Galician's (2004, p. 193) Myth #9 pulling her and her significant loves apart, Hurston tested this myth that states "all you need is love" and found it was clearly not a prescription for a lasting and committed relationship in her life.

But in her fictional world, where social rules could be turned on their head, Hurston introduced a stunning view of how gender roles could "create co-equality" (Rx #6; Galician, 2004, p. 163). In *Their Eyes Were Watching God*, she dared to make a younger, less materially stable man the hero to her older, socially elevated heroine. By doing so, Hurston turned the definition of a "real man" and a "real woman" inside out in literary splendor.

When Zora Neale Hurston wrote, she created worlds anew that have yet to be equaled in U.S. literature. This enigmatic genius, born at the turn of the 20th century, reigned as a star during the Harlem Renaissance known for its outstanding literary talents: Langston Hughes, Claude McKay, and Dorothy West, to name

a few. Today, Hurston—when she is known at all—is venerated for one of the most powerful love stories in modern literature, *Their Eyes Were Watching God*. First published in 1937, this groundbreaking story perplexed many of the critics of her day and finally waned in perceived importance by the end of the decade until it fell into virtual invisibility. Out of print within 10 years and out of both public and critical favor, this novel swelled to a new level of public appreciation in the 1980s. Most significantly, when a kindred artist, novelist Alice Walker, shared the story of her own personal pilgrimage to Hurston's unmarked grave, she inspired readers of feminist and African American literatures to also rediscover this author's writings (Walker, 1983).

Zora Neale Hurston's talents and output as a playwright, a novelist, a trained anthropologist, a folklorist, a journalist, and more defied easy classification. Still, *Their Eyes Were Watching God* soars as a stunning work amid a body of distinctive if not always commercially popular writings. In her own time, however, *Their Eyes* was largely a critical success when it first came out in 1937, attracting positive reviews from publications such as *The New York Times* and the *New York Herald Tribune* (Boyd, 2003, p. 300). By the time Hurston died in 1960, all of her books were out of print (p. 425).

HURSTON'S LIFE AND LOVE

Knowing something about Hurston's authentic, biographical life is not a prerequisite to enjoying her writings, but it helps. Born one of eight children in Florida, Hurston had Deep South roots that entwined themselves around the stories and folkways of her upbringing in all-black towns. Her life's work became committed to preserving and sharing delights as she experienced them: unique dialects, sayings, and tales expressing lived wisdom. Her sense of communal love, though, seemed shattered by her private grief experienced at home. When Zora was 9, her mother died. Chafing under the dictates of a stern father and a possessive young stepmother, Zora left home at 14 and lived independently thereafter. Although she maintained ties with her relatives throughout her life she rarely looked back to any family ties for sustained comfort (L. A. Hurston, 2004).

But she married three times and in an additional liaison she came close to complete romantic surrender. She met her first husband, Howard Sheen, after her arrival in 1919 to study at Howard University in Washington, DC. They married years later, in 1927, as then-Dr. Sheen began to set up a practice in Chicago, and Hurston sought to develop her budding career as writer in New York and anthropologist in the Caribbean. They divorced after a year. In 1939, Hurston married Albert Price III, a 23-year-old student and aspiring architect from a prominent African American family in Florida. They separated in 1940 and became legally divorced in 1943. Hurston's last legal marriage, in 1944, was to James Howell

Pitts, described as a businessman from Cleveland by biographer Valerie Boyd (2003). They divorced within the year (L. A. Hurston, 2004).

In their individual but similar ways, Sheen, Price, and Pitts represented men whose middle-class accomplishments or aspirations belied values tied to traditional households and social roles. While Hurston fought to establish herself as a writer and anthropologist, she abhorred the restrictions she perceived there would be if she became someone's wife at the expense of becoming her own artist. As she expressed in a letter to a nephew undergoing relationship problems, "Artistic people just don[']t go for much tying down even for the economic safety angle" (Kaplan, 2002, p. 751).

MEDIATED FANTASIES

Still, what is interesting is how Hurston became imprinted so strongly with a gilded map of romantic expectation. The key may be in her experiences as a lady's maid, beginning in about 1915, for an actress with a traveling musical theater troupe that performed light opera. While still a teenager, she became immersed in the culture and nuances of a genre that had enormous influence on the fledging mass media to come into prominence: radio, film, and television.

During the early decades of the 20th century, musical theater was part of the most popular entertainment of the day, known as vaudeville. A broad form of entertainment whose hallmark was its variety, vaudeville drew influences from the music halls in England, which had a tradition of "songs, dances, acrobatics, and pantomimes" ("Vaudeville," 1991, p. 1086). In the United States, these performances expanded to include minstrels, magicians, and traveling musical plays of the kind to which Hurston became attached. Although the popularity of the emerging new mass medium, film, would soon eclipse the popularity of stage shows within a few years after Hurston left the theater world, their effect would be profound nevertheless. In adapting these skits, comedies, and melodramas to film, early film producers found their successes "inextricable tied to vaudeville," as Smithsonian Institution archivists have noted (Library of Congress, 1999, n.p.).

It is not hard to imagine how an impressionable young Hurston might have absorbed the stories in which she was immersed, night after night. In the way that seems similar to how today's young people can become enthralled by sitcoms and serial dramas on television, Hurston (1942/1996) recalled that her immersion in the musical theater world schooled her in the plots of the most popular Gilbert and Sullivan plays to the grand operas in demand in her day. Then, as now, romances and the vagaries of love relationships were popular themes. Failed love, thwarted love, or successful love-but-at-a-price would have been solid themes then, as they are now. Still, for audiences who sought such plays for entertainment and escape, love had to conquer all on stage. Whereas pairing people with

totally opposite values is one of the major romantic myths of today's mass media (Galician, 2004), the drama of pairing couples from completely different backgrounds has been the fodder of popular drama since before Shakespeare. Hurston, bereft of parental guidance or practical role models for relationships, drew profoundly influencing parallels between work and love during this year-and-a-half work experience in her life. In her words, she felt matured through her experiences, implying a newfound ability to perceive separate and maybe irreconcilable roles for work and romance:

> I had seen, and I had been privileged to see folks substituting love for failure of career. I would listen to one and another pour out their feelings sitting on a stool back stage between acts and scenes. Then too, I had seen careers filling up the empty holes left by love, and covering up the wreck of things internal. Those experiences, though vicarious, made me see things and think. (Z. N. Hurston, 1942/1996, pp. 118–119)

Hurston's job ended in a final bit of irony, when her employer, Miss M__ decided to leave the stage for marriage after a whirlwind courtship of 4 months. Urging Hurston to return to school, the soon-to-be former actress, as the writer recalled in her memoirs (Z. N. Hurston, 1942/1996), made her protégé's future a substitute for her own stifled dreams: "She wished that she herself could go abroad to study, but that was definitely out of the question, now. The deep reservoir of things inside her gave off a sigh" (p. 116) So, in addition to seeing the stage dramas in which women regularly sacrificed for love, Hurston witnessed a real-life example in which a woman she admired traded career for home. Recording that a sigh accompanied this decision was Hurston's subtle editorial comment that, unlike on the stage, real-life trade-offs involving love and work came with some loss, some sadness.

Remembering her mother as encumbered by eight children and a domineering husband and watching her employer leave a profession for marriage must have convinced Hurston that women with personal dreams could not have husbands and vice versa. But that did not mean that Hurston would do without romance.

Published in 1942, her autobiography, *Dust Tracks on a Road*, came out before all three of her failed marriages took shape. However, *Dust Tracks* came on the heels of her 1937 novel, *Their Eyes Were Watching God*, a book she wrote while nursing her wounds over a huge romance with someone to whom she refers in her autobiography only by his initials—as "P.M.P."

The mysterious P.M.P. in Hurston's memoir became the catalyst for her novel *Their Eyes Were Watching God*. Hurston recalled him as "tall, dark brown, magnificently built, with a beautifully modeled back head" (Z. N. Hurston, 1942/1996, p. 205). Falling in love with him, she noted, was not just a casual descent, but "a parachute jump" (p. 205). Besides extolling his good looks, she commended his intellect as well, while overlooking his jealousy and their own combustible

arguments. However, when he begged her to give him her career and marry him, the relationship unraveled. Although she felt her work could coexist with marriage to him, Hurston assessed him to be the "master kind," a man who required "all or nothing" from a spouse (p. 208). In the midst of her turmoil, Hurston went to Jamaica on a funded research assignment where she wrote that she was "trying to embalm all the tenderness of my passion for him in *Their Eyes Were Watching God*" (p. 211). Later, a biographer (Boyd, 2003) identified P.M.P. as Percival McGuire Punter, a Columbia graduate student from Antigua and 21 years her junior (pp. 271–281).

A ROMANCE FOR THE AGES

Readers plunging into *Their Eyes Were Watching God* will find a coming-of-age novel like no other for many distinctive reasons. First, the story centers around Janie Mae Woods, a Southern African American woman born in poverty and raised by her maternal grandmother, called Nanny. Janie is an unwitting heroine. She has no particular distinction according to race or class. She has no grand dreams or ambitions that she expresses, other than an impatient yearning when she was 16, to see the world "be made" (p. 11). Second, all of the characters, save the most minor of ones, are African American. The 1930s society that Janie moves in, while proscribed by the racial segregation of the era, is never disempowered by that fact. Social status and power relationships, especially as they exist between men and women, define themselves on terms nearly, if not virtually, free from the dynamics of racial politics. Third, Hurston writes much of this novel using the language and dialect of the Southern folk she grew up around and whom she spent her professional career documenting. Alternating with clear passages that offer prosaic descriptions and crisp details, *Their Eyes* offers a reading experience that is both anchored in a specific place and time and anchorless in a compelling, universal story of love and choice.

Janie's adventures in love begin when an innocent kiss from a teenaged friend awakens uncertain stirrings. But to Nanny, such experimentation points to future problems. Her solution is to marry Janie off to Logan Killicks, an older neighbor who owns 60 acres and, as such, represents material stability to the aging grandmother worried about the future of her ward. Naively, Janie waits for marriage to turn into love. But when she discovers that the two can be totally separate things, she concludes that her first dream is "dead"; therefore, she has become "a woman" (Z. N. Hurston, 1937/1999, p. 25).

After a while, Janie literally runs away from this loveless marriage, captivated by the more sophisticated courtship and bold dreams of Joe Starks. With her beloved Nanny dead and a first husband expecting her to labor like a mule on their land, Janie imagines a happier future with the charismatic Starks. They

marry and set off for a new town, where Starks becomes mayor and owner of the town's most important business, a general store. But as Starks fulfills his personal ambition of becoming "uh big voice" (p. 46), Janie finds her role diminished as his partner. Although she shares in the work of maintaining the store and in ceremonial duties as the Mayor's wife, she finds that her husband sees any attention shown to her as a threat to the focus upon himself. He admonishes her not to talk freely in the store and insists that she hide her long and beautiful hair under a scarf. When she tries to express her fears over how success has kept them apart, Starks ignores her, insisting that her role as his wife should make her glad since it makes a "big [important] woman" out of her (p. 46).

When Starks dies after 20 years of marriage, Janie frees her hair and also her spirit to new possibilities. Nearing 40 years old, Janie has maturity, vitality, and material comfort as the widow of the richest man in town. And while eager suitors press for her attention, Janie realizes that she likes the new "freedom feeling" she is experiencing (p. 90). While she continues in this pleasure, a new one surprises her in the form of a free-spirited, younger man named Tea Cake. Unfazed by her status, Tea Cake invites her to play checkers, go fishing, and, eventually, share his life as a seasonal worker harvesting sugar cane, tomatoes, and string beans. Janie runs off and marries Tea Cake, confiding in her best friend, Phoeby, that she is determined to live her way, after a lifetime of trying to live "Grandma's way" (p. 114).

The rest of the novel takes off as Janie experiences her new life and her new love. Janie and Tea Cake laugh and argue, work and play, but their lives together seem bound by partnership and love. And, what animates Janie is the realization in her life, finally, of a successful prescription for love—one that allows her to create a "coequal relationship" through cooperation. Galician's (2004) Rx #6 for healthy coupleship, the ability to create "coequality," rests on an ability to challenge established gender roles. In *Their Eyes*, Janie and Tea Cake's relationship completely inverts the social roles that had been portrayed as models throughout and that Janie herself had experienced, in which a dependent woman was paired with an independent, "stronger" male (Myth #6; Galician, 2004). But rather than basking in the protection such a relationship was supposed to provide, Janie despaired. Instead, she thrived in a relationship with a man whom her community deemed unworthy of her because he was younger, less successful, and of a different social class.

Such inversions in Hurston's personal life never succeeded, however. Her husbands and her lover who inspired *Their Eyes* were all younger and socially less prominent than she. Yet in each case, the desire to be a couple never overcame a shared inability to unite over life goals. Just as Myth #9 warns, an unrealistic view of romantic love cannot overcome the challenges of two people living together who have "totally opposite values." For Zora, whose romantic imprint from

her formative years fixed upon an unyielding dichotomy in which work opposed love, the bridge needed to span the two perhaps seemed impossible to build in her own life.

And even in her fictional world, the perfect love she created in *Their Eyes* did not end perfectly. Tea Cake dies tragically, leaving Janie a widow once more. Her grief is tempered, however, by her loving memories of a partner who would never be dead until Janie herself "had finished feeling and thinking" (p. 193).

CONCLUSION: ROMANTIC FANTASY, ROMANTIC REALITY?

Since their nascent forms at the start of the 20th century, popular mass media have shaped our images of gender, sexuality, and gender roles through intentional constructions and strategies (Carstarphen & Zavoina, 1999). Hurston's autobiography *Dust Tracks on a Road* (1942/1996) attributes her powerful characters of Janie and Tea Cake to her internal need to grieve for a failed romance. Yet, the ambitious, socially aware, and independent-minded woman that she was also seemed to have known the external need for a heroine unlike no other. Since its revival in the 1980s, *Their Eyes* has stayed continuously in print as a novel and was transformed into a made-for-television movie featuring megastar Halle Berry as Janie and co-produced by media icons Oprah Winfrey and Quincy Jones. New audiences can now debate Janie's choices and evaluate the story's authenticity as a romance. For her part, author Zora Neale Hurston made painful choices in the pursuit of perfected romance in her own life. In the end, she gave herself and others the solace of a dream made into literature, becoming a timeless prescription for love.

STUDY QUESTIONS/RECOMMENDED EXERCISES

1. What were the choices author Zora Neale Hurston made for love and career and why?

2. The "light operas" and stage shows that influenced Hurston featured melodramatic plots and comic entanglements. What modern media genres reflect these strategies? How are women portrayed in these contexts?

3. Positive African American romantic roles are rarely seen in modern media, according to many critics. Do you agree or disagree? What examples would you cite?

REFERENCES

Boyd, V. (2003). *Wrapped in rainbows: The life of Zora Neale Hurston*. New York: Scribner.

Carstarphen, M. G., & Zavoina, S. (1999). *Sexual rhetoric: Media perspectives on sexuality, gender and identity*. Westport, CN: Greenwood Press.

Galician, M.-L. (2004). *Sex, love, and romance in the mass media: Analysis and criticism of unrealistic portrayals and their influence*. Mahwah, NJ: Lawrence Erlbaum Associates.

Hemenway, R. E. (1980). *Zora Neale Hurston: A literary biography*. Urbana, IL: University of Illinois.

Hurston, L. A. (2004). *Speak, so you can speak again: The life of Zora Neale Hurston*. New York: Doubleday.

Hurston, Z. N. (1937/1999). *Their eyes were watching God*. New York: HarperCollins.

Hurston, Z. N. (1942/1996). *Dust tracks on a road*. New York: HarperCollins.

Kaplan, C. (Ed.). (2002). *Zora Neale Hurston: A life in letters*. New York: Doubleday.

Library of Congress. (1999). *American memory: Content and historical context (American variety stage: Vaudeville and popular entertainment 1870–1920)*. Retrieved December 10, 2004, from http://memory.loc.gov/ammem/vshtml/vsfhcnt.html

Walker, A. (1983). *In search of our mothers' gardens*. New York: Doubleday.

Vaudeville. (1991). In G. Perkins, B. Perkins, & P. Leininger (Eds.), *Benet's reader's encyclopedia of American literature*. (p. 1086). New York: HarperCollins.

Meta G. Carstarphen *is Associate Dean and Gaylord Family Professor in the Gaylord College of Journalism and Mass Communication at the University of Oklahoma, where she has been a faculty member since 2002. Her professional experience is in public relations and journalism, and she has consulted in areas such as community relations, nonprofit public relations, and cross-cultural integrated communication. Carstarphen is the author of numerous articles and book chapters and editor of two books, including* Sexual Rhetoric: Media Perspectives on Sexuality, Gender and Identity *(1999) by Greenwood Press. Her latest is the textbook* Writing PR: A Multimedia Approach *(2004), published by Allyn & Bacon in Boston. Carstarphen was selected as a 1997–98 Research Fellow at The Poynter Institute For Media Studies, where she spent a year researching practices in covering race issues among professional journalists. She has shared the results of this work in many workshops and presentations. Most recently, she was selected as a 2005–06 recipient of a $20,000 "Dream Course" award from the OU Provost, based upon innovations for the "Race, Gender, and the Media" course she created at the university.*

CHAPTER 7

Interracial Love on Television: What's Taboo Still and What's Not

Sharon Bramlett-Solomon
Arizona State University

Sex and the City, West Wing, Scrubs, ER, Judging Amy, Ally McBeal, and *GirlFriends* are television shows with something in common—they all feature at least one interracial couple in a leading role. Integrated romance, a trend once strictly forbidden on American television, is now "blowing up" the set. Well, maybe not quite, but you could say it is on a roll after being taboo for most of television's history. No longer a network rarity, interracial couples are appearing on both daytime and prime time shows.

However, although you can find an integrated couple, or even several, on today's networks, you will be challenged to find a married interracial couple in prime time lead roles. Yet if television were truly colorblind, interracial couples of all sorts would commonly appear on the networks just as they are found in society. Still, more television shows than ever before are aggressively tackling interracial romance, reflecting a slowly growing prominence of intimacy depictions that once were strictly forbidden.

Twenty years ago, it would have been perilous for television producers to show intimacy between couples of different races because of laws against miscegenation and racist attitudes that risked losing audience support and commercial sponsorship. However, feeling that societal attitudes are more relaxed and accepting of mixed-race couples, as evidenced by the escalation of interracial dating and marriages, a wave of writers and producers since the start of the 21st century have developed integrated couple story lines (Orbe & Harris, 2001; Palmer, 2001). According to U.S. Census 2000, the number of interracial marriages in the United States rose from 0.4% (149,000) of all marriages in 1960, to 2.4% (1,348,000) of all marriages in 2000 (U.S. Census Bureau, 2000).

Another factor reflecting more public tolerance, producers have acknowledged, is the fact that interracial couples on television no longer prompt mounds of racist mail, even though opposition has not disappeared completely (Braxton, 2000). Essential to note is that although interracial couples on television before

the 1990s were rare and virtually taboo, they now increasingly are appearing on television and in a variety of genres—including dramas, comedies, movies, talk shows, documentaries, and soap operas.

Few social topics in America through the centuries have endured the timeless, provocative, and often titillating discussion that interracial romance has (Mason, 1999; Siegel, 2000). In this chapter I examine the evolution of interracial love on prime time television and provide the findings of my own content analysis of interracial couple representation and relationships on prime time television.

HISTORICAL BACKGROUND

Prime Time TV's First (and Only) Interracial Leading Couple: *I Love Lucy*

Television's first interracial couple was featured on the *I Love Lucy* show, a serial that made its debut in 1951 and still is very popular as a television network re-run (Chunovic, 2000). The show was groundbreaking in many ways but, most significantly, because it showcased as main characters a white woman (Lucille Ball) married to a Cuban American man (Desi Arnaz), who in real life were married. As husband and wife characters Lucille and Ricky Ricardo, they starred in a funny and vastly popular show that portrayed them as an average American couple.

In the show's planning stages, producers and writers suggested to Lucy that she should choose a white husband for the show. However, she stood up to them and refused to make a switch. She contended that, because in real life her husband was Cuban American, he would be her husband as well on the serial, regardless of public thought about an interracial couple (Chunovic, 2000). Meanwhile, programmers who wanted a white husband for Lucy soon were muted by the immense popularity of the show and the swift rise of the sweethearts who America adored.

In fact, the show became so popular that many shops and businesses noticeably shut down on nights the serial aired and, for the most part, the couple's race was pretty much ignored (Chunovic, 2000). Still, some critics speculated that regardless of Lucy's bravery and spunk, had Ricky been a dark-skinned Cuban in the 1950s pre-civil rights era, he would not have been on television as a white woman's husband (Chunovic, 2000; Siegel, 2000).

Of course, when it came to sexual behavior, the serial stayed within clearly visible boundaries. Intimacy between Lucy and Ricky was low, yet close to average for married couples on 1950s television. The couple occasionally kissed for a few seconds and expressed curt lines about love and affection, such as "Honey, I love you," and at times even embraced. Otherwise, Lucy and Ricky displayed little sexual behavior. They always slept in separate twin beds, and they never mentioned the word sex (Chunovic, 2000).

Sexual intimacy was a virtually unmentionable topic. For instance, even when Lucy became pregnant in real life and her character also was expecting a baby, the word *pregnancy* was never voiced on the show (Chunovic, 2000). In fact, Lucy's memorable line in a premiere show episode was: "Since I said 'I do' there are so many things we don't" (Chunovic, 2000, p. 36). Meanwhile, no prime time series in the 50 years since *I Love Lucy* has featured an interracial couple as lead characters.

Prime Time TV's First Interracial Kiss: *Star Trek*

During the time of the Civil Rights Movement in the 1960s and 1970s, television made a concession to the social pressure for enfranchisement by opening the door to a handful of African Americans, eventually including a few African American couples on shows such as *The Jeffersons* and *Good Times*; however, the door still was closed to interracial couples.

Television first demonstrated acceptance of story lines about racial integration and interracial friendships in the mid-1960s with shows such as *I Spy* and *Julia*. However, although allowing some acceptance of racial integration and a few couples of color, television producers never wrote story lines that showed integrated romance, because they largely avoid programs that would offend viewers and ruffle sponsors (Kennedy, 2002; Williams, 1992).

In 1968, *Star Trek* created a publicity wave as the first television show to feature a kiss between a white man and a black woman (Brown, 2002). Significantly, the kiss between Captain Kirk (William Shatner) and Lieutenant Ohura (Nichelle Nichols) took place after an alien took over the captain's mind, subtly suggesting that if Kirk had been mentally alert and fully aware of his actions, he would not have kissed Ohura.

Amazed at the smooch publicity, Nichols said public outcry over the kiss almost made her quit the show, until she received encouragement from Dr. Martin Luther King, who urged her to stay (Brown, 2002). Nichols told the press: "He said, 'For the first time, people who don't look like us will see us as we should be seen— not only as beautiful beings but intelligent and qualified'" (p. D2). When *Star Trek* creator Gene Roddenberry heard about Dr. King's support, Nichols said Roddenberry became teary eyed and said, "God bless him. Somebody knows what I'm trying to achieve" (p. D2).

Primetime TV's First Married White Man and Black Woman: *The Jeffersons*

In 1975, CBS featured the first married white man and black woman on television with its portrayal of Tom (Franklin Cover) and Helen (Roxie Roker) Willis on *The Jeffersons*. The interracial couple were the best friends of Louise and George Jeffer-

son and lived in the same apartment building. Although the characters were supporting roles rather than the main attraction, CBS was the first television network to portray a white and black married couple (Gates, 1989; Sanoff & Thorton, 1987; Siegel, 2000). Black and white audiences seemed to have little problem with the mixed couple, partly, perhaps, because they engaged in little touching and largely no intimacy.

Popular singer and lead guitarist Lenny Kravitz, the son of Helen Roker, recalled upon his mother's death in 1995, that when she tried out for the part of Helen and was asked if she could handle the role, she presented a photo with her real-life Jewish husband to substantiate her experience ("Obituary," 1995).

Daytime TV Soap Opera's First Interracial Couple:
One Life to Live

In 1968, American television reached another milestone and made headlines with its first depiction of an interracial couple on a daytime soap serial when *One Life to Live* featured a romantic relationship and engagement between a black housekeeper's daughter (Carla Gray) who passed as white and a white doctor (Paul Scott). Apparently, her masked ethnicity and the fact that her mate perceived her as being white provided an interracial setup that did not alienate viewers, because the program's ratings remained high, despite the interracial story lines (Bramlett-Solomon & Farwell, 1997; Lowry, Love, & Kirby, 1981; Rosen, 1986). The story line also represented the first projection of interracial, sexual behavior on daytime soaps, although hardly any intimacy took place between the couple.

Twenty years later, in the spring of 1988, soap-opera television reached another landmark when *General Hospital* featured the first interracial marriage in a daytime soap serial (Cassata & Skill, 1983; Larson, 1994). Since then, all of the daytime soaps at one time or another have featured occasional interracial couples, largely African Americans paired with whites or Hispanics with whites. However, their story lines have generally been short lived.

TV Documentary's and TV Movie's
First Interracial Couples

In addition to weekly serials, interracial couples also have appeared in television movies and in a few documentaries. In 1999, a PBS documentary filmmaker, Jennifer Fox, featured an in-depth look at the lives of the Wilson-Sims family, a middle-class African American father, a white mother, and their two interracial, adolescent children, in *An American Love Story*. This type of documentary a few decades before would never have been aired (Mason, 1999). The poignant film—

which focused on the couple's character, courage, joys, trials, and tribulations—at the same time underscored the ability of television to bring discourse about interracial dating and marriage to public light and into the mainstream culture.

In 2001, a television movie that received wide headlines for its multicultural and interracial love theme was Disney's 2001 prime time remake of Rodgers and Hammerstein's *Cinderella*, starring pop artist Brandy as Cinderella and Paolo Montalban as the prince. Critics praised the fable movie for its multiracial cast that, in addition to Brandy and Montalban, paired Whoopi Goldberg and Victor Garber as the queen and king.

Indeed, television has come a long way from years when interracial intimacy was strictly taboo, to the point today when interracial couples are featured on at least one or more shows on every network, including both daytime and prime time shows. A number of television reviewers have noticed the mixed race couple trend.

For example, newspaper columnist Ed Siegel (2000) reported in the *Boston Globe*: "The races are mixing in ways that would cause racists and ethnic purists—but hardly anyone else—to lose sleep" (p. D2). Media scholar Robert Entman described the networks' depiction of interracial couples as a "toe-in-the-water" approach: "Both *ER* and *Ally McBeal* have had these kinds of romances in the past few seasons, and it didn't result in outrage or an effect on ratings. So now there's a little more boldness in approaching interracial relationships" (Braxton, 2000, p. E2).

INTERRACIAL COUPLES ON PRIME TIME TELEVISION IN 2004

In addition to exploring the historical evolution of interracial couples on television, I conducted a 5-week content analysis of six networks (ABC, CBS, FOX, NBC, UPN, and WB) from March 2 to April 9, 2004, to determine the frequency and nature of interracial couple portrayal in their Monday through Friday lineups.

Examination of the six networks during the sample period revealed that of the 76 shows aired, 16 or 21% featured mixed-race couples. What is remarkable is that each of the six networks had two or more shows featuring interracial couples. However, although almost one-quarter of the 76 shows examined included at least one interracial couple, there was only one married couple during the 5-week sample period: Toni Childs and Todd Garrett, an African American female and white male were featured on *GirlFriends*.

A breakdown, by network, reveals that NBC had five shows featuring mixed-race couples (*Crossing Jordan*, *A.U.S.A.*, *Scrubs*, *West Wing*, and *ER*), WB had four shows (*Angel*, *Everwood*, *Dawson's Creek*, and *Greetings from Tucson*), UPN had three shows (*One on One*, *GirlFriends*, and *Buffy the Vampire Slayer*), FOX had two

shows (*Boston Public* and *That 70s Show*), ABC had two shows (*Boy Meets World* and *Once and Again*), and CBS had two shows (*Judging Amy* and *City of Angels*).

In essence, the television networks are more boldly and vigorously reflecting story lines featuring mixed race liaisons, and 21% of the 76 shows examined reflected this trend. NBC and WB had more shows with interracial couples than the four other networks.

What Is Allowed in the Story Lines
of Interracial Couples—and What Is Not

In addition to exploring the frequency of interracial couples, I conducted a qualitative assessment of the nature of interracial couple portrayal, which revealed that there is more going on in these depictions than simply boy meets girl. Differences were apparent between interracial and white couple portrayals—most notably in terms of what is allowed in the story lines and what is not.

Observation of the 76 prime time shows during the study period revealed that, although the numbers of interracial couples have increased on the networks, their story lines, roles, and sexual behavior were more restricted than those of white couples. In this investigation, sexual behavior and intimacy was defined as any verbal or physical act clearly sexual in nature or that had romantic, sexual, or erotic connotations.

Sexual Behavior

Examination of sexual behavior on the programs revealed that love between interracial, as well as white couples, consisted of both verbal and physical intimacy. However, for interracial couples there was definitely less of the erotic touching and conveyed passion commonly found among white couples in the shows. And although there were a few scenes of steamy love, interracial romance was more coy and reflected less heated or erotic sexuality than that reflected among white couples.

As noted, NBC and WB not only showed the most interracial couples, but also the most physical intimacy—with *Scrubs, ER, Angel, Crossing Jordan,* and *Dawson's Creek* all depicting bedroom scenes. However, more intimate and passionate sexual behavior was depicted among white than among interracial couples. Interracial couple intimacy generally consisted of kissing and hugging, with not much steamy sexual behavior displayed.

Relationship Duration

I also observed that relationships of interracial couples did not last as long as those of white couples, with the exception of the married couple, Toni and Todd

on *GirlFriends*. For example, despite their flurry of teenage dates and kisses on ABC's *Once and Again*, Grace (Sela Ward) and Jared (Robert Richard)—her African American love interest—do not show up again together in new season episodes of the show. In fact, interracial couples were more likely to be girlfriends, boyfriends, or dates, suggesting that for interracial couples, dating is more acceptable than long-term commitments or marriage. On the other hand, all of the interracial couples are featured in relationships both in and outside the bedroom, such that none fell into the one-night stand category.

Equality

Another trend observed was that most interracial couples on the networks tended to have equal job and socioeconomic status, exemplifying Galician's (2004) prescription for healthy relationships: "Create coequality; cooperate" (Rx #6; p. 163). On the other hand, some couples had unequal career and socioeconomic status. For example, in *Judging Amy*, romance brewed between Judge Amy Gray (Amy Brenneman) and her court service officer Bruce Van Exel (Richard Jones) and on *ER* between Dr. John Carter (Noah Wylie) and Makemba (Thandie Newton), a white doctor and a hospital office worker.

Racial Mix

In addition, I found more African American men with white women than any other race mix. African American women with white men (Toni and Todd on *GirlFriends* and Makemba and Dr. Carter on *ER*) or Asian women with white or African American men (Dr. Ming-Mei Chen played by Ming-Na and African American Dr. Gregory Platt played by Mekhi Phifer on *ER*) appeared far less than African American men and white women. Occasionally, African American men appeared with Hispanic women, such as fireman paramedic Monte "Doc" Parker and Dr. Sara Morales on *Third Watch*.

Also notable is the fact that in the interracial relationships observed, people of color largely were oblivious to their race, with little reflection of cultural differences or race issues. Interracial story lines mirrored those of white couples. There were, however, several exceptions—such as an episode of *West Wing*. The president's daughter Zoey Bartlet (Elisabeth Moss) became angry with her father when he told her that, because of white supremacist threats, she and Charlie Young (Dulé Hill), her African American boyfriend and the president's aide, could not go to a new dance club they had planned to attend. During lunch, when Zoey tells Charlie about her father's concerns, the young man storms out of the restaurant.

Producers of this show, as well as producers of a number of other serials with interracial couples, say public response to them largely has been supportive, with

only occasional opposition (Braxton, 2000). *West Wing*'s Dulé Hill said, "I thought there might be some negative reaction. But letters we're getting are all positive. People really seem to like it" (p. E2).

CONCLUSION

Given the history of television, in which interracial couples did not exist at first, the extent to which interracial intimacy is portrayed on television today can be considered an indication of how society has evolved and how far television producers have come in their willingness to present such depictions. Examination of television is justified by its potential influence on viewer conceptions of a variety of social and political topics—including ideas and perspectives on social change and racial integration. Because society is ever changing, it is essential to develop greater understanding of how interracial couple representation on television has progressed.

Love on television between individuals of different races has increased significantly over the past few years, with more shows than ever before casting interracial couples. However, interracial liaisons still are not commonplace—at least not to the point of no longer turning heads. Furthermore, interracial couples tend to face certain boundaries to which white couples are not subjected. They tend to have story lines with less frequency and longevity, are much more likely to be unmarried, and reflect little identification with ethnic culture. Interracial couples also do not have showcase roles. Amazingly, not since the *I Love Lucy* show's 1951 premiere has an interracial couple headlined a prime time television program.

Television, due to its constancy and pervasiveness, is viewed as the medium with the greatest potential to influence people's ideas and perspectives about cultures and racial groups with which they have little experience or no contact (Cassata & Skill, 1983; Palmer, 2001). Television presents explicit examples and implicit principles regarding cultural integration and race relations. Therefore, an important question to consider, now that interracial couples no longer are taboo, is whether these liaisons will move beyond present boundaries, allowing the depiction of deeper and more mature characters.

STUDY QUESTIONS/RECOMMENDED EXERCISES

1. The kiss between Captain Kirk and Lieutenant Ohura on Star Trek is considered to be the first kiss between an interracial couple on television; what does this kiss suggest about 1960s attitudes toward social integration and interracial couples?

2. To what extent do you feel mixed race couples on television are accepted today?

3. Were you surprised at the percentage of interracial couples found in the content analysis of prime time shows? Why or why not?

4. Why is it important to examine media portrayals of social issues and problems such as race and gender representation on television?

5. Conduct your own investigation over a 2-week period of interracial couples on two of the oldest and two of the newest networks. Focus on couple frequency as well as the messages revealed or implied in their representation.

6. Discuss with your classmates how you think social attitudes toward interracial couples may be changed 10 years from now.

REFERENCES

Bramlett-Solomon, S., & Farwell, T. (1997). Sex on soaps: An analysis of Black, White and interracial couple intimacy. In S. Biagi & M. Kern-Foxworth (Eds.), *Facing difference* (pp. 3–11). Thousand Oaks, CA: Pine Forge Press.

Braxton, G. (2000, March 22). TV finds drama in interracial dating. *Los Angeles Times*, p. E2.

Brown, P. (2002, January). *Star Trek* star almost quits. *Herald Sun* (Victoria, Australia), p. C3.

Cassata, M., & Skill, T. (1983). *Life on daytime television*. Norwood, NJ: Ablex.

Chunovic, L. (2002). *One foot on the floor: The curious evolution of sex on television from* I Love Lucy *to* South Park. New York: TV Books.

Gates, L. H. (1989, November 12). TV's black world turns, but stays unreal. *The New York Times*, p. G1.

Galician, M.-L. (2004). *Sex, love, and romance in the mass media: Analysis and criticism of unrealistic portrayals and their influence*. Mahwah, NJ: Lawrence Erlbaum Associates.

Kennedy, R. (2002, December). Interracial intimacy. *Atlantic Monthly*, 103–110.

Larson, S. (1994). Black women on *All My Children*. *Journal of Popular Film and Television*, *22*(1), 44–48.

Lowry, D., Love, G., & Kirby, M. (1981). Sex on the soap operas: Patterns of intimacy. *Journal of Communication*, *31*, 90–96.

Mason, M. S. (1999, September 10). Insightful look at the joys and trials of interracial marriage. *Christian Science Monitor*, p. 19.

Obituary: Roxie Roker. (1995, December 6). *Daily Variety*, p. 11.

Orbe, M., & Harris, T. M. (2001). *Interracial communication: Theory into practice*. Stamford, CT: Wadsworth Thompson Learning.

Palmer, K. S. (2001, January 22). Movie reflects interracial issues. *USA Today*, p. 15A.

Rosen, R. (1986). Soap operas: Search for yesterday. In T. Gitlin (Ed.), *Watching television* (pp. 43–50). New York: Pantheon.

Sanoff, A. P., & Thorton, J. (1987, July 13). TV's disappearing colorline. *U.S. News and World Report*, pp. 56–57.

Siegel, E. (2000, June 29.) Love is colorblind in the hottest shows on stage and screen. *The Boston Globe*, pp. 3–11. Retrieved July 5, 2000, from http://seattlepi.nwsource.com/lifestyle/race29.shtml

U.S. Bureau of the Census. (2000). *Interracial married couples: 1960 to present.* Retrieved April 25, 2004, from http://www.census.gov/population/socdemo/ms-la/tabms-3.txt

Williams, C. T. (1992). *It's time for my story: Soap opera sources, structures, and response.* Westport, CT: Praeger.

Sharon Bramlett-Solomon is an associate professor in the Walter Cronkite School of Journalism & Mass Communication at Arizona State University, where she teaches newswriting; race, gender and media; and mass media theory for graduate students. During her tenure at the Cronkite School, she has received two research awards and two teaching and service awards, and she was the recipient of the Barry Bingham Award from the National Conference of Editorial Writers. Her research focuses on media, race, and gender issues. In addition to a number of published book chapters, her scholarly articles have appeared in Journalism and Mass Communication Quarterly, Newspaper Research Journal, Mass Media & Society, Southwestern Mass Communication Journal, Howard Journal of Communications, *and* Journalism & Mass Communication Educator. *Her articles have appeared in numerous newspapers and popular magazines, including* The Arizona Republic, *the* Arizona Informant, East Valley (AZ) Tribune, Louisville's City Magazine, Focus *magazine,* Essence *magazine, and* Today's Arizona Woman. *Her professional background includes 7 years in newspaper reporting, public relations, and radio advertising sales. She was a graduate fellow at Indiana University, where she taught reporting courses and received her Ph.D. in 1987.*

CHAPTER 8

Jennifer Lopez and a Hollywood Latina Romance Film: Mythic Motifs in *Maid in Manhattan*

Diana I. Rios and Xae Alicia Reyes
University of Connecticut

Fairy tales have been firmly rooted in the U.S. social fabric. Viewers, readers, and listeners of our modernistic mediated folklore become well acquainted with fairytale motifs beginning in childhood and are particularly familiar with the ingredients of romance—the sugar and allspice of the film *Maid in Manhattan* (2002). Originally drafted as *The Chambermaid* by John Hughes, *Maid in Manhattan* offers an urbanized version of a lowly female's rescue by a man of more power and status. Girls and women recognize this and related romance motifs in stories such as *Rapunzel, Sleeping Beauty, Snow White*, and *Cinderella*. In this 21st century rendition, the urbanized chambermaid is updated as a woman of color—a Latina. Her lot is in a lower social class of the backstairs strata that is dedicated to self-conscious invisibility while caring for the desires and needs of wealthier detached patrons.

A wide array of motifs, analytical themes, and frameworks can be used in critiquing *Maid in Manhattan*. In this chapter we follow Galician's (2004) media literacy work on Hollywood's constructions of coupleship by revealing selected mass media myths/stereotypes of sex, love, and romance as well as providing prescriptive discussion of more realistic ways to view *Maid in Manhattan*. This analytical research focuses on 4 of Galician's (2004) 12 myths/stereotypes of mediated romance: (a) Males need to have superior status (Myth #6); (b) Actors are their characters (Myth #11); (c) Love at first sight happens frequently (Myth #2), and (d) Women must look like a centerfold or model to gain love (Myth #5).

Upon careful viewing, critical audience members will note that this film and most Hollywood romance films have aspects of all 12 mythic/stereotypical ingredients about which Galician has expounded upon, in addition to many other kinds of limiting sociocultural, ethnic/racial representations (for critiques on Latino and Latina representations, see Berg, 2002; Keller, 1994). Such is the nature of the commercial machine that quickly regurgitates stories that the public

has seen, heard, and read before. The practice of cookie-cutter creations of people, places, and things is unfortunately rewarded by audience members who continue to pay for and consume massive quantities of misrepresented reality. The long-term danger for our society and others in our global village is the integration of artificial, unattainable social and personal characteristics that are assumed to be realistic and reasonable. This writing is not intended to indict the popular audience, as Diana I. Rios has extolled the virtues of the active audience and audience members' active use of the mass media for sociocultural intentions (Rios, 1996, 2000, 2003). Media literacy writings, workshops, and media integration into formal educational curricula are ways in which our society is being informed about media consumption strategies. This research sheds light on the all-too-real and persistent problem of misrepresentation of close relationships in popular media.

BRIEF PLOT DESCRIPTION OF *MAID IN MANHATTAN*

Maid in Manhattan is the story of a New York Latina hotel maid, Marisa Ventura (Jennifer Lopez), who is mistaken for a rich jet-set occupant of a luxurious hotel suite by an actual hotel guest, Christopher Marshall (Ralph Fiennes), a wealthy playboy and state assemblyman who is planning to run for a seat in the U.S. Senate. Christopher is the son of a senator and is a well-known playboy. He is a typical guest in such hotels. His misperceptions about Marisa mount in several contexts while he builds a fantasy about her. Marisa, a poor single mother, does not correct Christopher's fantasy and thus becomes a co-conspirator, along with her workmates and son, in promoting the illusion. Marisa is confused about her actions and her feelings for Christopher. The couple's dreamy romantic relationship unravels when the true occupant of the suite informs both Christopher and the hotel management about Marisa's misrepresentation. As a result of the discovery of a series of deceitful events, Marisa is fired from her job, and Christopher does not contact or speak to her. However, her young son eventually orchestrates a reunion, resulting in the film's "they lived happily ever after" ending.

MYTH #6: MALES NEED SUPERIOR STATUS TO FEMALES

This romance film is typical in its requisite depiction of the male superiority and female dependency myth. Other components of the myth are that the female not be taller than the male or possess other intellectual or physical qualities that outshine those of the male character. Films that feature more able women indeed exist, as discussed by Galician (2004, pp. 163–173), but typically when a

woman has superior knowledge, wealth, or physical abilities, the narrative finds ways to correct the woman, demote her, or punish her to bring her down. Unfortunately, this minimizing is supposed to help the viewing audience accept the film and the romantic coupling. For example, Galician (2004) noted that in *Far and Away* (1992), a wealthier and taller character played by Nicole Kidman is put in her womanly place by being dumped fully clothed in a bathtub by her poorer love interest, played by Tom Cruise (p. 169). The narrative type of a superior man and a subordinate woman is foundational to *Pretty Woman* (1989), in which a wealthy businessman finds his love, not AIDS, in a prostitute. As well, a working class woman is rescued from her dreary factory life by a suave military officer in *An Officer and a Gentleman* (1982). Furthermore, the lonely, workaholic, character played by Jennifer Lopez in *The Wedding Planner* (2001) is rescued by a Prince Charming.

True to formula, audience members expect to see how Marisa Ventura of *Maid in Manhattan* escapes her social class and "moves up" through marriage, thus fulfilling what our society calls "The American Dream." This movie supports the social mythology of "rags to riches," lending evidence that such is reasonably attainable and that a woman can and should use a superior man to do this. Marisa's move into an aristocratic class by the end of the film is not through her own work but through her romance with Prince Charming as the boyfriend/prospective husband. Indeed, Christopher Marshall is presented as a package of magical dreams: white elite social class attainment, political power, and old inherited wealth. He is constructed as an ideal male and the path to upward mobility for any woman.

For a character like Marisa, the social class differences are exacerbated because of the film's fairy-tale promise that a woman of color with little education, money, and social status will be acceptable and quickly mobile in the white elite social class. The film shamefully attempts to challenge any critical arguments the audience might have about the reality of class and color bias in dialogs between Marisa and her mother. The guarded mother is concerned about Marisa's affair with the politician, who has an established reputation as a playboy. (He had broken off a well-publicized relationship with a woman shortly before setting his sights on Marisa.) The film twists the mother's concern into jealousy of Marisa's dreams, ethnic self-hatred, lack of esteem, and racist views about whites. The film also tries to make light of class and color during short confrontational remarks between Marisa and Christopher. During one scene they briefly touch on issues of poverty and urban housing just before Christopher sets out to make a political appearance. Christopher's demeanor is unflappable and cavalier, thus devaluing the meaty issue of urban housing and the related problem of ethnic segregation in U.S. cities.

In real life, mobility and success come as a result of much effort and numerous other favorable factors. In *Latino Success: Insights from 100 of America's Most Powerful Latino Business Professionals*, Failde and Doyle (1996) interviewed numerous highly successful women and men about their success stories, but none

offered an easy answer to share with others who wish to be successful in the
United States and around the world. What is clear is that even after backbreak-
ing, eye-straining, lung-piercing work, upward social class mobility is not guar-
anteed for anyone. Furthermore, there are special challenges based on ethnicity
and color. Waiting for a superior Prince Charming to mistake you as a member
of the same ruling families because you are wearing borrowed designer clothing
like Marisa is not practical, reasonable, or smart. We as audiences must recog-
nize that beneficiaries of generations of old global wealth (symbolized by Christo-
pher Marshall) are not necessarily eager to give away comforts to poorer people in
the spirit of sharing and equalizing social classes.

James (2003), a *New York Times* reviewer, boldly titled her critique of the film
"Upward Mobility and Downright Lies" and noted that *Maid in Manhattan* de-
clares, "At any moment a servant may become a master" (p. 1). This is indeed a
farce, as documented all too well in Romero's (1992) research on maids and
domestic work in the United States. Domestic service workers are an oppressed
labor class who make ends meet without glamour. Although there are a few cri-
tiques of the status quo through sharp-edged commentary by Marisa, audiences
notice there is an overriding push to accept faux realism about easy mobility and
a push to discredit the reality of ethnic/racial bias that we continue to grapple
with in our world.

Basing one's mobility on a man is self-limiting. It is unfair to the other human
being who is being used and unfair to the woman who is retarding her personal
growth. The film *Maid in Manhattan* feeds the audience with unrealistic expec-
tations about the type of man to wait for and the kind of man to form a partner-
ship with to feel fulfilled. Instead, a more valuable film would inspire girls and
women to improve their own self-concept, self-esteem, and specialized abilities.
For example, Romero (1992) described a domestic worker who was attempting
to save money to pay for college courses. Education is an important way for girls
and women to gain agency and self-power. Females and their partners should as-
pire to fair co-partnerships, free of the superior male illusions that are ever-
present in the mass media. As Galician (2004) recommends in her Rx #6, which
counteracts this myth: "Create co-equality, cooperate" (p. 55).

MYTH #11: ACTORS ARE THE ROMANTIC
CHARACTERS THEY PORTRAY

During the high publicity build-up of actress Jennifer Lopez in the late 1990s
and early 2000s, Diana I. Rios found it challenging to maneuver undergraduate
classroom discussions toward image critique of this contemporary star. Further-
more, the women who contributed to class discussion about Lopez or who com-
pleted short written assignments on advertising techniques resisted examination

of their consumption of Jennifer Lopez products with statements carrying senti-
ments such as "I would have bought the perfume anyway." In the upper division
class called Media and Special Audiences, we spend the semester in contempla-
tion and analysis of audience media use and media representations of people of
color (e.g., Asian Americans, African American, and Latinos) and people who are
subordinated in society (e.g., women, gays, and lesbians). Overall, the discussion
and writing demands of the media class are conducive to social and economic me-
dia structure critique as well as self-critique and peer group critique. However, a
vocal portion of the class drew a line at dissecting what appeared to be their sa-
cred icon. Most noteworthy was the confusion of Jennifer Lopez, the successful
professional person with image–celebrity construals, with character types and
average New York borough dwellers. It appeared that Jennifer, their "friend" who
was not present just then, needed to be defended and buttressed from personal as-
sassination veiled as academic exercises in deconstruction. Rios decided to elim-
inate the topic until distance and time cured hyperinfatuation with this performer.

The phenomenon of confusing actors with the characters they portray is com-
monly mentioned in stage and film star anecdotes that poke fun at unsophisti-
cated audiences of bygone eras. Contemporary confusion of actors with their roles
is documented well in writings on soap operas and serialized media in the United
States and around the world (Allen, 1995; Ang, 1996; Brown, 1994; Wilson,
2004). There are many overlapping reasons for this recurrence: the general action
in the narrative that moves the story (and the audience) from beginning to end;
the persuasive power of identification with the main characters; and news recy-
cling and the intentional conflation of performer and film character by the me-
dia industries.

In *Maid in Manhattan*, audiences are not really watching a housekeeping em-
ployee named Marisa. They are watching Jennifer Lopez-the-celebrity as Marisa,
and Marisa as Jennifer Lopez. The director, writers, and publicists promise the
audience a film that is exciting and sparkly and that cultivates a sense that we are
privy to the inside machinations of a parallel life—that of Jennifer Lopez herself
and her rise to fame and money. What could be a mundane story of working-class
life is made into a spectacle of escape and romance to titillate our senses about
the performer Jennifer Lopez, her career, and her highly publicized romances.
Audiences would not favor an expose on labor practices in the hotel industry.

Examining news stories during the time of this film's release shows us that news
writers often parrot news release information from publicity organs. News recy-
cling is a symptom of media convergence and narrow media ownership in which
media outlets are related to one another through controlling interests of larger in-
ternational corporations. News recycling allows news outlets to save effort, time,
and money while at the same time conducting publicity for patrons. Besides re-
sulting in mediocre media quality and narrow pools of news items for audiences,
this practice feeds confusion between objective information and commercially

manufactured information created for the purposes of ideological agenda-setting (support of the status quo) and just plain publicity.

In a *New York Times* review, Kennedy (2002) provided an example of how news recycling conflates Jennifer Lopez-the-performer with Marisa Ventura-the-character: "*Maid in Manhattan* seems tailored for Ms. Lopez's core fans, it may also appeal to those who will see authentic parallels between the story, which is more *Working Girl* than *Cinderella*, and Ms. Lopez's own life" (p. 1). Kennedy's byline includes the fact that the journalist reports on entertainment for MSNBC, a cable television channel. Not only does the article lack the careful assessment that one would expect in a periodical of this stature, but also stating that the audience would see "authentic parallels" smacks of pure propaganda.

Ty Burr (2002) wrote a more critically balanced piece for the *Boston Globe*, continuing the theme of screen life as real life but adding critical commentary as well, seemingly aimed at Lopez's publicity machine and its constructions: "Not coincidentally, Marisa's ambitiousness dovetails neatly with that of the woman playing her. But it says something about the success of *Maid* as a lovably old-school Hollywood confection that it plays a lot more believably than anything in Jennifer Lopez's actual romantic life" (p. E1).

CBS News transcripts of *The Early Show* of December 11, 2002, document a dialogue between anchor Rene Syler and Jennifer Lopez. In the excerpt below, Syler referred to the guest in the third person during their interview to illicit a response:

Syler: Just like her character in the film, Lopez has been able to follow her dreams. She says she feels grounded right now.

Ms. Lopez: You know, I feel very comfortable with where I am and very kind of centered and good and all of those, you know, very spiritual funny words. You know what I mean? I feel centered and in my right place and comfortable with myself.

Syler recycled the theme of the actor as the character throughout the interview with Lopez on *The Early Show*. In this excerpt, Lopez tacitly confirmed the parallel of the artificial and the real by not challenging or correcting the idea. Lopez extended the train of thought and the illusion by touching on her spiritual matters.

It is in our best interest to "deconstruct celebrities," per Galician's (2004) Rx #11 and to confront the fact that actors are not the characters they portray. Audiences are urged to listen, read, and view with discernment as well as to seek out wide media sources for topics of their interest. Strategic communications by the media companies fuel audience's confusion between reality and fantasy. Audiences should be aware that the captains of the media industry have long maintained the commercial goal over the public service goal, as described by Folkerts and Teeter (2002) in their historical overview. Corporations gain financially when

audience members accept and consume media about a media personality or star. The star, surrounded by myth, is the main product. We should note that press releases, "chance" sightings that are the fodder of broadcast gossip mongers, alleged clandestine photos taken by paparazzi that only select members of the public have the privilege to see if they buy a certain magazine are by and large orchestrated by the public relations apparatus of film corporations.

That there are uncanny similarities between Marisa Ventura and Jennifer Lopez is a publicity statement that audiences should not swallow whole. Audiences watching network and cable television during the time of the film's release (Winter 2002) may recall entertainment talk shows' repeated insistence that there was a parallel between the rags-to-riches story about a girl from the Bronx and the real-life story of the performer. Actually, Lopez came from a middle-class family with professional parents. The performer's romantic life has shown personal turmoil and challenges: A Prince Charming does not exist, and no such individual secured finances for her. She has indeed proven successful in business, making a great deal of money for herself.

MYTH #2: LOVE AT FIRST SIGHT

This myth can be discussed as being ineffective in the film. If audiences are to accept "love at first sight" between Marisa and Chris, their initial encounter should have constituted the magical moment. Despite the gritty circumstances, with Marisa-the-maid cleaning his elegant bathroom suite, their eyes would have met in a lingering glance between her cleaning and his using the bathroom. Instead, the characters understandably turn away quickly, avoiding the embarrassment caused by the situation, and the love at first sighting is postponed until Chris sees Marisa-as-upper-class-impostor wearing a Dolce & Gabbana outfit. Her borrowed clothing, or costume, artificially raises her stakes so that she can be considered an appropriate partner for a millionaire politician.

The likelihood of the Cinderella love story in the life of a hotel maid is explored briefly in Laura Barton's film review for the *London Times* (March 6, 2003). She interviewed three chambermaids of minority backgrounds who worked in the London area. They commented on the taxing nature of the job that leaves little time for walks in the park. One woman remarked that Marisa did not look very tired. Another commented that hotel guests overlook you. The third worker questioned that a man campaigning for the Senate would be friendly with a maid. Their final conclusion was that such a thing could not happen to a maid because she would be too busy cleaning. Elitism of patrons or hotel guests and the demanding labor of cleaning creates a near impossibility for moments that might be described as lingering glances related to love at first sight.

In the first encounter between Meryl Streep and Robert DeNiro in *Falling in Love* (1984), there are flashes of chemistry that are evident in several scenes. Yet the relationship between Streep and DeNiro's characters grew out of conversations that included the truth about their lives. There were no false pretenses. What might have been an initial spark through a love-at-first-sight moment or several moments grew into love. In *Maid in Manhattan* there are no meaningful personal conversations that could qualify the relationship as one founded on love.

Audiences should recall that Prince Charming of the Cinderella fairy tale pursued the mysterious ball guest. He searched high and low to find the maiden who could easily fit into the ball slipper. In *Maid in Manhattan*, Marisa flees from the ball (a formal benefit gala) without dropping her shoe or any other article of clothing, and Chris manages to intercept her outside before she disappears into the darkness. In the next scene, without knowing each other very well at all, they end up in his hotel room and have sex on their first and only date. Prince Charming and Cinderella conduct a one-night stand while he is under the impression that she belongs to the elite class. This departure from Latino values regarding sex is in itself problematic, including the fact that Marisa is pretending to be someone she is not.

The contexts of meeting between Marisa and Chris are too far fetched. Marisa was enticed and prodded by her pal to try on a guest's expensive clothing (without the owner's permission) and encouraged to attend the ball by a senior butler acting as fairy godfather. After Marisa is found out and fired from her job, audiences can only wonder whether Chris and Marisa would have ever reunited on their own. Because they did not circulate in the same worlds with similar relatives, friends, vacations, or luxuries, chance encounters would be highly unlikely. In an extremely unlikely scene, press conference journalists allowed Ty, Marisa's 10-year-old, to speak at length and bring about the couple's reconciliation, instead of taking him out of the room or ignoring him. For some unknown reason, the crowd and Chris are intrigued by the words from the babe's mouth, and Chris is suddenly moved to forgive Marisa's charade. Chris's sudden enlightenment at the press conference is an additional unacceptable narrative piece that does not support the theme of love at first sight that the film is trying to force on the audience. A man in love would have made an effort to hunt high and low for the alleged love of his life. More realistically, a righteous Marisa would have felt he was harsh and judgmental toward her. Realistically, she should not have spoken to the superficial charmer again.

You cannot immediately know that you are in a love with someone else. As Galician's (2004) Rx #2 reminds us, relationships require time. One spark of chemistry does not give insight into a person's compatibility or capabilities of love. Shared values, beliefs, and goals need time to honestly unfold. Couples need to spend enough quality time together to discover their common ground and their differences. They need to share experiences to get to know each other. The po-

tential to relate well to one another requires knowledge of the other's upbringing, educational experiences, dreams, and worldviews. Love grows out of discovery of shared values. Love evolves as the feeling of couplehood deepens through increased sharing. If opportunities for sharing are limited or artificial, as in the relationship between Marisa and Chris, there is very little from which to build a meaningful relationship. Overall, relationships take time.

MYTH #5: WOMEN MUST LOOK LIKE A CENTERFOLD OR MODEL TO GAIN LOVE

In our discussion of the love-at-first-sight myth, we introduced the story element that one must look like a model. In this case a model-type is a candidate for a man of Chris Marshall's social class and political ascent. These women are described in popular culture as trophy wives or Barbie dolls. To arrive at the model-type, the film offers us artificial constructions of working class Marisa parading as the frivolous socialite and social climber "Caroline." Marisa's momentary working-class consciousness-raising discourses temporarily neutralize her Dolce & Gabbana moments. Her true class background and false extravagant gear present a dichotomous person who is both bourgeois and proletariat. This dichotomy leaves an impression on Chris, who is puzzled by and attracted to her. He remarks, "She isn't like anyone I've ever met before, and I'll tell you something else, she's real." In real life there would have been some political oppositional research within and outside of his camp to identify where the "realness" came from. Political spin-doctors are defensive to avoid being surprised by any bad publicity during a campaign. Chris and his handler miss an opportunity to discover her true background when Marisa mentions her familiarity with the Bronx. Chris does not follow-up on this remark and thus continues to visualize her as a beautiful, wealthy hotel guest. The story builds on the image of the centerfold/model almost to an extreme when Marisa dusts off her Dolce and Gabbana ensemble and the camera pans to her buttocks. She asks Chris to check if the outfit is soiled. His tongue-in-cheek remark that it looks fine plays on Jennifer Lopez's celebrated derriere. This remark is also a reference to Jennifer Lopez's real-life attributes that are the focus of many commentaries and comedic portrayals that exaggerate this physical trait.

Discourses that point toward Marisa's character traits as potentially appealing to Chris are lost because of the emphasis on her appearance first as a wealthy guest and then as a glamorous guest at the gala. The lack of curiosity about her circumstances—she stated she was at the hotel for "work reasons"—is questionable when there are a number of opportunities to ask about her circumstances. When she mentions her familiarity with the Bronx, he chooses not to pursue the issue further. He appears to be content with her centerfold image and not at all concerned with Marisa as a person. This reinforces the image of the centerfold

as the main factor in attracting and keeping a man. It is further emphasized when Chris makes no effort to find out the truth after her misrepresentation is discovered. Until the intervention of Marisa's son, it seems clear to the viewer that Chris would not have taken a second look at a maid. Even though she was an attractive maid, her uniform and its status marker conceal her centerfold "beauty" that audiences are aware of. Hence, in this film, the centerfold image is insufficient unless it is also packaged in attributes that are linked to the upper class. The invisibility of servants, to those they serve, would have made Chris's interest in Marisa impossible.

A real meeting of minds and hearts requires an understanding of the whole person. Galician (2004) discussed models of realistic love that involve necessary elements of real love, including communication and friendship. Both of these elements are absent when the focus of the relationship rests on physical attributes projected by expensive clothing and jewelry. Unfortunately, the influence of a mass media driven by market forces conveys messages that these items contribute to making those who buy them look like the celebrities who don them. Material accouterments divert attention away from the human qualities that friendship and communication can build on for a loving relationship. Furthermore, the need to cement a relationship through positive interactions is neglected when romantic interludes are plagued by dishonesty. In a context of superficiality, with a focus on the material (e.g., clothing and jewelry), conversations between people are minimally engaging and lack the basic elements that lead to knowing another person well.

Bob Hoskins' character (the hotel butler) defends the humanity of the service class by stating, "What we do does not define who we are." It is clear that this is a hard pill for Chris's social class to swallow, as we see in derogatory commentary by two female hotel guests to whom Marisa attends. The commentary and interactions between the women and Marisa encapsulate prejudiced elite-class thinking about underlings of all kinds. A quality relationship includes valuing a partner's choices and admiration for his or her profession. Chris is discouraged from pursuing the relationship once Marisa's socialite status expires. And Marisa's talk seems contrived whenever Chris discusses his political activities. The film refuses to clearly acknowledge the incompatibility between Marisa and Chris, as based on social class status. However, it is apparent that she is no longer deemed a suitable mate once she falls from grace. As for Marisa's responses to Chris's professional goals, she questions and challenges his political stances on the few issues that they mange to communicate about. These potential disagreements would raise red flags in relationships. The limited and poor quality of their interactions provides a very weak foundation for a friendship and much less for a loving relationship. Galician (2004) clearly prescribed that we should look beyond the "cover" in our companions (Rx #5).

CONCLUSION

This media literacy research into Hollywood's constructions of coupleship in *Maid in Manhattan* reveals many misrepresentations and outright lies regarding sex, love, and romance. We applied four mythic motifs—males need to have superior status, actors are their characters, love at first sight, and look like a centerfold or model to gain love—to examine the film *Maid in Manhattan*, which depicts a Latina who works as a maid in the hospitality industry. Reinforcing the traditional fairy-tale romance and Hollywood romance genre film, the lower-status maid is rescued from her drudgery by a higher-status male. Adding an additional dimension to the fairy-tale rescue are the dynamics of race and ethnicity, which reinforce notions of justified white patriarchal power in our society. In addition Diana I. Rios noted that university students and other fans have trouble detaching themselves from performers who are their icons. Star-gazing and infatuation reduce a person's abilities to critically analyze popular media. At a basic level, fans can have trouble accepting that actors are not their characters. Furthermore, fans and even general audiences rarely have first-hand information about famous entertainers—most all information comes from public relations handlers. The critique of love at first sight emphasizes the fact that initial chemistry does not guarantee long-lasting or fulfilling coupleship. Love at first sight as a motif is all too common in romance films and is farcical when everyday people expect this as a path to real love. Average women are not commercial models or global entertainers, yet women and girls are provided with mediated ideals to emulate. It is unfortunate that the message in popular entertainment repeatedly received by women and girls is that they must look like centerfolds, models, or celebrities to gain fulfilling relationships. Women and girls need to build self-regard for their own beauty and worth and then seek depth of character in potential partners. Overall, real-world relationships take time and a great deal of work. They are not cut out of a storybook.

STUDY QUESTIONS/RECOMMENDED EXERCISES

1. If you saw *Maid in Manhattan* before reading this chapter's critical analysis, list your "before" and "after" perspectives on the film in two columns. Give yourself plenty of space on a sheet, with impressions and thoughts of the film before reading the chapter on the left side. Do not worry if you have scattered thoughts or incomplete ideas. With the chapter in mind, think about the film for several minutes. Write down your thoughts and impressions of the film after reading the chapter in the right column. List any differences.

2. To be a fan or to stargaze is not necessarily bad for audiences. Drawing from this chapter and others in this book, as well as your experiences, explain the possible benefits and detriments of being a movie star fan.

3. Think about socioeconomic class and social class positioning (where segments or strata of people are theoretically located in a society). What general contradictions exist in this film when contrasted with "real" life?

4. According to Rios and Reyes, how does the film weave arguments about social class and love relationships?

5. According to Rios and Reyes, how does the film present race/ethnicity and social class in a love relationship?

6. Why is "love at first sight" a myth with regard to an "honest love relationship"?

7. To what degree do your perspectives of *Maid in Manhattan* coincide or differ from those of the authors of this chapter?

8. Explain how the myth of "males must be superior" (#6) in a romantic relationship creates unnecessary limits and boundaries in our society. Base your explanation on *Maid in Manhattan* and other similar films.

9. The classic *Cinderella* narrative can be adjusted to make more valid statements about contemporary society. For example, a woman's strength and determination are illustrated in parts of the film *Ever After: A Cinderella Story* (1998) starring Drew Barrymore. In one part, this Cinderella physically carries the Prince away from thieves to save his life. You, too, can recreate the Cinderella story to exemplify mental and physical strength, intelligence, and persistence. Write a paragraph that starts with "Once upon a time. . ." and fill in the rest, challenging denigrating ideas or limits placed on females. You can do this assignment on your own or even working in a small group. You will find that to bring forth positive qualities of a female it is not necessary to oppress males in return. Strive for gender equity in your brief story.

REFERENCES

Allen, R. C. (1995). *To be continued: Soap operas around the world.* New York: Routledge.

Ang, I. (1996). *Watching Dallas: Soap opera and the melodramatic imagination.* New York: Routledge.

Barton, L. (2003, March 6). Women maid up: Jennifer Lopez stars as a chambermaid who falls in love with a hotel guest in her new film *Maid in Manhattan. The Guardian.*

Bass, M. (2002, December 11). CBS News Worldwide, Incorporated. *The early show* [Television broadcast]. New York: CBS News.

Berg, C. R. (2002). *Latino images in film: Stereotypes, subversion, resistance.* Austin, TX: University of Texas.

Brown, M. E. (1994). *Soap opera and women's talk.* Newbury Park, CA: Sage.

Burr, T. (2002, December 13). Jennifer is a modern day Cinderella in the old-fashioned romance Maid in Manhattan. *Boston Globe,* p. E1.

Failde, A., & Doyle, W. (1996). *Latino success: Insights from 100 of America's most powerful Latino business professionals.* New York: Simon & Schuster.

Folkerts, J., & Teeter, D. L. (2002). *Voices of a nation: A history of mass media in the United States* (4th ed.). New York: Allyn & Bacon.

Galician, M.-L. (2004). *Sex, love, and romance in the mass media: Analysis and criticism of unrealistic portrayals and their influences.* Mahwah, NJ: Lawrence Erlbaum Associates.

James, C. (2003, January 12). Upward mobility and downright lies. *New York Times,* p. 1.

Keller, G. D. (1994). *Hispanics and United States film: An overview and handbook.* Tempe, AZ: Bilingual/Review Press.

Kennedy, D. (2002, November 3). Homegirl, working woman, empire builder. *New York Times,* p. 1.

Rios, D. I. (1996). Chicano cultural resistance with mass media. In R. De Anda (Ed.), *Chicanas and Chicanos in contemporary society* (pp. 127–141). Boston: Allyn & Bacon.

Rios, D. I. (2000). Chicana/o and Latina/o gazing: Audiences of the mass media. In D. R. Maciel, I. D. Ortiz, & M. Herrera-Sobek (Eds.), *Chicano renaissance: Contemporary cultural trends* (pp. 169–190). Tucson, AZ: University of Arizona.

Rios, D. I. (2003). U.S. Latino audiences of telenovelas. *Journal of Latinos in Education, 2*(1), 59–65.

Romero, M. (1992). *Maid in the U.S.A.* New York: Routledge.

Wilson, T. (2004). *The playful audience: From talk show viewers to Internet users.* Cresskill, NJ: Hampton.

Diana I. Rios *is Associate Professor of Communication Sciences and Puerto Rican and Latino Studies at the University of Connecticut, where she has been a faculty member since 1997 and has also served as Associate Director of the Institute for Puerto Rican and Latino Studies until 2003. She earned her doctorate from the University of Texas at Austin. Her research interests include mass communication, cross-cultural communication, and communication processes with ethnicity, race, and gender. She is co-editor of* Brown and Black Communication *(2003), a textbook about Latinos and African Americans published by Praeger.*

Xae Alicia Reyes *is Associate Professor of Education and Puerto Rican and Latino Studies at the University of Connecticut, where she has been a faculty member since 1999. She earned her Ph.D. from the University of Colorado. Her research interests include educational ethnography, teacher education, school reform, and migration and schooling. She has taught at Rhode Island College, Brown University, and the University of Puerto Rico. She is author of* Language and Culture in Qualitative Research *(in press) published by Edwin Mellen Press.*

CHAPTER 9

Myths of Sex, Love, and Romance of Older Women in *Golden Girls*

Jo Anna Grant and Heather L. Hundley
California State University, San Bernardino

As with any demographic categorization, such as ethnicity, gender, economic status, people characterize the elderly by a myriad of myths and stereotypes. Some myths of aging adults include the notions that hearing loss and pain are normal, Alzheimer's disease is inevitable, cognitive activity dissipates, and overall health greatly declines. Other stereotypes of aging include the ideas that older people are crazy, asexual, and generally an inconvenience to society. Research has shown that all of these beliefs about older adults are false (Nussbaum, Pecchioni, Grant, & Folwell, 2000).

According to the Communication Predicament of Aging Model (Ryan, Giles, Bartolucci, & Henwood, 1986), stereotypes of older adults determine how people approach the communication interaction and how they interpret messages. For instance, physical markers of aging, such as gray hair or wrinkles, evoke stereotypical expectations of older adults in younger adults. The cues activate stereotypes, and younger people adapt their communication to match. If the stereotype activated is that all elders are deaf, younger people speak loudly. If the stereotype is that older adults suffer a decline in cognitive capacity, communication becomes very simplified resulting in "Elderspeak" or secondary baby talk. Such accommodations are common, but are ultimately patronizing and disempowering for older adults.

Stereotypes about older adults are also gender specific. Older women endure a range of stereotypes from the hag, the shrew, the crazy old lady to the little old lady, the grandmother, and the matron (Hummert, 1994). Whether the stereotypes are negative or positive, all of them can be damaging, and none provides a picture of older women in romantic relationships.

Stereotypes of aging also play a role in media portrayals of older women. In a study of advertising targeted to physicians, Hansen and Osborne (1995) found that drug advertisements portrayed older women using the "crazy old lady" stereotype. The ads depicted women of all ages 77% of the time and older adults (both men and women) in 84% of the ads. Even adjusting for the proportionately

larger incidence of depression in women (believed to be twice as much as it is in men), the ads depicted older women in greater need of antipsychotics, antidepressants, tranquilizers, and sedatives. Thus, the target audience (physicians) might receive the message that older women are less mentally balanced and are in need of chemical supplements.

Negative stereotypes of older women also persist in media depictions across cultures. Harwood and Roy (1999) examined the portrayal of older adults in magazine advertisements from India and the United States. The magazines' ads gave older women low visibility by portraying them less frequently than older men, even though older women comprise a larger segment of the population. In Indian magazines, older men were portrayed at work making decisions, whereas older women were shown in domestic settings performing chores such as cooking. The depictions were similar in U.S. advertisements. Older men were shown being leaders or professionals, whereas older women were shown in social settings or relaxing with family. These advertisements perpetuate the idea that the natural realm of men is the workplace, whereas home and family are the preferred domains of women.

Fortune magazine's listing of the top 50 businesswomen is a venue in which readers would expect mature women to be portrayed as powerful leaders. Shuler (2003), however, found this not to be the case. Images of businesswomen supported gendered stereotypes, including portrayals of the women executives as homemakers with photos of them in their living rooms surrounded by their children. Poses, wardrobe, and the text surrounding the photos contradicted the idea of hard, powerful businessmen, by making the women appear soft and powerless. Finally, the images focused upon the women's appearance and sex appeal. Shuler commented that these pictures looked more at home in *Glamour* or *Cosmopolitan* than in a business magazine. Even powerful businesswomen cannot escape the negative stereotypes that plague older women.

Television also supports negative stereotyping of older women. In their content analysis of primetime TV, Vernon, Williams, Phillips, and Wilson (1990) found that programming, including advertising, severely underrepresented older adults. When primetime TV portrayed elders, viewers saw a greater number of older men compared with older women. The programs and commercials generally depicted older men positively and older women negatively. Harwood and Anderson (2002) found a similar pattern when examining primetime comedies and dramas. The programs underrepresented older adults and women compared to the U.S. population, and overrepresented middle-aged white men. Thus, not only does primetime TV limit the visibility of older adults in general, it also perpetuates negative images of older women in particular.

Such TV portrayals do affect viewers. Televised characters play a vital function in viewers' social lives. Horton and Wohl (1979) coined the term *para-social*

relationships to represent the active social relationships between mass media characters and the audience. Audience members develop a feeling that they actually know the TV character as a friend or acquaintance. Piccirillo (1986) argued that these relationships are real to the audience and can evoke real emotions such as like, love, hate, or grief. Piccirillo also demonstrated that television writers and producers are aware of the feelings viewers have developed for the characters and thus set up plausible situations and rituals for saying good-bye to the characters at a series' conclusion or when a major character leaves a series. As the characters say good-bye, the viewers vicariously participate in this ritual to engage in emotional closure.

GOLDEN GIRLS

The hit situation comedy series *Golden Girls* stands in stark contrast to other negative portrayals of older women in the media. The *Golden Girls* series was produced by NBC from 1985–1992 and has been in continuous syndication since 1989. Rather than ignoring or marginalizing older women, the show features them living as housemates in Miami. The four main characters in this series, Dorothy Zbornak (Bea Arthur), Rose Nylund (Betty White), Blanche Devereaux (Rue McClanahan), and Sophia Petrillo (Estelle Getty) are not portrayed as hags, shrews, or crazy old women. Far from being ugly, they all dress stylishly, with glamorous makeup and coordinating accessories. Although they are all grandmothers, they do not feature that role as the center of their existence. Instead of portraying sexual inactivity, all of them date and have sex during the series.

Dorothy is the most intelligent of the four. Physically, she is very tall with a deep voice and a stern manner. As a teen, she became pregnant and married Stanley while still in high school. After two children and 38 years of marriage, Stan left Dorothy for a young flight attendant. They divorced, and she went to work as a substitute high school teacher, supporting herself and her aging mother (@ccess The *Golden Girls*, 2004). The series reveals Dorothy and Stan's evolving relationship with Dorothy's second thoughts, Stan's regrets, and their final resolution—friendship.

Sophia is Dorothy's mother. She is short and feisty and carries her purse with her wherever she goes. A native of Sicily, she grew up poor but happy. She moved to Brooklyn and raised three children with her husband, Salvatore. Following Sal's death, Stan put Sophia (against her will) in Shady Pines Retirement Home. Nevertheless, after Stan and Dorothy's divorce, the home burned and Sophia and Dorothy moved to the Miami house. Stereotypically Sicilian, Sophia keeps Mafia connections and loves to tell stories about the old days (@ccess The *Golden Girls*, 2004).

Rose is the archetypal "dumb blond" on the show. She is a sweet, naïve, good-natured person from ultra-rural St. Olaf, MN. She married Charlie after high school and had three daughters. When her husband died, she moved to Miami where she works as a grief counselor. She is renowned for telling long, pointless stories of her hometown (@ccess The *Golden Girls*, 2004).

Blanche is a characteristic Southern belle whose wealthy Atlanta bloodlines allow her to own the house that serves as the central set of the show. She frequently boasts that men have always admired her devastating beauty. After a brief stint as a Rockette in her younger years, she returned to Atlanta to marry her true love, George Devereaux. They raised four children. Following George's death, she moved to Miami. Blanche is always on the prowl for men and ready to share stories of her many sexual conquests (@ccess The *Golden Girls*, 2004).

Instead of depicting older women as embodiments of negative stereotypes, Kaler (1990) argued that the four main characters of *Golden Girls* actually portray a complete Jungian personality. Dorothy represents masculine reasoning through her exceptional height, intelligence, and position as a teacher. Blanche, the promiscuous Southern belle, represents the archetype of sensuality. As befits her name, Sophia represents the wisdom of experience through her tales of the Depression and of growing up in Sicily. Rose portrays metaphorical virginal innocence with her child-like trust and stories of farm life that convey her uncorrupted virtue.

Given that visual cues of aging can evoke negative stereotypical responses in interpersonal interactions and that active para-social relationships audiences have with TV characters can evoke strong emotional reactions, it makes sense that physical markers of aging in television characters could also evoke negative stereotypes in audience members' minds. These responses might even cause them to tune out or turn off the show. Perhaps the danger of losing viewers is why older adults are so underportrayed on television.

This risk is what makes *Golden Girls* such a bold undertaking for its creator Susan Harris and the network that produced it, NBC. The series was an instant hit in primetime in 1985. It ranked in the top 10 in the Nielsen ratings in its first six seasons and in the top 30 in its final 1992 season (TV.com, 2006). While on the air, the show received numerous awards and accolades, including 11 Emmys, 2 for best comedy, and 3 Golden Globe Awards (Lifetime Entertainment Services, 2004). The series is still quite popular. In April 2004, the series ranked as the eighth most requested unreleased show on DVD (Lacey, 2004). It also enjoys growing popularity with younger adults. Tim Brooks, Vice President of Research for Lifetime Television said that *Golden Girls* clicks with young women because "they don't talk like ladies their age, they talk and act like young people today, they're not beholden to men, they talk about sex, they run their own lives" (Turnquist, 2004, p. D-01). *Golden Girls* is a staple of the Lifetime Television Network airing 37 times weekly (Lifetime Entertainment Services, 2004).

MASS MEDIA MYTHS OF SEX, LOVE, AND ROMANCE

The situation comedy *Golden Girls* boldly contradicts general myths and stereotypes of older women; what about the show's portrayal of romantic relationships? Galician (2004) identified 12 media myths of sex, love, and romance and recommended 12 prescriptions that counteract these myths. She contended that the media portray coupleship in idealized ways that lead audiences to unrealistic expectations about their own romantic relationships. These expectations, in turn, can lead to broken, unsatisfying relationships and loneliness. In considering Galician's (2004) 12 myths and prescriptions and initially viewing the series, it was clear that four of the myths and prescriptions could be closely examined. Specifically, Galician (2004) stated that the media often portray the image that romantic partners are predestined (Myth #1), love at first sight exists (Myth #2), women must look like centerfolds (Myth #5), and men must be stronger, taller, smarter, and wealthier than their female counterparts (Myth #6). Additionally, Galician (2004) offered corresponding "prescriptions" to counter each myth. For instance, she suggested consideration of countless candidates (Rx #1), allowing relationships to develop over time (Rx #2), cherishing the completeness of your companions (Rx #5), and creating co-equality between men and women (Rx #6). In an initial screening of the *Golden Girls*, several episodes indicated the presence of these myths or prescriptions.[1] Therefore, we chose to critically examine the portrayal of these four myths and prescriptions to understand how they are supported or rejected by older female characters. This chapter focuses on whether *Golden Girls* embodied Galician's (2004) Myths #1, #2, #5, and #6 and their corresponding prescriptions.

METHOD

Sample

We used content analysis and discourse analysis to examine 37 episodes (18.5 hours) of *Golden Girls* that we taped from Lifetime TV during the summer of 2003. This convenience sample consists of episodes derived from six of the seven seasons aired. No shows from the sixth season appeared in the sample. The shows represented more than 20% of all the episodes produced and included the series

[1]Blanche's propensity for sex is obvious throughout the series. However, we thought Myth #4 would be difficult to code because situation comedies, such as this one, do not explicitly portray sexual acts. Such acts occur off screen, not allowing viewers to evaluate whether or not "sex is easy and wonderful" (Galician, 2004, p. 55).

finale "One Flew Out of the Cuckoo's Nest" (see Table 9–1 for episodes). The finale is important to include because it is the final word on the characters' over-all ideology. For instance, a character might have an epiphany about men or ro-mance. As Piccirillo (1986) implied, such a realization would leave viewers with a sense of psychological closure toward the topic.

Coding

We identified each episode by its season, production number, and airdate using Lifetime TV's episode guide (Lifetime Entertainment Services, 2004) and Wodell's (2003) listing of airdates. To examine the characters' portrayals of romantic rela-tionships, we conducted a discursive content analysis during the summer of 2004. According to Fiske (1984), "A discourse is both a topic and a coded set of signs through which that topic is organized, understood, and made expressible" (p. 169). For our analysis, the discourse/topic was sex, love, and romance. We exam-ined how the topic was organized and expressed through the four myths and pre-scriptions under investigation by examining the context of expressions and be-haviors, the social consequences that result, and the technical cues that indicate how the audience should react. Further, we coded for the presence/absence of a myth or prescription portrayed by any of the four main characters as well as the frequencies of verbal and nonverbal behaviors exhibiting the four myths and pre-scriptions under investigation.

Myth #1

Myth #1 is that the perfect partner is somehow predestined and its prescription (Rx #1) is to be open to a number of possible partners (Galician, 2004, p. 55). To examine this myth, we coded the presence or absence of mentions of "destiny," "the one," or "meant to be" by each of the four main characters. For the pre-scription, to "consider countless candidates," we listed by name or designation (e.g., "the photographer") each main character's current and past partners and counted them. During the process, we also made note of the women's expressed perspectives (positive or negative) on monogamy and promiscuity. This process offered insight as to whether the characters' actions coincided with their beliefs regarding Myth and Prescription #1.

Myth #2

Myth #2 is that love at first sight is possible. The prescription prefers rela-tionships to develop over time. For this myth, we identified each instance of any

TABLE 9–1.
Episodes of *Golden Girls* Used in the Sample
by Season and Production Number*

Season	Production No.	Episode Title	Original Airdate
1	8	That Was No Lady	12/21/85
1	9	The Triangle	10/19/85
1	21	Adult Education	02/22/86
1	24	Blind Ambitions	03/29/86
2	10	Big Daddy's Little Lady	11/15/86
2	12	Love, Rose	12/13/86
2	13	'Twas the Night Before Christmas	12/20/86
2	17	And Then There Was One	01/31/87
2	18	Bedtime Story	02/07/87
2	24	To Catch a Neighbor	05/21/87
3	4	Old Friends	09/19/87
3	1	Bringing Up Baby	10/03/87
3	7	The Housekeeper	10/10/87
3	16	Blanche's Little Girl	01/09/88
3	15	Dorothy's New Friend	01/16/88
3	17	My Brother, My Father	02/06/88
3	22	Mixed Blessings	03/19/88
3	23	Mister Terrific	04/30/88
3	25	Mother's Day	05/17/88
4	7	Sophia's Wedding (2)	11/26/88
4	10	Scared Straight	12/10/88
4	15	Two Rode Together	02/18/89
4	20	'Till Death Do We Volley	03/18/89
4	22	Little Sister	04/01/89
4	26	Rites of Spring Break In	04/29/89
5	8	Dancing in the Dark	11/04/89
5	5	That Old Feeling	11/18/89
7	9	Dateline Miami	11/02/91
7	10	Rose Loves Miles	11/16/91
7	12	From Here to the Pharmacy	12/07/91
7	3	The Pope's Ring	12/14/91
7	17	Questions and Answers	02/08/92
7	19	Journey to the Center of Attention	02/22/92
7	22	Rose: A Portrait of a Woman	03/07/92
7	25	One Flew Out of the Cuckoo's Nest (1)	05/09/92
7	26	One Flew Out of the Cuckoo's Nest (2)	05/09/92

*Note. The sample captured no episodes from Season 6.

of the four women meeting a stranger and falling in love. For the prescription, we coded each time any of the four women had friendships that evolved over time into love and romance.

Myth #5

Myth #5 involves stereotyping women to look like centerfolds. The prescription is to cherish the completeness of your companions. To discover how the show portrays these, we counted the number of verbal and nonverbal expressions of the characters' personal desire to be attractive for a man (e.g., dressing up or asking how they look). We distinguished between validating and rejecting the stereotype. We also counted the characters' positive and negative expressions about the attractiveness of other women viewed as competition for men. Next, we coded for positive and negative expressions of stereotypical female qualities (such as being demure, nurturing, or flirty). For the prescription, we coded whether or not the characters expressed positive qualities, other than looks, that are important for relationships (such as being smart, trusting, and loyal). The show signified these qualities through verbal and nonverbal cues such as characters' dialogue, actions, and the affirmations of other characters. For instance, to depict intelligence a character may be shown solving a crime or attending college, using intellectual phrases or references.

Myth #6

The final myth studied concerns superficial characteristics of men and the idea that a man should never be shorter, younger, weaker, poorer, or less successful than a woman (Myth #6). We counted the characters' positive and negative expressions of both the *superior* and *inferior* characteristics of men (e.g., poverty or weakness). The prescription for this myth is to create co-equality between men and women. To identify this behavior we coded whether or not the characters expressed or demonstrated affirmations of peer coupleship between men and women (such as going "Dutch," compromising, or collaborating).

Intercoder Reliability

To check for intercoder reliability, we independently coded the same five episodes (13.5% of the sample). With the use of Holsti's (1969) formula, the overall percentage of agreement was 90.0%. For individual categories, agreement ranged from 75% to 100%. We resolved disagreements by discussion and then divided the remaining 32 episodes and coded them separately.

GOLDEN GIRLS' PORTRAYAL OF SEX, LOVE, AND ROMANCE

The mass media often portray the message that romantic partners are predestined (see Myth #1). This is certainly not the case for the *Golden Girls* characters, and most specifically not for Blanche Devereaux. Our content analysis demonstrated that the four main characters romantically interacted with multiple partners during the series. The discourse analysis supported this practice through characters' verbal affirmations, laugh tracks, and an absence of negative consequences. For instance, in one episode (7:13)[2] Blanche entered the kitchen in her nightgown:

Dorothy: How was your date last night?

Blanche: It's too soon to tell. Wait until I send him home.

In another episode (7:25–26), Blanche was torn between entertaining her uncle from out of town and going on a date. She chose the tlater by rationalizing:

Blanche: Family you can see any time but a one-night stand only happens one night.

This dialogue coupled with the ensuing laugh tracks informs viewers that not only did Blanche date and take her dates home with her presumably for sex and engage in one-night stands, but also because there was no dialogue to critique her casual sexual attitudes, this was acceptable behavior as well.

In addition to instances such as the one just described, the show depicted the characters with myriad past partners in flashback scenes, and the characters themselves also made mention of many past relationships. Dorothy, Rose, and Sophia were consistent in terms of the number of current and past partners. Our sample depicted Dorothy with 5 partners (Glen O'Brian, 1:8; Elliot Clayton, 1:9; Detective Al Mullins, 2:24; a doctor, 7:10; and her ultimate husband, Lucas Hollingsworth, 7:24–25), while she spoke of 5 additional past partners (Stan Zbornak, many episodes; the "bug man," 4:20; 2 dates as a teenager, 3:16; and a doctor, 7:9). Rose had 4 current romances ("Mr. Terrific" a.k.a. Roger, 3:23; Ernie Faber, 2:12; a

[2]Specific episodes can be referred to in a number of ways: by title, by original airdate, or the way we have done it here—by season and production number during that season. In this notation the number before the colon is the season and the number after the colon is the production number. For episode titles and original airdates refer to Table 9–1. You will note that the original airdates do not necessarily follow the season and production number order. This is common. Actors' availability, director's schedule, or the need for specific sets or locations can dictate production order. Special programming, seasonal breaks, or postproduction requirements can delay the broadcast date.

Texan 7:10; and Miles Webber, 5:8) and mentioned 3 past relationships (Charlie Nylund, many episodes; John, 7:9; and Arne, 7:9). Sophia encountered 5 suitors (Sonny Venunccio, 2:12; Alvin Newcastle, 3:4; Murray Guttmann, 3:15; Max Whitestock, 4:7; and Mr. Panolli, 5:5) and mentioned 4 past beaus (Salvatore Petrillo, many episodes; her brother,[3] 2:18; a pepperoni salesperson, 1:9; and Guido Spirelli, 7:10). These portrayals suggest that the characters did not believe in one true partner; rather, they sampled various relationships.

Blanche epitomized the prescription to consider countless candidates. She had 7 different partners and spoke of 38 past partners. In fact, when Blanche was attempting to talk Rose into giving boudoir photos to her boyfriend, Miles, for his birthday (7:19), Blanche argued:

> **Blanche:** The pictures are just an intimate way to let a fellow know he's the one and only in your life. I've done it 20 or 30 times.

Because Blanche disclosed that she has taken boudoir pictures for 20 to 30 men, we know she had considered countless candidates. Further, the laugh tracks that followed this dialogue serve as an indication that Blanche really does not believe that "the one" exists. She truly exhibited the antithesis of "finding the one" with 45 men littered throughout her history.

Whereas the characters each verbally and nonverbally affirmed the prescription to consider countless candidates, each of them also positively mentioned the idea of a cosmically predestined partner. Dorothy, Blanche, and Sophia stated this once each (1:8 and 7:25–26, respectively), and Rose mentioned it three times (2:10, 5:8, and 7:25–26). Dorothy joined her housemates on the patio, for instance, and was talking about a man she has just recently met (1:8):

> **Dorothy:** We started talking and in 30 seconds I was in love.
>
> **Blanche:** Honey, you've been hit by the thunderbolt. Love at first sight. It happened to me once.
>
> **Rose:** I was hit by the thunderbolt once; it was the first time I saw my Charlie.

An absence of laugh tracks or critical commentary reveals to viewers that a cosmically predestined partner is possible, although rare. By the end of this episode, Dorothy learned that this man was married, and her heart was broken. Thus, regardless that the characters believed in love at first sight, Dorothy learned that this myth could result in negative consequences. Although they verbally affirmed

[3]Her family was apparently so large she did not even know all of her brothers and sisters. Sophia broke off the relationship when she found out they were siblings.

the myth, they all enacted the prescription, as witnessed by the parade of men in all four of the characters' lives.

Closely related to the concept that one's partner is predestined is the idea that there is such a thing as "love at first sight" (Myth #2). Again, the characters' behavior outweighed their words. Interestingly, whereas Dorothy, Rose, and Sophia verbally affirmed the possibility of love at first sight, they experienced friendships that developed into romance.

An understanding of each of the characters' individual perspectives of Myth #2 is more revealing. Of the four main characters, wise Sophia, the eldest, did not express the idea of love at first sight. Blanche and Dorothy, on the other hand, each mentioned this idea once (1:8). In the season finale (7:25–26), for example, Blanche arranged a blind date between Dorothy and her uncle Lucas. Neither party wanted to go on a blind date, but Blanche convinced them that the other person desperately wanted to meet. During the very boring dinner date, when the two learned of Blanche's strategy, they decided to get back at her and pretend they fell madly in love. As a joke, the morning after their date, Lucas showed up at the house and proposed to Dorothy in front of the other housemates:

Blanche (upset): What in hell's a matter with you? You just met! You don't even know each other! It's just your hormones playing tricks on you.

Rose: Oh, I think it's romantic. It's like something out of a 40s movie.

Blanche (turning to Sophia): Don't let her run off with the first man that comes along!

Thus, even though Blanche talked once about being "hit by the thunderbolt" in a previous episode, she is ultimately against the notion of love at first sight, especially when it involves her relatives. Rose, nevertheless, finds the idea "romantic." Blanche's experience with men may have shown her that love at first sight does not exist, yet she may still want to hold onto the romantic notion. Dorothy, however, may be intelligent enough not to support the myth, but like Blanche, she may want to believe in it anyway. Rose discussed the idea of love at first sight more than any other main character (3 times: 1:8, 2:10, and 7:25–26). She thought it to be romantic and fairy tale-like. This idea is consistent with her simplistic and innocent character.

For as many times as Rose positively disclosed the idea of love at first sight, she nevertheless enacted friendships that evolved into romances. Her actions contradicted her words; therefore, her attitude toward Myth/Rx #1 is unclear. The other characters, however, more often than not debunked the fairy-tale version of romance perpetuated in the media. Each of them substantially supported Rx #1 through their actions by considering countless candidates.

Centerfolds and Macho Men—Senior Style

In addition to exploring the myths that partners are predestined and love at first sight exists, we also examined two additional related myths in *Golden Girls*. Myth #5 suggests that to attract and keep a man, a woman should look like a centerfold. By this myth, the media establish conventional standards for an ideal woman. Another myth is that men should not be shorter, weaker, younger, poorer, or less successful than women (Myth #6). This myth shows the ideal man as taller, stronger, older, richer, more successful, and with a younger woman in tow.

In *Golden Girls* these myths are supported but within limits. Adjusting for the age of the characters, the audience can see that the series upholds the center-fold and macho man myths to a degree, which tells viewers that even in their golden years they must be concerned with beauty and constructed gender.

Throughout the shows under investigation, the four main characters expressed the importance of being attractive to get and/or keep a man, and their positive comments and actions exceeded the number of negative ones for each character. For instance, in one episode Blanche informed Rose, "You have to dress up to please him" (7:22), referring to Rose's boyfriend, Miles. Later in the same episode, Blanche warned Rose, "If you don't make yourself more interesting to Miles, you're going to lose him." In another episode, Dorothy was excited about a date and said, "Blanche, I need you to give me a manicure. Rose, I need you to lend me your pearls" (1:8). Examples like these were prevalent throughout the series as these ladies remained concerned about getting and keeping a man. Whereas Sophia supports the myth 5 times (1:9, 5:5, and 5:8),[4] she denounces it once (2:24). Dorothy espouses it in 8 instances (1:8, 1:9, 2:10, 7:5, 7:9, and 5:8) and challenges it 5 times (1:8, 2:10, 2:13, and 7:25–26). Rose upholds the myth 11 times (1:9, 2:12, 3:22, 5:8, 7:10, and 7:22) and dispels it 5 times (1:9, 2:10, and 7:22). Blanche validates this particular myth the most, 26 times (1:9, 2:10, 2:13, 2:24, 3:1, 3:4, 3:7, 3:15, 3:22, 5:8, 7:9, 7:10, 7:12, 7:17, and 7:22) and disclaims it only 5 times (1:9, 2:10, 7:1, and 7:13).

We also examined the characters' views about other women's attractiveness in terms of competing for men. When we coded the number of comments for each character about other women's physical attractiveness, the data revealed a simi-lar pattern to what the characters expressed in terms of their own attractiveness (Dorothy 1 time, 1:9; Rose 1 time, 2:12; and Blanche 9 times, 1:5, 2:10, 4:22, and 7:19), and they socially rewarded stereotypical female qualities (Dorothy 5 times, 3:4, 4:26, 5:8, and 7:19; Rose 7 times, 2:12, 4:26, 5:8, 7:9, and 7:22; Blanche 31 times, 1:5, 1:9, 1:21, 2:12, 2:17, 2:24, 3:4, 3:15, 3:17, 3:22, 3:25, 4:10, 4:26,

[4]The characters may display the behavior more than once per episode. Thus, the number of episodes cited may be less than the number of instances coded.

5:5, 5:8, 7:10, 7:13, 7:17, 7:19, 7:22, and 7:25–26; and Sophia 3 times, 1:9 and 5:8). For instance, when Dr. Clayton makes a house call to check on Sophia, Dorothy is smitten by him (1:9). When Blanche enters the room, she vies for his attention saying that she's in need of his "bedside manner." However, Dorothy tells her to back off because she "saw him first." In another episode (7:19), Blanche is overtaken with jealousy when the men at her bar are enamored with Dorothy's singing. She tells Dorothy, "I'm jealous of you." Later, she asks Dorothy if she's ever jealous of her, to which Dorothy responds, "Every day." Finally, in another episode (7:22) Blanche persuades Rose to do the boudoir photos for Miles' birthday by convincing her that the younger, attractive woman talking with him at career day was trying to steal him away from her. Nervous about the competition, Rose immediately complies.

Just as Sophia does not support or reject the notion of love at first sight (Myth #2); she does not express concern for competing with physically attractive women in the hopes of winning over a man. Interestingly, for as many times as the three remaining characters were seemingly concerned with other women's physical beauty to lure and compete for a man, they were simultaneously supportive toward other women's beauty (positive to negative, Dorothy 1–1, 7:19–1:9, Rose 2–1, 3:7 and 7:22–2:12, Blanche 11–8, 1:5, 1:9, 2:12, 3:7, 7:19, and 7:22–1:5, 2:10, 4:22, and 7:19). Examples of supportiveness for other women's beautiful qualities exist in a few episodes. For instance, Dorothy comforts Blanche during a "dry spell" (5:8):

> **Dorothy:** You are as attractive and desirable as you always were. A lot of men can be frightened by that. They don't know if they can handle that much woman. But honey, they're out there, wanting you as much as you want them.

In another episode, Blanche was angry at Dorothy because she was getting all of the male attention at a bar they frequented (7:19). They had a verbal confrontation in the ladies room:

> **Blanche:** The truth is I'm jealous of you. I knew I never had to worry about competing with any other woman because I'd always win. But when you sang the other night I realized why all those men were practically falling all over themselves to get to you. You light up the room. You do. You positively glow. You're just . . . you're beautiful.

This particular episode and dialogue perform two functions. First, viewers can see how Blanche was competing against Dorothy for men's attention. As the story unfolded, Blanche was wearing sexier dresses. By the last scene she was in a low-cut, bright-red, sequined, form-fitting evening gown and attempted to

entice the men by singing a slow-paced, sultry song, showing her legs and sprawling out on top of the piano. Second, by the episode's end, the friends agreed to cease their competition and make up. In doing so, Blanche provided supportive comments to Dorothy by telling her that she's beautiful. They, nevertheless, upheld the myth that outward attributes are necessary and vital in sustaining a romantic relationship.

Although the characters primarily affirm the centerfold myth, they also mention qualities other than looks that make a woman attractive (Rx #5), such as being "smart" (7:25–26), "interesting" (1:5), "loyal" (1:9), "forgiving" (1:9), "dignified" (1:21), "self-respecting" (1:8), "patient" (2:12), "kind" (3:16), "gentle" (3:16), "fun" (2:12), and "nurturing" (2:24). Although Dorothy's identification of these other important qualities may appear typical (coming from the smart one of the group), Blanche mentions just as many of these nonsurface qualities as does Dorothy (9 times each; Blanche, 1:5, 1:9, 1:21, 2:12, 2:17, 2:24, 3:16, 4:15, and 7:19; Dorothy, 1:8, 1:9, 1:21, 2:17, 2:24, 3:15, 4:15, 7:19, and 7:25–26). Blanche's remarks seem inconsistent because she is known as being self-centered, superficial, and material. Rose expressed such qualities 5 times (1:9, 1:21, 4:15, 5:8, and 7:25–26) and Sophia only twice (1:8 and 2:17).

All four women buy into the centerfold myth. In one episode (7:22), for instance, Blanche explains that Rose "must dress up to please him [Miles]." In another episode (7:12), Blanche states that she must get "all prettied up" for her date. Further, the women seemingly had a limitless clothing allowance and an endless array of outfits for they always dressed to the nines when going out on a date, dancing, shopping, or even entertaining at home.

Specifically, the show upholds the centerfold myth with a senior twist by adjusting the portrayals to fit older adults. Physical attractiveness, for these characters, includes maintaining one's weight at a socially acceptable level (they often engage in diets and exercise plans with concern to their weight), exhibiting coifed hair, radiating flawless skin, and donning decadent clothing, jewelry, and matching accessories. Obviously, *Golden Girls'* four main characters cannot duplicate a "Barbie-esque" style of beauty, regardless of the amount of flattering lighting, make-up, and camera angles. However, the characters do reflect centerfold-like qualities. Thus, in terms of mass media Myth #5, *Golden Girls* confirms that even seniors must remain concerned about contemporary notions of beauty to attract and keep a man.

Closely related to this ideal female stereotype, is the concept of the ideal man. Media Myth #6 states that the man should not be shorter, weaker, younger, poorer, or less successful than the woman (Galician, 2004). We found that overall *Golden Girls* supports the notion that romantic male partners must possess traditionally masculine qualities. Blanche depicted this myth the most (23 times, 1:5, 1:8, 1:9, 1:21, 2:12, 2:13, 3:15, 4:15; 4:22, 4:26, 5:5, 5:8, 7:9, 7:10, 7:12, 7:19,

and 7:22), Dorothy and Rose expressed support for the myth to the same degree (10 times each, Dorothy, 1:8, 1:9, 2:10, 2:24, 4:26, 5:8, 7:17, and 7:25–26; Rose, 2:12, 3:23, 4:26, 5:5, 5:8, 7:9, 7:10, 7:13, and 7:17), and Sophia even bought into it (6 times, 2:12, 2:24, 4:7, 5:8, and 7:25–26).

In our study, all of the men with whom the women were romantically involved were stronger, taller, and physically larger than the four main characters. For Sophia, Rose, and Dorothy, their romantic partners appeared to be their same age or older. Promiscuous Blanche, however, debunked this stereotype by having relationships with men of all ages. Further, all the men were more economically and professionally successful than the characters under study. Dorothy's ultimate partner, Lucas Hollingsworth, disclosed that he owned five hardware stores (7:25–26) whereas she was just a substitute high school teacher. In addition, Dorothy bragged to her friends that he was "handsome, strong, and virile" in bed (7:25–26). To no one's surprise, they married in the series finale. Rose's boyfriend and fiancé, Miles Webber, was a college professor (5:8). She worked part time at a counseling center. Both Dorothy and Blanche reported interests in several men who were physicians (1:5, 1: 9, and 5:8). Although Blanche worked at a museum, her other romantic partners included a television personality (3:23), an astronaut (1:5), a weatherman (3:15), and "a tight man with cast iron pecs, thighs that could choke a bear, and a butt you can eat breakfast off of" (7:10). Clearly, "manly men" are the objects of desire on Golden Girls.

Although all the leading characters affirmed Myth #6, interestingly, they also supported effeminate men on occasion. A variety of cues indicated several inferior qualities men depicted on Golden Girls. Generally, these men were shorter than the women and physically smaller than other men. Further, they were typically bald (7:19) and either displayed this openly (1:21), attempted a comb-over, or wore bad toupees (4:15). Other qualities included a lack of refinement, being "desperate, lonely, and pathetic" (7:25–26), "impotent" (2:12), "dumb" (4:7), afraid (2:24), unemployed (3:25), a "weak, broke yutz" (3:25), a virgin (7:9), and overly emotional (7:9). Typically, the characters responded negatively to such qualities (Dorothy 7 times, 1:21, 2:12, 3:4, 3:25, 4:15, 4:26, and 7:25–26; Rose 4 times, 2:24, 4:26, 7:10, and 7:25–26; Blanche 10 times, 2:10, 2:12, 2:13, 2:24, 4:26, 7:10, and 7:12; and Sophia 3 times, 2:24, 3:23, and 4:26). However, Rose and Sophia more often valued men who reflected effeminate qualities (Rose 6 times, 2:10, 2:22, 3:23, 4:22, and 7:9; and Sophia 5 times, 3:4, 3:15, 4:3, and 4:7). This reveals that the "dumb" character (Rose) and the "wise and witty" old woman (Sophia) are more accepting of men for who they are rather than ascribing to social codes of masculinity. Perhaps this situation suggests to viewers that only dumb women or very old women would be interested in inferior, effeminate men. The "smart" character and the "slutty" character, on the other hand, apparently represent traditional women who desire stereotypical conventions of

manly men as they both portray positive associations with Myth #6 and nega-
tive associations with Rx #6 more often than not. Thus, viewers are conditioned
to believe that only macho men are worthy of romantic partnership.

In sum, whereas *Golden Girls* debunks stereotypes of elderly women, the se-
ries simultaneously supports major mass media stereotypes as well as prescriptions
of sex, love, and romance within particular boundaries. The four Miami women
do not support the idea that a partner is predestined or "the one" (Myth #1);
hence, throughout the series they "consider countless candidates" (Rx #1). Ver-
bally, they express that "love at first sight" is possible (Myth #2); nevertheless,
they do not enact this behavior (Rx #2). In regard to emulating the stereotypi-
cally "ideal" woman (Myth #5) to attract and keep the stereotypically "ideal"
man (Myth #6), *Golden Girls* upholds these myths within limits. Overall, the se-
ries presents a cautiously optimistic view toward older adults, especially when it
comes to sex, love, and romance.

Advanced Years and Not-So-Advanced Lessons about Sex, Love, and Romance

In the 7 years that *Golden Girls* graced television sets weekly on network primetime
and its subsequent years in syndication, viewers have been ostensibly privy to an
older, more refined, learned approach to sex, love, and romance. The foursome did
not concede to conventional portrayals of crotchety, old, dried up women, bitter
with what life dealt. Nor did they conform to the matronly, grandmother types who
sat around knitting all day and making baked goods for pleasure. No, indeed, these
women were active in all facets of life. They traveled, worked, and remained so-
cially active. Romantically, they dated, had sex, got engaged, and married.

Although the romantic relationships on *Golden Girls* debunked mass media
stereotypes about older female adults in general, the show supported some me-
dia stereotypes about sex, love, and romance and debunked others. The four
women did not depict the idea that one true love exists. Instead, they sought
various candidates in dating, having one-night-stands and playing the field. The
Golden Girls did not support the idea of love at first sight. Even though three of
them made positive mention of the idea, their actions portrayed their true feelings
by developing their romantic relationships from established friendships. However,
the show did support Myths #5 and #6. Even for men and women in their 60s
and older, contemporary standards of masculine and feminine qualities continue
as important attributes for attracting the opposite sex.

This program opened the doors to positive depictions of seniors in society. For
instance, after the show's introduction, other programs such as *Empty Nest*, *Mur-
der She Wrote*, and *Matlock* illustrated to millions of television viewers that life is
not over after 50. Although it showed that older adults can continue living pro-
ductive, healthy lives, solving crimes, and remaining social, *Golden Girls* generally

does give in to traditional notions of physical attractiveness for both men and women. The media need to re-conceptualize notions of contemporary standards of beauty for men and women, even for older adults. Perhaps *Golden Girls* took the first step by breaking senior stereotypes and paving the way for improved representation of older adults.

STUDY QUESTIONS/RECOMMENDED EXERCISES

1. The Communication Predicament of Aging Model (Ryan et al., 1986) says that we react to cues of old age with the stereotypes that we hold of older adults. Find out what stereotypes of older women you hold. Picture an older woman whom you do not know—a "generic" old woman. For 3 minutes free-write a description about this person: what she looks like, what she does with her time, her personality, anything about her that occurs to you. Keep writing the whole time. If you run out of things to say, write something like, "I can't think of anything else to write. My mind is a blank. . . ." Now examine what you wrote for stereotypes. Is the old woman you pictured grandmotherly, a hag, a shrew, hard of hearing, crazy? How would this affect the way you communicated with a stranger who was an older woman?

2. Try the first exercise thinking about an older man instead of an older woman. What differences did you notice in the way you think about these people? What does the view you hold of older adults say about them in terms of sex, love, and romance?

3. After reading this chapter, you know quite a bit about Blanche's character. Based on this, how does she conform to or defy some of the other myths not discussed in this chapter?

4. Of the four main characters in *Golden Girls*, which one of them most fits your stereotypes about older women? Why? How? Which one least fits your stereotypes about older women? Why? How?

5. Identify three older television characters who are portrayed as dating or in romantic relationships. How does each one enact any of the 12 myths or prescriptions?

REFERENCES

@ccess The *Golden Girls*. (2004). *Profiles*. Retrieved July 18, 2004, from http://www.the-golden girls.com/index.html

Fiske, J. (1984). Popularity and ideology: A structuralist reading of *Dr. Who*. In W. D. Rowland, Jr. & B. Watkins (Eds.), *Interpreting television: Current perspectives* (pp. 165–195). Beverly Hills, CA: Sage.

Galician, M.-L. (2004). *Sex, love, and romance in the mass media: Analysis and criticism of unrealistic portrayals and their influences*. Mahwah, NJ: Lawrence Erlbaum Associates.

Hansen, F. J., & Osborne, D. (1995). Portrayal of women and elderly patients in psychotropic drug advertisements. *Women and Therapy, 16*, 129–141.

Harwood, J., & Anderson, K. (2002). The presence and portrayal of social groups on prime-time television. *Communication Reports, 15*, 81–97.

Harwood, J., & Roy, A. (1999). The portrayal of older adults in Indian and U.S. magazine advertisements. *Howard Journal of Communications, 10*, 269–280.

Holsti, O. R. (1969). *Content analysis for the social sciences and humanities*. Reading, MA: Addison-Wesley.

Horton, D., & Wohl, R. R. (1979). Mass communication and para-social interaction: Observation on intimacy at a distance. In G. Gumpert & R. Cathcart (Eds.), *Inter/media: Interpersonal communication in a media world* (2nd ed., pp. 188–211). New York: Oxford University Press.

Hummert, M. L. (1994). Stereotypes of the elderly and patronizing speech. In M. L. Hummert, J. M. Wiemann, & J. F. Nussbaum (Eds.), *Interpersonal communication in older adulthood: Interdisciplinary theory and research* (pp. 162–184). Thousand Oaks, CA: Sage.

Kaler, A. K. (1990). *Golden Girls*: Feminized archetypal patterns of the complete woman. *Journal of Popular Culture, 24*, 49–60.

Lacey, G. (2004, April 30). Most requested unreleased shows. *TVShowsOnDVD.com*. Retrieved April 30, 2004, from http://tvshowsondvd.com/userstats.cfm

Lifetime Entertainment Services. (2004). *Lifetimetv.com*. Retrieved April 29, 2004, from http://www.lifetimetv.com

Nussbaum, J. F., Pecchioni, L. L., Grant, J. A., & Folwell, A. L. (2000). Explaining illness to older adults: The complexities of provider-patient interaction as we age. In B. Whaley (Ed.), *Explaining illness: Theory, research, and strategies* (pp. 171–194). Mahwah, NJ: Lawrence Erlbaum Associates.

Piccirillo, M. S. (1986). On the authenticity of television experience: A critical exploration of para-social closure. *Critical Studies in Mass Communication, 3*, 337–355.

Ryan, E. B., Giles, H., Bartolucci, G., & Henwood, H. (1986). Psycholinguistic and social psychological components of communication by and with the elderly. *Language and Communication, 6*, 1–24.

Shuler, S. (2003). Breaking through the glass ceiling without breaking a nail: Women executives in *Fortune* magazine's "Power 50" list. *American Communication Journal, 6*(2). Retrieved January 8, 2005, from http://acjournal.org/holdings/vol6/iss2/articles/shuler.htm

Turnquist, K. (2004, June 7). New gold rush sassy '80s sitcom *The Golden Girls* strikes a humor vein with young women. *The Oregonian*, p. D-01.

TV.com (2006). The *Golden Girls*: Summary. CNET Networks. Retrieved July 22, 2006, from http://www.tv.com/the-golden-girls/show/131/summary.html?full_summary=1&tag=showspace_links;full_summary

Vernon, J. A., Williams, J. A., Jr., Phillips, T., & Wilson, J. (1990). Media stereotyping: A comparison of the way elderly women and men are portrayed on prime-time television. *Journal of Women and Aging, 2*, 55–74.

Wodell, R. (2003, May 4). *Golden Girls: Title and airdates guide.* Retrieved July 12, 2004, from http://epguides.com/GoldenGirls/

Jo Anna Grant *is an Associate Professor of Communication Studies at California State University, San Bernardino. She received her Masters in Communication from Texas Christian University in 1990 and her Ph.D. from the University of Oklahoma in 1996. Her research interests are in communication and aging, interpersonal relationships, and health communication. She has published several articles examining the perceptions of power and closeness in family relationships across the lifespan. Her work appears in gerontology journals and book chapters that examine the roles of God and religion in health, migration patterns of older adults into nursing care facilities, and explanations of illness to older adults. She teaches courses in interpersonal communication, health communication, persuasion and the media, small group communication, and research methods. Currently, she serves on the Board of Directors of the American Communication Association.*

Heather L. Hundley *is an Associate Professor of Communication Studies at California State University, San Bernardino. She received her Masters in Communication in 1994 from California State University Sacramento and her Ph.D. in 1999 from the University of Utah. Her interests include mass media, visual communication, critical/cultural studies, sports communication, and gender studies. Her journal and book chapter publications reflect this diversity and include analyses of* Cheers' *portrayal of beer and sexual practices, the Supreme Court's* Texas v. Johnson *flag burning case, and hegemonic practices in golf. She teaches a variety of courses such as media history, visual communication, television and radio production, media law, media and culture, and feminist theories. In the past 5 years, she has supervised the campus radio station and currently serves as the department's Graduate Coordinator.*

CHAPTER 10

"Love Will Steer the Stars" and Other Improbable Feats: Media Myths in Popular Love Songs

Anne Bader
Webster University

June's story:[1] Prior to falling madly in love at 16, I vividly remember listening to songs that spoke of love and wanted desperately to have someone of my own to love me. Within 4 months of my 16th birthday, I started dating Matt, who I fell madly in love with. Music definitely reinforced my belief that our love would last forever.

When *The Wedding Song* by Paul Stookey came out, I bought the "45" and listened to it endlessly, because this was what I wanted: marriage to Matt. The lyrics were so beautiful and spoke of a man and woman coming together and creating a new life because of their love. (I don't remember any verses with arguing about taking the trash out!) I was on the wife-and-mother career track at that point and was obsessed with getting married. I was 18 years old!

Matt and I married when he was 21 years old and I was 19. Within 3 years, we had Melissa. Talk about unrealistic expectations; by 23 years of age, I was a wife and mother and was very discouraged with my life. One of my most vivid memories was an argument with Matt that actually centered on popular songs. I was growing increasingly irritated with Matt and his lack of attention toward me. I told him that the song, *You Don't Bring Me Flowers Anymore* was starting to remind me of our marriage. His retort was to sing, *I Never Promised You a Rose Garden.* That exchange exemplified our marriage, which ended after 8 years.

I would have to say that unrealistic expectations threatened to ruin my life until I figured a few things out. It took until my 40s when I let the unrealistic expectations go and really started enjoying myself. I could also listen to a song about love and keep it all in perspective.

[1]This true story was written in response to an e-mail questionnaire administered as part of this study. Names have been changed to protect individuals' privacy.

Love it or not, American popular music surrounds us. It's in our homes, cars, schools, movies, restaurants, and offices. Mostly we love it, particularly during our adolescent years. Pop music separates us from our parents' generation and defines us as a cohort. (There is an immutable law: Parents must always believe their own music is superior in every way to their children's.)

Music and song lyrics often firmly embed themselves in the brain. Hum the first five notes of *(I Can't Get No) Satisfaction* for Baby Boomers, and they will be playing air guitar and dredging up lyrics before you can stop them. They might not be able to find their car keys, and they might lose their reading glasses on top of their heads, but they can often recall melodies and lyrics from 40 years ago.

The majority of popular songs concern love and romance (Ostlund & Kinnier, 1997). What do we learn from their portrayals of romantic relationships? Is love represented realistically, or do the lovers in songs provide models of romance that are unattainable? What do we know about media effects in relation to popular songs? Are they harmless bits of fluff, or do they promote unrealistic and unhealthy ideas about love relationships that could produce future unhappiness?

According to cultivation theorist George Gerbner (Gerbner, Gross, Morgan, Signorielli, & Shanahan, 2002), we are shaped by the stories we hear over and over again. Our ideas of appropriate behaviors, our cultural values, our expectations, our wishes, and our fantasies are influenced by the tales we listen to repeatedly. Is there a medium more repetitious than popular song? Is there a topic more explored in popular song than love relationships? Because popular songs so frequently concern love, and because these songs are both repetitious and pervasive, it is important that we understand the messages these songs contain and learn something about the impact they might have on us.

METHODOLOGY

First, existing literature was examined to discover how our culture defines love in its various manifestations. Then, 100 popular songs were selected from *Billboard's* Hot 100 annual charts (as reported by Whitburn, 1999), which annually rank the top 100 songs based on radio airplay and recording sales, regardless of genre. Songs in this study include an array of genres: rock 'n' roll, patriotic ballads, country, folk, Motown, jazz, R&B, rap, hip-hop, and so forth (Whitburn, 1999). To investigate possible changes in media messages over time, I looked at 50 songs from the 1960s (my pop music heyday) and 50 from the 1990s (my pop music terra incognita). The five most popular songs from each year within these decades were chosen because they are the songs most likely to be widely known and, therefore, potentially most influential.

Using Galician's (2004) 12 Major Mass Media Myths (p. 225) as the principal framework, I conducted a content analysis on the lyrics of the selected set of

songs, examining them for messages about sex, love, and romance. All song lyrics were accessed from Lyrics XP.com between September 4 and September 9, 2004.

For each song, these questions were asked:

Did the song concern romantic love?

If so, were any of Galician's myths present in the lyrics?

Songs were also examined for the qualities of love they contained, with the analysis based on a combination of Sternberg's (1997), Gottman's (1994), and Peck's (1978) descriptions of realistic love. In addition, I examined the results from my e-mail survey of subjects' beliefs about the impact of love song lyrics on their lives.

LITERATURE REVIEW

Socialization and the Media

Socialization is the process by which people learn what it means to be a member of a group, absorbing the thoughts and actions that are considered appropriate for that society (Bandura, 2002). Humans are socialized by the stories they hear and the behaviors that are modeled for them. Traditionally, this information has been transmitted chiefly by family, religion, schools, and peer groups. Mass media play a significant role in this process, too, with television being the most heavily studied media agent (Perse, 2000, p. 164). Children and adolescents imitate role models seen on television and become acquainted with the stereotypes used by television for simplified storytelling. Adolescents may be particularly vulnerable to media influence. Because they must accomplish a variety of tasks on their journey to adulthood, they utilize all the role model information at hand, including the media (Strasburger, 1995).

Cultivation theory suggests that the media play a role in shaping us by showing us, over and over again, a consistent set of messages about the structure of a society (Gerbner et al., 2002). Gerbner et al. have argued that mass media have had a profound impact on contemporary global society, not directly, but subtly and over time, by the repetition of mainstream ideology via commercial media. Although cultivation theory is most often associated with television, with a particular focus on violence, cultivation theory encompasses other forms of mass media, as well as other topics such as gender roles, political attitudes, ethnicity, race, and ageism (Gerbner et al., 2002). This theory seems particularly applicable to the Top 40 radio format as it existed in the 1960s. In those days, radio stations surveyed jukebox statistics and record store sales to compile a list of "hits" (Whitburn, 1999). These songs were played repeatedly, thereby providing a

unique opportunity for them to permanently emblazon themselves onto the brains of adolescent listeners.

Adolescents and Media Use

Young people today are avid media consumers. According to a 2005 Kaiser Family Foundation report, 8- to 18-years-olds spend an average of nearly 6½ hours a day with media. Nearly one-quarter of the time young people are using one medium, they are engaged in the use of other media as well. Because this age group is adept at media multitasking, such as sending instant messages to friends while listening to music and browsing the Internet, their actual use of media fills 8½ hours a day (p. 6). They watch television an average of 3 hours a day, which increases to almost 4 hours when DVDs, videos, and other recorded shows are included. They spend 1¾ hours a day listening to a variety of musical media—radio, CDs, tapes, and MP3 players. Computer use occupies 1 hour a day for non-homework purposes; video games take up an average of 49 minutes a day.

Media availability is greater than ever. Many young people have ready access in their own bedrooms; 68% of the participants in the Kaiser Family Foundation study have a TV in their bedroom, 54% have a VCR/DVD player, 49% have a video game unit, and 31% have a computer. Nearly two-thirds have portable CD players, tapes, or MP3 units that accompany them when they leave their bedrooms.

Some sex and race differences exist in media use. Girls listen to music more (2 hours per day) than boys (1½ hours), whereas boys spend far more time playing videos (72 minutes per day) than girls (25 minutes). Although rap and hip-hop are the most popular musical genres with all races, with 65% of young people listening on an average day, race is a significant factor in genre choice. More than 80% of the Kaiser Family Foundation's African American participants prefer rap and hip-hop, compared to 60% of Whites. Rock music is preferred by Whites, and salsa is selected predominantly by Hispanic youth (Kaiser Family Foundation, 2005, p. 29).

Although television watching lessens during the ages of 12 to 18 (Kaiser Family Foundation, 2005, p. 26), adolescents still spend significant time watching music videos, and their usage of other media, such as movies, popular music, and computers increases. Music is a dominant presence in teenagers' lives (Strasburger, 1995, pp. 81–82). Lyrics appear to provide moral and social guidance to some adolescents (Rouner, 1990). For teens, music creates identity and a sense of belonging within a group. Their choice of music tends to define their social group; teens unaware of current popular music are likely to be seen as social outsiders (Roberts, Christenson, & Gentile, 2003). Romantic love is a dominant theme, one that readily captures the interest of young people who are busy developing a sense of their gender and sexual identity (Ostlund & Kinnier, 1997). Many young

people use music to control or enhance moods, to energize themselves, or to lift their spirits (Roberts et al., 2003). It is reasonable to hypothesize that adolescents are influenced by the songs they hear.

According to Schor (2004), music that was formerly targeted to teenagers is now being marketed to *tweens*, an advertising category that includes children from approximately ages 6 through 12. Pop music lyrics are learned by 6- and 7-year-olds, and 7- and 8-year-olds watch MTV (p. 20). There is cause for concern that these children may be developmentally unprepared for the messages they receive. Content analyses of music videos indicate that up to 75% contain sexually suggestive material and more than half contain violence; sex stereotyping is common, with women being shown in a degrading fashion (American Academy of Pediatrics, 1996).

Media Effects of Song Lyrics

Surprisingly little research on the media effects of songs could be found; the studies that were found generally focused on violence and sexuality in music, particularly music videos. No research could be found that shows a direct cause-and-effect relationship between song lyrics and behavior, in terms of violence and sexuality.

Prinsky and Rosenbaum (1987) reported that many adolescents either did not know or did not understand the lyrics to popular songs. Sexual content often went undetected, euphemisms were missed, and metaphors were misconstrued. In another study, only 30% of teenagers knew the words to their favorite songs (Desmond, 1987). Hansen and Hansen (1991) found that lyrics are often less important than the music to their college-age subjects and that often lyrics are obscured by loud, guitar-driven rock music.

According to Roberts et al. (2003), two themes emerge in research on teenagers' attention to lyrics. First, the more important music is to teenagers, the more emphasis they place on lyrics relative to other song elements. Second, the more oppositional the lyrics are to mainstream society, the greater attention the fans of the defiant genre pay to the words, whether it is heavy metal, rap, or rock.

Ballard, Dodson, and Bazzini (1999) found that 83% of their subjects (160 predominantly White, middle- to upper-middle-class college students) expressed a belief that messages found in song lyrics do affect behavior. Most (56%) said they knew the lyrics of their favorite songs, and most (60%) said that they often agreed with the messages in those lyrics. Anderson, Carnagey, and Eubanks (2003) discovered a link between violent lyrics and an increase in aggressive thoughts and feelings. Although this study concerned violence and hostility rather than love and romance, it does suggest that songs have the ability to influence listeners.

No research that specifically addressed the effects of songs as socialization agents for adolescents concerning love, romance, and gender roles in love relationships was discovered.

Musical Component of Songs

Although this study focuses on song lyrics and their messages about love and romance, brief attention must be paid to the musical component of songs. Music appears to be universally loved. It exists in some form in all human cultures, and evidence of early musical instruments dates back at least 30,000 years (Weinberger, 2004). Scientists do not yet know why music is able to stimulate powerful emotional responses (Weinberger, 2004), although recent technological advances, particularly in the area of brain research, have the potential to produce more information about how we process, store, and retrieve musical information.

We respond to music from the earliest stages of life. Hepper (1991) showed that while still in utero, fetuses were able to recognize the difference between familiar and unfamiliar melodies. Kastner and Crowder (1990) found that even 3-year-olds were able to associate positive and negative emotions with musical samples. Music has been shown to produce measurable physical responses, including accelerated heartbeat and alterations in stress hormone levels (Weinberger, 1997) and chills, laughter, and tears (Sloboda, 1991). Blood and Zatorre (2001) reported that the same areas of the brain were affected by "shivers-down-the-spine" music as those involved in other gratifying activities, such as eating chocolate, having sex, and using cocaine.

Evidence of music's emotional power surrounds us, particularly in movies, television shows, and commercials, for which viewers take their emotional cues from accompanying scores. Stratton and Zalanowski (1989) reported that when there is a discrepancy between the mood of music and an accompanying image, the mood of the music actually overrides the mood of the mismatched image—suggesting that our perceptions can be influenced by the music we hear.

The combination of words with music makes songs especially powerful, striking the listener simultaneously on emotional (Sloboda, 1991) and cognitive levels (Wallace, 1994; Weinberger, 2004). Rainey and Larsen (2002) reported that when the text is connected, i.e., when the words have meaning, when they are related to the accompanying melody, and when the rhythm of the words matches the rhythm of the music, that powerful combination of elements assists both in short-term acquisition of the words as well as in long-term recall. This seems to have particular relevance for a study of popular songs, whose uncomplicated melodies, predictable rhythms, and generally simple lyrics are played repeatedly, enhancing the likelihood that they will be quickly learned and long remembered.

Media Myths about Sex, Love, and Romance

Galician (2004) surveyed 381 men and women from two different age groups (Baby Boomers and Generation Xers) to discover what they learned about sex, love, and romance from the mass media. She found a relationship between mass media usage and unrealistic romantic expectations for both men and women. Her study revealed that men appear to be even less realistic in their romantic attitudes than women. She argued that popular culture offers few portrayals of healthy relationships and that much research remains to be done to increase our understanding of media, myth construction, and love (pp. 91–94).

As part of her ongoing research, Galician (2004, p. 225) has identified a set of 12 Major Mass Media Myths of sex, love, and romance (presented as *Dr. FUN's Mass Media Love Quiz©*), which is used as the basis for the analysis of the songs in this chapter's study. For each of the 12 myths, Galician also provides a research-based Prescription (Rx) that summarizes nonmythical, nonsterotypical relational strategies and serves as an "antidote" to the related media myth. (The 12 myths and their prescriptions are listed in Chapter 1 of this book.) Galician noted that these prescriptions for healthy relationships are rarely presented by the mass media.

Theories of Realistic Love

In addition to using Galician's myths and prescriptions, for this chapter's content analysis I also used definitions of realistic love from the work of psychoanalyst M. Scott Peck (1978) and psychologists Robert Sternberg (1997) and John Gottman (1994).

In *The Road Less Traveled* (1978), Peck defined love as a *will* or *decision* rather than a feeling. He stated, "I define love thus: The will to extend one's self for the purpose of nurturing one's own or another's spiritual growth" (p. 81). He even went so far as to call romantic love "a dreadful lie" (p. 90) that serves to trick us into marriage. Peck's austere definition emphasizes the discrepancy between media portrayals of love and his experience as a psychotherapist, helping people work through the misery of failed marriages and broken lives.

Psychologist Robert Sternberg (1997) provided a broader model of love with his Triangular Theory of Love. Imagining the three points of a triangle to represent three components of love, intimacy, passion, and decision/ommitment, Sternberg theorized that different combinations of these elements result in eight kinds of love (pp. 315–316): non-love (no components of love are present), liking (only intimacy), infatuated love (only passion), empty love (only decision/commitment), romantic love (intimacy + passion), companionate love (intimacy + decision/commitment), fatuous love (passion + decision/commitment), and consummate love (intimacy + passion + decision/commitment).

Psychologist John Gottman (1994) postulated that successful relationships are based on positive interactions (pp. 56–67), which are facilitated by knowing each other well, sharing power with the partner, and holding shared values, goals, interests, and traditions (p. 223).

For this study, song lyrics were examined for evidence of these components of realistic love as well as for the myths and stereotypes.

DATA REPORTING AND ANALYSIS

Nonlove Songs

In this sample set of 100 songs (the 5 most popular songs from each year of the 10 years of the 1960s and 1990s), 25% (13 in the 1960s and 12 in the 1990s) did not concern romantic love. (Topics included hero ballad/character sketch, instrumental, dance, social issues, and loss unrelated to romantic love.) For the remaining 75 songs in the sample, the resulting myth counts are summarized in Table 10–1.

Love Songs and Media Myths

These results indicate that media myths are alive and well in American popular songs, with an average of 2.5 myths per love song. The actual Galician Myth Count per love song ranged from 0 to 7. (The only myth that no songs addressed was Myth #12, the statement about the effects of mediated myths and stereotypes.) The slight variance in myth counts between 1960s and 1990s songs suggests that, although mythical ideas in love songs might vary somewhat from year to year and decade to decade, the romantic myths identified by Galician have great staying power. We have been hearing them for centuries.

The only love song in which none of the 12 media myths appeared was Hanson's 1997 hit, *MMMBop* (Hanson, Hanson, & Hanson). This is partly because half of the lyrics consist of "Mmmbop, ba duba dop, Ba du bop, ba duba dop, Ba du bop, ba duba dop, Ba du." The remaining half of the words come closer than any others to Sternberg's (1997), Gottman's (1994), and Peck's (1978) ideas of realistic, mature, and enduring love, as summarized by Galician's Prescriptions (2004), which are "antidotes" to her 12 myths. We see commitment, effort, and decision in the following stanzas of *MMMbop*:

> You have so many relationships in this life, only one or two will last.
>
> You go through all the pain and strife,
>
> Then you turn your back and they're gone so fast.
>
> So hold onto the ones who really care, in the end they'll be the only ones there.

TABLE 10–1.
Summary of Myth Counts

	Myth*	1960s	1990s	Change Over Time	Total Myth Count	Myth in % of Love Songs
1	Your perfect partner is cosmically pre-destined, so nothing/nobody can ultimately separate you.	9	10	+1	19	25
2	There's such a thing as "love at first sight."	6	2	−4	8	11
3	Your true soul mate should KNOW what you're thinking or feeling (without your having to tell).	6	9	+3	15	20
4	If your partner is truly "meant for you," sex is easy and wonderful.	4	13	+9	17	23
5	To attract and keep a man, a woman should look like a model or a centerfold.	5	2	−3	7	9
6	The man should NOT be shorter, weaker, younger, poorer, or less successful than the woman.	26	23	−3	49	65
7	The love of a good and faithful true woman can change a man from a "beast" into a "prince."	2	2	0	4	5
8	Bickering and fighting a lot mean that a man and a woman really love each other passionately.	6	3	−3	9	12
9	All you really need is love, so it doesn't matter if you and your lover have very different values.	9	8	−1	17	23
10	The right mate "completes you"— filling your needs and making your dreams come true.	18	23	+5	41	55
11	In real life, actors and actresses are often very much like the romantic characters they portray.	2	2	0	4	5
12	Since mass media portrayals of romance aren't "real," they don't really affect you.	0	0	0	0	0
	Totals	93	97	+4	190	

*Myths are Galician's (2004) 12 myths and stereotypes of sex, love, and romance (from her *Dr. FUN's Mass Media Love Quiz*©).

The singers wonder, once lovers' physical beauty has faded over time, if love will endure despite change. The song ends wisely and poetically with:

> Plant a seed, plant a flower, plant a rose, you can plant any one of those.
> Keep planting to find out which one grows. It's a secret no one knows.

Ironically, the musical group Hanson consists of three brothers who were 11, 13, and 16 years old at the time MMMBop was recorded. Who would have expected a mature, myth-free depiction of committed love from the pens of such young men?

As might be expected, Myth #6: "The man should NOT be shorter, weaker, younger, poorer, or less successful than the woman" (Galician, 2004, p. 225) is found in nearly two-thirds (65%) of the love songs. Because of our culture's beliefs and expectations about male stereotypes, evidence for this myth in songs is frequently subtle but pervasive. In some cases male dominance is expressed overtly, as these words from the Rolling Stones' 1969 song Honky Tonk Women (Jagger & Richards, 1969) clearly convey: "I laid a divorcée in New York City, I had to put up some kind of a fight." A more recent example is No Scrubs (Briggs, Burross, & Cottle, 1999), in which Myth #6 is the essence of the entire song. In it, the female singers lay out their criteria for potential suitors: Men must have money, jobs, and cars. Most frequently, however, Myth #6 is conveyed through linguistic cues such as word choice or active versus passive voice that subconsciously inform listeners. Stereotypically, men are the strong, tall, powerful, active ones, whereas women passively look to men to choose, build, decide, and initiate.

Next highest in frequency with more than half of the songs (55%) is Myth #10: "The right mate 'completes you'—filling your needs and making your dreams come true" (Galician, 2004, p. 225). Faith in this myth could lead to the belief that love will somehow fix everything. If "love will steer the stars," according to the lyrics of 1969's #1 song, Aquarius/Let the Sunshine In (MacDermot, Rado, & Ragni, 1969), then love can certainly handle lesser tasks. It should be small potatoes to make someone love you because you simply want it or to fill an otherwise empty life with great purpose or to correct any one of a long list of woes.

Fully one-quarter (25%) of the love songs convey the message that somehow one's partner is "meant to be," written in the stars, forever inseparable (Myth #1). This myth is most beguilingly expressed in Bryan Adams' 1991 top hit, (Everything I Do) I Do It for You (Adams, Kamen, & Lange). His voice aching with love, the slow melody accompanied by luscious instrumentation, Adams delivers these lines like a caress:

> Look in to my eyes; you will see, what you mean to me.
> Search your heart, search your soul.

When you find me, then you'll search no more.

Don't tell me it's not worth trying for; you can't tell me it's not worth dying for.

You know it's true, everything I do, I do it for you.

There is no love, like your love, and no other, could give me more love.

There's nowhere, unless you're there, all the time, all the way.

Who can resist the temptation to wish for such a love? "There's nowhere unless you're there"—talk about personal power! Fortunately, our logical brains have the ability to recognize that, gorgeous though this song may be, it is patently false. Such "love" is neither healthy nor possible. It would not even be fun in a reality-based relationship. What would happen if one of the lovers had to take a business trip? Would the separation annihilate the one left behind? How wearying would it be to live with someone who never acted in self-interest? The weight of such emotional debt would quickly squash this romance.

Myth #4 and Myth #9 were each perpetuated in 23% of the songs. Myth #4—sex is effortlessly great—got a huge boost in the 1990s. Whereas earlier love songs addressed sexual issues indirectly, relying on innuendo and euphemism, it is apparent that our culture's sense of sexual propriety has shifted. Overt expressions of physical desire, erections, lovemaking, and sexual fantasies are plentiful in the 1990s songs, which had three times as many references to this myth. Even more surprising, many of the highly sexualized lyrics are performed by women, who unabashedly sing paeans of desire. Examples of these are Mariah Carey's *Fantasy*, Janet Jackson's *Escapade*, Monica's *The First Night*, and Christine Aguilera's *Genie in a Bottle*. Male singers contribute also, with songs like Sir Mix-a-Lot's *Baby Got Back* and Next's *Too Close*. These are the lyrics likely to strike terror into the hearts of tween parents whose children watch MTV and sing along.

Perhaps because songs are generally heard rather than seen, Myth #2: "There's such a thing as 'love at first sight'" (Galician, 2004, p. 225) and Myth #5: "To attract and keep a man, a woman should look like a model or a centerfold" (Galician, 2004, p. 225), are surprisingly infrequent in the sample songs, occurring 11% and 9%, respectively. Whereas television, magazines, and movies continually bombard us with images of physical perfection, the myths with a visual component are perhaps less important in song lyrics. Music videos, of course, do provide accompanying images to musical entertainment, but the focus of this study is on songs as they have traditionally been heard: music and lyrics that give free rein to the listener's imagination.

Which songs proved to be the most myth-laden? The 1960s winner is Roy Orbison's 1964 *Oh, Pretty Woman* (Orbison & Dees, 1964), with seven Galician media myths to its credit. This song has iconic status in American popular culture. More than 7 million copies of it have been sold, it was recorded by both Van Halen and Holy Sisters of the Gaga Dada in the 1980s, and its popularity

expanded even further when it became the theme song for the 1990 film, *Pretty Woman* (Milchan & Marshall, 1990).

The song's story is simple; much of it takes place inside the singer's head. The singer watches as an attractive woman walks by. He thinks she is unbelievably pretty, and wonders if she, too, feels lonely. Caveman-like, he gives a little growl. Silently he begs her to stop, talk with him, smile at him, stay with him; he would "treat her right." She passes him by. Forlorn, he is resigned to going home alone, but at the last moment she turns and walks toward the now euphoric man.

Although the dominant myth in *Oh, Pretty Woman* (#5) concerns physical appearance as the basis of a relationship, the song touches on six others. It is not necessary to mine the text very deeply before unearthing them. The singer knows, just by seeing this woman, that she is the one for him (#2). She can cure his loneliness (#7), relieve his existential pain (#10), and have a night of great sex (#4) just like that. He did not even have to utter a single word of his fantasy to her (#3). Whether it is her amazing ESP or his manly growling (#6), she returns to him and they live happily ever after.

What do we not hear about in the lyrics? Practically everything! We learn little about the singer, other than his fondness for a pretty face and his loneliness. We know nothing about his character, beliefs, life situation, aspirations, or maturity level. All we know about the woman is that she is physically attractive. Again, we learn absolutely nothing about her hopes, skills, or personality. She could be a rocket scientist; she could be a serial killer. Only her prettiness merits mention, which produces, then, a whiff of Myth #7: "All you really need is love." Values don't matter; they're not even mentioned.

What is the quality of love in this song? Of Sternberg's (1997) three components, we find only passion, which, unaccompanied by intimacy and commitment, constitutes mere infatuation. In this song, love is not seen as a decision or an act of will; promotion of spiritual growth for the lovers is certainly not addressed.

Where are examples of Gottman's (1994) positive interactions in this relationship? The man and woman do not even speak to each other in the song. Do we see elements of friendship between them? No. Do they know each other well? No. Do they hold shared values, goals, interests, and traditions? We certainly cannot tell. How realistically is love portrayed in this song? That we can tell—not at all.

What is the harm in a song that tells us only models and centerfolds are lovable? Plenty. For starters, most women are neither, which eliminates a sizable percentage of the female population as candidates for romance. A relationship based largely on physical appearance is doomed; no one is immune to the passage of time. Myth #5 can be particularly unhealthy for young women, who are surrounded by images of physical perfection in film, television, and magazines (see Wolf, 1991; see also Brumberg, 1997).

Despite the abundance of media myths in *Oh, Pretty Woman*, it is a brilliant song. It touches that howling-at-the-moon part of us, expressing our deepest long-

ings for that perfect someone who loves us unconditionally and will fill all our needs. Although we can appreciate this song's emotional punch, we must be aware that passionately expressed fantasies are not a prescription for healthy love relationships.

The 1990s champion contender for the most media myths per song is Celine Dion's *The Power of Love* (Applegate, Detmann, Mende, & Stern, 1994), the #5 hit of 1994. Although this song does not have the iconic status of Orbison's *Oh, Pretty Woman*, Celine Dion was an important voice in pop music of the 1990s, with a string of hits to her name. *The Power of Love* is a representative example of her songs that rhapsodize about love. Others include *Love Can Move Mountains* (1993), *My Heart Will Go On* (1997), *Because You Loved Me* (1996), and *I'm Your Angel* (1998), all big sellers that helped make the 1990s "the decade of the divas" (Whitburn, 1999, p. 120).

This song's primary myth is #10: "The right mate 'completes you', filling your needs, and making your dreams come true" (Galician, 2004, p. 225). With a name like *The Power of Love*, we suspect that some extraordinary claims are about to be made, and we are not disappointed. Slow and evocative, this song is an intimate depiction of two lovers, a man and a woman, waking together in the morning and making love. She looks into his eyes, holds his body, feels lost in his arms. Anytime the world is too much for her, or she feels she "just can't go on," being with him magically banishes these feelings. Greatly in love, she promises to always be with him; anytime he reaches for her, she is ready and willing. She is his lady and he is her man.

It is not necessary to look beneath the surface for evidence of the "man as rescuer" myth; the lyrics explicitly inform us. His love takes care of all her fears, anxieties, and troubles. The woman's fragility is underscored by her sense of being lost, her boundaries dissolved in his embrace.

He rescues her, *he* keeps her safe, *he* reaches for her, *he* teaches her; hmmm, sounds suspiciously like Myth #6 is involved in this song, too. The "man should not be shorter, weaker" myth is also reinforced by the use of terms *lady* (as opposed to *woman*) and *man*. Implicit in *lady* are connotative values of refinement and femininity. Ladies are demure, decorous, composed, and well behaved. Ladies never speak out of turn. Ladies serve tea. *Man*, on the other hand, connotes strength, command, and power. Consciously or not, the lyricist established a power imbalance by this word choice. *Woman* would have fit the meter, but its connotative strength would vie for power with *man*.

We are also told that, true to Myth #4, sex is pretty amazing for these lovers. Communication is largely nonverbal, accomplished by touching and staring into each other's eyes; there is no need to discuss a thing (Myth #3).

Given the woman's emotional dependence on the man, what happens if he leaves? How will she cope on her own? Or what if they marry and have a child? What if the baby keeps her up half the night and she just wants to sleep? Will

she still be there, ready for anything he wants, anytime he reaches for her? The realities of everyday life are bound to come crashing in on them.

The greatest harm in such a love song is its reinforcement of our cultural belief that love really can "steer the stars," and if it does not, then we just need to try loving longer, harder, and better. This belief can keep us trapped in dysfunctional relationships while we struggle to "get it right." In addition, the song promotes a sense of weakness and helplessness in women, when they might be better served by a sense of their own strength and power. It places men on perennial active duty as problem solvers and emotional props. We all need to nurture and be nurtured. We all must accept the reality that no mate can solve our own internal problems. These ideas, however, do not readily lend themselves to beautiful love songs.

In this study, only one song that provides a rational model for "cultivating one's own completeness," Galician's (2004) Rx #10 and the antidote to Myth #10 (p. 225) comes to mind. This song is Meat Loaf's *I'd Do Anything for Love (But I Won't Do That)* (Steinman, 1992), a "realistic romance" pas de deux that presents a significant number of media myths about love and then debunks them by the song's end.

Like many of Meat Loaf's songs, this is a *rock opera* (sometimes disparaged as *schlock opera*) piece, taking the form of a dialogue between a young man and the woman he desires (Mundy, 1993). Its dramatic nature is reminiscent of Andrew Lloyd Webber's compositions for musical theatre. The song opens with sounds of revving engines, presaging the adolescent male angst to come. The first verses are a litany of promises and declarations made to a woman by the male protagonist: He "would do anything for love," only she can save him, he'll be faithful "as long as the planets are turning, as long as the stars are burning," but he'd never forgive himself if they didn't have sex that very night. In between these vows, he beseeches the "God of Sex and Drums and Rock 'n' Roll," extravagant lyrics set to equally extravagant music.

The second half of the song presents the relationship from the woman's view. Just like Rapunzel, Snow White, and the countless other passive victims who populate our culture's stories, this woman awaits her rescuer. In lyrics that float airily above the general level of pop songwriting, she asks her suitor to fix everything for her (shades of Myth #7):

> Will you raise me up? Will you help me down?
> Will you help me get right out of this godforsaken town?
> Will you make it all a little less cold?
> Will you hold me sacred? Will you hold me tight?
> Can you colorize my life? I'm so sick of black and white.
> Can you make it all a little less old?

Myth #10—the right mate completes you—is clearly heard as the woman continues:

> Will you make me some magic with your own two hands?
>
> Can you build an Emerald City with these grains of sand?
>
> Can you give me something I can take home?
>
> Will you cater to every fantasy I've got?
>
> Will you hose me down with holy water if I get too hot?
>
> Will you take me places I've never known?

To all these requests, the hormone-fueled man pledges, "I can do that, I can do that!" But the song's tone shifts in the next verse as the woman realizes:

> After a while you'll forget everything, it was a brief interlude,
>
> A midsummer night's fling, and you'll see that it's time to move on.
>
> I know the territory, I've been around.
>
> It'll all turn to dust and we'll all fall down,
>
> And sooner or later you'll be screwing around.

Even though the man replies, "I won't do that," at this moment the listener realizes that the woman is probably right. The life cycle of many romantic relationships is necessarily short.

This song is packed with media myths about sex, love, and romance (at least 6 of Galician's 12 myths are evident), and the lyrics, like so many others, invoke the stars, the planets, and several gods, all in the name of love. Nevertheless, by juxtaposing the longings of archetypal male and female characters within a single piece, the song manages to convey a good deal of realism about romantic love. All the elements in this song—hyperbolic lyrics, overblown instrumentation, hormonal excess, adolescent male sturm und drang, and female stereotyping—combine to tell us that our unrealistic expectations will inevitably result in relationships that must either change or end. Prescription #10: "Cultivate your own completeness" (Galician, 2004, p. 225) is shown, rather than told, in this dramatic song of young love.

One curious aspect of this song is Meat Loaf's repetition of "I would do anything for love, but I won't do that." A common (smirking) interpretation of "but I won't do *that*" is that the protagonist would do anything for love except marry the woman. However, in his autobiography *To Hell and Back* (Meat Loaf & Dalton, 1999), Meat Loaf told how songwriter Steinman worried that the lyrics would not be understood. The "that" refers to the immediately preceding promise in every chorus (p. 277). For example, when he sings, "But I'll never forget the

way you feel right now, oh no, no way; I would do anything for love, but I won't do that," the intended meaning is that the singer promises to always remember how the woman feels just then. This provides an enlightening example of how listeners project their own thoughts, values, and concerns onto the meaning of a song with misconstruable lyrics.

CONCLUSION

Despite its necessarily subjective nature, this study provides a glimmer of understanding about the messages of love and romance contained in popular songs and establishes that not enough is known about the potential impact of song lyrics on the young people who hear them. I found no studies that specifically addressed the concerns of this study's central questions: What are the media myths concerning sex, love, and romance in popular song lyrics, and how might these messages impact future romantic relationships?

The content analysis of the 100 songs selected for this study revealed no short supply of Galician's (2004) 12 myths, with an average of 2.5 myths per love song. The top three myths were Myth # 6: "The man should NOT be shorter, weaker, younger, poorer, or less successful than the woman"; Myth #10: "The right mate 'completes you'—filling your needs and making your dreams come true"; and Myth #1: "Your partner is cosmically pre-destined, so nothing/nobody can ultimately separate you." All 12 myths except for Myth #12: "Since mass media portrayals of romance aren't 'real,' they don't really affect you" were found in the love songs.

In comparing love song from the 1960s with those of the 1990s, other than an increase in overt sexuality in song lyrics, little has changed in popular songs in those decades; the myths in songs from the 1960s were still there in the 1990s. From a cultivation theory perspective (Gerbner et al., 2002), the frequent, consistent repetition of ideas that men are dominant, women are submissive, all you really need is love, love can steer the stars, and so forth, could be giving young people very false expectations about real love.

In summary, we do not yet know enough about the influence of popular song lyrics on our cultural understanding of love. However, enough media research evidence exists to support the commonsense notion that "we are what we eat." Some messages in popular songs are not necessarily healthy ones for youth who are in the process of trying to sort out sex, love, and romance. It therefore could be useful for media literacy teachers to address the romantic content of popular songs when teaching adolescents.

Galician's "Major Mass Media Myths and Corresponding Prescriptions for Healthy Coupleship" (2004, p. 225) could be an effective teaching tool, not only

for pointing out harmful media myths but also for providing useful "prescriptions" as antidotes to the falsehoods. Likewise, it seems important for media creators to be aware of the influence they have on young people, keeping their development in mind when crafting media presentations.

In a country where failed marriages are the norm, where expectations of love are unrealistically high, and where we wish upon stars to live happily ever after, these are healthy prescriptions.

STUDY QUESTIONS/RECOMMENDED EXERCISES

1. Think of a popular song that sounds fairly normal when sung by one sex, but would appear as false or silly when sung by a person of the other sex. Why does the song work for one sex but not the other? How would the lyrics have to change to make the song believable for the other sex? What does the song teach us about our understanding of stereotypes and gender roles in romantic relationships?

2. Think about a song from your past that was especially meaningful to you. Can you remember the lyrics? When you hear the song, what memories are evoked? Does it take you to a specific time and place in your past? Describe what you liked about the song, what makes it stand out for you, and anything else special about it. For a class project, bring the song to class and be prepared to talk about its significance to you.

3. It is said that our media both shape us and reflect us. Think of a popular song that exemplifies this statement and explain the reasons for your choice.

4. Compare popular music of today with hits from the past. Do you think popular songs have changed over time, and if so, how? Are sex, love, and romance treated differently in contemporary love songs? Discuss whether men's and women's roles have changed in popular music. If so, in what ways are they different, and if not, how are they the same?

5. Media scholar George Gerbner sometimes quotes Scottish patriot Andrew Fletcher, who wrote in 1704, "If I were permitted to write all the ballads I need not care who makes the laws of the nation." Discuss Fletcher's idea in relation to popular love songs. Are our relationship "laws" embedded in these songs? Why or why not? Provide examples to support your ideas.

6. Think of a song that deals with love/sex/romance in a realistic, healthy way (for example, per Galician's *Prescriptions*). Why do you find it so? Explain what the song says to you about real, true love.

REFERENCES

Adams, B., Kamen, M., & Lange, R. (1991). (*Everything I do*) *I do it for you* [Recorded by B. Adams]. Hollywood, CA: A&M Records.

American Academy of Pediatrics. (1996). Impact of music lyrics and music videos on children and youth. *Pediatrics, 98,* 1219–1221.

Anderson, C., Carnagey, N., & Eubanks, J. (2003). Exposure to violent media: The effects of songs with violent lyrics on aggressive thoughts and feelings. *Journal of Personality and Social Psychology, 84,* 960–971.

Applegate, M., Detmann, W., Mende, G., & Stern, H. (1994). *The power of love* [Recorded by C. Dion]. New York: Epic/550 Music.

Ballard, M., Dodson, A., & Bazzini, D. (1999). Genre of music and lyrical content: Expectation effects. *Journal of Genetic Psychology, 160,* 476–487.

Bandura, A. (2002). Social cognitive theory of mass communication. In J. Bryant & D. Zillmann (Eds.), *Media effects: Advances in theory and research* (pp. 121–154). Mahwah, NJ: Lawrence Erlbaum Associates.

Blood, A., & Zatorre, R. (2001). Intensely pleasurable responses to music correlate with activity in brain regions implicated in reward and emotion. *Proceedings of the National Academy of Sciences of the United States of America, 98,* 11818–11823.

Briggs, K., Burross, K., & Cottle, T. (1999). *No scrubs.* TLC. New York: LaFace.

Brumberg, J. (1997). *The body project: An intimate history of American girls.* New York: Random House.

Desmond, R. (1987). Adolescents and music lyrics: Implications of a cognitive perspective. *Communication Quarterly, 35,* 276–284.

· Galician, M.-L. (2004). *Sex, love, and romance in the mass media: Analysis and criticism of unrealistic portrayals and their influence.* Mahwah, NJ: Lawrence Erlbaum Associates.

Gerbner, G., Gross, L., Morgan, M., Signorielli, N., & Shanahan, J. (2002). Growing up with television: Cultivation processes. In J. Bryant & D. Zillmann (Eds.), *Media effects: Advances in theory and research* (pp. 43–67). Mahwah, NJ: Lawrence Erlbaum Associates.

Gottman, J. M. (1994). *Why marriages succeed or fail.* New York: Simon & Schuster.

Hansen, C., & Hansen, R. (1991). Schematic information processing of heavy metal lyrics. *Communication Research, 18,* 373–411.

Hanson, C., Hanson, J., & Hanson, Z. (1996). *MMMbop.* Calabasas, CA: Dyad Music.

Hepper, P. G. (1991). An examination of fetal learning before and after birth, *The Irish Journal of Psychology, 12,* 95–107.

Jagger, M., & Richards, K. (1969). *Honky tonk women* [Recorded by the Rolling Stones]. London: London.

Kaiser Family Foundation. (2005). *Generation M: Media in the lives of 8–18 year-olds.* Retrieved May 15, 2005, from http://www.kff.org/entmedia/7250.cfm

Kastner, M., & Crowder, R. (1990). Perception of the major/minor distinction: Emotional connotations in young children. *Music Perception. 8,* 189–201.

Lyrics XP.com. (n.d.). [Song lyrics of the 50 top songs of the 1960s and the 50 top songs of the 1990s.] Accessed September 4–9, 2004, at http://www.lyricsxp.com/lyrics/

MacDermot, A., Rado, J., & Ragni, G. (1969). *Aquarius/Let the sunshine in* [Recorded by the Fifth Dimension]. London: Soul City.

Meat Loaf, & Dalton, D. (1999). *To hell and back: An autobiography.* New York: Regan Books.

Milchan, A. (Producer), & Marshall, G. (Director). (1990). *Pretty woman* [Motion picture]. United States: Buena Vista.

Mundy, C. (1993, November 25) Meat Loaf. *Rolling Stone, 670*, 15–16.

Orbison, R., & Dees, W. (1964). *Oh, Pretty Woman* [Recorded by Roy Orbison]. Nashville, TN: Sony/ATV Music Publishing.

Ostlund, D. R., & Kinnier, R. T. (1997). Values of youth: Messages from the most popular songs of four decades. *Journal of Humanistic Education & Development, 36*, 83–91.

Peck, M. S. (1978). *The road less traveled: A new psychology of love, traditional values, and spiritual growth.* New York: Touchstone.

Perse, E. M. (2000). *Media effects and society.* Mahwah, NJ: Lawrence Erlbaum Associates.

Prinsky, L. E., & Rosenbaum, J. L. (1987). "Leer-ics" or lyrics: Teenage impressions of rock 'n' roll. *Youth and Society, 18*, 384–397.

Rainey, D. W., & Larsen, J. D. (2002). The effect of familiar melodies on initial learning and long-term memory for unconnected text. *Music Perception, 20*, 173–186.

Roberts, D., Christenson, P., & Gentile, D. A. (2003). The effects of violent music on children and adolescents. In D. A. Gentile (Ed.), *Media violence and children: A complete guide for parents and professionals* (pp. 153–170). Westport, CT: Praeger.

Rouner, D. (1990). Rock music use as a socializing function. *Popular Music and Society, 14*(1), 97–107.

Schor, J. B. (2004). *Born to buy: The commercialized child and the new consumer culture.* New York: Scribner.

Sloboda, J. (1991). Music structure and emotional response: Some empirical findings. *Psychology of Music, 19*, 110–120.

Steinman, J. (1992). *I'd do anything for love (but I won't do that)* [Recorded by Meat Loaf]. Santa Monica, CA: MCA.

Sternberg, R. J. (1997). Construct validation of a triangular love scale. *European Journal of Social Psychology, 27*, 313–335.

Strasburger, V. (1995). *Adolescents and the media: Medical and psychological impact.* Thousand Oaks, CA: Sage.

Stratton, V., & Zalanowski, A. (1989). The effects of music and paintings on mood. *Journal of Music Therapy, 26*, 30–41.

Wallace, W. (1994). Memory for music: Effect of melody on recall of text. *Journal of Experimental Psychology, 20*, 1471–1485.

Weinberger, N. M. (1997). The musical hormone. *MuSICA Research Notes, 4*(2). Retrieved November 1, 2004, from http://www.musica.uci.edu/mrn/V4I2F97.html

Weinberger, N. M. (2004). Music and the brain. *Scientific American, 291*, 88–95.

Whitburn, J. (1999). *A century of pop music: A year-by-year top 40 rankings of the songs and artists that shaped a century.* Menomonee Falls, WI: Record Research.

Wolf, N. (1991). *The beauty myth: How images of beauty are used against women.* New York: Harper Collins.

Anne Bader *is an Adjunct Professor in the School of Communications at Webster University in St. Louis, MO. After a long career as a computer consultant, Anne changed directions and received her master's degree in Media Communications/Media Literacy from Webster University in 2004. In 2003 she worked as a research assistant on Dr. Art Silverblatt's book,* International Communications: A Media Literacy Approach. *She is a member of Alliance for a Media Literate America (AMLA), Action Coalition for Media Education (ACME), and Gateway Media Literacy Partnership. In her spare time, Anne volunteers for political campaigns, promotes media literacy to adult groups, enjoys music of all varieties, and has recently discovered a passion for quilting.*

CHAPTER 11

Power, Romance, and the "Lone Male Hero": Deciphering the Double Standard in *The Da Vinci Code*

Christine Scodari
Florida Atlantic University

Rhonda Trust
University of Connecticut

The Da Vinci Code, the popular novel by suspense-mystery author Dan Brown (2003), debuted as #1 on the *New York Times* list of best-selling fiction and remained high on that list and others like it for more than a year. It is second in a series featuring protagonist Robert Langdon, Harvard "symbologist," who first appears in another bestseller, *Angels and Demons* (Brown, 2000).

Controversy continues to flare over the subject matter of these works, which involve religion and religious organizations (especially the Catholic Church), certain religious doctrines, and challenges to such doctrines. In particular, *The Da Vinci Code* (Brown, 2003) resurrects the theory that the New Testament character of Mary Magdalene, whom the Catholic Church once declared a prostitute sans scriptural evidence (it later rescinded this precept), was actually much more important to Christ than Christendom acknowledges. Not only does Brown imagine that she was his closest disciple but also—via a precarious but entertaining mix of fact, theory, and conjecture—his wife and bearer of his progeny. According to the novel, a vital clue resides in Da Vinci's painting, *The Last Supper*, in which a figure we observe adjacent to Christ, said to be the apostle John, is suspiciously feminine.

In the novel Brown advances this theory through what erupts as a murder mystery. An elderly curator at the Louvre Museum in Paris is ritualistically slain prior to an appointment with Langdon. Police cryptographer Sophie Neveu, who also happens to be the victim's granddaughter, flees with Langdon when he is suspected of the crime. As the duo unravels codes and signs left by Neveu's grandfather to ferret out the real culprit, a grand tale purporting to tout the significance of all womankind is imparted.

A romance develops between Langdon and Neveu, the telling of which might be expected to buttress the broader theme of the novel. But does it? In *Sex, Love, and Romance in the Mass Media* (2004), Galician delineated myths of romance reproduced through mass media representations. Myth #6, "The man should NOT be shorter, weaker, younger, poorer, or less successful than the woman" (p. ix), invites a comparative accounting of the profiles of romantically linked characters and pertinent narrative elements. In fact, Galician's audience research revealed that the younger generation "retained this outdated hegemonic male-superiority/female-dependency myth" reproduced through, among other things, the "patriarchal coupleship and objectified females" characteristic of many music videos (p. 164). Chatman (1978) referred to constituents such as this as the *story* elements of narrative. But how might the narrative dimension of *discourse*, what Chatman labeled story structure, also confer upon a male character—in this case, Robert Langdon—an aura of superior power, authority, and achievement? Is Langdon an example of what has been described as the "lone male hero" (Haskell, 1987, p. 156), for whom a particular female partner, no matter how profound their coupling's depiction, is regarded as disposable and, therefore, weaker and less consequential? One might also wonder how readers of *The Da Vinci Code*, such as those discussing the novel and anticipating the film adaptation on key Web sites, have negotiated the gendered power relations operating within and in relation to the narrative.

This inquiry combines textual and audience analyses in the tradition of multi-perspectival cultural studies to fully explore these issues, centering on the romantic relationship depicted in *The Da Vinci Code* as inflected by the male protagonist's ongoing story line. It proceeds within the framework of Galician's (2004, p. ix) romantic myths, particularly the age, success, and power dimensions of Myth #6, with power defined in terms of mastery, autonomy, and transcendence. Theories of narrative and/or image (Chatman; 1978; Fiske, 1987; Haskell, 1987; Mulvey, 1975), especially as they pertain to gender, inform the study. Genette's (1997) notion of paratextual meaning undergirds analysis of the cover and cover notes and contributes to an understanding of how fan reactions and negotiations on the Internet create filters through which audiences might interpret and reinterpret a text. Audience study occurs via "virtual" observation of fan/reader commentary and/or interaction on relevant Web sites.

From James Bond to Indiana Jones to Marshall Matt Dillon, the lone male hero epitomizes the aesthetic of masculine prerogative described by Fiske (1987) in regard to television. Scodari and Felder (2000) cited the archetype as a reason behind creator and viewer resistance to romantic entanglements between lead characters in male-oriented television vehicles such as *The X-Files*. Whether this protagonist surfaces on the big screen, the small screen, or the printed page, the prospect of a female love interest lingering longer than a single installment is viewed as "distracting not only the hero but [also] the audience from the fun

and danger" (Haskell, 1987, p. 156). On the other hand, for the smattering of serialized heroines in existence, the opportunity to love and leave a series of revolving male counterparts is seldom granted.

Where and how do such disparities begin? The primacy of the male protagonist becomes evident in childhood, thereby cultivating preferences and expectations of which publishers who solicit adult-oriented manuscripts and those who author them are mindful. Weitzman, Eifler, Hokada, and Ross (1972) examined award-winning children's books and found that they characterized women as immobile and passive and males as independent and active. Males appeared in titles and central roles considerably more often than females (p. 91). Substantial increases in the number of women in central roles have not been unearthed in more recent investigations (Collins, Ingoldsby, & Dellmann, 1984; Helleis, 2004). Accordingly, Trites (1997) observed that "literary proclamations of female subjectivity are important because too often throughout history, female voices have been silenced" (p. 47).

THE FEMININE, THE MASCULINE, AND *THE DA VINCI CODE*

In *The Da Vinci Code* (Brown, 2003), continuing hero Robert Langdon professes:

> The ancients envisioned their world in two halves—masculine and feminine. Their gods and goddesses worked to keep a balance of power. Yin and yang. When male and female were balanced, there was harmony in the world. When they were unbalanced, there was chaos. (p. 36)

How true to this pronouncement are the novel's story elements and narrative structure? Do feminine and masculine subjectivities truly achieve balance?

Gender and Paratextual Meaning

One cannot always tell a book by its cover, but in this case the novel's jacket and jacket notes foreshadow gender inequalities to come, thereby demonstrating the relevance of Genette's (1997) notion of "paratextual" meanings that form "thresholds" between a text and its reception (pp. 1–2). The jacket is brick red in color, and the title, in large gold lettering, consumes the top half of its face. The bottom quarter features the author's name, also in large gold print. In between, there is the image of what appears to be a torn scrap of paper containing a fragment of Da Vinci's *Mona Lisa* with some unintelligible script (also in gold) written alongside and over it. Only the lower brow, eyes, and nose bridge of Mona Lisa's countenance are visible. The majority of the front cover, therefore,

verbally connotes the masculine (Da Vinci & Brown), whereas the feminine is represented by an image originally rendered by one of the males in question, and a fragmented image at that. Fragmentation and fetishization of the female body are characteristic of Mulvey's (1975) male-oriented "gaze" in visual media, as is the notion that such a body exists in passivity to be acted (e.g., marked) upon. Mona Lisa's disembodied eyes gaze back, but the novel's narrative and the scrutiny of images it chronicles are verbally executed.

The notes on the inside jacket flaps introduce the story from Langdon's perspective, as he "receives an urgent late night phone call." The back flap also contains a photo and brief bio of author Dan Brown. The back of the jacket displays testimonials from other authors, all of whom have masculine names. These characteristics also fortify masculine authority and prominence.

Gender and Narrative

In terms of *The Da Vinci Code*'s narrative and Robert Langdon's romance with Sophie Neveu, further inequities arise in the first 50 pages, even before Neveu is introduced. Echoing the previous installment, *Angels and Demons* (Brown, 2000), Chapter 1 of the book opens when Langdon, in Paris for a conference, is startled from his rest by a ringing phone (Brown, 2003, p. 7). The Prologue has already recounted elements of the criminal escapade in which he will soon be embroiled. Afterward, he remembers with modest chagrin an awards ceremony in which he was introduced by the female emcee as follows:

> Although Professor Langdon might not be considered hunk-handsome like some of our younger awardees, this forty-something academic has more than his share of scholarly allure. His captivating presence is punctuated by an unusually low, baritone speaking voice, which his female students describe as "chocolate for the ears." (p. 9)

The emphasis on intellect and accomplishment is apparent here, because Langdon is not "hunk-handsome" but has "scholarly allure." We are further informed by the third-person narrator that Langdon, considering he had just recently decided it was safe to wear tweed, interrupted the emcee before she could describe him as something along the lines of "Harrison Ford in Harris tweed" (p. 9). The entire passage links him to another lone male hero, Indiana Jones, the adventurous archaeologist portrayed by Harrison Ford in the famous film trilogy. In an early scene from *Raiders of the Lost Ark* (1981), the first movie in the trilogy, a tweed-clad Professor Jones is observed lecturing before a coterie of admiring, mostly female students, one of whom has written "I love you" across her eyelids.

Somewhat later (pp. 33–34), there is a brief mention of Vittoria, the heroine Langdon romanced and bedded in *Angels and Demons* (Brown, 2000). We are assured that the relationship is in the past and that this was not for a brush-off by

Langdon. Do we embrace the possibility that the right woman would be able to challenge what the narration refers to as Langdon's "lifelong affinity for bachelorhood" (Brown, 2003, p. 33)? Or, especially if we have appreciated firsthand the apparent sincerity of his story line with Vittoria, might we suspect that any new woman in his life would, despite whatever else the unfolding plot projects, turn out to be similarly expedient and transitory?

Sophie Neveu, we are informed, is 32 years of age and perceived by certain of her colleagues as a beneficiary of affirmative action (pp. 49–50). When we and Langdon first encounter her (p. 50), she is described as "young," accentuating the gender/age double standard also implicated by Galician's (2004, p. ix) Myth #6. In fact, Langdon speculates about her relationship to the deceased, briefly entertaining thoughts that she is the older man's "kept woman" before ascertaining the truth (Brown, 2003, p. 70). Langdon's specific age is calculated via *Angels and Demons* (Brown, 2000), in which he is said to be 40 (p. 5), and the fact that the events of *The Da Vinci Code* (Brown, 2003) are stated to occur 1 year later (p. 32).

Teacher–Pupil

Although Neveu is certainly accomplished, we are provided no sense of continuity for her character as a romantic or professional subject, no back story about her past loves, admirers, or successes. Neveu's back story is related primarily through childhood memories of being tutored by her grandfather, who refers to her as "Princess," whereas Langdon's expository recollections are of professing knowledge to his students. Indeed, references to Langdon's childhood or familial connections are absent from the narrative, rendering his character autonomous, timeless, and transcendent. Consequently, Langdon is constructed as teacher and Neveu as pupil. Moreover, the narration indicates Neveu by her first name while referencing the male hero and virtually every other male character except Silas, the submissive acolyte of a shadowy religious group, by his proper name. Silas, for whom no proper name is given, is also fashioned as pupil, engaging with an enigmatic overseer referred to as "Teacher."

Sexual Neophyte

Another parallel between Silas and Neveu emerges through juxtaposition. Chapter 15 details Silas's struggle against the lustful desires and acts deemed inimical to his devotion to Opus Dei, the secretive Catholic society. Chapter 16 alludes to Neveu's estrangement from her grandfather due to a girlhood trauma in which she inadvertently witnessed him engaging in something we immediately suspect was unconventionally sexual. Not only is each framed as apprentice, but also as sexual neophyte. Moreover, until the final chapters, the only significant female character besides Neveu is a chaste nun, Sister Sandrine.

Chapter 54 introduces Sir Leigh Teabing, former British Royal Historian, as another professorial figure. Upon meeting Neveu, he calls her a "virgin," explaining that the term applies to anyone who does not know the "true nature of the Holy Grail" (p. 229). Here, the already implicit connection between sexual inexperience and lack of intellectual wherewithal is explicitly made. Although the Grail's history, according to the novel, pits womankind's significance against the patriarchal dominion of the Church, Brown repeatedly places the heroine in a position of receiving tutelage from male elders, thereby depreciating her maturity more than age alone might warrant. Despite her grandfather's vocation and efforts to educate her in kind, when Neveu encounters a large print of Da Vinci's *The Last Supper*, she behaves as if she is mostly unacquainted with the painting, functioning as a foil so that Langdon and Teabing can authoritatively expose her and us to its feminine connotation (p. 243).

Narrative Tensions

We have to be told at the end of Chapter 18 that Langdon believes Neveu to be "a hell of a lot smarter" than he (p. 87). Both the broader theme of the novel and details such as this purport to advocate what Galician discusses as a "peer relationship" (pp. 165–167). In believing as he does, Langdon seems a fine candidate for egalitarian coupling. However, we are recurrently *shown* that Langdon is more conversant and effectual, and this tends to counter the notion that the equality either exists in this instance or is preferable in any instance. In virtually every chapter that focuses on the pair's detective work, it is Langdon who deciphers the vital clue that leads to the next stage in the investigation. The only exception is Chapter 30 in which Neveu's memories of her grandfather help to supply a missing piece of the puzzle. "I didn't choose it, my grandfather did," Neveu admits as she reveals the discovery to Langdon (p. 134). Inheritance, a passive quality, is Neveu's advantage, whereas actively and independently acquired knowledge is Langdon's. The latter trumps the former on most occasions, such as at the end of Chapter 19 in which Langdon tells Neveu, "Your grandfather's meaning was right in front of us all along" and proceeds to untangle a telling anagram (p. 98).

The final chapter situates the romance of Langdon and Neveu, which has developed in the context of their investigative partnership, but in light of Langdon's role as font of wisdom and Neveu's as receptacle. Sexual connotations aside, it is no wonder that the Grail, also perceived as receptacle, is here associated with the "sacred feminine." The murder mystery has been solved and Langdon vindicated. The two share a passionate kiss and promise to meet in Florence, with Neveu stipulating: "No museums, no churches, no tombs, no art, no relics" (p. 449). She has reunited with the grandmother she thought was long dead, and it is there that her quest for the Holy Grail stops short. Just as the story exalts Mary Magdalene's

supposed, familial connection to Christ, hereditary linkages, some going back millennia, are Neveu's endpoint and ultimate claim to fame. The feminine sphere is, therefore, stereotypically defined by the domestic and personal. For a fleeting moment, however, it seems as if the feminine has carried the day. Neveu's grandmother, while letting slip some intriguing clues, appears disinterested in and/or unable to verify the existence or location of the Grail. Could all this represent the triumph of femininity—the idea that the enrichment of relationships is the noblest, most satisfying quest for all?

Alas, the epilogue suggests otherwise. Back in the Louvre, a solitary Langdon experiences an epiphany, finally accomplishing his principal objective. He kneels before the Grail that is alleged to represent the true significance of womankind. Regardless, it is the masculine that has remained most sacred in the telling of this tale, its prerogative, superior expertise, and public orientation leading to this pinnacle of achievement. We are left to ponder the disposition of Langdon's romantic rendezvous with Neveu. However, it seems probable that Neveu's new-found family will become her ongoing focus, whereas Langdon will ever be the lone male hero, demonstrating his autonomy, mastery, and transcendence in continuing adventures, each one featuring another youthful, disposable, and not terribly sacred feminine presence.

GENDER AND NEGOTIATION:
DA VINCI DECODERS ONLINE

Online fans of *The Da Vinci Code* (Brown, 2003) can reflect and/or negotiate the gendered power relations associated with the novel, its romance, and/or screen adaptation. The film version, to be directed by Oscar-winning Ron Howard, was not yet in production at this writing. On the *Internet Movie Database*, a search of the title produced a page devoted to the film. Near the bottom of this page was an internal link to the corresponding fan discussion board on the database (Board: The Da Vinci Code, 2004). On several of the discussion threads active as of August, 2004, fans familiar with both of Brown's Robert Langdon novels debated which actors should be cast in the major roles, implicitly addressing the age aspect of Galician's (2004) Myth #6.

Negotiating Double Standards: Age and Appearance

Not only did participants on the discussion board (Board: The Da Vinci Code, 2004) fail to challenge the stereotypical older man/younger woman combination in the novel, they unconsciously sanctioned and exacerbated it by permitting a broader range of "age appropriateness" for male actors than for their female peers. Similarly, when Galician looked at perceptions of male/female media duos, she

found that her young subjects tended to overestimate the ages of the women in relation to the men (pp. 169–170). Although actor ages were only intermittently specified in these postings, they are readily discernible on the database.

In two threads focusing on the film's casting, the ages of actors recommended for the role of Robert Langdon averaged 46, or 5 years older than Langdon, whereas the ages of actors suggested for the role of Sophie Neveu averaged 32, or the exact age of Neveu. Twelve of 30 actors recommended for the part of Langdon were 5 or more years older than the character, compared with only 5 of 28 actors named to play his romantic counterpart. The eldest of the actors submitted to play Langdon, Harrison Ford, was 21 years his senior, whereas the youngest were 5 years his junior. The eldest actor mentioned for the role of Neveu, Julianne Moore, was 12 years older than she, whereas the youngest, Ludavine Sagnier, was 11 years shy of the character's age. Moreover, some of those suggesting younger actors to portray Langdon were apologetic in doing so. One poster felt that Mark Ruffalo would be perfect if he were a decade older. In fact, Ruffalo was only 5 years younger than Langdon. In contrast, with regard to Neveu, age-related qualms were only expressed when older actors, such as Juliette Binoche (age 40), were proposed.

Akin to age is physical appearance, and in this regard the discussions also reflected a broader range of acceptability for male performers. Neveu's physical attributes, that she is "curvy" and "freckled," were frequently offered as justifications for suggesting particular actors for the part. The submitted female actors are virtually all ingenues and/or romantic leading ladies, and one, Laetitia Casta, doubles as a swimsuit model. On the other hand, recommendations of a "Hollywood heartthrob" to play Langdon were met with derision. Somebody's preference for Tom Cruise, for example, was labeled "a joke." In fact, several of those proposed are character actors such as Philip Seymour Hoffman, David Strathairn, Kevin Spacey, and Anthony La Paglia. To the extent that the sex of the posters was apparent, it seems as if male users were willing and eager to accept a comparatively average-looking actor as Langdon, whereas both male and female fans insisted upon feminine pulchritude. This tendency reproduces Galician's (2004) Myth #5: "To attract and keep a man, a woman should look like a model or a centerfold" (p. ix). However, the fact that looks were not as vital for the male hero implies that he, more than his female corollary, was perceived primarily in terms of intellect and professional merit. It is interesting to note that Tom Hanks, who is not generally considered a "hunk" or "heartthrob" and would be 49 at the time of the film's production, was eventually signed to play Langdon.

Negotiating Gender: Story

In July 2004, nearly 3,000 reader reviews had been posted to The Da Vinci Code's web page on Amazon (Customer Reviews, 2004). The most recent 4 months'

worth of reviews were examined for this study. Although some of these users interacted and, in some cases, posted more than once, the chief function of this application is to allow participants to post a single commentary.

Although these commentators clearly recognized the purported theme of the novel to grant religious and, by extension, political power to womankind, few questioned the gendered power relations evident in the story's telling. Many debated the alternate religious history proffered by Brown, with some rejecting it as sacrilegious, "PC to tears" (Jano, 2004), catering to feminists, and "a ploy to appeal to women readers" (Miller, 2004). Although reminding users that the novel is only fiction was the most frequent rejoinder to the religious objection, a few reviewers did support the notion of the "sacred feminine." A reader of indeterminable gender wondered: "What's so wrong about female divinity anyway? Dan [Brown] makes a very good point, amongst many others, that the [B]ible was written by humans, and what's more MALE humans" (CJ, 2004). A Catholic, male reader concurred with Brown's view that the Church "fabricated out of thin air the vow of celibacy and suppressed any type of power or involvement of women. . . ." (Giraud, 2004). On the other hand, another male protested that the "attempt by Mr. Brown to convince us that the goddess cult and the 'divine feminine' are somehow superior to the Christian and Jewish faiths is pitiful," and proceeded to claim that pagan goddess worshipers engaged in the mass extermination of Christians (Wynn, 2004). In fact, the novel's thesis is that the sacred feminine is part and parcel of the history of Christianity. Still, the first user quoted above warned potential readers of the novel against the theological complaints: "Don't let the religious nuts and God Squad folk put you off this excellent work" (CJ, 2004).

Surprisingly few reviewers grappled with Sophie Neveu's function in the story. Of those who did, many reflected, but did not explicitly acknowledge, that her role was relatively insubstantial. One male user summarized: "The sudden appearance of the curator's daughter triggers the opening glimpses of a plot nearly 2,000 years old and Langdon finds himself fleeing for his life across Europe with the beautiful Sophia" (Ruby, 2004). Here, not only is the female hero designated by her first name, but also the name and relationship to the curator are incorrect. Moreover, she is described purely in terms of her physical appearance and familial bond with a male character.

A small number of users were more direct and counterhegemonic in their remarks. A female reader noted that Brown "obviously trusts that all his readers are as dense and uninformed on the subject matter as his character Sophie" (ladyoftheflowers, 2004). Another reviewer admitted:

> I had trouble imagining that Langdon felt anything more than brotherly toward her (he patronized her, he protected her, he educated her . . . hmmm, strange chauvinistic behavior for a believer in the sacred goddess . . . but he never seemed to truly be attracted to her). (A reader, 2004)

Galician (2004) recognized that "it's important to gain knowledge and skills to resist the power of mass media portrayals that promote unrealistic expectations of sex, love, and romance" (p. 14). As an antidote to Myth #6, she offers Prescription #6: "Create co-equality; cooperate" (p. 172). To grasp the pervasiveness and potency of romantic myths, however, it is important to realize that "unrealistic expectations" can breed in neglected and unexpected places, whether in, beneath, over, and/or in response to a surface-level story line. This analysis of *The Da Vinci Code* (Brown, 2003) and its "cyberfans" demonstrates that story structure, paratextual meanings, and online discourses can help to foster hegemonic beliefs and values concerning what is romantically "appropriate." Superior masculine "strength," defined in terms of age, maturity, knowledge, autonomy, achievement, and continuing lone male hero status, is bolstered by these frequently disregarded variables as well as most aspects of the basic story line despite the novel's ostensible theme of feminine power. Accordingly, media researchers and consumers who seek to promote and/or achieve cultural literacy must be mindful of and able to investigate the vast array of persuasive implements in the mass media's toolbox.

STUDY QUESTIONS/RECOMMENDED EXERCISES

1. Think of movie series in which the male protagonist is an example of the "lone male hero" (e.g., James Bond or Indiana Jones). Compare them to movie series in which the hero's love interest continues from episode to episode (e.g., Superman or Spider-Man). How do the romantic dynamics of each type reproduce and/or resist Galician's (2004) Myth #6: "The man should NOT be shorter, weaker, younger, poorer, or less successful than the woman" (p. ix)?

2. Based on the description of *The Da Vinci Code* given in this chapter, what changes would you suggest to those involved with the film adaptation to avoid reproducing Galician's Myth #6?

3. Think of some novels, television series, and/or films in which the female member of a romantic couple is clearly older than her male love interest. Is the age difference a key aspect of the plot? Would this probably be the case if the sexes were reversed? Does focusing on the age difference in an older woman/ younger man romance help to counter Galician's Myth #6 more than if this combination were just presented matter of factly?

4. Think of a romantic novel you have read. What was on the cover? Did the jacket and/or jacket notes affect your interpretation of the novel's romance, as Genette's (1997) notion of paratextual meaning predicts, especially in terms of Galician's romantic myths and prescriptions for overcoming them? Also, con-

sider whether and how the cover of this novel may have reflected Mulvey's (1975) male gaze.

5. Imagine for a moment that Robert Langdon in *The Da Vinci Code* became Roberta Langdon, and Sophie Neveu became Stephen Neveu. How might such a role reversal affect the way readers perceived the novel and the relationship? Would the story and/or dialogue seem more or less acceptable, satisfying, or supportive of Galician's Myth #6?

REFERENCES

A reader. (2004, May 18). Review of *The Da Vinci Code*. *Amazon*. Retrieved July 27, 2004, from http://www.amazon.com/exec/obidos/ASIN/0385504209/qid=1105633181/sr=2–1/ref=pd_ka_b_2_1/103–4444714–1934252

Board: The Da Vinci Code. (2004). *Internet Movie Database*. Retrieved August 30, 2004, from http://imdb.com/title/tt0382625/board/threads/

Brown, D. (1998). *Digital fortress: A thriller*. New York: Thomas Dunne Books.

Brown, D. (2000). *Angels and demons*. New York: Atria Books.

Brown, D. (2003). *The Da Vinci code*. New York: Doubleday.

Chatman, S. (1978). *Story and discourse: Narrative structure in fiction and film*. Ithaca, NY: Cornell University Press.

chrissu. (2004, April 6). The Da Vinci Code—March book club. *Cinescape*. Retrieved July 28, 2004, from http://messageboard.cinescape.com/harrypotter/ubbthreads/showflat.php?Cat=&Board=UBB14&Number=600620&Main=586448

CJ. (2004, April 9). Review of *The Da Vinci Code*. *Amazon*. Retrieved July 27, 2004, from http://www.amazon.com/exec/obidos/ASIN/0385504209/qid=1105633181/sr=2–1/ref=pd_ka_b_2_1/103–4444714–1934252

Collins, L. J., Ingoldsby, B. B., & Dellmann, M. M. (1984). Sex-role stereotyping in children's literature: A change from the past. *Childhood Education, 60*, 278–285.

Customer reviews: The Da Vinci Code. (2004). *Amazon*. Retrieved July 28, 2004, from http://www.amazon.com/exec/obidos/ASIN/0385504209/qid=1105633181/sr=2–1/ref=pd_ka_b_2_1/103–4444714–1934252

Duvet. (2004a, March 19). The Da Vinci Code—March book club. *Cinescape*. Retrieved July 28, 2004, from http://messageboard.cinescape.com/harrypotter/ubbthreads/showflat.php?Cat = &Board=UBB14&Number=600620&Main586448

Duvet. (2004b, April 6). The Da Vinci Code—March book club. *Cinescape*. Retrieved July 28, 2004, from http://messageboard.cinescape.com/harrypotter/ubbthreads/showflat.php?Cat=&Board=UBB14&Number=600620&Main=586448

Fiske, J. (1987). *Television culture*. New York: Methuen.

Galician, M.-L. (2004). *Sex, love, and romance in the mass media: Analysis and criticism of unrealistic portrayals and their influence*. Mahwah, NJ: Lawrence Erlbaum Associates.

Genette, G. (1997). *Paratexts: Thresholds of interpretation* (J. E. Lewin, Trans.). Cambridge, England: Cambridge University Press. (Original work published 1987)

Giraud, J. C. M. (2004, June 28). Review of *The Da Vinci Code*. *Amazon*. Retrieved July 27, 2004, from http://www.amazon.com/exec/obidos/ASIN/0385504209/qid=1105633181/sr=2–1/ref=pd_ka_b_2_1/103–4444714–1934252

Haskell, M. (1987). *From reverence to rape: The treatment of women in the movies* (2nd ed.). Chicago: University of Chicago Press.

Helleis, L. D. (2004). *Differentiation of gender roles and sex frequency in children's literature*. Unpublished doctoral dissertation. Maimonides University. Retrieved July 15, 2004, from http://www.esextherapy.com/dissertations/helleisdis.doc

Jano. (2004, March 8). Review of *The Da Vinci Code*. *Amazon*. Retrieved July 27, 2004, from http://www.amazon.com/exec/obidos/ASIN/0385504209/qid=1105633181/sr=2–1/ref=pd_ka_b_2_1/103–4444714–1934252

ladyoftheflowers. (2004, May 18). Review of *The Da Vinci Code*. *Amazon*. Retrieved July 27, 2004, from http://www.amazon.com/exec/obidos/ASIN/0385504209/qid=1105633181/sr=2–1/ref=pd_ka_b_2_1/103–4444714–1934252

Miller, L. F. (2004, April 12). Review of *The Da Vinci Code*. *Amazon*. Retrieved July 27, 2004, from http://www.amazon.com/exec/obidos/ASIN/0385504209/qid=1105633181/sr=2–1/ref=pd_ka_b_2_1/103–4444714–1934252

Mulvey, L. (1975). Visual pleasure and narrative cinema. *Screen*, *16*(3), 6–18.

Ruby, M. (2004, May 8). Review of *The Da Vinci Code*. *Amazon*. Retrieved July 27, 2004, from http://www.amazon.com/exec/obidos/ASIN/0385504209/qid=1105633181/sr=2–1/ref=pd_ka_b_2_1/103–4444714–1934252

Scodari, C., & Felder, J. L. (2000). Creating a pocket universe: "Shippers," fan fiction, and *The X-Files* online. *Communication Studies*, *51*, 238–257.

The Da Vinci Code—March book club (2004). *Cinescape*. Retrieved July 28, 2004, from http://messageboard.cinescape.com/harrypotter/ubbthreads/showflat.php?Cat=&Board=UBB14&Number=600620&Main=586448

Trites, R. S. (1997). *Waking sleeping beauty: Feminist voices in children's novels*. Iowa City, IA: Iowa University Press.

Weitzman, L. J., Eifler, D., Hokada, E., & Ross, C. (1972). Sex-role socialization in picture books for preschool children. *American Journal of Sociology*, *77*, 1125–1150.

Wynn, N. K. (2004, April 1). Review of *The Da Vinci Code*. *Amazon*. Retrieved July 27, 2004, from http://www.amazon.com/exec/obidos/ASIN/0385504209/qid=1105633181/sr=2–1/ref=pd_ka_b_2_1/103–4444714–1934252

Christine Scodari *is Professor of Communication and Women's Studies Associate at Florida Atlantic University, Boca Raton, where her teaching and research navigate among cultural and media studies, television, and gender. She was born in New York City, raised in the Maryland suburbs of Washington DC, and received her B.A. from the University of Maryland and her M.A. and Ph.D. in Communication from The Ohio State University.* Her 2004 book from Hampton Press, Serial Monogamy: Soap Opera, Lifespan, and the Gendered Politics of Fantasy, *explores articulations among age, gender, and romance in 1990s American daytime dramas, as well as audience negotiation of relevant stories through an innovative, virtual ethnographic approach. Additional research, appearing in forums such as* Critical Studies in Mass Communication, Communication Studies, Women's

Studies in Communication, *and* Popular Communication, *similarly investigates gender, age, romantic fantasy, and/or the relationship between the public and private spheres in popular media and online fan culture. The* X-Files, *romantic comedy film and television, science fiction television fandom, teen girl fandom,* Ally McBeal, *and* Sex *and the* City *are among the topics and texts considered in her published works.*

Rhonda Trust *is a doctoral student and Teaching Assistant in the Department of Communication Sciences at the University of Connecticut, Storrs. Born and raised in the environs of Boston, she received her B.A. in Communication Studies from nearby Bridgewater State College. In 2001 she went on to earn an M.A. in Communication at Florida Atlantic University, producing a thesis entitled "False Reflections: Appearance Esteem Attacks in Advertising in* Cosmopolitan, Working Woman, GQ, *and* Maxim." *While at Florida Atlantic University she presented a paper analyzing class, gender, and romantic representations in the movie* Titanic *at an annual conference of the Florida Communication Association. Her ongoing research agenda, to examine the function and role of communication in romantic relationships, is exemplified by a current project: "The Influence of Emotional Education on Expression of Anger in Romantic Relationships."*

Gender Equity Stereotypes or Prescriptions? Subtexts of the Stairway Scenes in the Romantic Films of Helen Hunt

David Natharius
Arizona State University

One of the most popular romantic actresses in the last decade has been Helen Hunt, whose appeal as a romantic heroine was recognized with her Academy Award® for her performance as Carol, the "good" single-mother waitress who changes Jack Nicholson's "beastly" character, Melvin, from a mean obsessive–compulsive hypochondriac to a kind and loving gentle curmudgeon in the 1997 film *As Good As It Gets*. The memorable dinner-date scene in which Melvin offers Carol his "compliment": "You make me want to be a better man" (to which Carol responds: "That's about the nicest thing anyone has ever said to me") is a perfect example of Galician's (2004) Myth #7: "The love of a good and faithful true woman can change a man from a 'beast' into a 'prince'" (p. 177).

The purpose of this chapter is to "*dis*-illusion" two films in which Helen Hunt coincidentally played the romantic female lead—*What Women Want* (2000) and *Dr. T and the Women* (2000)—that were critically identified as *feminist* films but that, when examined through visual and verbal subtexts, can be seen as examples of how movies perpetuate certain romantic myths and stereotypes identified by Galician (2004).[1]

FEMINIST FILM, GENDER COMMUNICATION, AND EQUITY

When a film is identified as feminist, it is usually because the story either portrays some equitable balance between the male and female characters or because

[1]For a detailed *dis*-illusioning of *As Good As It Gets* using the Seven Step *Dis*-illusioning Directions, see Galician (2004, pp. 232–239).

the conflict is about equity/equality between men and women. I frame my following comments within the understood academic perspective of gender equity as taught in courses in gender communication. Most courses in gender communication are taught from a feminist perspective. The courses begin with a review of the history of male/female relationships, both personal and professional, and how those relationships were (are) dominated by the male-oriented patriarchal values/perspectives of the societies in which these relationships are situated. Usually, some historical background is offered about the development of courses in gender communication, with the suggestion that one goal of these courses is to move men and women toward more equitable ways of communicating and relating in the professional workplace and in personal social interactions. This concept of equity is grounded in the feminist perspective of moving men and women toward more equal status in society, including male acceptance and treatment of women as equals in professional and personal relationships. Examples of recent textbooks in gender communication that reflect this approach, but with different degrees of emphasis on the gendered aspect of human communication, are those by Ivy and Backlund (2003) and Wood (2004).

With the underlying assumption of the feminist perspective, it is easy to see that it is as important for men to recognize how patriarchal societies have, historically, diminished the importance of women as it is for women to articulate their oppressed positions. Simply put:

> For men to "get it," at least intellectually, means that they understand cognitively what feminists or, in fact, most women are concerned with. To do that, they must hear women's voices. They can do that by reading feminist literature [and] by dialoguing with female friends and colleagues. (Natharius, 2000, p. 250)

During the 1980s and 1990s, a "White male backlash" emerged in response to the growing visibility of women in business and politics. Increased evidence of violence against women, including sexual harassment and date rape, lent credence to the perception that men were not ready to give up their entrenched patriarchal dominance. These themes were often seen in the action movies of the 1990s that were targeted to male audiences.

As late as 1995, in discussing the small percentage of women employed at upper professional levels and the almost absolute absence of women at senior faculty levels in business schools, Reardon (1995) suggested:

> Young or old, businessmen have been given little incentive to learn how women think or to patiently study female communication patterns. Look at it from their perspective. . . . What payoffs accrue from understanding women at work? Tolerating them is one thing. Laws require that. But making efforts to understand them is something else entirely. (p. 12)

Reardon's book is appropriately titled *They Don't Get It, Do They?*, which reflects the central concern of my review of two recent films that were identified as feminist by several critics but that were produced within the Hollywood patriarchal system.

Film as a Source of Information About Relationships

Before turning to the discussion of these specific films, I want to acknowledge that films in general have been a rich source of information for illustrating to viewers both appropriate and inappropriate ways to relate to other human beings. Within a romantic relationship framework, films have been notoriously guilty of perpetuating the myths and stereotypes that Galician (2004) deconstructed in detail ("*dis*-illusioned" is her broader term) in her textbook *Sex, Love, and Romance in the Mass Media: Analysis and Criticism of Unrealistic Portrayals and Their Influences*. In gender communication courses, movies and television programs have served as an extensive source of provocative discussion material because they provide perspectives of gender relationships that reflect past and present perceptions of how men and women relate to each other. Although these mediated images are usually distorted or amplified for dramatic or humorous effect, they nevertheless mirror a general expectation of what "good" relationships should look like.

Even from a superficial review of films that deal with personal and romantic relationships, it is easy to recognize that there are very few representations that attempt to realistically reflect the fundamental issues of equity in male–female relationships. The issue of equity is, simply stated, that men recognize and appreciate women's perspectives as being equally as important as their own male perspectives.

The most significant attempts to reduce inequality between women and men in American society have been directed to reducing the artificial and unnecessary perceptual differences that are the entrenched in social traditions as well as reinforced in the mass media. A clear distinction between equality and equity is well stated by Lorber (1994):

> The alternate goal [to equality]—equity—recognizes differences but tries to compensate for them by giving women benefits or protections, such as maternity leave or assignment to non-hazardous work. The goals of equality and of equity are actually the same. (p. 283)

Hollywood Endings and the Diminution of the Value of Women

An additional problem is the tendency of Hollywood filmmakers to fulfill the perceived need for happy endings to romantic stories (i.e., "*they*—a couple—lived

happily ever after"), even if the ending is, ultimately, severely limiting to the fe-male characters involved. No matter how intelligent or self-sufficient or actual-ized a woman may be, her ultimate happiness is found in being loved and taken care of by a man. These endings exemplify the rescue theme described by Gali-cian's (2004) Myth #6: "The man should NOT be shorter, weaker, younger, poorer, or less successful than the woman" (p. 163) as well as by her Myth #10: "The right mate 'completes you', filling your needs and making your dreams come true" (p. 201). Myth #10 is the only myth that Galician reports a majority of persons of both sexes who take her quiz believe is true (p. 202).

A classic example of this kind of diminution of the value of women is seen in the blockbuster film musical My Fair Lady (1964), based on the popular musical theater adaptation of George Bernard Shaw's nonmusical stage play Pygmalion. The film won eight Academy Awards® and is listed as one of the American Film Institute's Top 100 Films (American Film Institute, n.d.). We might excuse the filmmakers' blatant change of the not-so-happy original literary ending because they did not want to put a downer on an otherwise very appealing musical ro-mance; however, the film's ending does a great disservice to the equality of women by making Eliza return to Professor Higgins, who can only be characterized as a boor, snob, sexual harasser, and psychological abuser. My Fair Lady is only one of a countless number of films that can be seen to promote story lines that diminish or discount the value of female perspective.

Two recent films that were received with generally positive though lukewarm critical reviews are What Women Want (2000) and Dr. T and the Women (2000). Both films purport to represent images of men who, through the narrative, gain a greater insight into the perceptions of women. Many critics saw these films as feminist in that both films explored the cultural stereotypes that perpetuate the personal and professional inequalities between women and men. However, when the subtexts of these films are examined, we can see that the men represented have no greater understanding of women than countless numbers of traditional male characters in dozens of preceding films dealing with relational conflict issues between women and men.

In essence, these two films suggest that, even in the 21st century, men still "don't get it."

MYTHS/STEREOTYPES OR PRESCRIPTIONS?

What Women Want

One of the great myths about romantic relationships is that if we truly love and care for the other person, we will know what that person is thinking and wish-ing. Galician (2004) reported that slightly more than half of the college-age men

and half of the college-age women who responded to her *Dr. FUN's Mass Media Love Quiz* agreed with her Myth #3: "Your true soul should KNOW what you're thinking or feeling (without your having to tell)" (pp. 135–136).

This notion of mind-reading has a humorous depiction in *What Women Want*. The images of the macho male portrayed by Mel Gibson's attempts to discover what women want, by trying feminine products, created a continuing series of sight gags and role-reversal humor. Previews of the film featured a scene in which Mel Gibson shaves (actually, exfoliates with wax) his legs and puts on pantyhose.

The story line of this film revolves around an ad agency executive, Nick Marshall (Mel Gibson), who is an avowed chauvinist, due largely to his upbringing in Las Vegas by his showgirl mother. He is denied a promotion because the agency boss Dan Wanamaker (Alan Alda) wants a woman's perspective for its new campaigns. After a freak electrical accident leaves Nick with the ability to hear what women are thinking, he realizes he can use this new power to out-think Darcy McGuire (Helen Hunt), who was given the job he wanted.

For most of the story, he uses his mind-hearing ability to manipulate women into thinking and doing what he wants them to do. From a communication perspective, he has discovered the ultimate persuasive source—the mind of the person he wants to manipulate. He uses his mind-reading ability to take ideas from Darcy and make them appear to be his own—with such success that she is fired and he is given her position, as he wanted. At the end of the movie, he feels remorse for sabotaging Darcy (because he has been falling in love with her). When, in the movie's last scene, he goes to her apartment to finally admit his culpability, she forgives him, with a traditional "kiss-and-make-up" instant happy ending.

The film is an excellent choice for examining the issues of gender equity in the workplace. The objectification of women is almost overdone, but it provides a nice counterpoint to Nick's discovery of how he is objectified in women's minds. However, when the subtext of the film is examined, we can see that Nick can be added to a long list of male characters in movies who suddenly, for whatever reason, have an epiphany and decide that they are going to change their lives for a woman. This clearly reflects the myth of the power of a "good and faithful true woman" to change "a beast into a prince" (Myth #7; Galician, 2004, p. 177), a myth that Galician reported half of college-age men and 40% of college-age women believe is possible (p. 178). In that last scene at Darcy's apartment, Nick rushes up the stairs to find her before she moves out so he can admit to her his culpability. The symbolic climbing of the stairs offers the subtext of the man's rising to the level of the woman to apologize and again be "on her level." In other words, he has now changed from a beast (a lower-level being) to a prince worthy of being on the same plane as the princess/heroine. He admits all, she forgives him (a potentially dangerous act in reality), and in a final embrace, Nick gushes, "My hero!"

Although this ending fulfills the Hollywood notion of happy endings, it perpetuates the myth that a man can change simply because of the love of a good

woman. Of course, the real life statistics of spousal abuse are full of stories of women who believed that they, themselves, are to blame for the abuse they get and that if they only became better wives or girlfriends, their abusive male partners would indeed change for the better. As Galician (2004) has indicated, many women form this unhealthy belief from seeing these kinds of "beast-to-prince" happy ending Hollywood movies.

Dr. T and the Women

"How can someone who knows so much about women know so little about women?" That refrain was repeated several times by critics who reviewed this film. These reviews also pointed out that the film is cluttered by the usual subtexts and mis-directions common to Robert Altman-directed independent-style films.

The main character in Dr. T and the Women is Dr. Sullivan "Sully" Travis (Richard Gere), a very successful gynecologist in Dallas, TX, whose all-female clientele and all-female staff adore him and whose male friends envy his seeming understanding of women. The film is filled with the usual assortment of Altman characters, who create numerous subplots, subtexts, and meta-messages. The primary message that emerges, however, is that Dr. T, despite his effective sympathetic and charismatic bedside manner, really knows little about women when it comes to his own personal relationships. His wife has regressed into a mentally ill child-like state (requiring institutionalization), and his daughters behave in ways that confuse and bewilder him. He finds himself fascinated by the local golf pro, Bree (Helen Hunt), who seems different from all the women he has previously known.

In one final culminating scene, we see that he does not have a clue about how to create an equitable relationship with a woman, even one with whom he thinks he has fallen madly in love. In a stairway scene in the final moments of this film (ironically similar to the one What Women Want), Dr. T races up the stairway in Bree's condo to profess his love and his desire to run off with her. "You won't have to work," he assures her. "I can take care of you." But with one devastating phrase, she asks, "Why would I want that?" The surprising suggestion here is that rather than waiting "to be rescued," Bree is a self-sufficient feminist who subscribes to Galician's (2004) Prescription #6: "Create co-equality; cooperate" (p. 163) and Prescription #10: "Cultivate your own completeness" (p. 201).

This film can be analyzed as a satiric commentary on the traditional way that many men still think about their responsibilities to women, reflecting Galician's (2004) Myth #6: "The man should NOT be shorter, weaker, younger, poorer, or less successful than the woman" (p. 163). One method to explore this patriarchal attitude is to critique the climactic scene as representative of the dominant masculine perception of what makes an ideal relationship—in this case, a man who takes care of the woman so she does not have to "do anything." Of course, the underlying patriarchal assumption is that if a woman is doing anything (es-

pecially holding a job), she is only doing it because she does not have a man to take care of her and make her dreams come true.

THE SUBTEXT OF THE STAIRWAYS

An interesting visual intertext occurs in both these films when we see that the men, upon entering the homes of the women, need to climb a stairway to make contact with the female characters. An easy allusion is that these men must rise up to achieve the level of the women they are pursuing. In *What Women Want*, the characters end up on an equal plane; in *Dr. T and the Women*, the woman is still above the man at the climax of the scene, reflecting her more powerful position of independence from the typical Hollywood ending.

FINAL THOUGHTS

These two Helen Hunt films offer rich grounds for exploration of the concepts and practices of gender communication and interpersonal relationships. Most of all, they offer contemporary visions of how popular films maintain certain myths and stereotypes about how relationships can be fulfilled (or not, as in the case of Dr. T). There are certainly more provocative films that can be used to examine the complexity of gendered relationships; however, I reviewed these films because they are representative of the many films and TV shows that are the sources from which many people get their ideas of how men and women should relate with each other.

More importantly, from a feminist perspective that is the foundation of this analysis, these films need to be examined from a critical point of view that asks:

1. Are men really getting it?
2. Is there a reflection in these films that a greater percentage of men are really starting to understand what a great percentage of feminist women have been saying for at least four decades?

On the basis of this analysis, the answer to the first question is "no," and the answer to the second question is "probably not." The films discussed in this chapter do not really confront the hegemonic issues between women and men: We cannot really be sure that Nick has changed his ways, only that he has made a slick apology to Darcy, and the only discovery that Dr. T has made is that Bree is not the kind of woman he wants and still needs to possess.

The fundamental question centering on gender equity—*Does perceived equity between men and women actually exist?*—might still be answered by saying that men

may know more about what women want, but they have not yet made the great leap of understanding about equity that Nick makes so easily in *What Women Want*. But *What Women Want* is a fantasy. Of course, most women have not made the leap that Bree made in the different but equally fantasy-like *Dr. T and the Women*.

Because gender equity/equality is rooted in so many current social and political issues, we should be continually aware that the romantic myths and stereotypes that perpetuate much of our social thinking also influence how our culture deals with these issues. It appears that romantic myths will continue to influence many of our political, social, and personal decisions—even in the 21st century. Therefore, it is important to think critically about these portrayals and to *disillusion* them.

STUDY QUESTIONS/RECOMMENDED EXERCISES

1. What is the major distinction between "sex" and "gender?"

2. What is the difference between "equality" and "equity"? Do you think people should get equal pay for doing equal kinds of work? Do you think people should be allowed to do work for which they are physically qualified?

3. What myths from Galician's *Mass Media Love Quiz* best represent the prevailing attitudes in most professional settings?

4. Can you think of other films that have been touted as "feminist" but that are actually quite traditional—illustrating the myths and stereotypes rather than the prescriptions?

5. If you are a man, do *you* "get it"? If you are a woman, do you think the men in your life "get it"? Explain your reasons and dialog about solutions.

REFERENCES

American Film Institute. (n.d.). AFI's 100 years . . . 100 movies. Retrieved February 2, 2002, from http://www.afi.com/tvevents/100years/movies.aspx

Altman, R. (Producer & Director), & McLinden, J. (Producer). (2000). *Dr. T and the women* [DVD]. United States: Artisan Entertainment.

Brooks, J. (Producer and Director) & Johnson, B. (Producer). (1997). *As good as it gets* [DVD]. United States: Columbia-Tri-Star Home Entertainment.

Galician, M.-L. (2004) *Sex, love, and romance in the mass media: Analysis and criticism of unrealistic portrayals and their influences.* Mahwah, NJ: Lawrence Erlbaum Associates.

Ivy, D. K., & Backlund, P. (2003). *Exploring genderspeak: Personal effectiveness in gender communication* (3rd ed.). Boston: McGraw-Hill.

Lorber, J. (1994). *Paradoxes of gender*. New Haven, CT: Yale University Press.

Meyers, N. (Producer & Director). (2000). *What women want* [DVD]. United States: Paramount Pictures.

Natharius, D. (2000). The stifling of women's voices: Men's messages from men's movement books. In M. J. Hardman & A. Taylor (Eds.), *Hearing many voices* (pp. 239–252). Cresskill, NJ: Hampton Press.

Reardon, K. K. (1995). *They don't get it, do they? Communication in the workplace—Closing the gap between women and men*. Boston: Little, Brown.

Warner, J. (Producer) & Cukor, G. (Director). (1964). *My fair lady* [Motion Picture]. United States: Warner Brothers.

Wood, J. T. (2004). *Gendered lives: Communication, gender, and culture* (6th ed.). Belmont, CA: Wadsworth.

David Natharius (Ph.D., University of Southern California, 1974) is Professor Emeritus of Communication and Humanities, California State University, Fresno, where he developed the first gender communication course in the Department of Communication. Since 2001, he has been an Adjunct Professor in the Walter Cronkite School of Journalism & Mass Communication at Arizona State University (Tempe), teaching the course in Visual Communication for which he wrote the text Explorations in Visuality. He has produced more than 100 articles, book chapters, and convention presentations and is a Past President of the Western States Communication Association (WSCA), which honored him with its Distinguished Service Award in 1999. He was also a photographer in the United States Air Force. He is a life member of the Organization for the Study of Communication, Language, and Gender (OSCLG), for whose national convention he has served as local host. He is also a founding member of the Experiential Division of the National Communication Association (NCA). With his wife, Dr. Mary-Lou Galician, he conducts Realistic Romance® seminars and travels around the world. He enjoys introducing himself as "Mr. Dr. FUN."

III

CONFLICT

CHAPTER 13

Taming Brian:
Sex, Love, and Romance
in *Queer as Folk*

R. Anthony Slagle
*University of Puerto Rico,
Río Piedras*

Gust A. Yep
San Francisco State University

In the last several years, there have been an increasing number of queer char-
acters on television. Provisionally, we believe that the increased visibility of
diverse sexualities is a positive trend. However, it is vital that we seriously con-
sider the types of representations that appear in the medium. In this chapter, we
employ a media literacy perspective that is informed by queer theory to exam-
ine the relationship between two of the main characters, Brian and Justin, in
the U.S. version of *Queer as Folk*. To accomplish this, we focus on Galician's
(2004) Myth #7 and her corresponding prescription of coupleship in our analy-
sis of the first two seasons of the series. The relationship between Brian and
Justin is one of the most dominant relationships presented in the program. This
particular relationship is interesting for a number of reasons. First, in the pilot
Brian and Justin meet for the first time, and in every subsequent episode view-
ers watch the relationship develop. Second, the relationship between the two
men is not a normative one. In other words, although Brian and Justin develop
a relationship that is committed, the relationship has very particular rules that
distinguish it from what most would consider a "normal" relationship. Finally,
the dynamics of the relationship exemplify the principles of Myth/Prescription
#7. Our chapter is divided into four sections. First, we provide a brief history of
queer representations on television. Next, we present media literacy as our
theoretical framework followed by our analysis of the relationship between
Brian and Justin. We conclude with a summary and discussion of the impor-
tance of critical media literacy for the understanding of myths about sex, love,
and romance in the media.

QUEER REPRESENTATIONS ON TELEVISION
FROM *ELLEN* TO *QUEER AS FOLK*

There has been a virtual explosion of queer visibility on television in recent years. While it was once rare to see gay, lesbian, or bisexual (GLB) characters represented in the medium, such representations have become increasingly common (Gross, 2001). In recent years, GLB characters have been represented on shows such as *Roseanne, Melrose Place, Dawson's Creek, Ellen, Will and Grace,* and *Normal, Ohio.* Unfortunately, although queers are more visible than ever before, most of the representations leave much to be desired. Most queer characters are de-sexualized; any efforts that have given a nod to queer sexuality have been met with considerable resistance. In addition, the primary relationships of most queer characters is with heterosexuals. Even more recently, as cable programming has grown exponentially, queer visibility has grown even more with programs such as *Six Feet Under* (HBO), *The L Word* (Showtime), and the hit reality program *Queer Eye for the Straight Guy* (Bravo). Because the cable networks are not subjected to the same types of restrictions as the major networks (ABC, CBS, Fox, and NBC), there has been some improvement in the way that queers are represented in these programs. If the networks have been afraid that they would lose their audiences if they present queer sexuality, the cable networks demonstrate that this is not the case; many of these programs have enjoyed both commercial and critical success.

There are a number of reasons that media portrayals of queer relationships are important. First, it is important for queer people to be able to see realistic representations of non-normative relationships. Indeed, this is true of any group that is either under-represented or misrepresented in the media. However, because of the veil of silence placed on queer sexualities, queer relationships are seldom public in the "real world." In other words, queers are taught to keep their relationships quietly behind closed doors. When realistic portrayals of queer relationships are not available in the media, queer individuals often feel isolated. This silence is particularly pernicious for individuals as they are coming to terms with their sexuality. One adolescent explained that seeing "gay characters on my favorite TV shows has helped me get through some really tough times. It makes me feel like less of an outsider" (cited in Bloom, 2003, n.p.).

Second, it is important for heterosexuals to see realistic representations of non-normative relationships. Not all heterosexual relationships are the same. Indeed, many heterosexual relationships do not follow culturally constructed norms. For example, not all heterosexuals strive for monogamous relationships (Easton & Liszt, 1997; Overall, 1998; Robinson, 1997), many have no interest in getting married (Jamieson et al., 2002; Smock, 2000), and many have no interest in having children (Cain, 2001; Campbell, 1985). When the relationships that are presented on television follow culturally constructed notions of *healthy* relationships,

heterosexuals may have a difficult time identifying with media representations of relationships.

Third, it is important for all people—queers and nonqueers—to learn to live in a world that is diverse. To be successful in our lives, we must recognize that the world is full of people who are different from us. When the media fail to present realistic portrayals of queer relationships, they are doing a disservice to all of the members of society in general.

As we mentioned earlier, queer visibility on television has increased dramatically in recent years, and yet most of the representations of queer people are sterilized for the general public. Most queer characters are portrayed as the comic relief or as the devoted friend of a straight character (usually a female character). Queer characters are seldom involved in serious romantic relationships, and when they are, these portrayals seldom involve any type of sexual behavior, including kissing.[1] In an age when television is saturated with representations of heterosexuals engaging in sexual activity, queer characters are typically presented as asexual. As one queer columnist explained, "[G]ay people aren't obsessed with sex anymore than our heterosexual counterparts, true, but we do occasionally have sex. Except on television" (Graham, 2004, n.p.).

In Spring 1999, Channel 4 in Britain aired an eight-part queer drama titled *Queer as Folk*. Channel 4 was interested in developing a "distinctive place in British broadcasting for radical, experimental, minority television" (Munt, 2000, p. 531). The initial eight-part series was followed up with a two-part sequel, *Queer as Folk 2*, in February 2000. Although representations of sexuality are fairly common in European television markets, the British version of *Queer as Folk* did not go by unnoticed by conservative critics. As Munt pointed out the British Broadcasting Standards Commission (a governmental commission) received 138 complaints, and the Independent Television Commission (which regulates commercial television) received more than 160 complaints about the program "making *Queer as Folk* second only to the screening of Martin Scorsese's film *The Last Temptation of Christ*" (p. 532). Despite the controversy surrounding the program in Britain, producers Daniel Lipman and Ron Cowan took notice and negotiated with the creators to produce a version in the United States.

In December 2000, the U.S. version of *Queer as Folk* premiered on the Showtime network. The U.S. version, our focus in this chapter, centers on the lives of five gay men (Michael, Emmett, Ted, Brian, and Justin) and two lesbians (Lindsay and

[1]Although this phenomenon has been evident in numerous television representations, nowhere was it more evident than on the prime time soap opera, *Melrose Place*. *Melrose* included an openly gay character (Matt Fielding), and yet although the heterosexual characters hopped from bed to bed, at world record pace, Matt could not get laid to save his life. When Matt was finally supposed to kiss another man in the season finale in 1994, advertisers threatened to pull their sponsorship, and Fox cut away from the kiss to show another character watching in shock.

Melanie, a couple). The only regular heterosexual character is Michael's very sup-portive mother Debbie (although Justin's mother and his friend Daphne are also recurring characters). Not unlike the controversy in Britain, the U.S. version of the program drew the ire of many conservative groups.[2] *Queer as Folk* has often been compared to *Sex and the City* not only because of the sexual content but also because it has pushed the envelope in terms of representations of sexuality. De-spite the controversy surrounding the show, *Queer as Folk* ran for five seasons and became something of a cultural phenomenon not just for queer audiences but for heterosexual audiences as well (Shales, 2004).

Our position is not that *Queer as Folk* is void of problems. Indeed, there are a number of problems that we see with the program (e.g., the program has glossed over issues of race and class, and the relationship between the lesbian couple is very stereotypical). Nevertheless, *Queer as Folk* has addressed queer sex, love, and romance in a way that no other television program has ever dared.

QUEER THEORETICAL FRAMEWORK: MEDIA LITERACY

In an age of increasingly complex communication systems and technologies, me-dia literacy is an important theoretical approach to examining and consuming media messages. This approach is designed to help people understand and con-sume, analyze and evaluate, and produce and negotiate meanings in a cultural world made up of powerful images, sounds, and words. According to Giroux (1999), the focus of media literacy is to teach people "how to interpret critically the knowledge, values, and power that are produced and circulated through di-verse technologies and public spaces while linking such understanding to broader public discourses that invoke the interrelated nature of theory, understanding, and social change" (pp. 165–166). For example, media messages construct iden-tities and relationships and produce representations of individuals and groups in such a way that they "work to one's advantage or disadvantage" (Alverman & Hagood, 2000, p. 197). With a focus on critical understanding, one of the primary goals of media literacy is to enhance people's ability to engage and participate actively in a democratic society.

[2]Donald E. Wildmon, president of the American Family Association (2000), had this to say about *Queer as Folk*: "The country's moral fiber is quickly unraveling, and as bad as it has gotten on television in the last 25 years, I never thought I'd see the day when a TV series that shows men having anal and oral sex would be applauded by *Time* magazine and *TV Guide*" (n.p.), and the South Dakota Family Pol-icy Council ran a full page ad in the *Rapid City Journal* (2000) protesting the show in which they said that "[t]elevision has zeroed in on the deepest parts of the sewer, and it will hit its target" (Advocate.com, 2000, n.p.).

Media literacy is informed by a number of interdisciplinary intellectual traditions including cultural studies and queer theory. Both traditions focus heavily on the analysis and examination of cultural texts such as media representations. Broadly speaking, one of the primary goals of cultural studies is to understand the complex relationship between culture and power. More specifically, "cultural studies is concerned with all those practices, institutions and systems of classification through which there are inculcated in a population particular values, beliefs, competencies, routines of life and habitual forms of conduct" (Bennett as cited in Barker, 2000, p. 7). Cultural studies scholars are interested in uncovering the relationship between these popular values, competencies, and everyday behaviors (culture) and which individuals and groups are systematically advantaged and disadvantaged (power).

Consistent with cultural studies and focusing on sexuality in the formation of human subjectivity, queer theorists are also interested in exposing the relationship between culture and power (Slagle, 1995, 2003; Yep, 2003; Yep, Lovaas, & Elia, 2003). One of the ways in which power is exercised in the social world is normalization, that is, the process of constructing, establishing, communicating, producing, and reproducing a taken-for-granted and all-encompassing standard used to measure goodness, desirability, morality, superiority, and a host of other dominant cultural values (Yep, 2003). Through the process of normalization, normative identities and relationships are created and maintained. A normative sexual identity is unequivocally heterosexual. Although typically hidden from view (we do not normally label someone as heterosexual unless his or her sexuality is in question), it is the standard used to measure other forms of sexual identities and expressions. Similarly, a normative relationship is heterosexual, dyadic, monogamous, and procreative with sexual activity restricted to the private sphere (Elia, 2003). This relational arrangement is also the ruling standard used to judge all other relational forms including unmarried couples (cohabiting dyads), triadic relationships (romantic relationships involving three individuals), and same-sex couples (lesbian or gay relationships). One of the goals of queer theory is to examine the process of normalization and to deconstruct normative identities and relationships to expose the workings of power in current cultural arrangements.

Media literacy is a theoretical approach that emphasizes praxis. In other words, it applies theoretical constructs and relationships such as culture, power, normalization, and normativity to the decoding, evaluation, analysis, and production of media messages and products. According to the National Communication Association (1998, pp. 19–23), a media literate communicator is one who understands: (a) "the ways people use media in their personal and public lives" (e.g., how media messages affect people's personal and public lives); (b) "the complex relationships among audiences and media content" (e.g., media messages are open to multiple interpretations); (c) "that media content is produced within

social and cultural contexts" (e.g., the ability to evaluate message content and products); (d) "the commercial nature of media" (e.g., media messages and products are profit-driven), and (e) how "to use media to communicate to specific audiences" (e.g., recognize that media messages and products are consequential as they produce specific social and cultural views). To be a media literate communicator about human relationships and romantic ones in particular, we need to understand how normative relationships are constructed and maintained and how such constructions are harmful to both heterosexual and queer relational arrangements.

Using a media literacy approach, Galician (2004) examined sex, love, and romance in media messages and products. Although she focused on heterosexual relationships, her approach "is not meant to exclude same-sex or non-Western culture close relationships, to which its applicability might extend" (p. 7). Galician accurately pointed out that sex, love, and romantic relationships are presented unrealistically by the mass media. Such unrealistic depictions and representations are normalized to create and promote dominant and normative relational forms and expectations. For example, ideas and beliefs about "love at first sight" and the existence of "true soul mates" circulate widely in a variety of media forms, creating a normative standard for individuals to evaluate the quality and desirability of their own romantic attachments. In her attempt to demystify such normative relationships produced by the media industry, Galician (2004) developed an accessible guide to deconstruct mediated messages about sex, love, and romance (see *Dr. FUN's Mass Media Love Quiz*© in Galician, 2004).

Myth/Prescription #7

A powerful myth that circulates in the mass media, including television, film, books, newspapers, magazines, popular music, music videos, and popular folktales, is the belief that "the love of a good and faithful true woman can change a man from a 'beast' into a 'prince'" (Myth #7; Galician, 2004, p. 177). The myth suggests that the goodness, devotion, and love of a committed and dedicated woman can change an abuser into a gentle, loving human being. One of the dangers of the myth is that it perpetuates placing the responsibility for this change on the good person: If the bad person is not changing, then the good person is either not good enough or not trying hard enough. The abuser is exonerated from any responsibility. In addition, this myth is heteropatriarchal, that is, it is a manifestation of an overarching system of male dominance through the institution of compulsory heterosexuality (Yep, 2003). Typically, the good person is a woman who is attempting to change a man (Galician, 2004) and in this arrangement, the woman carries the burden, responsibility, and effort to "tame" him while his abusive behavior is excused, overlooked, or normalized.

To critically engage the above myth, Galician (2004) offers a prescription "Cease correcting and controlling; you can't change others (only yourself)" (Prescription #7; p. 177). She urged media consumers to understand that individuals are responsible for their own actions and behaviors. People are responsible for maintaining or changing their own behaviors and not the conduct of others. Through this process of awareness, individuals can become more mindful of the more and less functional aspects of themselves and others, engage in self-cultivation and improvement, and decide whether to remain in a relationship with another person without embarking on a journey to change this person's way of operating in the social world.

Using a media literacy approach, we queer Galician's myth and apply it to the relationship between Brian and Justin, two of the main characters in *Queer as Folk*. To queer the myth is to read it against the heteronormative grain (Slagle, 2003). We turn to this analysis next.

BRIAN AND JUSTIN IN *QUEER AS FOLK*

At the beginning of the series, Brian Kinney (Gale Harold) is a 29-year-old advertising executive who focuses considerable time and energy on his sexual conquests. In the first episode, Brian becomes a father as the result of donating his sperm to his lesbian friend Lindsay and her partner Melanie. Brian is generally represented as a self-centered man motivated by two things: sex and money/success. Brian is interested primarily in conquest, both sexually and professionally. He is not interested in relationships, and he does not fall in love. Rather, he is interested in having as many experiences as he possibly can. In the end, Brian believes that adults should take full responsibility for themselves and thus avoids taking responsibility for his friends. In fact, when Michael tells Brian he needs to take some responsibility for Justin, Brian replies:

> Ya know, I'm getting a little sick of people telling me what's my responsibility [*sic*]. If Lindsay and Melanie wanna go have a kid that's their responsibility. If what's his name—Justin—wants to go out and pick up guys, that's his responsibility. My responsibility is to myself. I don't owe anybody a god damn thing. (Episode 101)

When audiences are introduced to Justin at the beginning of the series, he is a 17-year-old high school senior coming to terms with his sexuality. During the first season, in particular, Justin is quite naive, although he learns a great deal very quickly. Justin comes out both at school and to his parents fairly early in the series. His parents, and his father in particular, are unhappy about this revelation—especially when they learn that he is involved sexually with a 29-year-old.

In the first episode, Justin goes to Liberty Avenue, the fictional queer ghetto in Pittsburgh, where he meets Brian for the first time. At first, Justin denies to Brian that he is inexperienced sexually and he lies about his age. However, when Brian takes him back to his loft, it becomes clear to Brian that Justin is a virgin. After having sex, Brian learns that Justin is much younger than he had originally thought. True to form, Brian expects Justin to leave after they have sex, but Justin clearly has different ideas. Indeed, Brian and Justin have very different expectations about their experience together. Whereas Brian viewed the interaction as a one-time pleasure, Justin begins to develop strong emotions for the older Brian. In fact, Justin declares to his friend Daphne that he is in love with Brian—the morning after they met.[3] Justin brings with him the normative model of his parents, for whom sex is something that is not just for fun, it is an expression of love and intimacy. Brian, on the other hand, takes the decidedly non-normative view that relationships are not for him. Justin is unable to understand how Brian can separate love and sex. At one point, he laments to Michael:

Justin: I came all the way here just to see him [Brian]. He doesn't want anything to do with me.

Michael: Yeah, well the thing you gotta know about Brian is, he's not your boyfriend. Brian doesn't do boyfriends.

Justin: Yeah, well, you weren't there when we were doing it. You don't know the things he did. He kissed me. You don't know anything. . . .

Michael: I know this, Brian is a selfish prick. He doesn't care about anyone but himself. If I were you, I'd just forget about him. (Episode 101)

When his parents discover that he is gay and that he is involved with Brian, Justin's father violently confronts Brian on two separate occasions. Because of this, Justin decides to leave home and stays with Brian—although Brian is not happy with the situation. Justin's mother shows up at Brian's office with Justin's clothes and money, and she tells Brian that he needs to take responsibility for the situation. Ultimately, Brian takes Justin back to his parents where his father tells Justin that he is not to see Brian anymore. Although Brian is not interested in a relationship with Justin, he angrily questions Justin's father about his expectation that Justin deny his identity. The father tells Brian to mind his own business and then Brian leaves—taking Justin with him. During the first two seasons, Justin moves several times: He lives with his parents, with Debbie Novotny (Michael's extremely gay-friendly mother), and with Brian. These changes in

[3]Although our focus in this chapter is on Galician's (2004) Myth #7 and corresponding prescription, the reader might be interested in the Myth #2: "There's such a thing as 'love at first sight'" (p. 127), and the corresponding prescription: "Consult your calendar and count carefully" (p. 127).

residence are primarily the result for Justin's growing frustration that he is unable to convince Brian to change his attitudes and behaviors.

At the end of the first season, Justin attends his senior prom with his friend Daphne. He had wanted Brian to go with him, but Brian refused. Ultimately, though, Brian shows up at the prom and the two men dance. After the prom, they say goodbye and Brian gets into his car. In his side mirror, Brian sees one of Justin's classmates violently attack Justin with a baseball bat (Episode 122). During the first episodes of the second season, Justin is comatose in the hospital as a result of the injuries that he suffered in the bashing. When Justin comes out of the coma, his mother (now divorced) takes him home. Ultimately, though, she turns to Brian and asks him to take Justin because, although she doesn't like him much, she believes that Brian is the one person who can give Justin the motivation to recover.

The sixth episode of the second season was an important turning point in the relationship between Brian and Justin. Justin walks into the apartment and finds Brian having sex with another man. Infuriated, Justin leaves and returns to Debbie's home. Michael reminds Justin that Brian isn't interested in a monogamous relationship and suggests that the reason Brian let Justin live with him was because he felt guilty that Justin had been attacked. Justin confronts Brian about this, and Brian doesn't deny it. This episode ends with Brian and Justin reconciling their differences and negotiating the terms of their relationship:

Brian: You were right. The reason I took you in was because you took a bat to the head. But it's not the reason that I want you to stay. But don't get the idea that we're some married couple, because we're not. We're not like fucking straight people. We're not like your parents, and we're not a pair of dykes marching down the aisle in matching Vera Wangs. We're queers and if we're together it's because we want to be, not because there's [sic] locks on our doors. So, if I'm out late, assume I'm doing exactly what I want to be doing—I'm fucking. And when I come home, I'll also be doing exactly what I want to be doing—coming home to you.

Justin: Okay. I want some things, too. You can fuck whoever you want, as long as it's not twice. Same for me. And no names or numbers exchanged. And no matter where you are, no matter what you're doing, you always come home by 2:00.

Brian: 4:00.

Justin: 3:00. One more thing—you don't kiss anyone else on the mouth but me. (Episode 206)

This is a major turning point for Justin, because he finally realizes that his persistent efforts to change Brian will never succeed; he finally understands that if he wants to stay in a relationship with Brian, he needs to agree to make some realistic

changes. In other words, Justin realizes that he cannot control how Brian functions socially.

For a while, this arrangement seems to work for Justin. However, when Brian decides to do nothing to celebrate Justin's birthday, Lindsay and Melanie take him to a violin recital instead (Episode 216). Justin is not a fan of classical music but finds himself very interested in the handsome violinist, Ethan. When Justin talks with Ethan after the recital, Ethan expresses his disappointment that Justin has a boyfriend. He also tells Justin that if he were his boyfriend, romance would be a central part of their relationship. Although Justin has accepted the arrangement with Brian, he finds himself thinking, once again, about his current relationship.

When Justin returns home from a weekend away, he enters the loft to find Brian having sex with his latest catch. Despite their arrangement, Justin is very disappointed and turns to Ethan. Ethan tells Justin that his previous boyfriend was a lot like Brian—he was only interested in going to clubs and picking up other men. Ultimately, Ethan explains that he wants a committed relationship with someone. This leads Justin to reconsider the arrangement that he made with Brian. Justin makes an attempt to have a romantic evening with Brian, and Brian tells Justin that he's too young to settle down. They argue, and Brian leaves. Angry and disappointed, Justin returns to Ethan (Episode 218). In the season finale of the second season (Episode 220), Justin is forced to make a choice between Brian and Ethan. Although Justin loves Brian, he realizes that Brian will never become the committed and romantic partner that Justin desires in a relationship. In the final moments of the episode, Justin leaves a dance club with Ethan while Brian looks on.[4]

Throughout the first two seasons, Justin tries in vain to change Brian to conform to the type of partner that Justin desires—one who follows a normative model. Justin, like most queer teens, has probably had little exposure to nonnormative relationships. As Justin grows, both intellectually and emotionally over the course of the series, his expectations eventually become more realistic. He recognizes that Brian will never change unless he wants to and that by trying to change Brian he is only damaging the relationship. In the end, Justin comes to the realization that he can only change himself and only if it is right for him.

CONCLUSION

In this chapter, we have examined the evolving relationship between Brian and Justin, two of the main characters in the U.S. version of *Queer as Folk*, using a me-

[4]It is worth noting that Justin discovers that Ethan, despite his promises, had sex with a fan while he was on tour. This ends the relationship, and Justin ultimately returns to Brian during the third season, having learned that normative relationships are not as idyllic as he had hoped.

dia literacy approach that is informed by queer theory. Queering Galician's (2004, p. 177) Myth #7: "The love of a good and faithful true woman can change a man from a 'beast' into a 'prince'," we look at how Justin was influenced by this myth in his ongoing attempt to change Brian in the first two seasons of the show. After meeting Brian and repeatedly hearing that Brian does not wish to have a boyfriend, Justin initially sets out to change him so that the two men can develop a normative relationship. Justin experiences pain, disappointment, and frustration as his ongoing attempts at "taming" Brian prove unsuccessful. However, in the process, both men start developing affinity and affection for each other. Although he wishes to change Brian by attempting to correct and control him, Justin realizes that ultimately he can only change himself. In the end, the two men make the decision to create and recreate, negotiate and renegotiate their own rules in the relationship. Ultimately, their rules are based on their desire to be with each other rather than conformity to heteronormative ideals and relationship expectations in society.

Our analysis of the relationship between Brian and Justin exemplifies the need to critically understand the powerful media images, sounds, and words that we are exposed to on a daily basis. These messages continue to perpetuate myths about sex, love, and romance and create expectations for normative relationships that can ultimately lead to personal disappointment and relational dissatisfaction. Consistent with media literacy advocates and researchers, we argue that normative relationships must be examined to understand the connection between culture and power and how such relationships ultimately limit and degrade some of our relationship choices while rendering others unintelligible. Although queer relationships have gained media visibility and cultural intelligibility in recent years, we must continue to pay close attention to the quality of the representations of such relationships in our increasingly globalized and mediated world.

STUDY QUESTIONS/RECOMMENDED EXERCISES

1. According to Slagle and Yep, why are media portrayals of queer relationships important? Can you think of examples of queer relationships in the media?

2. What is media literacy? Why is it important?

3. Discuss Myth #7. How is this myth presented in *Queer as Folk*? Can you identify other television shows that endorse this myth?

4. Discuss Galician's Prescription #7. Can you think of a romantic couple in a television show in which this prescription can be applied?

5. What is normalization? How does normalization work? Can you think of examples in the media?

6. After reading this chapter, what do you think of the relationship be-
tween Brian and Justin in *Queer as Folk*? What does this relationship tell us about
love, sex, and romance?

REFERENCES

Advocate.com. (2000, December 23–27). Right wing group runs ad attacking *Queer as Folk*.
 Retrieved September 23, 2004, from http://www.advocate.com/html/news/122300–
 122600/122300news03.asp

Alverman, D. E., & Hagood, M. C. (2000). Critical media literacy: Research, theory, and
 practice in "New Times." *The Journal of Educational Research, 93,* 193–205.

American Family Association. (2000, December 12). Mainstream media applaud Showtime's
 perversion. Retrieved September 23, 2004, from http://www.afa.net/activism/aa121200.asp

Barker, C. (2000). *Cultural studies: Theory and practice.* London: Sage.

Bloom, A. (2003). I want my gay TV! Retrieved September 21, 2004, from http: www.teen
 wire.com/infocus/2003/if_200319p255_tv.asp

Cain, M. (2001). *The childless revolution: What it means to be childless today.* Cambridge, MA:
 Perseus Publishing.

Campbell, E. (1985). *The childless marriage: An exploratory study of couples who do not want
 children.* London: Tavistock.

Cohen, R., Lipman, D., & Jonas, T. (Executive Producers). (2000–2003). *Queer as Folk* [Tele-
 vision series]. New York: Showtime.

Easton, D., & Listz, C. A. (1997). *The ethical slut: A guide to infinite sexual possibilities.* San
 Francisco: Greenery Press.

Elia, J. P. (2003). Queering relationships: Toward a paradigmatic shift. In G. A. Yep, K. E.
 Lovaas, & J. P. Elia (Eds.), *Queer theory and communication: From disciplining queers to queer-
 ing the discipline(s)* (pp. 61–86). New York: Harrington Park Press.

Galician, M.-L. (2004). *Sex, love, and romance in the mass media: Analysis and criticism of unre-
 alistic portrayals and their influences.* Mahwah, NJ: Lawrence Erlbaum Associates.

Giroux, H. A. (1999). *The mouse that roared: Disney and the end of innocence.* Lanham, MD:
 Rowman & Littlefield.

Graham, B. L. (2004). Let Matt get laid. Retrieved September 24, 2004, from http://www.brad
 lands.com/words/outlook/comment3.html

Gross, L. (2001). *Up from invisibility: Lesbians, gay men, and the media in America.* New York:
 Columbia University.

Jamieson, L., Anderson, M., McCrone, D., Bechhofer, F., Stewart, R., & Li, Y. (2002). Cohab-
 itation and commitment: Partnership plans of young men and women. *Sociological Review,
 50,* 356–377.

Munt, S. R. (2000). Shame/pride dichotomies in *Queer as Folk*. *Textual Practice, 14,* 531–546.

National Communication Association. (1998). The speaking, listening, and media literacy
 standards and competency statements for K–12 education. Retrieved September 21, 2004,
 from www.natcom.org/Instruction/K–12/standards.pdf

Overall, C. (1998). Monogamy, nonmonogamy, and identity. *Hypatia, 13*(4), 1–17.

Robinson, V. (1997). My baby just cares for me: Feminism, heterosexuality and non-monogamy. *Journal of Gender Studies, 6,* 143–157.

Shales, T. (2004, April 17). *Queer as Folk,* still daring to be different. *The Washington Post,* p. C01.

Slagle, R. A. (1995). In defense of Queer Nation: From identity politics to a politics of difference. *Western Journal of Communication, 59,* 85–102.

Slagle, R. A. (2003). Queer criticism and sexual normativity: The case of Pee-wee Herman. In G. A. Yep, K. E. Lovaas, & J. P. Elia (Eds.), *Queer theory and communication: From disciplining queers to queering the discipline(s)* (pp. 129–146). New York: Harrington Park Press.

Smock, P. J. (2000). Cohabitation in the United States: An appraisal of research themes, findings, and implications. *Annual Review of Sociology, 26,* 1–20.

Yep, G. A. (2003). The violence of heteronormativity in communication studies: Notes on injury, healing, and queer world-making. In G. A. Yep, K. E. Lovaas, & J. P. Elia (Eds.), *Queer theory and communication: From disciplining queers to queering the discipline(s)* (pp. 11–59). New York: Harrington Park Press.

Yep, G. A., Lovaas, K. E., & Elia, J. P. (Eds.). (2003). *Queer theory and communication: From disciplining queers to queering the discipline(s).* New York: Harrington Park Press.

R. Anthony "Tony" Slagle *(Ph.D., The Ohio State University, 1998) teaches communication in the Department of English at the University of Puerto Rico, Río Piedras. His research interests include rhetoric and popular culture, communication and gender, queer theory, communication and sexualities, and the rhetoric of HIV/AIDS. His interest in popular culture has helped him to realize the importance of seriously considering often overlooked and/or maligned communication phenomena that often have a significant cultural impact. Along these lines, he has published on queer theory and Pee-wee Herman, and he is currently working on an article about* The Rocky Horror Picture Show. *Dr. Slagle is an active member of National Communication Association (NCA), for which he has twice chaired the Caucus on Gay and Lesbian Concerns, was the founding chair of the Gay/Lesbian/Bisexual/Transgender Communication Studies Division, and has served on a variety of committees within the association. Dr. Slagle is also in his fourth year as the president of the Speech Communication Association of Puerto Rico (SCAPR). At his university, Dr. Slagle is the chair of the Institutional Animal Care and Use Committee (IACUC) and the compliance officer for laboratory animal research. He is currently the director of the Domitila-Domenech-Belaval Audio Visual Resource Center and the coordinator of the communication studies area in the Department of English. He recently received an award from the Speech Communication Association for his outstanding contributions to research in communication. A transplant from "above the snow belt," he currently lives in San Juan with his partner, Derick, and his beagle, Daisy.*

Gust A. Yep *(Ph.D., University of Southern California, 1990) is Professor of Speech & Communication Studies and Human Sexuality Studies at San Francisco State University. His teaching and research interests include critical intercultural communication, queer*

theory, communication and gender, media and popular culture, health communication, field research methods, and communication and sexualities. Dr. Yep co-authored Privacy and Disclosure of HIV in Interpersonal Relationships *(Lawrence Erlbaum Associates, 2003), which was nominated for the 2004 International Communication Association "Book of the Year" Award.* He was also the lead editor of Queer Theory and Communication: From Disciplining Queers to Queering the Discipline(s) *(Harrington Park Press, 2003). Dr. Yep's work has appeared in numerous interdisciplinary journals and anthologies, including* AIDS Education and Prevention, Feminist Media Studies, Hispanic Journal of Behavioral Sciences, International and Intercultural Communication Annual, International Quarterly of Community Health Education, Journal of American College Health, Journal of Gay, Lesbian, and Bisexual Identity, Journal of Homosexuality, Journal of Lesbian Studies, *and* Journal of Social Behavior and Personality, *to name only a few. He is the recipient of several teaching and community service awards, and he was the 1999 San Francisco State University nominee for the Carnegie Foundation "U.S. Professors of the Year" Award.*

CHAPTER 14

Myths of Romantic Conflict in the Television Situation Comedy

Aileen L. S. Buslig
Concordia College, Moorhead

Anthony M. Ocaña
North Dakota State University

Love and fighting have gone hand-in-hand in portrayals of couples' romantic relationships since the earliest days of television. "To the moon, Alice," Ralph Cramden would bellow at his wife on the 1950s sitcom, *The Honeymooners*, as he threatened to punch her "right in the kisser." Yet the message behind the constant bickering between Ralph and Alice was that fighting is really an indicator of the love they felt for each other. Although threats of physical abuse may be used as sources of humor less frequently in today's sitcom relationships, the myth that "bickering and fighting a lot mean that a man and a woman really love each other passionately" (Myth #8; Galician, 2004, p. 185) remains a prominent message in many sitcoms.

The television situation comedy (or sitcom) has been a popular form of entertainment for more than 50 years (Auter, 1990). Defined as a (usually half-hour) episodic series with a small cast of regular characters in a primarily humorous context (Cantor, 1980; Hough, 1981), the sitcom usually centers around a husband and wife and their family in some way, although nondomestic sitcoms also center around themes such as business or working groups, fantasy, or some other "situation" (Hough, 1981). However, it is quite common to find that romantic relationships figure prominently in the story lines of both domestic and nondomestic sitcoms and for conflict to be a source of humor in those relationships. The sitcom's long and lasting presence throughout the history of television and its ever-increasing sophistication and quality (Hough, 1981; Perkinson, 1991), leads one to ask the following question: What are the potential effects of the situation comedy on television audiences, particularly in reference to how people view conflict in romantic relationships? To begin to answer this question, one must first examine a primary component of the sitcom, the element of humor.

EFFECTS OF HUMOR

Although sitcoms may seem relatively benign, research suggests that the use of humor in a message can influence people without their conscious understanding of that influence. For example, as a method of gaining and sustaining attention, humor has been linked to improved memory and recall, because one must attend to a message for learning to occur in the first place (Oppliger, 2003; Schmidt, 1994). Additionally, the pleasurable arousal changes associated with the cognitive contemplation of humor is similarly expected to influence learning of information presented in a humorous way (McGhee, 1979, 1980). Other theorists have argued that humor is effective in reducing stress and tension and can help to put people into a better, more positive, mental state in which information is well received (Freud, 1963; Grotjahn, 1957/1966; McGhee, 1980). Furthermore, the stress reduction facilitated by humor is also likely to increase the persuasiveness of a message because the induced "positive mood" becomes associated with the message favorably (Cantor & Venus, 1980).

So what is to be made of the messages conveyed in sitcoms? More than 20 years ago, after conducting a 30-year evaluation of sitcoms, Hough (1981) bleakly proclaimed that sitcoms tend to be superficial and simplistic and lacking in dramatic depth. He hastened to add, however, that occasionally sitcoms have transcended their genre, undertaking serious topics with sensitivity (albeit generally with a happy ending), and he predicted hopefully that the future would increase this trend in television sitcoms. Certainly, it can be argued that sitcoms have become more sophisticated and realistic in their portrayal of relationships since Hough's research was conducted, as the best of the current sitcoms have regularly addressed real life concerns and recent events intelligently, while still managing to entertain their audiences. However, the question remains whether sitcoms portray the effects of conflict, a serious issue in itself, realistically.

SITCOM CONFLICTS AND REAL LIFE

Although Gottman (1994) suggested that some married couples who seem to "live to fight" (described as *volatiles*) can have successful marriages, he made sure to emphasize that even volatile couples must experience several positive interactions for every negative one they have. Gottman (1994) also warned that the volatile style is the riskiest of the three pure conflict styles that couples might adopt in their marriage, and the potential for excessive and hurtful conflict can cause irreparable damage to a romantic relationship. As Galician (2004) prescribed, "Courtesy counts" (p. 190) in real romantic relationships. Nevertheless, hurtful messages have been shown to be prevalent in sitcoms (Buslig & Ocaña, 2003).

One should also note that two other media myths contribute to conflict situations in real life. The belief that "your true soul mate should KNOW what you're

thinking or feeling (without having to tell)" (Myth #3; Galician, 2004, p. 135) leads to less successful conflict management, yet becomes perfect fodder for humor in the television sitcom. Believing that "the love of a good and faithful true woman [or man] can change a man [or woman] from a 'beast' into a 'prince' [or 'princess']" (Myth #7; Galician, 2004, p. 177) has also been the premise of many sitcoms or sitcom episodes, to the detriment of real people everywhere.

As viewers watch sitcom couples engage in conflict, it would seem easy to dismiss the argument that sitcoms, given their frivolous nature, can influence viewers' expectations of romantic relationships. However, one cannot ignore the powerful draw that humor has over large numbers of television viewers or the subtly persuasive effects of humor on memory. To determine whether dysfunctional conflict behaviors are presented as normal in successful romantic relationships, we examine how modern television sitcoms perpetuate myths regarding mind reading (Myth #3), partner transformation (Myth #7), and, most important of all, the belief that conflict is key to loving romantic relationships (Myth #8).

> RQ: To what extent do television sitcoms reinforce or counteract media myths about conflict in romantic relationships?

METHOD

To examine if and, if so, how Myth #8 is reinforced in current sitcoms, we conducted a content analysis. Additionally, examples of dialogue from analyzed sitcoms were used to illustrate the media myths supported or contradicted in the episodes.

Sample

Every sitcom shown during a one-week timeframe (January 5–11, 2003) on the four major networks (ABC, CBS, FOX, and NBC) was videotaped for coding and analysis. If any given sitcom was shown more than once, only the first episode was analyzed. A total of 25 episodes[1] were collected.

[1]The shows and couples coded for this study include: (ABC) 8 Simple Rules, Cate/Paul; According to Jim, Cheryl/Jim; The Drew Carey Show, Kelly/Drew; George Lopez, Angie/George; Less Than Perfect, Claude/Charlie; Life with Bonnie, Bonnie/Mark, Holly/Nicky*; My Wife and Kids, Wanda/Michael; (CBS) Becker, (no romantic couple); Everybody Loves Raymond, Debra/Ray, Marie/Frank; King of Queens, Carrie/Doug, Kelly/Deacon*; Still Standing, Judy/Bill; Yes, Dear, Christine/Jimmy, Kim/Greg; (FOX) Andy Richter Controls the Universe, Wendy/Keith*; King of the Hill, Peggy/Hank; Malcolm in the Middle, Allison/Reese, Nikki/Malcolm, Lois/Hal*, Piama/Francis; The Simpsons, Edna/Seymour, Marge/Homer*; That 70s Show, Donna/Eric, Jackie/Steven, Kitty/Red, Nina/Fez; (NBC) Frasier, Daphne/Niles*; Friends, Monica/Chandler, Rachel/Ross; Good Morning, Miami, Dylan/Gavin; Hidden Hills, Janine/Doug, Sarah/Zack; The In-laws, Alex/Matt, Marlene/Victor; Just Shoot Me, Maya/Elliot*; Scrubs, Carla/Turk, Elliot/JD, Lisa/JD, Mrs./Dr. Kelso; Will & Grace, Karen/Milo*. Couples marked with an asterisk (*) engaged in no direct conflict with each other during the show's episode.

Unit of Analysis

The unit of analysis for the study was the *conflict episode*. Based on Wilmot and Hocker's (2001) definition, a conflict episode consisted of an expressed or implied frustration with one's partner and the response it engendered. For the current study, only direct conflict between romantic partners in which both partners were present and engaged with one another was coded. Of the 25 sitcom episodes collected for analysis, 20 episodes contained at least one instance of conflict between romantically involved partners, for a total of 123 conflict episodes coded. Of the 5 episodes that did not contain conflict, one show (*Becker*) did not contain a romantic relationship and therefore provided no data for analysis. Another show (*Will & Grace*) contained indirect conflict, in which the couple used avoidance (Wilmot & Hocker, 2001) to deal with the conflict they had with one another, and the relationship was terminated by the end of the show. Three other shows (*Frasier, Just Shoot Me,* and *Andy Richter Controls the Universe*) contained a romantic relationship in which the couples did not engage in conflict during the episode, and all three relationships ended on a positive note by the end of the episode.

Coding Categories

Conflict episodes were analyzed by two coders so that inter-rater reliability could be calculated. Coders practiced together using two sitcom episodes not included in the final report, reporting after each conflict episode how they had evaluated it individually and discussing the episode until they came to consensus. For the actual study, for an episode to be counted as a conflict, both coders had to agree that a conflict had occurred, at which point they coded the event separately. Inter-rater reliabilities were calculated using Cohen's kappa (Cohen, 1960) for nominal-level variables and using Ebel's intraclass correlation (Guilford, 1954) for ratio-level variables. These are reported below.

Character Qualities

Characters involved in a conflict episode were coded for gender, sexual orientation, and character status (major/minor). Characters could be either major or minor to the sitcom, but at least one of those involved in the conflict episode had to be a regular character. Only conflicts involving characters involved in a romantic relationship were coded. Inter-rater reliabilities were calculated using Cohen's kappa (Cohen, 1960): for gender of senders and receivers, 96.7% agreement ($\kappa = .93$), and for sender and receiver status as a major or minor character, 99.2% agreement ($\kappa = .95$), with disagreements reflecting different opinions between coders on which partner initiated the conflict. There was 100% agreement between coders for all characters' sexual orientation.

Conflict Qualities

Qualities of the conflict episode itself were also coded, including the target of the conflict, the duration of the conflict, the valence of the conflict outcome, and the media myth or prescription (Galician, 2004) that was illustrated.

Coders determined whether the *target* of a conflict was a partner's behavior (e.g., partner neglected to do a requested chore), a partner's personality (e.g., partner is a "snob"), someone other than the partner (e.g., a family member or co-worker), the situation in which the partners find themselves (e.g., an overdrawn bank account), or some other cause. The length of time (i.e., *duration*) a couple spent engaged in a specific conflict was also recorded. Inter-rater agreement for these qualities of conflict was acceptable: conflict target, 83.6% agreement (κ = .73); conflict duration, 99% agreement (κ = .99). Additionally, to determine the proportion of time a particular couple engaged in conflict versus nonconflict interaction, the overall amount of time a couple appeared on-screen together or engaged in conversation with one another was measured. Because of the high intercoder reliability for conflict duration, this additional duration measurement was determined by only one coder.

Coders also determined whether the outcome *valence* of the entire conflict episode appeared to be positive and constructive for the relationship or negative and destructive to the relationship. Also coded was whether the conflict involved any of the pertinent media *myths* (Galician, 2004), including mind reading (Myth #3), partner transformation (Myth #7), or simply bickering (Myth #8), or instead illustrated Galician's (2004) corresponding *prescriptions*, "Communicate courageously" (Rx #3; p.135), "Cease correcting and controlling; you can't change others (only yourself!)" (Rx #7; p. 177), or "Courtesy counts: Constant conflicts create chaos" (Rx #8; p. 185). Inter-rater agreement for these qualities of conflict was also acceptable: conflict outcome valence, 93.4% agreement (κ = .83); conflict myth/prescription, 91.8% agreement (κ = .83).

RESULTS

A total of 41 different romantic couples were portrayed in 25 sitcoms over a 1-week time frame. Couples represented those who were married (n = 25, 61.0%), engaged (n = 2, 4.9%), dating (n = 12, 29.3%), and ex-daters for whom romantic tension was implied and evident (n = 2, 4.9%). All romantic relationships portrayed were heterosexual in nature, and most individual characters (N = 82) were major players on a show (n = 68, 82.9%). The total amount of time couples were portrayed interacting or appearing together on screen, regardless of whether they were engaging in conflict or not, averaged only 4 minutes (M =

236 seconds, $SD = 225.8$) per show. However, individual couples' interactions ranged from less than 1 second to more than 14 minutes (875 seconds) per show.

Characteristics of Conflict Episodes

As stated previously, a total of 123 conflict episodes were coded in sitcoms over a period of 1 week. During these conflict episodes, females ($n = 73$, 59.3%) initiated conflict more frequently than did males ($n = 50$, 40.7%). The target of the conflict was most frequently partner's behavior ($n = 74$, 60.2%), followed by the situation ($n = 17$, 13.8%), other people ($n = 15$, 12.2%), the partner's personality ($n = 14$, 11.4%), or another cause ($n = 3$, 2.4%).

Conflict episodes ranged widely in duration, from 2 to 245 seconds, with an average length just over half a minute ($M = 34.2$ seconds, $SD = 38.8$). Over an entire sitcom episode, the frequency of conflict episodes also varied, from 0 to 9 conflicts per couple, with an average of 3 conflicts ($M = 3.00$, $SD = 2.70$) for the 41 romantic couples portrayed. The total amount of time spent in conflict ranged from 0 seconds to more than 8 minutes (508 seconds) per romantic couple ($M = 102.5$ seconds, $SD = 122.7$). A comparison of conflict versus nonconflict interaction revealed that an average of almost 40% ($M = .38$, $SD = .29$) of couples' time together was spent in conflict.

Portrayals of Media Myths

Because 8 of the 41 romantic couples portrayed in the sitcoms viewed for this study did not engage in direct conflict during the week data were collected, conflict behaviors were analyzed for a total of 33 couples. Relationship types of the 33 couples were similar to the original 41 couples reported above: married ($n = 20$, 60.6%), engaged ($n = 2$, 6.1%), dating ($n = 9$, 27.3%), and ex-daters ($n = 2$, 6.1%). Also as before, most characters ($N = 66$) played a major part on a show ($n = 57$, 86.4%).

Media stereotypes were prominent in the romantic conflicts portrayed in television sitcoms, with most conflicts perpetuating Myth #8, bickering and fighting a lot are the key to a loving relationship ($n = 85$, 69.1%). Although general bickering predominated, other myths also factored into causes of some conflicts, as some characters tried to transform their partner's "beastly" behaviors (Myth #7, $n = 13$, 10.6%) or became upset because they expected their partner to be able to ascertain their wants and needs without being told (Myth #3, $n = 9$, 7.3%). Portrayals of Galician's (2004) prescriptions made up fewer than 15% of the strategies used by characters to address conflict situations (courtesy, $n = 8$, 6.5%; courage to ask, $n = 5$, 4.1%; cease controlling, $n = 3$, 2.4%).

More frequently than not, the individual conflict episode resulted in a negatively valenced outcome ($n = 93$, 75.6%). Using chi-square analysis, this finding was probed further, revealing a significant difference between the valence of conflicts when a myth versus a prescription was portrayed, $\chi^2 (1, N = 123) = 39.7$, $p < .001$. When myths were portrayed, 85% of the time they were negatively valenced ($n = 91$), whereas prescriptions were negatively valenced only 12.5% of the time ($n = 2$). The reverse of this pattern was seen when positively valenced conflict episodes were evaluated. Only 15% of conflict episodes depicting myths ($n = 16$) were viewed as having positively valenced outcomes, whereas 87.5% ($n = 14$) of conflicts depicting prescriptions were evaluated as having positive outcomes.

Furthermore, conflicts that had a positively valenced outcome ($m = 55.6$ seconds, $SD = 55.32$) took twice as long on average as conflicts that were negatively valenced ($m = 27.3$ seconds, $SD = 28.9$). Similarly, conflict episodes in which Galician's (2004) prescriptions were demonstrated ($m = 46.4$ seconds, $SD = 44.0$) generally took longer than conflict episodes that illustrated media myths ($m = 32.4$ seconds, $SD = 37.9$).

DISCUSSION

The proportion of time partners were shown in conflict with each other during a show might suggest to viewers that conflict is frequent, natural, and expected as a significant part of one's romantic relationships. For example, on the aptly titled *Still Standing* (Filisha, Hamil, & Weyman, 2003), married couple Bill and Judy spent more than 75% of their time together in conflict, bickering about each other's behavior ("How come you didn't answer the phone?"; "Aren't you overreacting a little?"; "How come you're still watching the game? You're supposed to be taking this box to Goodwill"), and expectations of mind reading:

Judy: I can't believe you told [our daughter] about Gina Morelli.

Bill: If you're going to lie, you have to tell me.

If, as Gottman (1994) suggested, couples should experience five positive interactions for every one negative interaction, many couples in today's sitcoms are falling far short of this goal. Although engaging in conflict is better than ignoring or being indifferent to one's partner (Gottman & DeClaire, 2001), it is still a risky endeavor when excessive. However, the prevalence of conflict between romantic partners in television sitcoms may be interpreted by viewers as endorsement of this classic media myth (Galician, 2004).

Furthermore, television sitcoms send mixed messages about the impact of conflict on relationships. On one hand, individual conflict episodes usually imply a negative (short-term) outcome, yet by the end of a show episode, the long-term impact on the relationship appears to be a positive one, as the couple expresses love or other positive regard for each other. For example, Dylan and Gavin (*Good Morning, Miami*; Goldstein & Bonerz, 2003) have negative conflicts related to all three myths coded in the current study: mind reading ("If you don't get why this is so important to me, [then you should go to St. Barts alone]"); transforming ("Can't you pretend to be gracious?"); and bickering ("Why do you have to be like that?"). In the end, however, the couple has renewed its commitment to the relationship, proving that love conquers all. The happy ending prevalent in sitcom romantic relationships seems to reinforce the myth that conflict is good for relationships, regardless of its valence.

However, when prescriptions are presented in sitcoms, they are not presented in a way that is rewarding to the audience. They are frequently associated with serious moments, not humorous ones, or when funny they are sometimes associated with a negative impact on the character. In an episode in which Malcolm (*Malcolm in the Middle*; Murphy, Thompson, & Melman, 2003) is uncharacteristically courteous in conflict situations with his girlfriend (and others), he is hospitalized with a peptic ulcer later in the show. His courtesy is shown to have a positive impact on his relationships, but the price for being courteous is his health. In a different example, Christine (*Yes, Dear*; Bowman, Pennie, & Meyer, 2003) ceases trying to control the beastly behavior of her husband, Jimmy, only to find that Jimmy's hurtful comments are overheard by their son, who runs from the room upset. The underlying message in this instance seems to be that Christine's (normally) controlling behavior is necessary for the happiness of the family.

However, in some instances, sitcoms do seem to depict the complexity of real conflict episodes. Some conflicts are shown to change as they progress, illustrating how a negative interaction can be altered by the introduction of positive communication behaviors like those prescribed by Galician (2004). For example, the final conflict between Cheryl and Jim (*According to Jim*; Driscoll & MacKenzie, 2003), which lasted over 4 minutes, began as Cheryl gave Jim the silent treatment, because of a previous transgression in the show. As it evolved, the conflict behavior shifted from an expectation of mind reading (the origin of the conflict), to having the courage to ask in an attempt to understand each other. A courteous discussion followed, resulting in Jim's finally understanding Cheryl's position and Cheryl's proclaiming, "You get it!" The lengthiness of Cheryl and Jim's final interaction aligns with previous conflict research (e.g., Wilmot & Hocker, 2001) that suggested that it takes time and effort to collaboratively work through conflict to achieve a positive outcome. The role of time in conflict is reinforced by the current study's findings, that positively valenced outcomes and those conflicts that included prescriptions took longer than negative-outcome and myth conflicts.

CONCLUSION

Although the primary purpose of sitcoms is to entertain, the messages sitcoms send can teach harmful lessons about how romantic couples should handle conflict. By prominently portraying bickering, mind reading, and transforming as regular and humorous behavior enacted by couples in romantic relationships, the belief that such behaviors are good for relationships is reinforced. In turn, the prescriptions to be courteous, to have the courage to ask, and to cease controlling are frequently presented as either the serious, less exciting side of relationships or as negatively consequential. Humor often stems from conflict in sitcoms, but the repercussions of hurtful and harmful couple interactions are rarely shown. Audiences may know that they should not take sitcoms seriously, but regular associations between the fun of humor in harmful interactions and the outcome of happy relationships may be difficult to overcome.

STUDY QUESTIONS/RECOMMENDED EXERCISES

1. In this study, Buslig and Ocaña found that conflicts that involved one or more of Galician's prescriptions took longer to resolve than conflicts involving only myths. Why do you think this is?

2. Buslig and Ocaña also found that female characters are more likely to initiate conflict with their partners than male characters, which is consistent with research in actual interpersonal relationships. Do you think the differences in conflict initiation are due to gender, or are there other factors that might explain the difference in conflict initiation.

3. Do you think situation comedies would be as interesting if they primarily represented Galician's prescriptions for healthy relationships rather than the myths about love? What is the role of conflict as a driving force behind many of the story lines in sitcoms? In other words, why does conflict seem to be more interesting to watch than healthy interactions between couples?

4. How do you think sitcoms compare to dramas in terms of their portrayals of the conflict myths discussed in this chapter? Observe how conflict is handled between romantic partners in a television drama. Are the consequences of handling conflict poorly different in dramatic series than in humorous ones?

5. Choose an episode of your favorite sitcom, and watch for portrayals of the myths studied in this chapter. For each instance of bickering (Myth #8), transforming (Myth #7), or mind reading (Myth #3) that you observe, how would you use Galician's prescriptions to rewrite the script to result in healthy and effective interaction?

REFERENCES

Auter, P. J. (1990). Analysis of the ratings for television comedy programs 1950–1959: The end of "Berlesque." *Mass Communication Review, 17,* 23–32.

Bowman, B. (Writer), Pennie, M. (Writer), & Meyer, J. (Director) (2003). Trophy husband [Television series episode]. In A. Kirschenbaum, & G. T. Garcia (Producers), *Yes, dear.* New York: Columbia Broadcasting System.

Buslig, A. L. S., & Ocaña, A. M. (2003). *"I love you, Dr. Slutbunny": Hurtful gender messages in TV sitcoms.* Paper presented at the annual meeting of the Central States Communication Association, Omaha, NE.

Cantor, M. G. (1980). *Prime-time television: Content and control.* Beverly Hills, CA: Sage.

Cantor, J., & Venus, P. (1980). The effect of humor on recall of a radio advertisement. *Journal of Broadcasting, 24,* 13–22.

Cohen, J. (1960). A coefficient of agreement for nominal scales. *Educational and Psychological Measurement, 20,* 37–46.

Driscoll, M. (Writer), & MacKenzie, P. C. (Director). (2003). Moral dilemma [Television series episode]. In J. Belushi, T. Newman, J. Stark, S. Bukinik, & M. Gurvitz (Producers), *According to Jim.* Burbank, CA: American Broadcasting Company.

Filisha, C. (Writer), Hamil, J. (Writer), & Weyman, A. D. (Director). (2003). Still bullying [Television series episode]. In D. Burroughs, T. Doyle, & J. Gutierrez (Producers), *Still standing.* New York: Columbia Broadcasting System.

Freud, S. (1963). *Jokes and their relation to the unconscious* (J. Strachey, Trans.). New York: W. W. Norton.

Galician, M.-L. (2004). *Sex, love, and romance in the mass media: Analysis and criticism of unrealistic portrayals and their influence.* Mahwah, NJ: Lawrence Erlbaum Associates.

Goldstein, J. (Writer), & Bonerz, P. (Director). (2003). The big leap [Television series episode]. In D. Kohan & M. Mutchnick (Producers). *Good morning, Miami.* New York: National Broadcasting Company.

Gottman, J. M. (1994). *Why marriages succeed or fail.* New York: Simon & Schuster.

Gottman, J. M., & DeClaire, J. (2001). *The relationship cure: A 5 step guide for building better connections with family, friends, and lovers.* New York: Crown.

Grotjahn, M. (1966). *Beyond laughter: Humor and the subconscious.* New York: McGraw-Hill. (Original work published 1957)

Guilford, J. P. (1954). *Psychometric methods.* New York: McGraw-Hill.

Hough, A. (1981). Trials and tribulations: Thirty years of sitcoms. In R. P. Adler (Ed.), *Understanding television: Essays on television as a social and cultural force* (pp. 201–224). New York: Praeger.

McGhee, P. E. (1979). *Humor: Its origin and development.* San Francisco: W. H. Freeman.

McGhee, P. E. (1980). Toward the integration of entertainment and educational functions of television: The role of humor. In P. H. Tannenbaum (Ed.), *The entertainment functions of television* (pp. 183–208). Hillsdale, NJ: Lawrence Erlbaum Associates.

Murphy, G. (Writer), Thompson, N. (Writer), & Melman, J. (Director). (2003). Malcolm holds his tongue [Television series episode]. In L. Boomer (Producer), *Malcolm in the middle.* Beverly Hills, CA: Fox Broadcasting Company.

Oppliger, P. A. (2003). Humor and learning. In J. Bryant, D. Roskos-Ewoldsen, & J. Cantor (Eds.), *Communication and emotion: Essays in honor of Dolf Zillmann* (pp. 255–273). Mahwah, NJ: Lawrence Erlbaum Associates.

Perkinson, H. J. (1991). *Getting better: Television and moral progress.* New Brunswick, NJ: Transaction.

Schmidt, S. S. (1994). Effects of humor on sentence memory. *Journal of Experimental Psychology, 20,* 953–967.

Wilmot, W. W., & Hocker, J. L. (2001). *Interpersonal conflict* (6th ed.). New York: McGraw-Hill.

Aileen L. S. Buslig *(B.ARCH., University of Miami, 1989; M.A. and Ph.D., University of Arizona, 1991, 1996) has been studying and teaching interpersonal communication for 15 years, although she has been an observer of relationships for as long as she can remember. A "Southerner" living in Fargo, ND, Dr. Buslig loves being an associate professor and co-director of the honors program for the Communication Studies and Theatre Art Department at Concordia College in Moorhead, MN, where she teaches a variety of courses, including interpersonal communication, communication theory, and research methods, as well as a special topics course on communication and gender. As an undergraduate, Dr. Buslig studied architecture, but after discovering some communication courses by accident, she decided to change directions after graduation. Following her desire to combine the study of architecture with her interest in communication behavior and interaction, Dr. Buslig earned her masters and doctorate at the University of Arizona. Reflecting her diverse interests, she has presented and published research on interpersonal privacy and deception, gender images in the media, the effects of architecture on emotional reactions and human interactions, and ethnocentrism in the United States before and after September 11. Dr. Buslig practices her communication skills with her husband, Anthony Ocaña, with whom she almost always has constructive conflict.*

Anthony M. Ocaña *(B.A., University of California, Santa Barbara, 1996) is a Presidential Fellow completing his Ph.D. in the Department of Communication at North Dakota State University in Fargo, ND. While studying communication as an undergraduate, Anthony developed his interest in mediation and conflict resolution. He applies his training in both traditional and transformative styles of alternative dispute resolution to his research on roommate conflict, conflict process and outcome satisfaction among divorcing couples, and the role of listening in mediation. In addition to conflict research, Anthony participates in and presents research on communication assertiveness, persuasive message effectiveness, organizational change and communication, media gender messages, and jury decision-making processes, and he recently received a "top three" paper award in the communication theory division of the Western States Communication Association for his research on Door-In-The-Face theory. While completing his degree, Anthony teaches undergraduate courses in communication and conflict, public speaking, business and professional communication, and research methods. In his spare time, Anthony enjoys traveling to different international locations with his wife, Dr. Aileen Buslig, and collecting stamps from the various countries they visit.*

CHAPTER 15

'Til Politics Do Us Part: The Political Romance in Hollywood Cinema

Jeanne Lynn Hall
The Pennsylvania State University

The title of this chapter is borrowed in part from a December 2003 *USA Today* cover story: The headline reads: "'Til politics do us part: Gender gap widens," and the subhead announces, "Highly educated couples often split on candidates" (Page, 2003, p. A1). The article is accompanied by a large, color photo illustration depicting a man and a woman with their eyes on each other but their backs to each other, he holding a Republican elephant statuette and she a Democratic donkey. The caption describes a "divided household" in which a married couple "find little common political ground." The woman in the picture is quoted as saying, "We write conflicting checks all the time" as contributions to competing candidates and parties, because "We just look at different things as important to us." Finally, she adds, "I have to vote to make sure I cancel him out."

The information in the body of the article is actually far more complex and contradictory than these attention-grabbing signifiers suggest. For example, the article explains that some studies have shown that although college-educated men tend to vote Republican and college-educated women tend to vote Democratic, there is a "twist at the top" among those who have taken postgraduate courses, with both groups leaning toward the Democrats. And it is not really clear that people are honest with their spouses (or, for that matter, with pollsters or journalists) when discussing their politics anyway; three-quarters of married men but only half of married women report that their spouses vote the same way they do. The article notes that researchers even have a name for this: the "'Sure, Honey' Factor." The list of complicating factors goes on, but the important point for my purposes here is that stories such as this one, splashed on the front page of the nation's self-proclaimed number one newspaper, promote and perpetuate a myth so pervasive in U.S. culture as to risk being thought of as natural or commonsensical: Opposites attract—and live happily ever after.

The "'Til politics do us part" story recalls mainstream media coverage of the courtship of Bill Clinton's chief strategist, liberal Democrat James Carville, and

George Bush's political director, conservative Republican Mary Matalin, in the heat of the 1992 U.S. presidential campaign. Their eventual marriage was widely celebrated in both the news and society pages of the popular press. Indeed, a characteristic review of their best-selling election year memoir, *All's Fair: Love, War, and Running for President* (Carville & Matalin, 1994), reads like a pitch for a classical Hollywood film. As *Time* magazine described the plot:

> [B]oy meets girl from the wrong party; boy loses girl to rival presidential campaign; and, after election, boy and girl reconcile and marry. It's *Romeo and Juliet, His Girl Friday* and *Adam's Rib*, with Bill Clinton and George Bush in supporting roles. (Shapiro, 1994, p. 78)

Similar media frenzies surrounded the right person/wrong party marriages of Maria Shriver and Arnold Schwarzenegger in 1987 and Karenna Gore and Drew Schiff in 1997. It is, of course, quite likely that, in reality, these people have much more in common than the mainstream media would lead us to believe. (They're all white, wealthy, highly educated, and accustomed to living in the public eye, for starters.) Nonetheless, popular press discourses surrounding such relationships focus on each couple's differences, the moral of the story almost always being that love conquers all.

Fictional oppositional romances can be found in music videos (Paula Abdul's *Opposites Attract*), situation comedies (CBS's *All's Fair* in the 1970s and ABC's *Dharma & Greg* in the 1990s), and even syndicated comic strips (the *Doonesbury* disc jockey who "came out" on the air, shocking talk radio listeners not with the news that his partner was a man but that he was in love with a Republican). Finally, however, it is undoubtedly Hollywood that has contributed most consistently and insistently to the widespread myth that romantic relationships flourish despite—and even because of—profound differences in two individuals' core values. The movies perform this function in a wide variety of popular genres, from comedies and dramas to westerns and musicals.

In this chapter, I focus on a particular group of films I call the political romance genre. My purpose is to render the structure and ideology of these films visible and open to critical examination. My overarching goal is to help deconstruct Myth #9: "All you really need is love, so it doesn't matter if you and your lover have very different values" (Galician, 2004, p. 193).

HOLLYWOOD'S POLITICAL ROMANCE

Hollywood filmmakers and U.S. audiences have long been fascinated by the notion that opposites attract. Conflicting political principles, party affiliations, and professional priorities have often been used as a foil to sexual, emotional, and

romantic pursuits in mainstream movies: the Soviet sentinel seduced by the cap-italist gigolo in *Ninotchka* (1939), the feminist defense attorney married to the pa-triarchal prosecutor in *Adam's Rib* (1949), the idealistic script editor attracted to the opportunistic impostor in *The Front* (1976), the environmental lobbyist courted by the incorruptible politician in *The American President* (1996), and the petit bourgeois shop owner cyber-seduced by the corporate heir in *You've Got Mail* (1998), to name a few.

The basic premise of many of these films is the same: A politically radical or liberal woman and a conservative or apolitical man fall in love. She is passion-ate and vocal about her convictions and committed to acting on them; he is ambivalent toward, dismissive of, or even hostile to the causes she champions and the candidates or parties she supports. They are nonetheless utterly—and often inexplicably—enchanted with one another. Political differences become stumbling blocks, or at least speed bumps, in the course of the couple's roman-tic pursuits. Eventually, the constructed conflict between the characters' per-sonal and political goals leads to a crisis that must be resolved before the clos-ing credits roll.

It is, of course, a convention of the Hollywood romance to invent plausible (or, in the case of romantic comedy, humorously implausible) obstacles to the course of what the audience instantly perceives as true love. But the use of pro-found political and philosophical differences as a narrative device to temporar-ily separate two lovers is infinitely different from the use of some comic mis-communication or case of mistaken identity. Most obviously, perhaps, the notion that political convictions are not—or should not be—among the reasons indi-viduals are attracted to or repelled by one another in the first place is hardly value-neutral.

The films mentioned above—along with many others, including *The Way We Were* (1973), *Norma Rae* (1979), *Guilty By Suspicion* (1991), *Dave* (1993), *Speech-less* (1994), *Bulworth* (1998), and *Two Weeks Notice* (2002)—are striking for the ways in which they make politics and romance roughly equal lines of action, link-ing the political pursuits and the love interests of the lead characters into chains of cause and effect. Such films can be usefully categorized as a hybrid genre—a seem-ingly diverse and yet distinct group of films sharing a recognizable set of narrative conventions, character types, visual icons, and structural patterns. The widespread and long-standing popularity of Hollywood's political romance warrants an in-vestigation into the dominant conventions of (and significant departures from) the genre and invites speculation about its relationship to American culture.

One cannot help noticing, for example, that the heroine's liberal politics are frequently associated with humorlessness, prudishness, physical unattractiveness, or emotional instability. It is usually up to the conservative hero to loosen her up, turn her on, make her over, or calm her down. The hero is typically tolerant of (and even sympathetic to) the heroine's political philosophies when discussed

in private but annoyed or embarrassed by them when displayed in public. He frequently attempts to intervene by introducing her to the pleasures of conspicuous consumption, impressing upon her the futility of political conviction, or emphasizing the toll her activism is taking on the couple's social, sexual, or family life.

Like so many other Hollywood genres, the fundamental impulse of the political romance is to continually renegotiate the tenets of American ideology. Indeed, what is so fascinating and confounding about Hollywood genre films, as Schatz (1981) astutely noted, is their "capacity to 'play it both ways,' to both criticize and reinforce the values, beliefs, and ideals of our culture within the same narrative context" (p. 35). The political romance film fulfills this capacity, in part, by configuring the personal and the political as essentially distinct (although causally related) lines of action, so that fundamental ideological differences might temporarily *interfere* with emotional and sexual pursuits, but they cannot in and of themselves *make* one character unattractive to another. In most of these films, the basic conflict is carefully constructed and neatly resolved, symbolically stripping both romantic love and political conviction of any meaningfulness in the end.

CONFLICTED COUPLES
AND ROMANTIC RESOLUTIONS

The premise of Hollywood's political romance—that a liberal woman and a conservative man fall in love—is usually established in one of four distinct plot lines. In the first, the initial attraction of a man and a woman to each other is mutual, and their profound political differences come to light only after an exciting flirtation or fledgling romance has begun. In the second, a couple is steadily dating or happily married (despite decidedly different core values) when they are faced with a politically charged situation to which they respond in dramatically different ways. In the third, a conservative man actively and knowingly pursues a liberal or radical woman, his attraction to her fueled at least in part by her political passion, which he sees as plucky or sexy. In the fourth, a left-wing woman pursues a right-wing man to whom she is physically or emotionally attracted despite her disdain or even contempt for his politics.

The central conflict in each of the four plots is thus the same, but it is constructed and resolved in a variety of different ways, with a corresponding range of ideological implications. Specifically, the four plots encourage viewers to perform different cognitive exercises (e.g., to advance and revise a variety of hypotheses about how the conflict between politics and romance might be "realistically" resolved in Hollywood terms) and to experience different emotions (i.e., to feel hope that the lovers will—or will not—end up together, and pleasure or displeasure at the eventual outcome). A survey of exemplary political romance films from both classical and contemporary Hollywood will serve to illustrate this spectrum.

Conflicted Couples

The Delayed Discovery Plot

Speechless provides a good example of the first plot, involving a delayed discovery of political differences. Julia (Geena Davis) and Kevin (Michael Keaton) meet at an all-night convenience store, where they coyly compete for the last box of sleeping pills before agreeing to share it. They do not realize that they are speechwriters for opposing candidates in a heated New Mexico Senate race, Julia as a committed campaign worker and Kevin as an avowedly apolitical freelancer. When the sleeping pills do not work, the two meet again at an all-night diner and catch a bit of campaign coverage on TV. The flirtation fizzles briefly when Julia casually refers to Kevin's candidate as a "Republican simpleton," and he calls her Democrat a "tax-and-spend knee-jerk liberal." But the depth of the divide does not become clear until *after* they have enjoyed a romantic midnight ride across the border in search of breakfast burritos and engaged in a steamy make-out session in the front seat of Julia's car. The chemistry between the two, celebrated in many mainstream reviews of the film, is palpable, and the audience is encouraged to hope that one of the two will jump sides—or, better yet, that both will drop politics altogether—to pursue the budding romance.

You've Got Mail is an extreme instance of the delayed discovery plot. Kathleen (Meg Ryan) is the perky proprietor of a small children's bookstore bequeathed to her by her mother, and Joe (Tom Hanks) is the cocky heir to a big box bookstore chain that routinely and ruthlessly puts independents such as Kathleen out of business. Although the film does not invoke oppositional politics per se, it does suggest that Kathleen owns and operates her little "shop around the corner" in defiance of chain store efficiency and corporate greed, everything Joe so richly represents. Unbeknownst to both, they are engaged in an anonymous online relationship, one that grows increasingly intimate and romantic even as their public battle grows more hostile—and Kathleen's prospects grow more dismal. Viewers familiar with the conventions of the romantic comedy genre anticipate that Joe will undergo a sincere transformation upon realizing that the woman he is systematically crushing in real life is the pen pal he has grown to cherish in cyberspace, paving the way for a happy ending.

The Tested Love Plot

Adam's Rib, a combination romantic comedy/courtroom drama from the classical era, illustrates the second plot, in which an existing relationship is tested by a situation or event with profound political implications. Spencer Tracy and Katherine Hepburn play Adam and Amanda, a happily married couple who have successful careers as attorneys in public and playfully refer to each other as

"Pinky" and "Pinkie," respectively, at home. When Adam agrees to prosecute a woman for shooting her errant husband (on the grounds that she did it), Amanda decides to defend her (on the grounds that he deserved it). Although both characters express a firm belief in the American legal system, Adam's formalist respect for the letter of the law is pitted against Amanda's feminist commitment to the spirit of the law. The debate grows increasingly strained, and the actual domestic violence Adam and Amanda argue about in the courtroom looms as a potential result of the ideological differences in their own home. At one point, Amanda dismisses her husband's admission that he "sees something he hates" in her, shouting, "No matter what you think you think, you think the same as I think!" A variety of plot contrivances, both comic and dramatic, encourage viewers to side with Adam and hope that Amanda will drop her feminist "antics" and tend to her troubled marriage.

The Front is a variation on the tested love plot. In this film the couple in question is not married or firmly committed, so their relationship seems more readily threatened by a crisis. Woody Allen plays Howard, aptly described by one reviewer as "an endearingly neurotic, amiably anarchic and slightly unscrupulous schnook" (Flatley, 1976, p. 15), who agrees to "front" as a television writer for a blacklisted friend during the "red scare" of communist infiltration into U.S. film and television industries in the 1950s. Although Howard is morally opposed to the blacklist, he benefits both financially and socially from it. In the guise of a profound and prolific author, he moves into an upscale apartment and attracts Florence (Andrea Marcovicci), a talented and beautiful script editor. When Florence becomes aware of the blacklist, she quits her lucrative job and commits herself to publishing an independent newsletter denouncing it. When Howard refuses to help or even to support her decision, she severs the relationship, utterly disillusioned. Unlike *Speechless* and *Adam's Rib*, *The Front* encourages viewers to regard the heroine's actions as courageous and altruistic and the hero's response as cowardly and selfish. Like *You've Got Mail*, *The Front* encourages viewers to hope that the hero will undergo a sincere transformation and act upon it, earning the heroine's love and respect in the end.

The "You're So Cute When You're Rad" Plot

Ninotchka exemplifies the third plot, in which a conservative man is irresistibly attracted to an initially resistant radical woman. Greta Garbo plays Ninotchka, a committed communist who travels from Moscow to Paris intent on reigning in three comrades who have been seduced by capitalism. Ninotchka tours the City of Light intent on studying the sewer system, only to be relentlessly pursued by Leon (Melvyn Douglas), a playboy who insists that she revel in the view from the top of the Eiffel Tower. (She agrees but insists on taking the stairs rather than

the elevator.) Ninotchka shuns the trappings of the opulent hotel at which she is stationed in favor of a working class diner, only to be sternly scolded by Leon for insulting the proud proprietor of the diner by ordering the simplest of fares (raw beets and carrots). She insists on the distinction between sexual attraction and romantic love, only to be encouraged by Leon to conflate the two. Ninotchka speaks passionately about the future of the common people and the necessity to grow grain and make bread to feed them. In one of the film's most poignant scenes, she notes that low-cut dresses fell out of fashion in Russia when women bore scars on their backs from the Cossacks' whips. Her heartfelt political conviction is nonetheless associated with efficiency, stoicism, and joylessness, whereas Leon's cavalier opportunism is seen as liberating and life-affirming. Viewers are encouraged to share Leon's proclamation that lovers of the world—rather than workers of the world—should unite.

The Against All Odds Plot

The Way We Were is a good example of the fourth plot, in which a radical woman is physically and emotionally attracted to her political nemesis, whom she doggedly pursues despite their profound philosophical differences. In this film, which spans the late 1930s to the early 1950s, Barbra Streisand plays Katie, a Young Communist League activist who fiercely defends Loyalist Spain, the Soviet Union, and eventually the Hollywood Ten. She nonetheless falls for Hubbell, the Big Man on Campus played by Robert Redford, who urges her to "be decadent, eat Eggs Benedict, vote Republican." They meet by chance years later and enter into a rocky romance and marriage. As Pauline Kael (1973) wrote in her *New Yorker* review of the film:

> The movie is about two people who are wrong for each other, and Streisand and Redford are an ideal match to play the mismatch: Katie Morosky, always in a rush, a frizzy-haired Jewish girl from New York with a chip on her shoulder; and Hubbell Gardiner, a WASP jock from Virginia with straw hair and the grin of a well-fed conquistador. (p. 158)

The emotional trials the two undergo are excruciating and viewers are forced to wonder whether and why they should remain together in the end.

Compromising Positions

In each of these films, the heroine's commitment to her cause is a key character trait, an essential part of her constructed being. Often, this is conveyed visually as well as narratively; for example, Ninotchka lovingly places a portrait of

Lenin in her hotel room, Katie proudly displays one of Franklin D. Roosevelt in her apartment, and Julia sheepishly admits to having one of John F. Kennedy in her kitchen. This emphasis on the heroine's political conviction is significant because in most cases she is faced with the choice of giving up her ideals—or at least compromising them—to win the love of the conservative or apolitical man. Moreover, audiences conditioned to anticipate a Hollywood happy ending are encouraged by these films to want her to do so, and to experience the most "romantic" resolution to the conflict as the "happiest" of endings, even if it involves compromise, sadness, or loss for the politically motivated woman. As *Playboy* magazine ("Movies," 1973) commented in a review of *The Way We Were*, "When did you last see a love story in which the honeymoon ended with a passionate political debate?" (p. 26). The answer, of course, is "not recently" or "not often." Hollywood is much more inclined to provide a romantic resolution to its constructed conflict in core values.

Romantic Resolutions

After the essential differences between the heroine and hero have been established, political romance films use a variety of strategies to resolve the resulting conflict. In the first plot resolution, the heroine simply abandons her political convictions or philosophical ideals to facilitate a romantic union with the hero, who remains essentially unchanged. In the second, it turns out that the heroine and hero are not so different after all, as she reawakens his inherent idealism, making them political allies instead of enemies. In the third, the hero undergoes a genuine transformation, inspired in part by the heroine's love (or the loss of it), paving the way for their eventual union. In the fourth resolution—arguably the most common in real life and significantly the most rare in Hollywood— profound political differences between two lovers really do spell doom for any kind of meaningful romantic relationship.

The "Love" Conquers All Resolution

Ninotchka and *You've Got Mail*, despite having been made more than 50 years apart, are strikingly similar examples of the first narrative resolution. Near the end of *Ninotchka*, the heroine returns to her beloved Russia heartbroken but committed to the prosperous future of the common people. The playboy Leon essentially kidnaps his lost lover, spiriting her out of the country under false pretenses and blithely assuring her that he will do so repeatedly if she attempts to return, thereby hurting her communist cause far more than any contributions she can make to it will help. The once staunch Soviet dreamily succumbs to the bubbles

of champagne, the charms of her suitor, and the capriciousness of capitalism (in the form of a silk slip and a fashionable hat) with the declaration: "Worlds will fall. Civilizations will crumble. But not tonight. Let us be happy." Ninotchka is such a sympathetic character that we hope against hope that she will be.

You've Got Mail serves as a painful reminder that such resolutions are not as old-fashioned as contemporary feminists might like to think. In this film, the big box bookstore boy learns that his online lover is in fact the little shop around the corner girl whose mom and pop business he is systematically destroying. In a tearful e-mail, she confides to him, "The truth is I'm heartbroken. I feel as if a part of me has died. And my mother has died all over again. And no one can make it right again." Viewers clinging to some hope that Joe, who *can* "make it right again," will do everything in his considerable power to do so to win her love are sadly disappointed. He just doesn't. Rather, Joe proceeds to court Kathleen overtly even as he bankrupts her covertly. Upon learning the truth in the last scene of the film, she tells him, "I wanted it to be you. I wanted it to be you so badly." *Somewhere Over the Rainbow* swells up on the soundtrack, prodding viewers to feel as happy about this resolution as Kathleen claims to be. Even the "Manly Man's Movie Reviews" Web site (which one might have expected to approve of Hanks' uncharacteristically macho character) expressed disbelief and disappointment that Ryan's character recovers from her loss almost instantly and forgives her suitor almost magically: "There is no exploration of some very real hurt here. Nor does Hanks attempt to rectify or address the fact that he has hurt someone he has come to love" (Rummel, 1999).

The Reawakening Resolution

Speechless heads dangerously in the direction of a similarly (un)happy ending, even contriving at one point to have its supposedly diehard Democrat heroine cheerfully scripting a 30-minute infomercial for her lover's "Republican simpleton." Finally, though, the narrative resolution of *Speechless* slides into the second category, in which the hero's sleeping idealism is reawakened by the heroine's passion and optimism. Kevin reveals to Julia that he once believed in the words he wrote but grew disenchanted upon realizing that the politicians who voiced them did not. This transformation is just believable enough to make the end of *Speechless*, in which Julia decides to run for office herself with Kevin as her speechwriter, satisfying. Finally, it turns out that both candidates have been bribed by the same corrupt tycoon, a plot twist that paves the way for a lasting union between the two lovers. (It also makes Julia's loyalty to her liberal candidate seem foolish in retrospect and validates Kevin's apolitical "gun-for-hire" attitude.) One could give the film credit for suggesting that the Republican and Democratic parties are not separate creatures at all, merely adjoining bellies of the same corporate beast,

but in fact the central message of the film is that no political convictions are more important than the promise of romantic love.

The Transformation Resolution

The Front exemplifies the third plot resolution, in which the hero undergoes a genuine transformation. Initially, Howard fronts to help out his friend (and admittedly to benefit himself in so doing). Later, he hopes to maintain the lifestyle to which he has grown accustomed (and still be seen as helping—or at least not hurting—the victims of the situation he is now exploiting). In the end, however, Howard's primary goal is to stop others from being hurt by the blacklist—in part to avenge the suicide of one blacklisted friend, in part to rebut the accusations of another, and in part to regain Florence's respect for him—but finally, I think, because he is convinced it is the right thing to do. Howard undergoes a fundamental transformation in the course of the narrative, from individual interest to class action. He is radicalized by the events surrounding him. It is highly significant that Florence does not buy into Myth #7: "The love of a good and faithful true woman can change a man from a 'beast' into a 'prince'" (Galician, 2004, p. 177). Rather (as noted earlier), following Galician's Rx #7: "Cease correcting and controlling; you can't change others (only yourself)" (p. 55) and Rx #9: "Crave common core-values" (p. 55), she severs the relationship when her lover encourages her to act contrary to her core beliefs. The ironically happy ending, in which Howard refuses to cooperate with the House Un-American Activities Committee and—embraced by his lost lover and surrounded by a throng of supporters—is taken off to jail, suggests that romantic love and political conviction are inextricably intertwined in those who are passionate about both.

The Realistic Resolution

The Way We Were exemplifies the fourth plot resolution, in which profound political and philosophical differences between two lovers really do spell doom for any kind of meaningful romantic relationship. But this film overdetermines the eventual split of its two protagonists by making them incompatible in so many ways that opposing political opinions are the least of their worries. As Hall (2006) found, popular press reviewers attributed the couple's irreconcilable differences variously to conflicting personality types, contrasting ethnic, religious, and regional backgrounds, and even to physical inequalities (i.e., Robert Redford was described by reviewers as far more desirable than Barbra Streisand). Katie herself lumps politics together with all of the script's other contrived reasons that she and Hubbell must part: "Tell me I'm not good enough. Tell me you don't like my politics. Tell me I talk too much, you don't like my perfume, my family, my pot roast. . . ." The couple does indeed split up—and we are left believing they are

better off apart—but Katie's politics, at the heart of her being and the overt premise of the movie, get lost in the shuffle.

CONCLUSION

The Way We Were, like *The Front*, at least attempts to explore ways in which emotional and physical attractions might be tempered by political differences. Both of these films try much harder than many other political romances, including *Ninotchka* and *You've Got Mail*, to deal with the possibility of very real philosophical differences interfering with love and marriage. As Galician (2004) reminded us:

> Mass media creators far prefer to send the message that love can overcome every barrier—even death. Unfortunately, they literally have to kill off their romantic couples before the end of the narrative—or fade to black at the early stage of the commitment—rather than show the more realistic not-so-happy endings of short-lived affairs based on the myth that all you need is love. (p. 195)

Hollywood film is important, as Wexman (1993) wrote, because it constitutes a significant cultural practice, the conventions of which are related to the way we live. As a form of modern popular ritual, movies define and demonstrate socially sanctioned ways of falling in love—acceptable ways of becoming a couple. The films discussed in this chapter are undoubtedly intended to be consumed as mere entertainment, but they function to perpetuate unrealistic and even dangerous notions about romantic love, as well as to trivialize or pathologize political conviction and activism as threats to love and happiness. All too often, in Hollywood's political romance, the most "acceptable" way for a woman to become part of a couple is to relinquish her core values.

Although the actual effectiveness of Hollywood movies in perpetuating the myth that love conquers all is the subject of further study and debate, the "'Sure, Honey' Factor," which suggests either that many men simply assume their wives share their political agenda and/or that many women do not bother to correct that impression, is particularly disturbing in this light. Ironically, although Hollywood's political romance films claim as their basic premise that "love conquers all," they define it rather unromantically as an attraction that is felt despite rather than because of who two people really are.

ACKNOWLEDGMENTS

This chapter is dedicated to the memory of Djung Yune Tchoi, doctoral candidate in the College of Communications at Penn State, whose insights on politics and romance will inspire me always.

STUDY QUESTIONS/RECOMMENDED EXERCISES

1. Choose any film in which two characters with different core values wind up together in the end. Envision the relationship 1 year later and then 5 years later. Questions to consider include: In the real world, do you think the couple would probably stay together or split apart? Would one or both characters compromise or change? Would the arrival of children draw them closer together or pull them further apart? What does this exercise suggest about the role Hollywood films play in perpetuating Myth #9?

2. Outline four ways in which the basic conflict of the political romance film genre is typically established and four ways in which it is typically resolved, as discussed in this chapter. Can you think of other films that employ similar conventions? Are there significant exceptions to the rules? What are the ideological implications of these narratives?

3. Conduct an analysis of a film character who is made to seem desirable onscreen (perhaps because he or she is played by a popular star) but whose core values, personality traits, or actions you might find undesirable or even repellant in real life. Then envision a character with the same qualities played by an actor or actress you find less appealing. Finally, envision the actor you find less appealing playing a character whose qualities you actually admire and desire in a partner. What does this exercise suggest about Hollywood films' ability to influence viewers' emotions and attitudes?

4. Hollywood romance films often feature a character who is involved in a relationship with "the wrong person" in the beginning—a character who must be dispensed with to allow for a union with "the right one" in the end. How do these films code the wrong ones as such? For example, are they assigned negative personality traits or physical imperfections? Classical films to consider include *Bringing Up Baby* (1938) and *His Girl Friday* (1940); contemporary films include *Sleepless in Seattle* (1993), *Speechless* (1994), and *You've Got Mail* (1998).

5. Consider the positive and negative qualities sometimes associated with political conviction and activism in Hollywood films. In your opinion, are politically motivated male and female characters depicted the same or differently? Do you think Hollywood films encourage male and female viewers to seek partners who share their core values or to buy into the notion that "opposites attract"?

REFERENCES

Carville, J., & Matalin, M. (1994). *All's fair: Love, war and running for president*. New York: Random House and Simon & Shuster.

Davis, G. (Producer), & King, R. (Writer), & Underwood, R. (Director). (1994). *Speechless* [Motion picture]. United States: MGM/UA.

Ephron, N., Shuler-Donner, L. (Producers), & Ephron, N. (Writer/Director). (1998). *You've got mail* [Motion picture]. United States: Warner Brothers.

Flatley, G. (1976, October 3). Woody Allen: "I have no yen to play Hamlet." *New York Times*, 15.

Franklin, S. (Producer, uncredited), Wilder, B. (Writer), & Lubitsch, E. (Director). (1939). *Ninotchka* [Motion picture]. United States: MGM.

Galician, M.-L. (2004). *Sex, love and romance in the mass media: Analysis and criticism of unrealistic portrayals and their influence*. Mahwah, NJ: Lawrence Erlbaum Associates.

Hall, J. L. (2006). Opposites attract: Politics and romance in *The Way We Were* and *Speechless*. *Quarterly Review of Film and Video, 23*(2).

Kael, P. (1973, October 15). The current cinema. *New Yorker*, 158–160.

Movies. (1973, December). *Playboy*, 26.

Page, S. (2003, December 18). 'Til politics do us part: Gender gap widens. *USA Today*, p. A1.

Ritt, M. (Producer), Bernstein, W. (Writer), & Ritt, M. (Director). (1976). *The front* [Motion picture]. United States: Columbia Pictures.

Rummel, J. D. (1999). *You've Got Mail*: It's okay. *Manly men's movie reviews*. Retrieved September 30, 2004, from http://morpo.com/movies/?id=83&au=2

Schatz, T. (1981). *Hollywood genres: Formulas, filmmaking & the studio system*. Philadelphia: Temple University Press.

Shapiro, W. (1994, September 19). Star-crossed politicos: *All's Fair*. *Time*, 78.

Stark, R. (Producer), Laurents, A. (Writer), & Pollack, S. (Director). (1973). *The way we were* [motion picture]. United States: Columbia Tristar.

Weingarten, L. (Producer), Karin, G. (Writer), & Cukor, G. (Director). (1949). *Adam's rib* [Motion picture]. United States: MGM.

Wexman, V. W. (1993). *Creating the couple: Love, marriage and Hollywood performance*. Princeton, NJ: Princeton University Press.

Jeanne Lynn Hall is an Associate Professor of Communications at the Pennsylvania State University, where she teaches courses in film history, theory, and criticism. She earned her bachelor of arts degree in journalism in 1981 and her master of arts degree in communication studies in 1984, both at the University of Michigan. She earned her doctorate in film studies at the University of Wisconsin in 1990. A former editor of Wide Angle, *Hall has published essays in* Cinema Journal, Film Quarterly, Film Criticism, Quarterly Review of Film and Video, Creative Screenwriting, *and* Journal of Communication Inquiry. *She is the author, along with husband and colleague Ronald V. Bettig, of* Big Media, Big Money: Cultural Texts and Political Economics *(Rowman & Littlefield, 2003).*

CHAPTER 16

"Five Total Strangers, with Nothing in Common": Using Galician's Seven-Step *Dis*-illusioning Directions to Think Critically about *The Breakfast Club*

Jennifer Hays
Arizona State University

Various film trends catering to young audiences had emerged over past generations, but movies in the last 20 years of the [20th] century appeared almost fixated on capturing certain youth styles and promoting certain perspectives on the celebration (or really, survival) of adolescence. (Shary, 2002, p. 18)

Over the last quarter-century, Americans have had a fascination with youth culture, and in no medium is this more apparent than in film (Shary, 2002). Whereas scholars have disagreed about why this phenomenon emerged, the success of teen coming-of-age, romantic-comedy genre movies of the 1980s and 1990s is undisputed. Beginning with the widespread acclaim of *Grease* (1977) and *Fast Times at Ridgemont High* (1982), Hollywood studios green-lighted scripts aimed at the new teen audiences who were packing the malls and, therefore, the movie theaters (Shary, 2002), resulting in the production of box office hits such as *Sixteen Candles* (1984), *The Breakfast Club* (1985), *Weird Science* (1985), *Better Off Dead* (1985), *Pretty in Pink* (1986), *Ferris Bueller's Day Off* (1986), *Dream a Little Dream* (1989), *Heathers* (1989), *Pump Up the Volume* (1990), and countless others.

Many of these films continue to resonate with audiences over the decades. Rutsch (2005) argued, "Though it has aged, *The Breakfast Club* is no cultural relic. Its examination of social classes, basic human interaction and high school dynamics continues to make it fodder for college classrooms" (p. 1). Rutsch explained:

It's not the first modern teen flick—that title might be given to the raunchy *Animal House* or *Fast Times at Ridgemont High*, but the interplay between the five archetypal characters makes it the most memorable. (p. 1)

In this chapter, I utilize Galician's (2004) seven-step *dis*-illusioning directions to analyze and critique romantic myths and stereotypes in one of the earliest and most popular of these teen romantic comedies—John Hughes' *The Breakfast Club*. Galician's seven-step method is a media literacy-based extension of traditional textual analysis and criticism. Her framework includes "three extra steps" (that she terms *Design, Debriefing,* and *Dissemination*) to "incorporate the *Reflection* and *Action* elements of a more dynamic plan—Action Learning's Empowerment Spiral (Awareness, Analysis, Reflection, and Action), which I consider to be crucial to our work" (p. 107).

The seven steps are

1. Detection (finding/identifying)
2. Description (illustrating/exemplifying)
3. Deconstruction (analyzing)
4. Diagnosis (evaluating/criticizing)
5. Design (reconstructing/reframing)
6. Debriefing (reconsidering/remedying)
7. Dissemination (publishing/broadcasting). (p. 107)

In my *dis*-illusioning of *The Breakfast Club,* I use the main headings (steps) and the applicable subheadings of the seven-step process that are delineated in the worksheets and sample provided by Galician (2004).

STEP 1: DETECTION

The Breakfast Club, was written, directed, and produced by John Hughes (1985), a major creator of movies in this genre. The entire R-rated 1985 movie (available in VHS and DVD formats) is the subject of this *dis*-illusioning exercise.

STEP 2: DESCRIPTION

The narrator of the movie's trailer describes the central characters, each of whom is a stereotype:

> . . . five total strangers, with nothing in common, meeting for the first time: a brain, a beauty, a jock, a rebel, and a recluse. Before the day was over, they broke the rules, bared their souls, and touched each other in a way they never dreamed possible. (Hughes, 1995)

Detailed Description

Five high school students are sentenced to Saturday detention, and although they begin the day as "a brain, an athlete, a basket case, a princess, and a criminal," they leave as friends (Hughes, 1995). Each student has been assigned detention for a different reason: Brian, the "brain" (played by Anthony Michael Hall), for acting out in class after receiving a poor grade on a lamp-making assignment in shop; Andrew, the "athlete/jock" (Emilio Estevez), for deliberately injuring another student while in the locker room; Claire, the "princess/beauty" (Molly Ringwald), for ditching class to go shopping; and John, the "criminal/rebel" (Judd Nelson), for causing a fake fire alarm. Alison, the "basket case/recluse" (Ally Sheedy), claims that she just "didn't have anything better to do" on a Saturday than to go to detention.

After spending just one the day together in the school's library, during which time they bicker and fight until the last moments of the film, the five students eventually begin to get to know each other and, despite their seemingly vast differences, become friends. Beyond this sudden friendship, two romantic couple-ships are also formed (the princess with the criminal; the loner with the jock) in the film's final moments.

Creator's Purpose

John Hughes' purpose in writing, producing, and directing the romantic teen comedy *The Breakfast Club*, as well as his other teen genre movies, was probably best stated by Hughes himself in an interview conducted by one of this movie's stars, Molly Ringwald: "Young people support the movie business, and it's only fair that their stories be told" (Ringwald, 1986, n.p.).

STEP 3: DECONSTRUCTION

Underlying Myths/Stereotypes

The primary myth illustrated by *The Breakfast Club* is Myth #9: "All you really need is love, so it doesn't matter if you and your lover have very different values," (Galician, 2004, p. 193). This myth is exemplified in the portrayals of the romantic relationships: between Claire, a beautiful preppy "little rich girl," and John, a pot-smoking rebel, as well as between Alison, an artistic loner, and Andy, a popular jock. In addition, the film also legitimizes Myth #2: "There's such a thing as 'love at first sight'" (Galician, 2004, p. 127); Myth #5: "To attract and keep a man, a woman should look like a model or a centerfold" (p. 153); Myth #7: "The love of a good and faithful true woman can turn a man from a 'beast' into

a 'prince'" (p.177); and Myth #8: "Bickering and fighting a lot mean that a man and a woman really love each other passionately" (p. 185).

Evidence for Linking Myths/Stereotypes; Specific Examples of Content and Form that Represent Embedded Values

This film powerfully perpetuates Myth #9 when, despite their very different values, two couples—the princess and the criminal; the loner and the jock—become romantically involved. Myth #2 is invoked by the suddenness of these romantic coupling, which is particularly surprising in light of the bickering and fighting (Myth #8) of all five characters throughout the majority of the film. Myth #5 is perpetuated when the reclusive Alison is only acceptable as a romantic partner for the popular jock after she gets a quick make-over from the beautiful Claire, and the entire movie suggests that Myth #7 is realistic.

From the very beginning of this film the differences in the values of all five characters are strongly depicted. The characters who eventually "fall in love" spend the first two-thirds of the movie fighting because of their differences concerning just about every key value that should be shared in a healthy relationship. One of the many examples of these differences is the following scene, about 20 minutes into the movie, in which John, the rebel/criminal, has just made fun of Andrew, the jock, for being involved in wrestling. Claire, the beautiful preppy princess (who will ultimately be paired romantically with John), responds:

Claire: You know why guys like you knock everything?

John: Oh, this should be stunning. . . .

Claire: It's 'cause you're afraid.

John: Oh, God! You richies are so smart; that's exactly why I'm not heavy in activities!

Claire: You're a big coward!

Brian: I'm in the Math Club—

Claire: See you're afraid that they won't take you. You don't belong so you just have to dump all over it. . . .

Brian: —the Latin Club—

John: Well, it wouldn't have anything to do with you activities people being assholes, now—would it?

Claire: Well, you wouldn't know. . . . You don't even know any of us.

John: Well, I don't know any lepers either, but I'm not gonna run out and join one of their fucking clubs.

Andrew: Hey, let's watch the mouth, huh. . .?

Brian: —and the Physics Club.

John: S'cuse me a sec. . . . What are you babbling about?

Brian: Well, what I said was . . . I'm in the math club, the Latin Club, and the Physics Club.

John: Hey, Cherry: Do you belong to the Physics Club?

Claire: That's an academic club. . . .

John: So?

Claire: So . . . academic clubs aren't the same as other kinds of clubs.

John: Oh, but to dorks like him, they are. What do you guys do in your club?

Brian: In Physics, um, we ah, we talk about physics . . . about properties of physics.

Bender: So it's sorta social. Demented and sad. But social. Right?

Despite the major differences among the teen characters depicted in this scene and throughout almost the entire hour and a half of *The Breakfast Club*, Claire and John (and Andrew and Alison) are romantically paired by the end of the film. During the last 10 minutes of the film, these couples come together and reinforce Myth #9.

As previously stated, in addition to Myth #9, *The Breakfast Club* also promotes several other myths. Myth #8 is illustrated in two successive scenes in the last minutes of the movie. First, John severely degrades Claire and causes her to cry hysterically. He yells at her, essentially calling her a spoiled little daddy's girl. He points out that she has never had to work and that everything she has, including a pair of diamond earrings that she is wearing, was paid for by someone else. He even points out the fact that she can never possibly understand him or his lifestyle:

> You don't know any of my friends, you don't look at any of my friends, and you certainly wouldn't condescend to speak to any of my friends, so just stick to what you know—shopping, nail polish, your daddy's BMW, and your poor, rich, drunk mother in the Caribbean.

Then, just a few minutes later, John and Claire share an intimate moment when Claire sneaks into a closet where John has been locked as punishment, and she kisses him. The princess and the criminal are portrayed as suddenly having become a romantic couple. Claire is shown being compassionate to John, and, after some soft, romantic transformation music plays, John finally makes a few sweet comments to Claire. The beast has turned into her prince (Myth #7). In the final scene Claire even gives John one of the diamond earrings that he teased

her about in the previous fight scene, and he is shown putting it into his ear and walking away from the school triumphantly as the credits begin to roll.

Although *The Breakfast Club* dedicates more time to the relationship of John and Claire, the other couple in the movie, Andrew the jock and Alison the basket case, also illustrate Myth #9, as well as several other myths. Andrew and Alison also have nothing in common throughout the majority of the movie, but after Claire gives Alison a quick beauty makeover, Andrew sees the "new" Alison (Myth #5 and Myth #2)—once the soft lighting and "love-at-first-sight" romantic music cue him and the audience. Within 2 minutes of Alison's makeover, she and Andrew are kissing. He even gives her a patch from his letterman jacket as they both leave the school at the end of the detention (which is also the end of the movie). Without her cosmetic makeover she was viewed by the other characters as a freak, and she never could have gotten the attention of Andrew, the school's popular athlete, but now that Alison is more traditionally pretty, the differences between the two no longer seem to matter.

STEP 4: DIAGNOSIS

The preferred (dominant) reading of this text is that despite major differences in interests and values and lifestyles, people can suddenly stop disagreeing and instantly bond as friends, and even lovers, if they will just be open and honest. The very unrealistic relationships presented in *The Breakfast Club* make it appear as though just this one day of bonding from a group based simply on various school rule infractions is enough of a foundation for true romantic love. This movie also teaches that even if someone is a complete jerk to you and you fight all of the time, you can still easily and quickly change the beastly behavior if you are compassionate and patient enough. This text also promotes the belief that all a shy weird girl needs is a superficial cosmetic makeover from a prom queen to get the most popular boy in school to fall instantly and madly in love with her.

The oppositional (resistive) reading questions the myths and stereotypes of this popular teen film. Although most enlightened people would agree that teaching lessons of tolerance and understanding for people who are different is good, it must nevertheless be noted that the basis of romance portrayed in this movie is extremely unhealthy. The oppositional reading substitutes rational relational strategies for the myths and stereotypes. Instead of Myth #9, the better course is Rx #9: "Crave common core values" (Galician, 2004, p. 193). Similarly, for Myth #8, substitute Rx #8: "Courtesy counts; constant conflicts create chaos" (p. 185); for Myth #5, substitute Rx #5: "Cherish completeness in companions (not just the cover)" (p. 153); for Myth #7, substitute Rx #7: "Cease correcting and con-

trolling; you can't change others (only yourself)" (p. 177); and for Myth #2, substitute Rx #2: "Consult your calendar and count carefully" (p. 127).

Comparisons with Rational Models

Unlike the romantic relationships depicted in *The Breakfast Club*, a rational model of love is one in which the couple share most of the same core values and perhaps even many of the same interests, friends, etc. As explained by Lazarus (1985) in *Marital Myths*, although someone with the opposite values may be exciting for a short period of time, long-term relationships are usually more successful if they are based on similarities instead of differences.

Potential Effects (Harm)

Although many women and men actually believe that it is not a problem for a romantic couple to have totally different values (Galician, 2004), people with very different goals often cannot achieve a successful relationship together. Like the couples portrayed in *The Breakfast Club*, real-life couples with opposing values often believe that opposites not only attract but also stay together happily. Audiences can be influenced by fictitious movie characters who seem to have loving relationships despite their differences. But these cinematic relationships are just that—fictitious, and they can be very damaging to anyone who uses them, even if only subconsciously, as a model for real relationships.

Judgment/Evaluation

The Breakfast Club was one of the more popular movies of the 1980s, and it continues to have a cult-like following. Although this movie does present some important themes (such as the need for tolerance and understanding), the examples of romantic relationships that it gives are disturbing as well as disturbed.

STEP 5: DESIGN

Realistic Reframing

Instead of having the two couples (John and Claire, and Andrew and Alison) leave the school as couples, a healthier model would be to have them just leave as friends. People with different values can maintain certain levels of friendship, or at least mutual respect and understanding; friends do not usually live together,

pay bills together, consider each other family, or raise children together. A successful romantic relationship is much more intense and long-lasting than most other friendships, and such an intensity can rarely be built upon unstable or competing values. As Galician (2004) asks, "Can you imagine a real-life dinner party mixing the on-the-street friends of the *Pretty Woman* hooker with her millionaire Wall Street boyfriend's polo set?" (p. 194).

The Breakfast Club could probably be just as successful without the unmotivated two romantic relationships. Instead, basis for the friendships between all five characters should be strengthened more. Claire could still even give John her expensive earring (or suggest that she might if their friendship continues after that one day in detention), but out of friendship instead of as a romantic gift. Andrew could come to see that Alison has beautiful qualities that are not merely physical. And perhaps Brian-the-Brain could even be accepted and even respected as someone other than a nerd with no romantic potential.

STEP 6: DEBRIEFING

Personal Harm From Myth

Like most women exposed to Western mass media, I cannot help sometimes being influenced by Myth #5 and, therefore, susceptible to being made to feel less-than-worthy because of unrealistic media models. I have known men who are also influenced by this myth, which establishes unrealistic expectations for them and makes them less satisfied with their own partners.

Other than that pervasive myth, Myth #9 has affected me the most. I have always loved stories in which opposites come together and find love, especially those in the teen film genre, such as *The Breakfast Club*. However, fortunately, I have spent much of my college career analyzing media; consequently, I have become well versed in media literacy techniques that have helped me maintain my enjoyment of these films while understanding the unhealthy nature of the relationships presented in them.

STEP 7: DISSEMINATION

Advocacy Action Plan

I strongly advocate media literacy, and I am specifically concerned about issues of media literacy that relate to the quality of life, such as the impact of mediated myths and stereotypes of sex, love, and romance. As a former high school teacher, I will continue to work with other educators to create successful media literacy

programs, to train secondary teachers in media literacy concepts, and to assist school districts to adopt media literacy curricula that will help young people throughout their lives.

STUDY QUESTIONS/RECOMMENDED EXERCISES

1. How would you "design" *The Breakfast Club* to make it fit Galician's Prescriptions instead of the myths and stereotypes? Would it still be as interesting? Can "healthy" portrayals be interesting? Explain.

2. Actors often become typecast or simply star in several movies of the same genre in which they play similar characters. It can be argued that several of the actors in *The Breakfast Club* fall into this category. Choose another movie in which one of the actors from *The Breakfast Club* also appears (Molly Ringwald in *Sixteen Candles*, e.g.), and compare his or her characters' romantic relationship(s) in the two films. Which, if any, of Galician's Mass Media Myths are depicted in your chosen film? Are any of her Prescriptions portrayed?

REFERENCES

Galician, M.-L. (2004). *Sex, love, and romance in the mass media: Analysis and criticism of unrealistic portrayals and their influence.* Mahwah, NJ: Lawrence Erlbaum Associates.

Hughes, J. (Producer/Director/Writer). (1985). *The breakfast club* [Motion picture]. United States: Universal Studios.

Lazarus, A. A. (1985). *Marital myths: Two dozen mistaken beliefs that can ruin a marriage or make a bad one worse.* San Louis Obispo, CA: Impact.

Ringwald, M. (1986, Spring). Molly Ringwald interviews John Hughes. *Seventeen.* Retrieved November 21, 2004, from http://www.riverblue.com/hughes/articles/molly17.html

Rutsch, D. (2005, January 24). After 'Breakfast': The 1985 film captured high school in ways that still ring true. *The Sacramento Bee.* Retrieved May 2, 2005, from http://www.sacticket.com/static/movies/news/0124breakfast.html

Shary, T. (2002) *Generation multiplex: The image of youth in contemporary American cinema.* Austin, TX: University of Texas Press.

Jennifer Hays *is a graduate student at Arizona State University, where she earned a Master of Mass Communication degree in 2003 from the Walter Cronkite School of Journalism and Mass Communication. A former high school English teacher, she centers much of her research on mass media and young adults, including topics related to homelessness, politics, civics, body image, and, of course, sex, love, and romance. Additionally, she enjoys engaging in the analysis of popular culture, and she is continuously researching innovative techniques for teaching lifelong media literacy. She and her husband Sean Hays, a*

graduate student in the Department of Political Science at Arizona State University, are developing a program of civics education and media literacy for use in grades K–12, as well as an accompanying training program for primary and secondary school instructors. Recently married (at Disneyland), Jen enjoys spending time at home with her husband and their "zoo," which consists of 2 inside cats, 12 well-fed strays, 2 dogs, 2 frogs, 2 horses, a snail, a tortoise, and a salt-water fish tank full of aquatic friends. She also collects PEZ, lots and lots of PEZ.

CHAPTER 17

Cue the Lights and Music: How Cinematic Devices Contribute to the Perpetuation of Romantic Myths in Baz Luhrmann's *Moulin Rouge*

Amber Hutchins
University of Utah

Filmmaker Baz Luhrmann wrote and directed the film *Moulin Rouge* as part of his "Red Curtain" trilogy: three films (*Strictly Ballroom* [1993], *William Shakespeare's Romeo + Juliet* [1996], and *Moulin Rouge* [2001]) that rely on highly stylized visuals to create a hyper-real love story. Love may be all you need, as the characters of *Moulin Rouge* staunchly insist, but Luhrmann relies on elaborate sets and costumes and well-known pop songs to craft a film that resonates with the audience instantaneously and through established symbols and the audience's own memories.

William Shakespeare's Romeo + Juliet, which preceded *Moulin Rouge* and featured similar elements, was based on Shakespeare's classic tale of star-crossed lovers. However, Luhrmann moved it to a modern-day but unidentifiable location. Props such as automobiles lacked make and model identification and added to the unreal reality of the film: It was familiar, but not distinct. *Romeo + Juliet* happened everywhere and nowhere. By suspending the story in this vaguely familiar environment that could not be associated or disassociated with the audience's own life, the message took center stage and ultimately assumed the reality that resonated with the audience. The result is that it is more real than real (Baudrillard, 1994), and the message of love's tragedy transcended the actual story.

Moulin Rouge's story line also borrowed previous material. Although the story line of a secret affair between a courtesan and an aspiring writer was Luhrmann's original idea, the backdrop of Belle Époque Paris and the Moulin Rogue nightclub contains elements of history that offer a wealth of romantic symbolism for the film to use. Paris is, after all, the most romantic city in the world, according to a long history of cinematic representation of the city. "We'll always have Paris" is a

famous line from *Casablanca* (considered one of the most romantic films of all time), and indeed we all will: It is well preserved on celluloid in films such as *April in Paris, Funny Face, Gigi, Forget Paris, French Kiss, An American in Paris,* and even animated cats are intoxicated by the romance of Paris in *Gay Purr-ee* (instructing children about the symbolic romance of Paris before they even enter puberty). There is hardly a moviegoer who would not recognize the Eiffel Tower as the logo of Paris and romance itself. Couple all that with the song *Ma Vie en Rose* by Edith Piaf—and the audience is immediately transported to an emotional state of heightened romanticism.

So as the film *Moulin Rouge* begins, there is already a shorthand created between the film and the audience. Images of Paris flashed on the screen do more than establish the location: They stimulate the viewer to recall an unlimited number of media messages in his or her existing schema. These messages range from simple to complex and include myths and stereotypes of romance that appear consistently in the media, in films, on television, and in books and across genres. Galician (2004) has identified 12 myths about romance commonly portrayed by the media, and those in the film *Moulin Rouge* benefit from the visual elements and music that take center stage in Luhrmann's production. Special effects and pop songs reinforce the story line's myths about love and romance.

A "SENSUAL RAVAGEMENT"

Harold Zidler (played by Jim Broadbent), owner of the Moulin Rouge, proclaims the nightclub's upcoming production to be a "sensual ravagement," but it is the film itself that is aptly described by this phrase. The visual elements of the film do not allow for audience disengagement until all of the potential symbolism and visual techniques have been exhausted. The quick pacing of the film, which includes segments that have been sped-up to convey excitement, forces the audience to frantically try to keep pace with the dense visuals. Plot and character development become secondary to the spectacle that Luhrmann has created.

Early in the film, the aspiring writer Christian (played by Ewan MacGregor) visits the Moulin Rouge nightclub with friends and falls in love with its star, Satine (Nicole Kidman), a courtesan and aspiring actress. Christian's hallucinatory experience with absinthe is perfect fodder for Luhrmann's style of filmmaking. The viewer begins to feel intoxicated alongside Christian by the rich color tones and sparkling rhinestones that are distorted to create a screen full of abstract reflections. But as the can-can begins and the camera swings about (mimicking the drunken euphoria of total immersion in spectacle), the audience is no longer concerned with a linear story but with the rapid procession of images arranged into vignettes. From vignette to vignette, the viewer moves through the story much as one would in a theme park dark ride.

Suspended from visual reality, the audience is allowed to enter a total sensory state, one in which falling in love is an instantaneous, involuntary response, as captioned in Galician's Myth #2: "There's such a thing as 'love at first sight'" (2004, p. 127). Lust and attraction are often portrayed in films as love; however, a deep, meaningful connection is highly improbable upon the first glimpse of a total stranger. But much like the icons of Paris, film has relied on the concept of love at first sight to create a situation in which characters are seemingly forced to act in a desperate fashion in the name of "love." Before the characters have even met, the audience is assumed to be complicit in the pursuit of love, at all costs.

In *Moulin Rouge*, Christian's initial attraction and subsequent interaction lead to a meeting with Satine in her private dressing room, where he proclaims his love amidst the clutter of her overstimulating dressing room. The room's décor echoes a pastiche of genres and styles that permeate the film, including Hollywood musicals, melodrama, rock opera, period romances, and postmodern experimental video. The interior of the room, set in a replica of an elephant and drenched in sumptuous tones—including the trademark rich red of Luhrmann's "Red Curtain" that literally opens and closes the film—is filled with symbolism. Indian statues and artifacts evoke exoticism, whereas the color red and a heart-shaped window offer more overt insistence that this is a truly romantic scene.

Aside from set design, special effects serve to create visual metaphors, the most significant being the scene in which Christian and Satine dance in romantic ecstasy, literally in the clouds above Paris. The dialogue does not need to express that this is a feeling of "walking on air" or having one's "head in the clouds." The cliché becomes reality through special effects and creates a much greater impact by being couched in the reality of the characters, who do not acknowledge that this as a dream sequence or some other device designed to indicate that the scene is discrete from the characters' reality.

Although Luhrmann does not use this scene to convey to the audience that they, too, can literally defy gravity through love, the idea that love should or can feel very much like dancing in the clouds is clearly articulated for the audience. It is a how-to or instructional model of romance and love that viewers can use to measure their own relationships. Do I feel as though I'm dancing in the clouds? If not, why not—when so many films, songs, television shows, and novels indicate that this is part of the true love experience?

"YOU'D THINK THAT PEOPLE WOULD HAVE HAD ENOUGH OF SILLY LOVE SONGS"

Moulin Rouge is essentially a musical, but with some spoken dialogue and few original songs. Luhrmann's use of previously released popular songs is another take on using adapted or factual material such as the historical setting of Paris in the early

1900s and the Moulin Rouge nightclub that is still open for business today. Certainly Luhrmann is a skilled and creative filmmaker, as is evident in his interpretation of Shakespeare for contemporary audiences while maintaining the Bard's original dialogue.

By using widely popular songs, Luhrmann has access to similar representational symbols of love as are available to him through visuals and special effects. For most, if not all, audience members, there is already an association of each song with the concept of love and perhaps even a personal experience that each song evokes. In the decoding process, audience members are free to explore more depth than intended in the encoding. Luhrmann is unaware of exactly what exists in viewers' schemas that can be triggered by a familiar love song, but by choosing songs that enjoyed immense popularity and high recognition (such as Whitney Houston's classic *I Will Always Love You*), he greatly increases the chances that a favorable association will occur, or, at least, identification of the song as one that many consider to be an exemplar of a love song.

In one musically saturated scene, Christian cheerfully attempts to convince Satine to fall in love with him, despite her reservations about an affair with a penniless writer, by singing no fewer than 10 love songs. Anything with love in the title is fair game: *Love Is a Many Splendored Thing* from the film of the same name, and *All You Need Is Love* by John Lennon.

In contrast, Satine issues most of her rebuttals in spoken dialogue and makes rational assertions; for example,

Christian: A life without love; oh, that's terrible.

Satine: No, being on the street—that's terrible.

The differences in how Christian and Satine approach love are indicative of their different values and beliefs. Galician's Myth: #9: "All you really need is love, so it doesn't matter if you and your lover have very different values" (2004, p. 193) refers to this tradition of mediated mismatched lovers' defying the odds and experiencing true love by following their hearts instead of their heads. Galician has reported that the success rate of a healthy relationship is very low for real romantic couples who have very different values. However, cinematic couples often overcome differences in beliefs and values on the screen, such as in *Pretty Woman* in which a Hollywood Boulevard hooker and a corporate mogul ride off into the sunset together in his limousine. Perhaps there has been no sequel to the film because even Hollywood cannot conceive of their relationship 10 to 20 years into the future.

Satine is concerned with real issues that affect her life and has chosen to put her career ahead of love. For her, it is a choice that has been made rationally—she is not reacting to a failed love affair or rejection. If she were an attorney or a

librarian eschewing love in favor of her career, Satine would be considered a workaholic (or possibly sexually dysfunctional, according to antifeminist stereotypes). However, in Satine's current career as a courtesan, falling in love has direct consequences, as we see later in the film when she faces a choice between Christian and an important wealthy client. She predicts that the situation will not only affect her career but also will be unhealthy for Christian as well. Christian laughs at this idea, but the outcome is exactly as she predicts. He never considers that a relationship with a courtesan will be incongruent with his naïve conception of love.

Christian continues to attempt to convince her that falling in love is appropriate and is actually what she desires as well. Although she had earlier confessed to falling in love with him when she mistook him for a rich investor, she is now aware of his true identity and has made her choice to remain true to her career aspirations. Unlike Julia Roberts' hooker in *Pretty Woman*, Satine is not looking for rescue by a man. She is a courtesan as a matter of necessity and as a way to pursue her goal of becoming an actress on par with Sarah Bernhardt, the legendary French actress. She agrees to entertain The Duke (the villain of the film, mainly considered evil because he threatens to come between Satine and Christian although his intentions to invest in the Moulin Rouge seem to be derived from his love for Satine rather than by a penchant for malevolence), as a condition of his investment in the Moulin Rouge that would allow her to further her career, but this appears to be a smart business decision under the circumstances, not an admission of her inability to take care of herself or the need specifically for a man to save her.

"You'd think that people would have had enough of silly love songs," Satine sings dismissively, borrowing a line from Paul McCartney, but the song she begins ultimately reaffirms the clichés about love that Christian uses in his lyrical assault on her resolve to resist falling in love. It is not long before she makes a complete turnaround and joins him in a version of David Bowie's *Heroes*. The song is intended to be the most convincing of the medley: by falling in love, the two will transcend time and existence. Heroes find fame and immortality through valiant deeds, and by portraying love as a heroic measure, Luhrmann makes the obstacles that two people of different beliefs will face seem noble and brave.

The audience knows full well that Satine will eventually acquiesce, but it is perplexing that she would do so after showing such determination to avoid a romantic relationship. Although Bowie's *Heroes* is intended to convey the most profound message of the medley, it is still very abstract—juxtaposed with Satine's concerns about living on the street, going hungry, ruining her chance of a serious acting career, as well as her concern about the effect that a relationship with a courtesan will have on Christian's naively positive disposition. Her willingness to abandon all of her beliefs in favor of a relationship with Christian is a validation

of the mediated messages that audiences have heard repeatedly throughout their lives. However, it is more of a testament to the proliferation of Galician's myths rather than to the power of love.

Through sheer volume of pop songs, Christian is able to eventually find one that strikes a chord with Satine and convinces her to change her mind. Is the audience just as vulnerable? Will we change our minds about an inappropriate partner because a particular song came on the radio? As portrayed by the media, we do—or we should at least feel as though doing so is normative behavior.

Christian writes a "secret song" for the two lovers to share as a way to express their love for one another without the notice of The Duke and other characters. An original song for the film, it includes the same ideas of immortality through love: "Come what may . . . I will love you until the end of time." Again, obstacles are shown as the elements that make love a noble and courageous endeavor, rather than as warning signs of incompatibility despite an initial attraction. The two have a choice to leave the Moulin Rouge and make a life together elsewhere, but instead they choose to conduct their affair in secret. This adds a gothic quality to their relationship, which is beautiful, dark, and ultimately doomed to fail—certainly in line with other tragic film love stories, such as the blockbuster *Titanic* (also framed within a true historic setting), in which the death of one of the lovers was intended to make the love story more poignant. Christian's secret song is another way to condense the film's story into emotionally charged symbols that the audience can absorb quickly and later use to encapsulate the entire film in their memory. Viewers associate positive feelings about the message in the song with positive feelings about the song and thus the film.

CONCLUSION

After the audience is bombarded with visual and auditory symbols of love, the resulting exhaustion and confusion lead to acceptance of the overall idea and any myths that are attached. But the audience is often unaware of what has transpired. Believing in Galician's (final) Myth # 12: "Since the mass media portrayals of romance aren't 'real', they don't really affect you" (2004, p. 219), we assume we are too sophisticated to blindly accept what the media portrays, yet the same myths about romantic love have been perpetuated in films, books, and songs consistently over the years. We may not be expecting to literally dance in the clouds or have a pop song change our lives, but we feel as though we should not settle for less than that feeling. Experiences of love that vary from the cinematic formula are not "true" love.

Luhrmann's *Moulin Rouge* is interesting in that it evokes feeling more than it tells a story, and the story that it does tell is considerably old-fashioned compared to his cinematography and artistic techniques. Films such as *Charlie's Angels* and *Tomb Raider* are considered to be of the postmodern mode of filmmaking, in that they offer little story substance and substantial visual style (perhaps no story at all) (Darlow, 2002). They can be compared to advertising, in which the entire production is based upon one message that is easy to summarize and has universal appeal. But even when there is less emphasis on content, the audience constructs a narrative with the elements available to them (Jameson, 1991). In *Moulin Rouge*, audiences are given symbols laden with meanings that all lead to the message of Christian's mantra: "Above all things, love."

STUDY QUESTIONS/RECOMMENDED EXERCISES

1. What are ways in which the filmmaker creates an "emotional atmosphere" other than through plot and dialogue? Are these techniques effective?

2. Aside from the Eiffel Tower, what are some other well-known visual symbols that are commonly associated with love and romance? Can you identify the origin of this association?

3. What responsibility, if any, does the filmmaker have to the audience? Should Hollywood be more concerned about the myths of sex, love, and romance that are included in mainstream films?

4. Are the visual techniques discussed in this chapter considered deceptive or simply "creative license"?

5. When a film has more emphasis on visual and audio elements than on story or realism, does it have less or more emotional impact than a more realistic story or even a documentary? Why?

REFERENCES

Baudrillard, J. (1994). *Simulacra and simulation*. Ann Arbor, MI: University of Michigan Press.
Darlow, D. (2002). *Hollywood Inc*. London: BBC TWO.
Galician, M.-L. (2004). *Sex, love, and romance in the mass media: Analysis and criticism of unrealistic portrayals and their influence*. Mahwah, NJ: Lawrence Erlbaum Associates.
Jameson, F. (1991). *Postmodernism or, the cultural logic of late capitalism*. Durham, NC: Duke University Press.

Luhrmann, B. (Producer/Director). (2001). *Moulin rouge* [Motion picture]. Australia and United States: 20th Century Fox.

Luhrmann, B. (Producer/Director). (1996). *William Shakespeare's Romeo + Juliet* [Motion picture]. Australia and United States: 20th Century Fox.

Amber Hutchins *is a doctoral student at the University of Utah. She was awarded her Master of Mass Communication degree from the Walter Cronkite School of Journalism & Mass Communication Arizona State University in 2002. Her research interests include media and popular culture, especially Disney studies. She has worked as a public relations professional in Phoenix, San Diego, and Salt Lake City.*

CHAPTER 18

Carpe Diem:
Relational Scripts
and "Seizing the Day"
in the Hollywood
Romantic Comedy

Laura L. Winn
Wayne State University

Go on, lean in. Listen. You hear it?—*Carpe*—hear it?—*Carpe, carpe diem*, seize the day, boys, make your lives extraordinary.

— "John Keating" in *Dead Poets Society* (1989)

In the above quotation from the popular movie, teacher John Keating (Robin Williams) encourages his students to seize control of life rather than passively accept what may come. This inspirational moment is the touchstone of the film, and his advice prompts a turning point for his students as they begin to take more personal risks in their own lives. In this chapter, I argue that there is a pervasive *Carpe Diem* (Latin for "seize the day") thematic within Hollywood romantic comedies, and this theme suggests a relational script in which dramatic gestures are upheld as the primary means of navigating important turning points in romantic relationships. In many ways, our "selves" are constructed by our romantic relationships as we simultaneously construct and maintain them. Hence, the "romantic vision" provided by Hollywood to help us negotiate our dating scripts might constitute a central piece of our overall identity. As relational scholar Sternberg (1995) noted, "We choose the person who presents us with the love story we like best, even though that person might not be the most compatible partner for us" (p. 544). Thus, our happiness in a relationship may well be determined by how close our actual relationship matches the story we create for our "ideal" relationship.

Because the media are so pervasive, the ways in which they represent dating relationships may have considerable importance for how we see ourselves as daters and what we perceive as "normal" and "desirable" for men and women (Galician, 2004). In fact, we often take information about "how to do" romance not only

from our peers and family but also from the media. And this is not surprising, given the power of the heterosexual romance as standard fictional trope throughout many media forms. In support of this notion, some research suggests that heterosexual college-aged respondents report a very consistent, traditionalist script with regard to dating norms and scripts within dating relationships (Gilbert, Walker, McKinney, & Snell, 1999; Laner & Ventrone, 1998, 2000; Rose & Frieze, 1993). Thus, identifying themes on the relational expectations portrayed in romantic movies may be an important step in understanding how such portrayed romantic scripts may affect interpersonal relationships (Galician, 2004).

The *Carpe Diem*[1] theme may be defined here as a dramatic impulse, gesture, or realization that changes a relational trajectory. The relational script suggested by this theme emphasizes risk-taking and impulse and de-emphasizes studied and rational forethought. As with any gamble, one may lose or win; but in the movies, these impulsive gestures usually work out well for the gambler. Although such moments make good drama, and a movie audience may perhaps be heartened by the notion that the characters can control events around them (and have the storybook "happy ending"), this theme also obfuscates the very real situational constraints and relational uncertainties prevalent in many real dating contexts.

In this chapter, I first review literature about both relational and romantic movie scripts and then trace the theme of *Carpe Diem* throughout several romantic movies.[2] As will be shown, the notion that an epiphany might change the course of a relationship invokes many of the myths discussed by Galician (2004). Those myths most intertwined with the *Carpe Diem* script explored here are as follows: First, Myth #1: "Your perfect partner is cosmically pre-destined, so nothing/nobody can ultimately separate you" and Myth #2: "There's such a thing as 'love at first sight'" (p. 55) suggest that there is actually little to risk because the outcome is likely to be the same: One's predestined partner need only "see the light." Similarly, Myth #9: "All you really need is love, so it doesn't matter if you and your lover have very different values" and Myth #10: "The right mate 'completes you'—filling your needs and making your dreams come true" (p. 55) suggest that "true" lovers can overcome all odds, and thus potential relational obstacles are minimized. Finally, Myth #7: "The love of a good and faithful true woman can change a man from a 'beast' into a 'prince'" (p. 55) suggests that if only one could find the "right" thing to say or do, a formerly dysfunctional relationship could become functional. Hence, a better understanding of the myths underlying

[1]*Carpe Diem* ("seize the day") is a major literary theme that is particularly prominent in 16th- and 17th-century romantic poetry (*Columbia Encyclopedia*, 2004), for example, the Robert Herrick poem ("Gather ye rosebuds while ye may").

[2]To survey a substantial breadth of romantic movies for this chapter, I consulted the following Web site movie lists: Greencine movie rentals at http://www.greencine.com/, Rotten Tomatoes movie reviews at http://www.rottentomatoes.com/, and Netflix movie rentals at http://www.netflix.com/Default.

the *Carpe Diem* movie theme may enlighten daters about the risks of enacting this relational script within their own relationships.

RELATIONAL SCRIPTS IN MOVIES

The Hollywood romantic comedy has become ingrained within American culture and society (Evans & Celestino, 1998; Rubinfeld, 2001). In fact, we are surrounded by easily accessible dating scripts of the "ideal romance" from the time we are young—beginning with the fairy tales we are told as children (Galician, 2004; Rubinfeld, 2001) and expanding into our adult lives in the form of the romantic movie. Rubinfeld (2001) contended that the typical romantic comedy follows a particular formula: (a) a chance meeting between a hero and a heroine who together represent a potential heterosexual couple, (b) internal or external obstacles to the recognition, declaration and legitimization of their mutual love, (c) the overcoming of these obstacles, and (d) a happy ending depicting a wedding or a promise of a wedding. In an exploratory thematic analysis, Gerali and I (Gerali and Winn, 2002) focused on those themes that might more specifically guide relational process. We examined 24 romantic comedies from the 1980s and 1990s and derived five relational scripts. The first theme entailed the portrayal of relationships in which the couple had a large disparity in background that was easily (or relatively easily) overcome within the course of the movie. Remaining themes included rescuing and makeover motifs, the intervention of fate or a personal epiphany, and an over-representation of the honeymoon dating phase in which relational difficulties are commonly dismissed or minimized by daters in the early stages of the relationship. All of these themes indicate a tendency to deflect responsibility for relational maintenance away from the portrayed daters' own communicative actions.

Sternberg (1995) suggested that many believe in the romantic fantasy motifs linked to classic romantic icons (e.g., Romeo and Juliet or Tristan and Isolde; see Galician, 2004). Hatfield and Sprecher (1986) contended that the process of falling in love entails substantial rumination about the ideal partner, the ideal relationship, and the ideal dating event. Not surprisingly, stories about ideal relationships guide the way we experience satisfaction within our experienced relationships, particularly when we become aware of discrepancies between our ideal and actual experiences (Sternberg, 1995; see also Radway, 1995). Sternberg (1995) contended that we construct love as a "story," using a series of scripts or themes to describe our relational actions and motivations to others, and we tend to then recreate these stories within our actual relationships. We derive these relational scripts from a number of sources: our own inclinations, observations of close relationships (e.g., family and friends), cultural norms, and media depictions of close relationships. Such relational scripts are "types of schema used to organize our

experiences and are usually composed of a set of stereotypical actions" (Laner & Ventrone, 2000, p. 489).

According to Sternberg's model of love (1986), there are three primary components: intimacy, passion, and decision/commitment. In Sternberg's conceptualization, decision/commitment is more realistic than that suggested by the *Carpe Diem* script; it is a gradual and sustained process. In romantic movies, relational decisions are more dramatic and sudden. For example, navy officer Mayo (Richard Gere) in *An Officer and a Gentleman* (1982) strode gallantly across the factory floor to swoop up Paula (Debra Winger) in a dramatic embrace, he carried his Cinderella out of her cinder pit and into a new life. Previously, their relationship had struggled because of his difficulties with commitment. However, Mayo comes to a sudden realization that she is "the one" and in this dramatic gesture he simultaneously makes a public commitment to her and presumably erases all of these previous difficulties. Mayo's romantic gesture here exemplifies well the *Carpe Diem* relational script, however, it is one that it is in conflict with the way real interpersonal commitment is enacted. It may well be the case that by uncritically accepting this overprivileging of a moment within relational movie scripts, we may bring a similar unrealistic expectation of dramatic and sudden change to our own relational scripts.

CARPE DIEM

In many romantic texts, there is a theme of sudden and dramatic change when the romantic relationship transitions from either a nonexistent or nonfunctional one to a functional one. For example, Lowery (1995) noted that in romance novels there is a standard plot line in which earlier misunderstandings are resolved in a single moment of clarification when each partner recognizes his or her love for the other. The recognition of one's "destined" partner (Myth #2) is a common fairy tale theme that can be traced through many romantic movies—both those directly depicting fairy tales (e.g., *Ever After: A Cinderella Story* or *The Princess Bride*) and those that are set in a modern context (e.g., *How to Lose a Guy in 10 Days*, *Message in a Bottle*, or *Serendipity*). Galician's (2004) Rx #1 ("Consider countless candidates [p. 55]) appropriately challenges the notion that one's perfect partner is cosmically predestined (Myth #1). Thus, simply sighting a "destined" partner and initiating contact may be considered one such *Carpe Diem* moment—once the lovers have done so, the course of the relationship is set. As Marie says in *When Harry Met Sally* (1989):

> All I'm saying is that somewhere out there is the man you are supposed to marry. And if you don't get him first, somebody else will, and you'll have to spend the rest of your life knowing that somebody else is married to your husband.

In Marie's view, there is no time to lose in finding that one right person and the finding of that person is crucial in obtaining a successful and happy life. She views the meeting (and "winning over") of this partner as an important milestone, and her statement emphasizes the fear entailed with not reaching this goal. However, there are a variety of other *Carpe Diem* themes shown in romance films. I now provide an in-depth consideration of five such themes: turning points, sudden transformation, overcoming oneself, overcoming the odds, and sacrifice.

Turning Points

In *Say Anything* (1989), Lloyd Dobler (John Cusack) holds a boombox playing a romantic song outside Diane's (Ione Skye) bedroom window in a last ditch effort to reclaim her love. An unequal pairing between Lloyd, an underachiever, and Diane, the school valedictorian, springs up as they prepare for life after high school and confront a number of complicated issues. Their relationship trajectory, unlike many originating in Hollywood, depicts the struggles the pair encounter in their relationship as they address both external and internal challenges. Overcome by concerns about her education, Diane breaks off the relationship to focus on her schoolwork. Lloyd, however, is determined that their relationship will succeed despite the vast difference in their educational goals. At the end of the movie, Diane leaves for a prestigious and demanding college program in England and Lloyd is by her side. The difficulties likely to arise in a real interpersonal relationship when partners have great disparities in future goals are not portrayed here (see Myth # 9). Realistic or not, the viewer takes away the knowledge that it was Lloyd's gesture that won the day—Diane's (realistic) concerns about their future compatibility are brushed aside in favor of this dramatic impulse.

For Lloyd, both his romantic gesture ("serenading" Diane outside her window) and his sudden impulse to move with her to England helped continue their relationship when Diane had decided against it. In both cases, their relationship had reached a critical point and his decision to "seize the day" resulted in the ongoing relationship when doing nothing would have resulted in a breakup. These critical points reflect Baxter and Bullis' (1986) concept of turning points. Here, one or both members of a couple are able to cite a particular salient transitional event or time that ushered in a change in the relationship itself. However, these turning points tend to be ordered along a socially predictable trajectory. Whereas most of Baxter and Bullis' (1986) turning points are linked to common social rituals such as "the first trip away together" or "the first kiss," *Carpe Diem* change moments in romantic movies tend to evolve quickly and with less subscription to social ritual. Each involves an epiphany that is self-sustaining, and no other actions or decisions are needed to evoke relational change.

In *Good Will Hunting* (1997) the all-important moment is wisely "seized," and the seizer is saved from "never knowing what might have been." In this movie,

Will (Matt Damon) experiences difficulty in reconciling his working class background with the opportunity he has to become a prominent scholar. In a sense, he has two different "worlds" and in the movie we see him in constant struggle when the borders of these worlds cross. He experiences difficulty discussing his home life with his college student girlfriend Schuyler (Minnie Driver) and is reluctant to introduce her to his working class friends. Because he cannot share these parts of himself with her, Will and Schuyler experience difficulties in their relationship. However, just as with *Say Anything*, the movie closes with Will abandoning his reservations and old life to follow his true love to a new life (see also *Can't Hardly Wait*). Conversely, cautionary tales about the perils of not seizing the moment appear in *My Best Friend's Wedding* (in which the moment is lost forever) and *Four Weddings and a Funeral* (in which this "moment" is repeatedly lost and only found only near the end). Thus, the core of risk endemic to romantic love is acknowledged by this *Carpe Diem* script and the "heroic" nature of those who take such risks is extolled.

Baxter and Bullis (1986) also noted that the college students they interviewed reported a turning point in which there was a sudden positive or negative psychic change in which one individual redefined the other, causing a change in the relationship. Such a psychic change might be involved when a person suddenly sees a friend as a viable dating partner. For example, in *My Best Friend's Wedding* (1997), Julianne (Julia Roberts) suddenly sees her friend Michael (Dermot Mulroney) in a more romantic light and redefines their friendship in the face of his approaching wedding to another. Her desire to date him occurs after her discovery of the wedding plans, and the movie's premise is focused on her difficulty in resolving this tension. Here, the psychic change is neither negative nor positive in nature—Julianne simply sees Michael in a different way and they reach a turning point in their relationship in which this new information must be addressed.

Sudden Transformation

A second *Carpe Diem* theme involves the sudden transformation of one character in the eyes of another (Andea, 2001). As in *My Best Friend's Wedding*, this could involve the reconceptualization of a friend who is suddenly viewed as a potential dating partner. Additional examples of this theme exist in *Someone Like You* (Andea, 2001), *Clueless*, and *Brown Sugar*. In *When Harry Met Sally* (1989), we follow the characters through a long-term friendship, and, by the end of the movie both have romantic feelings for the other. In the final scene, Harry (Billy Crystal) dramatically crashes a New Year's party, and when he and Sally (Meg Ryan) see each other across the crowded room, Harry rushes up to her and de-

clares his love. She initially denies him, until he produces a series of quirky and intimate details about their shared life experiences. She finally capitulates when he says, "I came here tonight because when you realize you want to spend the rest of your life with somebody, you want the rest of your life to start as soon as possible." Not only has he proven that he is willing to beg by enduring the uncertainty of her reaction as he enlists what he treasures about their life together, but also he is also willing to open himself up fully to the risk of rejection in this final culminating phrase. This dramatic phrase wins the day, and he succeeds in convincing her that he is "the one" (see Myth #1).

Another common variety of this theme is the makeover story suggested by Galician's (2004) Myth #7 (the Beauty and the Beast mythology). This theme is also present in movies such as *French Kiss* and *Green Card*, in which the female character's influence helps to transform the crude animism of the male. Such Pygmalion-like transformations are quite common in romantic movies (e.g., *Pretty Woman*, *My Fair Lady*, *She's All That*, and *My Big Fat Greek Wedding*). One manifestation of this may be seen in "dance transformation" movies when the addition of dancing skills and costume reconfigure one person in a sexier manner within the vision of the other (e.g., *Dirty Dancing* or *Strictly Ballroom*). Here, Cinderella dons her gown and captures the heart of the prince. The Sudden Transformation *Carpe Diem* moment is one in which the ugly duckling dramatically appears before the partner in swan guise and the partner suddenly sees the other in a more romantic light.

In one treatment of this theme, Carol the waitress (Helen Hunt) in *As Good as It Gets* (1997) wears a new dress to dinner with romance writer Melvin (Jack Nicholson), a man secluded from the world by his obsessive-compulsive disorder. When he sees her, he is clearly as enamored of her as any prince would be; however, his lack of social skills causes him to fumble and he refers to her new outfit as a "housedress." She is insulted and announces she will leave unless he pays her a compliment. Carol is a much more self-assured Cinderella than we commonly see, and it is actually Melvin's change from acerbic recluse (sometimes literally growling at others) due to Carol's influence that concerns the bulk of the movie. This movie also differs from the traditional "makeover" script in another way. Through the bulk of the movie, Carol clearly is not out to "save" a charming beast with her all-powerful love (Myth #7). Nor is she looking to be saved. She is simply a broke single mom trying to raise her asthmatic son, and it is merely Melvin's exposure to a "better person" that opens up the possibilities for change in his own mind. So, in a sense, when Melvin is able to overcome some of his fear of medication and treat his condition in the hopes of pursuing a personal relationship with Carol, it is really a transformation that he himself enacted.

Overcoming Oneself

Hence, the overcoming of a personal weakness coupled with a sudden and momentous announcement of conversion comprise a third *Carpe Diem* thematic. Here, a character must overcome some internal character flaw or weakness to win over a prospective partner. For instance, in *Groundhog Day* (1993), ladies man Phil (Bill Murray) is stuck in a time loop and must overcome his lack of empathy for others so that he can return to a normal time continuum and attempt a relationship with the woman he has fallen in love with (played by Andie MacDowell). The day repeats over and over, and Phil continues to try new ways of approaching people. Formerly, Phil had difficulty forming attachments to others. Now he is stuck in a particular day within a small town, and the townspeople begin to grow on him. He begins to feel affection for them, and these new attachments create an internal transformation. His new approach to the people around him make him more attractive to her, and the loop is ended, returning him to real time.

Just as Melvin had to gain some control over his mental illness in *As Good as It Gets*, characters in other movies must overcome mental illness (e.g., *Me, Myself & Irene* or *50 First Dates*), alcoholism (e.g., *Arthur*), and even a desire for suicide (e.g., *Better Off Dead*)[3] to pursue a new and more hopeful romantic prospect. A similar theme pervades other movies (e.g., *Bull Durham* or *Frankie & Johnny*); however, just as with Carol in *As Good as It Gets*, one character provides mentorship for another's reawakening. As Andea (2001) noted, some movies portray this internal obstacle as a reticence to enjoy life in the face of impending death (e.g., *Sweet November* or *Autumn in New York*), and thus, characters seize "the moments they have together" before the other passes away.[4] Yet another variation of this theme occurs when a character, frequently female, has been hurt in previous relationships but eventually succumbs to the persistent attentions of a new partner (e.g., *Bed of Roses, Children of a Lesser God, Hope Floats, Along Came Polly,* or *100 Women*). This type of internal transformation reflects Rx #1 ("Consider countless candidates") as constructed by Galician (2004, p. 55) to counteract Myth #1 ("Your perfect partner is pre-destined . . ."). Here, the transformation that must occur is the realization that Myth #1 is indeed a myth, and it is entirely possible for people to find relational happiness with more than one person.

[3]Although this movie is a comedy, and the suicide attempts are not treated with any seriousness or depth, this movie nonetheless portrays a teenage boy so despondent over the breakup with a former girlfriend that he is initially closed to the possibility of another relationship.

[4]In Andea's original conceptualization, *Carpe Diem* referred only to those movies for which characters realize there is a major impediment to their relationship (generally a terminal disease) and their decision to savor togetherness presages a short-lived but triumphant period of "seizing" life. However, in compiling my notes for this chapter, it became clear to me that this theme of "seizing the moment" was a more pervasive one.

In *St. Elmo's Fire* (1985), 20-something Kirby (Emilio Estevez) endures a humiliating night snowed in with the older woman (Andie MacDowell) he has come to declare his love for. It takes the whole movie for Kirby to store up the courage for this act. He knows it is "now or never" (lest his courage fail), but when he finds she is not alone and he tries to leave, his car fails him instead. Worse, he is given the boyfriend's pajamas to wear and left (albeit tenderly) in front of the fire as the couple go arm in arm to bed. They both place him clearly in a child-like role when he so desperately wants to be a man—she in turning him down and the boyfriend in not taking him seriously as a romantic threat. In fact, the next morning as they see him off, the boyfriend goes inside for a camera to capture the moment on film—just as he might have done with a favorite nephew. However, Kirby nonetheless seizes this moment to kiss her while the boyfriend is inside. Her surprisingly enthusiastic return of this gesture surprises even herself, and in the subsequent photo, her expression is baffled while Kirby grins in triumph. In this scene, one can see Kirby's overwhelming determination to make his romantic declaration (and reclaim his manhood), no matter the cost. And by his smile we see that he has succeeded. Kirby's impulsive and "stolen" kiss seemingly washes away his humiliation, hurt, and fear of rejection. Although it is somewhat unrealistic to expect that this type of pain can be forgotten so quickly, it is nonetheless the case that Kirby overcame his fear of rejection in this moment and his decision to "seize the moment" brought him some closure.

This "overcoming oneself" thematic might also take the form of "learning to savor life" and give up a negative attitude that has bound one to one's past. In *Lost In Translation* (2003), lonely wife Charlotte (played by Scarlett Johansson) strikes up a friendship with an older married man, Bob (Bill Murray) in a Tokyo hotel. Together, they explore the city and reawaken in each other a passion for life. To do so, both must let go of their past relational scripts and write new ones. For instance, Charlotte has accompanied her husband on his job transfer abroad and finds herself spending more and more time alone. She comes to realize that in moving with him to another country, she has sacrificed her own career goals and independence. When she begins her friendship with Bob she does it knowing it is a challenge to her marital vows, but this defiance helps her reclaim her sense of independence and by the end of the movie she clearly displays a renewed sense of confidence. However, in contrast to many movies of this nature, her friendship with Bob seemingly ends at the close of the film, and the two lead characters do not begin a new romantic life together.

A final version of this thematic entails the overcoming of a fear of commitment by one party (e.g., *The Bachelor*, *Jerry Maguire*, *Nine Months*, or *Fools Rush In*). Typically, this theme is gendered in that the woman is the one held responsible for the man's transformation—if she is valued enough, then he will overcome his reticence to commit and become a reliable partner (Myth #7). However, the character of Maggie (Julia Roberts) in *Runaway Bride* (1999) does provide one recent

countertype to this gendered pattern. In this movie, Maggie's repeated attempts at marriage, and her subsequent last-minute "escapes" (e.g., riding away from the altar on the horse she was supposed to arrive on) attract the attention of a reporter (played by Richard Gere). As the two get to know each other, Maggie again falls in love, and by the end of the movie she overcomes her fear of commitment and finally marries. In this process, it is her growing realization that her father's alcoholism has contributed to her fear of commitment that ultimately leads to her internal transformation.

Overcoming the Odds

A related thematic occurs when a *Carpe Diem* moment arises in the wake of a couple's having triumphed over "the odds" against them. Galician's (2004) Myth #9 holds that "All you really need is love, so it doesn't matter if you and your partner have very different values" (p. 55). Thus, some very real problems of cultural and interpersonal difference are glossed over in service to the inevitable happy ending. For example, in *Ghost*, the love of the main characters triumphs even over death.[5] In some cases (e.g., *Two Weeks Notice, 10 Things I Hate About You, The Ref*, or *Just Married*), the couple barely tolerate each other during the majority of the movie and show little evidence of compatibility. The viewer is left with the sense that their disputes are indicators of a relationship-sustaining "chemistry." In these modern remakes of Shakespeare's *Taming of the Shrew*, the couple bicker and appear to hate each other for most of the movie and then suddenly unites at the end of the film.[6] These movies provide good examples of Galician's (2004, p. 55) Myth #8 which holds that "Bickering and fighting a lot mean that a man and a woman really love each other passionately." Thus, the intact relationship is valorized as preferable to harmony, individual needs and opinions, and respect. Like those movies employing the Sudden Transformation theme, the romantic tension in these movies typically ends with the characters' sudden realization that they are attracted to each other.

Another common version of this theme offers a new thematic that entails the overcoming of cultural differences arising from the partners' coming from "different worlds." Such movies abound (e.g., *Grease, Harold and Maude, Good Will Hunting, Notting Hill, Green Card, Just Married, Overboard, French Kiss, Say Anything, Fools Rush In, My Big, Fat, Greek Wedding*, and *The American President*). In

[5]This may be seen as a contrast to other movies in which a partner dies, such as *Love Story* or *Ice Castles*, which more realistically depict death as an end to the relationship.

[6]Clearly, *The Taming of the Shrew* has embedded implications about gender, in that it is the woman who must be "tamed" to be deemed "suitable" for the man. However, the focus of this chapter is to highlight more general themes. A later examination of the portrayal of the relational themes described here might well yield substantial gendered implications.

Pretty Woman (1990), the large disparity in social class and situation existing between prostitute Vivian (Julia Roberts) and her rich and refined patron Edward (Richard Gere) is easily overcome in the course of their budding relationship. Edward demonstrates little difficulty with the disparity between them; however, because it is Vivian who must cross cultures, she is much more aware. Those who object to the pairing and present external obstacles to the relationship (a snooty shopkeeper and Edward's suspicious upper-class friend) are easily overcome and appear to present no lasting repercussions for the developing romance. In real life, a romance between a prostitute, no matter how warm-hearted, and a wealthy businessman would be likely to sustain significant challenges, both internally as a result of their different backgrounds, as well as externally as a result of prejudice from third-party objectors. But as the narrator contends at the end, "This is Hollywood, always time to dream, so keep on dreaming."

In *Pretty Woman*, Edward also overcomes his internal fears of commitment. When Edward catches Vivian with dental floss that he initially believed to be drugs, he says "Very few people surprise me," and it is clear that he has begun to see her in a new light at this moment. Despite his pronounced fear of intimacy, when the couple first kiss on the mouth, it is clear that Edward has overcome some of his reluctance. This moment also signals a turning point in Vivian's regard of Edward in that she clearly begins to define him more as a person and less as a dehumanized trick. The final dramatic ending—Vivian on the balcony (her fire escape) and Edward riding up in a white "horse" (limousine)—typifies the Hollywood romantic moment: It is simultaneously the overcoming of personal fears of commitment and a triumph over differences in their backgrounds. The couple's moment of triumph against those who would challenge their pairing becomes another iteration of *Carpe Diem*, and they seize the chance to break from their separate worlds and create a new one of their own. Unfortunately, the potential negative implications of this choice (e.g., loss of social support from family and persistent social stigmatization) are not dealt with.[7]

Sacrifice

At the end of *Pretty Woman*, it is clear that Vivian will go to live in Edward's world; she is already showing evidence of leaving her previous one before he arrives. However, in this she is also giving up the independence of her previous life in which she and friend Kit tell each other, "We say, 'When'; we say, 'How much.'" Although her life as a prostitute is no longer desirable to her, she is enterin into a relationship in which it is unclear how much of her identity will have

[7]Although they are much less prevalent, there are movies depicting the relational struggles experienced by couples with partners from different backgrounds (e.g., *Jungle Fever* or *Monsoon Wedding*), and these provide an important realistic contrast to these "couple triumph films."

to change or to what lengths she will have to go to accommodate Edward's desire for her to acclimatize to his world. In this, Vivian demonstrates the last *Carpe Diem* thematic of individual sacrifice for the sake of the relationship. Galician's (2004) Myth #9 holds that "All you need is love, so it doesn't matter if you and your lover have very different values" (p. 55); thus, this sacrifice of her former independence is not only noble and necessary for the relationship but also minimized: If she needs only love, then any regrets she might experience are trivial in the face of the sanctified couple.

Although most real-world relationships involve compromise on the part of both partners, Hollywood particularly lauds the individual, sacrificial, dramatic gesture. One such iconic moment occurs when Ilsa (Ingrid Bergman) gets on the plane at the end of *Casablanca* (1942). Although she is in love with Rick (Humphrey Bogart), she resolves to leave him and sacrifice her personal happiness in light of a greater cause. In this case, she returns to her husband, who is an active leader in the insurgence. It is clear that she believes that if she were to leave her husband she would inadvertently threaten his important work. In *Casablanca*, the cause of the couple is replaced with another cause; however, these powerful moments of individual sacrifice often entail sacrifice for the loved one. Such themes pervade romantic movies (e.g., *Titanic* and *Cold Mountain*). As an example, in *An Affair to Remember* (1957), Terry (Deborah Kerr) initially gives up her chance at happiness with Nikkie (Cary Grant) after she becomes disabled. Here, her decision not to pursue the relationship is prompted by the desire to preserve (what she presumes is) his happiness. She assumes that her disability will be a burden on him and that concern (and her own pride) lead her to sacrifice the relationship.

In fact, Evans and Celestino (1998) argued that in romantic comedies, individuals commonly find resolutions by risking or losing parts of their "self." Romantic movies frequently have this "Little Mermaid" motif, and the *Carpe Diem* sacrifice may be seen in those moments when one partner dramatically leaves a familiar world for the partner's. Just as in the Disney tale when Little Mermaid Ariel leaves her home in the sea to live on land with her prince, it is often the female who must adapt to the male partner's world (e.g., *Pretty Woman*, *Overboard*, and *Shrek*). As an example, in *Sleepless in Seattle*, Annie moves across the country to be with a man she has never met in person. In a slight twist on this theme, *Splash* retells the story of *The Little Mermaid* in a modern context—with the man going to live in the sea instead (see also *Somewhere in Time*).

Important aspects of personal identity are also sacrificed in this thematic. For instance, in *Sweet Home Alabama* (2002), Kate (Reese Witherspoon) gives up her life in New York after the sudden realization that she prefers a relationship with a man in her hometown. She "seizes the moment" and moves home, abandoning her career in the process. The couples' differing values are overlooked in favor of shared early background. In doing so, Kate must leave her career as a fashion

designer behind when she returns home to Alabama; however, we have seen no signs during the course of the movie that it was her desire to leave this career. In fact, her pride and excitement in doing her first fashion show are evident at the opening of the film. Thus, in leaving one man for another, she must also sacrifice the career she loves. Similarly, in *You've Got Mail* (1998), Kathleen (Meg Ryan) apparently reconciles her former anti-superstore values quite easily to begin a relationship with Joe (Tom Hanks), the heir to a superstore. The moment in which she chooses him over her former values is simultaneously a choice for the relationship over her individual identity needs.

In all of these instances, the sacrificing partner overwhelmingly desires the sacrifice and is often ecstatically radiant in the face of the triumph of romance. In such themes in which a former identity is left behind, Galician's (2004) Myth #10 (The right mate "completes you") is invoked—a myth intertwined with the movie *Jerry Maguire* (1996). As Galician noted, the moment in which Jerry (Tom Cruise) tells Dorothy (Renee Zellweger) "you complete me" has become an iconic one for romance fans. However, this sentiment necessarily places the sanctity of the relationship over individual self-fulfillment. Just as with *Pretty Woman*, *Jerry Maguire* invokes multiple *Carpe Diem* themes—all represented within this important moment. As Jerry makes this declaration, he is simultaneously overcoming his own fear of commitment and signaling to Dorothy that he has been transformed by her into a more committed person. This last initiative also invokes Galician's (2004, p. 55) Myth #7 ("The love of a good and faithful true woman can change a man. . . .").

Dorothy's acceptance of Jerry's initiative putatively indicates her belief that he is indeed changed and is now a more responsible and committed partner (Andea, 2001). She also famously responds with the line, "You had me at hello," challenging the notion that this change was even necessary. Nonetheless, this scene is a well-known relational turning point and encapsulates much of what comprises a *Carpe Diem* moment—the dramatic gesture that indicates a "seizing" of opportunities to change one's relational circumstances and advance the cause of a romantic relationship. Sometimes these themes entail less romantically poignant moments of self-sacrifice, yet they are still important sacrifices to the individual. For example, this might entail the giving up of a fortune (e.g., *Overboard, Arthur*) or a life savings (e.g., *French Kiss*) or the risking of a career (e.g., *The American President*) to win or save the partner. In *Pretty Woman*, money/power hungry Edward gives up an important business deal to gain the trust and love of Vivian. Whatever the sacrifice, it is clear that sacrifice itself is a consistent movie theme and in many cases is enacted with a sudden dramatic gesture. In this sense it presents an additional type of *Carpe Diem* theme.

As Adelman and Ahuvia (1991) noted, "In its purest form, romanticism sees love as the sole basis of marriage. Love, in turn, is seen as a mysterious force beyond the control of the individual. This magical view of love is the willingness to

sacrifice one's life for the beloved" (p. 271). However, they also noted that this romanticized view of sacrifice is in direct contrast to the rationality and overt bargaining process that underlie many types of dating practice (e.g., personal ads or matchmaking services). This contrast between ideal and actual may also hold implications for how we negotiate romantic relationships. As with all of the *Carpe Diem* themes presented in this chapter, this sudden sacrificial gesture presents a dramatic "seizing of the moment" at the expense of a more realistic portrayal of ongoing compromises and negotiations typical of most romantic relationships.

CONCLUSION

In sum, all of these themes support notions of the importance of "seizing the moment" within the Hollywood romance script. However, it is unclear to what extent Hollywood's valorization of the *Carpe Diem* script plays a role in how we navigate our own romantic relationships. Although, some research of the effects of media representations has suggested that mediated myths of relationships communicate unrealistic views of what a "normal" relationship is (see Galician, 2004; see also Shapiro & Kroeger, 1991), more research is clearly warranted. Because we develop our own romantic scripts for relationship over time—through personal experience and exposure to other real-world relationships, as well as to mediated ones—it is difficult to parse out what aspects of these scripts may be attributable to a particular source. In the case of some scripts, however, it is likely that romance movies do play a role in helping us develop our more generalized, schematic notions of the ideal relationship (Galician, 2004). And this may be particularly the case for adolescents and preteens, who have not had substantial relational experiences to challenge these more idealized notions.

Together, the *Carpe Diem* themes described in this chapter hold up the salient romantic gesture or experience of epiphany, triumph, or sacrifice as the primary method for navigating an important relational turning point. It is possible that by encouraging such relational scripts, people may over-rely on them in their own relationships; hence, these movies mislead some individuals into dysfunctional territory. For instance, they may sacrifice an aspect of identity (e.g., self-reliance) that they will later come to regret. Alternatively, if only one partner's scripts encourage such sacrifice, that individual is more likely to be taken advantage of within the relationship. In a sense, there is a gambler's motif at play here—in giving up some of one's self one bets that the other has the same scripts and thus "the brass ring" (the intact, satisfaction-filled relationship) will be obtained. Clearly, gambles do not always pay off, and thus the opportunity to lose arises when one has misperceived the "romantic story" of the other. This last issue also invokes Galician's (2004, p. 55) Myth #3, which states, "Your true 'soul mate' should KNOW what you're thinking or feeling (without your having to

tell)." Misperceptions abound in romantic relationships, and it is important to make decisions based on shared communication rather than on unarticulated relational scripts.

Many of the themes here suggest an unrealistic view of how the relational process may unfold. For instance, rather than working through a conflict, couples in these movies often jump in a moment to the state of "living happily ever after" (Galician, 2004; see also Gerali & Winn, 2002).[8] However, this happy ending script minimizes the extent to which real-life couples must work through conflict issues over time. Also, if one partner is waiting for the other to provide a dramatic gesture that solves all the troubles (e.g., being swooped up into a limousine) then this occurrence not only minimizes such problems but also places expectations on partners about which they might be unaware. At times, all partners in relationships must negotiate awkward moments of uncertainty, differences in viewpoints, and conflict. However, the *Carpe Diem* script suggests that such moments may be easily overcome merely by choosing the "right" dramatic gesture. As Galician (2004) suggested, we need to become more aware of our own internalized relational scripts and mythologies to understand more fully how they might be shaping our relational behavior.

ACKNOWLEDGMENTS

I thank two of my former students for influencing the early stages of this chapter: Laura Andea, who did a similar paper in a graduate seminar of mine, and Stephanie Gerali, who did an undergraduate independent study with me. Both students touched on the *Carpe Diem* theme in their more general explorations of romantic scripts in these movies, and these papers provided an important starting point for my development of the current chapter.

STUDY QUESTIONS/RECOMMENDED EXERCISES

1. Galician's myths uncover the unrealistic romantic expectations created by typical Hollywood scripts. What types of relational expectations do you think are created by the *Carpe Diem* relational script?

[8]Perhaps one means of educating ourselves about alternative relational scripts entails becoming more cognizant of those times when romantic movies challenge the traditional Hollywood romance script. Such opportunities arise, for example, when the dramatic *Carpe Diem* moment does not occur, and relationships have to be continuously negotiated (e.g., *Love and Basketball* or *When a Man Loves a Woman*) or when these moments do not occur as expected (e.g., *Gone with the Wind* or *Muriel's Wedding*).

2. Think about each of the *Carpe Diem* themes discussed in this chapter and consider the possible outcomes of enacting some of these moments within a real interpersonal relationship? What are the possible consequences for taking such risks? Do you believe that a romantic impulsive gesture can change the course of a relationship?

3. In this chapter, I argued that many of Galician's myths were prevalent in many of the *Carpe Diem* themes presented here. Do you think some of these *Carpe Diem* themes are consistently related to one myth rather than another? How?

4. What are some of your favorite movie moments that contain impulsive romantic gestures? What do you think makes these moments so relevant to you (and possibly others)? Why do you think it is that Hollywood moviegoers seem to be attracted to this type of *Carpe Diem* relational script?

5. Think about a personal example in which you felt the need to "seize the moment" in a relationship. How much thinking about the consequences did you do before you acted? At what point in the relationship did this occur? Where do you think this impulse came from? Can you see any link between your example and some of the *Carpe Diem* themes discussed in this chapter?

6. Have you ever given or received advice that involved "seizing the moment" in a relationship? What do you think prompted this advice?

REFERENCES

Adelman, M. B., & Ahuvia, A. C. (1991). Mediated channels for mate seeking: A solution to involuntary singlehood? *Critical Studies in Mass Communication, 8*, 273–289.

Albert, T. (Producer), & Ramis, H. (Director). (1993). *Groundhog day* [Motion picture]. Culver City, CA: Columbia Pictures.

Andea, L. E. (2001). *Celluloid loves: Premarital courtship in romantic movies at the turn of the century*. Unpublished class paper, Wayne State University.

Armstrong, S. (Producer), & Van Sant, G. (Director). (1997). *Good will hunting* [Motion picture]. New York: Miramax Films.

Bass, R. (Producer), & Hogan, P. J. (Director). (1997). *My best friend's wedding* [Motion picture]. Culver City, CA: Sony Pictures Entertainment.

Baxter, L. A., & Bullis, C. (1986). Turning points in developing romantic relationships. *Communication Research, 12*, 469–493.

Brooks, J. L. (Producer), & Crowe, C. (Director). (1989). *Say anything* [Motion picture]. Century City, CA: Twentieth Century Fox Film Corp.

Brooks, J. L. (Producer), & Crowe, C. (Director). (1996). *Jerry Maguire* [Motion picture]. Culver City, CA: Sony Pictures Entertainment.

Brooks, J. L. (Producer & Director). (1997). *As good as it gets* [Motion picture]. Culver City, CA: Sony Pictures Entertainment.

Brown, G. M., et al. (Producers), & Ephron, N. (Director). (1998). *You've got mail* [Motion picture]. Burbank, CA: Warner Bros.

Chaffin, S. (Producer), & Tennant, A. (Director). (2002). *Sweet home Alabama* [Motion picture]. Burbank, CA: Buena Vista Pictures.

Columbia Encyclopedia (6th ed.). (2004). Pearson Education, publishing as Infoplease. Retrieved January 24, 2005, from http://www.infoplease.com/ce6/ent/A0810553.html

Coppola, F. F. (Producer), & Coppola, S. (Director). (2003). *Lost in translation* [Motion picture]. Universal City, CA: Focus Features.

Donner, L. S. (Producer), & Schumacher, J. (Director). (1985). *St. Elmo's fire* [Motion picture]. Culver City, CA: Columbia Pictures

Elfand, M. (Producer), & Hackford, T. (Director). (1982). *An officer and a gentleman* [Motion picture]. Hollywood, CA: Paramount Pictures.

Evans, P., & Celestino, D. (1998). *Terms of endearment: Hollywood romantic comedy of the 1980s and 1990s.* George Square, Edinburgh: Edinburgh University Press.

Galician, M.-L. (2004). *Sex, love, and romance in the mass media: Analysis and criticism of unrealistic portrayals and their influence.* Mahwah, NJ: Lawrence Erlbaum Associates.

Gerali, S. A., & Winn, L. L. (2002). *Love conquers all: Gender roles and ideal relationships in touchstone Hollywood romantic comedies of the 1980s and 1990s.* Unpublished independent study paper, Wayne State University.

Gilbert, L. A., Walker, S. J., McKinney, S., & Snell, J. L. (1999). Challenging discourse themes reproducing gender in heterosexual dating: An analog study. *Sex Roles, 41*, 753–774.

Goldstein, G. W. (Producer), & Marshall, G. (Director). (1990). *Pretty woman* [Motion picture]. Burbank, CA: Buena Vista Pictures.

Haft, S. (Producer), & Weir, P. (Director). (1989). *Dead poet's society* [Motion picture]. Burbank, CA: Buena Vista Pictures.

Hatfield, E., & Sprecher, S. (1986). Measuring passionate love in intimate relations. *Journal of Adolescence, 9*, 383–410.

Laner, M. R., & Ventrone, N. A. (1998). Egalitarian daters/traditionalist dates. *Journal of Family Issues, 19*, 468–477.

Laner, M. R., & Ventrone, N. A. (2000). Dating scripts revisited. *Journal of Family Issues, 21*, 488–500.

Lowery, M. M. (1995). The traditional romance formula. In G. Dines & J. M. Humez (Eds.), *Gender, race, and class in media: A text reader* (pp. 215–222). Thousand Oaks, CA: Sage.

Lucchesi, G. (Producer), & Marshall, G. (Director). (1999). *Runaway bride* [Motion picture]. Hollywood, CA: Paramount Pictures.

McCarey, L., Wald, J. (Producers), & McCarey, L. (Director). (1957). *An affair to remember* [Motion picture]. Century City, CA: 20th Century Fox.

Radway, J. A. (1995). Women read the romance: The interaction of text and context. In G. Dines & J. M. Humez (Eds.), *Gender, race, and class in media: A text reader* (pp. 202–214). Thousand Oaks, CA: Sage.

Reiner, R. (Producer), & Ephron, N. (Director). (1989). *When Harry met Sally* [Motion picture]. Culver City, CA: Columbia Pictures.

Rose, S., & Frieze, I. H. (1993). Young singles' contemporary dating. *Sex Roles, 28*, 499–509.

Rubinfeld, M. D. (2001). *Bound to bond: Gender, genre, and the Hollywood romantic comedy.* Westport, CT: Praeger.

Shapiro, J., & Kroeger, L. (1991). Is life just a romantic novel? The relationship between attitudes about intimate relationships and the popular media. *American Journal of Family Therapy, 19,* 226–236.

Sternberg, R. J. (1986). A triangular theory of love. *Psychological Review, 93,* 119–135.

Sternberg, R. J. (1995). Love as a story. *Journal of Social and Personal Relationships, 12,* 541–546.

Wallis, H. B. (Producer), & Curtiz, M. (1942). *Casablanca* [Motion picture]. Burbank, CA: Warner Bros.

Laura L. Winn is Assistant Professor, Wayne State University, Detroit, MI. She earned a B.A. in Psychology from University of Wisconsin–Madison; an M.S. in Family Studies from University of Wisconsin–Madison; and a Ph.D. in Speech Communication from University of Georgia–Athens. Her research focuses on the way cultural constructs such as gender and social class influence close relationships. Her particular interest is the way in which such relationships are affected by "perceptual penalties" that are linked to cultural identities. Her teaching interests include interpersonal, relational, family, and nonverbal communication.

CHAPTER 19

Gangster of Love? Tony Soprano's Assault on Romantic Myths

Ron Leone and Wendy Chapman Peek
Stonehill College

When considering romantic relationships, no character on an HBO series has received more attention than Carrie Bradshaw from *Sex and the City*. Essentially, *Sex and the City* is "about" relationships, both platonic and romantic, and its critical acclaim makes it easy to overlook the fact that another successful HBO series, *The Sopranos*, a gangster drama, is—at its core—also about relationships, especially male–female ones. *The Sopranos* has received much criticism for its portrayal of two groups in particular, Italian Americans and women. Some authors, especially Gilbert (2002) and Lauzen (2001), have accused creator David Chase of fostering negative stereotypes about these groups through the use of imagery rooted in retrograde cultural myths. From another perspective, however, these views seem short-sighted in that they do not fully appreciate the complexity of Chase's method, which invokes traditional myths of many types to explore their tensions and contradictions, developing in the process a sophisticated analysis of how these stereotypes function with and against modern culture.

Chase subjects relationship myths to a similar treatment. Although *The Sopranos* certainly traffics in several of the 12 major media myths/stereotypes of sex, love and romance that Galician (2004) identified, the series ultimately goes beyond a simplistic deployment of the myths. Instead, it presents the myths as myths, unmasking them so as to reveal their true nature as destructive fictions. In developing relationships between characters over several seasons, *The Sopranos* demonstrates the dangerous consequences of investment in these myths and stereotypes and offers antidotes to quell their power.

THE SOPRANOS—AN OVERVIEW

The Sopranos addresses the intersection of the two families of Tony Soprano, a powerful New Jersey Mafia boss. The concerns of his immediate family—his wife

Carmela, their two children Meadow and A. J., and his domineering mother Livia—both parallel and conflict with those of his metaphorical family, the mobsters whose activities both support and endanger Tony's comfortable suburban lifestyle. Assisting Tony as he navigates between these powerful influences is Dr. Jennifer Melfi, his psychiatrist, who helps him to recover from recurrent panic attacks induced by the stress of his complicated responsibilities.

Moral conflicts of two types emerge as persistent themes throughout the series: the first is the conflict in values between Carmela's Catholicism and the violent and illegal activities that constitute Tony's normal business practices. Yet, Carmela's concern for the state of Tony's immortal soul is compromised by her own desire for the luxury and ease that his endeavors support. Although she seeks spiritual guidance from her priest Father Phil, Carmela finds it is as difficult to change her spending habits as it is to change Tony.

Sexual morality is another point of conflict in the series, as one of the traditional perquisites of the Old World mobster lifestyle, prostitutes and mistresses on the side, runs afoul of Carmela's embrace of New World suburban mores that demand a devoted monogamy from a sensitive husband. Carmela is thus torn between her allegiance through marriage to an older code of female subservience and her desire to become a modern woman, one whose voice and influence equal her husband's. Tony is likewise torn between Carmela's demand that he change and his mistress Gloria Trillo's desire that he devote himself completely to her.

THE SOPRANOS AND ROMANTIC MYTHS

Several of Galician's (2004) romantic myths provide useful frameworks for interpreting the conflicts these characters face. With Carmela, two myths that deal with values and change dominate: Myth #7: "The love of a good and faithful true woman can change a man from a 'beast' into a 'prince'" and Myth #9: "All you really need is love, so it doesn't matter if you and your lover have very different values" (p. 225). Relief for Carmela comes in the form of Rx #7: "Cease correcting and controlling, you can't change others (only yourself)" and Rx #9: "Crave common core-values." In addition to Myths #7 and 9, Tony's relationship with Dr. Melfi is also mediated by Myth #3: "Your true 'soul mate' should KNOW what you're thinking or feeling (without your having to tell)," which is resolved by Rx #3: "Communicate courageously." As a woman whose professional obligations require courageous communication and whose class places her liberal and law-abiding values at odds with Tony's, Dr. Melfi figures prominently in the expression of these myths. Finally, the relationship with Gloria Trillo is marked by Myth #10: "The right mate 'completes you'—filling your needs and making your dreams come true"; the incomplete Gloria never activates Rx #10: "Cultivate your own completeness."

Interestingly, the antidotes appear as the preferred reading of the text. Characters do in fact learn to communicate, cease controlling, crave common values, and cultivate their own completeness (Galician, 2004). Because the solution to the myths these characters struggle with are offered within the narrative, *The Sopranos* reveals itself as far more enlightened than its critics suggest.

TONY'S WOMEN

"Tell me about your women," commands Fran Feldstein, the mistress of Tony's father, and Tony responds, "What's to tell?" (from the Season 5 episode, "In Camelot").[1] But there is plenty, as Tony's consistently full dance card of amorous activity provides ample material for discussion of relationship myths. For this reason, this chapter concentrates on Tony Soprano himself, the man at the center of many women's lives. In fact, the opening shot of the first episode features Tony placed between two metallic female legs, the camera studying him as he peers, mystified, at the statue of the naked female outside the office of his psychiatrist, Dr. Jennifer Melfi. In *This Thing of Ours: Investigating* The Sopranos, the importance of female characters in Tony's life is discussed in terms of their "narrative authority" (Akass & McCabe, 2002) and as part of an evolution in the gangster genre (Donatelli & Alward, 2002). Both chapters emphasized that although the women in Tony's life do not necessarily win, they do exercise various degrees of power and control over him. Just as the series visually establishes Tony as a man both framed by women but also one figured at the center of their lives (and legs), so will we. Three relationships in particular are negotiated through romantic myths, as the characters involved struggle to find out the true nature of their connections. Tony's bonds with his wife Carmela, his psychiatrist Dr. Melfi, and his fiery girlfriend Gloria Trillo present opportunities to investigate the workings of these relationship myths as well as the efforts to achieve their antidotes.

The Spouse: Carmela Soprano

Besides his mother, the most dominant woman in Tony's life is Carmela, the source of much *agita* (stress). Although they encounter a variety of obstacles, from the mundane to the Mob-related, two media myths in particular structure the primary crises in their marriage. The dominant conflict is expressed through Myth #9: "All you need is love, so it doesn't matter if you and your lover have very

[1]Seasons 1–4 of *The Sopranos* were available on DVD at the time of this writing; Season 5 was not. Either DVD or television broadcast is specified in the reference list, in which individual episodes are listed alphabetically by writer(s).

different values" (Galician, 2004, p. 193). This theme, of course, encompasses more than just Tony and Carmela's relationship, for it structures the series as a whole. A central tension of the series is the direct contrast between the Old World imperatives of *omerta* (silence), loyalty, and control through violence, and the Brave New Suburban World of talk therapy, "interventions," and sensitivity training. Although much of this contrast is played for humor in the series, this conflict as expressed in Tony and Carmela's relationship, however, proves to be a recurring and painful impediment to a happy marriage, a point emphasized throughout the first five seasons of the show.

In Season 5, when Tony and Carmela are separated, she admits to a suitor that she was initially drawn to Tony not because of their similar interests but because he was "magnetic, bigger than life." "I was so young," she explains. "It was very exciting" ("Irregular Around the Margins"). The "It" of her sentence presumably refers to Tony's gangster world of big cars, rolls of cash, and impeccable service in restaurants (Karen Hill of *GoodFellas* was similarly charmed by her mobster boyfriend). His glamour, charisma, and money, we are meant to assume, were sufficient to draw her in and keep them together. Yet, at the moment when the show looks in on their lives, after two children and innumerable *goomahs* (mistresses), the bond no longer adheres, and the series dramatizes the cultural clash between Tony and Carmela through a variety of familiar, yet clever, devices. For example, although Carmela and Tony both take great pride in their Italian heritage, little besides their children, food, and the shared flux of their daily life holds them together. They do not read the same books, enjoy the same films, or even watch the same television shows. Although they occupy the same house, they travel in very different orbits: Carmela is rarely seen outside of the kitchen, where she cooks, whereas Tony is only occasionally seen in the kitchen, where he consumes.

The central impediments to their connection are Catholicism and consumerism. Carmela's spasmodic paroxysms of faith compel her to consult her priest, Father Phil, and to confess on Tony's behalf, "My husband, I think he has committed horrible acts" ("College"). Yet more alienating than traditional values are the modern ones that Carmela embraces with greater fervor and constancy. Carmela is an ardent acolyte of the cult of suburban middle-class consumerism, a belief with its own rituals (annual mother-daughter teas at the Plaza), shibboleths (attention deficit disorder [ADD], "self-actualization," and Roche Bobois), and approved texts (*Remains of the Day* and *Memoirs of a Geisha*). What distinguishes these worlds seems at first to be the inflexibility of the Mob code and the pliant moral relativism of modern American culture. Yet, ironically, modern relativism can be equally inflexible in assertion of its prerogative, and it is this intransigence on both sides that ignites much of the conflict between Tony and Carmela. In "Down Neck," when a school psychologist suggests that ADD might

explain A. J.'s theft of sacramental wine, Tony responds with an Old School suggestion:

Tony: All he needs is a whack upside the head.

Carmela: You'd hit somebody who was sick? You'd hit somebody with polio?

The language of this scene dramatizes the divide between Tony and Carmela. Whereas Tony speaks of doing a "tarentella on the kid's head," a cultural reference that invokes their Italian heritage and its traditional values, Carmela allies herself with the school psychologist and his cool professional argot of children's being properly "consequenced"—even though her grasp of this new world may be imperfect: "[ADD] is a disease, right?"

From the start of the series, it is clear that Carmela aspires to link herself with this new brand of American culture, with its enforced sensitivity and reliance on the guidance of outside experts. Indeed, she is a model for other Mob wives seeking to build a bridge to mainstream America. Although she is still tenuously tied to her culture by the ropes of gold she wears at her neck, Carmela is, especially through her daughter, making the transition to assimilation. Whereas Tony and his peers recognize that these two worlds are largely unbridgeable, a point brought home through repeated awkward encounters with the legitimate world, Carmela desires escape, which she voices largely through her consumer habits.

This conflict in values comes to a head when Carmela decides, at the end of Season 4, that she will no longer tolerate the *goomahs* that are part and parcel of the mobster lifestyle. Although in Season 1, she confessed to her priest that she regarded these women "as a form of masturbation," she now feels that too much is being asked of her, a view abetted by her liberated teenage daughter, Meadow, who cries, "Jesus, how could you eat shit from him for all those years?" ("Whitecaps"). This comment in particular marks the difference both between women of Carmela's and Meadow's generations and between Carmela and Tony. Whereas it is clear to Meadow that her mother should carve out a new life for herself, thereby gaining some self-respect—"Haven't you ever thought beyond being dependent on some man?" she asks her mother—Carmela was raised to be a traditional wife whose primary responsibilities were to cook, clean, and care for the family ("Unidentified Black Males"). When Carmela achieves her ideal of assimilation, by leaving behind both her unsatisfactory husband and her Catholic faith with its injunction against divorce, she is left with little to replace it. As she tells Meadow, "You have options. I have a lawyer." From Tony's perspective, however, such "shit" is included in the job description of a Mob wife. As he says to her when she seeks a separation, "Carmela, who the fuck did you think I was when you married me? . . . Where do you get off acting all surprised and miffed when there are women on the side? You knew the deal."

What Tony fails to acknowledge, however, is the extent to which Carmela ascribes to Myth #7: "The love of a good and faithful true woman can change a man from a 'beast' into a 'prince'" (Galician, 2004, p. 177). Carmela has thus combined Myths #7 and #9; although she and Tony "have very different values" (#9), nevertheless she believes that her love can transform him "from a 'beast' into a 'prince'" (#7). From the beginning of Season 1, Carmela struggles to turn Tony into a better man with the help of Father Phil, to whom she confides her secret hope in "College":

> **Carmela:** My husband, I think he has committed horrible acts . . . [but] I still believe he can be a good man.
>
> **Father Phil:** Then you help change him into a better man and then you will have done good in God's eyes.

Father Phil encourages her in pursuit of this myth. His words here work to increase Carmela's guilt and sense of responsibility, not only by perpetuating the myth that her love can change Tony but also by loading it with the weight of moral and religious obligations. Instead, "College," the central episode in this plot line, corrects this myth by focusing on three interrelated characters who attempt but fail to change others or themselves. In one story, Fabian Petrulio, a former mobster who testified for the FBI and then disappeared into the Witness Protection Program, shows up in this episode as Fred Peters, a man who has crafted for himself an inauthentic WASP identity as a travel agent in Maine. His disguise fails, however, as Tony spots him and strangles him outside his agency office. In a parallel plot, Carmela takes a rainy night with Father Phil as an opportunity to change him as well, from celibacy to sexuality. But her instruments of seduction—copious amounts of wine and a *Remains of the Day* DVD—fail to produce the desired effect. Paraphrasing Humphrey Bogart, she regretfully tells Father Phil the next morning, "Of all the *fanook* [gay] priests in the world, why did I have to get the one who's straight?" Similarly, Tony will not really change either, although he seems to be embarking on a new model of fatherhood as he drives Meadow around Maine to prospective colleges. In between reading quotations from Hawthorne and renting quaintly rustic motel bungalows, Tony finds time to stalk and kill Fabian Petrulio to repay an ancient wrong. The message of the episode, like the antidote to Myth #7, is that some people simply refuse to change, no matter how much love or energy is directed toward the effort.

In Season 5, Carmela charts a different course, deciding, per Rx #7 (Galician, 2004), to cease in her project of transforming Tony from "beast" to "prince" and embarking instead on a new relationship with a man who appears already to be royalty. Robert Wegler, A. J.'s English teacher, seems to possess those common values that Carmela craves. He is sensitive, reads books, and is genuinely interested in Carmela and her desires. Little does Carmela realize, however, that she

and Robert do not share those values on an equal footing. For as much as she aspires to the cultural cachet of education and the arts, she herself possesses little familiarity with that world and, further, has little patience for acquiring it in the way she demands from her children—through study. When Robert recommends that she read *Madame Bovary*, we learn that Carmela cannot spell Flaubert, let alone manage to finish the novel: "I think he could have said what he has to say in a lot less words" ("Sentimental Education"). The irony is that just as Carmela has shed the project of transforming Tony, she herself has become Robert's project, as he works to change her from an Italian American princess (who dropped out of college) to a woman who shares his cultural values. Robert, it appears, is himself entangled with Myth #7.

Yet, Robert's own limitations in the eyes of Carmela are also brought out in this sequence, as she realizes, however tacitly, that she and Robert do not share two very potent common values—money and Catholicism. The contrast between Tony and Robert is dramatized by the types of gifts they buy. To impress Carmela, Robert buys her a first edition of *Madame Bovary*, a princely gift, especially on a high school teacher's salary. But modesty forces him to correct himself, "Well, Modern Library's first edition." Financially, he is not in Tony's league, and the gift merely merits a "What a wonderful thing to have in the den." At the same time, Carmela's cyclic bout of Catholic fervor surfaces, as later in the episode she breaks off a make-out session with Robert, saying in a panic:

> **Carmela:** I can't right now. . . . I'm too upset. . . . Do you realize under the laws of the Church I'm still married?
>
> **Robert:** The Church?

Robert is unable to mask his incredulity. Like a good yuppie, he has shed the entanglements of religion, exchanging his Daily Missal for a Borders frequent-buyer card.

At this point, Carmela would seem to be stuck, a woman seduced and abandoned by two relationship myths. Yet Father Phil's earlier advice on a different topic offers Carmela Galician's (2004) Rx #7 to solve her problem with Tony: "Cease correcting and controlling, you can't change others (only yourself)" (p. 177). Speaking about the seeming unfairness of Christian doctrine, Father Phil states that one must "tolerate, accept and forgive" others, words that suggest that Carmela should indulge Tony his indiscretions, both criminal and libidinal ("College"). But what Carmela comes to acknowledge, eventually, is that she must "tolerate, accept and forgive" her own choice of Tony. If she owns up to her complicity in accepting his way of life, "the deal" that Tony mentioned above, then she can cease correcting and controlling him. Carmela must face the fact of her choice, "forsaking what is right for what is cozy. Allowing what I know is evil in my house . . . because I wanted things . . . this house, money in my hands,

money to buy anything I ever wanted." Only when Carmela confronts her own participation in this situation can she decide how much change she is willing to choose for herself.

What Carmela comes to realize, then, is twofold: (a) that she can't change Tony, she can only change herself (Rx #7, the antidote to Myth #7) and (b) that she and Tony do share more common core values than she had supposed. Through the course of Season 5, she comes to crave anew those common values that she and Tony share (Rx #9, the antidote to Myth #9). One powerful bond is, still, money. When Carmela tells Tony in Season 4 that he can no longer use money to buy her compliance to his cheating, refusing his offers of expensive gifts, there is good reason to believe her. As she says, she has had enough and will not be bought off with any more emerald rings, as in "Whitecaps." But there may be a note of bad faith in her protestations. As Tony reminds her, "You knew every step of the way exactly how it works. But you walk around that fucking mansion in your $500 shoes and your diamond rings, and you act like butter wouldn't melt in your mouth" ("Unidentified Black Males"). The viewer is reminded of Carmela's conversation with her friend Charmaine Bucco in Season 1. The episode "Denial, Anger, Acceptance" dramatizes the economic difference between the two women, one who married into the Mob and the other who married the poor but honest chef, Artie. Throughout "Denial, Anger, Acceptance" Carmela pities Charmaine, offering her opportunities to make money in Carmela's employ, as caterer, server, and maid. To highlight their disparity, the episode is punctuated by Carmela's repeated hand gesture, a regal summoning of folding her carefully manicured hands into her palm. But the movement also suggests Carmela's grasping, her ever-hungry appetite for accumulating new objects. Charmaine's and Carmela's relationship takes a surprising turn, however, when Charmaine reveals that she and Tony dated before he wed Carmela and that, in fact, Charmaine might have married Tony. She didn't, she says, because "it wasn't for me. . . . Stop worrying about me. We both made our choices. I'm fine with mine."

Carmela is a woman who made her choice, even if at times she conveniently forgets that fact. When in the divorce proceedings, it becomes clear that Carmela can find no attorney to represent her and that most of Tony's money is hidden in undeclared assets, she seems to realize the limitations of her noble but impecunious position. One could argue that she reconciles with Tony in part, because, if she cannot get to his assets in divorce, she will get them through marriage. And that is essentially what happens, as Tony and Carmela reconcile over a lunch in which he agrees to buy her a large parcel of property so that she can begin her career as a developer. The title of the Season 1 episode, "Denial, Anger, Acceptance," describes Carmela's feelings about money as they change throughout the series. Whereas she begins by denying her own complicity in the Sopranos' lavish lifestyle and consequently sees Tony as fundamentally different from her, she grows angry with herself and him for the way both use money to buy off emotional

emptiness. By the end of Season 5, however, Carmela has accepted the extent to which she and Tony communicate through money and enjoy the ease it affords them and their children.

Yet, Tony and Carmela are not merely mercenary characters; they share positive values as well, a point that Season 5 develops. Her father's 75th birthday party ("Marco Polo"), in particular, provides Carmela with the opportunity to redefine herself and her loyalties so that they mesh with Tony's. When her parents' friends, Dr. Russ Fegoli and his wife, assimilated Italians of the highest order, slight Tony's gift and look askance at the *cafone* (lower-class) merriment at the party, Carmela angrily sides with Tony, telling her embarrassed mother, "There are Italians all around with their closet self-loathing. I just never wanted to believe my mother was one of them." She identifies herself as being in league with Tony, a proud *cafone* as well, rejecting the *meddigan* (assimilated) aspirations that once drove her. In addition to this incident, the party also presents in sentimental detail the other core values that Carmela and Tony share: commitment to family, to food and fun, and to a generous hospitality that marks the best of who they are. The episode title works two ways. As in the game of the episode title, Carmela and Tony succeed in discovering anew their shared values.[2]

The final moment of reconciliation occurs at 5:24 in the morning when Tony, booked into the Plaza Hotel, has awakened from a dark dream and has no one else to call. Carmela answers on the first ring, and he narrates his dream, "I had one of my Coach Molinaro dreams." She understands and they continue to talk ("The Test Dream"). What has solved their relationship impasse is, finally, her recognition that she must take Tony as he is and alter her behavior to get what she needs. More powerfully, however, it is her newfound appreciation of their core common values—money, family, and shared personal history—that renews them as a couple. Because, really, besides your shrink and your wife, who else will listen to your dreams?

The Therapist: Dr. Jennifer Melfi

The relationship with Tony's "other woman"—his psychiatrist, Dr. Jennifer Melfi—is introduced in the first scene of the show's first episode ("The Sopranos"). After suffering from what we learn is a panic attack, Tony finds himself in therapy with Melfi. The session is used as a framing device in the pilot, introducing viewers to main characters and setting plot lines in motion. Melfi establishes ground rules for the relationship, reminding him not only of the confidentiality of their conversations but also of her duty to report to authorities

[2]Marco Polo is a children's swimming pool game, in which one child, with eyes closed, shouts, "Marco," and the others must respond, "Polo"—while trying to avoid being tagged.

any crime that she is told may be committed. Tony feigns acceptance and embarks on this new relationship by lying to her.

Arguably, Tony's most complex relationship is with Melfi, who, in her words, represents "all the things you feel you are missing in your wife and your mother." By the episode's halfway point, when she poses a question that may force him to reveal an uncomfortable truth, he digs into his familiar bag of relationship tricks. First, he tries misdirection through flirting: Instead of answering her, he locates her Tufts degree on the wall, and, reminded of their shared heritage, asks, "What part of the boot you from, hon?," before expressing how much his mother would have loved their union. When she deflects his advance and persists with her questions, he reverts to anger and aggression, lamenting the loss of "Gary Cooper, the strong, silent type," who didn't have to look inward and scrutinize his own behavior or be asked questions about failing to do so. When she is still not deterred, Tony walks out.

Charm, followed by violence and abandonment, is Tony's modus operandi with many of the other women in his life, and, even though his relationship with Melfi goes through this cycle, she remains a presence in his life. During the show's first season, the Tony-Melfi relationship is best characterized by the emergence and dominance of two myths, Myth #3: "Your true 'soul mate' should KNOW what you're thinking or feeling (without your having to tell)" and Myth #9: "All you really need is love, so it doesn't matter if you and your lover have very different values" (Galician, 2004, p. 135). Both are shown to be illusory. Myth #9, introduced as a divider in the Tony–Melfi relationship in the pilot episode, is finally and directly revealed to be a myth that prohibits a romantic coupling in the first episode of Season 5. Before discussing how these myths are handled, it should be noted that one of the most intriguing and important aspects of the Tony–Melfi relationship is that it never enters the realm of a sexual union, except in his fantasies, which is highly unusual for Tony. By not allowing the two to become romantically engaged, despite Tony's attempts and Melfi's secret infatuation, *The Sopranos* stands as a valuable critique of the myths from Galician's text. Melfi's infatuation with the gangster figure in her office parallels a phenomenon described by Akass and McCabe (2002), in which viewers of cinematic gangsters see these violent men as heroic figures. In this capacity, she functions as viewers' stand-in, most prominently in Season 3. But, as Nochimson (2003) pointed out, to Tony she does not represent a sexual alternative to Carmela but an alternative value system.

The two myths intersect later in Season 1 ("Pax Soprana"). During a session with Melfi, Tony mistakes a therapeutic breakthrough for the achievement of a romantic connection. The episode begins with Tony bringing her a coffee when they meet. "Decaf, right?" he correctly intuits, pleased with this minor insight that confirms his major feelings. He then begins by saying, "My wife and I, all we do is fight," for him a sign that his wife does not connect with him in the profound

way Melfi does. The episode emphasizes again and again the failure of communication between Tony and his other women. When, after a miserable anniversary dinner, Tony apologizes to Carmela, she snaps:

Carmela: You don't even know what you're apologizing for.

Tony: What do you want me to say? Tell me. I'm lost at sea here.

Despite Tony's attempt to "communicate courageously" (Rx #3, Galician, 2004, p. 135), this theme of miscommunication escalates throughout the episode: Tony shouts at Carmela, "You wanna tell me what's goin' on here?" as she buys ever more expensive furniture. Later in bed, the most intimate setting between them, they still do not understand each other. As Tony wakes with a start out of an erotic dream starring Melfi, Carmela jumps awake, hopefully.

Carmela: You want sex?

Tony: No, go back to sleep.

Even Irina, Tony's *goomah*, misunderstands him repeatedly, in this case to more comic than tragic effect. In "Pax Soprana," Tony encourages her to dress like Melfi.

Tony: Wear something a little more professional, you know, like you're in business.

Irina: Fuck you, Tony. I'm no whore.

In contrast, Tony's next session with Melfi is easy and comfortable as the two complete each other's sentences and she laughs, "unprofessionally," she confesses, yet gleefully at his jokes. However, after he presents her another cup of coffee, Melfi adds a new ground rule to the existing ones: "No gifts." Again, Tony feigns acceptance, but this time escalates his gift-giving when, after learning of her automotive problems, has her car stolen and repaired. She is the object of his fantasies and, true to form, he is turning on the charm. Later in the episode he confesses his love for her and tries to kiss her. She deflects his advance and in doing so initiates dialog with him. When she learns that his gift giving has gone far beyond coffee, she rebukes him by "communicating courageously" (Rx #3, Galician, 2004, p. 135) and telling him that his comfort with her, their unspoken connection, is not equivalent to a romantic liaison. In this episode, the myth is corrected both coming and going. Because Tony assumes that ineffable communication is the distinguishing sign of one's "true soul mate," he further believes both that he is not in love with Carmela (because their communication is difficult) and that he is in love with Melfi (because they communicate effectively

without words). He is wrong on both counts. Melfi's choice to communicate courageously produces a liberating effect on both Tony and his wife, so that when he returns home, the two talk for the first time in the episode, telling each other the truth of their fears and anxieties about the other. The antidote achieves the desired effect, and the episode ends with a kiss. Further, Melfi's value system—one that she may skirt from time to time but does not traverse completely—is shown to be at odds with Tony's. Like many of the women in his life, Melfi requires payment, but, unlike the others, she cannot be bought.

By the end of Season 1, the Tony–Melfi relationship has walked through Tony's romantic paces. After charm—in the form of gift giving—fails, violence and abandonment follow. In the season's final episode ("I Dream of Jeannie Cusamano"), Tony smashes the table in Melfi's office during a session before leaving in anger and follows it up with a phone call telling her to "lam it," as her life, now that it is known that he sees her, is in danger.

They reconcile in Season 2, as Myth #7 ("beast" to "prince") comes to dominate the relationship. Unlike the myth's probing in the Tony–Carmela marriage, it is complicated in two ways. First, Melfi is Tony's therapist and is trying to help him transform; second, she is the stand-in for an audience that wants to see Tony more as prince than beast. As the audience's representative, Melfi is forced to examine her own attraction to Tony. She begins abusing alcohol, and, in an attempt to regain some control in her life, she consults a therapist, Dr. Eliot Kupferberg. By Episode 5 ("Big Girls Don't Cry"), it is apparent that although she is "protected" by the cover of a professional therapist trying to help a patient, both Kupferberg and the audience know that she is drawn to Tony, in part at least, because of the danger he represents. In her own therapy, she admits to having "feelings for him, but not sexual" ones.

In terms of the myths, Melfi finds herself in a lose–lose position. If she is acting out of a sense of conscience and feels that abandoning Tony is professionally irresponsible, then her different value system (from his) is on display. Her guilt over no longer seeing a patient who still needs help reinforces her commitment to her work and clients and also reminds us of how different she and Tony are. On the other hand, if she is motivated by a desire to help turn this beast into a prince, she is falling into the trap of Myth #7. Even with the veneer of professionalism on her side, she cannot correct, control, or change Tony. Realizing that her best efforts are not going to change him, Melfi starts changing herself in Season 2 by abusing alcohol more frequently. Her self-abuse reaches its nadir in Episode 11 ("House Arrest"), when she drinks vodka before a session with Tony, is asked to leave a restaurant after creating a scene, and is prescribed Luvox, a drug used to treat obsessive-compulsive disorder, by Kupferberg.

In an interesting turnaround, the Tony–Melfi session that follows her drinking is filled with uncomfortable silences, Melfi's slurred speech, and Tony's recognition that therapy seems to be "a waste of time." For the moment, Tony has become the

honest communicator in this relationship, and Melfi's degeneration reinforces the impossibility of changing this beast into a prince. But Melfi is not Tony. She admits in therapy that she is losing control and is determined to regain it. In their final session of the season, no longer slurring her words, Melfi "senses sorrow" in Tony, who, earlier in the episode ("Funhouse") killed one of his oldest friends when he learned that he had become an FBI informant. As in their first meeting in the pilot, Tony avoids the subject by reverting to his old tricks. When none works, he walks out, ending both his brief stint as honest communicator and the second season of the Tony–Melfi relationship on a low note.

The third season of *The Sopranos* is the last one as of this writing in which the Tony–Melfi relationship plays a major role. It is also the richest and most significant in the context of the myths. In Episode 3 ("Fortunate Son"), the couple emerges from their lull, as Tony shows up for therapy determined to overcome his panic attacks (the latest one brought on after he warns Meadow's new half-black friend Noah to stay away from her). Tony has a breakthrough in the session, locating the genesis of his blackouts as the day he saw his father amputate a man's finger for nonpayment of a loan. When Melfi offers comforting words, Tony replies, "It wasn't traumatic. It was a rush." Despite the progress they have made, we are again reminded of their different value systems (Myth #9), which will always separate them.

In the next episode ("Employee of the Month"), which won an Emmy for writing, Melfi's personal life is highlighted. She has reconciled with her husband and is making progress in her own therapy with Kupferberg. Both men encourage her to break it off with Tony, whom the recovering Melfi realizes she cannot change from beast to prince. When she suggests to Tony that he may be ready to move on to a behaviorist, he pulls a new trick out of the bag—neediness.

> **Tony:** I ask you to get serious in here [therapy], and when it gets hard, you pawn me off on somebody else.

Her guilt, however, leads her to backpedal:

> **Melfi:** I'm just introducing the idea, something for you to think about.

Tony's and Melfi's different value systems are never more apparent than they are shown to be in the "Employee of the Month" episode. Shortly after her session with Tony, as she is leaving work, she is violently attacked in her building's parking garage and raped in a stairwell. Despite her ability and willingness to identify her attacker, he is released on a technicality. A short time after, she goes to Wrap Nation for lunch and sees her attacker's picture on the wall, under "Employee of the Month." Shaken, she flees the restaurant without her food. She fantasizes about revenge, and her anger, frustration, and bloodlust all crescendo in a night-

mare of vengeance. In her next session with Kupferberg they dissect the dream, which she describes as empowering. A Rottweiler plays a prominent role in the dream, and Melfi interprets its presence as protector, not attacker: "Oh my God, the dog, a Rottweiler. . . . Big head, massive shoulders, direct descendant of the dog used by the Roman armies to guard their camps." At this moment, she realizes that her opportunity for vengeance is not restricted to the realm of dreams.

Melfi: Who could I sick on that son of a bitch to tear him to shreds?

Kupferberg: Oh. . . .

Melfi: No feeling has ever been so sweet as to see that pig beg, and plead, and scream for his life.

Melfi's frustration with the justice system that failed her conflicts with her inability to live outside society's rules, as Tony does: "Don't worry, I'm not going to break the social compact. But that's not saying there's not a certain satisfaction in knowing that I could have that asshole squashed like a bug if I wanted."

More than ever before, Melfi serves as stand-in for the audience, embodying the desire that "Soprano justice" be meted out to this violent rapist whom law enforcement has let slip through the cracks. Her refusal to act on this vengeful impulse—in one of the series' (and television's) most compelling scenes—irrefutably and permanently marks the Tony–Melfi relationship as dissimilar at its core. As Croft (2001) noted, Melfi is "smart enough to know that once she does ask [for Tony's 'help'], she will have made a pact for life" (p. 3) with him.

In terms of Myth #9, the Tony–Melfi relationship takes a back seat at this point, returning briefly and directly in the first episode of Season 5 ("Two Tonys"). After another breakup at the end of Season 4, Tony shows up at Melfi's office, wanting to take their relationship "in that other [romantic] direction." Melfi flatly refuses, acknowledging their different core values: "In a personal relationship, I don't think I could sit silent."

This Mistress: Gloria Trillo

As the prominence of Myth #9 diminishes as mediator of the Tony–Melfi relationship, Myth #10 emerges: "The right mate 'completes you'—filling your needs and making your dreams come true" (Galician, 2004, p. 201) as Tony embarks on a relationship with Gloria Trillo midway through Season 3. The inappropriateness of their connection is signaled by the very scene of their meeting in Melfi's waiting room. These are two obviously incomplete and vulnerable people looking for easy answers by turning to someone else. In looking to the other to complete

themselves, both turn from "cultivating[ing their] own completeness" (Rx #10, Galician, 2004, p. 201) through the hard work of individual therapy and instead seek quick fulfillment in each other. Melfi gets to double her role as audience stand-in here, this time in the specific context of Myth #10. In addition to mediating our ambivalence toward Tony, Melfi gives voice to the folly of looking to another to complete one's self.

The Tony–Gloria relationship intensifies quickly, and he eventually tells Melfi about it in "Pine Barrens":

Tony: She makes me happy.

Melfi: Does she seem happy to you?

Melfi carefully brings all conversations about Gloria back to Tony's perceptions, feelings, and thoughts; it is a formidable and foreshadowing question that reveals Melfi's concerns that neither Tony nor Gloria has cultivated his or her own completeness. "Being with Gloria makes me happier than all your Prozac and your therapy bullshit combined," Tony tells Melfi in the next episode; she in turn labels their love an "*amour fou* . . . that's French for 'crazy love,' love that's all-consuming" ("Amour Fou"). The dangerous consequences of these myths become clear when Tony fails to complete Gloria, as he makes her wait night after night while he attends to his family and business obligations. When Tony tells Gloria the relationship is over, she threatens to tell his family about the affair. Tony grabs her by the throat and begins to strangle her. Gloria's attempted "suicide by Soprano" reveals the depths of her incomplete sense of self, as her only defense is a pathetic injunction to Tony, "Kill me." After breaking up with her, he returns to Melfi a chastened man, resolving once again to cultivate his own completeness through therapy.

Midway through Season 4, Tony learns that Gloria has finished the job of committing suicide ("Everybody Hurts"). Angry, drunk, and feeling betrayed by Melfi, Tony shows up at her office in a volatile state.

Tony: Why the fuck didn't you help her?

Melfi: She slipped through everyone's grasp.

Tony: She reached out to me, for me to care, and I wasn't there for her.

Although his expression of guilt and remorse may suggest an emotional breakthrough of sorts, Melfi echoes Rx #10, emphasizing that he cannot cure or complete her. As usual, Melfi brings the discussion back to Tony—"Why are you so quick to blame yourself?"—emphasizing that cultivating his own completeness is the most constructive thing he can do.

CONCLUSION

Through Tony's relationships—his strained marriage to Carmela, his revealing therapy with Dr. Melfi, and his volatile fling with Gloria Trillo—*The Sopranos* punches holes in romantic myths so often perpetuated in the media (Galician, 2004). Carmela embodies the impossibility of changing a man "from beast to prince," especially when she is unwilling, despite her claims to the contrary, to change herself first (p. 177). In line with Galician's Rx for Myth #7, what she does in fact change is her self-awareness. By doing so, Carmela realizes that she and Tony actually share values that she thought separated them, demonstrating the veracity of Rx #9 (p. 193). Equally compelling is his relationship with Dr. Melfi. Like Carmela, she cannot change Tony from beast to prince either, because he simply does not want to change. Unlike in his relationship with Carmela, when Tony tries to initiate a romantic relationship with Melfi, she tells him that it "matters" that they have different values, a statement of the importance of Rx #9. The Tony–Melfi relationship also sheds light on Myth #3. Tony's infatuation with Melfi is fueled, in part, by his acknowledgment of their unspoken connection and subsequent belief that she understands him better than Carmela does. Rx #3— "Courageous communication"—trumps the "soul mates'" myth of unspoken love (p. 135). And finally, Tony's brief, combustible relationship with Gloria Trillo reinforces the importance of developing one's own "completeness" and the mistake of looking for someone else to do it for you (Rx #10 and Myth #10, respectively).

Although *The Sopranos* will never be mistaken for *Sex and the City*, for all its hits and sit-downs, drinks at the "Bing," and meals at Vesuvio, the show ironically promotes Galician's Prescriptions while making Galician's romantic myths— through the misadventures of Tony, the "gangster of love"—take the "dirt nap."

STUDY QUESTIONS/RECOMMENDED EXERCISES

1. Can you think of any other television shows that reveal Galician's (2004) myths as false and prescriptions as preferred readings? Which myths and prescriptions do those shows address? How?

2. Does the fact that *The Sopranos* is on HBO allow it to address relationships in a more authentic way than programs on broadcast television? Because they are less subject to regulation than broadcast TV networks, are cable networks like HBO, Showtime, or even F/X, providing us with several shows that present more honest portrayals of relationships?

3. *The Sopranos* features two characters—Dr. Jennifer Melfi and Fr. Phil Intintola—who offer counsel to lead characters Tony and Carmela Soprano. Do

these "mediating" figures point characters toward Galician's prescriptions? Can you think of "mediating" characters from other television shows? Do they? How?

4. How do other portrayals of mobsters—for example, in movies like such as *The Godfather*, *GoodFellas*, or *Casino*—compare to *The Sopranos* in relation to Galician's myths?

5. How fairly are female characters' perspectives on relationships in *The Sopranos* presented compared with perspectives of male characters?

REFERENCES

Akass, K., & McCabe, J. (2002). Beyond the Bada Bing! Negotiating female narrative authority in *The Sopranos*. In D. Lavery (Ed.), *This thing of ours: Investigating The Sopranos* (pp. 60–71). New York: Columbia University Press.

Chase, D. (Writer & Director). (1999). The Sopranos. *The Sopranos* [DVD]. Hollywood, CA: HBO Home Video.

Chase, D. (Writer), & Patterson, J. (Director). (1999). I dream of Jeannie Cusamano. *The Sopranos* [DVD]. Hollywood, CA: HBO Home Video.

Chase, D., Green, R., Burgess, M. (Writers), & Patterson, J. (Director). (2004). All due respect. *The Sopranos* [Television series episode]. Hollywood, CA: HBO.

Chase, D., Kessler, T. A. (Writers), & Patterson, J. (Director). (2000). Funhouse. *The Sopranos* [DVD] Hollywood, CA: HBO Home Video.

Chase, D., Winter, T. (Writers), & Van Patten, T. (Director). (2004). Two Tonys. *The Sopranos* [Television series episode]. Hollywood, CA: HBO.

Croft, K. (2001, April 9). *Made women: The Sopranos deals with female emotional and sexual desire better than any other show on TV.* Retrieved September 2, 2004, from http://archive .salon.com/sex/feature/2001/04/09/mob_women/index.html

Donatelli, C., & Alward, S. (2002). "I dread you"? Married to the Mob in *The Godfather*, *Good-Fellas*, and *The Sopranos*. In D. Lavery (Ed.), *This thing of ours: Investigating The Sopranos* (pp. 146–161). New York: Columbia University Press.

Galician, M.-L. (2004). *Sex, love, and romance in the mass media: Analysis and criticism of unrealistic portrayals and their influence.* Mahwah, NJ: Lawrence Erlbaum Associates.

Gilbert, S. M. (2002). Life with (god)father. In R. Barreca (Ed.), *A sitdown with The Sopranos* (pp. 11–25). New York: Palgrave MacMillan Press.

Green, R., Burgess, M. (Writers), & Senna, L. (Director). (1999). Down neck. *The Sopranos* [DVD]. Hollywood, CA: HBO Home Video.

Green, R., Burgess, M., Chase, D. (Writers), & Patterson, J. (Director). (2002). Whitecaps. *The Sopranos* [DVD]. Hollywood, CA: HBO Home Video.

Green, R., Burgess, M. (Writers), & Coulter, A. (Director). (2004). Irregular around the margins. *The Sopranos* [Television series episode]. Hollywood, CA: HBO.

Green, R., Burgess, M. (Writers), & Patterson, J. (Director). (2001). Employee of the month. *The Sopranos* [DVD]. Hollywood, CA: HBO Home Video.

Imperioli, M. (Writer), & Buscemi, S. (Director). (2002). Everybody hurts. *The Sopranos* [DVD]. Hollywood, CA: HBO Home Video.

Imperioli, M. (Writer), & Patterson, J. (Director). (2004). Marco Polo. *The Sopranos* [Television series episode]. Hollywood, CA: HBO.

Kessler, T. A. (Writer), & Bronchtein, H. J. (Director). (2001). Fortunate son. *The Sopranos* [DVD]. Hollywood, CA: HBO Home Video.

Lauzen, M. (2001, April 16). *Don't forget the brutalized women behind 'The Sopranos.'* Retrieved September 2, 2004, from http://www.sicilianculture.com/news/sopranoswomen.htm

Manos, J., Jr., Chase, D. (Writers), & Coulter, A. (Director). (1999). College. *The Sopranos* [DVD]. Hollywood, CA: HBO Home Video.

Nochimson, M. P. (2003). Waddaya lookin' at? Re-reading the gangster genre through *The Sopranos*. *Film Quarterly, 56*(2), 2–13.

Renzulli, F., Chase, D. (Writers), & Van Patten, T. (Director). (2001). Amour fou. *The Sopranos* [DVD]. Hollywood, CA: HBO Home Video.

Renzulli, F. (Writer), & Taylor, A. (Director). (1999). Pax soprana. *The Sopranos* [DVD]. Hollywood, CA: HBO Home Video.

Saracini, M. (Writer), & Gomez, N. (Director). (1999). Denial, anger, acceptance. *The Sopranos* [DVD]. Hollywood, CA: HBO Home Video.

Weiner, M. (Writer), & Bogdonavich, P. (Director). (2004). Sentimental education. *The Sopranos* [Television series episode]. Hollywood, CA: HBO.

Weiner, M., Chase, D. (Writers), & Coulter, A. (Director). (2004) The test dream. *The Sopranos* [Television series episode]. Hollywood, CA: HBO.

Weiner, M., Winter, T. (Writers), & Van Patten, T. (Director). 2004. Unidentified black males. *The Sopranos* [Television series episode]. Hollywood, CA: HBO.

Winter, T. (Writer), & Buscemi, S. (Director). (2004). In Camelot. *The Sopranos* [Television series episode]. Hollywood, CA: HBO.

Winter, T. (Writer), & Van Patten, T. (Director). (2000). House arrest. *The Sopranos* [DVD]. Hollywood, CA: HBO Home Video.

Winter, T. (Writer), & Van Patten, T. (Director). (2000). Big girls don't cry. *The Sopranos* [DVD]. Hollywood, CA: HBO Home Video.

Winter, T., Van Patten, T. (Writers), & Buscemi, S. (Director). (2001). Pine barrens. *The Sopranos* [DVD]. Hollywood, CA: HBO Home Video.

Ron Leone *is an associate professor in the Communication Department at Stonehill College, Easton, MA, where he teaches media and cinema studies. He earned a B.A. degree from Rhode Island College in 1990, an M.S. from Boston University in 1995, and a Ph.D. from Syracuse University in 2000. His research interests include media effects and their relationship to media regulation systems, and he has published articles about the Motion Picture Association of America's film ratings system in* Journal of Communication, Popular Communication, *and* Communication Research Reports. *He is currently working on several manuscript-length projects.*

Wendy Chapman Peek *is an associate professor in the English Department at Stonehill College, Easton, MA, where she teaches medieval literature, and television and cinema*

studies. She earned the B.A. degree at Rutgers College in 1983 and a Ph.D. from Cornell University in 1993. Her research interests are balanced between literature of the European Middle Ages and films of the American West. As a medievalist, she has published "King by Day, Queen by Night: The Virgin Camille in the Roman d'Eneas," which appeared in Menacing Virgins: Representing Virginity in the Middle Ages and Renaissance. Her work on Westerns has appeared in the Journal of Popular Culture and the Journal of Popular Film and Television. Her current project is a book-length manuscript on masculinity in 1950s Westerns, tentatively titled Complicated Shadows.

CHAPTER 20

Remakes to Remember: Romantic Myths in Remade Films and Their Original Counterparts

Jennifer J. Asenas
The University of Texas at Austin

Films are more than just entertainment. They are important discourses, in part, because they have a unique ability to capture the attention of millions in a way that no other medium can. Unlike other types of media, film singularly focuses viewers on the screen, the characters, and the story line (Petro, 1986). Films are also significant because they reflect and influence a culture's social, political, and moral conflicts. Rushing and Frentz (1978) argued that films project "the collective images, fantasies, and values of the culture in which the film is created" (p. 64). Moreover, films are a reflection of the societal and historical norms at the time of their making (Horton & McDonald, 1998). Hence, we might expect that political and cultural changes might also influence the kinds of stories we see in contemporary films.

We like some of our stories so much that film studios often update older offerings for contemporary audiences. Remakes of films "spaced years apart offer observations on cultural mores, roles and relationships in the same culture at two different times" (Champoux, 1999, p. 210). Therefore, the originals and their remakes offer a unique opportunity to examine what we think about sex, love, and romance in the mass media across relatively large periods of time. In this chapter I examine three pairs of such films: *An Affair to Remember* (1957)[1] and *Love Affair* (1994); both the 1961 and 1998 versions of *The Parent Trap*; and *The Shop Around the Corner* (1940) and *You've Got Mail* (1998).[2] I identify the myths

[1]*An Affair to Remember* is also a remake of an earlier film called *Love Affair* (1939). However, *An Affair to Remember* seems to have become the most memorable of the three. For example, *Sleepless in Seattle* (1993) references *An Affair to Remember*, not the original. Thus, I chose to use *An Affair to Remember* because it is more readily identifiable than the original.

[2]The film *In the Good Old Summer Time* (1949) is also a remake of *The Shop Around the Corner*. I chose to use the original because *You've Got Mail* references *The Shop Around the Corner* rather than the intermediate remake. Kathleen Kelley's store is actually named The Shop Around the Corner.

about love in both the original and the remake of the films, compare each original with its remake, and draw some conclusions.

THE FILMS AND THEIR MYTHS

An Affair to Remember

An Affair to Remember, released in 1957, was directed by Leo McCarey. This classic tale of romance finds its main characters, Nikki Ferrante (Cary Grant), world renowned playboy, and nightclub singer, Terry McKay (Deborah Kerr), on a ship headed for New York from Italy. The two meet and are instantly attracted to one another (Myth #2; Galician, 2004, p. 131). Even though they are both already engaged, they kindle their attraction by spending a romantic afternoon in Villefranche with Nikki's grandmother, Janou, who seems to think that Terry is the "right" woman for her grandson. Upon their return to the ship, the couple decide to leave their respective partners, strike out on their own, and meet each other atop the Empire State building in 6 months to marry. Their plan might have worked had Terry not been hit by a car while crossing the street on her way to the Empire State building rendezvous. She is taken to the hospital and learns that she may never walk again. Nikki, however, does not know that Terry has been in an accident and believes that she stood him up. Months later they see each other at a Christmas performance. Motivated by curiosity, Nikki finds Terry's apartment and visits her to find out why she did not meet him as planned. Slowly he puts the pieces together and realizes that she is injured. Now knowing that she did not purposefully stand him up, Nikki embraces Terry and the picture fades.

After viewing this film you might believe "your perfect partner is cosmically pre-destined, so nothing/nobody can ultimately separate you" (Myth #1; Galician, 2004, p. 124) and that "There's such a thing as 'love at first sight'" (Myth #2; Galician, 2004, p. 131). These concepts are based on the idea "that somewhere out there is your other missing half" (Galician, 2004, p. 120). Nikki and Terry are on an ocean liner headed toward their respective fiancés when they meet each other and fall in "true" love. Nothing can keep this couple apart, not even a life-threatening car accident or lack of communication. In the end, they are brought together because of love, not because they have worked at their relationship together.

A related myth is that "All you really need is love, so it doesn't matter if you and your lover have very different values" (Myth #9; Galician, 2004, p. 198). The circumstances under which the two decide that they would like to be married are absurd. They have fallen in love in a fantasyland, and in truth, neither of them knows what it is like to be self-supporting, much less to support a family, because

both have been financially supported by their respective fiancés. Neither one of them has thoroughly considered the consequences of such impulsive actions nor how this relationship might fare with those changes. How can they know how they will feel about each other when reality sets in? We are left to believe that love can handle everything.

The central myth of the film is Myth #7: "The love of a good and faithful true woman can change a man from a 'beast' into a 'prince'" (Galician, 2004, p. 182). Nikki may not look like a beast, but his treatment of women certainly qualifies him for this label. We get a brief glimpse of his "work" toward the beginning of the film. A recent lover, Gabriella, phones him and says, "You beast. How could you speak of love to me . . . and you are vowed to be married." Her reproach does not stop him from continuing in his old patterns of behavior. The night that he meets Terry he tells her:

> You saved my life. I was bored to death. I hadn't seen one attractive woman on the ship since we left. Now isn't that terrible? I was alarmed. I said to myself, "don't beautiful women travel anymore?". And I was saved. I hope.

Nikki is consistently on the prowl, loving and leaving women as he pleases.

Janou hopes that Terry will change her grandson for the better. During their visit, Janou tells Terry, "I don't mind confessing to you. I have been worried about him. Sometimes I'm frightened. . . . But when I see you with him I feel better. . . . There is nothing wrong with Nicolo that a good woman couldn't make right." In other words, she thinks that Terry can "fix" her grandson by making him a faithful man. And, in many ways, Nikki does improve himself to be with Terry. He finds his own job and remains faithful to Terry during their 6-month hiatus. The problem is that the desire to change is external and dependent on Terry, not Nikki. It is foolhardy to believe that your partner will turn into the man or woman of your dreams simply because you are in love. The prescription here is to "Cease correcting and controlling; you can't change others (only yourself!)" (Rx #7; Galician, 2004, p. 182).

Love Affair

Glen Gordon Caron's 1994 remake of An Affair to Remember—Love Affair—shares key story elements of the 1957 version, although the details have been changed. This Love Affair begins on an airplane that makes an emergency stop somewhere in the South Pacific. Singer/songwriter/interior decorator Terry McKay (Annette Bening) and retired football player Michael Gambril (Warren Beatty) end up on a Russian cruise ship to Tahiti so they can catch a plane to Australia. Like the characters of An Affair to Remember, they almost instantly fall for each other even though they are betrothed to other people (Myths #1 and #2).

They also take a romantic trip to a small island to visit Mike's aunt, Ginny (Katherine Hepburn). Hepburn's character also believes that Mike belongs with Terry and sends them off with an unspoken blessing. The two return to New York with plans to meet in 3 months atop the Empire State building to marry. True to form Terry is hit by a car en route, leaving Mike wondering what went wrong. He later finds Terry and the two end the film in an embrace.

Like its predecessor, *Love Affair* plays on the myth that two people are destined to be together (Myth #1). A complex chain of events leads to Terry and Mike's romantic cruise: a change of seats on the airplane, an emergency landing, and a last-minute change in plans to take the same ship. Thus, we are lead to believe that Terry and Mike were meant to meet and fall in love.

And like their counterparts in *An Affair to Remember*, Mike and Terry decide that they can live on love (Myth #9). Mike decides that it will take him 3 months to get his life together, leave his fiancé, and find a job. Terry is not sure what she will do in the interim, but knows that she, too, will leave her fiancé. They do not consider the possibility that in the process of "improving" themselves they might also change and become different people. All that matters is that they will be able to be together.

Mike is also "beastly" in *Love Affair* (Myth #7). He relies on the generosity of rich women to care for his needs. However, in this remake Terry is more aware of Michael's flaws. On the plane trip back to New York Mike reminds Terry that he has never been faithful to anyone in his life. He asks Terry what her father might say about a guy like him. Terry replies, "[My father would say,] 'Let me get this straight. You're hung up on some guy because you two cruised around Gilligan's Island and Bali Ha'i for 3 days. Isn't that a little nutty?'" But Terry is undaunted by Mike's track record, believing that their relationship will be different. She believes that he will break his pattern of behavior and be true to her.

Mike's Aunt Ginny agrees with Terry. In an awkward conversation she explains to Terry that ducks are not monogamous and are shamelessly indiscreet, whereas swans stay with one partner for life. Ginny uses the animals as a metaphor for Michael:

> He's so busy in other places, pursuing other things, if you'll excuse the expression, other ducks. . . . But I'm not sure Michael is a duck, although he does a pretty good imitation of one. Sometimes I feel he's desperate. . . . Oh, I think Michael may just be the ugly duckling. He doesn't know he's a swan. He thinks he is a duck, and he'll probably continue to behave like a duck until he finds another swan.

Ginny seems quite confident that Terry is the "good and faithful" swan Michael has been looking for all along, who will turn him into a swan "prince."

The myths about love and romance remain the same between these two films, which indicates their significance for our culture today. It does not matter how

many times we are told that the best predictor of future behavior is past behavior: We want to believe that the love shared between two people "meant for each other" will "fix" each other.

The Parent Trap (1961 version)

The original *The Parent Trap*, released in 1961, was directed by Dennis Swift. The film begins at summer camp, where identical twins, Sharon McKendrick and Susan Evers (both played by Hayley Mills) meet each other for the first time. The girls were separated at birth by their parent's divorce and Sharon has lived in Boston, MA, with only her mother, whereas Susan has lived in Carmel, CA, with her father. They decide to switch places to learn about the parent they have never met. Upon switching, Sharon (pretending to be Susan) finds out that her father, Mitch Evers (Brian Keith), is engaged to Vicky Robinson (Joanna Barnes). The two girls decide to put a stop to the impending marriage by "unswitching" and bringing their mother Margaret "Maggie" McKendrick (Maureen O'Hara) to California to "bust up" the wedding plans. The girls try hard to help their parents rekindle their old romance, but the parents cannot seem to stop quarreling. The girls' final ploy to get their parents back together is a family camping trip, but the fast-talking Margaret tricks Vicky into going instead. The girls decide to "submarine" Vicky and play numerous pranks that ultimately result in the dis-engagement of Vicky and Mitch. When Mitch and the girls arrive home the girls go upstairs to wash up, while Mitch and Margaret have a heart to heart. They kiss and make up. The film ends with the girls dreaming of their parent's second wedding, featuring themselves as the maids of honor.

The Parent Trap relies on the myth that your partner is predestined and nothing can separate you from your fated partner (Myth #1). Even though Margaret and Mitch divorced, divided their children, and live on opposites sides of the United States, their undying love somehow brings them together in the end. This film asks us to believe that it was fate, not coincidence, that Sharon and Susan attended the same camp, met, and devised a plan to reintroduce their parents to one another. The rekindling of Mitch and Maggie's romance reinforces the idea that one's "perfect partner" is out there and that nothing can keep true lovers apart. Additionally, the couple reunites without changing their poor relational pattern. This suggests that love is enough to sustain their relationship (Myth #9).

Clearly the central myth of the film is that "Bickering and fighting a lot mean that a man and a woman really love each other passionately" (Myth #8; Galician, 2004, p. 190). According to Galician, "This myth is so pervasive in mediated portrayals of romantic love that it's almost a tradition of the romantic genre" (Galician, 2004, p. 186). Mitch and Margaret cannot stop picking at one another. Upset that Margaret might ruin his wedding plans, Mitch begins to order her

around, to which she replies, "Don't you use that tone of voice with me. We're not married anymore, remember? . . . I'll do anything that I please and don't start ordering me around! . . . I lamed you once and I can do it [again]—now stand back. . . ." Mitch doesn't stand back and Margaret gives him a black eye. This is not the first time that they have had a physical altercation. Covering his eye Mitch laments, "Why do you have to get so physical? I can't even talk to you about anything. You're always trying to belt me with something." From their initial interaction in the film it is easy to understand why they divorced.

What is disconcerting is that they treat each other the same regardless of whether they are fighting or flirting. At the end of the film the two sit down to dinner together and are apologizing for their childish behavior. Mitch decides it is his turn to apologize:

Mitch: While everybody's apologizing I think maybe I better do mine, too. I mean about the other night. I didn't mean for it to sound like that. I guess I'm not very good with the compliments, what with growin' up out here with cows.

Margaret: Oh, now, don't gimme that old "growing up with the cows" routine. You handed me that years ago.

Mitch: I did not.

Margaret: You certainly did.

Mitch: Well, it worked didn't it? You liked it.

Mitch's apology is more of an excuse for his poor behavior. And instead of explaining to Mitch that he hurt her feelings, Margaret simply escalates the situation. It is almost as if they do not know how to be nice to one another. And although their bickering is quite humorous at times, the sad commentary on their relationship is that fighting is their only means to loving one another.

Instead of openly discussing their feelings with mutual respect they tear each other down, saying hurtful things they do not really mean. Their constant conflict is not a sign of "passion but as a danger signal that accurately predicts the high likelihood of the failure of a coupleship" (Galician, 2004, p. 187). Despite her upper-class Bostonian manners, Margaret forgets the simple act of courtesy to the one she supposedly loves, and Mitch, more often than not, fans the flames of her "Irish temper." They never work through their problems; they are trapped in an unsustainable cycle of breaking up and making up. To address this serious problem is Prescription #8: "Courtesy Counts; constant conflicts create chaos" (Galician, 2004, p. 190). Respectful disagreement is necessary for a healthy relationship. However, constant bickering and conflict that includes tearing each other down is counterproductive and may lead to the end of a relationship.

At the heart of Mitch and Maggie's relational problems is a lack of communication. Maggie falls into the trap of believing Myth #3: "Your true 'soul mate' should KNOW what you're thinking and feeling (without your having to tell)" (Galician, 2004, p. 140). When Mitch does not respond the way that she wants, her feelings are hurt. Instead of communicating to Mitch what she needs from him, she exacerbates the problem by responding with anger. In the same vein Mitch simply does not communicate his feelings to Maggie. He expects her to understand his pathetic attempt at a real apology as a sign of his love. For this relationship to work both Maggie and Mitch need to learn how to "Communicate courageously" (Rx #3; Galician, 2004, p. 140). It may not be easy to communicate our feelings. Sometimes we do not know how to express what we feel. But, to maintain a healthy relationship it is necessary to verbally communicate our feelings and needs to our partner.

The Parent Trap (1998 version)

The 1998 remake of The Parent Trap, directed by Nancy Meyers, begins in much the same way. The girls, Annie James (from London, England) and Hallie Parker (from Napa, CA) (both played by Lindsay Lohan) are twins who meet at camp, switch places, and find out that their father, Nick Parker (Dennis Quaid) plans to wed Meredith Blake (Elaine Hendrix) in a few weeks. Again, the girls realize that it will take their combined efforts to stop the wedding and to reunite their parents. However, the reaction of their mother, Elizabeth "Liz" James (Natasha Richardson), is different than in the original. Instead of reacting with strong words and sarcasm, Liz is entirely flustered claiming, "If the man didn't make me so crazy we'd still be married!" Nick's reaction is also different. He is intrigued and delighted, not angry when he sees Liz. He is nostalgic and cannot seem to remember the reason they divorced in the first place. She replies, "We were so young, and we both had tempers and said stupid things and so I packed . . . you didn't come after me." To which he responds, "I didn't know you wanted me to" (Myth #3).

The girls make a last ditch effort to get them back together with a campout. Meredith is tricked into attending instead of the mother, and, of course, the girls play dirty tricks on her to make her leave their father. When they get home, Nick tries again to rekindle their romance by showing Liz his wine collection. He shows her the bottle of wine that they drank on their wedding night and claims to own all remaining bottles of the same vintage. He tries to kiss her, but she refuses. The next day she and Annie get on a plane back to England. When they arrive home, Hallie and Nick are waiting. He says to her, "I made the mistake of not coming after you once, Lizzie. I'm not going to do that again, no matter how brave you are." The film ends with photographs from their second wedding.

The myth of predestination (Myth #1) is again present in the remake. Annie excuses the chain of coincidences as like-mindedness. She tells her father, "I guess you and mom kind of think alike because you both sent us to the same camp." Nonetheless, the plot works over time to create a scenario in which two people who split up their twins to ensure that they "would never see each other again" serendipitously meet again and fall back in love.

Notably absent from this film is the destructive bickering of the original. There is a brief discussion of a hairdryer that was thrown in Nick's direction, but the fighting that is the highlight of Mitch and Margaret's relationship in the 1961 version is neither the cause of nor the remedy for Nick and Elizabeth's relational woes. Instead, their relationship fell prey to the myth that your true soul mate should be able to read your mind (Myth #3). Hoping that your partner will know what you want and need is a risky game that can result in the termination of a relationship. This is certainly true in the 1998 remake of The Parent Trap: Liz left, hoping that Nick would come after her, but he did not, and so she believed that he really did not love her. It becomes clear later on that he might have given chase had he known that she wanted him to come after her. This might have debunked the myth, except, in the end, it is Nick's ability to read Liz's mind and chase after her this time, find her in London, and rekindle their romance. From her reaction, it is clear that this is what she wanted him to do. She wanted Nick to prove his love by knowing what she wanted without having to say the words to him. Like Mitch and Maggie in the 1961 version of The Parent Trap, Nick and Liz need to communicate openly with each other (Rx #3).

Ultimately, both the new and the old versions of The Parent Trap rely on the myth that love is all you need to make a relationship work (Myth #9). In the remake, Liz makes an attempt to demystify this belief:

> **Elizabeth:** And I suppose you just expect me to go weak at the knees and fall into your arms and cry hysterically and say, "We'll just figure this whole thing out. A bicontinental relationship with our daughters' being raised here and there. And you and I just picking up where we left off and growing old together." And, and come on, Nick, what did you expect? To live happily ever after?
>
> **Nick:** Yes, to all of the above. Except you don't have to cry hysterically.
>
> **Elizabeth:** Oh, yes I do.

However, her attempt to resist the myth fails, and we are left with the belief that their love alone will be strong enough to make their lives work together. Whereas effort and desire might make it possible to work through these obstacles, it would take honesty (Rx #3) and commitment, which Liz and Nick have not demon-

strated to be their strong suit. They could not even figure out how to share their children, much less share their lives.

The central myth of the original 1961 film, the belief that bickering is a sign of love (Myth #8), is replaced with an equally fallacious notion that one's partner can read one's mind (Myth #3). Although the omission of the physical violence is certainly a step in the right direction, the 1998 remake of *The Parent Trap* does not offer a realistic version of love and romance. Both films are equally guilty of suggesting that the cause of divorce is also its cure, which may only serve to deepen our belief in the myths.

The Shop Around the Corner

The Shop Around the Corner is a 1940 black-and-white film directed by Ernst Lubitsch. It is about co-workers who find, in the end, that they have been secret pen pals. The film begins at Matuscheck and Company, which is "just around the corner from Andrassy Street—On Balta Street, in Budapest, Hungary." There Miss Klara Novak (Margaret Sullavan) tries to gain employment, with no help from the senior sales clerk Mr. Alfred Kralik (James Stewart). Mr. Matuscheck hires Ms. Novak anyway, and she and Mr. Kralik disagree almost every time they have the chance. The situation comes to a head one night when they are asked to stay late to fix the front window displays. However, this same evening, Mr. Kralik and Miss Novak have plans to meet their pen pals, who, although they do not know it, happen to be each other. In the meantime, Mr. Kralik is fired, so he decides he cannot meet his pen pal because he now has "no future." Miss Novak eventually makes it to the café where the two were to meet. Overcome with curiosity, Mr. Kralik also goes to the café to see the woman he has been writing to and fallen in love with. Of course, he sees Miss Novak sitting and waiting patiently for her pen pal to show. Mr. Kralik decides to go in and speak with her, but the situation goes awry, and they wind up quarreling again (Myth #8).

The next day Miss Novak reports to work to ask for some time off to deal with her lovesickness and finds Mr. Kralik in the front office, not knowing that he has been rehired and made the manager. She is granted the time off and leaves immediately. Having now decided to pursue a romantic relationship with Ms. Novak, Mr. Kralik goes to visit her to try and get on her good side. The attempt is somewhat successful, and the two get along better when she returns to work. Mr. Kralik now has plans to ask for her hand in marriage. At the end of the work day on Christmas Eve, he reveals that he has been her pen pal all along, and they decide to marry.

In the 1940s it was a given that "the man should NOT be shorter, weaker, younger, poorer, or less successful than the woman" (Myth #6). Men were still expected to earn the household income. This is an obstacle for Mr. Kralik. He

believes that he will need a raise to support his wife, so he cannot ask Miss Novak to marry him until he can secure his financial future. When his financial future is uncertain, he decides not to meet Miss Novak at the café because "this morning I had a position, a future. . . . She's expecting to meet an important man. I'm in no mood to act important tonight." He assumes that without a job he is unworthy of love and cannot ask her to marry him because he is unable to fulfill his duty as a man and as a husband.

Another dated myth that the film plays on is the idea that bickering is really a sign of love between two people (Myth #8). From their initial face-to-face meeting, Mr. Kralik and Miss Novak do not get along. The situation worsens the longer they work together. For example, Mr. Kralik delivers a message for Mr. Matuscheck to Miss Novak. The exchange immediately turns into a quarrel:

Kralik: I noticed you wore a yellow blouse with light green polka dots yesterday.

Novak: No, Mr. Kralik, as usual you are mistaken. It was a green blouse with light yellow dots. And everybody else thought it very becoming. I don't remember ever remarking about your neckties. . . . So please leave my blouse alone. It's none of your business.

Kralik: Well, I'm sorry. Mr. Matuscheck seems to think it is my business.

Novak: Oh, yes, that's right. I'm working under you. Well, from now on I'll telephone you every morning and describe exactly what I'm going to wear. And before I select my next season's wardrobe, my dressmaker will submit samples to you. Imagine you dictating what I should wear!

Kralik: Well, for heaven sake, I don't care what you wear. If you want to look like a pony in the circus, that's all right. But I have troubles of my own without your blouse coming between Mr. Matuscheck and me!

Novak: Listen, I sold as much goods yesterday as anybody in the shop. . . . Did you tell that to Mr. Matuscheck?

Kralik: Yes, I did.

Novak: And what did he say?

Kralik: Tell her not to come in that blouse anymore!

Novak: Tell him I won't!

Kralik: I will!

These kinds of exchanges occur frequently and throughout the film. You would never imagine that the same two people could be in love, yet they claim to be. Mr. Kralik says of his pen pal, "She is the most wonderful girl in the world. . . . She has such ideals and such a viewpoint on things that she's so far above the girls you

meet today that there's no comparison." And Miss Novak equally dotes on her pen pal. Claiming that he and Mr. Kralik are nothing alike, she tells Kralik, "He's tactful. He's sensitive. . . . It's difficult to explain a man like him to a man like you. When you would say, 'black,' he would say, 'white.' When you would say, 'ugly,' he would say, 'it's beautiful.'" On paper they seem like a perfect match, but in person they can't seem to stop fighting.

The cross words exchanged by the two and the love that they share on paper demonstrate another myth in this film, that love is all you need (Myth #9). Mr. Kralik claims:

> If I'd only known how you felt about me in the beginning, things would have been different. We wouldn't have been fighting all the time. If we did quarrel it wouldn't have been over handbags but over something like whether your aunt or grandmother should live with us or not.

In other words, if they had only known that they loved each other before they met and began to bicker incessantly things would have been different. The flaws in this logic are apparent. In person they are so sure that they are wrong for each other, but somehow the person that they present in their letters proves otherwise. The inconsistency is never resolved. The couple assumes that their patterns of interaction will miraculously change now that think they are in love.

You've Got Mail

You've Got Mail, released in 1998, was directed by Nora Ephron. The film is an interesting update on The Shop Around the Corner. Instead of exchanging letters, Kathleen Kelley aka Shopgirl (Meg Ryan) and Joe Fox aka NY152 (Tom Hanks) exchange e-mails. The film begins with charming e-mails that they send to one another, full of funny quips and endearing thoughts, but they do not exchange "specifics," so they do not know each other's real name or occupation. This becomes a central tension in the film because they happen to be in the same business. Kathleen is the owner of a small children's bookstore, The Shop around the Corner (a wink to the original this film is remaking), which she inherited from her mother. Joe is the owner of the multimillion dollar mega-bookstore chain called Fox Books. The two accidentally meet one day and are charmed by each other, unaware that they are already e-mail pen pals. The real tension begins when Fox Books opens a store near The Shop Around the Corner. From then on, the two quarrel with one another every time they meet.

However, in the anonymous realm of e-mail they continue to get along just fine and decide to finally meet in person. Joe confesses to a friend that Kathleen is "the most adorable creature I've ever been in contact with, and if she turns out to be as good looking as a mailbox I'd be crazy not to turn my life upside down

and marry her." Unfortunately, when Joe gets to the café, he looks in and sees that Shopgirl is actually his business competitor. He decides not to tell her that he is NY152 but does decide to sit and try to chat for a while. The scene turns ugly and, seeing that there would be no hope for their relationship, Joe leaves. In the meantime, Fox Books finally puts The Shop Around the Corner out of business.

Kathleen is crushed. As she closes the shop for the last time, she pauses and narrates her e-mail to NY152. Unable to bear the pain by herself she confesses:

> My store is closing this week. I own a store. Did I ever tell you that? . . . Soon it will just be a memory . . . [and] the truth is I'm heartbroken. I feel as if a part of me has died, and my mother has died all over again, and no one can ever make it right.

This might have been the end of their relationship, but Joe pursues Kathleen. He visits her while she is sick in the hopes of becoming her friend. From then on the two "happen" to meet each other on the streets of New York and do become good friends. Joe finally decides that Kathleen can forgive him, and he meets her in the park. Kathleen does not seem surprised that NY152 is, in fact, Joe Fox. The two embrace, and Kathleen says, "I was hoping it would be you."

Initially this film appears to utilize the same myth of its predecessor, that bickering is a sign of love (Myth #8). But unlike Miss Novak and Mr. Kralik, Kathleen and Joe only fight about their work. The tension is not about their personalities but their economic competition. As Shopgirl and NY152, Kathleen and Joe are charmed by one another. The feeling is replicated in their initial contact. Joe takes his younger relatives to Kathleen's bookstore, where she is reading a story to children. He is enchanted by her and tries to hide his identity as Joe Fox, the owner of the chain bookstore that will threaten her livelihood. It is not until Kathleen learns that the man she flirted with in her store is her competitor that they quarrel. On a chance meeting she confronts him:

Kathleen: You were spying on me, weren't you? You probably rented those children.

Joe: Why would I spy on you?

Kathleen: Because I am your competition, which you know perfectly well or you would not have put up that sign, "just around the corner."

Joe: The entrance to our store is around the corner, there is no other way of saying it. It's not the name of store; it's where it is. And you do not own the phrase, "around the corner." Look, the reason I came into your store is because I was spending the day with Annabel and Matt, and I was buying them presents. I'm the type of guy who likes to buy his way into the hearts of the children who are his relatives. And there's one place to find a chil-

dren's book in the neighborhood, and that will not always be the case, and it is a charming little bookstore. You probably sell, what, $350,000 of books every year?

Kathleen: How did you know that?

Joe: I'm in the book business.

Kathleen: I am in the book business.

Joe: Me, a spy? Oh, absolutely. I have in my possession the super-duper secret printout of the sales figures of a store so inconsequential, yet full of its own virtue, that I was immediately compelled to rush over there for fear that it's going to put me out of business.

Kathleen is dumbstruck, unable to answer his witty, sarcastic remarks. Their subsequent interactions are equally nasty. Kathleen even learns to reciprocate his wit. During their exchange in the café she remarks, "If I really knew you, you'd know what I'd find? Instead of a brain a cash register, instead of a heart a bottom line." Again, it is apparent that the source of their conflict is the business competition.

Strangely enough, this myth is similar to the heroic model of love, in which romance and marriage are based on the "pursuit and capture of woman by the man" (Hendrix, as cited in Galician, 2004, p. 40). This model of romance relies on Myth #6: "The man should NOT be shorter, weaker, younger, poorer, or less successful than the woman" (Galician, 2004, p. 172). One might think that a remake 62 years after the original might produce a more egalitarian image of romantic relationships. Initially, the film does. Kathleen and Joe are equals in cyberspace and independent financially, but it does not remain this way. Fox Books puts Kathleen out of business. She is, in essence, defeated by Joe and no longer his equal. Somehow Kathleen forgives him, even though closing her store was emotionally devastating.

To illuminate just how gendered this version of romance is, imagine what would happen if the two switched places. Would Joe have been able to forgive Kathleen for putting him out of business? I doubt it. Regardless of the lip service we pay to equitable relationships, popular culture continues to portray unequal relationships, and we continue to think they are romantic.

The differences between *The Shop Around the Corner* and *You've Got Mail* are subtle, but meaningful. They demonstrate our continued practice and belief in gender disparity in relationships (Myth #6). The difference is really about the form of inequality. Galician's (2004) textbook *Sex, Love and Romance in the Mass Media: Analysis and Criticism of Unrealistic Portrayals and Their Influence* reported in both chapter 3 (p. 38) and chapter 12 (p. 165) that behavior that communicates superiority (inequality) is destructive to relationships. Healthy relationships "create

co-equality" and foster cooperation (Rx #6; p. 172). Although Galician found that 80% of Generation Xers reported that they did not agree with inequality between the sexes, in-depth interviews suggested they do not practice what they preach (p. 164). In other words, our heads may tell us that inequality is wrong, yet we often find ourselves living the stereotypical gender norms in our romantic relationships. To change these norms in both theory and practice requires us to think about both our everyday behaviors as well as lifetime decisions.

CONCLUSIONS

The idea of a remake is to produce the same story again. However, we also might expect that remakes would reflect a contemporary values system. The films analyzed in this chapter suggest that even updated versions of our favorite stories rehash old myths about love. Most of the myths found in the original film are also found in its remake. There are few differences between An *Affair to Remember* and *Love Affair*. Both films perpetuate the myths that love at first sight is possible (Myth #2), that we are destined to meet the right mate (Myth #1), that love can overcome any real life obstacles (Myth #7), and that love is all that is necessary to sustain a relationship (Myth #9). The original *The Parent Trap* (1961) wants us to believe that constant bickering is a sign of true love (Myth #8). Thankfully, this myth is absent in the remake. The new version of *The Parent Trap* (1998) suggests that your partner can and should read your mind (Myth #3), that one's perfect partner is predestined (Myth #1), and, finally, that true love is all you need to maintain a relationship (Myth #9). *The Shop Around the Corner* also incorporates Myth #9 and relies heavily on Myth #8, which suggests that bickering denotes romantic love. Quarreling between the two lovers is also present in *You've Got Mail*, although it serves a different function. The fighting between the couple is more indicative of the belief that a man should be the superior member of the couple (Myth #6). This suggests that love is a contest and that inequitable relationships can produce intimate, passionate, and committed relationships.

Film remakes have the potential to both demonstrate the inadequacy of our myths about love and present us with realistic and healthy ways of loving. However, these films reinforce rather than refute these myths. This mythic stability suggests that we remain emotionally tied to our misconceptions about love. In our heads we may know that films portray unrealistic myths about love, but in our hearts we still want to believe that one magical day we will find our true love and live happily ever after. Unfortunately, if we live by the wisdom of these films, we are setting ourselves up for failure and heartbreak.

STUDY QUESTIONS/RECOMMENDED EXERCISES

1. In all three remade films analyzed in this chapter, the female and male characters appear to enact progressive gender roles. How do these roles affect the plot of each respective film? How are gender roles related to myths about romance and marriage in the media?

2. Are myths about love, romance, and marriage especially conservative in these films because they are remakes? Or are these myths prevalent in romance films that are originals?

3. What do the remade films analyzed in this chapter suggest about love, romance, and marriage historically? Should we dismiss these films because they are a product of a bygone era? Or do these films still appeal to modern audiences?

4. Either individually or in a group, identify and study a set of remade films. Rewrite the plot of the newer version using Galician's suggestions to reflect a realistic version of the relationship in the film.

5. Either individually or in a group, identify "classic" romance films and important scenes from those films. Explain why that version of romance is problematic and how the scene should be changed to reflect a more realistic version.

6. Think of other film remakes (examples: *Father of the Bride/Father of the Bride*, *Sleepless in Seattle/An Affair to Remember*, *Solaris/Solaris*, *The End of the Affair/ The End of the Affair*, *The Preacher's Wife/The Bishop's Wife*). Have the class identify a film that has been remade. What kinds of myths do these films engender? Do older films seem to use different myths than more recent films?

REFERENCES

Beatty, W. (Producer), & Glenn, G. C. (Director). (1994). *Love affair* [Motion picture]. United States: Warner Home Video.

Champoux, J. E. (1999). Film remakes as a comparative view of time. *Educational Media International, 36,* 210–217.

Ephron, N., Shuler-Donner, L. (Producers), & Ephron, N. (Writer/Director). (1998). *You've got mail* [Motion picture]. United States: Warner Brothers.

Galician, M.-L. (2004). *Sex, love, and romance in the mass media: Analysis and criticism of unrealistic portrayals and their influence.* Mahwah, NJ: Lawrence Erlbaum Associates.

Golitzen, G. (Producer), & Swift, D. (Writer/Director). (1961). *The parent trap* [Motion picture]. United States: Walt Disney Home Video.

Horton, A., & McDonald, S. Y. (1998). Introduction. In A. Horton & S. Y. McDonald (Eds.), *Play it again Sam: Retakes on remakes* (pp. 1–11). Berkeley, CA: University of California Press.

Lubitsch, E. (Producer), & Lubitsch, E. (Director). (1940). *The shop around the corner* [Motion picture]. United States: MGM.

Petro, P. (1986). Mass culture and the feminine: The "place" of television in film studies. *Cinema Journal, 25*, 5–21.

Rushing, J. H., & Frentz, T. S. (1978). The rhetoric of *Rocky*: A social value model of criticism. *Western Journal of Speech Communication, 42*, 63–72.

Shyer, C.. (Producer), & Meyers, N. (Director). (1998). *The parent trap* [Motion picture]. United States: Buena Vista Home Video.

Wald, J. (Producer), & McCarey, L. (Director). (1957). *An affair to remember* [Motion picture]. United States: Twentieth Century Fox.

Jennifer J. Asenas is a Ph.D. candidate in Communication Studies in the area of rhetoric and language at the University of Texas at Austin, where she teaches Professional Communication Skills to undergraduates. She earned the B.A. (1999) and M.A. (2002) degrees in Communication Studies with an emphasis in rhetoric from California State University, Long Beach. As a master's student she won a research fellowship from The Center for First Amendment Studies, and as a doctoral student she won a research fellowship from the University of Texas at Austin. Her current research interests include the study of modern myth, collective memory, narrative, and social change.

IV

COMPLETION

CHAPTER 21

"Must Marry TV": The Role of the Heterosexual Imaginary in *The Bachelor*

Andrea M. McClanahan
East Stroudsburg University of Pennsylvania

The media have done their part to make sure society continues to abide by the belief that without a romantic male counterpart a heterosexual woman is incomplete. Books such as Helen Fielding's (1996) *Bridget Jones' Diary* and television shows such as *Sex and the City* (1998–2004) portray single heterosexual women as constantly searching for a romantic other to fulfill them. The number of self-help books designed to aid single women in finding their perfect mate abound (Amador & Kiersky, 1999; Bawden, 2000; Broder & Claflin, 1990; Cabot, 1987; DeAngelis, 1997; Doyle, 2001; Fein & Schneider, 1996a, 1996b). The various forms of media have perpetuated the heterosexual imaginary—the idea that to be fulfilled in life, one must be involved in an opposite-sexed romantic relationship.

One trend in popular culture feeding the belief that to be complete one must be involved in a romantic relationship is "*Must* Marry TV" (Vejnoska, 2002, p. 1F, emphasis in original). Must Marry TV is a television trend that attempts to pair a woman and a man in a long-lasting romantic relationship through a game-show format. Vejnoska (2002) explained, "What the somewhat tongue-in-cheeky *Who Wants to Marry a Multi-Millionaire* started two years ago is now a full-blown reality trend" (p. 1F). Among the shows in "Must Marry TV" are *Who Wants to Marry a Multi-Millionaire?*, *Bachelorettes in Alaska: Looking for Love, Love Cruise, Marry My Dad, Joe Millionaire, Average Joe, Mr. Personality, The Bachelorette*, and *The Bachelor*. All claim to provide men and women the opportunity to find true love and happiness by creating a successful relationship.

THE BACHELOR: ITS CONTENT AND ITS CRITICS

One of the most prominent and continuous successes in "Must Marry TV" is American Broadcasting Corporation's (ABC) reality television show, *The Bachelor*.

The Bachelor is a romance reality show that positions 25 single women in competition for the grand prize: a single bachelor ready to settle down and get married. The winner of the show walks away in love with the bachelor, and, if all goes well, the possibility of wedding bells in the near future. The host of the show, Chris Harrison, explained, "This is no ordinary relationship show. This is about something real, something permanent—you know, the whole 'till-death-do-us-part-thing'" (Fleiss, 2002a, n.p.).

Indeed, *The Bachelor* is about "something real," but it is doubtful it has to do with the relationships formed between the bachelor and the bachelorettes. Rather, *The Bachelor* acts as a reminder to audiences that in our society, individuals, at some point, must find their "other," specifically, their opposite sex romantic other, to be fulfilled. With 18.2 million people tuning in for the final episode of the first season of *The Bachelor* on April 25, 2002 ("ABC looking," 2002), the reminder is obviously appealing to our society. Ty Burr (2002) of *Entertainment Weekly's EW.com* argued, "In its car-wreck awfulness—in the way it treats everyone except its host as so much disposable meat—*The Bachelor* is an amplification of the dating wars so precise and realistically nuanced in its neuroses as to be both anthropologically mesmerizing and scary as hell" (n.p.). Friedman (2002) asserted, "The cheese factor is undeniable, but *The Bachelor* makes a connection with its audience beyond the vicarious thrill. The faces may be glamorous, but the quest for love and acceptance is universal" (p. 20).

The two most important components of *The Bachelor* are the chosen bachelor and the 25 bachelorettes. Alex Michel, the bachelor selected for the first season of the show, was introduced to the audience on March 25, 2002, with the statement from Chris Harrison, the host of the show, "Nobody's perfect. But after conducting a series of in-depth background checks, our bachelor seems like the real deal" (Fleiss, 2002a, n.p.). ABC marketed Alex as the most eligible man in America and the best man to fill the shoes of the bachelor (Fleiss, 2002a). However, this decision was not without criticism. Mark Perigard (2002) explained, "Cross Al Gore with Screech from *Saved by the Bell* and you get Alex Michel. A Stanford graduate, Michel is proof that earning an MBA doesn't necessarily mean one is smart. Or likeable" (p. O25). Just as Perigard (2002) criticized Alex, Burr (2002) stated, Alex "might as well have 'Yuppie Prototype' stenciled on is forehead" (n.p.). Therefore, despite Alex's credentials having been impeccable and desirable, at least by ABC's standards, critics have not missed the fact that agreeing to be on a show such as this leaves Alex's character in question.

Whereas criticism surrounds the bachelor, more discussion centered on the 25 single women who volunteered to be a part of the show. Chris Harrison explained:

> When we announced that one of America's most eligible bachelors was looking to get married, the response was overwhelming. Women from all over the country sent in tapes hoping they might become one of our 25 bachelorettes. Apparently, there are a lot of women looking for Mr. Right. (Fleiss, 2002a, n.p.)

Close to 1,000 women responded to ABC's call for women to participate in *The Bachelor* (Porter, 2002). The level of response to the "mating call" ultimately left the door wide open for criticism of the 25 women chosen for the show. To a television audience and critics, the women appeared fairly desperate and willing to do just about anything to obtain the feeling of well-being that comes with being in a romantic heterosexual relationship. Hinkley (2002) explained that Alex is more appealing than the average man because he "is ready to get married—a phrase that, as we all know, causes every unattached women in America to drop whatever she's doing along with any trace of self-respect, and line up to snag him" (p. 79). Burr (2002) described the women as "Twenty-five desperate, single, staring-down-the-biological-close, neck-chords-strained-from-constant-smiling women" (n.p.). David Bauder (2002) of *KnoxNews* [On-Line] simply said the women were "desperate for attention." Surprisingly, little attention and criticism was focused on the desperation of Alex to be in a relationship.

Audiences and critics acknowledge and understand the absurdity of a television show based upon one man's choosing his future wife from a pool of 25 women in a matter of 6 weeks (Albertini, 2003; Bauder, 2002; Burr, 2002; Friedman, 2002; Henry, 2002; Vejnoska, 2002). However, something about the show has made it popular among television audiences. Albertini (2003) noted:

> Romance reality is emotionally powerful. It offers [the audience] other things we want, from a false sense of order within the complications of dating rituals to a chance to identify, in a complicated and ambivalent manner, with the emotions and outcomes of the shows' plots. (p. 12)

THE HETEROSEXUAL IMAGINARY AND MYTH # 10

I argue that the popularity of *The Bachelor* is embedded in the promotion of *the heterosexual imaginary*. Ingraham (1999) explained the heterosexual imaginary as the "belief system that relies on romantic and sacred notions of heterosexuality in order to create and maintain the illusion of well being" (p. 16). Therefore, individuals feel that to be fulfilled or complete in life, they must have a romantic relationship with a member of the opposite sex. The heterosexual imaginary coincides with Myth #10: "The right mate 'completes you,'—filling your needs and making your dreams come true" (Galician, 2004, p. 201).

Throughout the remainder of this chapter, I analyze the first season (March 25–April 25, 2002) of the reality television show *The Bachelor*, including all six episodes and the "Women Tell All" (Fleiss, 2002g) episode that aired before the finale of the show on April 25, 2002. I chose *The Bachelor* for analysis because it is the first multi-episode reality show focused on pitting women against each other for the purposes of winning a man over a matter of several weeks. The extended time frame of *The Bachelor* is important in understanding how this television series

"makes or attempts to make, meanings that serve the dominant interests in society" as well as the ways in which it "circulates these meanings amongst the wide variety of social groups that constitute its audiences" (Fiske, 1997, p. 1).

I investigate *The Bachelor* to uncover mediated myths of sex, love, and romance, as explained by Galician (2004) in her book *Sex, Love, and Romance in the Mass Media: Analysis and Criticism of Unrealistic Portrayals and Their Influence*, perpetuated in this reality television show. To reveal the various components that make up the narratives maintaining these myths, I conduct a textual analysis of *The Bachelor*. I recognize that texts largely comprise narratives. Brown (1987) explained, "Narrative is an iconic social representation of moral action, an expression and preparation" (p. 157). Further, "Narrative enables us to understand the actions of others and endow them with meaning because it is throughout narratives that we live and understand our own existence" (Brown, 1987, p. 165).

To better demonstrate the promotion of the myths of sex, love, and romance in *The Bachelor*, I first describe the heterosexual imaginary and heterosexuality as an institution in detail to help explicate how this belief contributes to the myths of romantic relationships present in *The Bachelor*. Second, I deconstruct *The Bachelor* to provide an in-depth discussion of the myths embedded within this romance reality text. Finally, I discuss the implications of the myths in the text, the nature of "Must Marry TV" as a damaging form of romantic narrative, and the embedded nature of the heterosexual imaginary in our society.

Theoretical Underpinnings

The theoretical underpinnings of this chapter focus on the heterosexual imaginary as a means to construct the myths of sex, love, and romance in the media in *The Bachelor*. The heterosexual imaginary is the belief that to achieve a sense of well-being in life, one must be involved in a heterosexual romantic relationship (Ingraham, 1999). Ingraham (1999) asserted:

> Through the use of the heterosexual imaginary, we hold up the institution of heterosexuality as timeless, devoid of historical variation, and as "just the way it is" while creating social practices that reinforce the illusion that as long as this is "the way it is" all will be right in the world. Romancing—creating an illusory—heterosexuality is central to heterosexual imaginary. (p. 16)

In other words, the heterosexual imaginary promotes heterosexuality as the only acceptable social arrangement that can possibly lead to romance and then marriage to achieve happiness.

Richardson (1996) explained, "Heterosexuality is institutionalised [sic] as a particular form of practice and relationships, of family structure, and identity. It is constructed as a coherent, natural, fixed and stable category; as universal and

monolithic" (p. 2). Further, to achieve the ultimate in terms of heterosexuality, individuals must be a part of the institution of marriage—the ultimate pairing of a man and woman in a relationship that "completes" him or her. Richardson (1996) further explicated, "It is heterosexuality as marriage and 'the family' which is associated with the nation and, moreover, seen as necessary for ensuring its survival, its strength and well being" (p. 17). As Baumgardner and Richards (2000) asserted, "Sullied and unequal institution or not, the reality is that marriage, or a committed relationship that is acknowledged by society (and health-insurance companies), is what most people—not just Bridget [Jones] and Ally [McBeal]—still want" (p. 40).

Constructions of Myth #10

The Bachelor acts as a tool to promote the heterosexual imaginary through the perpetuation of multiple myths regarding sex, love, and romance in the mass media. Although I could discuss many of the myths present in The Bachelor, I chose to concentrate on the one myth that I argue provides the focus of The Bachelor and the need for competition for love. Myth #10: "The right mate 'completes you'—filling your needs and making your dreams come true" (Galician, 2004, p. 201) is the crux of this and other Must Marry TV shows. There are three main ways by which The Bachelor perpetuates this myth. The first is through showing the women as desperate to be validated by a male romantic partner who desires them—in this case, Alex. Second, The Bachelor constantly shows the audience how the lives of the bachelorettes could be better and more complete if they were paired in a romantic heterosexual relationship with Alex. Finally, the exits of the rejected women from the show clearly construct the women as "losers" and, thus, incomplete because they are not in a romantic relationship.

Competing for the Bachelor

First, the bachelorettes on the show admit they are willing to compete against 24 other women to win the attention of a man with whom they only get to spend a limited amount of time over a 6-week period. Through this willingness to compete for male attention, the women demonstrated that they have a strong desire to be paired with a male other to feel validated as a woman. The 25 bachelorettes are well aware of the competition they have to face to win the bachelor's attention and affection. In Episode One (Fleiss, 2002a) several of the bachelorettes commented on the competition they were facing. Katie remarked, "I'm nervous about going up against these 24 women and having to be competitive for a man." Lanease stated, "I'm a little nervous about the chances I'm going to make it through this first round because the women are beautiful and they're smart and I'm like, can I compete with these women?" Amanda asserted, "I consider myself

very competitive. I know what I want and I always go for it." These comments show the bachelorettes recognized their situation and were willing to compete with other women for the chance at fulfillment through a romantic relationship.

I argue that this competition and acknowledgment of it by the women is the first instance of showing women as willing to do anything to achieve a sense of well-being that comes with achieving the heterosexual imaginary—of being complete because of a relationship (Myth #10; Galician, 2004, p. 201). If these women are willing to compete against each other for a man whom they briefly meet and about whom they know very little, then there is clear evidence that there must be an intense desire to be paired with a male other and fulfill the heterosexual imaginary. The actions of the women on the show speak to their desire to be in a romantic relationship to be validated as a woman.

At the end of "The Rose Ceremony," the elimination round in *The Bachelor*, the television audience had an opportunity to hear the reactions of the women Alex decides to eliminate. In Episode One, Amber was eliminated and responded in tears by saying, "I'm a good person. Anyone could miss that. But he didn't miss it in the other girls, did he?" (Fleiss, 2002a). Amber illustrates that for her to feel validated as a "good person" she needs Alex, or possibly just a male companion, to make her complete. Trista further showed this need for validation by the bachelor in Episode Two when she asserted, "I want him to find me desirable" (Fleiss, 2002b). Katie explained that although she is not particularly interested in Alex and does not feel a romantic connection to him, she is still "wishing he would give me [a rose]. You know, to validate the whole purpose of the show" (Fleiss, 2002g). Kim, after being eliminated in Episode Four remarked, "There's [sic] other men out there for me. He's just not the one right now" (Fleiss, 2002d). Although Kim realized that Alex not choosing her to continue in the game is acceptable, her remarks document her desire to be paired with a male, even if it is not Alex. However, Kim did approach being eliminated from the show in a healthier manner than did some of the other women by recognizing Prescription #1: "Consider countless candidates" (Galician, 2004, p. 225).

After The Rose Ceremony in Episode Three, Rhonda immediately launched into an anxiety attack, gasping for air while stating, "You have these hopes that someone is going to see something" (Fleiss, 2002c). Rhonda's reaction indicates that some of the women on the show feel as though they need to have a male significant other for validation as a woman. On the show, "Women Tell All," Chris Harrison interviewed Rhonda about her dramatic departure from the television series. Harrison remarked, "There is one guy now in your life that thinks you're terrific. So, congratulations on your new boyfriend" (Fleiss, 2002g). This remark by the host of the show further perpetuates the belief that women on the show, to be validated as "good" or "attractive" women, need to have a male counterpart. Thus, Rhonda's "winning" a boyfriend after her departure from the show demonstrates that she is attractive to a member of the opposite sex, despite her elimination by Alex.

Life Is Better With the Bachelor

The second way in which *The Bachelor* perpetuates the myth that "the right mate 'completes you'" (Myth #10; Galician, 2004, p. 201) is to show how the bachelorettes on the show would have better and, thus, more complete lives, if they were to "win" the bachelor. On *The Bachelor*, the bachelorettes and Alex went on fantasy dates. Specifically, two individual fantasy dates clearly depicted how Alex could add to the lives of the chosen bachelorettes. In Episode Three (Fleiss, 2002c), Shannon was chosen to go on a personal one-on-one date with Alex. The date started out with Shannon being told to dress casually for the evening. However, as soon as Alex arrived in formal attire, Shannon realized that she was in for a "pretty woman" type of evening. Shannon was escorted to Rodeo Drive to find an evening gown to wear on the date. After accomplishing this task, Alex and Shannon went to a private room for dinner where Shannon was greeted with a $300,000 necklace and earring set. Then, Alex and Shannon ate dinner and were serenaded by violins as they danced on the balcony overlooking the city. Both remarked at the end of the evening about the romantic nature of the date and how neither one had been on a date of this magnitude before. Shannon stated that her date with Alex was the best date she has ever had and will probably ever have (Fleiss, 2002c). This date demonstrates how Alex can provide Shannon with experiences, and more importantly, a sense of validation and well-being, that she would not be privy to if it were not for her being with Alex in this romantic relationship.

Another instance of *The Bachelor* illustrating the benefits of fulfilling the heterosexual imaginary is the date between Alex and Amanda in Episode Five (Fleiss, 2002e). Alex and Amanda went on an overnight date to New York City. At the beginning of the date, Alex spoke about how excited he is to be able to show Amanda New York City because she has not been anywhere larger than Kansas City. In a sense, Alex was giving Amanda the world with this date by opening up her eyes to new adventures. Alex's and Amanda's date was full of romantic adventures, including a carriage ride through the streets of the city while cuddling in a blanket together, ice skating at a private rink where the couple was able to hold hands and kiss each other, and dinner at Tavern on the Green. The date ended with Alex and Amanda choosing to share a hotel room for the remainder of the night. This date falls into the fairy-tale category that includes the man rescuing the woman from her dull-hum-drum type life[1]; in this case Alex rescued Amanda from her sheltered existence in Kansas. Alex opened Amanda's eyes to the possibilities that lay ahead of her if only Alex chooses her as the ultimate bachelorette. Along with opening Amanda's eyes, the eyes of the television

[1]In this instance, Alex Michel was also fulfilling Myth #6: "The man should NOT be shorter, weaker, younger, poorer, or less successful than the woman" (Galician, 2004, p. 162, emphasis in original) because Alex provided opportunities to Amanda that she was unable to afford on her own.

audience were opened to see what can happen if a single woman becomes paired with a male in a romantic relationship to fulfill the heterosexual imaginary and be complete.

Outside of the individual fantasy dates, I argue that The Rose Ceremony offered the bachelorettes a sense of completion through Alex's choosing the women to continue for the chance at love and romance. The entire elimination round was set up to mirror the possibility of Alex proposing to one of the women. For *The Bachelor*, The Rose Ceremony is the validation point for the women. If a woman receives a rose, she is deemed worthy enough to remain in the game, and she is afforded a sense of well-being or happiness by Alex's decision.

The women sat or stood around the room where The Rose Ceremony took place and patiently waited for Alex to call the names of the women of his choice and individually ask them, "[Name], will you accept this rose?" The question is reminiscent of a proposal in which the man asks, "[Name], will you marry me?" I argue that the similarity of The Rose Ceremony to a wedding proposal is intentional. A wedding proposal provides women with, in most cases, a guaranteed achievement and security of the heterosexual imaginary through what our society deems the ultimate act of love—marriage. The Rose Ceremony mirrors a wedding proposal because the overall mission of the television series was for one of the women in the end to receive a wedding proposal from Alex. The Rose Ceremony acts as a reminder to the women that they are one step closer to fulfilling the dream of being involved in a romantic relationship and thus more complete in their lives.

Losers of the Heterosexual Imaginary

The Rose Ceremony has another side. This is the point in *The Bachelor* at which some women have to leave the show as losers of the heterosexual imaginary. I argue the portrayal of the losers on the show is the third construction of the myth that "the right mate 'completes you'" (Myth #10; Galician, 2004, p. 201). The Rose Ceremony is key in creating and portraying the women not selected by Alex as losers in the game. First, the elimination ceremony, by design, points out that the women who will be leaving the show are incomplete because they are still without a male romantic partner. During the ceremony, Alex called out the names of the women he wanted to stay whereas the other women were ignored until the end when Chris Harrison said, "Take a few minutes and say your goodbyes."

Specifically, the producing and editing of *The Bachelor* clearly point out the losers to the audience. As The Rose Ceremony takes place, the camera pans the room so that each woman is viewable to the television audience. Then, as Alex called out a name and waited for that woman to appear in front of him, the camera went directly to those women still waiting to hear their name called. The cameras caught various expressions on the faces of the remaining bachelorettes. For

instance, in Episode Two, (Fleiss, 2002b) the camera focused on Angelique as soon as Rhonda's name was called. Angelique's mouth opened and she appeared shocked that Alex would choose Rhonda and then immediately, as if she remembered she is being filmed, forced her mouth back into a smile. In addition, during the same ceremony, when Lanease's name was called, the camera focused on Melissa, still without a rose, who showed disbelief that Lanease had received the last rose of the night. Along with focusing on the faces of the women not yet chosen by Alex, the camera also panned the folded hands of the women without roses throughout the ceremony. The focus on the empty hands pointed out the several women without a rose and, thus, without a man.

The Rose Ceremony during Episode Three (Fleiss, 2002c) provided an interesting view of the winners and the losers in the show. Throughout the entire ceremony, the camera kept focusing on Trista and Rhonda. After one name was called, the camera focused on Trista, and after another name was called, the camera focused on Rhonda. To the television audience, it was evident that Rhonda was becoming increasingly distraught as names, other than her own, continued to be called. Christina, the bachelorette sitting next to Rhonda, remarked at the end of the ceremony:

> I'm really worried about Rhonda. I kind of thought if she wasn't chosen she might have a pretty severe reaction. I did think she was starting to get a little upset when Alex was starting to make his decisions and hand out the roses. I could tell she was going to get really upset if she didn't get a rose. (Fleiss, 2002c)

Indeed, Rhonda did have a severe reaction to the situation, launching into an anxiety attack during her exit interview. The reaction by Rhonda was dramatic and helped in showing the audience how much Rhonda was hoping to finally be "complete" through a romantic relationship with Alex.

Other instances of the bachelorettes appearing as losers abound on *The Bachelor*. The emotional reactions of the women in various situations show that the women have a significant level of fear at losing out on an opportunity to be joined with a male other and, thus, complete at the conclusion of the game. The clearest example was during Episode Three when three of the remaining eight women were chosen for individual dates with Alex and the other five women had to go on a group date. After Shannon received the last invitation for an individual date, she explained:

> And then all of a sudden, I feel like I am looking around and everyone in the living room is starting to stare at me. Just because they really really wanted that alone time with Alex. And I know Rhonda shot a little look at me and there were a few people who were really upset. (Fleiss, 2002c)

The reaction of the other women toward Shannon illustrated that the women were feeling as though they had lost Alex and their opportunity to persuade

him to pick them during the next elimination round. Alex also experienced these feelings at the beginning of the group date. Alex stated, "Honestly, none of these women were giving me good vibes. They were all mad at me. I was just glad these women didn't have guns" (Fleiss, 2002c).

The Rose Ceremony and other situations throughout the series point to certain women as losers in this game of love. This is a message to single women everywhere that without a romantic partner to "complete" you, you, too, are a loser. In a series where the heterosexual imaginary and Myth #10: "The right mate 'completes you'—filling your needs and making your dreams come true" (Galician, 2004, p. 201) are the focus and the prize, there is no other way to see the women who walk away from the show without Alex by their side. The women who do not win Alex are the losers, and Amanda, the woman who received the last rose of the game, is the winner—the only woman who will achieve a sense of well-being through a romantic heterosexual relationship based upon the concept of the heterosexual imaginary (Fleiss, 2002f).

Other Myths

Other myths outlined by Galician (2004) are noticeable in *The Bachelor*. Myth #5: "To attract and keep a man, a woman should look like a model or a centerfold" (p. 153) is apparent in the construction of the television series. The women selected to participate on *The Bachelor* resemble models. There is minimal racial diversity in the television series. However, this does not translate into alternative depictions of beauty in terms of weight, hair, and body shape. Although there is no published data on the sizes of the women chosen for the show, any viewer can see the women are of smaller than average stature—with most being a women's size 6 or smaller. All but one of the 25 bachelorettes had long hair. Melissa, the bachelorette with short hair, still had hair that reached her chin. Albertini (2003) noted, romance reality "shows require that the women be attractive along very traditional lines—blondes with supermodel bodies and surgical enhancements" (p. 12). Albertini (2003) further stated that although the fourth season (September 24–November 19, 2003) of *The Bachelor* featured Bob, a slightly overweight and humorous man, these are "characteristics that might get a woman onto *Last Comic Standing* but never onto *The Bachelor* or *The Bachelorette*" (p. 12). Additionally, the design of the show allows for maximum viewing of the women in bathing suits and other revealing clothing. For instance, in Episode Two (Fleiss, 2004b), five of the women went on a fantasy date to a spa. All of the women wore bikinis and the cameras focused on the bare skin of the women when they were attempting to get into the mud baths and later showering in the communal bath area.

Another myth shown in *The Bachelor* is, "The man should NOT be shorter, weaker, younger, poorer, or less successful than the woman" (Myth #6; Galician,

2004, p. 163, emphasis in original). This myth becomes abundantly clear in *The Bachelor* because of the selective depiction of the women to the audience. As each woman spoke to the camera, a banner with the name of the contestant, her age, and her occupation appeared at the bottom. Trista, one of the two finalists, was shown with the caption, "Trista—Miami Heat Dancer." This caption only signals Trista's hobby as a dancer and neglects to inform the audience that she is also a pediatric physical therapist ("Trista," 2002). Angela, a bachelorette eliminated the second week, was presented as a "Hooters Waitress" although she is both an insurance agent and a waitress ("Angela," 2002).

Although the previous two myths are certainly present in the design, selection, and editing of *The Bachelor*, Myth #10: "The right mate 'completes you'—filling your needs and making your dreams come true" (Galician, 2004, p. 201), is the crux of this and other "Must Marry TV" shows. The myth that to be complete in life, one must be involved in a romantic relationship is prominent throughout *The Bachelor* by showing the bachelorettes as willing to do anything to feel validated, convincing the audience that the lives of the individual bachelorettes could be better if they were in a romantic heterosexual relationship and through constructing the bachelorettes who are eliminated as "losers" of the heterosexual imaginary. The perpetuation of this myth leads to many questions revolving around why individuals watch romance reality shows and the dangers of the portrayals of those without a romantic other.

WHY PEOPLE WATCH MUST MARRY TV

From the time children (especially girls) begin to speak and play, they are taught that being in a romantic relationship will fulfill their every need in life. From "Wedding Day" Barbie to playing house, they learn that being paired in a romantic relationship is the ultimate goal. Rich (1986) argued, "Heterosexual romance has been represented as *the* great female adventure, duty, and fulfillment" (p. 648, emphasis in original). However, the "reality" of romance is much different. Radway (1984) explained that women tend to consume romance texts because of the disappointment of the actual heterosexual relationships in which they find themselves. Maher (2004) asserted, "Real life inevitably pales in comparison to popular culture's representation of both true love and male-female bonds" (p. 199). Individuals feel let down by their real-life romances and do not necessarily feel the completion they were originally guaranteed from engaging in a romantic heterosexual relationship. Maher (2004) affirmed:

> When heterosexual romance is supposed to be the ultimate fulfillment of your femininity and the highlight of your life, imagine the surprise when reality sets in. He

resembles neither a pirate nor a prince, he has nose hair, and he doesn't pay that much attention to foreplay anymore. And of course, the pirate/prince might never come at all. How do you get out of feeling let down? For many women . . . you find ways to soothe yourself within the system. (p. 200)

Radway (1984) explained women engage in romance literature to escape, and Maher (2004) asserted the same is true for women who sit down and watch *The Learning Channel's* daytime line up of shows such as *A Wedding Story* and *A Baby Story*. Perhaps the engagement in Must Marry TV shows is also due to the need to escape the reality of romance. *The Bachelor* provides the audience with fantasy dates and dream getaways that many couples do not have the time to take, much less the money to afford.

CONCLUSION

The need to escape from "real" romance and relationships demonstrates that there are valid dangers associated with the myths of sex, love, and romance in the media as outlined by Galician (2004) and also the need for the "prescriptions for healthy coupleship" postulated by her. Specifically, along with denying the "reality" of romance through escaping to media images, the myth that "The right mate 'completes you'" (Myth #10; Galician, 2004, p. 201) contributes to the stigma attached to women who do not, because of choice or chance, participate in a heterosexual romantic relationship.

There are alternatives to the heterosexual imaginary and Myth #10: "The right mate 'completes you'—filling your needs and making your dreams come true" (Galician, 2004, p. 201). Galician (2004) forwards Prescription #10: "Cultivate your own completeness" (Galician, 2004, p. 225) to help individuals recognize that individuals are complete, even without a romantic other. In recalling a personal experience, entertainer Lily Tomlin (as cited in Raymond, 1986) remarked, "I've actually seen a man walk up to four women in a bar and say: 'Hey, what are you doing here sitting all alone?'" (p. 3). Raymond (1986) asserted, "The perception is that women without men are women without company or companionship" (p. 3). However, friendship offers single individuals intimate relationships that fulfill the need for "intimacy, sharing, and continuity" (Stein, 1978, p. 109). Obviously, there are multiple ways to be fulfilled in life. Single women are—despite not being involved in romantic relationships that necessarily lead to marriage—fulfilled in life and, while absent a "male" other, are not without "others" in their lives.

Although there are multiple ways to be "complete" in life (Galician, 2004), single heterosexual women remain a spectacle to friends, family, and society. Must

Marry TV, in particular *The Bachelor*, portrays single women as pathetic because they have not fulfilled the heterosexual imaginary.[2] I am not arguing that the women who chose to participate on the show are desperate single women only looking for a male companion to make their lives complete. As Daniella, one of the bachelorettes on *The Bachelor*, explained, "I think I was just really surprised by the media's reaction as far as them saying, gosh these women are so desperate, they are all there to get married. Can't they find their own guy? I mean, look around. Do we look like 25 desperate women? I don't think so" (Fleiss, 2002g). Rather, I argue that the portrayals of these women throughout the series place single women in a negative light because they are shown as only having one goal in mind—obtaining the bachelor to complete them. Henry (2002) asserted, "We'll never know if the bachelorettes are in it for the man or his money, the 15 minutes of fame or a lifetime of commercial endorsements" (p. F1). The heterosexual imaginary and the myth that "the right mate 'completes you'" (Myth #10; Galician, 2004, p. 201) is promoted at the expense of single women who take part in the show and single women in general who may feel incomplete because they are not in a romantic relationship.

Unfortunately, since the first season of *The Bachelor*, there have been five more seasons of *The Bachelor* and three seasons of *The Bachelorette*. More Must Marry TV series premiere during each television season. This chapter is only a beginning conversation for the deeply needed scrutiny of romance reality and the myths of sex, love, and romance in the media. Future researchers need to explore the reasons individuals watch Must Marry TV, the reasons participants choose to be on a show of this magnitude, the differences in perceptions of the bachelor and the bachelorettes, the television show *The Bachelorette* where 25 men compete for the affection of 1 woman, and alternatives to romance reality that focus more on the "Prescriptions for healthy coupleship" (Galician, 2004, p. 225) rather than emphasizing the myths of sex, love, and romance in the media. Only through further exploration will we begin to understand how popular culture continues to thrive by promoting the heterosexual imaginary despite creating a feeling of insignificance for those women involved in "real" relationships and for those who are single.

[2]Although there was a substantial amount of criticism surrounding the bachelorettes on *The Bachelor*, there was little criticism surrounding the bachelor, Alex Michel. I argue that the lack of criticism is reflected in the idea that Alex was practically guaranteed fulfillment of the heterosexual imaginary at the end of the show. Additionally, he did not have to compete for the women and was never portrayed as a "loser" to the audience. Alex was portrayed as "prince charming"—ready to settle down and get married. Research needs to be conducted comparing the perceptions of single men ready to marry versus single women ready to marry. In *The Bachelor* it is clear that Alex is viewed as a mature adult because of his decision, but the women are criticized for theirs.

STUDY QUESTIONS/RECOMMENDED EXERCISES

1. Before discussing this chapter, ask students to informally interview at least three individuals who watch a television show that falls into the category of "Must Marry TV." During the class meeting, have students discuss their findings and how they feel about the responses. This should lead to a productive discussion on why people watch "Must Marry TV," the differences in the perception of men and women on the shows, and the "reality" of romance reality television. Sample questions for the interviews include:

 a. Which "Must Marry TV" shows do you watch?

 b. What makes you interested in the television show?

 c. What is your perception of the males who participate on the show?

 d. What is your perception of the females who participate on the show?

 e. Do you believe the relationships between the men and women end happily once the show is over?

 f. What do you view as "real" about the show versus what is "fake"?

2. There are many terms used to describe single men and women. Have students discuss their perceptions of single women and single men older than age 30. Compare the differences in language used to describe the two groups and the differences in perceptions of the two groups.

3. Baumgardner and Richards (2000) asserted, "Sullied and unequal an institution or not, the reality is that marriage, or a committed relationship . . . is what most people—not just Bridget [Jones] and Ally [McBeal]—still want" (p. 40). In a society in which almost half of all marriages end in divorce, why do you feel marriage is such an important life target for individuals? What role does heterosexual imaginary play in the compulsion to get married? Do shows such as *The Bachelor* simply play upon the fear individuals may have of never being married?

4. Based upon the discussion of "The Rose Ceremony" on *The Bachelor*, reconstruct the elimination round in a way that would portray the women eliminated in a positive light. Is there a way to rework the elimination round so that the women would not be portrayed as "losers" to the audience? Is there a way in which the ceremony could be rewritten so that the women are not portrayed as incomplete because they have lost the bachelor?

5. Myth #5: "To attract and keep a man, a woman should look like a model or centerfold" (Galician, 2004, p. 153) is discussed briefly in relation to *The Bachelor*. Do you agree with Albertini's (2003) statement that although the fourth

season of *The Bachelor* featured Bob, a slightly overweight and humorous man, these are "characteristics that might get a woman onto *Last Comic Standing* but never onto *The Bachelor* or *The Bachelorette*" (p. 12)? Do you think an overweight woman could succeed in a show such as *The Bachelor*? What are the problems of only including supermodel-looking women on "Must Marry TV" shows?

REFERENCES

ABC looking for "Bachelorette." (2002). *Zap2It.com*. Retrieved April 28, 2002, from http://www.tvzap2it.com/news/tvnewsdaily.html?24790

Albertini, B. (2003, Fall). So wrong it's right: The guilty pleasures of reality television. *Iris*, 12.

Amador, X., & Kiersky, J. (1999). *Being single in a couples' world: How to be happily single while looking for love*. New York: Fireside.

Angela: The bachelorettes. (2002). *The Bachelor*. Retrieved April 15, 2002, from http://www.abcnews.go.com/primetime/specials/bachelor/bios/Angela.htl

Bauder, D. (2002). "The Bachelor" could succeed in taking television to new low. *KnoxNews*. Retrieved April 1, 2002, from http://www.knoxnews.com/cr/cda/article_print/1,1250,KNS_357_1060386,00.html

Baumgardner, J., & Richards, A. (2000). *Manifesta: Young women, feminism, and the future*. New York: Farrar, Straus, and Giroux.

Bawden, J. (2000). *Get a life then get a man: A single woman's guide*. New York: Plume.

Broder, M., & Claflin, E. (1990). *The art of living single*. New York: Avon.

Brown, R. H. (1987). *Society as text: Essays on rhetoric, reason and reality*. Chicago: University of Chicago Press.

Burr, T. (2002). The dating lame. *Entertainment Weekly's EW.com*. Retrieved April 20, 2002, from http://www.ew.com/ew/article/commentary/0,6115,220366_3_0_,00.html

Cabot, T. (1987). *How to make a man fall in love with you*. New York: Dell Books.

DeAngelis, B. (1997). *The real rules: How to find the right man for the real you*. New York: Bantam Books.

Doyle, L. (2002). *The surrendered single: A practical guide to attracting and marrying the man who's right for you*. New York: Fireside.

Fein, E., & Schneider, S. (1996a). *The rules: Time tested secrets for capturing the heart of Mr. Right*. New York: Warner Books.

Fein, E., & Schneider, S. (1996b). *Rules for on-line dating: Capturing the heart of Mr. Right in cyberspace*. New York: Pocket Books.

Fiske, J. (1997). *Television culture*. New York: Routledge.

Fleiss, M. (Producer). (2002a). Episode one. *The bachelor* [Television series episode]. Burbank, CA: ABC.

Fleiss, M. (Producer). (2002b). Episode two. *The bachelor* [Television series episode]. Burbank, CA: ABC.

Fleiss, M. (Producer). (2002c). Episode three. *The bachelor* [Television series episode]. Burbank, CA: ABC.

Fleiss, M. (Producer). (2002d). Episode four. *The bachelor* [Television series episode]. Burbank, CA: ABC.

Fleiss, M. (Producer). (2002e). Episode five. *The bachelor* [Television series episode]. Burbank, CA: ABC.

Fleiss, M. (Producer). (2002f). Episode six. *The bachelor* [Television series episode]. Burbank, CA: ABC.

Fleiss, M. (Producer). (2002g). Women tell all. *The bachelor* [Television series episode]. Burbank, CA: ABC.

Friedman, J. (2002, March 25). Television review: Looking for love in front of millions. *Los Angeles Times*, p. 20.

Galician, M.-L. (2004). *Sex, love, and romance in the mass media: Analysis and criticism of unrealistic portrayals and their influence.* Mahwah, NJ: Lawrence Erlbaum Associates.

Henry, A. (2002, April 21). When looking for love becomes voyeuristic. *Wisconsin State Journal*, p. F1.

Hinkley, D. (2002, March 27). Utterly unengaging TV contest's prize. *The Daily News* [New York], p. 79.

Ingraham, C. (1999). *White weddings: Romancing heterosexuality in popular culture.* New York: Routledge.

Maher, J. (2004). What do women watch? Tuning in to the compulsory heterosexual channel. In S. Murray & L. Ouellette (Eds.), *Reality TV: Remaking television culture* (pp. 197–212). New York: New York University Press.

Perigard, M. A. (2002, March 23). "Bachelor" is no dream date. *Boston Herald*, p. 25.

Porter, R. (2002). Facilitating love on "The bachelor." *Zap2it.com.* Retrieved April 2, 2002, from http://tv.zap2it.com/news/tvnewsdaily.html?24778

Radway, J. (1984). *Reading the romance: Women, patriarchy, and popular literature.* Chapel Hill, NC: University of North Carolina Press.

Raymond, J. G. (1986). *A passion for friends: Toward a philosophy of female affection.* Boston: Beacon Press.

Rich, A. (1986). *Blood, bread, and poetry: Selected prose 1979–1985.* New York: W. W. Norton.

Richardson, D. (1996). Heterosexuality and social theory. In D. Richardson (Ed.), *Theorising heterosexuality: Telling it straight* (pp. 1–20). Buckingham, UK: Open University Press.

Stein, P. J. (1978). The lifestyles and life changes of the never-married. *Marriage and Family Review, 1*, 1–24.

Trista: The bachelorettes. (2002). *The Bachelor.* Retrieved April 15, 2002, from http://www.abc.abcnews.go.com/primetime/specials/bachelor/bios/Trista.html

Vejnoska, J. (2002, June 8). Networks say "I do" as couples court. *The Atlanta Journal-Constitution*, p. 1F.

Andrea M. McClanahan is an assistant professor in the Department of Communication Studies at East Stroudsburg University of Pennsylvania in East Stroudsburg. She earned her Ph.D. from Ohio University in 2003, her M.A. from Ball State University in 1999, and her B.A. from Bloomsburg University of Pennsylvania in 1998. Her research focuses on the alternative life choices of heterosexual women—including the choice to remain single and/or childless—and how these choices are conveyed in the media and received by society. She has co-authored several book chapters on age-related infertility. She focuses her teaching in rhetorical studies, gender and communication, argumentation, and persuasion.

CHAPTER 22

"Real" Love Myths and Magnified Media Effects of *The Bachelorette*

Lisa M. Glebatis
The University of Texas at Austin

Trista: This is a day I've dreamt about my entire life. Since I was a little girl, I've had visions of a man who I could see my future with [*sic*] but someone whose face was always blurred until now.

Ryan: I love you with every ounce of who I am, and offer you my hand, my heart and soul, and my love forever, if you'll have it.

—*The Bachelorette*, February 19, 2003

Six weeks prior to these confessions, Trista and Ryan were complete strangers. But thanks to ABC's 2003 reality romance, *The Bachelorette*, this couple formed and even made the ultimate commitment to marry. It is not uncommon to see scenes like this on television. Bachen and Illouz (1996) even opined that romance may be an obsessive theme in our culture. *The Bachelorette* capitalized on this American interest in romance with a seven-episode series showcasing 25 men vying for the affection of bachelorette Trista Rehn. Ryan emerged as the winner of a fiancée.

An estimated 20 million people tuned in to witness the engagement of Trista and Ryan (Gliatto, 2003). Although many viewers may admit to deriving entertainment value from this romantic story, would they acknowledge being influenced by the show in any way? Numerous studies have found support for a link between media images and viewers' conceptions of romance (Bachen & Illouz, 1996; Illouz, 1998; Wood, Senn, Desmarais, Park, & Verberg, 2002). These studies found media effects not only with children who have little experience with romance but also with adults who are presumably more in tune with what happens in the "real world."

Attempting to better understand the specific ways in which television influences viewers' romantic notions, Segrin and Nabi (2002) discovered that people who consumed higher amounts of the "relationship-specific genre expressed more

immediate and idealistic marital intentions" (p. 257). These results parallel Gali-
cian's (2004) findings that the discordance between mediated images and what
happens in the real world creates unrealistic expectations that are potentially
harmful for relationships (p. 220). This chapter addresses 3 of the 12 mass medi-
ated sex, love, and romance myths that Galician (2004) identified as factors con-
tributing to relationship disillusion.

To enhance the importance of critically analyzing televised images of romance,
I will first elaborate on Galician's (2004) Myth #12: "Since mass media portray-
als of romance aren't 'real,' they don't really affect you" (p. 219). Although I
have not performed an effects study, I have synthesized previous findings and
expounded upon characteristics of The Bachelorette that point to potentially en-
hanced effects of the show's ideologies on viewers. As a source of information
about dating and romance, The Bachelorette unfortunately presents many poten-
tially harmful messages, including Galician's Myth #2: "There's such a thing as
'love at first sight'" (p. 127) and Myth #10: "The right mate 'completes you'—
filling your needs and making your dreams come true" (p. 201). Following the me-
dia effects discussion, I will cite specific examples from the text to explain how
these myths are prominently represented in The Bachelorette.

THE SHOW

The Bachelorette is particularly ripe for analysis of romantic messages as it depicts
the formation of a couple. After two seasons of The Bachelor had aired, produc-
ers flipped the gender roles and put bachelorette Trista Rehn in the position of
power. The Bachelorette is now in its third season but throughout the years, the
general formula has stayed the same: After going on a week of whirlwind dates
with either individuals or small groups, the bachelorette decides who is still in the
running to win her heart. Each episode culminates in a "rose ceremony" in which
a previously mandated number of men either receive roses as a symbol of con-
tinued relationship potential or receive their notice to go home. The final episode
depicts the selection of one man and the next step in the couple's commitment to
one another—the chosen male has the option to propose.

MAGNIFIED EFFECTS MODEL

The recent explosion of the reality genre has further blurred the lines between the
television world and real world. The diversity of shows in this genre is framed in
different ways, and various editing decisions have an impact on how the audi-
ences process the content. As Hall (1980) asserted, institutional network struc-

tures visually and aurally encode messages into meaningful discourse so that they may be decoded by viewers to serve as entertainment, instruction, or persuasion or have a variety of other "effects." Media effects is a blanket term describing how television, film, print, and other sources of mass information may influence what we think about, how we interpret events, and the ways in which we act.

Television viewers do not receive media effects uniformly, and there are a host of variables that contribute to the relative influence of this medium. To argue for the potentially magnified effects of *The Bachelorette's* romantic messages on view-ers, I have created a show-specific media effects model involving variables of generic similarities, suspense, parasocial relationships, and estimations of realism. Because the interrelated nature of the variables is a bit complicated, Figure 22–1 presents a visual illustration of these components.

I argue that two factors—similarities to preestablished genres and maintenance of suspense—enhance the likelihood of parasocial relationships for viewers of *The Bachelorette*. Parasocial relationships, or feelings of closeness on behalf of a viewer

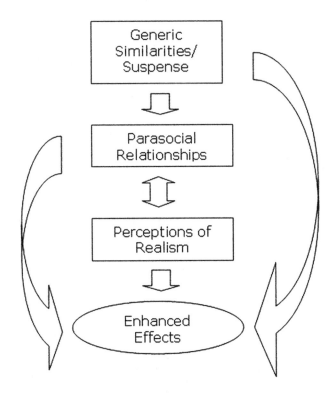

FIGURE 22–1. Enhanced Media Effects Model.

toward a media personality (Horton & Wohl, 1956), have a bidirectional influence with perceptions of realism. By themselves, parasocial relationships are positively related to effects, but the factor of realism perception may also moderate and enhance that relationship. Generic similarities, while contributing to the formation of parasocial relationships, may also directly enhance perceptions of realism. The interrelated nature of parasocial relationships, perceptions of realism, and effects is supported by various studies, as discussed in the next section.

Parasocial Relationships, Realism, and Effects

Hoffner and Cantor (1991) asserted, "After watching a series regularly for a period of time, or several sequels to a film, viewers become familiar with the personalities, preferences, and habits of characters and may come to feel that they know the characters as well as friends or neighbors" (p. 90). The theory of parasocial interaction was developed in 1956 by Horton and Wohl to explain this phenomenon of forming realistic (pseudo) relationships with media personalities.

The association between parasocial interaction and perceptions of realism is multidirectional in that parasocial interactions constitute a dimension of perceived reality and are also assumed to affect the perception of reality (Rubin, Perse, & Powell, 1985). Potter (1988) asserted a more specific relationship between these variables, explaining that evidence of parasocial relationships "means that they [viewers] have created a strong sense of realness about that character" (p. 28). Rubin and Perse (1987) alleged that signs of parasocial interaction are considered an indication that viewers are actively processing the content of that program. It is perhaps this active processing that led Potter (1986) to find that viewers are more "likely to be influenced by it [content they perceived to be real] than are viewers who believe the content to be fictional or stylized" (p. 168).

The positive correlation between parasocial relationships and realism forms the basis of my effects theory, demonstrating how viewers may more readily adopt the messages present in *The Bachelorette*. I will now discuss the two variables of generic similarities and suspense that I posit may collectively enhance the likelihood and strength of parasocial relationships.

Generic Parentage

TV Guide has classified *The Bachelorette* as part of the nascent genre of reality television (2005, p. 120), but it is important to recognize the show's generic derivations: Many forms of reality television have antecedents in soap opera and documentary. Like soap operas, *The Bachelorette* is serial in nature and showcases melodramatic content. Comparing the reality program *Big Brother* to soap operas, Fetveit (2002) noted that "this social laboratory will produce 'real life soap characters'" (p. 134). Although soaps and documentaries may seem dissimilar, *The Bachelorette* incorporates aspects of both. Like documentaries, reality romance pro-

grams present events that really happened, but only after they have been heavily edited. As Benson and Anderson (2002) asserted, "One [a documentary film-maker] works from social actuality but necessarily imposes form upon that actual-ity, turning it into what may be implied by the terms *art* or *fiction*" (p. 1). "Real-ity" will never exist on television according to Butler (1994) because television producers cannot present a situation without "first recasting it in the language of television and thereby modifying or 'fictionalizing' it to some extent" (p. 65).

Although there are arguably many differences between soap operas and real-ity programs such as *The Bachelorette*, the serial similarity is notable because it frames melodramatic content so that audiences are more likely to become in-vested in the program. Allen cited the "resistance to closure" as one key charac-teristic of soap operas (1985, p. 137) and offered the hypothesis that we "cannot help but be inside the narrative flow" of the show until we find ourselves posi-tioned at "The End" and are therefore able to reflect back on the entire text (1992, p. 109). This observation can be successfully appropriated to interpret the viewing experience of *The Bachelorette*: This 6-week reality romance is not as long-lasting as a typical soap opera but, according to Allen's definition, may be classified as a "less open serial" because closure (in the form of the couple be-coming engaged) is delayed until the very end (1992, p. 107).

Serials and less open serials encourage audience involvement in the show and connection to characters. Even scripted, purely fictitious television programs po-tentially become very real to their viewers. Buckman (1992) observed that soap opera fans will send characters cards and gifts celebrating fictitious milestones and further notes that soap fans will oddly write to fictional characters asking "favours [sic] or advice about personal problems" (pp. 192–193). It seems obvious that these characters are played by actors and that the alien abductions, betrayals, and returns from the dead depicted on soap operas are not representative of real life. However, Shrum (1999) found that heavy soap opera viewers (those who watched 4 or more hours a week) held "more distrustful attitudes towards people and a greater belief that they would experience marital problems" (pp. 16–17). If the perceived realism of soap operas and soap opera characters is so high, what are the implications for viewers of a show that is touted as "real"?

The similarities of serial form and melodramatic content potentially substan-tiate the claim that reality audiences are likely to form parasocial relationships with the personalities. Furthermore, the similarities to the documentary genre offer tentative support that audiences may overestimate the realness of the con-tent with which they are being presented. Nichols (1991) observed:

> Technique, style, and rhetoric go to compose the voice of documentary. . . . It is a proposition about how the world is . . . that invites consent. "This is so, isn't it?" The work of rhetoric is to move us to answer, "Yes, it's so," tacitly—whereby a set of assumptions and an image of the world implant themselves, available for use as ori-entation and guide in the future. (p. 140)

Because reality television is a relatively new genre, audiences may use their familiarity with documentary and soap opera genres as frameworks to evaluate the content of *The Bachelorette*. The melodramatic content, serial nature, and rhetoric of "realness" may incite viewers to form parasocial relationships and to overestimate realism.

Suspense

The serial nature of *The Bachelorette* has important implications beyond its similarity to soap operas. The format probably enhances viewer suspense and encourages speculation as to what will happen next. Throughout the season, anticipation continuously builds, encouraging viewers to tune in to the last few episodes. This format has been successful enough to proliferate: Network executives have increasingly employed the reality television format of having a short run of original episodes so that audiences will be encouraged to turn in consistently each week to various shows (Carter, 2003).

Because there is no closure until the seventh episode, audiences are encouraged to speculate as to the final outcome. Although audiences cannot reflect back on the entire text until the end (Allen, 1992), they may try to make sense of the previous events. Because of the evaluative and speculative response the serial structure elicits, the audience is encouraged to have a communal viewing experience, either by watching with a group or discussing the episode later with others. Through online message boards, numerous magazine articles, talk shows, and even personal conversations, the viewing experience may transcend that one night a week.

There are many message boards dedicated to discussions of the show. Two days before the final episode, many of the contributors to the official ABC message board (http://abc.abcnews.go.com/primetime/bachelorette/gallery) offered their opinions of the remaining men and guessed who would be chosen. One contributor offered:

> Seriously though, I think it has been Charlie from the start. I think he is the only one that can stand up to her demands—and she seems like she could be a very demanding person. Ryan is too sweet and shy. I think from the very first night she "felt" something for Charlie, and we can't help who we love. (February 17, 2003)

Another contributor agreed but provided a nonverbal analysis to support speculation that Charlie would win: "She smiled exactly the same way when both Ryan and Charlie were mentioned . . . the only difference was she touched her hair when they mentioned Charlie . . . every time someone mentions Charlie, she gets nervous . . . meaning that he's the one" (February 17, 2003).

In his analysis of viewing behaviors, Farhi (2002) noted that many women watch the show "communally . . . offering running commentary on the proceedings" (p. 1). The Web site for the fall 2003 season of *The Bachelor* (http://abc.abcnews .go.com/primetime/bachelor) even encouraged people to host "Bachelor Parties" (offering up a link for "Evites" so that one could easily e-mail invitations to these parties). The way we watch television has notable implications as to how we may evaluate the programs. Through this communal viewing experience and discussion of the show, the characters may take on even more life-like qualities (viewers talk about them as if they were "real" people). Communal viewing encourages audience members to form parasocial relationships and become more involved in the program.

The order in which the men are called during the rose ceremony also has implications for how viewers respond to the text. Ryan and Charlie were both rhetorically constructed to appear as if they were the favorites: through the use of Trista's video diary commentary (in which she was the only one in the shot, speaking directly to the camera) and through the disproportionate amount of camera time focused on their interactions with Trista. It seemed that the first roses were given to the men who would obviously be chosen and the more surprising roses were doled out last. The editing of the show therefore encouraged us to think that Ryan and Charlie were in the lead (and to verbalize our impressions during the communal viewing experience) and then validated that impression when the men were given the first two roses.

The two aspects of *The Bachelorette* that I have discussed—generic derivations and suspense—both potentially enhance the parasocial relationships formed by the viewers. The parasocial relationships and verisimilitude may collectively enhance the effects of the text's messages on the audience. The enhanced media effects implied by these program characteristics debunk the myth that television is inconsequential entertainment (Myth #12; Galician, 2004, p. 219), thereby strengthening the importance of analyzing the potentially harmful messages in *The Bachelorette*. In the next section of this chapter I examine how the existence of love at first sight (Myth #2; p. 127) and the need for a mate to complete one's life (Myth #10; p. 201) are represented in the program.

MYTHS IN *THE BACHELORETTE*

The Bachelorette has been criticized for reducing "courtship and matrimony to a Darwinian TV sport" (Farhi, 2002, p. C1). Like most sporting events, there is a time constraint on *The Bachelorette* (6 weeks) and an end goal (the formation of a relationship). Although no one can accurately predict the outcome of every game within the first few seconds, many people (announcers, gamblers, sports writers, spectators, and others) attempt to do so. The same often holds true with

those who are players in the game of love. The participants on *The Bachelorette* are no different: Throughout the series, the time-tested nature of love takes a back seat to the immediate gratification of love at first sight, Galician's Myth #2 (2004, p. 131).

The stakes of this game are also raised because finding a mate is framed as a life-long goal for the participants (Myth #10; Galician, 2004, p. 201). Just as winning a championship game is considered the pinnacle of an athletic career, finding a partner is considered the ultimate personal goal on *The Bachelorette*. Although this may be a legitimate goal for many, the importance of finding a mate is emphasized to the point at which personal connections are correspondingly deemphasized. In the following sections, I will explain how both of these myths are rhetorically constructed through the dialogue and visuals of *The Bachelorette*.

Galician's Myth #2: Love at First Sight

In the first episode of *The Bachelorette*, 10 minutes were devoted solely to showing the men exiting their limousines and introducing themselves to Trista one by one. Although many interactions involved the standard greeting of "Hello, Trista, my name is . . .," more significance was attached to some of the initial meetings. For example, Brian noted, "I do believe in love at first sight. . . . You never know" (January 8, 2003). Contestant Brooke also conceded to the possibility: "If there's love at first sight, I think he [Rob] has it" (January 8, 2003). This quote was repeated again in subsequent episodes and in the advertisements for upcoming episodes.

By the end of the first evening and after conversing with them for only a few minutes, Trista already made predictions about which men had the strongest relationship potential. She confessed to host Chris Harrison that Charlie, Russell, Ryan, and Jamie all made great first impressions. Within that group, Charlie and Russell seemed to stand out the most. With regard to Russell, Trista said, "It felt right. It just felt like it was meant to be. . . ." Charlie's appearance also sparked something in her as Trista noted, "The person I'm most sexually attracted to is probably Charlie," adding, "Hands down, he's got it, he's got the look" (January 8, 2003).

Although Trista admitted having feelings for several of the men upon meeting them, her first impressions of Charlie and Russell were strongly emphasized throughout the series. A clip of Charlie leaving the limousine in Episode One was replayed in several subsequent episodes. That Charlie was the final man to meet Trista may have been crafty foresight on behalf of producers. As he was batting cleanup, there was something more memorable about Charlie's first meeting with Trista. The scene was visually enhanced with glowing lights and the dialogue was pleasing as Charlie announced the "good news" that he was the last one. Their interaction drew laughter and a big smile from Trista, and the two just seemed to hit it off.

Trista discussed her "gut reaction" to Russell and Charlie in candid video diaries and in interviews with host Chris Harrison. Whereas the host interviews seemed very intimate, the video diaries encouraged parasocial interaction in that the speaker appeared to be talking right into the camera (and directly to the audience)—as if we were her confidants while she was confessing her feelings about the men. In the second episode, the audience was made to feel we had an omniscient presence as we witnessed "private" conversations with the men. Trista admitted to Russell, "I'm feeling this incredible chemistry with you" right before they kiss (January 15, 2003). Shortly after the kiss was shown, Russell confessed in a video diary, "I think Trista and I both realized tonight that it was meant to be. My gut feeling tonight is that I will be the last man standing." It is important to keep in mind that these confessions of a lifelong relationship potential were made after only the second meeting between Trista and Russell.

Although Trista's first impression of Russell was strong, it was Charlie who really gained her attention. Trista disclosed to Charlie in the second episode, "I hadn't had any one person just blow me away, but when you stepped out of the limo, I was like 'oh my God, that's him'. . . . So you have no worries" (January 15, 2003). As the dates progressed, Trista appeared to trust her first instincts about Charlie even more as she asserted that the attraction was not just on a "physical level" but they have "had this crazy connection . . . since he stepped out of the limo" (January 29, 2004).

Trista made many references to her strong first reactions toward Russell and Charlie. Russell was eliminated in the second to last episode after the two engaged in much bickering. Throughout the series, however, Trista maintained that there were fireworks when she met Russell. Charlie was not eliminated until the final episode, and their relationship progressed to a more intimate level than did that of Trista and Russell. The notion of falling in love at first sight with Charlie was repeated again visually and/or aurally in all of the episodes: The scene of Charlie's stepping out of the limousine is shown or Trista's verbally recounting her striking reaction to him, providing many reminders of love at first sight. Ironically as Trista rejected Charlie in the final episode, she confessed: "Charlie, the first time that I saw you, I got chills on top of my goosebumps. When you stepped out of the limo, a tiny little voice inside of my head told me that you were the one. But Charlie, my heart has led me another way" (February 19, 2003).

Although Trista's decision to choose Ryan over Charlie or Russell went against the existence of love at first sight, the myth still figured as a prominent part of the narrative. In all of these episodes, "gut" reactions were cited as factors in Trista's decisions. Indeed, the audience (and at least one of the men) seemed to buy into the myth of love at first sight. The message boards were dominated by speculation that Charlie would be the victor. As Ryan noted in a post-finale interview on *Good Morning America*, his friends and family were so convinced Charlie had won, they fervently attempted to console him (February 20, 2003).

Unfortunately, Charlie also bought into Trista's confessions of love at first sight, saying after the final ceremony that he felt "hit by a bus," citing as explanation of his surprise, "Trista has told me, she said, 'You know, when you got out of the limousine, I knew you were the one'" (February 19, 2003). In this situation, it appears that Trista followed Galician's (2004) advice, "Real love takes real time" (p. 131) and got to know the shy Ryan better throughout the 6 weeks, per Rx #2: "Consult your calendar and count carefully."

Galician's Myth #10: You Complete Me

Why would people go on television to find a mate, allowing their friends, family, and complete strangers to watch their admitting personal feelings, engaging in intimate moments, and possibly suffering heartbreak? One believable answer is that these people are desperate to find a life partner, and this is indeed a prominent theme throughout *The Bachelorette*.

Like love at first sight, the myth that one's life will be completed by a mate (Myth #10; Galician, 2004, p. 201) originated in the first episode and was represented throughout the series. Trista made it clear before she met the men that finding a romantic relationship was a high priority for her. As host Harrison interviewed her, many of Trista's statements pointed to the importance of finding a mate. She explained, "The one thing I want in life is to be in love. And after tonight, I know it's going to happen. . . ." (January 8, 2003). The goal of this process was for Trista to find "Mr. Right." Although I am not criticizing each participant's focus on finding a mate, the intense importance placed on having a romantic relationship made it seem that not being married (or not wanting to be married) is somehow wrong. Not everyone is in the right position for a long-term relationship. As Galician (2004) advised, "First, you have to complete yourself" ("Cultivate your own completeness," Rx #10; p. 203).

Many of the men announced serious intentions in the first episode. Eventual victor Ryan noted that he would "go to any lengths for love because it's such a valuable thing these days" (January 8, 2003). Runner-up Charlie confessed: "I'm a hopeless romantic. I know ultimately my life won't be fulfilled until I meet, you know, the right woman" (January 8, 2003). Some of the others admitted to putting their work and careers on hold (Jamie even gave up a professional basketball contract in Germany) to get to know Trista, signaling a strong level of involvement in the courtship process.

The participants' comments about needing a mate became more serious as the episodes progressed. Trista and some of the remaining men noted that forming a long-lasting relationship was essential to their well-being. It seemed that many of the contestants had achieved educational, financial, and career goals, and all that was left was to find someone with whom to live that life. As Russell stated in the third episode, "I have everything in my life. I just don't have some-

one to share it with" (January 22, 2003). When Trista met Russell's family, his sister asserted in an interview, "I can tell he likes Trista, and I can tell he's looking for a mate" (January 29, 2003).

Finding a wife also appeared to be a high priority for Charlie. As he got closer to "winning" the competition, Charlie confessed in a video diary, "Everything that I've been in search of for the past 28 years is starting to come together" (February 19, 2003). This powerful statement made it seem that finding a wife had been Charlie's main goal for his entire life. Another extension of the goal of finding a wife is having a family, something that Charlie also noted: "I ultimately do want a wife and I want a family and I want children. . . ." (February 19, 2003). So did these men really want Trista to be their wife, or did they just want a wife (and a childbearer)? In this situation, it is as if finding a mate was prioritized over the personal connection that the men and Trista may (or may not) have formed.

In the final rose ceremony, the importance of becoming engaged was magnified. Ryan said to Trista in a videotaped message, "I won't be quite satisfied until I have someone I love to share my life with. If you'll have me, I'd like that person to be you" (February 19, 2003). In a video diary edited to follow Ryan's confession, Trista placed the utmost importance on the proposal she was about to receive, stating, "I've dreamt about this moment since I was little. . . . The culmination of all my dreams is about to happen. . . ."

In her speech in which Trista tells Ryan that she has chosen him, she was already attaching babies, grandbabies, and other dreams to their future:

> Since I was a little girl, this is the day I have dreamt about my entire life. Since I was a little girl, I had visions of a man who I could see my future with but someone whose face was always blurred until now. Now I not only see his face but I see a future of dreams come true. I see smiles and laughter. I see babies and grandbabies. I see comfort and safety. I see a white dress and I see it with you. You stepped out of my dreams and into my world. . . . (February 19, 2003)

This passage clearly illustrates the fact that there may be an extra variable to the myth of needing a mate to complete one's life. Many of the men on *The Bachelorette* did express the need to find a mate to "share their life with," but the sentiment that sometimes got left out was that they wanted a life partner and children, two things that go hand in hand in the American dream. Based on the commentary from Trista, the men, and some of their families, the message the show appears to be sending is that the participants already have a life envisioned and all that is left to fulfill those dreams is to insert a husband or wife. This show represents an opportunity to "fill that hole" in their lives, but there is not always a great focus on the person who will fill that hole.

The myth of needing someone to complete your life is somewhat challenging for me to evaluate critically. I do believe that many people innately want to share

their life with someone and that this goal is not necessarily harmful to them. The manner in which this theme is represented in *The Bachelorette* has many positive aspects: Trista was a successful physical therapist, and she claims to have achieved many of her life goals. Several of the men were in a similar position of having met many of their personal goals. There is nothing wrong with these pictures as I see them.

One criticism I have arises when a mate is wanted so badly that the person to fill that spot is ranked in secondary importance to the role that will be filled. In my opinion, greater importance should be placed on finding the right person for you, not just a mom or dad for the children you envision as part of your life. What if you are unable to have children and find you are stuck in a relationship not built on love but on a mutual goal that will never be realized? Trista asserted that she rejected Charlie because that relational foundation was not there. Although he was obviously crushed by her decision, she claimed that he was not in love with her. Ryan on the other hand, was one of the few participants who did not mention vague dreams of having a future with just anyone: He explained, "I won't be quite satisfied until I have someone *I love* to share my life with" (February 19, 2003).

Another criticism of this courtship portrayal is that marriage is framed as the supreme goal for the participants. Charlie and Trista acknowledged that this has been a dream of theirs for *life*, thereby sending the message that marriage is the normal goal for anyone. Currently, homosexual marriages are not sanctioned by our federal government. Marriage is stereotypically viewed as a feminine goal, but it is projected that 25% of all black women and 10% of all white women in their 20s will never marry (Furstenberg, 2001, p. 224). Does this program encourage viewers to think that unmarried women and men are in some way "abnormal?" Based on the dialogue and presentation of the show, I must say, "yes." However, marriage is obviously not the right way of life for everyone, nor is legal marriage currently possible for everyone. Although it may be a "future" goal for some, many young people watching *The Bachelorette* or *The Bachelor* (and we know from Farhi [2002] that about one in three viewers is a woman) may be pushed into a state of panic to find their own mate after watching these people desperately compete for the love of one individual.

CONCLUSION

Based on effects literature, it is evident that television serves as a love and courtship guide for people of all ages (Rx #12; Galician, 2004, p. 219). Furthermore, it is likely that reality romance programs such as *The Bachelorette* affect viewers even more than purely fictitious programming. *The Bachelorette's* similarities to soap opera and documentary genres may invite viewers to evaluate the

content as more realistic and encourage them to form pseudo-relationships with the personalities on the show. The suspense incited by the construction of the semiserial narrative also has notable implications for how the content may be perceived. Viewers are more likely to discuss the program with others and to speculate about the outcome, thereby making the program and the personalities feel more real to them. The resulting parasocial relationships and high estimations of realism build on one another, collectively magnifying media effects. It is important to recognize that these mediated images of romance and courtship might affect viewers and, therefore, it is important to be critical of the love myths that are represented in the program.

In the beginning of the first episode, viewers were inundated with Myth #2, the existence of love at first sight (Galician, 2004, p. 127). We were then reminded through the dialogue and the repetition of Charlie's exiting the limo that Trista felt "fireworks" when first meeting Russell and thought she knew Charlie was "the one" from the start. The ending of the show contradicted these gut reactions as Trista chose Ryan; however, the damage was done and viewers were presented with several episodes reiterating the power of love at first sight.

Perhaps the participants were trying to believe in love at first sight because they were so desperate to find a mate who would fulfill their dreams. The importance of pairing off is inherent in the concept of the show and is emphasized throughout by the dialogue. The participants' comments regarding finding a life partner got more serious yet stayed impersonal throughout the process. Ryan did say that he wanted someone he "loves" to spend the rest of his life with, yet Trista and some of the other men merely discussed vague lifelong dreams of having a spouse and a family. The emphasis on finding a mate (any mate) to complete one's life simultaneously devalues the importance of a compatible love connection and overvalues the importance of getting married (in a society in which many people may not want to or may not be able to enter into a legal bond).

Producer Mike Fleiss has repeatedly denied ABC's requests to stretch out the length of The Bachelor and The Bachelorette because "If you keep the cycle tight, each episode has real stakes. And that's key" (as cited in Kiesewetter, 2003). This point is also key to explaining the show's focus on love at first sight and the important of having a mate. As Galician (2004) noted regarding love at first sight, it is "far easier to portray (and simpler for audiences to follow) than the more cerebral and time-intensive processes of love" (p. 129). For audiences to become invested in this show, they must believe in the romantic myths that are being presented. If there are no real stakes, the show would not be likely to draw as many viewers.

Although sitting on one's couch to enjoy a television program may not seem like a dangerous activity, media effects literature alerts us to the fact that television viewing also has real stakes. Unfortunately, The Bachelorette perpetuates

the unrealistic notions that we need love and we need it now. Viewers should be aware of the ways in which television may affect them and also critically evaluate the idealistic myths presented to them in romantic media.

ACKNOWLEDGMENT

A portion of this chapter was derived from my Master's thesis. I thank my M.A. advisor, Dr. Thomas W. Benson, for his guidance.

STUDY QUESTIONS/RECOMMENDED EXERCISES

1. What are some differences you have observed between reality television and purely fictitious programs? How do you think these differences affect your viewing experience?

2. Have you formed any parasocial relationships with media personalities? Can you think of friends who have formed these pseudo-relationships? To what extremes have you or your friends taken these relationships?

3. How do you watch television (where, with whom, etc.)? Does your answer vary according to the show you are watching? How do you think this variation alters your perception of the content?

4. *The Bachelorette* producer Mike Fleiss has refused requests to extend the number of episodes in a season. Do you think a longer courtship period would decrease the prevalence of love myths represented in the show? Explain.

5. Do you agree with Bachen and Illouz (1996) that love is an obsessive theme in our culture? What media examples can you cite to support your answer?

REFERENCES

ABC official *Bachelorette* web page. Retrieved April 4, 2003, from http://abc.abcnews.go.com/primetime/bachelorette/gallery

Allen, R. C. (1985). *Speaking of soap operas.* Chapel Hill, NC: University of North Carolina Press.

Allen, R. C. (1992). Audience-oriented criticism and television. In R. C. Allen (Ed.), *Channels of discourse, reassembled* (pp. 101–137). Chapel Hill, NC: University of North Carolina Press.

Bachen, C. M., & Illouz, E. (1996). Imagining romance: Young people's cultural models of romance and love. *Critical Studies in Mass Communication, 13,* 279–308. Retrieved March 1, 2003, from ProQuest Direct Database.

Benson, T. W., & Anderson, C. (2002). *Reality fictions: The films of Frederick Wiseman* (2nd ed.). Carbondale, IL: Southern Illinois University Press.

Buckman, P. (1984). *All for love: A study in soap opera.* Salem, NH: Salem House.

Butler, J. G. (1994). *Television: Critical methods and applications.* Belmont, CA: Wadsworth.

Carter, B. (2003, December 22). Networks find reality has become part of life. *The New York Times,* Retrieved December 27, 2003, from www.nytimes.com

Farhi, P. (2002, November 20). Popping the question: Why has "The Bachelor" become irresistible to women? *The Washington Post,* p. C1. Retrieved September 21, 2004, from ProQuest Direct Database

Fetveit, A. (2002). Reality TV in the digital era: A paradox in visual culture? In J. Friedman (Ed.), *Reality squared: Televisual discourse on the real* (pp. 119–137). New Brunswick, NJ: Rutgers University Press.

Fleiss, M. (Executive Producer). (2003, January 8). Episode one. *The bachelorette* [Television series episode]. Burbank, CA: ABC.

Fleiss, M. (Executive Producer). (2003, January 15). Episode two. *The bachelorette* [Television series episode]. Burbank, CA: ABC.

Fleiss, M. (Executive Producer). (2003, January 22). Episode three. *The bachelorette* [Television series episode]. Burbank, CA: ABC.

Fleiss, M. (Executive Producer). (2003, January 29). Episode four. *The bachelorette* [Television series episode]. Burbank, CA: ABC.

Fleiss, M. (Executive Producer). (2003, February 5). Episode five. *The bachelorette* [Television series episode]. Burbank, CA: ABC.

Fleiss, M. (Executive Producer). (2003, February 12). The bachelorette reunion special. *The bachelorette* [Television series episode]. Burbank, CA: ABC.

Fleiss, M. (Executive Producer). (2003, February 19). Episode six. *The bachelorette* [Television series episode]. Burbank, CA: ABC.

Furstenberg, F. F., Jr. (2001). The fading dream: Prospects for marriage in the inner city. In E. Anderson & D. S. Massey (Eds.), *Problem of the century: Racial stratification in the United States* (pp. 224–246). New York: Russell Sage Foundation.

Galician, M.-L. (2004). *Sex, love, and romance in the mass media: Analysis and criticism of unrealistic portrayals and their influence.* Mahwah, NJ: Lawrence Erlbaum Associates.

Gliatto, T. (2003, March 10). Heading for a wedding. *People,* 58–59.

Hoffner, C., & Cantor, J. (1991). Perceiving and responding to mass media characters. In J. Bryant and D. Zillman (Eds.), *Responding to the screen: Reception and reaction processes* (pp. 63–102). Hillsdale, NJ: Lawrence Erlbaum Associates.

Horton, D., & Wohl, R. R. (1956). Observations on intimacy at a distance. *Psychiatry, 19,* 215–229.

Hall, S. (1980). Encoding/decoding. In S. Hall, D. Hobson, A. Lowe, & P. Willis. (Eds.), *Culture, media, language* (pp. 128–138). Cambridge, MA: Unwin Hyman.

Illouz, E. (1998). The lost innocence of love: Romance as a postmodern condition. *Theory, Culture, & Society, 15,* 161–186.

Kiesewetter, J. (2003, February 12). Reality show producer ABC's hottest property. *The Cincinnati Enquirer.* Retrieved January 18, 2004, from www.enquirer.com

Nichols, B. (1991). *Representing reality.* Bloomington and Indianapolis, IN: Indiana University Press.

Potter, W. J. (1986). Perceived reality and the cultivation hypothesis. *Journal of Broadcasting & Electronic Media, 30*, 159–174.

Potter, W. J. (1988). Perceived reality in television effects research. *Journal of Broadcasting & Electronic Media, 32*, 23–41.

Rubin, A. M., & Perse, E. M. (1987). Audience activity and television news gratifications. *Communication Research, 14*, 58–84.

Rubin, A. M., Perse, E. M., & Powell, R. A. (1985). Loneliness, parasocial interaction, and local television news viewing. *Human Communication Research, 2*, 155–180.

Segrin, C., & Nabi, R. L. (2002). Does television viewing cultivate unrealistic expectations about marriage? *Journal of Communication, 52*, 247–263.

Shrum, L. J. (1999). The relationship of television viewing with attitude strength and extremity: Implications for the cultivation effect. *Media Psychology, 1*, 3–25.

TV Guide. (2005, January 16–22).

Wood, E., Senn, C. Y., Desmarais, S., Park, L., & Verberg, N. (2002). Sources of information about dating and their perceived influence on adolescents. *Journal of Adolescent Research, 17*, 401–417.

Lisa Glebatis *is a Ph.D. candidate at the University of Texas at Austin. She earned her M.A. in 2004 from The Pennsylvania State University. Her scholarly interests revolve around rhetoric of media, as well as branching out to media effects.*

CHAPTER 23

The "Reality" of Reality Television Wedding Programs*

Erika Engstrom
University of Nevada, Las Vegas

> A wedding is a wondrous event. No pageantry unfolds with more drama, and no one remains unaffected by witnessing the celebration. It is, after all, one of the most beautiful moments in a woman's life.
>
> —Letitia Baldrige, *Legendary Brides* (2000)

One of the most beautiful moments in a woman's life, as etiquette expert Letitia Baldrige contended, also serves as the one event commonly considered to be the culmination of a romantic relationship. Historically, however, the union of two people through marriage did not require evidence of "true love"; only in the 19th century did romance and marriage become associated with each other. Today, romance has become inextricably linked to, at least, the prospect of marriage, and it has achieved an almost mythic quality as an essential part of weddings, the first step toward the "happily ever after" of familiar fairy tales. "After all," asserted Otnes and Pleck (2003), "marriage is still seen as the endpoint of romance, and a lavish wedding as the best portal to marriage" (p. 11). This expectation that a romantic relationship will lead to marriage—but first to a big wedding—has become naturalized and ingrained into our image of the wedding as the endpoint of romance.

Just as the stories presented in Harlequin romance novels have a strict set of rules with the reader already knowing how the story will go, as Modleski (1982) observed, so have we come to already have an idea of how the wedding itself should unfold. The wedding as a plot line in numerous popular films and television programs demonstrates the popularity of the wedding as a means by which

*Portions of this chapter are based on the author's articles "Hegemony in Reality-Based TV Programming: The World According to *A Wedding Story*," in *Media Report to Women* (2003), 31(1), 10–14, and "Hegemony and Counterhegemony in Bravo's *Gay Weddings*," in *Popular Culture Review* (2004), 15(2), 34–45.

we can see romantic love symbolized as the union of two people. As Ingraham (1999) asserted: "Weddings, marriage, romance, and heterosexuality become naturalized to the point where we consent to the belief that marriage is necessary to achieve a sense of well-being, belonging, passion, morality, and love" (p. 120).

Similarly, the lavish, traditional *white wedding* (so named because the bride wears a white gown) with a church ceremony has become the "natural" pattern for weddings. As a major social occasion in today's American society, the wedding also comprises a full range of elements and practices, such as gift giving, artifacts, costumes, and scripted behaviors (Otnes & Scott, 1996). Considered as a whole, as Currie (1993) stated, the wedding and all its accompanying material aspects "signifies commitment and shared love" (p. 415).

The unquestioned, commonsense notions we hold about romance as the lead-in to marriage and the wedding "script" itself both illustrate hegemony, what Italian philosopher Antonio Gramsci characterized as "the dominant cultural and political order" (Zompetti, 1997, p. 72). Simplified, it refers to the "prevailing, commonsense view for the majority of social participants" (White, 1992, p. 167). Thus, hegemony serves as "the natural, unpolitical state of things accepted by each and everyone" (van Zoonen, 1994, p. 24), those everyday practices and values regarding social life that we do not question.

This applies to the wedding and marriage as well, as Ingraham (1999) stated, ". . . we live with the illusion that marriage is somehow linked to the natural order of the universe rather than see it as it is: a social and cultural practice to serve particular interests" (p. 120). These interests, according to Ingraham (1999), include the bridal industry, and through them results the maintenance of the status quo. Related to these ideas about marriage as being natural, Geller (2001) noted that in a time when women have the option not to marry, the allure of matrimony remains a mystery. One can use hegemony—a society's dominant worldview manifested through common-sense notions and practices of its members—as an explanation for the still-desired goal of marriage and the perpetuation of the wedding ideal.

In her guide to media criticism, *Sex, Love and Romance in the Mass Media: Analysis and Criticism of Unrealistic Portrayals and Their Influence*, Galician (2004) described and deconstructed 12 hegemonic, widely held myths and stereotypes of love and romance. Love myths often include weddings as their denouements. For example, we all know that Cinderella (or Rapunzel, or Snow White) marries her prince in a beautiful wedding and lives happily ever after.

Whereas Hollywood films and television shows have long given audiences their versions of "dream" and "fairy tale" weddings, replete with lavish sets, luxurious costumes, and a bride and groom professing their undying love for each other, recent reality television programs purport to show "real couples" getting ready for their more realistic weddings. They offer viewers a glimpse into the authentic love stories of ordinary couples and provide a means to examine how myths about love

and romance reveal themselves in the lives of real people. But do these programs, which viewers watch to get ideas for their own real-life weddings (Noxon, 1999; Weiss, 2000), also depict realistic romance?

In this chapter, I discuss the presence of several myths regarding love and romance listed by Galician (2004) that apply to wedding programs in the reality television genre. I specifically consider those myths Galician (2004) described that reflect the supposed "ease" with which people find partners and decide to marry them: Myth #1: "Your perfect partner is cosmically pre-destined, so nothing/nobody can ultimately separate you" (p. 119); Myth # 2: "There's such a thing as 'love at first sight'" (p. 127); Myth #9: "All you really need is love, so it doesn't matter if you and your lover have different values" (p. 135); and Myth #10: "The right mate 'completes you'—filling your needs and making your dreams come true" (p. 135). I also discuss how these programs promote the idea that with the right person, marriage is easy and wonderful, a variation on Myth #4: "If your partner is truly meant for you, sex is easy and wonderful" (p. 145).

In that weddings center on the bride and her physical appearance (with special apparel, make-up, and hair), Myth #5 also applies: "To attract and keep a man, a woman should look like a model or centerfold" (Galician, 2004, p. 153). Additionally, because weddings highlight the roles of men and women (who later take on the roles of husband and wife), Myth #6: "The man should NOT be shorter, weaker, poorer, or less successful than the woman" (p. 163) also surfaces in some episodes of the wedding programs I critique in this chapter.

Galician's Myth #12, regarding the effects of mass media portrayals of romance, "Since mass media portrayals of romance aren't 'real,' they really don't affect you" (2004, p. 219), relates directly to this genre of television programming. Because reality television frames itself around the drama of real people and real events, viewers might perceive that programs in this genre truly reflect unscripted, unedited versions of everyday life. Even though these programs base themselves in reality, rather than a fictional world dreamed up by a writer, such notions of idealized romance still manage to manifest themselves as viewers see and hear couples interact with each other and profess their feelings about each other and their weddings.

"REAL" WEDDINGS ON TELEVISION

Although weddings depicted in Hollywood movies certainly have appealed to their (mostly female) audiences, "live" and videotaped programs make what we see on television more plausible, in a way, than movies, as Feuer (1983) observed: ". . . from a certain technological and perceptual point of view, television is live in a way that film can never be. Events can be transmitted as they occur; television (and videotape) look more 'real' to us than film" (p. 13).

Taking this notion a step further, in that videotape and live broadcasts serve as the preferred modes of reality television shows, we get the impression that television can capture *real life*—people acting naturally, unaware that others are watching them. Thus, rather than watching a taped, highly edited version of what happens to and by the ordinary folks in these programs, the noncritical viewer perceives a picture of the world as it exists. The content of such programs relies on the drama of real events and their participants—which defines the reality TV genre (Consalvo, 1998). Thus, television and reality television in particular hold more potential than fiction to truly reflect hegemony found in real life.

The reality genre has existed in television throughout its history, and the televised wedding concept as a basis for a regular television series actually dates back to 1951 (McNeil, 1991). The daytime program titled *Bride and Groom* aired live on the CBS network in New York before a coast-to-coast audience. In recent years, television wedding documentaries combine entertainment and news-style reporting on all the behind-the-scene details involved with putting on the big event. These programs offer viewers a *video verité* account of weddings of celebrity and noncelebrity couples, similar to the *cinema verité* fly-on-the-wall approach used in film (Calvert, 2000).

MEDIA MYTHS AND THE REALITY TELEVISION WEDDING SHOW

In this chapter, I critique three reality television wedding series using Galician's (2004) myths regarding the nature of romance and love: The Learning Channel's *A Wedding Story*, the Oxygen network's *Real Weddings from The Knot*, and Bravo's *Gay Weddings*, one of the newer and less traditional reality wedding programs that documents the wedding planning of same-sex couples. These programs, using documentary techniques, all follow real-life couples preparing for their weddings, giving viewers a backstage glimpse of the work, time, and effort that go into the planning of what is considered a person's, especially a woman's, most important day. All three programs approach the wedding as a social event, focusing on the days and hours before the wedding day and then on the ceremony and reception. Oftentimes, we see the happy couple riding off in a decorated "just married" car or limousine, or, occasionally, in the more romantic horse and carriage. Even as one of these programs, *Gay Weddings*, offers a counterhegemony to the assumption that weddings are reserved for heterosexual couples, all three programs frame the wedding in terms of the traditional wedding script: a formal wedding featuring a ceremony of some sort followed by a lavish party that incorporates wedding rituals and artifacts.

I chose these programs because they include information, through on-camera and voice-over narration, that offers insight into the couples' relationships in

terms of how they met and what each partner means to the other. These programs differentiate themselves from other reality-style television documentaries and one-time specials by providing viewers with footage of the couples over the course of days and even weeks before the wedding day. They provide enough individual episodes of different couples to allow for analysis of their overall and continuing messages and themes regarding romance and the way people today go about organizing weddings. They also collectively have received media attention through news stories and critiques that have noted their ratings successes and, especially in the case of *Gay Weddings*, uniqueness among other reality television offerings and television programming in general (Alter, 2002; Barovick, 2000; Brown, 1999; Cook, 2003; "Gay Weddings Go Prime Time," 2002; Harrigan, 2002; Larson, 2002; Noxon, 1999; Piepenburg, 2002; Roddy, 2000; Weiss, 2000).

These programs offer little surprise in terms of denouement: We already know the story, and the expected happily-ever-after ending, as embodied in notion that the right mate completes us and makes our dreams come true (Myth #10), becomes folded into our idealized notions of the wedding and, to a broader extent, romantic love. They celebrate the wedding ceremony's purpose as the ultimate, public consummation of romantic love and showcase Galician's myths that tell us our partners are predetermined by destiny (Myth #1) and love is all we need (Myth #9). In the following analyses, I discuss how each program incorporates Galician's romance myths and perpetuates these unrealistic notions of love in the style of television we have come to recognize and refer to as "reality."

To the uncritical viewer, these programs might provide evidence that the myths are actually true, because, after all, the couples do go through with their weddings and seem to be happy at the end of the show. What viewers do not see or hear holds just as much importance as the content included in the narratives of these programs. These omitted elements serve as the basis for my suggestions aimed at making these reality programs even more real, so that viewers can see that true love (which, in fact, does exist) encompasses more than the feelings and actions of the wedding day, going far beyond the fantasy created by the traditional wedding so widely depicted in mass media today.

The Learning Channel's *A Wedding Story*

Of the three wedding series examined here, *A Wedding Story* is the oldest, premiering on The Learning Channel (TLC) in 1996. The tremendous popularity of televised weddings, especially that of Britain's Prince Andrew and Sarah Ferguson in 1986, served as the inspiration for the program, targeted at the cable outlet's female audience (Barovick, 1999; Weiss, 2000). By 1999, with 200 episodes produced, the show had more than 1 million viewers, making it one of the most popular programs in TLC's history (Brown, 1999; Noxon, 1999). Its popularity reached new status when, in 2001, NBC's *Saturday Night Live* parodied the show

with a skit about a couple's theme wedding based on the groom's fanaticism with the rock group KISS.

Each episode of A *Wedding Story* follows the same basic pattern and includes the following: a brief segment on the couple's background, in which each partner describes how they met and who proposed in what setting; activities of the bride and groom before the wedding; the rehearsal of the ceremony and rehearsal dinner; the bride and groom separately preparing for the wedding; the wedding ceremony itself; and the reception. The only narration comes from either the bride or groom or from natural sound. The show always ends with a beautiful wedding. Indeed, the show's producers find its strength in its uniformity and predictability (Noxon, 1999). This uniformity in the weddings themselves, which largely follow the traditional white wedding (this term will be used hereafter to describe weddings in which the bride wears a formal white wedding dress) format, adds to hegemonic notions about weddings as expensive and involving numerous participants.[1]

A *Wedding Story*'s executive producer says the program looks for "really good, classic love stories" and couples who "can express themselves and their love for each other" (Brown, 1999). This emphasis on couples' love stories manifests itself in the many voice-overs and on-camera sound bites from the bride and groom as well as other participants in the wedding. In the first few minutes of the show, viewers hear how the couple met, down to the minutest details, such as what each person was wearing, where they were, and the circumstances surrounding their first meeting. Viewers then learn how these couples' romances developed. Some began as friendships, and some as long-distance courtships.

Couples also share their marriage proposal stories; these follow a similar pattern in nearly all episodes, with the man surprising his girlfriend with an engagement ring and asking her to marry him on bended knee. This cliché of the man's proposing and buying an expensive (diamond) ring illustrates an additional romance myth, described by Galician (2004) that reflects traditional gender roles: "The man should NOT be shorter, weaker, younger, poorer, or less successful than the woman" (Myth #6; p. 163). Galician offers a prescription to this myth to counter the pressures put on "the man" in the relationship to propose marriage to the woman: "Create co-equality; cooperate" (Prescription #6; p. 163). A true partnership, one in which both parties assume equal responsibilities for the health of the relationship and subsequent marriage, would entail both partners' agreeing to the marriage, rather than the man's "popping the question."

Throughout each episode, viewers see couples attending ceremony rehearsals and rehearsal dinners, brides trying on their gowns, grooms and groomsmen visiting the tuxedo shop for last-minute fittings, and learn how others view the couple. Viewers get the sense that all involved approve wholeheartedly of the match. As

[1]Based on the author's analysis of 100 episodes in "Hegemony in Reality-Based TV Programming: The World According to A *Wedding Story*," in *Media Report to Women* (2003), *31*(1), 10–14.

one bridesmaid, who arranged the blind date that brought together Dorothy and Shane, put it, "When you see them together, you get it. They just fit" ("Dorothy and Shane," 2004). A friend of Tim and Heather offered a similar comment, "He has found his soul mate" ("Heather and Tim," 2004). These comments reinforce two of Galician's (2004) myths: that one's partner is cosmically predestined (Myth #1; p. 119) and that a person becomes a whole being only with the right mate (Myth #10; p. 201).

Couples describe how they feel about their soon-to-be spouse, often through either voice-over narration or on camera interview-style. Although viewers never see or hear the interviewer, one can deduce the questions being asked off-camera: "Why do you love [name]?" or "Why do you want to marry [name]?" I found remarkably similar responses in the five episodes from different seasons I viewed.[2] For example, brides and grooms often use words such as "soul mate" and "best friend" to describe their partners (some even use the term "partner"). Jason says of his wife-to-be, "She makes me a whole person." Evan says of his bride, "Michelle really completes me," whereas, separately, Michelle says, "He brings balance to my life" ("Michelle and Evan," 2004). Even 20-year-old Christine, whose occupation remains unknown, says of Kyle, her 22-year-old firefighter husband-to-be, "He completes me" ("Christine and Kyle," 2004).

Comments such as these illustrate these couples' belief that they have found the one person in the world who makes their existence worthwhile, which illustrates Galician's Myth #10: "The right mate 'completes you'—filling your needs and making your dreams come true." (2004, p. 201). When Esmeralda says of Jason, "I can't imagine not having him," she emphasizes that not only does he complete her, but also that she cannot live without him ("Esmeralda and Jason," 2004).

The idea of permanence and perfection illustrates couples' "knowing" they have found the right person, illustrating Galician's Myth #1: "Your perfect partner is cosmically pre-destined, so nothing/nobody can ultimately separate you" (2004, p. 119). Viewers hear these happy couples expressing their good fortune in finding the perfect person who is "the one." "She's everything I've been looking for," says Evan of his wife-to-be Michelle ("Michelle and Evan," 2004). "I knew right then that this is it," says Dorothy ("Dorothy and Shane," 2004).

For the most part, viewers do not hear of past relationships; the program excludes mention of failed relationships that these "perfect" couples had to experience before finding their perfect match. It seems couples find each other magically, without having to "consider countless candidates," (Prescription #1; 2004, p. 119). The resulting message implies that for these couples (and, thus, for viewers) love eventually will come and that it is just a matter of waiting.

[2]Episodes of A *Wedding Story* can remain in rotation for years. Title and air date of the episodes discussed here are as follows: "Michelle and Evan," September 20, 2004; "Dorothy and Shane," September 28, 2004; "Esmeralda and Jason," September 28, 2004; "Heather and Tim," September 30, 2004; and "Christine and Kyle" September 2004, exact date unavailable.

Episodes of A *Wedding Story* end with joyous dancing at the couple's reception, complete with footage of the cake-cutting ritual and toasts to the happy couple. As the celebration unfolds, voice-overs by the couples summarize their wedding stories and their good fortune in finding true love. Shane, together with Dorothy for 4 years before marrying her, says living every day with her is "going to be fantastic" ("Dorothy and Shane," 2004). Jason foresees happiness in 30 years similar to that of his wedding day: "I don't think that's going to fade," he says, concluding, "I think we have found true love and we're just lucky to find each other" ("Esmeralda and Jason," 2004). These comments illustrate an adaptation of Galician's Myth #4, "If your partner is truly meant for you, sex is easy and wonderful" (2004, p. 145). For this program, viewers get the (mistaken) impression that if your partner is truly meant for you, *marriage* is easy and wonderful. In sum, marriage, as portrayed in A *Wedding Story*, serves as simply the continuation of the love and happiness couples experience on their big day.

Oxygen's *Real Weddings from The Knot*

According to http://www.theknot.com, The Knot "is the most comprehensive resource for couples seeking information and services to help plan their wedding and their future lives together." Self-claimed as the number-one wedding Web site, with 2.1 million unique users, The Knot also appears in magazine form. In 2002, The Knot announced its collaboration with the Oxygen network, the cable outlet aimed at women viewers and co-founded by media mogul Oprah Winfrey, to produce a reality-based mini-series (Larson, 2002). First aired in January 2003, the series featured five episodes over the course of a week, with a weekend "marathon." A second season, starring five more couples, aired in January 2004, with a bridal fashion show special following a marathon of those episodes. By then, the president of programming for Oxygen Media claimed that the series' ratings increased by 100% from January 2003, drawing 2.7 million viewers to "Oxygen's Wedding Week" in 2004 ("Oxygen Proposes to The Knot," 2004).

Similar in format to TLC's A *Wedding Story*, *Real Weddings from The Knot* follows couples "from all walks of life with all kinds of weddings are featured, providing viewers with a real-world understanding of what weddings are really like" ("Oxygen Proposes to The Knot," 2004). The miniseries includes lavish, formal weddings as well as down-sized weddings from around the country. Of the 10 episodes from the first two seasons, one even featured the upscale New York wedding of Susan Orlean, author of *The Orchid Thief*.[3]

[3]Episodes of *Real Weddings from the Knot* can be repeated from year to year. Title and air dates of the episodes discussed here are as follows: "Lori and Mark," January 25, 2004; "Cara and Aaron," January 21, 2004; "Kaijsa and Ryan," January 19, 2004; "Orisha and John," January 19, 2004; "Catina and Todd," June 8, 2003; "Susan and John," June 8, 2003; and "Danielle and John," June 7, 2003.

As with *A Wedding Story*, *Real Weddings from The Knot* provides viewers with a countdown to the wedding ceremony. Narration comes from the bride, groom, and others via natural sound or on-camera commentary, with scripted voice-overs by the bride at the beginning and conclusion of each episode. Viewers watch couples engaged in mundane tasks, such as shopping for shoes, printing out a wedding program, and shopping at Wal-Mart. On-screen titles, such as in the case of Orisha and John, who already live together and have a daughter, "1 month—Living in Sin," or "1 day—The Rehearsal" ("Orisha and John," 2004), separate segments presented in chronological order that give viewers a sense that the big day is approaching quickly. Episodes conclude with the wedding reception, with the familiar dancing, cake cutting, banquet-style dinner, and champagne toast.

For the most part, the focus stays on the wedding planning with only occasional commentary about what the brides and grooms in these relationships actually feel about the other or why they wish to marry. Some couples tie the planning of their weddings to their views of marriage itself, seeing the work and effort that go into putting on the ceremony and intricate maneuvers of the reception as a kind of training for married life. Taken together, the impression left with the viewer is that these couples somehow magically found each other and that destiny brought them together, illustrating Galician's Myth #1: "Your perfect partner is cosmically predestined, so nothing/nobody can ultimately separate you" (2004, p. 119). This idealistic view of romance remains strongly held even by those on the program who have been married previously. For example, Mark, a divorced father of two girls, sees his wedding to Lori (whose age and occupation are never mentioned) at a resort in the Bahamas as a way to bring their families together "and say in front of them that we love each other and that we'll love each other forever" ("Lori and Mark," 2003). John, who will marry Orisha (the mother of his young daughter) comments, "If you love someone, things are going to happen the way they're supposed to happen" ("Orisha and John," 2003). Galician has noted that this myth encourages people to be passive about their relationships: ". . . waiting for 'destiny' and its magical signs is easier than taking responsibility for your own life and love by doing your own work and trusting your own judgments" (2004, p. 124).

The idea of wholeness that a partner brings (Myth #10; Galician, p. 201) serves as a recurrent theme in *Real Weddings from The Knot*. Just as couples in *A Wedding Story* speak of their spouse-to-be as completing them, several couples in this program refer to this idea of wholeness that marriage brings. For example, Kaijsa, who met Ryan in college, and converts to Judaism the day before their ritzy hotel wedding, says, "I think we complement each other and I think we're really lucky to have that balance" ("Kaijsa and Ryan," 2004). In fact, *Real Weddings from The Knot* presents brides and grooms as one entity; individual identities seem unimportant. For example, reference to the occupation or age of these couples remains absent. Viewers get no identifying information (via on-screen graphics or

titles) about these people when they watch this program. They only find out Danielle and John's occupation in a promotional spot for the series. However, truly motivated viewers were able to find out more about these couples through *The Knot*'s Web site; only there could they find out the "real" story behind these couples' backgrounds in terms of age and occupation (and last names). For example, on the web page devoted to the episode of Danielle, a model, and John, a self-made millionaire, one can read that 29-year-old Danielle's occupation is actually "volunteer" and that 36-year-old John is founder and chairman of a financial services firm ("Danielle & John: Gatsby Style in Newport, RI," 2003). By omitting this information from the content of the program itself, the underlying message further enhances the notion that these people only exist within the context of each other; their identities as individuals seem unimportant compared to their identities as couples. In this regard, *Real Weddings from The Knot* perpetuates Myth #10, instilling in viewers the notion that one is incomplete without one's mate (or *any* mate) (Galician, 2004, p. 201).

The notion of identity appears in a subtler way in the episode featuring author Susan Orlean. When she and husband-to-be John (Gillespie, whose occupation remains unknown in the episode) get their marriage license, she asks him repeatedly if she should change her name, to which he repeatedly answers it is up to her. She finally decides that she will; her decision to take on John's name symbolically makes them one. The idea of cultivating one's own completeness (Prescription #10; Galician, 2004, p. 201) clearly does not "go" with getting married; it seems that for women, especially, marriage requires her to abandon her prewedding identity.

Gender roles found in traditional marriage manifest themselves in the episode featuring Catina and Todd. Their wedding story centers on their involvement in their church, including undergoing premarital counseling with their minister ("Catina and Todd," 2003). This couple identifies explicitly the traditional duties and responsibilities of husbands and wives, agreeing that the husband is the head of the household with the wife submitting to him, according to Biblical instruction. As Todd assumes his dominant role, he also takes on the responsibility of providing for his new wife. The notion that "real men" take care of their women and support them (most often financially) illustrates Galician's Myth #6, which dictates that the man in the relationship, or marriage in this case, should not be less successful than the woman (2004, p. 163).

Several brides refer to their wedding day as the day they can be "a princess" and have their "fairy-tale wedding." Viewers watch these brides get ready for their big moment by having their hair and make up done and dressing in their beautiful, white, and often expensive, wedding gowns. For example, Cara wants her wedding at a castle: "I'd like to be a princess, but I'm just a chick from Brooklyn who likes to gamble," she says in her opening voice-over ("Cara and Aaron," 2003). However, this "chick from Brooklyn" insists on looking like a princess on

her wedding day and expresses deep unhappiness with her custom-made wedding gown as we see her try it on after several alterations. For Orisha, her white wedding gown symbolizes marriage itself: "I feel like a princess. It's starting to hit home. The whole reason why we're here is this dress, the marriage of me and John Stinson. . . . Oh, my God, I feel like a princess" ("Orisha and John," 2003).

These brides' comments and the attention given to the bride's presentation of self in terms of outer beauty reinforces Galician's Myth #5, which concerns the required physical attractiveness of women: "To attract and keep a man, a woman should look like a model or a centerfold" (2004, p. 153). The preparation devoted to a bride's physical appearance, coupled with the mystical aura created by the perfect wedding gown, emphasizes the expectation that she look flawless on her wedding day (and thereafter, if she wants to keep her husband). Unfortunately, these programs promote the idea that a woman's worth lies in her ability to look good, rather than attaining and demonstrating intangible qualities such as character and intelligence. Galician's Prescription #5, "Cherish completeness in companions (not just the cover)" (2004, p. 153), becomes overshadowed when programs like this one emphasize the superficial aspects of the wedding—the bride's gown and her role as a "princess"—rather than the quality of the impending marriage and the individuals who will comprise it.

Compared with A Wedding Story, the "real weddings" in Real Weddings from The Knot rely more on the video verité approach, as viewers accompany these brides and grooms on their various errands as their wedding plans unfold, rather than on substantial commentary on the nature of couples' relationships. Love and romance, although given some attention during the course of these stories, seem to take a backseat to the "work" of the wedding. Few of the other participants, such as relatives or members of the wedding party, provide any assessment of these couples' relationship or compatibility. However, clichés regarding predestined love (Myth #1; Galician, 2004, p. 119) and completeness provided by their relationship (Myth #10; Galician, 2004, p. 201) surface on the rare occasions that these brides and grooms do comment on their relationships rather than on their wedding plans.

Bravo's Gay Weddings

A Wedding Story and Real Weddings from The Knot feature male–female couples, which we naturally think of when we hear the word wedding and which illustrate clearly the hegemonic notions we hold about love and romance as being, naturally, heterosexual. As Oswald (2000) noted, "Our society privileges heterosexual marriage, and thus weddings also link the personal decision to marry with an institutional heterosexual privilege carrying profound social, legal, financial, and religious benefits" (p. 349). Weddings, as noted by Geller (2001) and Ingraham (1999), implicitly reflect heterosexism, the "reasoned system of bias regarding sexual orientation" (Jung & Smith, 1993, p. 13).

The Bravo mini-series *Gay Weddings* clearly offers a counterhegemonic per-spective to traditional marriage and focuses on the difficulties faced by same-sex couples who desire the same societal recognition granted by the formal wedding. The program premiered in September 2002 as an eight-part series of half-hour episodes featuring four gay or lesbian couples who plan and ultimately go through with their commitment ceremonies.[4] The show's debut coincided with *The New York Times'* announcement that its Sunday editions would begin publishing no-tices of gay and lesbian unions ("Gay Weddings Go Prime Time," 2002). The pro-gram drew largely positive reaction from media critics and reviewers, from the both mainstream and gay press (Alter, 2002; "Gay Weddings Go Prime Time," 2002; Piepenburg, 2002). After Bravo aired *Gay Weddings* opposite the 2003 Superbowl, its "surprise success" in viewership led the cable channel to develop other gay-themed programs, such as *Queer Eye for the Straight Guy*, notably with a female audience in mind (Cook, 2003).

Shot in the same *video verité* style as *A Wedding Story* and *Real Weddings from The Knot*, *Gay Weddings'* inclusion of only four couples over a total of 4 hours al-lows for a more in-depth look into how these couples not only plan their wed-ding days but also how they cope with adversity, mainly in the form of family dis-approval. On-camera and voice-over narration from the couples, their families, and friends who occasionally speak directly into the camera during video diary segments provide extensive commentary and insight into how these couples cope with the challenge of putting on a gay wedding in a heterosexual world.

The four couples consist of Dan, 37, a movie studio executive, and Gregg, 35, a travel company vice president; Scott, 32, a consultant, and Harley, 29, who is in sales; Lupe, 32, who works in marketing, and Sonja, 39, an emergency room su-pervisor; and Dale, 32, an entertainment lawyer, and Eve, 30, a graduate film student. Unlike the straight wedding programs such as *A Wedding Story* and *Real Weddings from The Knot*, viewers get all the information about the couples' ages, occupations, and length of relationship via on-screen graphics. Viewers also find out how the couples met and learn of the prior relationships of some of these in-dividuals. For example, Sonja has a son from a past heterosexual relationship, and Dale had a boyfriend before she fell in love with Eve. By providing this personal information, the program helps viewers see these couples as real people, with real jobs and real problems as they plan their unconventional weddings.

Similar to other wedding reality programs, *Gay Weddings* provides a peek at the various wedding planning activities of these couples, such as searching out cere-mony sites, choosing wedding apparel, and deciding on the specifics of their cer-emonies. Unlike the other programs, however, *Gay Weddings* allows for more access to the "backstage" part of its weddings, which Goffman (1959), in his use of dra-

[4]All eight episodes of *Gay Weddings* aired in a series marathon January 26, 2003.

maturgy to explain the stylization of public behaviors, termed the *back region*. If we consider the wedding venue as the *front region*, where the wedding (or performance) takes place, we can consider video footage leading up to the wedding as the back region, where "the suppressed facts make an appearance" (Goffman, 1959, p. 111).

Although wedding guests may not have access to the back region, the viewing audience does, which makes even the back region in these reality programs, in effect, the front region. In the back region of *Gay Weddings*, we see couples cry and express disappointment when things do not go their way, as in the case of Eve, whose parents decide to back out of providing her and Dale with financial help with their wedding. Dale's family does not perceive her wedding to Eve with the same significance as her siblings' (heterosexual) weddings. As Dale comments: "It doesn't seem that big of a deal. It's not that special, you know. It's not like someone's big wedding day" (Episode One). We also get some rather honest confessions of frustration and tensions, with the overriding worry for all these couples being the acceptance they crave from their families regarding their choice of partner. This acceptance serves as especially cogent points for Dale and Eve, whose parents appear ambiguous about their wedding; Scott, who has never even "officially" come out to his parents; and Dan, whose mother still cannot accept nor understand that he loves and wants to marry a man.

Familiar themes of love and romance experienced by heterosexual couples exist within these wedding stories, which serve to demonstrate the universality of romantic love despite the accepted social norm of heterosexuality as the basis for weddings. Although none of these weddings hold legal status, these couples still want to declare their love for each other in public and with public acceptance, a common theme among gay couples (Lewin, 1998). For instance, in Episode One, these couples explain why they have chosen to hold a wedding. Dale asks, "Why get married if you're gay?" Her partner Eve replies, "Why get married if you're straight? It's the same reason." Says Dan, "It's about this guy" (pointing to himself) "and this guy" (pointing to Gregg) "becoming one."

Galician's media myths of love and romance surface here as well, such as, "The right mate 'completes' you—filling your needs and making your dreams come true" (Myth #10; Galician, 2004, p. 201). Notions of perfection, as in finding the "perfect partner," give way to more direct explanations of the nature of these gay couples' relationships. "A marriage, union, whatever you want to call it, this is the person I'm going to spend the rest of my life with," explains Lupe about Sonja (Episode One). Whereas Dan says he thinks he is "a more complete person" with Gregg (Episode Three), the overall impression left by these couples' comments about their partners sounds more matter-of-fact than romantic. Indeed, Scott's comment about Harley illustrates the need for simple acceptance, rather than dreamy ideas of love and romance: "When is it ever going to be OK? This person is my life" (Episode One).

We also see some of the couples bickering (Myth #8) and talking about the instability within their relationships, which relates to Myth #9: "All you really need is love, so it doesn't matter if you and your lover have very different values" (Galician, 2004, p. 193). This myth meets reality in the story of Scott and Harley, who hold vastly different views on almost everything and constantly disagree over the minutest wedding details, such as what they will wear, whom to invite, and the amount of religion to be included in their ceremony. In the first episode, Harley admits that in their relationship, "opposites attract all the way." Although a media myth, Scott and Harley seem to truly believe it, even in the face of all their admitted differences.

In the second episode, we find out that Scott and Harley are seeing a couples' counselor, and Scott is also seeing his own counselor. He tells friends that his counselor told him that Harley might not be the best partner for him. Indeed, Scott admits in a video diary segment, "Truthfully, Harley and I have actually been talking about whether or not we should get married or even stay together." He concludes by saying they have "serious issues that have to be addressed" (Episode One). Scott and Harley's adherence to the myth that love will conquer all (Myth #9; Galician, 2004, p. 193), even serious rifts clearly recognized before the wedding, illustrates the power of emotion ("love") over logic in determining whether a relationship will last or not.

In addition to the illustration of the myth that "all you need is love" (Myth #9; Galician, 2004, p. 193), Scott and Harley's constant bickering serves as a variation of Myth #8: "Bickering and fighting a lot mean that a man and a woman really love each other passionately" (Galician, 2004, p. 185). Because "constant conflict creates chaos" (Prescription #10; Galician, 2004, p. 185), one wonders whether Scott and Harley will be able to resolve their problems, or whether their relationship will last at all.

For another couple, Dan and Gregg, differences in core values surface in a less overt way. The issue of children serves as a subject of disagreement, with Gregg wanting to have children, whereas Dan says the issue will "stay on the back burner" (Episode Two). Although their relationship does not compare to that of Scott and Harley's, one sees a clear difference of perspective regarding each partner's future goals. Whereas Myth #9 tells us that all we really need is love, Galician rightly noted that "shared values are what form the basis of lasting romantic relationships" (2004, p. 198).

Despite the obstacles encountered by all four couples, they all do have their weddings at the end of the series. These weddings mimic traditional, heterosexual weddings, complete with traditionally worded vows, an officiant presiding over the ceremony, and a reception. However, these portrayals differ significantly from those in other wedding shows: In terms of the ideals of romance and love, these wedding stories appear more honest, as viewers see the couples expressing

misgivings and nervousness and even questioning whether they should stay together at all.

COMPARISON AND CONTRAST

All three programs examined here—A *Wedding Story*, *Real Weddings from The Knot*, and *Gay Weddings*—situated themselves in the drama of real people and real events. All illustrate a hegemonic view of love and romance by assuming and forwarding an unquestioned, common-sense worldview that romantic relationships require some kind of "official" and public (legal or not) acknowledgment—a recognition that takes the form of a wedding. By appearing on these programs, the couples featured, both hetero- and homosexual, implicitly endorse this view. All base their reasons for having a wedding on the fact that they love each other and want their family and friends present to witness their declarations of love. Additionally, all the weddings follow the traditional wedding format, with special apparel, a ceremony in which vows and rings are exchanged, and some kind of party to mark the event. Whether the budget is large or small, all the weddings involve considerable time and effort in planning, which reflects these couples' common values regarding the importance of the wedding as a major step in their relationships.

Especially for A *Wedding Story* and *Real Weddings from The Knot*, the reality of marriage and the work required to maintain a successful marriage do not receive as much attention in couples' on-camera and voice-over commentary as much as their emotions and feelings about each other. Rather, the wedding day serves as the endpoint, and high point, of the romantic relationship, with all efforts geared toward making sure the wedding unfolds as planned. This comes as no surprise, really, when one realizes that the romance and love surrounding the picture-perfect wedding attracts viewers, especially female viewers, to these programs. If these couples talked about the effort needed to sustain a healthy, fulfilling marriage or the risk that the marriage might not last, rather than how wonderful their lives are now because they have found love, these programs might have trouble attracting an audience. Additionally, the time constraints of a half-hour program, with commercials, would preclude such a reality check.

Of particular note regarding these two programs is that viewers generally do not learn of couples' ages or occupations. Instead, the focus clearly stays on the impending ceremony and reception. For heavy viewers of these programs, especially, the romance of the wedding (couched in terms of fairy tales and princess brides) crowds out the reality of married life. Establishing a solid relationship with one's partner takes time, something these programs do not emphasize as much as the planning that precedes the big wedding day. Showing viewers how these

couples interact aside from wedding planning would not make for exciting or
interesting video or create the satisfaction viewers get from watching an elabo-
rate, romance-filled wedding of ordinary people with whom they can relate. All
these programs end with successful weddings, with couples apparently working
through their disagreements and differences and overcoming the seemingly large
obstacles that might have impeded their wedding plans.

The misplaced hope of marital success portrayed in these shows reinforces
Galician's Myth #9, which claims that it doesn't matter if partners have differ-
ent values (2004, p. 193) and contradicts research findings showing that ho-
mogamy, or the similarity of individuals' traits and values, is essential to marital
satisfaction (Cook & Jones, 2002). Galician's Prescription #9, "Crave common
core-values" (2004, p. 193), counters the idea that opposites attract and reiterates
the advice of marriage researchers.

Because these programs depend on a happy ending and a happy wedding, re-
alistic portrayals of couples in trouble and actually breaking up cannot be shown.
But in real life, weddings do get called off, and couples do break up before the
wedding day, never to get back together. In this regard, these programs do a dis-
service to viewers by promoting myths about love and romance rather than pro-
viding their viewers with skills to build loving and healthy relationships that Gali-
cian (2004) forwards in her prescriptions, such as craving common core-values
(Prescription #9; p. 193) and the importance of conflict resolution skills (Pre-
scription #8; p. 185).

Alternatives to marriage and a formal wedding such as cohabitation or even
elopement are viewed as suspect and do not "count." We might not consider a
down-sized wedding or elopement as legitimate as a big wedding because, as
Otnes and Pleck (2003) noted, advertisers have "increasingly reinterpreted the
visual and verbal components of weddings as symbols of joy and desire for myr-
iad products and services," resulting in the detachment of the wedding from mar-
riage (p. 2003). Similarly, the symbolic qualities of the wedding, such as love and
joy, are manifested through tangible goods, such as a multitiered cake, designer
wedding gown, and high-priced reception. In short, more love translates to more
spending. The result points to the perpetuation that the wedding and its subse-
quent marriage, whether recognized by the state or not, is a crucial and neces-
sary means by which life partners can receive full acknowledgment of their love
and commitment.

CONCLUSION: MYTHS AND PRESCRIPTIONS

In this chapter, I examined how reality television wedding shows portray ideas of
love and romance and how relationships become validated by the wedding. The
very existence of these programs points to our society's belief that weddings serve

as a natural, unquestioned, common-sense component of love between men and women. This idea has become so ingrained in us that, as Bravo's *Gay Weddings* demonstrates, even persons in same-sex relationships also perceive the necessity of having a wedding. All three programs discussed here contribute to a hegemony regarding love and marriage, with the wedding serving as a required step toward making a relationship "legitimate." When added to the milieu of wedding-related messages disseminated widely by other mass media, these programs demonstrate how the media industry perpetuates the status-quo idea that a marriage ceremony necessitates all the expense, artifacts, time, and effort associated with the resplendent wedding.

These reality-based shows also could counter myths of love and romance with the more healthy prescriptions. For example, Rx #1: "Consider countless candidates" (Galician, 2004, p. 119) could be incorporated into these programs simply by having couples mention previous relationships and why they did not work—and what makes their current relationship so much better for them. Likewise, Rx #9: "Crave common core-values" (Galician, 2004, p. 193) could be fostered through more focus on these couples' more considered beliefs. One of the couples in *Gay Weddings* had clear problems with their relationship, yet they went ahead with the wedding. Because the program ends with the wedding itself and does not include a follow-up segment to let viewers see how the relationship is going, viewers are left with the impression that this couple's problems disappeared once they had their wedding—implying that a wedding will cure what ails a relationship and that marriage is trouble-free.

Galician (2004) also addressed the mistaken notion people hold about mass media portrayals of romance as being innocuous through her Myth #12, "Since mass media portrayals of romance aren't real, they really don't affect you" (2004, p. 219). As Segrin and Nabi (2002) reported, research clearly counters this myth: the "maintenance of idealized expectations is clearly associated with watching a genre of television that focuses heavily on romantic and marital relationships," such as romantic comedies and soap operas (p. 259). If entertainment programming has been found to affect people's ideas of romance, reality television holds even more potential to cultivate idealized notions of love. Viewers need to realize that even these "reality" programs are highly edited and do not and cannot truly reflect "the good, the bad, and the ugly" of wedding planning nor of couples' relationships when the cameras are turned off. Reality television is still television, created with certain viewpoints and by producers, directors, and editors, who tell a story subjectively—even when based on the actions of regular people going about their regular lives.

Although these programs may educate viewers about wedding planning, they also need to provide a more complete picture of the relationships of the couples they present and of marriage planning. Couples' thoughts and negotiations concerning marital responsibilities, expectations concerning finances, and plans re-

garding children need to be included in these stories as well. Until they are, the critical viewer must heed Galician's caution: "Calculate the very real consequences of unreal media" (Prescription #12; 2004, p. 219).

STUDY QUESTIONS/RECOMMENDED EXERCISES

1. What are the similarities and differences between Hollywood film versions of weddings and TV reality show versions of weddings (such as the ones discussed in this chapter)? Which ones resemble the weddings you have attended?

2. In that the wedding programs described in this chapter depend on ratings to exist in the first place, do you think that weddings of people who elope or who marry at city hall with only a few witnesses would ever be included in these programs? Could the "drive-through" weddings now offered in Las Vegas, for example, ever be framed as a romantic experience? Why or why not?

3. What qualities in a relationship, straight or gay, do you think make a happy union? Do you think that the wedding truly is a requirement for a happy and healthy relationship? Why or why not?

4. What characteristics of reality television programs do you think appeal to viewers and make them so popular?

5. When compared to the "pageantry" and glamour of the wedding, marriage seems almost a letdown. Why do you think that is? Why wouldn't a reality program that centers on newly married couples or long-married couples appeal to television viewers?

REFERENCES

Alter, E. (2002, August 29). 'Gay weddings' a different reality. *Media Life*. Retrieved March 20, 2003, from http://www.medialifemagazine.com/news2002/aug02/aug26/4_thurs/news5thursday.html

Baldrige, L. (2000). *Legendary brides*. New York: Harper Collins.

Barovick, H. (1999, October 18). Labor, love and ratings. *Time, 154*(16), p. 103.

Brown, J. (1999, August 25). Fairytale weddings get TV treatment. *The Detroit News*. Retrieved January 2, 2001, from http://detnews.com/1999/entertainment/9908/25/08250087.htm

Calvert, C. (2000). *Voyeur nation: Media, privacy, and peering in modern culture*. Boulder, CO: Westview Press.

Consalvo, M. (1998). Hegemony, domestic violence and "Cops": A critique of concordance. *Journal of Popular Film and Television, 26*(2), 62–70.

Cook, J. (2003, July 22). Bravo launches two gay-themed shows. *The Salt Lake Tribune*. Retrieved November 5, 2003, from http://www.sltrib.com/2003/Jul/070222003/Tuesday/77539.asp

Cook, J. L., & Jones, R. M. (2002). Congruency of identity style in married couples. *Journal of Family Issues, 23,* 912–926.

Currie, D. H. (1993). "Here comes the bride": The making of a "modern traditional" wedding in Western culture. *Journal of Comparative Family Studies, 24,* 403–421.

"Danielle & John: Gatsby style in Newport, RI." (2003). *theknot.com.* Retrieved January 20, 2005, from http://www.theknot.com/ch_article.html?Object=A21230143659

Feuer, J. (1983). The concept of live television: Ontology as ideology. In E. A. Kaplan (Ed.), *Regarding television: Critical approaches—an anthology* (pp. 12–21). Los Angeles: American Film Institute.

Gay weddings go prime time. (2002). *MSNBC.com.* Retrieved March 23, 2003, from http://msnbc.com/news/797708.asp

Galician, M.-L. (2004). *Sex, love, and romance in mass media: Analysis and criticism of unrealistic portrayals and their influence.* Mahwah, NJ: Lawrence Erlbaum Associates.

Geller, J. (2001). *Here comes the bride: Women, weddings, and the marriage mystique.* New York: Four Walls Eight Windows.

Goffman, E. (1959). *The presentation of self in everyday life.* New York: Doubleday.

Harrigan, L. (2000, December 7). Fate playing pivotal role for couple. *Hartford Courant* [Manchester Extra section], p. 1.

Ingraham, C. (1999). *White weddings: Romancing heterosexuality in popular culture.* New York: Routledge.

Jung, P. B., & Smith, R. F. (1993). *Heterosexism: An ethical challenge.* Albany, NY: State University of New York Press.

Larson, M. (2002, October 22). Oxygen, The Knot exchange vows. *MediaWeek.com.* Retrieved October 4, 2004, from http://www.mediaweek.com/mk/

Lewin, E. (1998). *Recognizing ourselves: Ceremonies of lesbian and gay commitment.* New York: Columbia University Press.

McNeil, A. (1991). *Total television.* New York: Penguin Books.

Modleski, T. (1982). *Loving with a vengeance: Mass-produced fantasies for women.* Hamden, CT: Archon Books.

Noxon, C. (1999, July 25). Sunday television section. *The New York Times.* Retrieved September 21, 1999, from http://archives.nytimes.com/archives/search/

Oswald, R. F. (2000). A member of the wedding? Heterosexism and family ritual. *Journal of Social and Personal Relationships, 17,* 349–368.

Otnes, C., & Pleck, E. H. (2003). *Cinderella dreams: The allure of the lavish wedding.* Los Angeles: University of California Press.

Otnes, C., & Scott, L. M. (1996). Something old, something new: Exploring the interaction between ritual and advertising. *Journal of Advertising, 25,* 33–50.

Oxygen proposes to The Knot: 10 more episodes of "Real Weddings from The Knot." (2004, March). Press release. Retrieved October 4, 2003, from http://www.theknot.com

Piepenburg, E. (2002, September 6–12). Going to the chapel: Cable watchers tune into gays tying the knot. *Gay City News.* Retrieved October 10, 2003, from www.gaycitynews.com/GCN15/the chapel.html

Roddy, D. (2000, February 26). Picture this: A TV wedding that lasts. *Post-Gazette.com.* Retrieved January 29, 2001, from http://www/post-gazette.com/columnists/2000022roddy.asp

Segrin, C., & Nabi, R. L. (2002). Does television viewing cultivate unrealistic expectations about marriage? *Journal of Communication, 52,* 247–263.

van Zoonen, L. (1994). *Feminist media studies*. Thousand Oaks, CA: Sage.

Weiss, T. (2000, April 14). Lights, bride, baby: The Learning Channel reaps high daytime ratings with real-life dating, weddings, births. *Hartford Courant*, p. D1.

White, M. (1992). Ideological analysis and television. In R. Allen (Ed.), *Channels of discourse* (pp. 161–202). Chapel Hill, NC: University of North Carolina Press.

Zompetti, J. (1997). Toward a Gramscian critical rhetoric. *Western Journal of Communication*, *61*, 66–86.

Erika Engstrom *is Associate Professor of Communication Studies and Associate Dean of the Greenspun College of Urban Affairs at the University of Nevada, Las Vegas. She earned her bachelor's degree in radio-television in 1984 and master's degree in communication in 1986 from the University of Central Florida, and she was awarded her Ph.D. in mass communication in 1991 from the University of Florida. Her research of televised weddings and gender in the mass media has been published in* Journal of Media and Religion, Popular Culture Review, Journal of Broadcasting and Electronic Media, *and* Journalism and Mass Communication Quarterly. *She teaches courses in gender and nonverbal communication. She and her male partner cohabited for 6 years before their spur-of-the-moment wedding at a Las Vegas wedding chapel in 1999.*

CHAPTER 24

Unrealistic Portrayals of Sex, Love, and Romance in Popular Wedding Films

Kevin A. Johnson
The University of Texas at Austin

What do you think about when you see or hear the word *marriage*? Undoubtedly, you have developed an image and/or relationship to this concept. The reason we have such deeply embedded beliefs about marriage is that it is a central institution in our society. As such, views of marriage are political. For example, U.S. President George W. Bush (2003) declared, "Marriage is a sacred institution, and its protection is essential to the continued strength of our society" (n.p.). Whereas Bush has visualized marriage as a heterosexual union, Sullivan (1997) advocated same-sex marriage by arguing that "the right to marry is, in many ways, more fundamental than the right to vote" (n.p.). On the other hand, gay/lesbian/bisexual/transgender activist Ettelbrick (1997) asked, "Since when is marriage a path to liberation?" If the debate over same-sex marriage demonstrates anything, it is that people have a passionate attachment to the idea of this seemingly simple word. The word marriage might be small, but stories continue to get built around it every day.

What are some of the stories told about marriage? Aside from our experiences associated with actually attending weddings, we are bombarded by stories of weddings and marriages all the time in the mass media. Thus, this chapter utilizes Galician's (2004) 12 myths of sex, love, and romance in the mass media as a framework for analyzing portrayals of weddings and marriages. On television, we see weddings as pivotal moments in plot lines for shows such as *Friends, Dharma & Greg, Spin City, Baywatch, Suddenly Susan, Everybody Loves Raymond,* and *NYPD Blue.* We hear about weddings in the music industry, including those of Britney Spears, Jennifer Lopez, Jessica Simpson, Michael Jackson, and Madonna. Then, there are the "reality" shows, including *The Bachelor, The Bachelorette, Joe Millionaire,* and *The Wedding Story.* In sports, radio, and television we hear talk about Tiger Woods and Elin Nordgren, Anna Kournikova and Sergei Federov, Nomar Garciaparra and Mia Hamm, and Andre Agassi and Steffi Graf. On the radio we hear about Howard Stern's marriage and the weddings of numerous

local hosts. In the cinema we see movies such as *Father of the Bride, My Big Fat Greek Wedding, Four Weddings and a Funeral, Runaway Bride,* and *The Wedding Singer.* In short, weddings are everywhere in mass media. Ingraham (1999) provided a compelling case that "the visual stimulation of the wedding story is a powerful means for suturing an audience to the interests represented in a film or television show" (p. 126).

Mass media play an influential role in the way people view sex, love, and romance in their own lives. Galician (2004) found, "Higher usage of certain mass media is related to unrealistic expectations about coupleship, and these unrealistic expectations are also related to dissatisfaction in real-life romantic relationships" (p. 5). The primary implication of unrealistic expectations of weddings and marriage is an increased likelihood of divorce (Dreyfus, 2005). Thus, an examination of weddings and marriage as they appear in mass media is important. The purpose of this chapter is to trace Galician's (2004, p. 225) myths of unrealistic portrayals of sex, love, and romance as they appear in popular films that feature wedding events, including the engagement, planning, wedding, and honeymoon. In addition to exploring sites of Galician's myths as they appear in wedding films, I also suggest two additional myths specific to these mediated wedding depictions.

I have divided this chapter into four sections. In the first section I describe the methodology, including a list of the analyzed films. In the second section I report some of the occurrences of Galician's (2004) myths in these popular wedding films. In the third section, I provide two additional myths that might be added in relation to weddings and marriage that are not included in Galician's 12. Finally, I provide some suggestions for future research of mass media portrayals of weddings and marriage.

METHOD

To determine precisely what a "popular" film featuring a "wedding event" is, I examined a combination of both the top-grossing wedding films and the results of a Google search to find the most commonly recurring wedding films that appeared on "top wedding picks" (different lists found Web sites as favorite films about weddings).

From this search, the movies selected for this study were *American Wedding* (2003), *Father of the Bride* (1991), *Fools Rush In* (1997), *Four Weddings and a Funeral* (1994), *Just Married* (2003), *Meet the Parents* (2000), *Mr. Wrong* (1996), *Muriel's Wedding* (1995), *My Best Friend's Wedding* (1997), *My Big Fat Greek Wedding* (2002), *Runaway Bride* (1999), *The Wedding Planner* (2001), and *The Wedding Singer* (1998). Although all of these films were analyzed to determine the pres-

ence of myths, not all of the films are included in the discussion of the portrayals of the myths.

MYTHS IN WEDDING FILMS

Because "love and marriage go together like a horse and carriage," it is not surprising to find unrealistic portrayals of sex, love, and romance appearing in wedding films. I found that 11 of the 12 myths were present in the studied films. The only myth that was not in the films was Myth #12, which says that since mass media portrayals of romance aren't real, they don't really affect you (Galician, 2004, p. 225). The reason for its nonappearance is that in this study I do not examine the link between media effects and people. Rather, I examine the messages that movies display. Thus, in this section I analyze each of the other 11 myths as they appear in the films.

Myth #1: "Your Perfect Partner is Cosmically Pre-destined, So Nothing/Nobody Can Ultimately Separate You"

Galician (2004) traced this myth to ancient Athens and the Platonic ideal that your missing half is somewhere out there because the gods of antiquity were jealous and separated your true love from you. She also noted, "But you know you're living in the 21st century. And you're a human capable of changing and improving your 'destiny' rather than irrationally letting it enslave you" (p. 120). This myth of the cosmically predestined "one" is present in nearly all of the wedding films.

In *American Wedding*, old high school classmates and best friends reunite in the third movie of the *American Pie* trilogy for a wedding of one of the best friends. In this movie, Kevin (Thomas Ian Nichols) says to Finch (Eddie Kay Thomas) regarding Jim's (Jason Biggs) choice to get married: "You don't think there's one girl that you're destined to spend your entire life with?" Finch says, "They're all for me, Kevin." Leaving aside issues of Kevin's choice of the word *girl* and the heterocentric nature of this conversation, this dialogue displays several views about marriage: Kevin's view of marriage is that there is one cosmically destined woman with whom to spend the rest of his life; Finch's view of marriage is that of an institution that ought to be avoided at all costs and replaced with "having" all women. So the message here is that you should only marry someone if you are cosmically predestined or else you should "have" multiple partners if you are male and never get married.

The myth can also be present in the language of "the one" or "doomed" that evidences a logic of destiny and helplessness. In *The Wedding Singer*, a wedding

singer meets a poor woman, they fall in love, and despite seemingly insurmountable odds, they end up together when the movie ends. In the movie, Julia (Drew Barrymore) says, "Actually, I am not sure how serious the guy is that gave this [engagement ring] to me. Right now I feel like I'm *doomed* to walk the planet alone forever."

In *My Best Friend's Wedding*, Julianne (Julia Roberts) steals a truck to chase Michael (Dermont Mulroney), whom she wants to marry. However, Michael is chasing Kimmy (Cameron Diaz), whom he wants to marry. During the chase, Julianne calls George (Rupert Everett) on her cell phone, and he tells her "Michael's chasing Kimmy. You're chasing Michael. Who's chasing you? Get it? There's your answer—Kimmy. Jules, you're not *the one*."

In *The Wedding Planner*, Maria (Jennifer Lopez) is a successful wedding planner who is rescued by Dr. Steve Edison (A.K.A. "Eddie," played by Matthew McConaughey) from what could have been a fatal accident. The two then spend a wonderful night together. Soon after, however, Maria finds out that Eddie is the groom in a wedding she is hired to plan. Complicating the matter is that Massimo (Justin Chambers) wants to marry Maria but tells Eddie, "I could never forgive myself if I got in the way of true love. I am not *the one* . . . you are *the one*.*" By referring to these individuals as "the ones" for each other and thinking about love in terms of destiny (being "doomed"), these films demonstrate that this myth is active in reinforcing the ancient Platonic ideal that you will find your fated mate.

Myth #2: "There's Such Thing as 'Love at First Sight'"

In discussing Myth #2, Galician (2004) referred to the concept of "Cupid's arrow," which fosters the belief that you will be "struck" by love. She explained that in media portrayals of this myth, "love is maneuvered beyond reason and choice—and beyond our own responsibility" (p. 128). The most glaring example of the Cupid's arrow myth appears in *Just Married*, when Tom (Ashton Kutcher)—upset about his honeymoon with Sarah (Brittany Murphy)—tells his friend Fred (Alex Thomas): "We had the perfect relationship that was ruined by marriage. I mean, you saw us, right? We were perfect from the minute we met, right?" Fred answers, "Yeah, in fact, it was nauseating." Fred confirms what Tom already knew—he loved Sarah at first sight. After this short dialogue, the scene shifts to a flashback fantasy of Tom, where he first meets Sarah on the beach while playing football. Sarah gets hit in the head with the football, Tom comes over to help her, and they are struck by love (or was it the football?). We will later find that *Just Married* combines this myth with Myth #8 (that bickering and fighting a lot shows a loving relationship) to create a supposedly humorous portrayal of being married.

Myth #3: "Your True 'Soul Mate' Should KNOW What You're Thinking or Feeling (Without Your Having to Tell)"

In this myth, those who are true soul mates should know what the other is thinking. Galician (2004) cautioned, "The mind-reading dysfunction is one of the most destructive in love relationships (and indeed in any interpersonal relationships). Fortunately, it's one of the easiest to replace" (p. 137). She did admit, however, that it takes a partner who "*wants* to hear what you really mean" for this unhealthy behavior to be remedied (p. 137). This myth, which is demonstrated in many movies, is notable in *Fools Rush In*, the story of a nightclub promoter and a Las Vegas showgirl's one night stand that leads to marriage after she discovers that she is pregnant. A consistent theme throughout the film is that Alex Whitman (Matthew Perry) and Isabel Fuentes (Salma Hayek) are destined to be together (Myth #1). This theme is reinforced by the repeated mantra, "There are signs everywhere." However, as the plot develops, Alex gives Isabel many mixed signals, which come to a head when she shouts, "I'm not a mind reader, Alex!" Ironically, at the end, it turns out that Isabel actually *is* a mind reader: She fulfills his unspoken desire by agreeing to move to New York with him as long as they stay in Las Vegas until their baby is born. Aside from the whole issue of the woman's making sacrifices for the man, this scene demonstrates that if two people are destined to be together, they should be able not only to read the other person's mind but also to act in a way that accommodates what is in the other's mind.

Myth #4: "If Your Partner Is Truly Meant for You, Sex Is Easy and Wonderful"

In identifying this myth, Galician (2004) noted that "making sex easy and wonderful enough equates to a meant-to-be relationship" and that focusing "on sex suggests that sex is the most important and affirming aspect of a relationship, yet it is only one of the three key elements of Sternberg's Triangular Theory of Love" (p. 148). The other factors are *intimacy*, which is the emotional component, and *decision/commitment*, which is the intellectual or cognitive component (Sternberg, as cited in Galician, 2004). In short, this myth suggests that if sex is good, the relationship will work. This myth is present throughout *American Wedding*, in which Jim (Jason Biggs) and Michelle (Alyson Hannigan) are the groom and bride of the movie's title. In the opening scene, Jim, who is trying to propose to Michelle in a restaurant, suggests that she look behind her napkin (where he has hidden the engagement ring). However, she attempts to read Jim's mind, so she goes under the table and starts to perform oral sex on him in the middle of the restaurant. This is not surprising because there are very few scenes in which Jim and Michelle's relationship is not sexualized (including in *American Pie*, the first

film in the trilogy—*American Wedding* being the third). This wedding film reifies the myth that if sex is wonderful, then your partner is "the one" for you to marry.

Myth #5: "To Attract and Keep a Man, a Woman Should Look Like a Model or a Centerfold"

We are exposed to many images of the "idealized" man and woman in the mass media. Galician (2004) commented, "Countless normal males and females irrationally attempt to ape models who are 20% under normal healthy weight, who devote full time to their appearance, and who appear in digitally enhanced specially lit settings in which all imperfections are artificially removed" (p. 155).

The images of the ideal male and female forms are advanced in numerous popular wedding films. *Muriel's Wedding* is a classic ugly-duckling tale mixed with romance. For example, in *Muriel's Wedding*, friends of Muriel (Toni Collette) criticize the way she looks by telling her that her hair is terrible and she is a bit overweight, so she will never attract a husband to marry her. She does appear a bit overweight and her hair is not the same as hair of those who are considered stylish, but the conclusion of never finding a husband does not logically follow from such a description. Although Muriel does find someone to marry her, the groom's motivation is purely financial (to advance his swimming career); thus, in the end, this myth is reinforced as she does not end happily married. Rather, she ends back where she started—living with her girlfriend.

Myth #6: "The Man Should NOT Be Shorter, Weaker, Younger, Poorer, or Less Successful Than the Woman"

Galician (2004) argued that this myth is invalidating and equally unfair to both men and women:

> Just as it's dehumanizing for women to be objectified as attractive body parts, so is it inhumane to view men as a meal-ticket or security guard. Women who are looking for a knight-in-shining-armor should ask themselves what they think they need to be rescued from! (p. 165).

In *American Wedding*, Jim is taller, but Michelle frequently dominates him with her strength. Interestingly, we never find out who is richer because we do not know what they do for a living. Both of their families appear to be well off, and both are in the same year of school (near the same age). In *Just Married*, Tom comes from a poor family with lower social status; Sarah's parents are wealthy and upper class. However, he is definitely taller and stronger. In *The Wedding Singer*, both Julia (Drew Barrymore), a waitress, and Robbie (Adam Sandler), the wedding singer, appear to make the same amount of money, but Robbie does buy into

this myth earlier in the movie, when Julia is engaged to another man who is wealthy: Robbie tries to win her heart by applying for a job in a bank. In response to the interviewer's question about whether he has any experience with money, Robbie admits: "Actually sir, I really need this job to impress a girl. . . . You don't even have to give me a job. If you could just give me some business cards with my name on, I think that might help." (Although he buys into this myth in the middle of the movie, it is overshadowed by Myth #1 at the end of the movie, when Robbie and Julia are shown to be cosmically meant for each other.)

Myth #7: "The Love of a Good and Faithful True Woman Can Change a Man from a 'Beast' into a 'Prince'"

The "beast" in this myth is rarely a person who is physically less than appealing. Galician (2004) cautioned:

> A troubling aspect of most media portrayals of this myth is that the "beast" (male or female) is always depicted as a particularly mean and abusive character who should be loved because there's a tiny morsel of goodness buried somewhere in there that the "good" partner should be perceptive and patient enough to discover and tease out. (p. 179)

She argued that portrayals of this myth might best be understood metaphorically "as archetypal depictions of the struggle of good and evil *within* oneself, with the hope that our own good side will ultimately triumph over the baser side" (p. 179).

This myth was not found in many wedding films in this study. However, one glaring example is *American Wedding*, in which Stifler (Sean William Scott), the obnoxious party/fraternity type guy, goes from talking about sex most of the time, losing the wedding ring, throwing massive parties, and arguing loudly with people, to being a "prince" in the end by giving a flower and being nice to a woman for whom he has "fallen."

Myth #8: "Bickering and Fighting a Lot Mean that a Man and a Woman Really Love Each Other Passionately"

This is perhaps one of the most difficult myths to judge. Galician (2004) explained the delicate balance by reminding us not to confuse "unhealthy dramatic bickering and fighting with healthy respectful disagreement" (p. 187). If a couple has constant conflicts, then there is a greater likelihood that the conflicts are not a sign of passion. Rather, the constant bickering should be interpreted as "a danger signal that accurately predicts the high likelihood of the failure of a coupleship" (Galician, 2004, p. 187). This myth is most prevalent in *Just Married*. For example, on the honeymoon in the French Alps, Tom is driving to the hotel

and Sarah is navigating. Sarah is a bit late in telling Tom to turn, so he turns quickly and nearly hits a truck. After the quick turn, he gets out of the car and yells, "If you would have told me about the turn maybe before we passed it, I wouldn't have had to pull such a NASCAR evasive maneuver!" Sarah yells back, "I was looking at the map. Someone has to navigate!" After a short pause, she says, "Listen to us. We sound like an old married couple." Tom then replies, "Never again." Then they make up by hugging and kissing. This scene is one of many scenes where they continue bickering and even becoming physically abusive and violent. I chose this scene because Sarah's choice of comparison to an "old married couple" displays a view of marriage that those who are together the longest show their love by bickering more frequently. Despite this unhealthy behavior, the couple stays together at the end of the movie.

Myth #9: "All You Really Need Is Love, So It Doesn't Matter if You and Your Lover Have Very Different Values"

This myth can destroy the notion of mutual respect. When values conflict, it becomes difficult for one or both of the partners to respect where the other one is spending time and money. Galician (2004) noted, "It's confusing and hurtful when what's important to one isn't to the other. Resentments can build—as one partner or the other begins to wear masks and play roles that are inauthentic" (p. 194). This myth is demonstrated in *My Best Friend's Wedding* by Kimmy's willingness to change what she values to marry Michael. After a fight with Michael, Kimmy tells Julianne (Michael's "best friend"):

> No matter if he wants crème brulée or Jell-O, I love him. And whatever delusions I drove Michael to, there is truth at the heart of it. You see, I want him to work for my father. I want to stay in school, and I want a life of my own. Please tell him that it's my fault and that I love him.

This is exactly what Galician (2004) cautioned against. Kimmy is willing to forsake her values (going to school and having a life of her own), as if her true values are not important to her anymore. The truth at the heart of all of it is that there is a conflict in values, but she specifically says that love will be able to overcome that truth.

In most of the wedding films, there is no mention of such multiple points of potential conflicts. More simply, in some movies values do not conflict because certain values are not discussed. Most of these conflicting values that can produce strains on a relationship could be discussed in real life through premarital counseling sessions, but there was not a single film that showed couples receiving such counseling. Instead, the films advanced the myth that because two people

love each other, they can get married and everything will work itself out. However, there are many questions that are unanswered by both the woman and the man before they get married in films, such as: What are their expectations of marriage? What is the role of religion in their life? What do they expect of their spouse religiously? What is the role of a husband? What is the role of a wife? How do they express anger? How should conflicts be resolved in marriage? Do they want to have children? These questions could help eliminate myths in a marriage, which might explain the absence of them in these movies.

Myth #10: "The Right Mate 'Completes You'— Filling Your Needs and Making Your Dreams Come True"

To illustrate this myth, Galician (2004) used a banking metaphor to explaining the problem in believing that you need someone to complete you:

> Your condition is like that of an applicant for a bank loan. Strange as it seems, lending institutions tend to give money to people who "don't need it"—that is, to people with appropriate collateral who represent "good risks" for repayment. People who desperately "need" the money are not considered good risks to pay back. (p. 203)

Because all of the films in this study are centered around marriage, they all exemplify Myth #10, whether or not the unions are between couples who have— per Galician's Rx #10—cultivated their own completeness.

Myth #11: "In Real Life, Actors and Actresses Are Often Very Much Like the Romantic Characters They Portray"

Because actors and actresses often play similar characters in different films, many people confuse these performers' roles with their real lives. Galician (2004) explained the danger of this myth:

> It's one thing to appreciate talented artists for their professional work, but it's quite another to confuse reality with fiction. It's actually the ultimate *dis*-service to these stars, who are idealized and thus objectified and dehumanized not only by the unfeeling corporate interests that benefit from their popularity but also by the so-called loving worshipers who—lacking any genuine intimacy with their favorites—are engaged in what we can only describe as infatuated or possibly fatuous (foolish) relationships (to extrapolate from Sternberg's model). (p. 211)

Julia Roberts (*Runaway Bride* and *My Best Friend's Wedding*) and Hugh Grant (*Four Weddings and a Funeral*) both star in films in this study. Galician (2004) identified fans of these stars as being particularly susceptible to this myth.

ADDITIONAL MYTHS SPECIFIC
TO WEDDING FILMS

I also found evidence for two additional myths that pertain specifically to wedding films.

The first additional myth is "You can have the wedding of your dreams and afford it, too." The ritual performance of weddings in films is much more costly than the average wedding in real life, and the cost of a wedding in real life is arguably too high. Ingraham (1999) noted that weddings such as those that appear in *Four Weddings and a Funeral* and *My Best Friend's Wedding* "easily equal or exceed the $45,000 model in *Father of the Bride*" (p. 135). In *My Big Fat Greek Wedding*, the bride's parents are able to give a house as a wedding gift! In *Just Married*, the honeymoon was in the French Alps at the nicest hotel. The honeymoon in *Muriel's Wedding* was in the Caribbean. In *My Best Friend's Wedding* there was mention of the honeymoon being in Florence, Italy. All of these glamorous locations involve expenses that are much higher than those for the average wedding, which is between $20,000 and $25,000 ("Statistics on," 2004; "Wedding Facts," 2004; "Wedding Facts & Trends," 2004). The average annual joint income of those getting married is just over twice that, and it is not uncommon for people to go into debt to pay for their wedding (Bayot, 2003; Valhouli, 2004). Therefore, wedding films are unrealistic in their portrayals of weddings as being affordable at more than $45,000.

A second wedding movie myth is "Financial struggles have nothing to with the success of a relationship." In nearly every wedding film studied, love is stripped of any financial difficulties or considerations. There are no discussions of how the bills will get paid, who will pay the bills, how the married couple will make buying decisions, how much debt each person brings into the marriage, what their spending habits are, and whether they are spenders or savers. Some studies rank disagreements over money as a major strain on relationships (Dye, 2004; Zagorsky, 2003). However, even if financial strains are not widespread, they are still a major part of a marriage that is left unexamined in wedding films.

CONCLUSION

In my analysis of popular wedding films, I found that myths about sex, love, and romance abound. I do not mean to imply that there are not potentially challenging portrayals in these movies. To the contrary, many of these films might provide glimpses of myths while also challenging them. In the end, the goal is to enrich our own sexual, loving, and romantic relationships by avoiding and debunking destructive myths and substituting the rarely portrayed prescriptions (Galician, 2004, p. 225).

STUDY QUESTIONS/RECOMMENDED EXERCISES

1. Which of the myths in wedding films did you find the most interesting? Why?

2. In what way are portrayals of weddings in movies "political"?

3. Which of the movies in this chapter appeared in the most myths?

4. What are some of the ways that some movies discussed in this chapter might debunk myths about marriage? Which prescriptions do they support?

5. Do you encounter unrealistic expectations of weddings in your own life that correspond to the myths portrayed by wedding films? If so, what are these expectations?

6. Alone or with others in a group, choose a wedding movie that is not covered in this chapter. Analyze the myths that are portrayed, debunked, and absent in the movie. Remember to include the additional two myths that pertain solely to wedding movies.

REFERENCES

Bayot, J. (2003, July 13). For richer or poorer, to our Visa card limit. *New York Times*. Retrieved September 18, 2004, from http://www.nytimes.com/2003/07/13/business/13WED.html

Bush, G. W. (2003). Marriage protection week, 2003. *White House* Web site. Retrieved September 30, 2004, from http://www.whitehouse.gov/news/releases/2003/10/20031003-12.html

Castle, N. (Director). (1996). *Mr. wrong* [Motion picture]. United States: Buena Vista.

Coraci, F. (Director). (1998). *The wedding singer* [Motion picture]. United States: New Line.

Dreyfus, E. A. (2005). *Divorce: What went wrong?* Retrieved January 20, 2005, from http://www.planetpsych.com/zPsychology_101/relationships/divorce.htm

Dye, L. (2004, October 1). Study explains money problems in marriages: Surprise, surprise: Study finds men and women see finances differently. *ABC News*. Retrieved July 24, 2006, from http://abcnews.go.com/Technology/story?id=97626&page=1

Dylan, J. (Director). (2003). *American wedding* [Motion picture]. United States: Universal.

Ettelbrick, P. (1997). Since when is marriage a path to liberation? In R. M. Baird & S. E. Rosenbaum (Eds.), *Same-sex marriage: The moral and legal debate*. New York: Prometheus.

Galician, M.-L. (2004). *Sex, love, and romance in the mass media: Analysis and criticism of unrealistic portrayals and their influence*. Mahwah, NJ: Lawrence Erlbaum Associates.

Hogan, P. J. (Director). (1995). *Muriel's wedding* [Motion picture]. United States: Miramax.

Hogan, P. J. (Director). (1997). *My best friend's wedding* [Motion picture]. United States: Columbia/Tristar.

Ingraham, C. (1999). *White weddings: Romancing heterosexuality in popular culture*. New York: Routledge.

Levy, S. (Director). (2003). *Just married* [Motion picture]. United States: Fox.

Marshall, G. (Director). (1999). *Runaway bride* [Motion picture]. United States: Paramount.

Newell, M. (Director). (1994). *Four weddings and a funeral* [Motion picture]. United States: MGM/UA.

Roach, J. (Director). (2000). *Meet the parents* [Motion picture]. United States: Universal.

Shankman, A. (Director). (2001). *The wedding planner* [Motion picture]. United States: Columbia Tri-Star.

Shyler, C. (Director). (1991). *Father of the bride* [Motion picture]. United States: Touchstone.

Statistics on weddings in the United States. (2004, September 27). *Soundvision* Web site. Retrieved September 27, 2004, from http://soundvision.com/info/weddings/statistics.asp

Sullivan, A. (1997, April 4). Gay marriage. *Slate*. Retrieved April 8, 2000, from http://slate.msn.com/id/3642

Tennant, A. (Director). (1997). *Fools rush in* [Motion picture]. United States: Columbia/Tristar.

Valhouli, C. (2004, April 22). What your honeymoon will cost: Prices for the $7 billion-a-year industry are on the rise. *Forbes.com*. Retrieved September 15, 2004, from http://msnbc.msn.com/id/4806540

Wedding facts. (2004). *American Greetings* Web site. Retrieved September 27, 2004, from http://pressroom.americangreetings.com/Summer04/WeddingFacts04.html

Weddings facts & trends. (2004). *Hallmark* Web site. Retrieved September 27, 2004, from http://pressroom.hallmark.com/wedding_facts.html

Zagorsky, J. L. (2003). Husbands' and wives' view of the family finances. *Journal of Socio-Economics, 32*, 127–147.

Zwick, J. (Director). (2002). *My big fat Greek wedding* [Motion picture]. United States: HBO.

Kevin A. Johnson *earned both a B.A. and an M.A. in Communication Studies with an emphasis in Rhetorical Studies from California State University, Long Beach. He has traced the representations of the marriage ritual from the ancient Sumerian goddess Innana to present-day conceptions of marriage. To understand popular conceptions of the desirable characteristics of marriage, for his Master's thesis he examined more than 300 articles that made arguments against same-sex marriage. He has presented his research of marriage and the way Americans talk about marriage at numerous professional conventions, and he has also presented many film critiques at professional conferences. He teaches courses about enjoyment and desire as communication factors, professional communication skills, and argumentation and debate. He has completed his Ph.D. coursework in rhetoric and language at The University of Texas at Austin. He is married to Jennifer Asenas, who is also the author of a chapter in this book and a Ph.D. candidate.*

CHAPTER 25

The Agony or the Ecstasy? Perceptions of Valentine's Day

Deborah Shelley
University of Houston–Downtown

When I was a little girl, I remember anxiously awaiting Valentine's Day at school, when my dreams could be easily fulfilled by the cards stuffing my red and white valentine holder. Every year on Valentine's Day my father would come home with red heart-shaped boxes of chocolates—a large box for my mother and a small one for me. Although I appreciated my own small box, I would look longingly at my mother's, dreaming of the day when my dreams would be fulfilled by large heart-shaped boxes. Obviously, by the age of 5, I already believed Myth #10: "The right mate 'completes' you—filling your needs and making your dreams come true" (Galician, 2004, p. 201). But after all, isn't that what Valentine's Day is all about? Galician (2004) said that the majority of men and women do agree with this myth, so why shouldn't I when my own life experience confirmed it? But Galician (2004) also discovered that half the women and slightly more than half the men believed Myth #3: "Your true 'soul mate' should KNOW what you are thinking and feeling, without your having to tell" (p. 135). Wanting partners who fulfill their dreams and complete them does not seem to be enough; many people also expect their partners to be mind readers.

The reality is, however, that for some of us, Valentine's Day brings unfulfilled dreams, broken hearts, and perhaps even feelings of not being "normal," instead of heart-shaped boxes, because the media have convinced us of the importance of Valentine's Day, creating for us unrealistic expectations of dreams that could only be fulfilled by others. The media constantly bombard us with messages about sex, love, and romance and what more appropriate time for this than Valentine's Day? The bombardment begins as early as December 26, when Christmas decorations come down so that valentine decorations can go up, starting a 7-week journey of unrelenting hype (Corlet, 2003). Newspapers and magazines are filled with ads for cards, flowers, and candy. Radio broadcasts describe romantic evenings at special restaurants, TV commercials show radiant women receiving diamonds from their sweethearts, and stores abound with valentine treasures of

every kind. As a result of this media onslaught, is it any wonder that we expect our dreams to be fulfilled by our loved ones on Valentine's Day?

Women, especially, seem to feel that Valentine's Day is important because it is the one day each year when we can reasonably expect our otherwise reluctant lovers to verbalize their feelings and overtly demonstrate their affection. Of course, the underlying message from the media is that if our lovers do not acknowledge Valentine's Day, they are, in effect, saying that they do not really care.

VALENTINE'S DAY ANALYSIS

Methodology

I conducted a two-part study that examined how the media construct the "myth" of Valentine's Day, reinforcing beliefs in Myth #10 (Galician, 2004, p. 201) and Myth #3 (Galician, 2004, p. 135).

As I researched the topic of Valentine's Day, I came across numerous Internet postings by individuals who expressed their opinions and experiences regarding Valentine's Day. Interestingly, all of their postings were negative, which led me to wonder if people generally had negative attitudes about this day or if only those with negative experiences bothered posting their thoughts. In addition, their comments kept referring to the influence of the media and how disillusioned they were at not having their dreams fulfilled—the same dreams that the media helped to establish. I decided to compare their "rants" to the attitudes and perceptions of university students to determine whether they also possessed negative attitudes about Valentine's Day and whether they felt that the media influenced their perceptions. I conducted interviews with 124 university students, asking them questions based on the Internet postings, to see whether their responses were similar in terms of their belief in these myths.

Origins of Valentine's Day

The origins of this day are steeped in mystery, with roots in both Christian and Pagan traditions ("The History of Saint Valentine's Day," n.d. b). By the 4th century B.C., the Romans honored Juno, the Goddess of Love, on February 14 and celebrated the Feast of Lupercalia on February 15 ("The History of Saint Valentine's Day," n.d.). Lupercalia was a fertility festival that included a custom in which young men would draw from a jar the names of teenaged girls who would become their sexual companions for the rest of the year ("Valentine's Day: Not Like It Used Be," 1998–1999).

Valentine was a 3rd century priest who was imprisoned and then executed on February 14, 270 A.D., for marrying couples in defiance of the emperor's orders. Valentine fell in love with his jailer's daughter and, just before his death, sent

her a letter from prison, signing it, "From your Valentine" ("The History of Valentine's Day," n.d. a). After his death, he was made the Patron Saint of Lovers and the overseer of a festival on February 14 during which young men offered handwritten messages of affection to the women they admired ("The History of Valentine's Day," n.d. d).

In 469 A.D. the pope changed the celebration of Lupercalia on February 15 to a celebration honoring St. Valentine on February 14 that included the custom of having men seek the affection of women they admired through handwritten greetings. Printed cards replaced handwritten and handmade ones by the late 18th century ("The History of Valentine's Day," n.d. c); Hallmark produced its first valentine in 1913 and now offers more than 3,600 different Valentine's Day greeting cards ("Valentine's Day 2004," 2004). According to the Greeting Card Association, Americans today exchange more than 1 billion cards, and Valentine's Day has become the second largest card-sending holiday of the year ("St. Valentine's Day Trivia," 1996–2004).

Contemporary Celebrations

The excitement and romance of Valentine's Day begins for us at a very early age. I was only a few years old when I received my first heart-shaped box from my father. In elementary school, I remember making valentine holders out of construction paper and then anxiously awaiting the day when my holder would overflow with valentines, and my children did the same when they were young. In the episode entitled "Diamonds" of CBS's *Everybody Loves Raymond* (Stempe, 1997), Ray's 5-year-old daughter Allie proudly showed her parents the valentine with the chewing gum stuck in the middle that she received from a little boy in her class. According to Allie, it meant, "He must really love me."

Approximately 74% of Americans today celebrate Valentine's Day, about half of all Americans will give at least one valentine card, and one-third of those cards will accompany gifts. Consumers spent an average of $77.43 in 2004 on cards and gifts, including more than 35 million heart-shaped boxes of chocolates ("St. Valentine's Day Trivia," 1996–2004; "Valentine Trivia," n.d.).

Whereas most men want chocolate, most women want valentines that express love and romance, according to Patrick Carr, valentine manager for Hallmark:

> A year from now, most women won't remember what they had for dinner or the valentine chocolates they ate. But they will remember the valentines and probably will have kept every valentine, especially when personal notes are written in them. ("This Year, Think 'Love'," 2004)

Carle, a relationship therapist and author of numerous books about love, echoed Carr: "Valentines are feel-goods! That's why many people choose to save them"

("Putting Love into Words," 2004, n.p.). Consumers agree that messages of love are treasures they will keep forever because rereading the cards enables them to relive their memories, over and over again.

Men seem to experience more difficulty than women at putting their feelings into words, and valentines excel at doing this for them. According to Carle:

> In our hurried world, people too often put their feelings on the back burner because they don't have the words to express them. But when they see the precise words that express their deep emotions, they have the desire to share them. ("Putting Love into Words," 2004, n.p.)

Carr also said the only thing women remember more passionately than the valentines they got is the valentine they did not get ("Putting Love into Words," 2004). If a woman expects to receive one and does not, she will probably be very disappointed. Fortunately, most men understand that Valentine's Day is important and are likely to buy cards that say, "I love you."

Marketing the Myth of Valentine's Day

According to Katz (2003), "This holiday has become larger than life, and you can blame marketing for making it so" (p. 51). Christmas might be the only holiday celebration that exceeds Valentine's Day, but Christmas is based on a religion that is still honored and practiced today and is sanctioned by the U.S. government as a national holiday. Valentine's Day, however, is based on a pagan religion that is no longer practiced and is not sanctioned as an official holiday. So why does it receive so much attention? The implicit meaning of Myth #10 (Galician, 2004, p. 201), perpetuated by the mass media, is clear: "You're nobody 'til somebody loves you," as the song goes.

The media go to incredible lengths to market Myth #10 (Galician, 2004, p. 201) and the whole valentine "myth," especially for those willing to pay the price. For instance, one of the more extravagant deals in 2004 was a romantic $125,000 celebration offered by the Ritz-Carlton, Lake Las Vegas, which included his and hers Mercedes to keep and a butler to prepare s'mores over a lakeside bonfire (Silver & Hallett, 2004). Concierge of Romance is a Florida-based service that arranges special celebrations; frequently requested are private chefs ($150–$200) and masseuses who make house calls ($75 an hour) (Silver & Hallett, 2004). Many hotels, from the most expensive to the more modest, offer services such as rose petal-covered beds, breakfast in bed, and heart-shaped bathtubs.

Hallmark's primary advertising strategy for years has revolved around the slogan, "When you care enough to send the very best," and their TV commercials show card recipients turning their cards over to check for the Hallmark name on the back, even before they read the card ("Putting Love Into Words," 2004).

The implicit message here is that if the Hallmark designation is not there, the sender just did not care enough, and, therefore, the recipient must not have been special enough. FTD entices us with "Say it with flowers" in their magazine and online ads ("FTD Press Release," 2004), and Russell Stover compels by advertising their candy as "Only the Finest" ("St. Valentine's Day Trivia," 1996–2004). And what woman could resist a man after he has given her a diamond from De Beers ("A Diamond Is Forever: What's Hot," n.d.) because their TV ads tell her "A diamond is forever." All of these slogans are intended to encourage men and women to buy into Myth #10 (Galician, 2004, p. 201) by convincing them that they are responsible for fulfilling their partners' dreams. To do otherwise would be equivalent to saying to their partners that they did not want to say it with flowers, send the very best, or give something that would last forever. De Beers goes one step further toward ensuring our cooperation by featuring an advertisement that is part of their "Seize the Day" campaign ("A Diamond Is Forever: What's Hot," n.d.) that reads "This Valentine's Day we are refraining from using silly Cupid references, trite love poems, and jokes about roses, cards, or chocolates. You might want to do the same." And what better way to do the same than with a diamond? Also part of the "Seize the Day" campaign, another ad tells readers "For once you'll know exactly what she's thinking," which perfectly describes Myth #3: "Your true soul mate should KNOW what you are thinking and feeling (without your having to tell)" (Galician, 2004, p. 135). The implication, of course, is that she is thinking of a diamond, and De Beers would be very happy to provide one. But I wonder what he is thinking?

Some people are convinced that Hallmark originated the whole Valentine's Day "insanity" to increase their profits, and there is no doubt that the holiday is extremely lucrative to our economy ("Valentine's Day Can Bite Me," 2004). For example, FTD, the leading provider of floral services and products in the United States, had revenue of $75.3 million for the period of January 1–February 23, 2004, and revenue of only $31 million for the following period February 24–March 31, 2004. The FTD advertising budget for January 1–February 23, 2004, was $15.1 million, whereas their budget for February 24–March 31, 2004 was only $5.8 million. FTD clearly spent more money on advertising during the period leading up to Valentine's Day, but they also reaped greater profits ("FTD Press Release," 2004).

In a fact sheet dated February 19, 2004, as reported by Hoover's Online, Jim McCann, CEO of 1-800-Flowers.com, said "We were very pleased with our results from Valentine's Day." Hoover's Online showed that 1-800-Flowers.com revenue for the 3rd quarter of fiscal year 2003–04, December 29–March 30, was $124.1 million; profit was $51 million; and the budget for marketing and sales was $35.7 million ("1-800-Flowers.com Fact Sheet," 2004). For the same quarter of 2002–2003, Hoover's Online reported revenue for 1-800-Flowers.com of $115.4 million, profit of $44.7 million, and marketing costs of $31.5 million. Like

FTD, 1-800-Flowers.com also spent more on advertising for Valentine's Day and clearly profited more by doing so, as have other "valentine" merchants.

One display of "I love you only" valentine cards actually read "Now available in multi-packs" ("Ron's Anti-Valentine's Day Wake," 2004). Talk about sharing equally! Instead of encouraging us to show affection for someone special, this advertisement actually promoted "sharing" our affection with everyone. But of course, all that sharing increases profits.

We are put under a great deal of pressure at this time of year and all because of what many consider to be this "fake" holiday. So what do many of us do when placed under such pressure? We procrastinate! Despite the fact that we all know when Valentine's Day is, many of us wait until the last minute to make any plans for celebrating. Fifty percent of valentines are sold during the week before Valentine's Day, and the most elaborate cards are sold only 48 hours before ("St. Valentine's Day Trivia," 1996–2004). Fortunately for us, the media are always there to help us pull off the myth, even at the last minute. A press release for 1-800-Flowers.com (2004) stated, "Love for procrastinators is possible with last minute gifts from 1-800-Flowers.com. For all you romantic procrastinators out there, help is on the way." According to Jim McCann, "Luckily for these procrastinators, we have the ability to play Cupid, even at the last minute. . . . 1-800-Flowers.com provides hope for those who wait until the last minute to find the perfect Valentine's gift" ("1-800-Flowers.com Press Release," 2004).

As media-literate consumers, we might recognize the fallacy of Myth #10 (Galician, 2004, p. 201), acknowledging the fact that we, alone, are responsible for fulfilling our own dreams without depending on someone else to do it for us. As Galician's (2004) Prescription #10 states, "Cultivate your own completeness" (p. 201). But in the process of completing ourselves, how many of us are willing to ignore Valentine's Day and risk alienating our loved ones? We know that flowers are more expensive on Valentine's Day than at other times, and cards are overly sentimental and overpriced. However, we also know that it is better to show up with a hastily purchased card or a bunch of wilted flowers than to show up empty-handed. Indeed, media messages are designed not only to encourage us to buy but also to make us feel guilty if we do not. "Show someone you care" and "When you care enough to send the very best" imply that if we do not do these things then we do not really care, and who wants to send that message, intentional or not? As for unintentionally forgetting, 54% of men feel that forgetting Valentine's Day is an "almost unforgivable offense," and 36% of women agree (Soukup, 2004).

Valentine's Day Reality

In the "Three Valentines" episode of NBC's *Frasier* (Hanning, 1999), Frasier was invited to dinner by his attractive station manager. He did not know if she in-

tended the evening to be a date or a business meeting, but his friend Roz said that, because it was Valentine's Day, it had to be a date. The implication here was that the only people allowed to have dinner out on Valentine's Day were those in love or at least those who were investigating the possibility of romance. But what about those people who actually do have business to conduct? Or friends who have not seen each other for a while and just want to visit? Or people who might actually be hungry and want to eat?

The result of all the media pressure surrounding Valentine's Day is that it has become something of a competition: What did you get and how much did it cost? Do people worry about whether their offerings are good enough or big enough or expensive enough and whether their partners will be pleased? In a *Family Circus* cartoon (Keane, 2003), a young daughter came home from school and told her mother that she would never sit next to another little girl on the bus again because "When I told her I got 26 valentines, she said, 'Don't feel bad!',", as if 26 valentines were inadequate! I wonder how many would have been enough for her?

The elementary schools of my children and my nieces and nephews had policies stating that if the children were going to bring valentines to school, they had to bring one for every child in the class, so that no one was left out. Leaving no child out was admirable, but at the same time this practice definitely took away from the original spirit and intent of Valentine's Day. How do you explain to a 6 year-old that he must give a valentine to the bully who hit him last week, in addition to giving one to his best friends? And although children's cards are not really about love, children surely begin to develop their own perceptions and expectations about Valentine's Day from this early experience.

Not only do the media messages pressure us to fulfill someone's dreams but they also have made it increasingly more expensive to do so, with men spending about 25% more on gifts than women spend (Soukup, 2004). My husband, who is a frequent purchaser of flowers, assured me that the price of roses can more than double for Valentine's Day, and heart-shaped boxes hold less candy and are more expensive than traditional boxes. Cards are elaborate, beautiful, and expensive, and many restaurants offer special Valentine's Day menus, also expensive. So while the media push us to celebrate Valentine's Day with our loved ones, they also make sure that businesses will profit from our doing so. Regardless of the offer on 1.800.Flowers.com to help out procrastinators, just try to find roses (or any kind of fresh flowers), an undamaged box of candy, a decent card, or a restaurant with an empty table at the last minute. According to one disgruntled Internet contributor,

> If you want a laugh, go to Hallmark sometime in the evening and watch freaked-out men try to pick out "the" card. Or visit the nearest grocery store and watch people fight over the shriveled remains of flowers in a last-ditch effort for sex. ("Love Sucks Month," 1996–2003)

And regardless of what we paid for them, many of the items that we so eagerly sought out and purchased before February 14 unfortunately looked like cheap junk the day after.

The focus of Valentine's Day also seems to have shifted from flattering those in love to punishing those who are not in love. According to a fact sheet on the 1-800-Flowers.com Web site (2004): "Valentine's Day means so much to so many people, an opportunity to show how we truly care about those special someones in our lives. . . . 1-800-Flowers.com makes it so easy to capture just the right sentiment. . . ." But amid such messages encouraging us to fulfill our partners' dreams, there is also an underlying message that is all too clear: This is a time for lovers, and if we do not have one, we do not get to participate. While encouraging us to go out and fulfill someone else's dreams, the media simultaneously imply that if Valentine's Day passes by with no gifts for us, then we must not be special to anyone. The ads do not say anything about simply sharing a nice evening with a friend, but they do imply that if we do not have a valentine sweetheart, there must be something wrong with us. So when Hallmark advertises "When you care enough to send the very best," it seems they are saying that if we do not get cards from Hallmark, then no one cares about us, or, at best, that someone might care but just not enough.

The Web site for WSL Strategic Retail Services (2003) actually stated that if we did not get something red, heart-shaped, sweet or lovey-dovey this past Valentine's Day, then we were among the few who did not. Thinking our "incompleteness" excluded us from this "private club" would be bad enough, but having someone else point it out to us could be devastating. According to the American Floral Association, at least 15% of women must feel excluded from the private club because they respond by sending themselves flowers on Valentine's Day ("St. Valentine's Day Trivia," 1996–2004).

If we believe in the myth and yet we do not have partners to "complete" us, it would be natural for us to begin to doubt ourselves: Either we are not good enough or beautiful enough or lovable enough. But Lazarus (1985) said that we make a huge mistake when we expect someone else to complete us. Not only is it unfair of us to place the burden of our happiness onto someone else, but it also gives us an excuse for not accepting responsibility for our own unhappiness. Likewise, it is unnecessary and even risky for us to accept the responsibility for completing someone else. This puts tremendous pressure on us to deliver and would probably produce tremendous guilt if we failed.

Hendrix (1992) stated, "Our attempt to get through another what is missing in ourselves never works, for personal emptiness cannot be filled by a partner" (p. 220), nor can we find true happiness until we are willing to do the work to make ourselves whole. As long as we are preoccupied with completing someone else, we will not have the time or energy to complete ourselves.

Unfortunately, the movie *Jerry Maguire* (Brooks, Crowe, & Crowe, 1996) went a long way toward reinforcing Myth #10 (Galician, 2004, p. 201) with its emphasis on "You complete me." Although many viewers found the movie and the sentiment to be terribly romantic, Galician (2004) said that expecting our partners to complete us was not romance but robbery. Her prescription for Myth #10 (Galician, 2004) clearly states, "Cultivate your own completeness" (p. 201). In addition to significantly reinforcing Myth #10, *Jerry Maguire* also "exemplifies the codependency model's dysfunction" (Galician, 2004, p. 204). Depending on someone else to make us happy or taking responsibility for the happiness of someone else, even on Valentine's Day, sets up both of us for a dysfunctional codependent relationship.

Likewise, it is foolish for us to expect that our partners should instinctively know what it is that we want and need (Galician, 2004, p. 135), because people are not mind readers, and we should not expect them to be. Several of the items on Eidelson and Epstein's (1982) Relationship Belief Inventory (RBI) measure our belief in Myth #3 (Galician, 2004, p. 135). The RBI was designed to assess unrealistic or dysfunctional expectations that led to problems in intimate relationships, and Eidelson and Epstein (1982) stated that an unrealistic belief in the mind reading myth led to disappointment.

Lazarus (1985) said that, although we might learn to read our partner's reactions quite accurately, we will never become mind readers. He suggested that our relationships would probably be better if we were up front with our partners. Valentine's Day would also probably be a lot more enjoyable if we would share with each other our expectations for the day rather than waiting to be disappointed when we received something we did not like, or even worse, when our partners forgot us. Instead, we should do as Galician (2004) stated in her prescription for Myth #3: "Communicate courageously" (p. 135) and tell our partners what we want.

AUDIENCE ANALYSIS

Internet Audience

Based on an understanding of how the media market the myth of Valentine's Day, I wanted to know how successful they were at encouraging people to embrace or reject their invitation to celebrate the day. In particular, I wanted to determine whether people believed in the myth of a partner to fulfill their dreams, as well as one who is a mind reader, based on how they were influenced by the media messages they received. I began with the Internet and people's postings about their responses to this occasion.

The Internet provided a number of sites devoted to people's negative reactions to Valentine's Day, including "Valentine's Day Can Bite Me" (2004) and "A Different View of that February Curse" (Trinidad, 1994). According to "The alt.suicide.holiday Valentine's Day survival kit" (Orf, n.d.):

> Every year you glare in contempt and hatred at these ignorant fools who buy into this money-making scheme of unabashed, transparent nothingness, thinly disguised as a day to show that special loved one just how much you care, while leaving those of us who are not in the throes of love to feel rejected, unloved, and downright inadequate. And those of you who are lucky enough to share the companionship of another are very aware that passing this wretched date by unheeded will result in scorn and contempt from your partner. (n.p.)

Is it not interesting that the same person who views "these ignorant fools" with such contempt goes on to refer to them as "lucky enough" to be in romantic relationships? This response, however, was typical of what I found on the Internet; all of the postings were negative. They were written by people who admitted that they were not (at the time) involved in romantic relationships, and many of them admitted to never having been in a relationship.

One Internet site ("Love Sucks Month," 1996–2003) invited unhappy people to submit their "anti-Valentine's Day rants." Following are some of the responses indicating how much these people wished Myth #10 (Galician, 2004, p. 201) applied to them:

> Saint Valentine worked for Hallmark. . . . It tortures the couple-less. . . . It's a shame that people are made to feel bad (by the media) because they don't have a love in their life, and all because of [sic] FAKE holiday.
>
> Valentine's Day sucks for women, too. Just because there's chocolate doesn't mean it still doesn't suck. Lots of us don't have dates and have to buy our own.
>
> . . . it's great if you have it but if you don't it sucks to be you . . . you're sitting there listening (to the media) with a broken heart wondering why you never have great times like this.
>
> It hurts to be reminded (by the media) that you aren't celebrating and aren't being celebrated on a holiday that is supposed to be about love.
>
> I have an iota [sic] of sympathy for anyone complaining about their boy friend or girl friend AT LEAST YOU . . . HAVE ONE! I have always been alone.
>
> I have NEVER had anyone by my side on v-day. You know what valentine's day [sic] does to people like me?? It shreds up our insides. It makes us want to pull our hair out and cry. It makes us feel more lonely than we already do.
>
> . . . the sad truth of knowing you're all alone hits you the most on this torturous day, hoping someone, anyone, will give you a box of candy or send you a dozen roses . . . it never happens. . . .

> Knowing that there's love out there and you don't have any makes you feel like there's something wrong with you. . . .

It sounds as if those who posted their feelings online assumed that they were doomed to "incompleteness" and that being in a romantic relationship and having disdain for Valentine's Day were mutually exclusive. They must have been right to a degree, since I did not find any postings from people with positive experiences. Although there certainly must be people in relationships who feel that the media has overhyped the occasion, their comments were few and far between and were still negative, focused on the extreme pressure they felt on this day to create the "perfect" romantic experience for their partners. As one writer stated (Katz, 2003):

> We suddenly feel like we have to run out and find the perfect gift. It may produce tremendous anxiety to find just the right thing or loads of guilt if we fail. . . . (p. 51)

Another writer (Trinidad, 1994) stated, "We are bombarded with hearts, Cupids, flowers and candies. We feel the pressure of the marketing ploys . . . designed to suck your purse or wallet dry on overpriced gimmickry" (p. 4).

Although it would seem that some of the Internet contributors would like to have a special someone for Valentine's Day, others are cynics who say they want nothing to do with it. On his Web site ("Ron's Anti-Valentine's Day Wake," 2004), Ron asked people to write in with their suggestions for conversation hearts candy. Some of the replies he received were "I love you, but not in that way," "No, I won't be yours," "Nice try," "No!," "You wish," "You're not my type," and "I don't go for guys like you." These are hardly the messages we envision when we think of love and romance, but obviously this must be how some people feel! The fact is that, although most valentines are probably appreciated, sending valentines can also be risky. What if we send them and are rejected, so that, on a day when others are celebrating their love, we are being told that we are not good enough? Imagine getting up the nerve to send a valentine, only to have the recipient respond with "You wish!" At the same time, I cannot help wondering whether these declarations against romance are not defense mechanisms used by people to justify why they are not in relationships.

Even those who are in relationships do not always look forward to Valentine's Day or regard it as a positive experience to be anticipated. According to postings on "Ron's Anti-Valentine's Day Wake" (2004):

> It's pretty sad i [sic] have a girlfriend and you think i would be out doing something with her today . . . but . . . she made plans with her friends and didn't even ask me if i wanted to do a damn thing today, so here i sit alone on the worst day of the year.

> Valentine's Day sucks when your man spent a year in another country, finally gets
> home, has been home for a month and you still haven't heard from him 2 days be-
> fore Valentine's Day so you don't know if he's dead, sick, or an. . . !

Although most of the postings did not indicate the gender or age of the writer,
those who posted their thoughts shared such negative experiences and associa-
tions with Valentine's Day that I wondered whether their experiences were typi-
cal and how they would compare with the experiences of others.

University Students

I conducted face-to-face interviews with 41 male and 83 female university stu-
dents between the ages of 20 and 40 concerning their attitudes about Valentine's
Day. The questions I used were based on the information contained in the on-
line postings, including whether or not subjects had ever been in romantic rela-
tionships, whether they were currently in relationships, and how long they had
been in those relationships. I then asked for their opinions about Valentine's
Day, including whether or not they looked forward to and celebrated Valentine's
Day, whether they gave and received gifts, what their expectations were for
Valentine's Day, and whether or not they were disappointed or angry about their
experiences and with their partners.

The results for the university students reinforced the Internet postings in terms
of how difficult it was to be alone when all around you were receiving cards, flow-
ers, and gifts. Students spoke of how they felt left out when others were celebrat-
ing, and they had no one with whom to celebrate. Women especially talked of
the resentment they felt at the attention others received. Amy (name changed)
said that she got caught up in the excitement and wanted a valentine gift be-
cause she saw those around her receiving gifts; she thought that maybe it wouldn't
be so bad if she didn't have to watch it going on all around her. Julie explained
that, in her high school, for $1 you could send a carnation to another student dur-
ing class; she waited and hoped for even one carnation that never came. Theresa
wanted to pop the balloons that others carried around the halls because she so
desperately wanted some of her own. John told of working at an elementary school
and seeing children cry when they did not receive any (or enough) valentines.

Other students talked of the pressure from the media to participate in the
Valentine's Day extravaganza, despite the cost. Brian said he bought gifts out of
a sense of obligation, Allen because his wife expected it, and Rick out of a need to
impress his girlfriend and his friends. Ellen worked in retail and told of the many
times a man would ask her to pick out something for his wife or girlfriend rather
than taking the time to find something himself, leading her to fear that she would
receive such an impersonal gift from her own valentine.

Many students felt disappointed when their valentine efforts weren't reciprocated, especially when their partners forgot or just didn't feel the need to remember them in some way. Of the students 90% (112) said the worst gift they ever received was nothing at all. Susan told of trying so hard to make a special celebration for her boyfriend, who then responded that he didn't know they were going to do anything special, despite the fact that they had discussed their special plans in advance. Kim said that, based on the ads that she had seen on TV, she was expecting her Valentine's Day celebration with her husband to be incredibly romantic, so she was disappointed when their dinner conversation revolved around mundane matters such as whether or not she picked up the dry-cleaning.

A number of women were disappointed with the gifts they received and hated trying to fake appreciation. Terri told of her dismay when, after 5 years of dating, her boyfriend led her to believe that he was finally going to propose. Naturally, she was disappointed when he gave her a bracelet instead—one that she would have liked under other circumstances, but when offered in place of an anticipated engagement ring, she didn't even want it. Greg said that, in response to his flowers, his wife became furious, wanting to know why he had to wait until Valentine's Day rather than bringing her flowers all year long. Despite the stereotype that all women love flowers, when asked about the worst gift she ever received, Rebecca said, "Flowers! What am I going to do with flowers?"

Karen admitted that she was often disappointed in what her boyfriend gave her, not just for Valentine's Day but for all gift-giving occasions. When I asked why she didn't just tell him what she wanted, her reply was that if he loved her, he should know what would make her happy without her having to tell him. This is Myth #3 clearly stated: "Your true 'soul mate' should KNOW what you're thinking or feeling (without your having to tell)" (Galician, 2004, p. 135). Many students, especially women, echoed the same thought; they said they didn't really believe in the myth, but they thought their partners should know them well enough to know what they would really like for Valentine's Day. I found it very interesting that these students could not see that they actually did believe the myth. A *For Better or Worse* comic strip (Johnston, 2003) illustrated this problem well. John and Ellie were walking down the street, window-shopping, when she spotted a beautiful necklace and pointed it out to him. He asked if he could get it for her for Valentine's Day, and she replied that she was just admiring it. He told her to go in and try it on, but she said it was too expensive. As they left, she was pleased with herself and pictured him presenting her with the beautiful necklace for Valentine's Day while he thought to himself, "I wish she'd tell me what she really wants."

Some students seemed concerned about the sense of obligation that accompanied gifts. Several men expressed concern that if their wives received something nice one year, they would expect something even better the next year, leaving the men under pressure to outperform themselves from year to year. Others

seemed to think of gift giving in terms of themselves and what they would get in return, believing the bigger, the better. Harry stated, "If I buy her a bigger necklace, she will think I love her more, and I will get more sex." Women worried about what they were expected to do in return for what the man was offering. Cindy stated that she hated to see her husband walk in with flowers because she knew that meant he wanted something from her.

The majority of the students interviewed (almost 100%) expressed the conviction that love shouldn't be limited to one day, and 90% (110) believed that Valentine's Day was superficial and materialistic, a fake holiday created by the media to profit at the public's expense. Students consistently expressed the desire for sincere, honest, spontaneous expressions of love rather than ones that came because they were expected or because their partners felt obligated. They felt that, if you truly love someone, you should show it throughout the year rather than waiting for one designated day. They felt that partners who were really secure in their relationships didn't need a special day to show their love. Students wanted gifts because their partners wanted to give them and not because the calendar said it was time to do so. They especially believed that true love should never come with a price tag. Valentine's Day, it seems, has actually given romance a bad name ("Resurrect Romance Week," 1996–2004). Real romance is not about money or competition, so why is it that we think we have to spend money to be romantic?

Some students admitted that, for those who had difficulty expressing their feelings, Valentine's Day gave them a way to do it, especially through a card that might actually verbalize what they didn't know how to say. Of the respondents 85% (105) said that although they didn't expect to receive anything, it was nice when they did; 52% (65) said that, although love should be expressed year-round, Valentine's Day presented the opportunity to do something extra special, and 80% (98) expressed the desire to be remembered, especially those extremely busy people whose lives included children.

Many students said that receiving a gift was not as important as the chance to reconnect with their partners. Melissa remembered her most memorable Valentine's Day as the time she saw her husband on TV. He was buying her flowers and talking to a friend about how much he loved her, unaware that he was being videotaped. When she saw him on TV, she was overwhelmed, not by the flowers but by what he said. Elizabeth related that her husband wrote her a letter every Valentine's Day, telling her how he felt about her, and she kept and cherished every one as a constant reminder of his love. Pam thought the most significant thing about her celebration with her husband was the fact that, after 20 years and four children, his attention meant that he still found her desirable.

Although 85% (105) of the interviewees said that they really didn't expect anything on Valentine's Day, those who actually did express a desire for something wanted simple things such as time together, a quiet dinner, and a little attention. They obviously felt that receiving something material was not nearly as

important as being appreciated. Likewise, the majority of those who were disillusioned about Valentine's Day were much less concerned about not receiving a gift than they were about being alone.

DISCUSSION

I found it very interesting to compare the people who posted their feelings on the Internet with the university students that I interviewed. Those who posted comments about their Valentine's Day experiences were extremely negative, ridiculing the celebration and those who participated. However, I wonder if their negativity might not have been a defense mechanism to protect them from the obvious pain they felt over their lack of romantic involvement and joyful Valentine's Day experiences. Although I am not sure if there is any way to actually determine that, too many of them (almost 100%) referred to how rejected and left out they felt to not wonder if they would not jump at the chance to share the day with someone else, if the opportunity presented itself. In addition, too many of them (almost 100%) mentioned the pressure they received from the media to think that the media did not play a big role in creating their pain.

The expectations of the university students centered more on downplaying the day and not putting so much pressure on others to "fulfill their dreams" and "read their minds." This group did express some dissatisfaction with their Valentine's Day celebrations, but they did not express negativity to the same extent that the Internet group did. Although they also referred to the pressure from the media to make Valentine's Day special, rather than expecting expensive demonstrations of affection, they just wanted to know that their partners cared. They especially did not like the idea of feeling obligated to show their affection on Valentine's Day rather than wanting to show it all year long, so perhaps their more realistic expectations led to less disappointment. Any way you look at expectations for Valentine's Day though, communicating courageously and cultivating your own completeness make so much more sense (Galician, 2004).

CONCLUSION

Soukup (2004) said that 25% of people would begin a relationship that was not right for them just so they would not be alone on Valentine's Day. I once had a friend who would do the same thing in an effort to live out Galician's Myth #10. She would go out with any willing partner, even one she would not normally consider, just so she would not be alone on February 14. In a way, she was like me when I was 5: Her "dreams" may have been fulfilled, but at what cost? I certainly relished the chocolates I received on Valentine's Day, but when I ate too many

of them, I got sick. Although my behavior could be excused as the foolishness of a child, the same behavior is just sadly pathetic in an adult. My friend would settle for a less-than-suitable man for this one day, just so she would not be alone, when all his valentine gifts could never really fill the void in her life. Only she could do that. And how were her dates supposed to read her mind and know what she wanted when she did not even know?

Obviously, the media have gone overboard in promoting Valentine's Day, capitalizing on those in love and ostracizing those who are not. But the real harm comes from promoting the idea that we should depend on others to fulfill our dreams, and that, if we do not have someone to do that for us, then we are personally lacking in some way. We have taken a day on which we were meant to show appreciation for others and turned it into a powder keg that could explode if we are not successful in pulling off the myth.

For some of us, Valentine's Day has even become a nightmare to be dreaded—surely not what the Romans or St. Valentine intended. Those of us who are not in relationships need to do something to change our situations, for if we sit at home alone, waiting for someone to do it for us, we may have a long wait. As Galician's Rx #10 exhorts, we need to take responsibility for our own happiness rather than waiting for someone to do it for us.

Celebrating Valentine's Day might be fun, but it really is not necessary, nor is it necessarily a true indication of love. Anyone with money can buy things, and it is much easier for some people to buy something than to verbally express their feelings. But even people with plenty of money are not mind readers and should not be expected to instinctively know what will make us happy, especially if we do not even know.

Love should not carry a price tag, nor should showing our affection for another be limited to Valentine's Day. If we are truly in love, we should not need a special day to prove it or expensive things to show it. But as long as we look to others to fulfill our dreams and expect them to do so with no help from us, we are doomed to disappointment. We, alone, are responsible for making our own dreams come true, and not even heart-shaped boxes can do that for us.

STUDY QUESTIONS/RECOMMENDED EXERCISES

1. Do you agree or disagree with the movie *Jerry Maguire* and the belief that the right mate "completes" you? What harm can you see in believing Myth #10: "The right mate 'completes' you, filling your needs and making your dreams come true"?

2. Galician stated that expecting a mate to complete you was robbery rather than romance. Do you agree or disagree—and why?

3. Many people believe that if you have been in a significant relationship for long enough that you should be able to "read" your partner (Myth #3). What problems do you see in this belief?

4. Do you think it is possible to keep the romance in Valentine's Day if you reject belief in Myth #10? How would you go about doing this?

5. Do you agree or disagree with the statement that Valentine's Day is a "fake" holiday? How have you personally have been affected by media portrayals of Valentine's Day? What would you suggest doing to make Valentine's Day more "real?"

REFERENCES

Brooks, J., Crowe, C. (Producers), & Crowe, C. (Writer/Director). (1996). *Jerry Maguire* [Motion picture]. United States: Gracie Films/Tristar Pictures.

Corlett, C. (2003, February 10). Can't buy me love? *Brandweek, 44*(6), 16. Retrieved November 1, 2004, from http://www.adweek.com/aw/search/search_results_taxo.jsp

A diamond is forever: What's hot. (n.d.) Retrieved January 18, 2005, from http://www.adiamondisforever.com/hot/asadvertised.html

Eidelson, R. J., & Epstein, N. (1982). Cognition and relationship maladjustment: Development of a measure of dysfunctional relationship beliefs. *Journal of Consulting and Clinical Psychology, 50,* 715–720.

FTD Press Release. (2004, May 12). Retrieved October 5, 2004, from http://www.hoovers.com/ftd/-ID_41921-/free-co-fin-annual.xhtml

Galician, M.-L. (2004). *Sex, love, and romance in the mass media: Analysis and criticism of unrealistic portrayals and their influence.* Mahwah, NJ: Lawrence Erlbaum Associates.

Hanning, R. (1999). Three valentines (K. Grammer, Director). In K. Grammer (Producer), *Frasier.* New York: National Broadcasting Company.

Hendrix, H. (1992). *Keeping the love you find: A guide for singles.* New York: Pocket Books.

The history of Saint Valentine's Day. (n.d.) Retrieved April 27, 2004, from http://www.pictureframes.co.uk/pages/saint_valentine.htm

The history of Valentine's Day. (n.d. a) Retrieved April 27, 2004, from http://www.historychannel.com/exhibits/valentine/history.html

The history of Valentine's Day. (n.d. b) Retrieved April 27, 2004, from http://www.historychannel.com/exhibits/valentine/history2.html

The history of Valentine's Day. (n.d. c)Retrieved April 27, 2004, from http://www.historychannel.com/exhibits/valentine/history3.html

History of Valentine's Day. (n.d. d) Retrieved April 27, 2004, from http://www.theholidayspot.com/valentine/history_of_valentine.htm

Johnston, L. (2003, February 9). *For better or worse.* Corbel, Ontario, Canada: Lynn Johnston Productions, Inc.

Katz, D. (2003). What makes our hearts smile. *Lesbian News, 28*(7), 51.

Keane, B. (2004). *Family Circus.* New York: King Features Syndicated.

Lazarus, A. A. (1985). *Marital myths: Two dozen mistaken beliefs that can ruin a marriage or make a bad one worse.* San Luis Obispo, CA: Impact.

Love sucks month aka Valentine's Day is a fraud. (1996–2003). Retrieved April 27, 2004, from http://www.nonpc.org/luv.html

1-800-Flowers.com Fact sheet. (2004). Retrieved October 5, 2004, from http://www.hoovers .com/free/search/simple/xmillion/index.xhtml?page=1&query_string=1-800-flowers.com &which=company&x=24&y=8

Orf, L. (n.d.). *The alt.suicide.holiday Valentine's Day survival kit.* Retrieved April 27, 2004, from http://www.contrib.andrew.cmu.edu/~norm/love.html

Putting love into words: Valentine is universal symbol. (2004). Retrieved October 11, 2004, from http://www.pressroom.hallmark.com/val_day_universal-symbol.html

Resurrect Romance Week. (1996–2004). Retrieved April 30, 2004, from http://www.theromantic .com/resurrect.htm

Ron's anti-Valentine's Day wake. (n.d.). Retrieved April 27, 2004, from http://www.pacifict.com/ ron/valentine/vd.html

Silver, M., & Hallett, V. (2004, February 16). What I spent for love. *U. S. News & World Report, 136*(6), 65.

Soukup, E. (2004, February 16). Hear it for the boys. *Newsweek, 143*(7), 10.

Stempe, K. (1997). Diamonds (M. Lembeck, Director). In R. Romano (Producer), *Everybody Loves Raymond.* New York: Columbia Broadcasting System.

St. Valentine's Day trivia. (1996–2004). Retrieved April 30, 2004, from http://www.theromantic .com/valentinesday/trivia.htm

This year, think "love" on Friday for your Saturday sweetheart. (2004). Retrieved October 11, 2004, from http://www.pressroom.hallmark.com/val_day_think-love.html

Trinidad, E. (1994, February 11). A different view of that February curse. *USC Daily Trojan,* p. 4. Retrieved April 27, 2004, from http://www.westworld.com/~elson/me/columns/ evol.html

Valentine's Day can bite me. (2004.) Retrieved April 27, 2004, from http://www.angelfire.com/ ma/avideto/vday.htm

Valentine's Day: Not like it used to be. (1998–1999) Retrieved January 19, 2005, from http:// www.wilstar.com/holidays/valentine.html

Valentine's Day 2004. (2004). Retrieved October 11, 2004, from http://www.pressroom.hall mark.com/val_day_facts.html

What do these Valentine's symbols mean? (2004). Retrieved October 11, 2004, from http://www .spirituality.indiatimes.com/articleshow/37153230.cms

Valentine trivia. (n.d.) Retrieved October 11, 2004, from http://www.backyard.com/current/ 258pl.htm

WSL Strategic Retail—How America shops. (2003). Retrieved January 18, 2005, from http://www .wslstrategicretail.com/publications/edge/0203/left_valentine.html

Deborah Shelley *is Associate Professor of Communication Studies and Assistant Chair of the Department of Arts and Humanities at the University of Houston–Downtown. She earned a B.A. in Speech from the University of North Carolina in 1972, an M.A. in Speech from San Francisco State University in 1974, and a Ph.D. in Communication with a minor*

in Management from Louisiana State University in 1976. Her current research interests lie in issues regarding sex, love, and romance, including perceptions of Valentine's Day and readers' responses to romance novels. Her teaching areas are family communication; interpersonal communication; sex, love, and romance in the mass media; and film studies. She has been married for 33 years to her college sweetheart, and she has two children—a daughter who is a 10th grade English teacher and a son who is a graduate student in Creative Writing. Her hobbies are traveling, reading, and playing bridge.

APPENDIX

Resource Guide to Sex, Love, and Romance in the Mass Media: Some Additional Publications, Films, Television Shows, Songs, and Web Sites

Debra L. Merskin
University of Oregon

This final chapter offers some additional resources for teachers, students, and researchers. The first section includes nonfiction books and scholarly journal articles that could be used as supplemental readings or research sources. Other sections list samples of films with weddings; television shows that illustrate myths and stereotypes about sex, love, and romance; and popular songs that can be used for study or for creating classroom atmosphere. Also included are media literacy Web sites and—just for fun—a few related fiction and popular books.

Extensive lists of books, films, televisions programs, and songs specifically manifesting each of the 12 myths of *Dr. FUN's Mass Media Love Quiz*© are also included in each of the 12 chapters of Part II of Galician's (2004) *Sex, Love, and Romance in the Mass Media: Analysis and Criticism of Unrealistic Portrayals and Their Influence* (Lawrence Erlbaum Associates). In addition, her Web site (www.RealisticRomance.com) maintains the archives of her annual *Dr. FUN's Stupid Cupid & Realistic Romance® Awards™* for mass media portrayals of sex, love, and romance in the mass media—announced each Valentine's Day—with full citations for each of the 12 Stupid Cupid Award winners (one for each of the myths) and 12 Realistic Romance® Award winners (one for each of the prescriptions) as well as the winners of the Stupidest Cupid Award and the Realistic Romance® Grand Prize.

NON-FICTION BOOKS AND SCHOLARLY
JOURNAL ARTICLES

Ackerman, D. (1995). *A natural history of love*. New York: Vintage.

Altman, D. (2001). *Global sex*. Chicago: The University of Chicago Press.

Banks, J. (2003). Prurient interests: Sexuality, ideology, and popular communication. *Popular Communication, 1*(1), 5–13.

Beatty, M. (1987). *Codependent no more: How to stop controlling others and start caring for yourself*. New York: HarperCollins.

Blumstein, P., & Schwartz, P. (1983). *American couples*. New York: William Morrow.

Branden, N. (1980). *The psychology of romantic love*. New York: Bantam.

Buscaglia, L. (1996). *Love: What life is all about*. New York: Bantam.

Buss, D. M. (1984). *The evolution of desire: Strategies of human mating*. New York: Basic Books.

Connolly, J., Furman, W., & Konarski, R. (2000). The role of peers in the emergence of romantic relationships in adolescence. *Child Development, 71*, 1395–1408.

Durham, M. G. (1998). Dilemmas of desire: Representations of adolescent sexuality. *Youth & Society, 29*, 369–490.

Feiring, C. (1996). Concepts of romance in 15-year old adolescents. *Journal of Research on Adolescence, 6*, 181–200.

Fisher, H. (1992). *Anatomy of love: A natural history of mating, marriage, and why we stray*. New York: Fawcett Columbine.

Furman, W., Brown, B. B., & Feiring, C. (Eds.). (1999). *The development of romantic relationships in adolescence*. New York: Cambridge University Press.

Galician, M.-L. (2004). *Sex, love, and romance in the mass media: Analysis and criticism of unrealistic portrayals and their influence*. Mahwah, NJ: Lawrence Erlbaum Associates.

Gottman, J. (1994). *Why marriages succeed or fail . . . and how you make yours last*. New York: Simon & Schuster.

Gottman, J. (1999). *The seven principles for making marriage work*. New York: Crown.

Hamon, R. R., & Ingolds, B. B. (2003). *Mate selection across cultures*. Thousand Oaks, CA: Sage.

Harvey, K., & Shalom, C. (Eds.). (1997). *Language and desire: Encoding sex, romance, and intimacy*. London: Routledge.

Hendrix, H. (1988). *Getting the love you want: A guide for couples*. New York: Henry Holt.

Hendrix, H. (1992). *Keeping the love you find: A guide for singles*. New York: Pocket Books.

hooks, bell. (2001). *All about love: New visions*. New York: Perennial.

hooks, bell. (2001). *Salvation: Black people and love*. New York: Perennial.

hooks, bell. (2003). *Communion: The female search for love*. New York: Perennial.

Hopkins, A. (1994). *The book of courtly love: The passionate code of the troubadours*. New York: HarperSanFrancisco.

Johnson, R. A. (1985). *We: Understanding the psychology of romantic love*. San Francisco: Harper.

Johnson, R. A. (1989). *She: Understanding feminine psychology*. New York: Perennial Currents.

Johnson, R. A. (1989). *He: Understanding masculine psychology*. New York: Perennial Currents.

Katz, S. J., & Liu, A. E. (1988). *False love and other romantic illusions*. New York: Pocket Books.

Keen, S. (1999). *To love and be loved*. New York: Bantam.

Kerner, S. (1994). *The culture of love: Victorians to moderns*. Cambridge, MA: Harvard University Press.

Lee, J. A. (1976). *The colors of love*. Englewood Cliffs, NJ: Prentice-Hall.

Lee, J. A. (1988). Love styles. In R. J. Steinberg & M. L. Barnes (Eds.), *The psychology of love* (pp. 119–138). New Haven, CT: Yale University Press.

Plato. (1960). The symposium. In *The republic and other works* (B. Jowett, Trans.). Garden City, NY: Dolphin. (Original work published 385 B.C.E.).

Regan, P. C. (2002). *The mating game: A primer on love, sex, and marriage*. Thousand Oaks, CA: Sage.

Schulman, S., & Collins, W. (Eds.). (1997). *Romantic relationships in adolescence: Developmental perspectives*. San Francisco: Jossey-Bass.

Schulman, S., & Scharf, M. (2000). Adolescent romantic behaviors and perceptions: Age- and gender-related differences, and links with family and peer relationships. *Journal of Research on Adolescence, 10*, 99–118.

Schulman, S., & Seiffge-Krenke, I. (Eds.). (2001). Adolescent romance: From experiences to relationships [Special issue]. *Journal of Adolescence, 24*(3).

Segrin, C., & Nabi, R. L. (2002). Does television viewing cultivate unrealistic expectations about marriage? *Journal of Communication, 52*, 247–263.

Sternberg, R. J. (1987). Liking versus loving: A comparative evaluation of theories. *Psychological Bulletin, 102*, 331–345.

Sternberg, R. J. (1988). Triangulating love. In R. J. Sternberg & M. L. Barnes (Eds.), *The psychology of love* (pp. 119–138). New Haven, CT: Yale University Press.

Sternberg, R. J. (1998). *Cupid's arrow: The course of love through time*. New York: Cambridge University Press.

Stone, L. (1988, February). A short history of love. *Harper's*, pp. 26–27.

Tannen, D. (2001). *You just don't understand: Women and men in conversation*. New York: Perennial Currents.

Tanner, L. T., Haddock, S. A, Zimmerman, T. S., & Lund, L. K. (2003). Images of couples and families in Disney feature-length animated films. *American Journal of Family Therapy, 31*, 355–373.

Vannini, P. (2004). Will you marry me? Spectacle and consumption in the ritual of marriage proposals. *The Journal of Popular Culture 389*, 169–185.

Weisser, S. O. (Ed.). (2001). *Women and romance: A reader*. New York: New York University Press.

BOOKS (FICTION AND POPULAR CULTURE)

Austen, J. (1983). *Pride and prejudice*. New York: Bantam Classics.

Bronte, E. (1983). *Wuthering heights*. New York: Bantam Classics.

du Maurier, D. (1994). *Rebecca*. New York: Avon.

Duncan, D. J. (2002). *The River Why*. Berkeley, CA: University of California Press.

James, H. (1990). *The American*. New York: Signet Classics.

Hazzard, S. (1990). *The transit of Venus*. New York: Penguin.

Hemingway, E. (1995). *The sun also rises*. New York: Scribner.

Morrison, T. (2003). *Love*. New York: Knopf.

Marquez, G. G. (2003). *Love in the time of cholera*. New York: Vintage.

Neruda, P. (2004). *Twenty love poems and a song of despair*. Chicago: Giron.

Patchett, A. (2002). *Bel canto*. New York: Perennial.

Ruff, M. (2004). *Set this house in order*. New York: Perennial.

Tolstoy, L. (2004). *Anna Karenina*. New York: Penguin.

Shakespeare, W. (1997). *Sonnets of William Shakespeare*. New York: Gramercy.

Smart, E. (1992). *By Grand Central Station, I sat down and wept*. New York: Vintage.

Wharton, E. (1999). *Age of innocence*. New York: Vintage.

Williams, J. (1988). *Stoner*. Little Rock, AR: University of Arkansas Press.

FILMS

Movies About Weddings

American Wedding (2003)

Father of the Bride (1991)

Fools Rush in (1997)

Four Weddings and a Funeral (1994)

Honeymoon in Vegas (1992)

How to Marry a Millionaire (1953)

Just Married (2003)

Meet the Parents (2000)

Mr. Wrong (1996)

Muriel's Wedding (1995)

My Best Friend's Wedding (1997)

Royal Wedding (1951)

Runaway Bride (1999)

The Best Man (1999)

The Wedding Gift (1994)

The Wedding Planner (2001)

The Wedding Singer (1998)

Movies with Wedding Scenes

It Happened One Night (1934)

The Deer Hunter (1978)

The Godfather (1972)

See also American Film Institute (AFI) "AFI's 100 Years . . . 100 Passions" (online at http://www.afi.com/tvevents/100years/passions.aspx)—the 100 "most passionate films of all time," which were selected by "a blue-ribbon panel of leaders from the film community, including film artists (directors, screenwriters, actors, editors, cinematographers, etc.), critics, historians and film executives." Heading the list as the most romantic U.S. film ever is *Casablanca* (1942). The 400 nominees are also listed, along with the judges' criteria and other factoids about some of the winners. This listing makes for great classroom discussion as well as academic debate.

TELEVISION PROGRAMS

Buffy the Vampire Slayer
Desperate Housewives
Everybody Loves Raymond
Friends
Seinfeld
Sex in the City
The Sopranos

SONGS

(The timing of the recording is provided in minutes and seconds.)

A *Thing for You* (Gloria Estefan) 4:05
All I Need (Jack Wagner) 3:31
Can't Fight This Feeling (REO Speedwagon) 4:57
Can't We Try? (Dan Hill with Vonda Sheppard) 3:59
Could I Have This Dance? (Anne Murray) 3:15
Every Time You Go Away (Paul Young) 5:26
Get Here (Oleta Adams) 4:37
Giving You the Best That I Got (Anita Baker) 3:53
Groovy Kind of Love (Phil Collins) 3:30
Have I Told You Lately? (Rod Stewart) 3:59
Heart Light (Neil Diamond) 4:26

Here and Now (Luther Vandross) 5:24

How Am I Supposed to Live Without You? (Michael Bolton) 4:16

I Swear (All-4-One) 4:20

I Want to Know What Love Is (Foreigner) 5:01

If You Don't Know Me by Now (Harold Melvin and The Blue Notes) 3:29

I'll Always Love You (Taylor Dayne) 4:32

Lady (Kenny Rogers) 3:47

One in a Million You (Larry Graham) 4:12

Right Here Waiting (Richard Marx) 4:25

Somewhere Out There (Linda Ronstadt and James Ingram) 4:00

Stuck on You (Lionel Richie) 3:11

The Power of Love (Celine Dion) 5:45

These Dreams (Heart) 4:16

This Is the Time (Billy Joel) 5:01

Time After Time (Cyndi Lauper) 4:01

Total Eclipse of the Heart (Bonnie Tyler) 5:37

Unforgettable (Natalie Cole with Nat King Cole) 3:31

Vision of Love (Mariah Carey) 3:32

What a Fool Believes (The Doobie Brothers) 3:44

When a Man Loves a Woman (Percy Sledge) 2:52

When Will I See You Again? (The Three Degrees) 3:02

You Are so Beautiful (Joe Cocker) 2:42

You Light up my Life (Debby Boone) 3:40

You Make Me Feel Brand New (The Stylistics) 4:47

You're the Inspiration (Chicago) 3:51

WEB SITES

ACME: Action Coalition for Media Education (www.acmecoalition.org)

Alliance for a Media Literate America (www.amlainfo.org)

American Academy of Pediatrics (www.aap.org/family/mediaimpact.htm)

Center for Media Literacy (www.medialit.org)

Children Now (www.childrennow.org/)

Citizens for Media Literacy (www.main.nc.us/cml)

Just Think Foundation (www.justthink.org)

Media Awareness Network (www.media-awareness.ca/english/news/index.cfm)

Media Education Foundation (www.mediaed.org)

Media Education Lab at Temple University (www.reneehobbs.org)

Media Literacy Clearinghouse (medialit.med.sc.edu/)

Media Literacy.com (www.medialiteracy.com)

Media Watch (www.mediawatch.com)

National Telemedia Council (www.nationaltelemediacouncil.org)

New Mexico Media Literacy Project (www.nmmlp.org)

Northwest Media Literacy Center (www.mediathink.org)

Project Look Sharp (www.ithaca.edu/looksharp)

Debra L. Merskin is an Associate Professor and Communication Studies Sequence Coordinator in the School of Journalism & Communication at the University of Oregon. Her Ph.D. (1993) is from the S. I. Newhouse School of Public Communication, Syracuse University, and her Master of Liberal Arts degree (1989) is from the University of South Florida, Tampa. Her research appears in journals such as Journalism & Mass Communication Quarterly, The Howard Journal of Communications, Sex Roles, *and* Journalism Educator, *and in book chapters in* Growing Up Girls, Dressing in Feathers, *and* The Girl Wide Web. *She is currently writing a book on race, gender, and media (Blackwell). She teaches courses in communication and cultural studies; media and society; sex, love, romance, and media; and girl culture and the media. Her personal loves are yoga, dance, Myszka, Nib, Wicker, and above all else and others, her husband Douglas.*

AUTHOR INDEX

SUBJECT INDEX